高等学校建筑类专业英语规划教材

English for Art Design
艺术设计专业

杨豪中 徐 娅 主编

中国建筑工业出版社

图书在版编目(CIP)数据

高等学校建筑类专业英语规划教材 艺术设计专业/杨豪中，徐娅主编. —北京：中国建筑工业出版社，2010.8
ISBN 978-7-112-12200-4

Ⅰ. ①高⋯ Ⅱ. ①杨⋯②徐⋯ Ⅲ.①艺术-设计-高等学校-教材 Ⅳ. ①J06

中国版本图书馆 CIP 数据核字(2010)第 118755 号

　　本书编者经历了多年的艺术设计专业外语课程的教学实践和教学改革，力图把积累的素材综合而又简捷地编写出来，以适应艺术设计专业的教学需求。在教材编写过程中力求反映 21 世纪艺术设计专业的现状和趋势，体现基础理论、基础知识、基本技能；新思想、新内容、新知识、新特点；具备思想性、科学性、先进性、实用性、启发性；以适应艺术设计专业本科教学需求。

　　为把教学素材综合反映出来，适应不同层次的需要，本书采用近似于单元式的结构，全书共分四个单元，即学科背景、艺术设计专业知识、艺术设计专业前沿发展、艺术设计专业设计实践。内容力求精练，处理力求简洁，突出主要思想技巧，尽量避免重复，以达到简捷的目的。这样，在不大的篇幅中既容纳了基本内容，也介绍了思想技巧。

＊　　＊　　＊

责任编辑：张文胜　田启铭
责任设计：李志立
责任校对：王金珠　王雪竹

高等学校建筑类专业英语规划教材
English for Art Design
艺术设计专业

杨豪中　徐　娅　主编
＊
中国建筑工业出版社出版、发行(北京西郊百万庄)
各地新华书店、建筑书店经销
北京天成排版公司制版
北京建筑工业印刷厂印刷
＊
开本：787×1092 毫米 1/16 印张：25¾ 字数：778 千字
2010 年 9 月第一版 2010 年 9 月第一次印刷
定价：**46.00** 元
ISBN 978-7-112-12200-4
　　　(19472)

前　言

众所周知，随着经济的全球化和信息化，英语已成为人们最重要的交际工具，专业英语应用能力也显得越来越重要。专业外语成为高等院校日益重视的专业课程，众多高校都将专业外语作为必修必考内容，但不同专业的专业外语课程教学内容和教学要求有所不同。

编者经历了多年的艺术设计专业外语课程的教学实践和教学改革，试图把积累的素材综合而又简捷地编写出来，以适应艺术设计专业的教学需求。在教材编写过程中力求反映21世纪艺术设计专业的现状和趋势，体现基础理论、基础知识、基本技能；新思想、新内容、新知识、新特点；具备思想性、科学性、先进性、实用性、启发性；以适应艺术设计专业本科教学需求。这是编写本教材的初衷。

艺术设计专业外语与设计实践有紧密联系，因此教材的编写非常重视教材内容的思想性。专业外语教学的目标不仅是学生英语应用水平的提高，而且力求专业视野的扩展和专业知识的累积，本质上说它是扩展学生专业知识领域的重要工具。从这样的思路出发，近年来编者把专业英语应用与设计理论知识融合为一体进行教学。从作者的实践来看，这门综合课程可以较好地体现和实现设计思想与设计实践的交叉、转换和融合。

为把教学素材综合反映出来，适应不同层次的需要，编者采用近似于单元式的结构，使得单元之间逻辑依赖关系不复杂。

这样就可作为几个层次的教材使用，例如（每一个单元约占 16 学时）：

* 学科背景：城市规划、建筑设计、设计管理等专业的 4 个 4 学分课程；包括了土木类设计领域的基本内容和基础知识。

* 艺术设计专业知识：针对艺术设计专业，在上一单元的基础上增加与本专业密切相关的基础知识。

* 艺术设计专业设计实践：本单元的全部内容可作为与专业设计合并开设的 16 学分课程教材。

* 艺术设计专业前沿发展：综合类大学开设的 16 学分课程，帮助学生掌握本专业领域最为前沿的发展趋势和最新的理念观点。

每个单元内各节的安排也有灵活性，例如每一单元的扩展阅读部分完全可以留给学生自己阅读。按笔者的教学实践，学生完成它们后可得到应有的训练。

本书在实现这个整体框架时，内容力求精练，处理力求简洁，突出主要思想技巧，尽量避免重复，以达到简捷的目的。这样，在不大的篇幅中既容纳了基本内容，也介绍了思

想技巧。

　　本书全体编者衷心感谢被引用的各种参考文献的作者，是他们的研究成果奠定了本书的编写基础。在本书的编写过程中，得到了西安建筑科技大学、中国建筑工业出版社和编者所在单位领导的大力支持，在此表示衷心的感谢！同时也要感谢专业外语系列教材各位编者的大力支持与真诚合作。

　　作者虽然工作努力，但实践和认识毕竟有限，本书不足之处在所难免，诚望读者不吝赐教。

<div align="right">

杨豪中　徐娅

2010 年 6 月 6 日

</div>

CONTENS

Part Ⅰ Background Knowladge ·· 1

Intensive Reading ·· 1
 Lesson 1 City Planning ··· 1
 Lesson 2 Functional Considerations of Building Types ·································· 19
 Lesson 3 Soclological and Psychological Aspects ······································· 44
 Lesson 4 The Evolution of Perception ··· 61
Extensive Reading ··· 81
 Art Of The Fifteenth Century ··· 81
 Art After The Renaissance ·· 83
 Abstract And Expressionistic Art ··· 85

Part Ⅱ Basic Theory ·· 88

Intensive Reading ·· 88
 Lesson 5 The Role of the Landscape Designer ·· 88
 Lesson 6 Hard Landscape Design ··· 108
 Lesson 7 Soft Landscape Design ··· 123
 Lesson 8 Visible Landscape ··· 135
 Lesson 9 The Defined Open Space ·· 153
 Lesson 10 The Process of Programming ··· 165
Extensive Reading ··· 186
 Pablo Picasso ··· 186
 Henry Moore——The World's Grandest Old Man of Sculpture ·············· 188
 Henry Matisse ··· 190

Part Ⅲ Academic Frontiers ·· 192

Intensive Reading ··· 192
 Lesson 11 Urban Publicspace: The Role of Squares ································· 192
 Lesson 12 John Notman and Landscape Gardening in Philadelphia ········ 211
 Lesson 13 Garden Cities: Sustainable Design: Past, Present, Future ······ 229
 Lesson 14 Multi-sensory Experience: the Significance of Touch ··········· 246
 Lesson 15 Landscape Planning: a History of Influential Ideas ············· 268
Extensive Reading ··· 290
 How to Write a Data Sheet ·· 290
 Tactics for Job-Hunt Success ·· 293
 Top Ten Tips for Career Fair Success ·· 294

Part Ⅳ　Design Project ··· 297

Intensive Reading ··· 297

Lesson 16　Office Landscape ······························· 297

Lesson 17　Recreate Nature From Debris—Third Millennium Park

in Bogotá, Columbia ······························· 316

Lesson 18　Splendid Sight in the Swedish Estate——Meet the

Requirements of Different Group ····················· 338

Lesson 19　Regeneration of Post-industrial Sites on Sydney Harbour ·········· 366

Lesson 20　Enjoy the Fresh Air in the Limited Space——

Garden in the Slice up House ······················· 386

Extensive Reading ·· 401

Vintage Vienna's Imperial Flavor ························· 401

London Art Galleries ·································· 403

Shanghai Returns to The Pinnacle of Fashion ················· 404

Part I Background Knowladge

Intensive Reading

Lesson 1 City Planning

City planning is the integration of the disciplines of land use planning and transport planning, to explore a very wide range of aspects of the built and social environments of urbanized municipalities and communities. Regional planning deals with a still larger environment, at a less detailed level.

Based upon the origins of urban planning from the Roman era, the current discipline revisits the synergy of the disciplines of urban planning, architecture and landscape architecture.

Another key role of urban planning is urban renewal, and re-generation of inner cities by adapting urban planning methods to existing cities suffering from long-term infrastructural decay.

Asthetic

In developed countries, there has been a backlash against excessive man-made clutter in the visual environment, such as signposts, signs, and hoardings. Other issues that generate strong debate among urban designers are tensions between peripheral growth, increased housing density and planned new settlements. There are also unending debates about the benefits of mixing tenures and land uses, versus the benefits of distinguishing geographic zones where different uses predominate. Regardless, all successful urban planning considers urban character, local identity, respect for heritage, pedestrians, traffic, utilities and natural hazards.

Planners are important in managing the growth of cities, applying tools like zoning to manage the uses of land, and growth management to manage the pace of development. When examined historically, many of the cities now thought to be most beautiful are the result of dense, long lasting systems of prohibitions and guidance about building sizes, uses and features. People enjoy compression. Georgetown, in Washington, D. C. surety one of the most delightful residential areas of our country, has narrow brick homes set wall to wall along its narrow, shaded streets. Its brick walk pavements, often extending from curb to facade, are opened here around the smooth trunk of a sycamore or punched out there to receive a holly, boxwood, a fig tree, or bed of myrtle. In this compact community, where

space is at such a premium, the open areas are artfully endorsed by fences, walls, or building wings to give privacy and to create a cool and pleasant well of garden space into which the whole house opens.

What they missed, what they need, is the compression, the interest, the variety, the surprises, and the casual, indefinable charm of the neighborhood that they left behind. This, in essence, is the appeal of the Left Bank of Paris, of Sam (n) Francisco's Chinatown, of Beacon Hill in Boston. This same charm of both tight and expansive spaces, of delight variety, of delicious contrast, of the happy accident, is an essential quality of planning that we must constantly strive for. And one of the chief ingredients of charm, when we find it, is a sense of the diminutive, a feeling of pleasant compression. Private or community living spar (c) es become a reality only if they and the life within them are kept within the scale of pleasurable human experience.

Safety

Historically within the Middle East, Europe and the rest of the Old World, settlements were located on higher ground (for defense) and close to fresh water sources. Cities have often grown onto coastal and flood plains at risk of floods and storm surges. Urban planners must consider these threats. If the dangers can be localized then the affected regions can be made into parkland or Greenbelt, often with the added benefit of open space provision.

Extreme weather, flood, or other emergencies can often be greatly mitigated with secure emergency evacuation routes and emergency operations centres. These are relatively inexpensive and unintrusive, and many consider them a reasonable precaution for any urban space. Many cities will also have planned, built safety features, such as levees, retaining walls, and shelters.

In recent years, practitioners have also been expected to maximize the accessibility of an area to people with different abilities, practicing the notion of "inclusive design," to anticipate criminal behaviour and consequently to "design-out crime" and to consider "traffic calming" or "pedestrianisation" as ways of making urban life more pleasant.

City planning tries to control criminality with structures designed from theories such as socio-architecture or environmental determinism. These theories say that an urban environment can influence individuals' obedience to social rules. The theories often say that psychological pressure develops in more densely developed areas. This stress causes some crimes and some use of illegal drugs. The antidote is usually more individual space and better, more beautiful design in place of functionalism.

Transport

Very densely built-up areas require high capacity urban transit, and urban planners must consider these factors in long term plans.

Fig. 1-1 Underground station in city

Although an important factor, there is a complex relationship between urban densities and car use.

Transport within urbanized areas presents unique problems. The density of an urban environment can create significant levels of road traffic, which can impact businesses and increase pollution. Parking space is another concern, requiring the construction of large parking garages in high density areas which could be better used for other development.

Good planning uses transit oriented development, which attempts to place higher densities of jobs or residents near high-volume transportation. For example, some cities permit commerce and multi-story apartment buildings only within one block of train stations and multilane boulevards, and accept single-family dwellings and parks farther away.

Floor area ratio is often used to measure density. This is the floor area of buildings divided by the land area. Ratios below 1.5 could be considered low density, and plot ratios above five very high density. Most exurbs are below two, while most city centres are well above five. Walk-up apartments with basement garages can easily achieve a density of three. Skyscrapers easily achieve densities of thirty or more.

City authorities may try to encourage lower densities to reduce infrastructure costs, though some observers note that low densities may not accommodate enough population to provide adequate demand or funding for that infrastructure. In the UK, recent years have seen a concerted effort to increase the density of residential development in order to better achieve sustainable development. Increasing development density has the advantage of making mass transport systems, district heating and other community facilities (schools, health centres, etc) more viable. However critics of this approach dub the densification of development as 'town cramming' and claim that it lowers quality of life and restricts market-led choice.

Fig. 1-2 Blight may sometimes cause communities to
consider redeveloping and urban planning.

Process

The traditional planning process focused on top-down processes where the urban planner created the plans. The planner is usually skilled in either surveying, engineering or architecture, bringing to the town planning process ideals based around these disciplines. They typically worked for national or local governments.

Changes to the planning process over past decades have witnessed the metamorphosis of the role of the urban planner in the planning process. More citizens calling for democratic planning & development processes have played a huge role in allowing the public to make important decisions as part of the planning process. Community organizers and social workers are now very involved in planning from the grassroots level.

Developers too have played huge roles in influencing the way development occurs, particularly through project-based planning. Many recent developments were results of large and small-scale developers who purchased land, designed the district and constructed the development from scratch. The Melbourne Docklands, for example, was largely an initiative pushed by private developers who sought to redevelop the waterfront into a high-end residential and commercial district.

Recent theories of urban planning, espoused, for example by Salingaros see the city as a adaptive system that grows according to process similar to those of plants. They say that urban planning should thus take its cues from such natural processes.

Notes

1. City Plan：城市规划专业英语：
town planning 城镇规划

Gardening＝Landscape architecture 园林＝景观建筑学

Urban landscape planning and design 城市景观规划和设计

Urban green space system planning 城市绿地系统规划

Urban design 城市设计

The cultural and historic planning 历史文化名城

Protection planning 保护规划

Urbanization 城市化

Suburbanization 郊区化

Public participation 公众参与

Sustainable development（sustainability） 可持续发展（可持续性）

Pedestrian crossing 人行横道

Human scale 人体尺寸

Landscape node 景观节点

plazas 广场

Urban redevelopment 旧城改造

Urban revitalization 城市复苏

Visual landscape capacity 视觉景观容量

2. Georgetown, in Washington, D. C

Georgetown is a neighborhood located in the Northwest quadrant of Washington, D. C., along the Potomac River waterfront. Founded in 1751, the city of Georgetown sub-stantially predated the establishment of the city of Washington and the District of Columbia. Georgetown retained its separate municipal status until 1871, when it was assimilated into the District of Columbia. Today, the primary commercial corridors of Georgetown are M Street and Wisconsin Avenue, which contain high-end shops, bars, and restaurants. Georgetown is home to the main campus of Georgetown University and the Old Stone House, the oldest standing building in Washington. The embassies of France, Mongolia, Sweden, Thailand, Venezuela, and Ukraine are located in Georgetown.

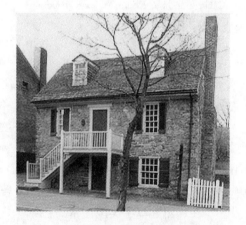

Fig. 1-3 The Old Stone House, 1765, oldest surviving building in Washington, D. C.

乔治镇位于华盛顿特区西北角的波托马克河岸。乔治镇建于 1751 年，实际上要比华盛顿和哥伦比亚特区的建立都早。在 1871 年被并入了哥伦比亚特区以前，乔治镇一直是独立的城市。今日，乔治镇主要的商业街道是 M 大街和威斯康星大道，在那里有商店、酒吧和餐馆。乔治镇大学和老石屋——华盛顿最古老的建筑，以及法国、蒙古、瑞典、泰国和乌克兰的大使馆都位于此地。

Much of Georgetown is surrounded by parkland and green space that serve as buffers from

development in adjacent neighborhoods, and provide recreation. Rock Creek Park, the Oak Hill Cemetery, Montrose Park and Dumbarton Oaks are located along the north and east edge of Georgetown. The neighborhood is situated on bluffs overlooking the Potomac River.

乔治镇到处都是公园和绿色空间，成为了邻近区域发展的缓冲区，为市民提供娱乐休闲空间。石溪公园、橡树丘墓园、蒙特罗斯公园和敦巴顿橡树园沿着乔治镇的北部和东部边缘依次排开。该区域位于可以俯瞰波托马克河的河岸高处。

Georgetown is home to many historic landmarks including：

乔治镇的著名的历史建筑包括：

Fig. 1-4 P Street NW, in Georgetown, features conduit streetcar tracks installed 1890s, but out of use since January 3, 1960 when the Cabin John line, Route 20, was abandoned

Fig. 1-5 While Georgetown's outside looking

- The City Tavern Club, built in 1796, is the oldest commercial structure in Washington, D. C.
- 城市酒馆俱乐部，建于 1796 年，是华盛顿历史最悠久的商业建筑。
- The Chesapeake and Ohio Canal, begun in 1829.
- 乞沙比克—俄亥俄运河，建于 1829 年。
- Dumbarton Oaks, 3101 R Street, NW, former home of John C. Calhoun, U. S. vice president, where the United Nations charter was outlined in 1944.
- 敦巴顿橡树园，R 大街 3101 号，曾是美国副总统约翰·C·卡尔豪的家，1944 年他在那里起草了美国宪章。
- The Forrest-Marbury House, 3350 M Street, NW, where George Washington met with local landowners to acquire the District of Columbia. Currently the Embassy of the Ukraine.
- 福瑞斯特·马布里住宅，M 大街 3350 号，乔治·华盛顿在那里会见了当地的土地拥有者，他们向华盛顿要求建立哥伦比亚特区。现在这所住宅成为了乌克兰大使馆。
- Georgetown Lutheran Church was the first church in Georgetown, dates back to 1769. The current church structure, the fourth on the site, was built in 1914.
- 乔治镇路德教会教堂是乔治镇的第一座教堂，始建于 1769 年。现在的教堂建筑是

第四次在原址重建，建于 1914 年。

- Georgetown Presbyterian Church was established in 1780 by Reverend Stephen Bloomer Balch. Formerly located on Bridge Street（M Street），the current church building was constructed in 1881 on P Street.
- 乔治镇长老教会教堂是 1780 由斯蒂芬·布鲁姆·巴克教士兴建的。原址位于桥街（M 大街），现在的教堂建筑是 1881 年在 P 大街上建造的。
- Healy Hall on Georgetown's campus, built in Flemish Romanesque style from 1877 to 1879 was designated a National Historic Landmark in 1987.
- 乔治镇大学的希利厅，属于罗马风建筑，建于 1877～1879 年，在 1987 年被指定为国家历史地标。
- The Oak Hill Cemetery, a gift of William Wilson Corcoran whose Gothic chapel and gates were designed by James Renwick, is the resting place of Abraham Lincoln's son Willie and other figures.
- 橡树山公墓，由威廉·威尔逊·科科伦资助修建，哥特式的教堂和大门由詹姆士·兰威克设计，那里是阿伯拉罕·林肯的儿子威利等人的安息之所。
- The Old Stone House, built in 1765, located on M Street is the oldest original structure in Washington, D. C.
- 老石宅，建于 1765 年，位于 M 大街，是华盛顿最古老的建筑。

Fig. 1-6　The Forrest-Marbury House

Fig. 1-7　The Chesapeake and Ohio Canal

Fig. 1-8　The City Tavern Club

Fig. 1-9　The Forrest-Marbury House

Fig. 1-10 Georgetown Lutheran Church

Fig. 1-11 ChurchOak Hill Cemetery

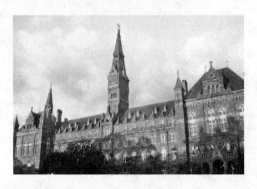

Fig. 1-12 Healy Hall on Georgetown's campus

Fig. 1-13 Georgetown
Presbyterian Church

3. the Left Bank of Paris

Popular sights such as the Eiffel Tower, the Louvre and the Arce de Triumphe may have a lasting appeal.

著名的景观对人们永远有吸引力，比如埃菲尔铁塔，卢浮宫和卡鲁塞尔凯旋门。

Paris's Left Bank romanticised for generations as the hang-out of bohemians, poets, writers and intellectuals in everything from the musical Moulin Rouge to the novels of Ernest Hemingway, still manages to take hold of the imagination.

巴黎的左岸非常浪漫，一直都是波希米亚人、诗人、作家和学者的聚集地，从充满音乐的红磨坊到欧内斯特·海明威的小说，它们仍控制着人们的灵感。

Populated by students, artists and art dealers, who frequent beautiful cafes, corner shops and enticing restaurants, the Left Bank has a local feel. Two Left Bank districts of Paris in particular——the Latin Quarter and St-Germain——stand out as must-see districts to explore.

在左岸住满了学生、艺术家和艺术品商人，他们常常就在美丽的咖啡馆、街边书店和迷人的餐馆中流连，左岸有着独特的感受。巴黎左岸两个特别的地方——拉丁区和圣日耳曼，一定要去看。

Although popular with many tourists, part of the beauty of the Latin Quarter and St-Germain is that they are busy, without leaving you feeling as if you are in a tourist trap.

Every street down which you turn holds something of interest to the inquisitive tourist: a bar frequented by Picasso, or the crypt of a famous philosopher such as Descartes. It is a place where rubbing shoulders with history and experiencing all the romance of the Parisian way of life is unavoidable.

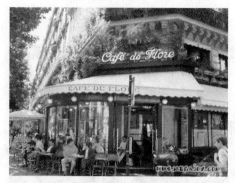

Fig. 1-14　Cafe in Left Bank of Paris　　　Fig. 1-15　Old picture of cafe

虽然到处都是游客，但是拉丁区和圣日耳曼的美丽之处在于它们是繁忙的，没有时间让你感觉到是在旅行。每个街道都会有好奇的游客感兴趣的事：毕加索常常出现的酒吧，或者笛卡尔等著名哲学家住过的地下室。在那里，人们会与历史擦肩而过，不可避免地体验到所有巴黎生活方式的浪漫。

What's more all the sights everyone visiting Paris wants to see——the Louvre, Notre Dame and the Eiffel Tower in particular——are all within easy walking distance.

每个参观巴黎的人想去看的地方——卢浮宫，巴黎圣母院和埃菲尔铁塔——都位于这个可以缓缓步行的区域内。

4. San Francisco's Chinatown

San Francisco's Chinatown is the oldest Chinatown in North America. It is also the largest Chinese Community outside of Asia, according to The New Encyclopaedia Britannica Micropaedia vol. 10, 2007 Ed. Established in the 1850s, it has featured significantly in popular culture venues such as film, music, photography and literature. It is one of the largest and most prominent centers of Chinese activity outside of China.

旧金山的唐人街是北美历史最悠久的中国城。根据《简明不列颠百科全书》（卷 10，2007 版），它也是亚洲以外最大的中国人聚居地。旧金山唐人街建于 19 世纪 50 年代，它最大的特征就是流行文化的聚集地，比如电影、音乐、摄影和文学。它也是中国之外最大和最主要的中国文化活动中心。

Within Chinatown there are two major thoroughfares. One is Grant Avenue, with the famous Dragon gate; St. Mary's Park that boasts a statue of Dr. Sun Yat-Sen; a war memorial to Chinese war veterans; and a plethora of stores, restaurants and mini-malls that cater mainly to tourists. The other, Stockton Street, is frequented less often by tourists, and it presents an authentic Chinese look and feel, reminiscent of Hong Kong, with its produce and fish markets, stores, and restaurants. Chinatown boasts smaller side streets and famed alleyways that also provide an authentic character.

　　唐人街内有两条主要的街道，一条是都板街：著名的龙门、圣玛丽公园中的孙中山的雕像、战争纪念碑以及很多的书店、餐馆和小型商场都位于此地，它们主要为游客售卖商品。另一条是市德顿街，游客较少，呈现出一种浓烈的中国外观和感受，令人想起香港——那里的产品和鱼市、商店和餐馆。唐人街其他较小的街道和著名的小巷也是如此。

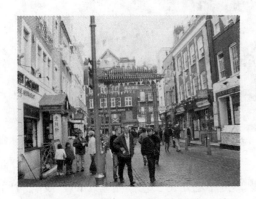

Fig. 1-16　San Francisco's Chinatown

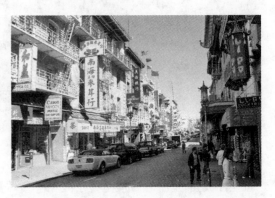

Fig. 1-17　San Francisco Chinatown is the Western Hemisphere's largest Chinatown

Another major focal point in Chinatown is Portsmouth Square. Due to its being one of the few open spaces in Chinatown, Portsmouth Square bustles with activity such as Tai Chi and old men playing Chinese chess. A replica of the Goddess of Democracy used in the Tiananmen Square protest was built in 1999 by Thomas Marsh, and stands in the square. It is made of bronze and weighs approximately 600lb (270kg).

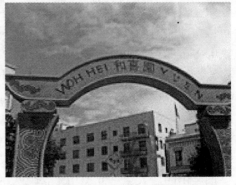

Fig. 1-18　Woh Hei Yuen Park located in San Francisco's Chinatown

　　唐人街的另一个焦点是朴次茅斯广场。由于它是唐人街仅有的开放空间，朴次茅斯广场总是在举行活动，比如太极拳，老人们下中国象棋。1999年马世通在天南门的朴次茅斯广场建造了民主女神的复制品，这座雕像站立在广场之中，由青铜铸成，大约270kg。

List of parks in Chinatown

- Portsmouth Square—花园角广场；
- Chinese Playground—华人游乐场；
- Woh Hei Yuen Park—和喜园；
- St. Mary's Square—圣玛丽公园。

5. Beacon Hill in Boston

Beacon Hill is a 19th-century downtown Boston residential neighborhood situated directly north of the Boston Common and the Boston Public Garden. Most people think of

city living as anonymous and isolating. But this cozy enclave, filled with nearly 10000 people, is more like a village than an anonymous city. It has a rich community life, with neighbors knowing neighbors and everyone meeting on the Hill's commercial streets and at its myriad activities.

比根山区在 19 世纪是波士顿的中心，位于波士顿中心绿地公园的北部。绝大多数人认为在城市中居住是孤独的。但是居住了接近 1 万人的比根山区，更像是乡村而非城市。这里有丰富的社区生活，邻居们相互熟悉。

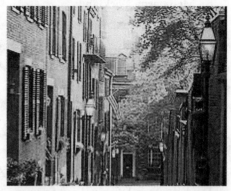

Fig. 1-19 brick row houses in Beacon Hill

Approximately one-half mile square, Beacon Hill is bounded by Beacon Street, Bowdoin Street, Cambridge Street and Storrow Drive. It is known for its beautiful doors and door surrounds, brass door knockers, decorative iron work, brick sidewalks, perpetually - burning gas lights, flowering pear trees, window boxes, and hidden gardens. Its architecture, mostly brick row houses, includes the Federal, Greek Revival and Victorian periods, as well as early 20th-century colonial revival homes and tenements. The architecture is protected by restrictive regulations that allow no changes to any visible part of a structure without the approval of an architectural commission.

比根山区面积大约 1.5 平方英里，以灯塔街、波登街、剑桥街和斯多若车道为界，以美丽的大门和环境而闻名：黄铜的门钹，装饰的铁艺，砖铺的小路，永远燃烧的汽灯，开满鲜花的树木以及隐藏其后的花园。那里的建筑大都是砖砌的联排住宅，包括联邦式、希腊复兴式和维多利亚式，还有 20 世纪早期的殖民地式住宅。建筑受到了严格的立法保护，不经过建筑委员会批准禁止对其外露的部分做任何改变。

Fig. 1-20 early 20th-century
colonial revival home

Beacon Hill contains a South Slope, a North Slope and a Flat of the Hill. Charles Street is the neighborhood's main street and is filled with antique shops and neighborhood services. The Massachusetts State House is at the top of the Hill overlooking Boston Common.

比根山区包括南坡、北坡和山顶区。查尔斯街是当地主要的街道，布满了古董店和社区服务设施。马萨诸塞州州政府就位于比根山顶。

6. Melbourne Docklands

Docklands (also known as Melbourne Docklands to differentiate it from London Docklands) is an inner city suburb in Melbourne, Victoria, Australia occupying an area adjacent to Melbourne's Central Business District (CBD).

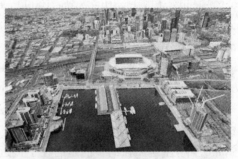

码头区(也称墨尔本码头区,为的是和伦敦码头区有所区别)是澳大利亚维多利亚区墨尔本市的市内区域,位于墨尔本中央商务区附近。

Docklands is bounded by Spencer Street, Wurundjeri Way and Charles Grimes bridge to the east, CityLink to the west and Lorimer Street across the Yarra to the south.

码头区向东到达斯潘塞街,乌兰德杰瑞路和查尔斯格里姆斯大桥,向西到达市际公路,向南到达跨越亚拉河的劳瑞姆大街。

Docklands is a primarily waterfront area centred around the banks of the Yarra River. The area is the product of an ongoing urban renewal project to extend the area of the CBD (excluding Southbank and St Kilda Road).

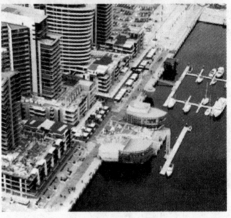

Fig. 1-21 Melbourne Docklands

码头区主要集中在亚拉河两岸的滨水区域。这里的发展是正在进行的延伸中央商务区城市复兴项目的结果(不包括南岸和圣科达路)。

Docklands includes the Melbourne landmarks Etihad Stadium, Southern Cross Station and the Southern Star Observation Wheel.

在码头区,有墨尔本的地标建筑——阿提哈德体育场、南十字星车站和南星观景摩天轮。

From the 1880s, the Docklands were used for docks, rail infrastructure and industry but mostly fell out of use following the containerisation of shipping traffic. The space remained vacant and unused during the 1980s and it fell in to disrepair. Docklands became notable during the 1990s for its underground rave dance scene, a dance culture which survives through popular organised events held at Docklands Stadium.

19 世纪 80 年代以来,码头区到处都是码头、铁路设施和工业区,但绝大多数已经改为轮船装卸货物的场所。20 世纪 80 年代,这里仍然到处是废弃破败的空地。码头区在 20 世纪 90 年代开始以其地下狂欢舞蹈而闻名;这是一种在码头区体育馆中举行大众活动所产生的舞蹈文化。

The stadium (then known as Colonial Stadium) in 1996 was built as a centrepiece to kick-start developer interest in Docklands. Urban renewal began in 2000 as a collection of several independent but themed developments with staged development milestones. The

project was tendered out and overseen by VicUrban, an agency of the State government of Victoria. The brief for the master plan was for wide open water promenades and road boulevards with contributions of landscaping and public art commissions to be made by each developer. VicUrban promotes its vision of Docklands as having a future (2015) residential population of 20000. Docklands as a tourist attraction with 20 million visitors a year.

体育馆(也被称为殖民地露天运动场)在 1996 年建造,是码头区发展之初感兴趣的发展商们所修建的重要建筑。2000 年开始的城市复兴项目带来了许多独立但有共同主题的发展,成为码头区阶段性发展的里程碑。这些项目接受维多利亚州政府城市发展部管理和控制。总平面设计纲要提供了开阔的开放水道和林荫大道,对每个发展商都规定了景观和公共艺术项目方面的限制。城市发展部提出码头区未来(2015 年)人口将达到 2 万人。码头区每年吸引了 2000 万游客来此旅游。

Despite being almost completely redeveloped, Docklands does retain a handful of significant heritage buildings mostly related to the area's industrial and maritime history. Most of the heritage buildings remaining on the site have been redeveloped and integrated into the development or will be in future.

尽管绝大多数区域完全是重新建造的,码头区仍保留了许多重要的、与地区工业和航海时代相关的历史建筑。绝大多数历史建筑保留在了已经重新建设基地中,并与现今或未来的发展规划相融合。

Docklands has become a sought-after business address, attracting the national headquarters of National Australia Bank, ANZ, Medibank Private, Bureau of Meteorology, Myer, National Foods as well as the regional headquarters for AXA Asia Pacific, Ericsson and Bendigo Bank. The Business Park model of large low-rise campus-style office buildings combined with transport and proximity to city centre is seen by many in the real estate industry to be one of the reasons behind the success of the Docklands office market.

码头区已经成为了受到追捧的商业区,吸引了澳大利亚国家银行、ANZ 银行、私人健康医疗保险公司、气象局、Myer 百货公司、天然食品有限公司的国家总部以及法国安盛保险集团亚太地区,爱立信公司和本迪戈银行地区总部的进驻。商务公园模式的大量低层校园风格办公楼,便利的交通和靠近市中心的地理位置,被许多房地产产业视为码头区办公楼市场获得成功的原因之一。

While still incomplete, Docklands developer-centric planning has been widely criticised and many Melbourne politicians and media commentators lament its lack of green open space, pedestrian activity, transport links and culture.

在建设没有完成之前,码头区的发展中心规划就已经受到了广泛的批评,许多墨尔本政治家和媒体评论员哀叹其缺乏绿色开放空间、步行活动、交通联系和文化。

7. Salingaros

Nikos A. Salingaros (born in Perth, Australia) is a mathematician and polymath known for his work on urban theory, architectural theory, complexity theory, and design philosophy. He has been a close collaborator of the architect and computer software pioneer Christopher Alexander, with whom Salingaros shares a harsh critical analysis of con-

ventional modern architecture. Like Alexander, Salingaros has proposed an alternative theoretical approach to architecture and urbanism that is more adaptive to human needs and aspirations, and that combines rigorous scientific analysis with deep intuitive experience.

尼科斯·A. 萨林加罗斯（出生于澳大利亚的珀斯）是以城市理论、建筑理论、复杂性理论和设计哲学而著名的数学家和学者，他是建筑师和计算机软件专家克里斯托弗·亚历山大亲密的合作者，萨林加罗斯和他一起对传统意义上的现代建筑进行严厉批评。和亚历山大一样，萨林加罗斯也提出了对建筑学和城市规划理论的改变——更为重视人类的需求和期望，运用演进的科学分析人类直觉体验。

Salingaros published substantive research on Algebras, Mathematical Physics, Electromagnetic Fields, and

Fig. 1-22　Nikos A. Salingaros

Thermonuclear Fusion before turning his attention to Architecture and Urbanism. Salingaros still teaches mathematics, and is Professor of Mathematics at the University of Texas at San Antonio. He is also on the Architecture faculties of universities in Italy, Mexico, and The Netherlands.

萨林加罗斯对代数、数学物理和电磁学领域进行了研究，在对热核巨变的研究之后又转向了建筑学和城市规划。萨林加罗斯至今仍然教授数学，是德州大学圣安东尼奥分校的数学教授。他也是意大利、墨西哥和荷兰等国大学的建筑学教授。

Vocabulary

1. avenue　*n.* 林荫路；道路；通路：an avenue to success 成功之路 | an avenue of escape 逃路 | Books are avenues to knowledge. 书是通向知识的道路。| The best avenue to success is hard work. 勤奋是最佳的成功之道。

［近义词］way, route, road, course, path, pathway, opportunity, chance, access, approach, gateway, outlet, passage

［辨析］**avenue 大街、林荫路**：指长而广阔的街道，两旁有树或华丽的住宅，可用作比喻，如达到某种目的或目标的途径。

The avenue to success is hard work. 获得成功的最好办法就是努力工作。

way 道路：系最普通的用词。

There is a way under trees. 树下有一条路。

lane 小路、巷：指狭窄的乡间小道或城市中两旁房屋间的小巷。

There are many country lanes in English. 在英国有许多乡间小道。

path 小路：指被践踏而成的只供人行走的小路。

The path up the hill is steep. 到山上去的小路很陡。

road 道路：指可通车辆的广阔平坦的大路。

The road is now opened for traffic. 这条路现在可以通行。

2. extent　*n.* ①长度；宽度；广度；大小　②（一片）地区　③程度，分量，范围，

界限，限度：the full extent of the Sahara desert 撒哈拉大沙漠的广阔｜What is the extent of your garden? 你的花园有多大？｜see full extent of the park 看到公园的整个范围｜a vast extent of land 辽阔的土地

［短语］to a great extent　大部分

to some extent　在某种程度上

to such an extent that　达到那种程度以至

to the full extent of　充分地，最大限度地，在尽可能范围内

to the least extent　极少地，最低地

［近义词］distance，length，range，area，amount，bounds，degree，reach，scope，size，sphere，spread，stretch，width，volume，breadth，bulk，compass，dimension，duration，expanse，measure，quantity，sweep，term

［辨析］**extent** 程度、范围：可指长度或区域，也可指广阔和渊博。

From the roof you can see the full extent of the park.　从屋顶上你可以看到公园的全景。

distance 距离：指两点或两地间的距离。

The distance from the farm to the city is ten miles.　农场和市镇相距十英里。

length 长、长度：指空间两端间的长度，或指时间的长短。

The room is twenty feet in length.　这房间长二十英尺。

range 范围、界限：指两极限间的距离。

His reading is is a very wide range.　他阅读的范围很广。

3. holly boxwood fig tree turf

holly　*n.*　冬青树

boxwood　*n.*　黄杨木

fig tree　*n.*　无花果树

turf　*n.*　草皮；草根土；草地

4. vista　*n.*　①（从两排树木或房屋等中间看出去的）狭长的景色；远［深］景 ②（树木、房屋等）排成列的景色，林荫路：a vista of the lake 湖的远景　shady vista of elms 夹道遮荫的榆树

5. spaciousness　*n.* 空间感

6. monotonous　*adj.*　①单调的；无变化的：absolutely monotonous 绝对单调的 ②因单调而使人厌倦的：a monotonous task　单调而使人厌倦的工作

［近义词］boring，humdrum，dull，tedious，tiresome，wearisom，routine，flat，unvaried，repetitive，uninteresting，irksome

［辨析］**monotonous** 单调的：指因单调而无兴趣。

He is leading a monotonous life.　他过着单调的生活。

boring 令人厌倦的：指令人讨厌的。

She has a boring face.　她有一张令人讨厌的面孔。

humdrum 单调的：指平凡无味的或枯燥而无生气的。

Life seemed humdrum to him.　生活在他看来似乎单调无味。

Sentence

Another key role of urban planning is urban renewal, and re-generation of inner cities by adapting urban planning methods to existing cities suffering from long-term infrastructural decay.

城市规划的另一个关键作用是实现城市复兴，并且通过运用城市规划方法而使长期处于基础设施衰败的现有城市中心区再次重生。

What they missed, what they need, is the compression, the interest, the variety, the surprises, and the casual, indefinable charm of the neighborhood that they left behind. This, in essence, is the appeal of the Left Bank of Paris, of San Francisco's Chinatown, of Beacon Hill in Boston.

人们所失去的、需要的，正是紧凑感、趣味性、多样性、新奇性和偶然性，是他们以前所生活的居住区难以描绘的迷人魅力。从本质上来说，这就是巴黎塞纳河左岸、旧金山中国城、波士顿比根山区的吸引人之处。

Private or community living spaces become a reality only if they and the life within them are kept within the scale of pleasurable human experience.

只有保持在令人舒适的人类体验尺度之内，私密性和社会生活空间以及其中的生活才能实现。

Translation

第 1 课　城　市　规　划

城市规划是土地使用规划和交通规划学科的综合，研究城市非常广泛的建筑和社会环境的各个方面。区域规划则处理更广大的环境，相对细节层面较少。

基于古罗马时代的城市规划思想起源，当今学科重新开始研究城市规划、建筑学和景观建筑学的协同作用。

城市规划的另一个关键作用是实现城市复兴，并且通过运用城市规划方法而使长期处于基础设施衰败的现有城市中心区再次重生。

美观

在发达国家，视觉环境中存在人为的环境混乱问题，比如路标，标志和警示系统。城市设计师之间产生激烈争论的问题还包括城市边缘发展、住宅密度增加和规划新居住点之间的紧张关系；居住和土地使用功能混合与划分不同功能的地理分区之间也有无止境的争论。无论如何，所有成功的城市规划都考虑到了城市特征、当地特性、对历史遗产的尊重、步行者、交通、基础设施和自然危机。

在管理城市方面，城市规划师是很重要的，他们运用分区等方法来管理土地的使用，以及控制城市发展的速度。从历史角度看，现在许多被认为是最美丽的城市都是控制密度以及使用长期有效的建筑尺度、用途和特征管理法令和导则系统的结果。人们欣赏紧凑。华盛顿特区的乔治镇，绝对是美国最令人愉悦的居住区之一，狭长的砖住宅沿着狭窄、荫蔽的街道一个紧挨一个。砖铺的小路常常从路边一直延伸到门前，这些小路或者直接与种

着埃及榕的平滑干道相接，或是以冬青、黄杨、无花果树、加州桂与干道相隔。在这种紧凑社区中，空间是如此的优质，开放区域巧妙地以篱笆、墙体或建筑两翼围合，在户外的花园空间中创出私密性和安静的、令人愉悦的深邃。

人们所失去的、需要的，正是紧凑感、趣味性、多样性、新奇性和偶然性，是他们以前所生活的居住区难以描绘的迷人魅力。从本质上来说，这就是巴黎塞纳河左岸，旧金山唐人街、波士顿比根山区的吸引人之处。既紧凑又向外扩张的空间同样迷人，因为具有令人愉悦的多样性，令人赏心悦目的对比，令人快乐的偶然性，是我们必须不断追求的规划设计的基本特性。我们发现，缩小的感觉、令人愉快的收敛感觉是吸引人的主要因素之一。只有保持在令人舒适的人类体验尺度之内，私密性和社会生活空间以及其中的生活才能变成现实。

安全

在中东、欧洲和其他古老地区，定居点位于较高地面（为了防御），并接近新鲜的水源。城市常常是在滨海和洪水泛滥的平面上发展形成，冒着被洪水和暴风雨侵袭的危险。城市规划师必须考虑到这些危险。如果危险是局部性的，那么受影响的区域可以规划成公园用地或绿化带，这样又可以增加开放空间面积。

极端天气、洪水或其他紧急状况往往通过紧急状态安全疏散路线和应急中心来获得彻底解决。这种做法成本相对廉价并且不具打扰性，许多规划师将它们作为所有城市空间的合理预防措施。许多城市也规划和建造了安全设施，比如河的堤岸、防护墙和庇护所。

最近几年，规划师也期望实现不同层次的人群在同一区域内最大限度地相融，实现"兼容设计"概念，以此来减少犯罪行为和"设计消除犯罪"，并且考虑将"交通阻碍"或"步行系统"作为使城市生活变得更愉快的方法。

城市规划尝试以社会建筑学或环境决定论等理论来指导能够控制犯罪行为的城市结构设计。这些理论认为城市环境可以影响个人对社会规则的服从，并且提出密度更高的发达区域往往造成更大的心理压力。这种压力会引起一些犯罪和滥用药物等社会问题。解决方法往往是在功能主义场地中引入更为私人的空间和更好、更美观的设计。

交通

城市区域内的交通呈现出独特的问题。城市环境的密度可能带来严重的道路交通问题，甚至可能影响商业和增加污染。另一个关注点是停车空间——需要在高密度区域中建造大量的车库。

优秀的城市规划通过转变发展方向，尝试将密度更高的工作和居住放置在大容量交通附近。例如，一些城市规划将商业和多层公寓修建在有火车站和多线道林荫大道地段内，并在稍远的位置放置单体住宅和公园。

城市规划常常用容积率来测算密度。容积率等于建筑面积除以占地面积。普遍认为1.5以下的比率是低密度，高于5则是高密度。绝大多数远郊地区的占地率都在2以下，而绝大多数市中心都超过了5。有地下车库的无电梯公寓很容易就达到3的密度。而摩天大楼很容易就达到30以上的密度。

虽然一些观察家注意到低密度可能无法满足全部人口的基础设施需求，但是城市管理部门仍然鼓励降低城市密度以减少基础设施费用。在英国，最近几年实施了增加居住密度的努力，目的是更好地获得可持续发展。不断提高发展密度胜于创造大量的交通系统，区

域制热和其他社会设施(学校,健康中心,等等)。然而,这种方法的反对者们提出发展的增密会造成"城镇拥堵",并降低生活质量和限制市场导向的选择。

程序

传统的城市规划大多是从上至下的过程,由城市规划师制订规划。规划师往往是在调查研究、工程学或者建筑学方面专家,基于这些学科理念提出城市规划程序。他们大多是国家或地方政府的工作人员。

过去几十年规划程序的改变已经见证了城市规划师在规划程序中角色的转变。更多的市民呼吁民主的规划和大众在城市规划发展程序中起重要作用,要求允许公众制定重要的规划决策。

发展商们通过项目规划设计,在影响城市发展方式方面起到了巨大的作用。最近许多城市发展都是大型或小型发展商们所造成的,他们购买土地,设计区域并仓促建造。例如墨尔本码头区,是寻求将滨河区域重新发展为高端居住和商业区的私人发展商们所修建起来的。

最近萨林加罗斯等人提出的城市规划理论,将城市视为一种自适应系统,其发展过程类似于植物的生命系统。因此城市规划能够从这种自然过程中寻找到线索。

Lesson 2　Functional Considerations of Building Types

Architectural programming is the development of a spatial organization, given the limitations of a specific situation that represents an optimum environment for the activities of people. This process is based on the space requirements of the human body, thus on its dimensions and proportions. Therefore buildings and spaces that show little relationship to the human scale are known to cause stress and other discomfort.

The specific quality of an architectural design can always be related to the elements of its principal use. The task of architect consists of collecting and processing information about this use and defining the resulting functions of the building. To avoid reinventing the wheel with every new people, the architect must be familiar with the inventory of general building types and their functional characteristics.

Schools

Schools are for learning, which involves much more than the passing on of information from teachers to students. In schools, children learn how to live in groups other than families, and their introduction into social life should happen in a human, warm, and natural environment. Many schools that are organized efficiently in terms of teaching show few of the qualities above.

The architect must define the program in collaboration with the school board and also with various community groups, because many schools have adult evening classes, public performances, and meetings, and school recreational facilities may serve the whole community. In addition to the conventional approach, many schools use team teaching and other alternatives, which all require increased space and greater flexibility.

The optimum classroom capacity depends on the grade and subject, ranging from 20 pupils in first grade to an art class in high school with over 50 students. Typical floor areas of classrooms are between 700 and 1100 square feet. Noise aversion is a major factor in the arrangement of classrooms, but the single most important consideration in school design is life safety. A school building requires higher safety standards than do must other projects.

Since most schools today are experimenting with new ways of teaching and with creative play activities, flexibility has become a very important design factor. The typical classroom unit often gives way to organization patterns of small groups that change to the activities of the class.

Housing

The volume of residential construction is always greater than the total volume of all

other building types combined. Dwelling units have taken an endless variety of shapes, from tents to high-rise apartments; yet their functional problems complex that each design poses a new challenge to the architect.

The conventional house organizes the maim functions into separate rooms but since the activities of a household follow the general pattern only vaguely, great flexibility is required. Children, for great many functions as they grow up, and even a bathroom, which seems to have a clear functional definition, may be used for such activities as laundering and exercising, or even serving as a darkroom.

The functional questions to be addressed in planning a dwelling unit are, how much space do people need, and how can spaces be arranged for optimum circulation patterns? Certain relationships have become conventional standards. Bedrooms, for instance should have direct access to bathrooms, dining areas and kitchens need to be together, the outdoors should be accessible from the living room. And so on.

Furniture types and combinations are greatly standardized in our society, as are the tolerances for spacing them. Although people are not aware of the actual dimensions, we tend to feel uncomfortable in a dining area that has less than 2 feet of table space per person or less than 2 feet of clearance between the chairs and the wall.

Multifamily living, in apartments or condominiums is becoming the dominant form of housing in our cities. Multifamily units are a result of the need for greater economy, which can be served by using repetitive modules, simple unit outlines that minimize party walls, and high ratio of interior volume to exterior wall area. Access and circulation are more complex in multiple dwelling projects, and there is a need for such additional areas as corridors, lobbies recreation rooms, and service facilities. Economy of circulation can be achieved by placing small units with greater night traffic close to access points and large family unites at the corners of the structure. This arrangement also reduces the length of hallways and increases the window area of Large units. Bathroom and kitchen units will need less in the way of mechanical services if they can be placed back to back. In high rise apartment buildings the ground floor serves a multitude of functions, becoming the central area of the project and the element that links the indoors to the out-door space.

Notes

1. Human Body Human Scale 人体 人体尺度
Human scale means "of a scale comparable to a human being".
人类尺度就是：“与人类相比较的尺度”。

A number of characteristic physical quantities can be associated with the human body, the human mind, and the preservation of human life.
许多人类特有的身体物理参数可以与人体、人类思想和人类生命的防护联系起来。

- Distance: one to two metres (human arm's reach, stride, height);

- 距离：1~2 米(人类手臂范围、跨距和高度)；
- Attention span：seconds to hours；
- 注意范围：秒到小时；
- Lifespan：approximately seventy years；
- 寿命：大约 70 年；
- Mass：kilogrammes；
- 体重：公斤；
- Force：newtons；
- 力量：牛顿；
- Pressure：one standard atmosphere；
- 压力：标准大气压；
- Temperature：around 300K（room temperature）。
- 温度：大约 300K(房间温度)。

Fig. 2-1 Human scale

Science vs. human scale
科学和人类尺度

Many of the objects of scientific interest in the universe are much larger than human scale (stars, galaxies) or much smaller than human scale (molecules, atoms, subatomic particles).

科学领域感兴趣的宇宙物体大多远大于人类尺度(星星、星系)或者远小于人类尺度(分子、原子、亚原子粒子)。

Similarly, many time periods studied in science involve time scales much greater than human timescales (geological and cosmological time scales) or much shorter than human timescales (atomic and subatomic events).

类似地，许多科学研究的时间尺度远长于人类的时间尺度(地质和宇宙论时间尺度)，或者远远短于人类时间尺度(原子和亚原子时间尺度)。

Mathematicians and scientists use very large and small numbers to describe physical quantities, and have created even larger and smaller numbers for theoretical purposes.

数学家和科学家使用非常大或小的数字来描述物理参数，为理论研究甚至创造了更大和更小的数字。

Human scale in architecture
建筑的人类尺度

Humans interact with their environments based on their physical dimensions, capabilities and limits. The field of anthropometrics (human measurement) has unanswered questions, but it's still true that human physical characteristics are fairly predictable and objectively measurable. Buildings scaled to human physical capabilities have steps, doorways, railings, work surfaces, seating, shelves, fixtures, walking distances, and other features that fit well to the average person.

人类与环境相互影响的基础是人类的实际尺寸、能力和限制。人体测量学领域仍然有许多至今仍无法回答的问题，但是可以肯定的是，人类的物理特性必然具有相当的可预知性和真实测量性。能够测量人类物理能力的建筑元素有踏步、走廊、栏杆、工作面、座

位、架子、固定物、步行距离以及其他可以很好地适应普通人的其他设施。

Humans also interact with their environments based on their sensory capabilities. The fields of human perception systems, like perceptual psychology and cognitive psychology, are not exact sciences, because human information processing is not a purely physical act, and because perception is affected by cultural factors, personal preferences, experiences, and expectations. So human scale in architecture can also describe buildings with sightlines, acoustic properties, task lighting, ambient lighting, and spatial grammar that fit well with human senses. However, one important caveat is that human perceptions are always going to be less predictable and less measurable than physical dimensions.

人类通过感官能力对环境产生相互影响。人类感知系统研究领域，就如感知心理学和认知心理学，并不是精密的科学，因为人类信息传递过程不是纯粹的物理行为，感知受到了文化因素、个人背景、体验和期望的影响。于是建筑学的人类尺度研究领域中，也可以用视线、声学特性、聚光、漫射光和空间语汇这些很适合人类感受的概念来描绘建筑。然而，一个重要的问题是人类感受常常不能像实际尺寸一样可以预知和测量。

Human scale in architecture is deliberately violated：

下列情况下有意违背建筑学中的人类尺度：

- for monumental effect. Buildings, statues, and memorials are constructed in a scale larger than life as a social/cultural signal. The extreme example is the Rodina (Motherland) statue in Volgograd (Stalingrad).

- 为了获得雄伟的效果。建筑物、雕塑和纪念碑以更大的尺度建造，作为社会/文化的标志，极端范例是伏尔加格勒的 Rodina(祖国)雕像。

- for aesthetic effect. Many architects, particularly in the Modernist movement, design buildings that prioritize structural purity and clarity of form over concessions to human scale. This became the dominant American architectural style for decades. Some notable examples among many are Henry Cobb's John Hancock Tower in Boston, much of I. M. Pei's work including the Dallas City Hall, and Mies van der Rohe's Neue Nationalgalerie in Berlin.

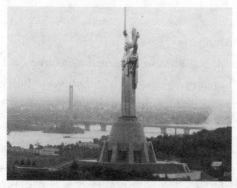

Fig. 2-2 Rodina (Motherland) statue

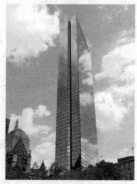

Fig. 2-3 John Hancock Tower in Boston

- 为了美学效果。许多建筑师，特别是现代主义建筑师，设计的建筑强调结构的纯粹性和形式的清晰性，这些完全盖过了人类尺度。数十年中这种风格一直都在美国建筑中占据主流。一些著名的范例包括：亨利·考伯设计的波士顿约翰汉考克大厦，贝聿铭的大部分作品（如达拉斯市政厅）以及密斯·凡·德罗的柏林新国家画廊。

- to serve automotive scale. Commercial buildings that are designed to be legible from roadways assume a radically different shape. The human eye can distinguish about 3 objects or features per second. A pedestrian steadily walking along a 100-foot (30-meter) length of department store can perceive about 68 features; a driver passing the same frontage at 30mph (13m/s or 44ft/s) can perceive about six or seven features. Auto-scale buildings tend to be smooth and shallow, readable at a glance, simplified, presented outward, and with signage with bigger letters and fewer words. This urban form is traceable back to the innovations of developer A. W. Ross along Wilshire Boulevard in Los Angeles in 1920.

- 为汽车行进的尺度服务。从道路可以清晰认知的商业建筑设计往往具有与众不同的形体。人类眼睛每秒可以区分大约 3 个物体或特征。沿着 100 英尺（30 米）的商业大楼稳速步行可以感受到大约 68 个特征；相同路段以 30 里/小时（13 米/秒或 44 英尺/秒）开车经过可以感受到 6 或 7 个特征。汽车行进尺度的建筑物往往是平滑的；在一瞥之间就可以认知；简单；表达一种外向型；有着字体很大、话语很少的标牌。这种城市形式可追溯到 A. W. 罗斯 1920 年在洛杉矶威尔谢大道的改革。

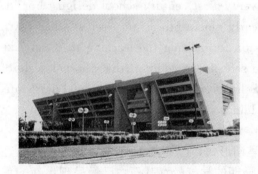

Fig. 2-4 the Dallas City Hall

Fig. 2-5 · Neue Nationalgalerie in Berlin

Human body

- Human body features. 人体特征。
- The human body is the entire physical and mental structure of a human organism.
- 人体是指人类生物体完整的物理和精神结构。
- The average height of an adult male human is about 1.8m (6 feet) tall and the adult female about 1.6 to 1.7m (5 to 5.5 feet) tall. This size is firstly determined by diet and secondly by genes. Body type and body composition are influenced by postnatal factors such as diet and exercise.

- 成年男性的平均高度是 1.8 米左右，成年女性是 1.6～1.7 米左右。这一尺寸首先受饮食的影响，其次受基因的影响。身体类型和身体构成受饮食和锻炼等后天因素的影响。

- The human body consists of a head, neck, torso, two arms and two legs.

- 人体由头部、颈部、躯干和四肢构成。

- By the time the human reaches adulthood, the body consists of close to 100 trillion (100000000000000) cells, the basic unit of life. Groups of cells combine and work in tandem to form tissue, which combines to form organs, which work together to form organ systems.

- 随着时间的流逝人体发育成熟，大约由接近 100 万亿个细胞——生命的基本单位构成。细胞群相互结合在一起形成组织，组织形成器官，器官形成生命系统。

- The organ systems of the body are: the Musculoskeletal system, the Cardiovascular system, the Digestive system, the Endocrine system, the Integumentary system, the Urinary system, the Lymphatic system, the Immune system, the Respiratory system, the Nervous system, and the Reproductive system.

- 身体的各系统包括：骨骼系统、心血管系统、消化系统、内分泌系统、体壁系统、泌尿系统、淋巴系统、免疫系统、呼吸系统、神经系统和生殖系统。

2. School Design　学校设计

Trends in shool design　学校设计倾向

Many of the principles for site and building organization have evolved from earlier forms but have taken on new significance in twenty-first century school design. For instance, neighborhood schools, a cornerstone of early nineteenth century schools has taken on new significance. There is a new emphasis on formalizing the learning that can take place within the surrounding community of the school. In addition, the size and scale of school buildings is being seriously challenged. Schools are becoming smaller and more intimate in many urban school centers. Finally, buildings are being organized in ways that help transition from smaller home environments that are safe, secure and inviting.

许多学校的基地和建筑布置原则都发展自早期形式，但是在 21 世纪，学校设计已经呈现出新的内容。例如，社区学校——19 世纪早期的学校教育基石，已经呈现出新的重要性。人们开始强调学校周围社区内所发生的学习。另外，学校建筑的规模和尺度受到了极大的挑战。学校建筑在许多城市变得更小和更亲切。最终，建筑组织的目的变成了能够帮助学校转变为安全、亲切的小型家庭环境。

Plan Schools as Neighborhood-Scaled Community Learning Centers
将学校设计为邻里尺度的社区学习中心

The potential exists to transform the traditional school building into a community-learning center that serves the educational needs of the entire population in the community. Typically, a community-learning center can be created by interlacing residential neighborhoods, various existing community and school organizations, functions and facilities. The

community school most often functions as a cohesive facility or network of closely adjacent facilities. Locating the community-learning center in neighborhoods will provide a symbolic identity for that community. Facilities that are close to the neighborhoods of the children they serve provide opportunities for children to walk and bike with the added public health benefit of increasing their physical activity, rather than relying on more costly modes of transportation. Community schools often will provide a variety of services, at flexible schedules, accessible by people of different backgrounds. By providing facilities accessible for the entire community, the center will create increased involvement and awareness of the value of education (Warner & Curry, 1997). School facilities that act as true community centers serve the broader societal goals of providing the setting for meaningful civic participation and engagement at the local level.

传统的学校建筑具有转变为社区学习中心的潜力，以满足社区内全体居民的学习教育需求。一般来说，一座社区学习中心可以通过相互交织在一起的居住邻里、各种各样现有的社区和学校组织、功能和设施来产生。社区学校最常见的功能是将附近的设施汇聚在一起。在邻里中设置社区学习中心将为社区提供象征性的身份认知。邻里附近的儿童设施可以为孩子提供散步和骑车的场所，增加他们的活动，增进公共健康，而不是依靠更昂贵的交通运输到很远的地方进行活动。社区学校常常提供各种各样的服务，有灵活的计划，易于不同背景的人们接受。通过提供整个社区可利用的设施，中心将创造不断增加的参与性和人们对教育价值的认识。通过在社区层次提供有意义的市民参与，作为社区中心的学校设施可以实现更广泛的社会目标。

Fig. 2-6 Neighborhood-Scaled Community Learning Center

Plan for Learning to Take Place Directly in the Community
为直接发生在社区的学习设计

A variety of social and economic factors have created an environment in which many educators recognize that learning happens all the time and in many different places. The school building is just one place learning takes occurs. While the school building is often perceived as a community center, the idea of embracing the whole community as a learning

environment has evolved in a complementary fashion. Educational programs can, and are taking advantage of educational resources in urban, suburban and rural settings alike. Formal educational program partnerships have been established with museums, zoos, libraries, other public institutions, as well as local business workplace settings.

各种各样的社会和经济因素使许多教育者认识到，可以在任何时间、任何场所学习。学校建筑只是学习场地之一。而学校建筑作为社区中心，将整个社区扩展为学习环境的想法已经发展为一种理念。教育机构可以，也正在利用城市、郊区和乡村中的教育资源。博物馆、动物园、图书馆、其他公共机构，以及当地商业场所，已经成为了正式的教育项目参与者。

Create Smaller Schools
创造更小的学校

Barker and Gump in their classic book "Big School, Small School?" demonstrated through their research that small schools (100～150), in comparison with large schools (over 2000) offer students greater opportunities to participate in extracurricular activities and to exercise leadership roles. In particular, they found that participation in school activities, student satisfaction, number of classes taken, community employment, and participation in social organizations have all been found to be greater in small schools relative to large schools. Garbarino (1980) later found that, small schools, on the order of 500 or less, have lower incidence of crime levels and less serious student misconduct. Subsequent research indicates that smaller elementary schools particularly benefit African-American students' achievement.

巴克和甘在他们的著作《大学校还是小学校?》中通过阐述了他们的研究理念：小学校(100～150)，与大学校(超过2000)相比，能够为学生提供更多参与课外活动和实践领导角色的机会。他们发现，学校活动的参与性、学生的满意度、课程数量、社区利用程度、社会机构的参与度，所有一切都是小型学校要好于大型学校。加伯利诺随后发现，少于500人的小型学校犯罪率较低，并且学生严重不当行为相对于大型学校要少。其他学者随后的研究也表明，规模较小的小学特别有利于非裔美国学生获得好的成绩。

For educational planners and architects the research on small schools suggests that the size of learner groupings should be roughly 60～75 students in pre-school, 200～400 students in elementary school, 400～600 in middle school and not more than 600～800 students in secondary school.

对于学校设计师和建筑师来说，小型学校的研究表明，每个学校的学习群体大小应该保持在60～75人，小学人数应控制在200～400人，中学400～600人，高中不要超过600～800人。

Consider Home as a Template for School
将家作为学校模板

The transition from the home setting to institutional settings such as the school environment can be stressful, especially for younger children. Experience tells us that building in physical and

social home-like characteristics may reduce anxiety on the part of both parent and child, help children feel more comfortable and enable the student to concentrate on learning.

家庭环境到学校环境的转变，就如学生处于学校环境时可能是慌慌张张的，特别是对于年龄较小的孩子。经验告诉我们，具有真实和社会家庭特征的建筑可以减少父母和孩子的焦虑感，帮助孩子感到更舒适，使学生能够集中精力学习。

Use friendly, "home-like" elements and materials in the design of the school when appropriate and possible. Home-like characteristics might include: creating smaller groupings of students often called "families" in the middle school, designing appropriately-scaled elements, locating restrooms near instructional areas, providing friendly and welcoming entry sequences, creating residentially sloping roofs, and creating enclosed "back-yards". Use familiar and meaningful elements from the surrounding residential neighborhood as the "template" for the imagery of the new school.

在所有适合和可能的时候，在学校设计中友好地使用"家庭"元素和材料。像家一样的特征可能包括：在中学设置较小的、常常称为"家庭"的学生群体，设计尺度适合的元素，将卫生间设置在距离教学区域较近的位置，提供友好的入口空间序列，创造住宅般的倾斜屋顶，创造围合的"后院"。使用类似的源自周围居住环境的元素作为新学校的形象化的"模板"。

3. Team Teaching 协同教学

In many higher education institutions, the usual pattern of teaching is still largely based on an individual lecturer bearing responsibility for students in a course module or unit. At some levels of learning though, for example in postgraduate seminars, this model is replaced by a team teaching approach which involves a number of lecturers (usually between two and five) and possibly non-teaching professional support staff as well. To carry out effective team teaching requires a re-orientation on the part of individual staff members and departmental administrators.

在许多高等教育机构，常用的教学模式仍是个体讲授者负责一个课程或单元的学生学习。在某些学习层次，例如研究生学习，这种模式被协同教学所取代——众多讲授者（常常在 2~5 名）和非教学人员也参与其中。为了实现高效的协同教学，需要对部分教师和部门管理者重新定位。

In team teaching a group of teachers, working together, plan, conduct, and evaluate the learning activities for the same group of students. In practice, team teaching has many different formats but in general it is a means of organising staff into groups to enhance teaching. Teams generally comprise staff members who may represent different areas of subject expertise but who share the same group of students and a common planning period to prepare for the teaching. To facilitate this process a common teaching space is desirable. However, to be effective team teaching requires much more than just a common meeting time and space.

在协同教学中，一组教师一起工作，共同计划、指导和评价同一学生群体的学习活动。在实践中，协同教学有各种不同的形式，但一般来说它是一种组织教师群体提高教学

的方法。教学组一般由可以代表不同研究领域的成员组成，他们共享相同的学生、共同计划备课。为了实施这个过程，必须有共同的教学空间。然而，实现高效的协同教学不仅仅只是需要进行普通会谈的时间和空间。

In view of the additional complexity which team teaching initiatives introduce into departmental organisation and in view of the time needed for staff to adapt to the new structures, it is relevant to ask what benefits accrue from team teaching. How, for instance, does team teaching benefit lecturers, part-time tutors, students, and departments as a whole?

协同教学将产生额外的组织复杂性，考虑到教师适应新的教学结构所需要的时间，我们就会问：协同教学的优势是什么。例如，协同教学对于教师、兼职教师、学生和整个部门有什么好处？

- **For Lecturers,** who so often work alone, team teaching provides a supportive environment that overcomes the isolation of working in self-contained or departmentalized class-rooms. Being exposed to the subject expertise of colleagues, to open critique, to different styles of planning and organisation, as well as methods of class presentation, teachers can develop their approaches to teaching and acquire a greater depth of understanding of the subject matter of the unit or module.

- **对教师，** 他们常常独自工作，协同教学提供一种支持环境来消除自我的或分部门的课堂孤立。展现同事之间的各自专长，开放评论，展现不同的设计和组织风格，以及课堂演示方法，教师们可以发展自己的教学方法并且获得对所教授单元或模块的更深入理解。

- **Part-time staff** can be drawn more closely into the department as members of teams than is usually the case, with a resulting increase in integration of course objectives and approaches to teaching.

- **兼职教师** 可以比惯有模式更深入地成为团队中的一员，参与部门的工作，可以提高课程目标和教学方法的综合性。

- **Team teaching can lead to better student performance** in terms of greater independence and assuming responsibility for learning. Exposure to views and skills of more than one teacher can develop a more mature understanding of knowledge often being problematic rather than right or wrong. Learning can become more active. Students could eventually make an input into team planning.

- **协同教学可以提高学生的成绩。** 学生拥有更大的独立性和学习责任。多位教师展现观点和能力可以帮助学生更深入地理解知识，这种理解常常是充满问题的，而不只是对或错。学习可以变得更积极。学生可以最终也投入到协同教学的设计中。

Fig. 2-7　team teaching

Team teaching is where a group of lecturers works together to plan, conduct, and evaluate the learning activities of the same group of students. However, it would be a mistake to think that team teaching is always practised in the same way. Its format needs to be adapted to the requirements of the teaching situation. Some possible options are where:

协同教学是指一组教师一起计划、实行和评价相同学生群体的学习。然而，如果认为协同教学常常以相同的方式来实行就错了。协同教学的形式需要适应教学条件。方法包括：

- two or more teachers teach the same group at the same time;
- 2 位或更多教师同时教授同一群体；
- team members meet to share ideas and resources but generally function independently;
- 团队成员会面，分享观点和资源，但是通常独立教学；
- teams of teachers share a common resource centre;
- 教师团队分享共同的资源中心；
- a team shares a common group of students, shares planning for instruction but team members teach different sub-groups within the whole group;
- 团队分享共同的学生群体，分享教学计划，但是团队成员在整个群体内分成不同的小组；
- certain instructional activities may be planned for the whole team by one individual, for example planning and developing research seminars;
- 某些教学活动可以由个人为整个团队计划，例如计划和发展研究课程；
- planning is shared, but teachers each teach their own specialism or their own skills area;
- 共享计划，但教师各自教授自己的专业或能力领域；
- teams plan and develop teaching resource materials for a large group of students but may or may not teach them in a classroom situation.
- 团队为庞大的学生群体计划和发展教学资源内容，但是可能在或者不在一间教室同时教授。

4. Floor Area 建筑专业英语

floor area 建筑占地面积

construction area 建筑面积

plot ratio, floor area ratio 容积率＝建筑面积/总占地面积

building density, building coverage 建筑密度＝建筑占地面积/总占地面积

greening rate 绿地率＝绿化面积/总占地面积

5. Housing Design 住宅设计

Casa Milà

米拉公寓 建筑师：A. 高迪

Casa Milà, is a building designed by the architect, Antoni Gaudí, and built during the years 1906～1910, being considered officially completed in 1912. It is located at 92, Passeig

de Gràcia in the Eixample district of Barcelona, Catalonia, Spain.

米拉公寓，由建筑师安东尼·高迪设计，建于 1906～1910 年，1912 年正式完工。这座建筑位于西班牙泰罗尼亚大区的巴塞罗那格斯雅大道 92 号。

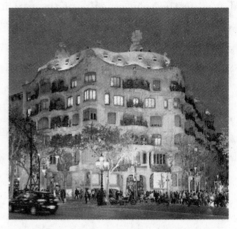

The design by Gaudi was not followed in some aspects. The local government objected to some aspects of the project, fined the owners for many infractions of regulations, ordered the demolition of aspects exceeding the height standard for the city, and refused to approve the installation of a huge sculpture atop the building-described as "the Virgin".

高迪的设计没有追随某种风格。当地政府反对设计的一些方面，并以该建筑违反了许多规范而对业主进行罚款，命令拆除超过城市高度标准的部分，并拒绝批准建筑顶上一个巨大雕塑——名为"少女"——的安装。

Fig. 2-8　Casa Milà Central Atrium

Casa Mila was in poor condition in the early 1980s. It had been painted a dreary brown and many of its interior color schemes had been abandoned or allowed to deteriorate, but it has been restored and many of the original colors revived.

米拉公寓在 20 世纪 80 年代早期情况非常糟糕。建筑被涂以沉闷的棕色，许多室内色彩主题被废弃，或者破败不堪，但这一切现在已经被恢复了，许多最初的色彩重新展现。

The building is part of the UNESCO World Heritage Site "Works of Antoni Gaudí". The building is owned by Caixa Catalunya.

该建筑是被联合国教科文组织列为世界遗产的"安东尼·高迪作品"之一。建筑现属于 Caixa Catalunya 银行。

Casa Milà was a predecessor of some buildings with a similar biomorphic appearance.

米拉公寓是有着类似生物形态外观建筑的先驱。

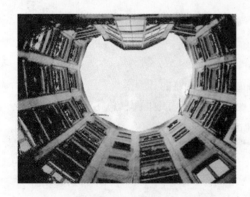

Fig. 2-9　Casa Milà Central Atrium

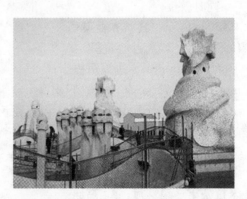

Fig. 2-10　Casa Milà Rooftop in Spring

Rietveld Schröder House

施罗德住宅，建筑师：G. 里特维德

　　The Rietveld Schröder House (Dutch：Rietveld Schröderhuis) (also known as the Schröder House) in Utrecht was built in 1924 by Dutch architect Gerrit Rietveld for Mrs. Truus Schröder-Schröder and her three children. She commissioned the house to be designed preferably without walls. The house is one of the best known examples of De Stijl-architecture and arguably the only true De Stijl building. Mrs. Schröder lived in the house until her death in 1985. The house was restored by Bertus Mulder and now is a museum open for visits. In the year 2000 it was placed on the UNESCO list of World Heritage Sites.

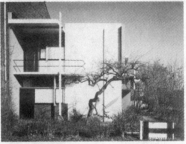
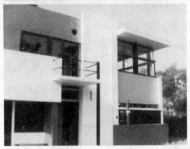

　　施罗德住宅(荷兰语：Rietveld Schröderhuis)位于乌德勒支省，1924 年由荷兰建筑师 G. 里特维德为施罗德夫人和她的三个孩子设计。她提出住宅要尽量没有墙体。施罗德住宅是风格派建筑的著名范例，也被认为是唯一真正的风格派建筑。施罗德夫人一直在此居住，直到 1985 年去世。施罗德住宅由伯图斯·穆德修复，现在是对外开放参观的博物馆。2000 年这座住宅被列入联合国教科文组织的世界遗产名录。

　　The Rietveld Schröder House constitutes both inside and outside a radical break with all architecture before it. The two-story house is built onto the end of a terrace, but it makes no attempt to relate to its neighbouring buildings.

Fig. 2-11　Rietveld Schröder House

　　施罗德住宅的室内和室外与它以前的所有建筑完全不同。两层的住宅在一个平地的尽头修建，但是它没有尝试任何与其周围建筑相似的设计。

　　Inside there is no static accumulation of rooms, but a dynamic, changeable open zone. The ground floor can still be termed traditional; ranged around a central staircase are kitchen and three sit/bedrooms. The living area upstairs, as an attic, in fact forms a large open zone except for a separate toilet and a bathroom. Rietveld wanted to leave the upper level as was. Mrs Schröder, however, felt that as living space it should be usable in either form, open or subdivided. This was achieved with a system of sliding and revolving panels. When entirely partitioned in, the living level comprises three bedrooms, bathroom and living room. In-between this and the open state is an endless series of permutations, each providing its own spatial experience.

　　室内没有固定的房间分布，而是一种动态、可变的开放区域。第一层仍是传统的布局

方式；围绕中心楼梯布置厨房和三个卧室。生活空间在楼上，就像一层阁楼，形成了除独立卫生间以外的开放区域。里特维德曾想让上层保持传统住宅布局。但是施罗德夫人感到生活空间应该是以任何形式都可使用的——开放或划分。这通过一种可滑动和拆卸的隔板实现了。当完全使用隔板时，上层由 2 个卧室、浴室和起居室构成。在分隔状态和开放状态之间是数不清的布置排列，每种都提供其独有的空间体验。

The facades are a collage of planes and lines whose components are purposely detached from, and seem to glide past, one another. This enabled the provision of several balconies. Like Rietveld's Red and Blue Chair, each component has its own form, position and color. Colors where chosen as to strengthen the plasticity of the facades; surfaces in white and shades of grey, black window and doorframes, and a number of linear elements in primary colors.

建筑立面是平面和线条的拼贴，它们的构成被有意地分离，似乎相互可以滑动。由此也创造出许多阳台。就如同里特维德的红蓝椅，住宅的每个部分都有独立的形式、位置和色彩。色彩选择是为了加强立面的可塑性：白色的表面和灰色的阴影；黑色的窗户和门框；大量原色的线性元素。

Villa Savoye
萨伏伊别墅，建筑师：勒·柯布西耶

The Villa Savoye is the seminal work of the French architect Le Corbusier. Situated at Poissy, outside of Paris, it is one of the most recognizable architectural presentations of the International Style. Construction was substantially completed ca. 1929.

萨伏伊别墅是法国建筑师勒·柯布西耶的初期作品。建筑位于巴黎郊外的波瓦西，它是"国际式"最著名的建筑代表作之一。该建筑于1929 年完工。

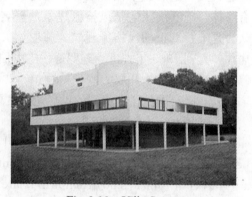

Fig. 2-12　Villa Savoye

The house was emblematic of Le Corbusier work in that it addressed "The Five Points", his basic tenets of a new aesthetic of architecture constructed in reinforced concrete：

萨伏伊别墅是勒·柯布西耶强调"新建筑五点"的代表作，他认为建筑新美学的基本原则是：

1. The pilotis, or ground-level supporting columns, elevate the building from the damp earth allowing the garden to flow beneath.

支柱层，或者称为地面层独立支柱，将建筑从潮湿的地面上升起，花园在下方穿过。

2. A flat roof terrace reclaims the area of the building site for domestic purposes, including a garden area.

水平屋顶平台为家庭使用开辟出与建筑占地相等的领域，包括一个花园。

3. The free plan, made possible by the elimination of load-bearing walls, consists of partitions placed where they are needed without regard for those on adjoining levels.

　　自由的平面，可能通过减少承重墙来实现，在需要的地方进行分区，没有考虑相互连接的问题。

　　4. Horizontal windows provide even illumination and ventilation.

　　水平横窗提供照明和通风。

　　5. The freely-designed facade, unconstrained by load-bearing considerations, consists of a thin skin of wall and windows.

　　自由的立面，不受承重的限制，由薄壁和窗户构成。

　　The Villa Savoye was designed as a weekend country house and is situated just outside of the small village of Poissy in a meadow which was originally surrounded by trees. The polychromatic interior contrasts with the primarily white exterior. Vertical circulation is facilitated by ramps as well as stairs. The house fell into ruin during World War II but has since been restored and is open for viewing.

　　萨伏伊别墅是一座周末度假乡村住宅，位于波瓦西这个小乡村外部的一片草地上，这里原来四周都是树木。色彩丰富的室内和主要呈白色的室外形成对比。坡道和楼梯解决了垂直交通。该建筑在第二次世界大战期间遭到毁坏，但是当时就进行了修复并向公众开放。

　　Corbusier designed the building to use a flat roof, a move he said was for functionality, though may have been partly due to way it looked for him. Indeed the roof failed its functionality, as the roof leaked, causing the owners to attempt to take Corbusier to court. However at the same time WW2 broke out, and Corbusier left the area, leaving the building in a state of disrepair.

　　柯布西耶在设计中使用了水平屋顶，他声称是为了功能性的改变，虽然部分原因可能是他希望这样去表现。事实上屋顶在功能性上是失败的——因为屋顶漏雨，使得业主尝试将柯布西耶告上法庭。然而同时第二次世界大战爆发了，柯布西耶离开了那里，任由建筑破败下去。

Fallingwater
流水别墅　建筑师：弗兰克·劳埃德·赖特

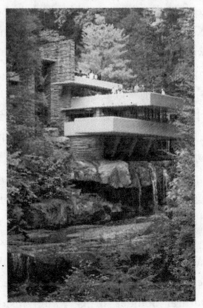

　　Fallingwater, also known as the Edgar J. Kaufmann Sr. Residence, is a house designed by American architect Frank Lloyd Wright in 1935 in rural southwestern Pennsylvania, 50 miles southeast of Pittsburgh. The house was built partly over a waterfall in Bear Run, in the Laurel Highlands of the Allegheny Mountains.

　　流水别墅，也被称为考夫曼住宅，是美国建筑师弗兰克·劳埃德·赖特 1935 年在宾夕法尼亚州的西南部乡村设计的住宅，位于匹兹堡东南 50 英里处，住宅部分凌驾于熊溪的瀑布之上，属于阿利根尼山脉的月桂高地区域。

　　Hailed by TIME magazine shortly after its completion

Fig. 2-13　Fallingwater

as Wright's"most beautiful job,"the home inspired Ayn Rand's novel The Fountainhead.

《时代》杂志在这个被赖特认为是"最美丽的工作"的建筑完成后不久就报道了它，住宅的灵感来自艾茵·兰德的小说《源泉》。

Fallingwater was the family's weekend home from 1937 to 1963. In 1963, Kaufmann, Jr. donated the property to the Western Pennsylvania Conservancy. In 1964 it was opened to the public as a museum and nearly five million people have visited the house since (as of January 2008). It currently hosts more than 120000 visitors each year.

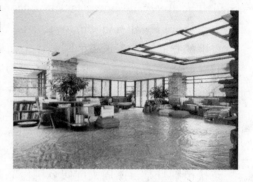

Fig. 2-14 Interior of Fallingwater depicting a sitting area with furnishings designed by Wright

流水别墅从 1937 年到 1963 年作为家庭周末度假屋使用。1963 年，考夫曼将别墅捐给了宾夕法尼亚州自然资源保护组织。1964 年住宅作为博物馆向公众开放，开放后有接近 500 万人参观过该住宅（截至 2008 年 7 月）。每年有超过 12 万人来此参观。

Fallingwater stands as one of Wright's greatest masterpieces both for its dynamism and for its integration with the striking natural surroundings. The extent of Wright's genius in integrating every detail of this design can only be hinted at in photographs. This organically designed private residence was intended to be a nature retreat for its owners. The house is well-known for its connection to the site: it is built on top of an active waterfall which flows beneath the house. The fireplace hearth in the living room is composed of boulders found on the site and upon which the house was built. Wright had initially intended that these boulders would be cut flush with the floor, but this had been one of the Kaufmann family's favorite sunning spots, so Mr. Kaufmann insisted that it be left as it was. The stone floors are waxed, while the hearth is left plain, giving the impression of dry rocks protruding from a stream.

流水别墅以其物理学、与自然环境的融合而成为赖特最伟大的杰作之一。赖特整合设计每个细节的天分只能在照片中找到蛛丝马迹。有机设计的私人居住空间成为业主的自然隐蔽所。住宅因其与基地的联系而闻名：它建在流动的瀑布之上，瀑布的水在住宅底部流动。起居室中的壁炉台是由住宅建于其上的大石块建造的。赖特最初想将这些石块切割平滑后再用于地面，但是粗糙的石块形成了考夫曼家庭非常喜欢的阳光照射效果，于是考夫曼坚持就让它保持原样。石板地面是打过蜡的，而壁炉台保持原有质感，给人以从水面突出的干燥岩石的效果。

Integration with the setting extends even to small details. For example, where glass meets stone walls, there is no metal frame. There are stairways directly down to the water. And in the"bridge"that connects the main house to the guest and servant building, a natural boulder drips water inside, which is then directed back out. Bedrooms are small, some even with low ceilings, perhaps to encourage people outward toward the open

social areas, decks, and outdoors.

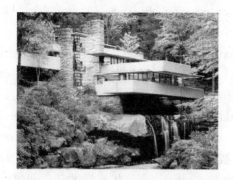

Fig. 2-15 Fallingwater in spring

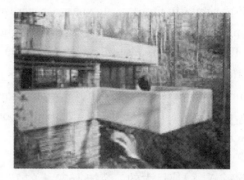

Fig. 2-16 The cantilevers at Fallingwater

与环境的融合甚至延伸到了非常小的细节中。例如，玻璃直接架在石墙上，没有金属框架；楼梯直接向下延伸到溪水之上。"桥梁"联系着住宅主体和客房以及仆人区域，自然的石块散落在溪水中，沿着它们可以直接走到后出口。卧室很小，一些甚至有很低的天花板，可能是为了鼓励人们多待在开放的公共区域、平台和室外空间之中。

The active stream (which can be heard constantly throughout the house), immediate surroundings, and locally quarried stone walls and cantilevered terraces (resembling the nearby rock formations) are meant to be in harmony, in line with Wright's interest in making buildings that were more "organic". Although the waterfall can be heard throughout the house, it can't be seen without going outside. The design incorporates broad expanses of windows and the balconies are off main rooms giving a sense of the closeness of the surroundings. The experiential climax of visiting the house is an interior staircase leading down from the living room allowing direct access to the rushing stream beneath the house.

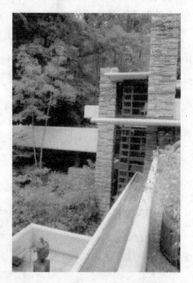

Fig. 2-17 The strong horizontal and vertical lines are a distinctive feature of Fallingwater.

流动的溪水(在整个住宅都可以听到)立即使环境生动起来，取自当地采石场的石墙和悬挑阳台(类似岩石的形式)形成了和谐，与赖特创造更"有机"建筑的兴趣一致。虽然整个住宅都可以听到瀑布的声音，但是不走到室外是看不见瀑布的。设计融合宽敞的窗户和阳台，使主要的房间无法产生与周围环境相隔离的感受。参观住宅的体验高潮是一段室内楼梯从起居室直接连到住宅下面奔腾的溪水上。

Unite d'Habitation

马赛公寓　建筑师：勒·柯布西耶

Le Corbusier's most influential late work was his first significant postwar structure——the UnitÈ d'Habitation in Marseilles of 1947~1952. The giant, twelve-story apartment

block for 1600 people is the late modern counterpart of the mass housing schemes of the 1920s, similarly built to alleviate a severe postwar housing shortage. Although the program of the building is elaborate, structurally it is simple: a rectilinear ferroconcrete grid, into which are slotted precast individual apartment units, like "bottles into a wine rack" as the architect put it. Through ingenious planning, twenty-three different apartment configurations were provided to acccommodate single persons and families as large as ten, nearly all with double-height living rooms and the deep balconies that form the major external feature.

勒·柯布西耶最有影响力的后期作品，首个战后重要作品——马赛公寓（建于 1947～1952 年）。这座巨大的、容纳 1600 人的 12 层公寓是 20 世纪 20 年代现代主义后期集中化住宅主题的产品，类似的建筑都是为了减轻战后严重的住宅短缺问题。虽然建造的过程很仔细，但结构很简单：直线性的混凝土网格，再分割成预制的单体公寓单元，建筑就像"酒架上的瓶子"一样摆放着。通过天才般的设计，建筑提供了 23 个不同的公寓户型来满足从单身到 10 人家庭的居住，两层高的起居室和深阳台形成了主要的建筑外观特征。

The Marseille unite d'habitation brings together Le Corbusier's vision for communal living with the needs and realities of post-war France. Up to 1600 people live in a single-slab "vertical village", complete with an internal shopping street halfway up, a recreation ground and children'snursery on the roof, and a generous surrounding area of park land made possible by the density of the accommodation in the slab itself.

马赛公寓充分表现出勒·柯布西耶对于战后法国公共居住需求和现实的看法。1600 多人居住在一个单一厚重的"垂直乡村"中，建成后在建筑中部有一条内部的商业街，屋顶上有娱乐休闲和照顾孩子的空间，公寓极高的居住密度使得周围大面积的公园领地变得可能。

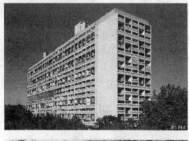
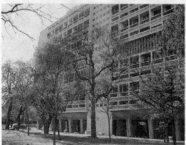
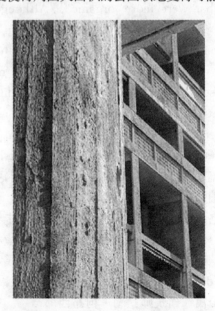

Fig. 2-18　the UnitÈ d'Habitation in Marseilles

Fig. 2-19　raw concrete texture of The Marseille unite d'habitation

The Unit introduced the world to raw concrete-with its texture defined by the wooden planks shaping it when it was poured. This unwitting prototype for the New Brutalism to follow came from necessity: not only was there insufficient steel in post-war France for a steel construction, but there was insufficient skilled labor for consistent, precise construction.

公寓向世界展现了原始的混凝土——它的质感由浇灌混凝土时使用的木质板条形成。这种新粗野主义的无意识建型源自其必然性：战后法国的钢铁工业不仅没有足够的钢铁，而且也没有足够与之相配合的熟练工人进行精确的建造。

6. Multifamily Living 集合住宅

To be sure, multifamily living is, architecturally speaking, arranged much more along Big Love lines than flophouse rules. You probably wouldn't want a bunch of families under one roof. But a set of friendly families living in adjacent homes, with a shared backyard? That seems quite reasonable. Better, in fact, on quite a few measures than the single family arrangements we currently advantage.

当然，从建筑角度来说，集合住宅要比单体住宅建立更多的规则。你可能不希望多个家庭在一个屋檐下生活。但是邻居之间能够在共享的后院中进行一系列友好的家庭生活，又会如何？似乎这已经足够成为这样做的理由。事实上，更好的一面是，我们现在可以利用比单体住宅更多的措施。

There's this strange acceptance of the idea that as we move into adulthood, we should radically de-emphasize our community and connectedness in order to purchase a big house near a good school with a large lawn. But even if you accept the implicit prioritization of children as right and good and natural, it's not clear that this is the best way to help your kids. The multiplication of imagined communities would allow for much more supervision, flexibility, social capital, community, and even financial support. Community is good for everyone.

我们进入成年后都接受了这种理念：应该从根本上重新强调我们的社会性和联系性，目的是购买邻近好学校的、有巨大草坪的大住宅。但即使你认为对于孩子来说最重要的依次是适合的、良好的、自然的，却仍不清楚集合住宅是帮助你的孩子的最好方法。增加这种复合住宅社区将提供更多的监督、灵活性、社会资本、社区，甚至是资金支持。社区对每个人都有好处。

Rokko Housing One
六甲山集合住宅 建筑师：安藤忠雄

The building is composed of a group of units, each measuring 5.8 meters by 4.8 meters. In section, it conforms to the slope, and in plan, it is symmetrical. In ascending the slope, gaps are intentionally created. The gaps relate to each other and unite the entire building; at the same time they serve as a plaza. A total of 20 units are mounted along the slope creating exclusive ter-

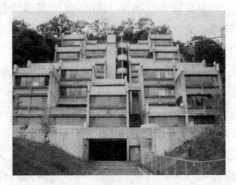

Fig. 2-20 Rokko Housing One

races facing various directions overlooking the ocean. Life in these diverse units will concentrate around the terrace and the opportunity to communicate with nature.

建筑由一组单元构成，每个单元长 5.8 米，宽 4.8 米。建筑剖面与斜坡相符合，建筑平面对称。在向上爬坡时，建筑师有意设计了一些缝隙。缝隙之间相互联系，贯穿于整个建筑之中，同时也作为住宅的活动平台。由 20 个单元组成的建筑沿着斜坡创造出从各个方向俯瞰海洋的阳台。这些不同单元中的生活将围绕阳台、与自然的交流展开。

Architecture represents an autonomous system of thought. To think architecturally is not merely to deal with external conditions or to solve functional problems. Architects must train themselves to ask fundamental questions, to give free rein to their individual architectural imaginations, and to consider human beings, life, history, tradition, and climate. We must create architectural spaces in which man can experience—as he does through poetry or music—suprise, discovery, intellectual stimulation, peace and the joy of life.

建筑表现思想。以建筑的角度去思考不仅仅是处理外部条件或解决功能问题。建筑师必须锻炼自己提出基本的问题，自由支配自己的建筑想象——考虑人类、生活、历史、传统和气候。我们必须创造人类可以体验的建筑空间——就像是体验诗歌或音乐——惊奇、发现、思想灵感、和平和生活乐趣。

7. Outdoor Space　室外空间

As cities across the region continue to grow and become more cosmopolitan and as more ambient outdoor spaces become available, a greater percentage of our time is being spent in the open air.

随着城市跨越地域而变得更具世界性，无处不在的室外空间变得更加有效，我们在开放的空间中花费更多的时间。

It is estimated that, for nine months of the year, residents spend as much as 60% of their leisure time outside.

据估计，一年中的 9 个月，居民 60% 的空闲时间都在户外。

Add to this increasing periods of pleasant weather and more outdoor leisure opportunities, and the result is a definite shift in lifestyle and in how we spend our time and money. This has most certainly had a significant effect on furniture and space design, with indoor most definitely moving outdoor.

随着好天气的增多就会有更多室外休闲活动的机会，结果我们的生活方式和如何分配时间和金钱的方式都发生了明显改变。当然这也对家具和空间设计产生了巨大的影响。毫无疑问，室内的一切正在移向室外。

Nowhere is this lifestyle shift more evident than in the recent announcement from Dubai Municipality who stated that it plans to undertake 109 landscape and beautification projects at a cost of approx. $126m as part of its Strategic Plan for the period 2007~2011.

没有什么地方的生活方式改变程度会比迪拜更为明显，他们宣称计划建造 109 处景观和美化项目，大约耗费 12600 万美元，作为其 2007~2011 年的战略规划。

The plan aims to increase the per capita share of greenery to 23.4m² by the end of the

plan and to raise the total area of cultivated land to 31.5% of the urban land by 2011.

迪拜规划目的是到 2011 年增加绿化面积到 23.4 平方米/人，增加绿化总面积到占整个城市的 31.5%。

The design of outdoor space, has an important impact on how we feel about ourselves and how we behave. The design of outdoor space is fundamental to an individual's well-being and as a direct consequence of this, the prosperity of a city. Not only does this relate to public spaces but also to commercial and private outdoor space.

Fig. 2-22 urban planning of Dubai Municipality

室外空间设计，对于人们自身的感受和行为有重要影响。室外空间设计是个人健康的基础，而其直接后果就是城市的繁荣。这一目标不仅与公共空间相关，还与商业和私人室外空间相关。

Outdoor design is now an important growing market given the increase in homeowners but also the increased number of hotels and available public spaces. The lines between indoor and outdoor are becoming less defined and furnishings are now being used in similar ways in both spaces.

在酒店和可利用公共空间不断增加的环境下，室外空间设计现在成为不断发展的重要市场。室内和室外之间的分界变得更为模糊，两种空间以类似的方法来使用设施和家具。

Ergonomically designed, with detailing and color co-ordination, just as much effort and money is now spent to make these outdoor spaces an extension of every day living.

人性化设计与细部和色彩相配合，是因为现在人们有更多的精力和金钱来使这些室外空间成为日常生活的延伸。

Vocabulary

1. Proportion *n.* ①比率，比例 ②平衡，配合 ③部分 ④面积；容积：a large proportion of the earth's surface 地球表面的大部分

［短语］do a sum in［by］proportion 按比例计算

factor proportion 要素比例

in admirable proportion 非常均衡

in（direct）proportion to 与……成正比例

in inverse proportion to 与……成反比例

in proportion as［to］ 按……的比例；与……成比例；和……相称；和……比较起来

ratio and proportion 比率及比例

［近义词］part, amount, division, fraction, portion, fragment, section, component, share, segment, measure

［辨析］**proportion** 比例：指各部分的比例相称，系科学上的用词。

The air becomes cooler in proportion to the height of the ground. 地势愈高则空气愈凉。

rate 比率：系使用极广的用词。

He is charged at the rate of 5 cents per word. 他每个字要付五分钱。

ratio 比例：这词仅用在数学和计算上。

It is in the ratio of about one to every twenty. 大约是一对二十的比例。

2. Function *n.* 职责，职能；功能；作用；官能，机能

The function of an adjective is to describe or add to the meaning of a noun. 形容词的作用就是修饰名词。

［近义词］act，behave，go，operate，perform，run，serve，work

［辨析］function 功能、机能：常指器官的作用。

The function of the heart is to pump blood through body. 心脏的功能是使体内的血液循环。

operation 作用：指一定法则的作用。

The new law goes into operation from the day of its promulgation. 新法律自颁布之日起实行。

action 作用：系普通的用词，可指机械的、物理的、化学的作用。

We may see the action of acid on glass. 我们可以看到酸在玻璃上所起的作用。

3. Recreation *n. adj.* 休养；娱乐；消遣：a recreation ground 休养地；娱乐场

［短语］recreate oneself with 以……为消遣（或娱乐）

［近义词］hobby，diversion，pastime，play，sport，entertainment，amusement，avocation，relaxation，enjoyment，fun，games，leisure，activity

［辨析］recreation 娱乐、消遣：指工作之余的消遣活动。

Fishing is a healthful recreation. 钓鱼是有利于健康的娱乐活动。

hobby 嗜好：指个人的业余爱好，如集邮、种植蔷薇等。

Gardening，collecting postage stamps or old swords are hobbies. 种植花木、集邮、集古剑等皆是嗜好。

diversion 娱乐，消遣：指从严肃的事物中分散注意力或休闲、取乐。

Chess and billiards are his favorite diversions. 下棋和打台球是他最喜爱的消遣方式。

pastime 娱乐、消遣：系普通的用词，指任何可资消遣的东西。

Baseball is a favorite pastime in America. 棒球在美国是最受欢迎的消遣活动。

4. Facility *n.* ①设施，设备 ②方便，便利，设备，器材，工具，装置，机构：There are facilities for cooking in the kitchen. 厨房里有烹饪设备。

facilities of travelling 旅游设施

hospitals and other health care facilities 医院和其他的医疗保健设施

servicing facilities 辅助设备

［近义词］ability，ease，skill，talent，efficience，expertness，gift，bent

5. Tolerance *n.* ①宽容，忍受，容忍，耐性 ②［物］容限；③［植］耐阴性，耐

量 ④机械或建筑的；公差，偏差

6. clearance *n.* 间空，间隔；距离：a clearance of 12 feet 距离 12 尺 close clearance 不大间隙 | an underpass with a 13-foot clearance 有 13 英尺净空的高架桥下通道

7. Access *n.* 进入；信道；入口，通路：There is no access to the street through that door. 穿过那个门没有通向大街的路。| The only access to that ancient castle is along a muddy track. 到那座古老城堡去的唯一通道是一条泥泞小路。

［近义词］entering, admittance, proximity, reach

［辨析］access 通路、接近的方法：指进入或使用（人或物）的方法或权利。

Professors have free access to the library. 教授可以自由进入图书馆。

admission 许可、进入：指进入某一场所或某一组织、职业等，同时强调与"进入权利"相关联的目的、权利和责任。

He has the requirements for admission to the university. 他具备进入该大学的条件。

admittance 准许进入：仅表示进入某一场所的权利，并不含其连带的目的或其他方便等。

He gained admittance to the park, but without a ticket he could not obtain admission to the exhibition. 他可以进入公园，但没有票，不能进入展览会会场。

entrance 入口、大门：指供人进入的门，大门或通道。

The entrance to the cave had been blocked up. 洞的入口被阻塞了。

Sentence

Architectural programming is the development of a spatial organization, given the Limitations of a specific situation that represents an optimum environment for the activities of people.

建筑设计是在特定情境中限定空间的发展，特定情境所表达的是人们活动的最佳环境。

The specific quality of an architectural design can always be related to the elements of its principal use. The task of architect consists of collecting and processing information about this use and defining the resulting functions of the building.

建筑设计的特殊性质常常与其主要应用元素相关。建筑师的任务包括选择和处理有关使用和确定建筑最终功能的信息。

The conventional house organizes the maim functions into separate rooms but since the activities of a household follow the general pattern only vaguely, great flexibility is required.

传统住宅将主要功能通过分隔房间组织起来，但既然家庭活动所遵循的一般模式很含糊，住宅就需要更多灵活性。

Multifamily units are a result of the need for greater economy, which can be served by using repetitive modules, simple unit outlines that minimize party walls, and high ratio of interior volume to exterior wall area.

集合住宅是寻求更经济生活的结果，它可以使用不断重复的模块，简单的单元轮廓将

单元之间共有的墙壁减至最低，提高了室内面积和外部墙体面积的比例。

Translation

第 2 课　建筑类型的功能性考虑

建筑设计是在特定情境中限定空间的发展，特定情境所表达的是人们活动的最佳环境。建筑设计过程以人类身体对空间的需求为基础，也就是以空间的尺度和大小为基础。因此，那些表现出与人类尺度没有关系的建筑和空间，会引起压迫感和其他不适。

建筑设计的特殊性质常常与其主要应用元素相关。建筑师的任务包括选择和处理有关使用和确定建筑最终功能的信息。为避免针对不同人群设计出相同的建筑，建筑师必须非常熟悉建筑类型及其功能特征。

学校

学校是用来学习的，所包含的内涵远远超出教师向学生传递知识。在学校中，学生学到如何在家庭以外的社会群体中生活，他们向社会生活的融入应该在一个充满人性的、温暖的和自然的环境进行。许多学校都是根据教学展示的需要而进行有效组织，几乎没有是根据上面所列的性质进行组织的。

建筑师必须与学校董事会以及各种各样的社会团体合作，因为许多学校都有成人夜校、公共课程和会议举办等功能，而学校的娱乐设施可以为整个社区服务。除了传统方式以外，许多学校还使用协同教学以及其他可选择的方式，这一切都需要增加空间和增强灵活性。

最佳的教室容量由班级级别和使用主体决定，从 1 年级 20 个学生/教室到高中艺术课 50 个学生/教室。标准教室面积一般在 700～1000 平方英尺。避免噪声干扰是教室布置的一个重要因素，而学校设计最重要的考虑是安全。学校建筑要求的安全标准比其他项目要高。

既然今天绝大多数学校正在尝试新的教学方式和组织更具创造性的活动，灵活性就成了一个非常重要的设计因素。标准的教室单元常常被小组组织模式所淘汰，这种小组教学改变了班级的活动方式。

住宅

居住建筑数量常常比其他建筑类型加在一起还要多。住宅户型的形式有着无数的可能性，从帐篷小屋到高层公寓。然而，它们的功能却越来越复杂，每一个设计都是对建筑师的新挑战。

传统住宅将主要功能通过分隔房间组织起来，然而，既然家庭活动所遵循的一般模式很含糊，住宅就需要更多灵活性。孩子，随着他们的成长会有许多功能需要，甚至是一间看起来有非常清晰功能定义的浴室，也可能用作洗涤、练习等活动，或者甚至作为暗室。

在设计住宅单元时所产生的问题是，人们需要多少空间，空间如何布置才能产生最佳流通模式。某些空间关系已经变成了传统惯例。例如卧室应该直接与浴室联系，餐厅和厨房应相互联系，从起居室应可以直接到达户外，等等。

现今社会中家具的类型和组合非常标准化，容纳它们的空间也是一样。虽然人们并没有意识到实际尺寸是多少，但是在小于 2 英尺/人的餐桌空间，或是餐椅和墙的距离小于 2

英尺的餐厅中仍会感到不适。

　　公寓中的集合住宅正在成为城市住宅的主要形式。集合住宅是寻求更经济生活的结果，它可以使用不断重复的模块，简单的单元轮廓将单元之间共有的墙壁减至最低，提高了室内面积和外部墙体面积的比例。入口和流线在复式住宅项目中更为复杂，需要增加额外的面积，比如走廊、穿堂、娱乐室以及服务设施。可以通过将接近入口、主要用于夜间交通的小型单元空间和建筑角部的大型家庭单元空间放置在一起获得流线的经济性。这种安排也减少了走廊的长度并增加了大空间的开窗面积。浴室和厨房单元如果背靠背的设计的话，就可以减少机械设备的数量。高层公寓建筑的第一层具有很多功能，成为项目的中心区和室内外空间的联系。

Lesson 3 Soclological and Psychological Aspects

In conventional building program the sociological and psychological needs of the future users receive very little consideration. This leads to shortcomings in the design that become obvious when people fail to use spaces in the manner conceived by the architect. Architects are frequently blamed for the design of spaces that make it impossible for people to live and work in comfort. One reason for this situation is certainly our lack of scientific knowledge about the effect of the total environment on human well-being and behavior.

It is usually the client who furnishes the architect with the date program of a project. This information, expressed in terms of the number of people to be accommodated and business-related data about desirable human qualities, which ultimately may be more important to the inhabitants than economic efficiency. As a result, our urban environment is no longer desirable for anyone.

Although architects try to design structures for the life-styles of specific users, unconsciously they are guided by the standards they consider to be adequate for themselves. Yet the qualities of privacy, comfort, sociability, and community living should be defined in accordance with the specific culture of the users of each project; when this is not done, results are unsatisfactory.

We know that there exists a relationship between the physical environment and the social and interpersonal behavior of people. But although we can measure human tolerance levels regarding noise, pollution, isolation, overcrowding, and so on, we cannot say with accuracy which designs will bring people together and which plans are likely to keep them apart. Indeed, recent case studies of housing projects make it doubtful whether the influencing of human behavior through design should even be attempted. The example of the Pruitt-lgoe public housing project in ST. Louis demonstrated that a structure designed to encourage social mixing can lead to fears among neighbors so severe that security comes to be valued more than all planned facilities for socializing, which initially were thought to be the chief attraction of development.

Another case of friendship versus privacy values became apparent when the design of washrooms for dormitories was studied. It was shown that more friendships were made in dorms with common bathrooms than in those with private ones. Can architects consider all these unintentional effects of design in their programming?

Even if the architect knows about the effects of lack of mobility and greater neighborhood orientation and dependence of poor families, he or she will not have the time or the means to translate all data into an effective building program. Perhaps this is the function of a planner-sociologist, in collaboration with both client and designer, since most people are unable to articulate feeling about their environment precisely and rationally sociologist

would also be needed to help define how people experience different environments.

Visual and spatial terms cannot be related directly to elements of human behavior that are described with the same words. The architect, for instance, many say that the physical environment is"flexible, " "free, " "harmonious" or "open, " but it would be an erroneous over-simplification to assume that a"free"floor plan will make people feel free or that a fence on the property line will discourage difficulties in predicting the direction in which physical design will influence human behavior are illustrated by the case of plazas. Since open spaces between buildings are associated historically with communal activities in politics, religion, or commerce, planners today intend to use the plaza design to create a sense of community. In most cases, though, this concept does not come alive because the designers have neglected the specific patterns developed by the public in their contemporary leisure activities.

A resent study on the visual impact of buildings suggested that the architect's perception of the aesthetic quality of buildings is apparently very different from that of nonarchitects. The very examples picked by the architects as good, beautiful, and interesting were found to be bad, ugly, and boring by nonarchitects. In a different follow-up study of a housing project, a very low percentage of the people interviewed were aware at all of non-practical, aesthetic qualities. These examples confirm the suspicion that the architect may be out of touch with the human experiences an needs of the users.

Having developed their own terms and concepts in communicating, architects are sometimes unaware that their language of ideas of space and design is not readily understood by clients. The architect may often wish that a client's visual awareness were greater, but it is incumbent on him or her to arrive an understanding of a non architect's way of conceiving space, form, and style.

Too many architects assume that by simply changing our environment it is possible to change human behavior. This concept spawned the myth that a move from a slum to a new housing estate will automatically bring improvements in health, morals, and patterns of living. This deterministic attitude is too simple; the actual success of housing is determined not only by the reaction of the actual user to the planned physical environment, but also by a highly complex interaction between the physical environment, natural or man-made, and the user's social organization and values.

Notes

1. Sociology 社会学

Sociology (from Latin: socius) is the scientific or systematic study of society, including patterns of social relations, social stratification, social interaction, and culture. Areas studied in sociology range from the analysis of brief contacts between anonymous individuals on the street to the study of global social interaction. Numerous fields within the discipline concentrate on how and why people are organized in society, either as individuals or as members of associations, groups, and institutions. Sociology is considered a branch of

the social sciences.

社会学（来源于拉丁语：socius）是对社会进行科学或系统的研究，包括社会关系、社会现象、社会交往和文化。社会学研究领域可以从街道上人与人之间简短接触的分析扩展到对全球社会现象的研究。学科领域主要集中在人们为什么以及如何组织成为社会，或作为单体，或作为联合、群体和机构的成员。社会学是社会科学的一个分支。

Sociological research provides educators, planners, lawmakers, administrators, developers, business leaders, and people interested in resolving social problems and formulating public policy with rationales.

社会学研究为教育家、规划师、法律工作者、管理者、发展商、企业领导以及对解决社会问题和规范公共政策感兴趣的人提供基本原理。

Sociology, including economic, political, and cultural systems, has origins in the common stock of human knowledge and philosophy. Social analysis has been carried out by scholars and philosophers at least as early as the time of Plato.

社会学，包括经济、政治和文化系统，是人类知识和哲学共有部分的起源。早在柏拉图时期，学者和哲学家们就已经开始了社会分析。

Sociology later emerged as a scientific discipline in the early 19th century as an academic response to the challenges of modernity and modernization, such as industrialization and urbanization. Sociologists hope not only to understand what holds social groups together, but also to develop responses to social disintegration and exploitation.

社会学作为一门科学在 19 世纪出现，成为对现代性和现代化挑战的学术回应，比如工业化和城市化。社会学家不仅希望去理解是什么组成了社会群体，还希望发展出对社会解体和扩张的回应。

The basic goal of sociological research is to understand the social world in its many forms. Quantitative methods and qualitative methods are two main types of sociological research methods. Sociologists often use quantitative methods——such as social statistics or network analysis——to investigate the structure of a social process or describe patterns in social relationships. Sociologists also often use qualitative methods——such as focused interviews, group discussions and ethnographic methods——to investigate social processes. Sociologists also use applied research methods such as evaluation research and assessment.

社会学研究的基本目标是了解现实世界的多种形式。定量法和定性法是两种重要的社会研究方法类型。社会学家常使用定量法——比如社会数据或网络分析——去调查研究社会过程的结构或描述社会关系模式。社会学家常使用定性法——比如进行面谈，群体讨论和人种学方法——去调查研究社会过程。社会学家也使用应用研究方法，比如评价和

Fig. 3-1 Social interactions and their pros and cons are studied in sociology

评估。

The choice of a method in part often depends on the researcher's epistemological approach to research. For example, those researchers who are concerned with statistical generalizability to a population will most likely administer structured interviews with a survey questionnaire to a carefully selected probability sample. By contrast, those sociologists, especially ethnographers, who are more interested in having a full contextual understanding of group members lives will choose participant observation, observation, and open-ended interviews. Many studies combine several of these methodologies.

部分来说，方法的选择常常依赖于研究者的认识论方法。例如，那些关注数据推广性的研究者绝大多数以调查问卷的形式对经过仔细选择的可能范例进行结构化面谈。相反，那些对群体成员进行全面的背景理解更感兴趣的社会学家，特别是人类学者，将选择参与性观察、观察和开放面谈。许多研究结合了若干方法论。

Sociologists use three basic theoretical approaches: 1. The structural-functional approach, 2. The social-conflict approach, and 3. The symbolic-interaction approach.

社会学家使用的三种基本理论方法：1. 结构—功能方法，2. 社会—矛盾方法，3. 符号—相互作用方法。

2. Psychology　心理学

Psychology is an academic and applied discipline involving the scientific study of mental processes and behavior. Psychologists study such phenomena as perception, cognition, emotion, personality, behavior, and interpersonal relationships. Psychology also refers to the application of such knowledge to various spheres of human activity, including issues related to everyday life (e. g. family, education, and employment) and the treatment of mental health problems. Psychologists attempt to understand the role of these functions in individual and social behavior, while also exploring the underlying physiological and neurological processes. Psychology includes many sub-fields of study and application concerned with such areas as human development, sports, health, industry, media, and law.

心理学属于理论和应用学科，包括精神过程和行为的科学研究。心理学家研究现象，比如感觉、认识、情感、个性，行为以及人与人之间相互关系。心理学也将这些知识应用到各种人类行为，包括与日常生活相关的问题(比如，家庭、教育和就业)和精神健康问题的处理。心理学家尝试去理解这些功能在个人和社会行为中的作用，也研究潜在的生理学和神经病学的过程。心理学包括许多研究和应用的次领域，比如人类发展、运动、监控、工业、媒体和法律。

The study of psychology in a philosophical context dates back to the ancient civilizations of Egypt, Greece, China and India. Psychology began adopting a more clinical and experimental approach under medieval Muslim psychologists and physicians, who built psychiatric hospitals for such purposes.

哲学背景下的心理学研究可以追溯到埃及、古希腊、中国和印度古文明。中世纪，心理学开始采用一种更接近临床和实验的方法，当时的穆斯林心理学家和医生建立了精神病学医院。

Though the use of psychological experimentation dates back to Alhazen's Book of Optics in 1021, psychology as an independent experimental field of study began in 1879, when Wilhelm Wundt founded the first laboratory dedicated exclusively to psychological research at Leipzig University in Germany, for which Wundt is known as the "father of psychology". 1879 is thus sometimes regarded as the "birthdate" of psychology.

虽然心理学实验研究数据的使用可以追溯到 1021 年阿尔哈曾的《光学之书》，但直到 1879 年威廉·冯特在德国莱比锡大学建立了首个专门用于心理学研究的实验室，心理学才成为一门独立的实验研究领域。因此，冯特被称为"心理学之父"，1879 年也因此被称为心理学的"诞生日"。

Fig. 3-2　Auguste Rodin's *The Thinker*.

During the 1890s, the Austrian physician Sigmund Freud developed a method of psychotherapy known as psychoanalysis. Freud's understanding of the mind was largely based on interpretive methods, introspection and clinical observations, and was focused in particular on resolving unconscious conflict, mental distress and psychopathology. Freud's theories became very well-known, largely because they tackled subjects such as sexuality, repression, and the unconscious mind as general aspects of psychological development. These were largely considered taboo subjects at the time, and Freud provided a catalyst for them to be openly discussed in polite society.

在 19 世纪 90 年代，澳大利亚籍医生西格蒙德·弗洛伊德提出一种心理治疗的方法，被称为心理分析。弗洛伊德对精神的理解大部分是以解释性方法、内省和临床观察为基础，特别关注解决潜意识的冲突、精神压抑和精神病理学。弗洛伊德的理论变得非常著名，大部分是因为他将性、压抑和潜意识精神作为心理学发展的一般方面。这些方面在当时大部分被认为是避讳和禁止研究的，而弗洛伊德提供了在文明社会开放讨论它们的机会。

When an area of interest requires specific training and specialist knowledge, especially in applied areas, psychological associations normally establish a governing body to manage training requirements. Similarly, requirements may be laid down for university degrees in psychology, so that students acquire an adequate knowledge in a number of areas. Additionally, areas of practical psychology, where psychologists offer treatment to others, may require that psychologists be licensed by government regulatory bodies as well.

从事该领域需要经过特殊训练和掌握专业知识，特别是在应用领域，心理学机构通常建立管理机构来满足培训需要。类似地，可能制定必须获得心理学学位的要求，学生必须在许多领域有充分的知识。另外，实践心理学领域中，向他人提供服务的心理学家可能也需要有政府管理机构授权的资质。

3. The Effect of the Total Environment on Human Well-being and Behavior 环境对人类行为的影响

Volumes have been designed for the intended purpose of torturing the occupants. It has been said that during the Spanish Civil War an architect was ordered to devise such a chamber. He developed a translucent, polyhedron of sharply intersecting planes——an insidious enclosure in which a locked-in victim found himself unable to lie, sit, stoop, or kneel. The surfaces were slippery, burning hot in the sun, and frigid in the cold of night. In any light, the colors were distressing if seen alone; seen together, in their discordant clashing, they soon became maddening.

空间可以是为了折磨占用者而设计。据说在西班牙内战期间有一位建筑师被命令设计一个这样的会议室。他设计了半透明的、平面相互交错的多面体——一个阴暗的封闭体，身处其中、被锁上的受害人发现自己不能躺着、坐着、弯腰或跪下。空间表面非常光滑，在太阳下变得很热，在夜晚又变得很冷。在任何照明下，色彩如果单独看都是令人苦闷的；一起看，色彩又会不调和并且相互冲突，它们很快变得令人发狂。

If it is possible to devise distressing volumes, then, conversely it should also be possible to create volumes that yield an experience of pleasure. We may recall a favorite golf course fairway as such an agreeable space. Expansive, free, and undulating, it is open to the sky, enclosed with foliage, and carpeted with turf.

如果能够设计令人苦闷的空间，那么反过来也可能创造令人愉悦的空间。我们可以回忆受人喜爱的高尔夫路线作为令人愉悦的空间——广阔的、自由的和起伏的，它向天空开敞，绿化围绕，铺满草地。

An outdoor space of far different mien is the cascade approach and plaza of New York's Rockefeller Center. It is walled by a canyon of metal, masonry, and glass and has a base of cut stone and terrazzo; its overhead plane is a tower-framed segment of sky, relieved by the tracery of foliage and the moving color of waving flags. Here is a space artfully planned to attract, refresh, and excite us and condition us for entry into the elegant restaurants, shops, and offices at its sides. Not far away, we can find yet another outdoor space of high design refinement. The garden of the Museum of Modern Art is an urbane volume eminently suited as a backdrop and visual extension of the adjacent galleries or as a place in which to wander through sunlight and dappled shade, viewing the pools and sculpture.

Fig. 3-3　plaza of New York's Rockefeller Center

纽约洛克菲勒中心的广场和阶梯是风采极为不同的室外空间。空间由金属、砖石和玻璃围合，用切割的岩石和水磨石作基础；头顶的天空被高耸的塔楼围合，从树叶缝隙和飘动旗子的流动色彩中露出。这一处巧妙设计吸引、振作和激发我们，引导我们走向边上精

致的餐馆、商店和办公室。在不是很远的地方，可以发现另一个设计精美的室外空间。现代艺术博物馆的花园是一个雅致的空间，非常适合作为附近画廊的背景和视觉延伸，或者作为一处漫游在阳光和树影下，观赏水池和雕塑的场所。

There will come to mind, upon reflection, many other similarly pleasant site spaces——a picnic spot on some lakeshore, a stadium, a public square, a residential swimming pool and garden. By analysis, we find that all are pleasant because, and only because, in size, shape, and character they are manifestly suited to the purposes for which they were intended.

在头脑中会浮现许多其他类似的令人愉悦的场所空间——湖边的野餐点、体育场、公共广场、居住区的游泳池和花园。通过分析，我们发现这一切令人愉悦是因为，并且也只是因为，在尺度、形体和特性方面它们都很明确地适合于所指定的意图。

As an instructive exercise, we might list the abstract qualities or spatial characteristics of a serous of varying volumes, each designed to induce a predetermined response：

作为指导，我们可以列出一系列各种空间的抽象特性或空间特征，每个都能够引起预定的反应：

Tension：Unstable forms. Split composition. Illogical complexities. Clash of colors. Intense colors without relief. Visual imbalance about a line or a point. No point at which the eye can rest. Hard, polished, or jagged surfaces. Unfamiliar elements. Harsh, blinding, or quavering light. Uncomfortable temperatures in any range. Piercing, jangling, jittery sound.

紧张：不稳定的形式；分裂的构成；不合逻辑的复杂。色彩的冲突；紧张的色彩没有任何放松；在一条线或一个点上的视觉不平衡；没有眼睛可以休息的点；坚硬、磨光或锯齿状的表面；不熟悉的元素；刺眼的、眩目或波动的光线；任何范围内不舒服的温度；刺耳的、吵闹的、令人战战兢兢的声音。

Relaxation：Simplicity. Volumes varying in size from the intimate to the infinite. Fitness. Familiar objects and materials. Flowing lines. Curvilinear forms and spaces. Evident structural stability. Horizontality. Agreeable textures. Pleasant and comfortable shapes. Sift light. Soothing sound. Volume infused with quiet colors——whites, grays, blues, greens.

放松：简洁；从亲密到无限的空间尺度变化；适当性；熟悉的物体和材料；流动的线条；曲线的形式和空间；明显的结构稳定性；水平；令人愉悦的质感；愉快和舒适的形体；经过过滤的光线；令人感到安慰的声音；充满平静的色彩——白色、灰色、蓝色、绿色。

Fright：Sensed confinement. An apparent trap. A quality of compression and bearing. No points of orientation. No means by which to judge position or scale. Hidden areas and spaces. Possibilities for surprise. Sloping, twisted, or broken planes. Illogical, unstable forms. Slippery, hazardous base plane. Danger. Unprotected voids. Sharp, protruding elements. Contorted spaces. The unfamiliar. The shocking. The startling. The weird. The uncanny. Symbols connoting horror, pain, torture, or applied force. The dim, the dark, the eerie, the brutal. Pale and quavering or, conversely, blinding garish light. Cold blues, cold greens. Abnormal, monochromatic color.

惊悸：感到被禁闭；明显的陷阱；压缩和承重感；失去方向感；无法判断位置或尺度；隐藏的领域和空间；惊奇的可能性；倾斜的、扭曲的或破裂的平面；不合逻辑的、不

稳定的形式；光滑的、危险的基础平面；危险；不受保护的空洞；尖锐的、突出的元素；扭曲的空间；不熟悉的；可怕；令人吃惊；神秘怪异；离奇怪诞；表现恐怖、痛苦、苦闷或强力的符号；昏暗的、黑暗的、阴森的，野蛮的空间感受；苍白和颤抖的，或者眩目的光线；冷蓝、冷绿；反常的单色。

Gaiety: Free space. Smooth flowing forms and patterns. Looping, trembling, swirling motion accommodated. Lack of restrictions. Forms, colors, and symbols that appeal to the emotions rather than to the intellect. Temporal. Casual. Lack of restraint. Pretense acceptable. The fanciful applauded. Warm, bright color. Sparkling, shimmering, shooting, or glowing light. Exuberant, lifting sound.

快乐：自由的空间；平滑流动的形式和图案；容纳循环的、颤动的、漩涡状的运动；缺乏限制；感染情绪而非思想的形式、色彩和符号；暂时的；偶然的；缺乏抑制；易于接受；空想的喝彩；温暖的、明亮的色彩；闪烁发光或光辉的光线；丰富的、上升的声音。

Contemplation: Scale not important since subjects will withdraw into their own sensed well of consciousness. Total space mild and unpretentious. No insinuating elements. No distractions of sharp contrast. Symbols, if used, should relate to subject of contemplation. Space providing a sense of isolation, privacy, detachment, security and peace. Soft, diffused light. Tranquil and recessive colors. If sound, a low muted stream of sound to be perceived sub consciously.

沉思：尺度并不重要，因为感受者已经退回到意识的自我感受之中；整个空间是温和、不受注意的；没有暗示性的元素；没有明显的对比来分神；如果使用符号，应该与沉思的感受者密切相关；空间提供一种隔离的、私密的、分离的、安全的、和平的感受；柔和的、漫射的光线；安静和隐性的色彩；如果有声音，是一种特别注意才能觉察到的低沉声音。

Dynamic action: Bold forms. Heavy, structural cadence. Solid materials such as stone, concrete, wood, or steel. Rough, natural textures. Angular planes. Diagonals. The pitched vertical. Concentration of interest on focal point of action, as to rostrum, rallying point, or exit gate through which the volume impels one. Motion induced by sweeping lines, shooting lights, and climactic sequences of form, pattern, and sound. Strong, primitive colors——crimson, scarlet, and yellow-orange. Billowing banners. Burnished standards. Martial music. Rush of sound. Ringing crescendos. Crash of brass. Blare of trumpets. The roll and boom of drums.

运动：清晰的形式；沉重的结构韵律；稳固的材料，比如石材、混凝土、木材或钢材；粗糙的、自然的质感；有棱角的平面；斜纹；向前方倾斜的垂直面；行动焦点集中，主席台，召集点，或者空间前进通过的出入口；通过连绵的线条，照射的光线，形式、图案和声音的高潮迭起所引起的运动；强烈的、原始的色彩——深红、猩红和黄橙色；翻滚的旗帜；磨光的旗杆；军乐；声音的浪潮；渐强的铃声；铜管乐器的碰撞；喇叭的巨响；隆隆的鼓声。

Sensuous love: Complete privacy. Inward orientation of room. Subject the focal point. Intimate scale. Low ceiling. Horizontal planes. Fluid lives. Soft, rounded forms.

Juxtaposition of angles and curves. Delicate fabrics. Voluptuous and yielding surface. Exotic elements and scent. Soft, rosy pink to golden light. Pulsating, titillating music.

爱：完全私密性；空间向内的朝向；受焦点支配；亲密的尺度；低矮的顶棚；水平的平面；流动的生活；柔软的、圆形的形式；角度和曲线并置；精致的织物；艳丽柔顺的表面；外国元素和氛围；柔软的玫瑰粉红到金色的光线；波动的令人愉快的音乐。

Sublime spiritual awe: Overwhelming scale that transcends normal human experience. Soaring forms in contrast to hold one transfixed on a broad base plane and lift upward to or beyond some symbol of the infinite. Complete compositional order, often symmetry. Highly developed sequences. Use of costly and permanent materials. Connotation of the eternal. Use of chaste white. If color is used, the cool detached colors, such as blue greens, blue, and violet. Diffused glow with shafts of light. Deep, full music with lofty passages.

崇敬：压倒性的尺度超越了人的正常体验；高耸的形式与站在广阔地平面的人形成对比，向上提升来表现或者超越无穷大的象征；完整的构成秩序，常常是对称；高度完善的序列；使用昂贵和持久的材料；永恒的内涵；纯白的使用；色彩使用冷色，比如蓝绿色，蓝色和紫色；一束束光线向外扩散发光；深刻的、强烈的音乐伴随着向上的通路。

Displeasure: Frustrating sequences of movement or revelation. Areas and spaces unsuited to anticipated use. Obstacles. Excesses. Undue fiction. Discomfort. Annoying texture. Improper use of materials. The illogical. The false. The insecure. The tedious. The blatant. The dull. The disorderly. Disagreeable colors. Discordant sounds. Uncomfortable temperature or humidity. Annoying light. That which is ugly.

不快：混乱的运动或展现序列；领域和空间不适合参与其中的用途；障碍；过度；不适当的想象；不舒适；恼人的质感；不适合的材料使用；不合逻辑的；失败的；不完全的；沉闷的；喧嚣的；黯淡的；无序的；不一致的色彩；不调和的声音；不舒适的温度或湿度；恼人的光线；丑陋的。

Pleasure: Spaces, forms, textures, symbols, sounds, light quality, and colors all suited to the use, whatever it may be. Satisfaction of anticipations, requirement, or desires. Sequences developed and fulfilled. Unity with variety. Harmonious relationships. A resultant quality of beauty.

愉快：空间、形式、质感、象征、声音、光线品质以及色彩，一切都与使用相适合，不管用途如何；对参与性、需求或期望的满足；完善的序列；多样性的统一；协调的关系；美观。

4. Privacy 私密性

Privacy is the ability of an individual or group to seclude themselves or information about themselves and thereby reveal themselves selectively. The boundaries and content of what is considered private differ among cultures and individuals, but share basic common themes. Privacy is sometimes related to anonymity, the wish to remain unnoticed or unidentified in the public realm. When something is private to a person, it usually means there is something within them that is considered inherently special or personally sensitive. The

degree to which private information is exposed therefore depends on how the public will receive this information, which differs between places and over time. Privacy can be seen as an aspect of security——one in which trade-offs between the interests of one group and another can become particularly clear.

私密性是指个人或群体将自己或有关自己的信息与外界隔离的能力，因此有选择地揭示自己。私密的界限和内涵根据文化和个体的差异而有所不同，但是共享基本主题。私密性有时和隐姓埋名相关，希望在公共领域不被注意到或者没有被认出。当一些事对于一个人来说是私密的时候，常常意味着其中有些内容是被认为非常特别的或者个人很敏感的。因此，私人信息被揭露的程度取决于公众将如何接受这一信息，这一点随着场所和时间的变化而不同。私密性可以被看作安全性的一个方面——一个群体和其他群体利益之间的利益交换可以变得特别清晰的地方。

The right against unsanctioned invasion of privacy by the government, corporations or individuals is part of many countries' privacy laws, and in some cases, constitutions. Almost all countries have laws which in some way limit privacy; an example of this would be law concerning taxation, which normally require the sharing of information about personal income or earnings. In some countries individual privacy may conflict with freedom of speech laws and some laws may require public disclosure of information which would be considered private in other countries and cultures.

政府、公司或个人拒绝私密性未经许可受到侵犯的权利在许多国家受保密法保护，有些还写入了宪法。几乎所有的国家都有以某种方式限制私密性的法律；典型范例就是有关税收的法律，通常要求有关个人收入方面信息的共享。在一些国家，个人私密性可能与言论自由的法律相矛盾，一些法律可能要求在其他国家和文化中被认为是私密信息的公开。

Types of privacy 私密性的类型

The term "privacy" means many things in different contexts. Different people, cultures, and nations have a wide variety of expectations about how much privacy a person is entitled to or what constitutes an invasion of privacy.

"私密性"这个词意味着许多不同背景的事物。不同人种、文化和民族，在有关私密性方面应该给予个人多少权利或者什么才构成私密性的侵犯方面有很大的不同。

Physical 身体的

Physical privacy could be defined as preventing "intrusions into one's physical space or solitude". This would include such concerns as:

身体的私密性可以被定义为防止"侵入个人的身体空间或独处"。这将包括下列方面：

- preventing intimate acts or one's body from being seen by others for the purpose of modesty; apart from being dressed this can be achieved by walls, fences, privacy screens, cathedral glass, partitions between urinals, by being far away from others, on a bed by a bed sheet or a blanket, when changing clothes by a towel, etc.
- 为了谨慎的目的防止亲密的行为，或者一个人的身体被其他人看到；除去穿衣，还可以通过墙体、栅栏、私有遮蔽物、单面压花玻璃、小便池之间的隔板、远离其他人，在床上通过床单或毛毯，当更衣时通过毛巾等等来获得。

- video, as aptly named graphics, or intimate acts, behaviors or body part.
- 视频，更适当的名字是图像，或亲密的动作，行为或身体接触。
- preventing unwelcome searching of one's personal possessions.
- 防止不受欢迎的个人财产搜查。
- preventing unauthorized access to one's home or vehicle.
- 防止未经授权进入一个人的家或车内。
- medical privacy, the right to make fundamental medical decisions without governmental coercion or third party review.
- 医学私密性，在没有政府强制规定或第三方当事人监督的情况下进行的基本医学措施。

Physical privacy may be a matter of cultural sensitivity, personal dignity, or shyness. There may also be concerns about safety, for example one has concerns about being the victim of crime or stalking.

身体的私密性可能是关于文化敏感性、个人尊严或羞怯的问题。也涉及安全性，例如一个人担心成为犯罪或攻击的受害者。

Informational　信息的

Data privacy refers to the evolving relationship between technology and the legal right to, or public expectation of privacy in the collection and sharing of data about ones self. Privacy concerns exist wherever uniquely identifiable data relating to a person or persons are collected and stored, in digital form or otherwise. In some cases these concerns refer to how data is collected, stored, and associated. In other cases the issue is who is given access to information. Other issues includes whether an individual has any ownership rights to data about them, and/or the right to view, verify, and challenge that information.

信息私密性是指技术和法律权利之间的关系，或者公众在个人信息的选择和分享中的私密性期望。在任何特别明确的有关个人或群体资料被选择和储存的地方——不管是数字还是其他形式——都存在对私密性的关注。有些时候关注的是资料如何被选择、储存和联系。有些时候问题是什么人可以接触到信息。其他问题包括个人是否拥有自身信息的所有权，以及/或者观看、核实和对信息提出疑问的权利。

Various types of personal information often come under privacy concerns. For various reasons, individuals may not wish for personal information such as their religion, sexual orientation, political affiliations, or personal activities to be revealed. This may be to avoid discrimination, personal embarrassment, or damage to one's professional reputation.

各种类型的个人信息常常处于私密性的关注之下。由于各种原因，个人可能不希望个人信息，比如他们的宗教、性取向，政治观点，或个人行为被揭示出来。这可以避免歧视、个人尴尬，或避免破坏个人的职业名誉。

Organizational　组织的

Governments agencies, corporations, and other organizations may desire to keep their activities or secrets from being revealed to other organizations or individuals. Such organizations may implement various security practices in order to prevent this. Organizations

may seek legal protection for their secrets. For example, a government administration may be able to invoke executive privilege or declares certain information to be classified, or a corporation might attempt to protect trade secrets.

政府机构、公司和其他组织可能希望保持他们的行为或机密不被揭示给其他组织或个人。这些组织可以实施各种安全措施，为的是阻止这类事情的发生。组织可以寻求法律保护他们的机密。例如，政府管理机构能够拥有特权，声明某些信息被保护起来，或者一个公司可以尝试保护商业机密。

5. Pruitt-lgoe Public Housing Project 布鲁特—伊果公共住宅项目

American cities more than most others suffer from the good intentions of urban planners. A case in point is the swing to highrise, low-rent housing projects in the 1950s. Built to literally lift the poor above the grime of slums, they instead deteriorated into vertical slums that now contribute so much to the congestion, isolation and ugliness of U. S. cities that urban planners often must wish that they could just knock them down and start over from scratch.

与全世界绝大多数城市相比，美国城市承受了更多城市规划师们的良好意愿。典型案例就是 20 世纪 50 年代低出租率的高层住宅项目。也许建造这些建筑真的让贫民不再居住在肮脏的贫民窟中，但是拿来代替破败拥挤的贫民窟的东西现在又变得如此拥挤、孤立和丑陋，城市规划师们常常希望他们可以只是把贫民窟拆除并重新开始规划。

Fig. 3-4 Picture when Pruitt-lgoe was putting up.

St. Louis' city planners got an official O. K. for their proposal to demolish two eleven-story units in Pruitt-lgoe, a mammoth low-rent black housing project located a few blocks from St. Louis' downtown section. Eventually the wrecker's ball will level most of the 31 other buildings.

圣路易斯的城市规划师们得到了官方的许可，批准他们拆除布鲁特—伊果——一个巨大的低出租率黑人住宅项目——占据圣路易斯市中心街区的两座 11 层住宅。最终清障车将推平其他 31 座建筑。

The $36 million project, designed by Architect Minoru Yamasaki (who also designed New York's World Trade Center), attracted national attention as a model of public housing when it was built 16 years ago. Its 33 slablike buildings contained modern plumbing, and there were plans for garden apartments and generous landscaping. Yamasaki's "skip stop" elevators opened on only every third floor, which he hoped would become galleries for strolling and games.

耗资 3600 万美元、由建筑师雅马萨齐（他设计了纽约世贸中心）设计的住宅项目，当它在 16 年前建成的时候，成为了公共住宅的标准模式，吸引了全国的注意。33 幢板式建筑拥有现代的管道设备，也设计了花园公寓和丰富的景观。雅马萨奇设计的"跳跃停留"电梯每三层才停一次，他希望这里可以成为散步和游戏的长廊。

Fig. 3-5 Demolish of Pruitt-lgoe Fig. 3-6 Interior of Pruitt-lgoe building

Ghost Town. Today Pruitt-lgoe is a case study in misery. Three-fourths of its 2800 apartments stand empty. Rows of abandoned, windowless buildings loom against St. Louis' skyline like a modern ghost town. Yamasaki's galleries, ill-lighted and unpainted, are havens for junkies and muggers.

鬼城。今天的布鲁特—伊果已经成为了悲惨境遇的典型研究案例。2800 间公寓的 3/4 都是空的。一排排废弃的、没有窗户的建筑在圣路易斯的天际线中隐约可见，就像是一座现代的鬼城。雅马萨奇的长廊，没有照明，也没有油漆过，成为了毒贩和强盗的避难所。

The reason Pruitt-lgoe failed is sociological and financial, rather than racial. Planners built in the worst slum in St. Louis. Many of the first tenants were drawn from the high-crime area, and brought their problems with them. As a result, the working-class white and black families living in Pruitt-lgoe began to move out. With apartments empty, St. Louis welfare officials pressured the Public Housing Authority to admit more welfare cases.

布鲁特—伊果失败是由于社会和财政方面原因，而不是种族。规划师们将这个项目在圣路易斯最糟糕的贫民窟上建造起来。许多首批租户都来自高犯罪率的区域，并将问题一起带到了这里。结果，生活在布鲁特—伊果的工人阶层白人和黑人家庭开始搬出。公寓空置，圣路易斯的福利官员向公共住宅管理机构施加压力提供更多福利住宅。

The result was disaster. The proportion of welfare cases grew until they made up the majority of the project's population. The children of these deprived families formed street gangs, terrorized tenants and vandalized buildings. Because families earned no money, they could not pay existing rents. Rents were lowered, while maintenance costs went up, causing such a strain on the PHA that funds that would have been used to keep up smaller public-housing projects around the city had to be diverted into Pruitt-lgoe.

结果是灾难性的。福利住宅比例不断增长，直到它们占据了项目人口的主体。这些失去家庭的孩子形成了街道帮派，恐吓居民和破坏建筑。因为家庭挣不到钱，他们付不出租金。租金下跌，而维护费用上升，引起公共住宅管理机构的紧张，原本用于城市周围较小公共住宅项目的资金被转到布鲁特—伊果。

Rampaging Junkies, city officials had no choice but to skimp on services. Untended facilities began to fall apart. Elevators stalled. Because windows were inadequately screened, several children

fell out.

到处都是毒贩，城市官员没有选择，只能马马虎虎的管理。没有很好维护的设施开始毁坏。电梯延误。因为窗户没有足够的遮挡，许多孩子掉了下来。

Pruitt-Igoe's slide into disaster was also caused by economy measures that compromised Yamasaki's original design. Landscaping was reduced to a few oases of green. Steam pipes were left uncovered, and a number of people were severely burned. Public toilets were eliminated from the ground floors and playgrounds, and out of either urgency or irritation, children resorted to elevators or hallways to urinate. Cramming 12000 people into 57 acres of land exacerbated already grim social problems.

Fig. 3-7 Windows in Pruitt-Igoe

布鲁特—伊果陷入灾难也是因为经济措施损害了雅马萨奇最初的设计。景观被减少到只有一些小绿洲。蒸汽管道完全没有遮盖，许多人被严重烧伤。第一层和运动场的公共厕所被取消，或者紧急或者愤怒，孩子们在电梯或走廊上小便。1200 人塞进 57 英亩的土地加剧了早已严峻的社会问题。

Urban planners are taking the St. Louis story to heart. They now realize that public housing cannot be used as a dumping ground for welfare cases, since without the higher rentals paid by working families, no project can afford the services and repairs needed to prevent decay. Low-rent projects should be dispersed throughout urban areas. This would avoid the congestion caused by large developments like Pruitt-lgoe.

城市规划师们对圣路易斯的教训进行了深刻的反思。他们认识到公共住宅不能作为全新的福利住宅来使用，因为工人家庭无法付出更高的租金，没有项目可以负担阻止破败所需要的服务和维修。低出租率项目应该在整个城市领域中分散开来。这将可以避免像布鲁特—伊果这样的大型发展项目所引起的拥挤。

Vacabulary

1. conventional *adj.* ①因袭的，传统的，习惯的 ②常规的，普通平凡的 ③受俗套束缚的，按习惯办事的，陈旧的：a conventional design 传统图案｜conventional opinions 旧观念

[近义词] customary, routinely, habitual, usual

[辨析] conventional 习俗的、传统的：指依照公认的形式或习俗，缺乏独特性。
The chairman made a few conventional remarks. 主席说了几句客套话。
ceremonial 正式的、礼貌的：指与礼仪或习俗有关的礼貌，可指合乎礼仪的或有关礼节的。
She received me in a ceremonial way. 她非常礼貌地接待了我。
ceremonious 好礼的，隆重的：指礼节周到的或拘泥于礼节的，用于形容人或事。
The banquet was a ceremonious affair. 那个宴会是一件很拘泥于形式的事。

formal 正式的：指遵守惯例与习俗，强调正确性，坚定不移，缺乏亲切与自然。

A judge has a formal manner in a law court. 在法庭上法官应有符合礼俗的举止。

2. conceive　*vt.*　想象；构想；设想：a badly conceived plan 设想不周的计划

［近义词］think, believe, consider, regard, deem, hold

［辨析］conceive 构思、想象：指观念、计划，设想的形成、产生和发展。

I simply can't conceive how to spend my spare time. 我实在想不出如何安排我的闲暇时间。

envisage 想象：指清楚或具体地想象。

He had not envisaged the matter in that light. 他从没从那方面想过这事。

fancy 想象、假想：指在现实的基础上，按照愿望作无拘束的想象。

He fancied himself a super athlete. 他想象着自己成为一名超级运动员。

imagine 想象：指在脑海里形成一个清晰明确的印象。

I like to imagine myself flying a plane. 我喜欢想象自己驾驶着飞机。

3. furnish　*vt.*　①布置家具，配备家具　②供给，提供：The room was furnished with the simplest essentials, a bed, a chair, and a table. 房间里只布置了最简单的必需品，一张床、一把椅子和一张桌子。

［近义词］equip, appoint, accouter, outfit, arm, rig, decorate, arrange, display, fix up

［辨析］furnish 供给：指供给生活所必需的或为了生活舒适所必需的东西。

We furnished the living room. 我们把客厅布置好了。

provide 供给、供应：指提供生活必需品即食物、衣服等。

We provide children with food and clothes. 我们为孩子们提供衣食。

equip 装备、供给：指装备所需要的东西。

We equipped the kitchen. 我们把厨房里的东西都配齐了。

4. interpersonal　*adj.*　人与人之间的，需要与他人接触的：interpersonal relationships 人与人之间的关系

5. dormitory　*n.*　(学校等的)宿舍，集体宿舍；(在市内工作的人的)郊外住宅区：Children sleep in dormitories when they live at school. 孩子们住在学校时，在宿舍睡觉。| a dormitory town 市郊住宅区

［近义词］diggings, hostel, dorm, living, quarters, hostel, dorm, living, quarters

6. mobility　*n.*　①移动性，流动性，机动性　②善变，易变性，灵活性，表情丰富　③民众，群众，老百姓

［近义词］movability, motion, portability, flxibility, animation, agility

7. values　［*pl.*］生活的理想，道德标准，社会准则：ethical values 伦理的价值标准

［辨析］value 价值：指与他物比较时某物的价值。

This one is of more value than that one. 这一物品的价值比那一物品大。

cost 价格：指物品的成本或原价，它低于售出的价钱。

The cost of the house was high. 这幢房子的成本很高。

worth 价值：指物品自身的价值，它是不变的。

She bought a jewel of great worth. 她买了一块极有价值的宝石。

Sentence

In conventional building program the sociological and psychological needs of the future users receive very little consideration. This leads to shortcomings in the design that become obvious when people fail to use spaces in the manner conceived by the architect.

一般的建筑项目很少考虑到未来使用者的需要。这导致了设计中存在非常明显的缺点，人们不会完全如建筑师所构想的那样使用空间。

It is usually the client who furnishes the architect with the date program of a project. This information, expressed in terms of the number of people to be accommodated and business-related data about desirable human qualities, Which ultimately may be more important to the inhabitants than economic efficiency.

常常是由客户向建筑师提供项目的资料。这类信息，以可容纳人数和关于人们对建筑物的期望的商业资料来表达，对于居住者来说，这些可能最终比经济性更重要。

We know that there exists a relationship between the physical environment and the social and interpersonal behavior of people. But although we can measure human tolerance levels regarding noise, pollution, isolation, overcrowding, and so on, we cannot say with accuracy which designs will bring people together and which plans are likely to keep them apart.

我们知道在实际环境与人们的社会行为、交往行为存在有相互关系。但是虽然我们可以测定人们对于噪声、污染、孤独、拥挤等等的容忍程度，却不能准确地说出哪一个设计会使人们融合，而哪个设计会使人们隔离。

The architect, for instance, many say that the physical environment is "flexible," "free," "harmonious" or "open," but it would be an erroneous over-simplification to assume that a "free" floor plan will make people feel free or that a fence on the property line will discourage difficulties in predicting the direction in which physical design will influence human behavior are illustrated by the case of plazas.

例如，建筑师常常说实际环境是"具有伸缩性的"、"自由的"、"协调的"或"开放的"，但是过于简单化地就推定"自由"的平面将会使人感到自由，或者是认为围起围栏就可以减小判断方向的困难都是完全错误的。以广场为例说明人类行为对设计的影响。

Translation

第3课 社会学和心理学方面

一般的建筑项目很少考虑到未来使用者的需要。这导致了设计中存在非常明显的缺点，人们不会完全如建筑师所构想的那样使用空间。建筑师常常由于设计的空间无法让人们舒适生活而受到责备。产生这种情况的原因之一，是在某种程度上我们缺乏有关整体环境对于人类健康和行为影响的科学知识。

常常是由客户向建筑师提供项目的资料。这类信息以可容纳人数和关于人们对建筑期望的商业资料来表达，对于居住者来说，这些可能最终比经济性更重要。结果，我们的城

市环境不再像任何人所期望的那样。

虽然建筑师尝试去按照特定使用者的生活方式来设计建筑，但是不知不觉中他们就会按照自己满意的标准设计。然而私密性、舒适性、社交性以及社会生活应该由每个项目使用者的特定文化来决定，如果不是这样做，结果就不会是令人满意的。

我们知道，实际环境与人们的社会行为、交往行为存在相互关系。但是虽然我们可以测定人们对于噪声、污染、孤独、拥挤等等的容忍程度，却不能准确地说出哪一个设计会使人们融合，而哪个设计会使人们隔离。事实上，最近对住宅建筑项目的案例研究中，人类行为对设计的影响这个课题甚是否值得进行尝试产生怀疑。以圣路易斯的布鲁特—伊果公众住宅为例，说明通过设计促进社会融合的建筑可能会导致邻居之间的相互恐惧，最后严重到安全性比所有社会性都珍贵的地步，而我们最初认为社会性是开发项目的主要吸引力。

另一个友谊与私密性价值的对立在研究宿舍的盥洗室设计时变得非常明显。可以看出，宿舍共用浴室比宿舍拥有私人浴室可以使人们更亲密。在设计过程中建筑师可能考虑到所有这些无意识的设计效果吗？

即使建筑师们知道缺少灵活性、更大范围的邻里定位和依赖大众家庭的后果，他或她也不会有时间或是有办法将所有资料转变成可行的建筑方案。也许这应该是社会学家与客户和设计师共同合作。所完成的工作，既然绝大多数人无法非常精确和理性地清晰表达自己的感受，那么社会学家也不能独自确定人们在不同环境的体验。

不能将视觉和空间术语与描述人类行为的语汇直接等同起来。例如，建筑师常常说实际环境是"具有伸缩性的"、"自由的"、"协调的"或"开放的"，但是过于简单化地就推定"自由"的平面将会使人感到自由，或者是认为围起围栏就可以减小判断方向的困难都是完全错误的。以广场为例，既然建筑物之间的开放空间在历史上就与政治、宗教、商业等社会活动相联系，今天的设计者们仍继续将广场设计成产生社会意识的空间。虽然在大量设计中这一概念并没有真正成形，因为设计者们忽视了当代公众闲暇时间活动所发展出的特定空间类型。

最近有关建筑物的视觉印象研究表明，建筑师对于建筑物美学性质的感受明显不同于非建筑师。建筑师们所青睐的、认为好的、美观的和有趣的建筑，却被非建筑师们认为是坏的、丑陋的、令人厌烦的。一项住宅设计研究中，只有极少一部分人完全意识到了非实用性的美学性质。这些都证实了我们的怀疑——建筑师可能不再关注人类体验和使用者的需要。

在相互交流中发展出自己的术语和概念后，建筑师有时意识不到他们所用的描述设计和空间理念的词汇，客户并不能直接加以理解。建筑师可能常常希望客户的视觉识别力是非常高的，但是他或她却有责任以非建筑师的方式来使对方理解构思的空间、形式和风格。

大多建筑师都认为，通过简单地改变我们的环境就有可能改变人类的行为。这种想法产生了只要从贫民窟中搬到新住宅中就会自然而然地改善健康、道德和生活方式的神话。这一决定性态度想得过于简单了。住宅真正的成功不仅仅由现实使用者对于设计的实际环境的反映决定，还由自然或人工的实际环境与使用者的社会构成和社会准则之间非常复杂的相互作用决定。

Lesson 4 The Evolution of Perception

The earliest"structures"were purely functional; they were shelters. Yet on the inner walls of these caves man produced the first painting-incredibly beautiful and lifelike-more than 70000 years ago. From the picture plane, man translated what he had perceived into three dimensions, thus creating free-standing structures. With these structures, as with every other human creation, people strove to communicate with their fellow creatures and with their god/s/. When the inevitability of one's own death came to be realized, structural designs took on a grander, more permanent aspect communication with the future. The pyramids were built to last-forever. The ward becomes form.

Architectural language, however, is not a strictly visual communication but a combination of perception understanding and emotional response. Architectural awareness is learned so early in life that it becomes partly intuitive. Architecture is perceived as a compressed statement of our varied external environment, and it is valued according to our internal environments.

Since almost everything man-made is used by people-especially architecture-a direct connection exists between the human body and building. Once measurements were based on various parts of the body and allusions to them remain in the language as idioms rule-of-thumb, arm's length, a head taller or shorter. The system of inches and feet, which as-

Fig. 4-1 Anarrow, high-ceiling room

sume that the measure of the thumb's breadth was 1 inch was gauged by people with wide thumbs and big feet/1 foot＝12 inches/. Thus people use their experience of body/space need to judge dimensional/ acceptability in architecture.

Buildings and sculpture are perceived as being"at rest. "Since the human body at rest is "balanced", an unbalanced building may appear to be moving or falling (such as the famous Leaning tower of Pisa). Similarly, a room attuned to body measurements is perceived as harmonious whole, and a picture hung"crooked"disturbs the mind behind the eye. Our aesthetic judgment is influenced by such fundamental perceptions as the following: the horizon is a horizontal line; the force of gravity of falling is a vertical line; the angle of these two lines is a right angle.

Space. Architecture used to be considered to be mass of form-improving on nature, as it were. A modern definition, taken from behavioral psychology, is that architecture is the

manipulation of space to accommodate the movement of people (behavioral psychology it-self being the manipulation of people to accommodate an existing space, an idea that is be-hind a large portion of building-construction economics). Our senses have learned to accu-rately interpret perceived space; that is, lines of perspective symbolize distance on the pic-ture plane.

Space that lack ventilation or light or limit freedom of movement give rise to feeling of restriction and discomfort, yet a person live in such confinement for many years if necessa-ry, since survival space is much smaller than agreeable of pleasant space. Depending on in-dividual space needs. A room with a low ceiling, no windows, and narrow door frame, textured walls, and carpeted floor may be either cozy or oppressive. A narrow, high-ceiling room may give some the impression of being trapped in a box canyon. Twis-ting or curved walls may produce disorientation. The fear of restricted spaces is known as claustrophobia, gear of open spaces is called agoraphobia. Some people also fear heights or depths. Amusement park "funhouses" are deliberately designed to induce these fears.

Even spaces on a two-dimensional page can affect content comprehension. Material that is broken up into short paragraphs is more easily read and, to many, more "agreeable" to read.

Expert manipulation and utilization of space can invoke every emotional reaction known to mankind. People reveal their psychology by the way they arrange space and themselves within the space. We act differently in a church and in a ballpark. The shape of space offers some indication of how one is expected to behave in that space. Behavior is usually dictated by amount movement permitted. Men are better orientated with respect to movement and direction in rectangular rooms, and they feel disorientation in square or round rooms. For women, the reverse is tare. In this society rectangular rooms are con-sidered to be ordinary living or working space; square or round rooms tend to be either ver-y ancient or very modern and are associated with art, culture, and religion.

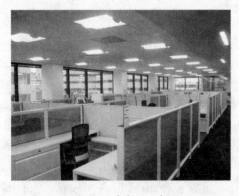

Fig. 4-2 some of the working space Fig. 4-3 Art Space

Our spatial boundaries are not our skins; rather, they extend varying distances beyond our physical selves according to our individual need for territory. Persons who invade

one's personal space are perceived as potential enemies. If an invasion is accidental, as in a crowded elevator we remain quiescent and avert our eyes from others to avoid provoking of seeming to exhibit aggressive or defensive attack. On the other hand, we interpret a deliberate invasion, such as an attempted sales pitch or sexual seduction, as an actual attack on our physical selves, and we respond according to our social conditioning. Thus we perceive our personal space as part of our physical space.

Notes

1. The Earliest"Structures"　最早的"建筑"

The oldest existing monuments of architecture——those of Chaldaea and Egypt——belong to an advanced civilization. The rude and elementary structures built by savage and barbarous peoples, like the Hottentots or the tribes of Central Africa, are not in themselves works of architecture, nor is any instance known of the evolution of a civilized art from such beginnings. So far as the monuments testify, no savage people ever raised itself to civilization, and no primitive method of building was ever developed into genuine architecture, except by contract with some existing civilization of which it appropriated the spirit, the processes, and the forms. How the earliest architecture came into existence is as yet an unsolved problem.

最古老的现存建筑——卡尔迪亚王国和埃及的纪念碑——属于发达的文明。原始和初级的建筑由原始人和野蛮人建造，就如何腾托人或是中亚的部落。它们本身并不是建筑作品，也不是任何从这里开始的文明艺术发展的例证。经过验证，原始人并没有将这些纪念碑提升到文明的高度，建筑原始的建造方法也没有发展到真正的建筑，只是承担了一些当时文明的精神、过程和形式。最早的建筑如何出现至今仍是没有解决的问题。

Primitive Architecture is therefore a subject for the archaeologist rather than the historian of art. If we may judge of the condition of the primitive races of antiquity by that of the savage and barbarous peoples of our own time, they required only the simplest kinds of buildings, though the purposes which they served were the same as those of later times in civilized communities. A hut or house for shelter, a shrine of some sort for worship, a stockade for defence, a cairn or mound over the grave of the chief or hero, were provided out of the simplest materials, and these often of a perishable nature. Only the simplest tools were needed for such elementary construction. There was ingenuity and patient labor in work of this kind; but there was no planning, no fitting together into a complex organism of varied materials shaped with art and handled with science. Above all, there was no progression toward higher ideals of fitness and beauty. Rudimentary art displayed itself mainly in objects of worship, or in the decorations of canoes and weapons, executed as talismans to ward off misfortune or to charm the unseen powers; but even this art was sterile and never grew of itself into civilized and progressive art.

原始建筑因此成为了考古学家而不是艺术史学家的研究主体。如果可以通过我们这个时代的野蛮人来判断古老的原始人的状况，那么原始人只需要最简单的建筑，虽然这些原

始建筑所提供的服务和后期文明社会中的建筑是一样的。茅舍或住宅都是为了提供遮蔽物，一些类型的圣地都是为了礼拜，围栏是为了防御，石碑或土丘是为了纪念首领或英雄，但是在原始社会这些功能都是由容易腐烂的最简单材料所提供。只需要最简单的工具用于这些初级的建造。这种工作需要灵巧和耐心；但并不需要设计，不需要组合在复杂的、有各种各样材料的、由艺术形成和需要科学处理的构造中。首先，没有朝向和美观等更高的理念。原始艺术展现的主要是崇拜的对象，或者是独木舟和武器的装饰，或者作为避免灾祸的护身符，或者展现无法看到的权利；但是甚至这种艺术也没有发展下去，没有成为文明和进步的艺术。

These monuments vary widely in age as well as in excellence some of them belong to Roman or even Christian times; others to a much remoter period. They are divided into two principal classes, the megalithic structures and lake dwellings. The latter comprises a considerable number of very primitive houses or huts built on wooden piles in the lakes of Switzerland and several other countries in both hemispheres, and forming in some cases villages of no mean size. Such villages, built over the water for protection from attack, are mentioned by the writers of antiquity and portrayed on Assyrian reliefs.

这些纪念碑年代分布很广，也很优秀，其中一些属于罗马时期甚至是中世纪；其他属于更遥远的时期。它们被分成两类：巨石建筑和湖泊住所。湖泊住所包含相当数量的非常原始的住宅或茅舍，它们建造在瑞士和南北半球其他国家湖边的木桩上，形成了没有固定尺度的村庄。这些村庄建造在水边目的是防止攻击，古代的作家曾提及这一点，在亚述的浮雕上也有所描绘。

The megalithic remains of Europe and Asia are far more important. They are very widely distributed, and consist in most cases of great blocks of stone arranged in rows, circles, or avenues, sometimes with huge lintels resting upon them. Upright stones without lintels are called menhir; standing in pairs with lintels they are known as dolmens; the circles are called cromlechs. Some of the stones are of gigantic size, some roughly hewn into shape; others left as when quarried. Their age and purpose have

Fig. 4-4　Stonehenge in England

been much discussed without reaching positive results. It is probable that, like the lake dwellings, they cover a long range of time, reaching from the dawn of recorded history some thousands of years back into the unknown past, and that they were erected by races which have disappeared before the migrations to which Europe owes her present populations. That most of them were in some way connected with the worship of these prehistoric peoples is generally admitted; but whether as temples, tombs, or memorials of historical or mythical events cannot, in all cases, be positively asserted. They were not dwellings or palaces, and very few were even enclosed buildings. They are imposing by the size and num-

ber of their immense stones, but show no sign of advanced art, or of conscious striving after beauty of design.

欧洲和亚洲遗留下来的巨石非常重要。它们分布广泛，绝大多数以大体量的石块成列、圆或成对布置，有时在它们之上还有巨大的过梁。直立的没有过梁的石块被称为石柱（巨石纪念碑）；成对站立有过梁的被称为墓室牌坊；圆形的被称为环状列石。一些石块体形巨大，一些石块被粗略地砍成特定形体；其他的就保持原样。对于这些巨石的年代和目的，人们进行过很多讨论但没有达成积极的结果。可能就像湖边住宅一样，这些巨石覆盖了广泛的历史时期，从有记载的历史之初，到数以千年的未知过去，竖立它们的人们早已消失了，很久以后才有移民到达那里成为了现在的欧洲人。绝大多数巨石与史前人们的礼拜有关系，这一点得到了普遍认同；但是究竟是作为寺庙、坟墓还是历史或神化事件的纪念，还不能做出肯定的判断。它们不是住宅或宫殿，甚至极少是封闭围合的建筑。它们有宏伟的尺度和大量巨大的石块，但是没有展现出先进的艺术，或者有意识的设计美学。

These crude and elementary products of undeveloped civilizations have no place, however, in any list of genuine architectural works. They belong rather to the domain of archaeology and ethnology, and have received this brief mention only as revealing the beginnings of the builder's art, and the wide gap that separates them from that genuine architecture.

然而，这些原始和初级的未发展文明的产品，没有列在任何真实建筑作品之中。它们事实上属于考古学和人种学领域，只是作为揭示建筑艺术的开始简短提及，巨大的中断将它们从真实建筑中分离。

2. The Pyramid　金字塔

A view of the pyramids at Giza from the plateau to the south of the complex. From right to left are the Great Pyramid of Khufu, the Pyramid of Khafre and the Pyramid of Menkaure. The three smaller pyramids in the foreground are subsidiary structures associated with Menkaure's pyramid.

从平原向南观看吉萨金字塔，从右到左依次是胡夫金字塔，哈法拉金字塔和门卡乌拉金字塔。前景中三个较小的金字塔是门卡乌拉金字塔附属物。

Fig. 4-5　the pyramids at Giza

The Egyptian pyramids are pyramid shaped structures located in Egypt, and were built as a tomb for dead pharaohs. There are over 100 Egyptian pyramids, most of which were built during the Old and Middle Kingdom periods. The first Egyptian pyramid was the Pyramid of Djozer which was built during the third dynasty under King Djozer. The pyramid was designed by Imhotep as a tomb for the King. The best known Egyptian pyramids are the Giza pyramids which are recognized among the largest structures ever built and are the only remaining monuments of the Seven Wonders of the Ancient World.

埃及金字塔是指位于埃及的金字塔形体建筑，是为死去的法老建造的陵墓。在埃及有超过100座金字塔，绝大多数是在古王国和中王国时期建造。首座埃及金字塔是左塞尔金字塔，建于第三王朝左塞尔王统治时期。这座金字塔由伊姆贺特普设计，作为国王的陵墓。最著名的埃及金字塔是吉萨金字塔，也被认为是最大的建筑和世界七大奇迹中唯一保留下来的纪念碑。

The shape of Egyptian pyramids is thought to represent the primordial mound from which the Egyptians believed the earth was created. The shape is also thought to be representative of the descending rays of the sun, and most pyramids were faced with polished, highly reflective white limestone, in order to give them a brilliant appearance when viewed from a distance. Pyramids were often also named in ways that referred to solar luminescence. For example, the formal name of the Bent Pyramid at Dahshur was The Southern Shining Pyramid.

人们认为埃及金字塔的形体象征原始的土丘，埃及人相信大地就是从土丘开始产生的。金字塔的形体也被认为是太阳向下的光线的表现，绝大多数金字塔以磨光、高反射的白色石灰岩饰面，为的是当从一定距离观看的时候金字塔能有一个光辉灿烂的外观。金字塔常常也以参考太阳光的方式来命名。例如，代赫舒尔的弯曲金字塔正式的名称是南方闪耀金字塔。

While it is generally agreed that pyramids were burial monuments, there is continued disagreement on the particular theological principles that might have given rise to them. One theory is that they were designed as a type of "resurrection machine."

人们普遍认为金字塔是陵墓的纪念碑，但是就建造它们的特定理论原则方面存在很多争论。一种理论观点认为金字塔是作为一种"重生机器"设计的。

The Egyptians believed the dark area of the night sky around which the stars appear to revolve was the physical gateway into the heavens. One of the narrow shafts that extends from the main burial chamber through the entire body of the Great Pyramid points directly towards the center of this part of the sky. This suggests the pyramid may have been designed to serve as a means to magically launch the deceased pharaoh's soul directly into the abode of the gods.

埃及人相信夜晚天空中围绕星星的黑暗领域是通往天堂的大门。从主要的墓室穿过整个巨大金字塔的狭窄通道直接指向这部分天空的中心。这说明金字塔可能被作为将已故法老王的灵魂魔法般地直接射入神的所居之处的工具。

All Egyptian pyramids were built on the west bank of the Nile, which as the site of the setting sun was associated with the realm of the dead in Egyptian mythology.

所有的埃及金字塔都是建在尼罗河的西岸，那里是太阳下落的位置，这也是与埃及神话中的死亡之域相联系的。

The number of pyramid structures in Egypt today is reported as being between 81 and 112, with a majority favouring the higher number. In 1842 Karl Richard Lepsius made a list of pyramids, in which he counted 67. Pyramid 29 that Lepsius called the "Headless Pyramid" remained lost until being found in an archaeological dig in 2008.

今天，埃及金字塔的数量在81～112座之间，大部分人倾向于后者。1842年卡尔·理查德·莱普修斯列出了一份金字塔的清单，他记录了67座。被莱普修斯称为"无头金字塔"的第29号金字塔直到2008年才由于考古挖掘而发现。

The imprecise nature of the count is related to the fact that as many smaller pyramids are in a poor state of preservation and appear as little more than mounds of rubble, they are only now being properly identified and studied by archaeologists.

无法精确计算是因为许多较小的金字塔现在保护得很差，它们看起来就像是废弃的石料堆，只有经过考古学家很仔细的鉴定和研究才能确定。

Abu Rawash 阿布拉瓦须

Abu Rawash is the site of Egypt's most northerly pyramid—the mostly ruined Pyramid of Djedefre, son and successor of Khufu. Originally it was thought that this pyramid had never been completed, but the current archaeological consensus is that not only was it completed, but that it was originally about the same size as the Pyramid of Menkaure.

Fig. 4-6　Abu Rawash

阿布拉瓦须金字塔是位置最靠北的金字塔，大部分由于修建德吉德夫雷金字塔——胡夫的儿子和继任者的陵墓——而被毁坏。最初人们认为这座金字塔从未彻底建成，但是最近的考古研究认为它不仅建成了，而且最初建成的尺度和门卡乌拉金字塔一样大。

Its location adjacent to a major crossroads made it an easy source of stone. Quarrying-which began in Roman times—has left little apart from a few courses of stone superimposed upon the natural hillock that formed part of the pyramid's core. A small adjacent satellite pyramid is in a better state of preservation.

邻近主要交叉路口的位置使它很容易获得石料。采石场——从罗马时代就开始采石——除了一些石块被运到大自然的小丘之上建造金字塔核心部分的痕迹之外，几乎没有留下任何遗迹。附近一个小型附属金字塔保存状态更好一些。

Giza 吉萨

Giza is the location of the Pyramid of Khufu; the somewhat smaller Pyramid of Khafre; the relatively modest-sized Pyramid of Menkaure, along with a number of smaller satellite edifices known as "Queen's pyramids"; and the Great Sphinx.

吉萨是胡夫金字塔、较小的哈法拉金字塔和相对中等尺度的门卡乌拉金字塔所在地，周围有许多更小的附属物——"王后金字塔"和狮身人面像。

Of the three, only Khafre's pyramid retains part of its original polished limestone casing, near its apex. This pyramid appears larger than the adjacent Khufu pyramid by virtue of its more elevated location, and the steeper angle of inclination of its construction—it is, in fact, smaller in both height and volume.

Fig. 4-7 Map of Giza pyramid complex

Fig. 4-8 Pyramid of Khafre and the Great Sphinx

这三座金字塔中，只有哈法拉金字塔在它的顶点附近保存了部分最初用磨光石灰石建造的掩体。这座金字塔由于位置更高，而且建造的倾斜角度更陡，所以看起来比旁边的胡夫金字塔都大 ——事实上，它在高度和体量上都较小。

The Giza Necropolis has been a popular tourist destination since antiquity, and was popularized in Hellenistic times when Pyramid of Khafre was listed by Antipater of Sidon as one of the Seven Wonders of the World. Today it is the only one of those wonders still in existence.

吉萨金字塔群从古代就已经成为了非常受人欢迎的旅游目的地，在古希腊时期人口众多，当时胡夫金字塔被腓尼基旅行家昂蒂帕克列为世界七大奇迹之一。它也是今天唯一现存的七大奇迹。

3. Rule-of-Thumb 拇指规则

A rule of thumb is a principle with broad application that is not intended to be strictly accurate or reliable for every situation. It is an easily learned and easily applied procedure for approximately calculating or recalling some value, or for making some determination.

拇指规则（又叫经验法则）是广泛应用的原则，并不是在任何情况下都完全严格精确或可靠。它对于粗略计算或恢复某些价值，或做出某些决定来说是易于学习和应用的过程。

Origin of the phrase 习语的起源

The earliest citation comes from Sir William Hope's The Compleat Fencing-Master, second edition, 1692, page 157："What he doth, he doth by rule of thumb, and not by art."The term is thought to originate with wood workers who used the length of their thumbs rather than rulers for measuring things, cementing its modern use as an inaccurate, but reliable and convenient standard.

最早出现在威廉·霍普爵士1962年出版的《The Compleat Fencing-Master》（第二版）的第157页："他所做的，完全是靠拇指规则（经验），而不是技艺。"拇指规则据说是来源于木工工人，他们不用尺子，而是伸出拇指来测量木材的长度或者宽度，现代它作为一种不准确、但是可靠和方便的标准使用。

It is often claimed that the term originally referred to a law that limited the maximum thickness of a stick with which it was permissible for a man to beat his wife, but this has been fully discredited as a hoax. Sir Francis Buller, a British judge, was alleged to have stated that a man may legally beat his wife, provided that he used a stick no thicker than his thumb. However, it is questionable whether Buller ever made such a pronouncement and there is even less evidence that he phrased it as a "rule of thumb"; the rumoured statement was so unpopular that it caused him to be lambasted as "Judge Thumb" in a satirical James Gillray cartoon.

拇指规则常被认为最初是指限制棍子最大粗度的法律，这条法律允许丈夫殴打妻子，但是这完全已经变成了一个笑话。英国的法官弗朗西斯·巴勒爵士，宣称一个男人可以合法地殴打妻子，前提是打人的棍子不能比拇指粗。而巴勒是否真的实施过这样的宣判也是没有证据可考的，甚至没有什么证据表明他将其表达为"rule of thumb（原意为拇指法则）"。传说如此不受欢迎，以致在詹姆斯·吉尔瑞的讽刺漫画中他被称为"拇指法官"。

Examples of usage 使用范例

Financial-Rule of 72. A rule of thumb for exponential growth at a constant rate. An approximation of the doubling time formula used in population growth, which says divide 70 by the percent growth rate (the actual number is 69.3147181 from the natural logarithm of 2, if the percent growth is much less than 1%). In terms of money, it is frequently easier to use 72 (rather than 70) because it works better in the 4%~10% range where interest rates often lie. Therefore, divide 72 by the percent interest rate to determine the approximate amount of time to double your money in an investment. For example, at 8% interest, your money will double in approximately 9 years (72/8＝9).

金融—72法则. 以固定速率指数增长的经验法则。一种用于得出总数增长一倍的时间的公式近似方法，就是说用百分比增长速度来除70（真实数字是69.3147181，来自2的自然对数，如果百分比增长非常非常小于1%）。对于货币，常常使用72法则更简单（而不是70），因为它在4%~10%的范围里更好用，而利率常常在这个范围里浮动。因此，用百分比利率来除72就得出了在一项投资中使你的资金翻倍的时间。例如，在8%的利率下，你的资金将在大约9年（72/8＝9）中翻一倍。

Tailors' Rule of Thumb. This is the fictional rule described by Jonathan Swift in his satirical novel *Gulliver's Travels*：

裁缝的"经验法则"。这是由乔纳森·斯威夫特在他的讽刺小说《格列佛游记》中描述的虚构法则。

"Then they measured my right Thumb, and desired no more; for by a mathematical Computation, that twice round the Thumb is once around the Wrist, and so on to the Neck and Waist, and by the help of my old Shirt, which I displayed on the Ground before them for a Pattern, they fitted me exactly."

"接着他们测量我的右拇指，接着什么也不用做了；因为通过数学计算，拇指周长的两倍是手腕的周长，而脖子和腰部也是如此，在他们面前地面上展示的旧衬衣的帮助下，

他们得到了裁减尺寸，这些尺寸很适合我。"

Marine Navigation. A ship's captain should navigate to keep the ship more than a thumb's width from the shore, as shown on the nautical chart being used. Thus, with a coarse scale chart, that provides few details of nearshore hazards such as rocks, a thumb's width would represent a great distance, and the ship would be steered far from shore; whereas on a fine scale chart, in which more detail is provided, a ship could be brought closer to shore.

海上航行。一艘船的船长应该使船保持距离岸边超过航海图所展现的一拇指宽度。因此，比例粗糙的图，很少提供近海区域危险的细节，比如岩石，大拇指宽度代表足够远的距离，船只就可以保持远离岸边；然而制作精良的航海图可以提供更为详细的细节，船只就可以更靠近岸边。

Etiquette. In a formal place setting, the silverware and the dinner plate should be set back from the edge of the table a length equal to the distal phalanx of the thumb.

礼节。在正式场合，银器和餐盘放置的位置与桌边的距离应该等于拇指趾骨的距离。

Brewing. Before the invention of thermometers, the brewer tested the wort by placing his thumb in it. When he could reliably place his thumb in the wort without having to remove it because of the heat, the wort was cool enough to pitch the yeast.

酿造。在发明温度表之前，酿造商们通过把拇指放在里面来测试麦芽汁的温度。当他能够把拇指放在麦芽汁中不必由于热度而移开时，麦芽汁就足够凉而可以发酵了。

4. Arm's Length Principle　公平法则

The arm's length principle (ALP) is the condition or the fact that the parties to a transaction are independent and on an equal footing. Such a transaction is known as an "arm's-length transaction". It is used specifically in contract law to arrange an equitable agreement that will stand up to legal scrutiny, even though the parties may have shared interests (e. g., employer-employee) or are too closely related to be seen as completely independent (e. g., the parties have familial ties).

公平法则(ALP)是指一种条件或事实：双方的交易是独立的、建立在平等的基础之上的。这种交易被认为是"公平交易"。它具体应用在贸易相关法律中，为的是制订公平协议，要经得起法律的仔细审查，即使双方可能分享利益(比如——雇佣者和雇员)或者过于密切相关以致于无法视为完全独立(比如，家庭成员之间)。

A simple example is the sale of real property from parents to children. The parents might wish to sell the property to their children at a price below market value, but such a transaction might later be classified by a court as a gift rather than a bona fide sale, which could have tax and other legal consequences. To avoid such a classification, the parties need to show that the transaction was conducted no differently than it would have been for an arbitrary third party. This can be done, for example, by hiring a disinterested third party such as an appraiser or broker, who can offer a professional opinion that the sale price is appropriate and reflects the true value of the property.

一个简单的范例就是父母向孩子出售不动产。父母可能希望向他们的孩子出售资产的

价格低于市场价值，但是这种交易可能随后被法庭认为是礼物而不是真正的出售，可能会造成交税和其他法律后果。为了避免如此认定，交易双方需要展示他们的交易，与和完全不相关的第三方交易在实施方面没有任何不同。这是可以实现的，例如通过雇佣完全无关的第三方比如估价师或经纪人，他们可以提供出售价格多少合适的专业观点和反应资产的真实价值。

The principle is often invoked to avoid undue government influence over other bodies, such as the legal system, the press, or the arts. For example, in the United Kingdom Arts Councils operate "at arms length" in allocating the funds they receive from the government.

公平原则常常使用，以避免非法的政府影响施加于其他机构，比如在法律系统、出版业或者艺术行业。例如，英国的艺术委员会在分配他们从政府那里得到的资金时就运用"公平原则"。

The Organisation for Economic Co-operation and Development (OECD) has adopted the principle in Article 9 of the OECD Model Tax Convention, to ensure that transfer prices between companies of multinational enterprises are established on a market value basis. In this context, the principle means that prices should be the same as they would have been, had the parties to the transaction not been related to each other. This is often seen as being aimed at preventing profits being systematically deviated to lowest tax countries. It provides the legal framework for governments to have their fair share of taxes, and for enterprises to avoid double taxation on their profits.

经济合作与发展组织（OECD）在经济合作与发展组织税收协定范本中的第9条就采用了该原则，以保证跨国公司之间的交易价格是建立在市场价值基础之上。在这种背景下，公平原则意味着价格应该和它们所具有的价值一致，交易的双方不能相互有关联。这常常被认为是为了阻止从低税收国家抽取利益。公平原则为政府提供法律框架，保持他们税收的公平性，避免了企业为了政府的利益而被两次征税。

The use of "arm's length principle" is extended as a new concept in tort law. A person should keep an "arm's length" distance from another to avoid offensive or harmful contact, otherwise a battery or assault may result if one person goes too close to another without consent. To keep an "arm's length" from another person is respect to his/her bounds of dignity.

"公平原则"作为新概念运用到了侵权行为相关法律中。一个人应该保持与他人的"公平"距离，以避免令人不快或有害的接触。如果一个人在没有得到允许的情况下过于接近其他人，可能导致殴打或攻击。保持与他人的"公平"被认为是他或她的尊严界限。

5. Leaning Tower of Pisa 比萨斜塔

The Leaning Tower of Pisa (Italian: Torre pendente di Pisa) is the freestanding bell tower, of the cathedral of the Italian city of Pisa. It is situated behind the cathedral and is the third oldest structure in Pisa's Piazza del Duomo (Cathedral Square) after the cathedral and the baptistry.

比萨斜塔（意大利语：Torre pendente di Pisa）是意大利比萨大教堂的独立钟楼，位于大教堂的后面。比萨斜塔位列大教堂和洗礼堂之后，是比萨大教堂广场的第三古老建筑。

Although intended to stand vertically, the tower began leaning to the southeast soon after the onset of construction in 1173 due to a poorly laid foundation and loose substrate that has allowed the foundation to shift direction. The tower presently leans to the southwest.

虽然被设计成垂直站立的钟塔，但是从1173年一开工，由于基础不牢和土地过于松散使得基础发生方向变化，比萨斜塔就开始向东南方倾斜。斜塔现在正是倾向东南方。

Fig. 4-9 The Leaning Tower of Pisa

The height of the tower is 55.86m (183.27ft) from the ground on the lowest side and 56.70m (186.02ft) on the highest side. The width of the walls at the base is 4.09m (13.42ft) and at the top 2.48m (8.14ft). Its weight is estimated at 14500 tons. The tower has 296 or 294 steps; the seventh floor has two fewer steps on the north-facing staircase. The tower leans at an angle of 3.97 degrees. This means that the top of the tower is 3.9 metres (12ft 10 in) from where it would stand if the tower were perfectly vertical.

斜塔距离地面最低边高55.86米（183.27英尺），最高边高56.70米（186.02英尺）。基础的墙体厚度是4.09米（13.42英尺），顶部墙厚2.48米（8.14英尺）。它的重量估计达14500吨。斜塔有296或294个台阶：第七层面向北方的楼梯少两个台阶。斜塔倾斜角度是3.97度。这意味着如果斜塔完全垂直的话，它的顶部将高出3.9米（12英尺10英寸）。

Construction 建造

The Tower of Pisa was a work of art, performed in three stages over a period of about 177 years. Construction of the first floor of the white marble campanile began on August 9, 1173, a period of military success and prosperity. This first floor is surrounded by pillars with classical capitals.

比萨斜塔是一件艺术品，经历了3个阶段大约177年完成。这座白色大理石钟楼首层的建造开始于1173年9月9日，是取得军事成功和繁荣的一段时期。比萨斜塔的首层由古典造型的柱子围绕。

The tower began to sink after construction progressed to the third floor in 1178. This was due to a mere three-meter foundation, set in weak, unstable subsoil. This means the design was flawed from the beginning. Construction was subsequently halted for almost a century, because the Pisans were almost continually engaged in battles with Genoa, Lucca and Florence. This allowed time for the underlying soil to settle. Otherwise, the tower would almost

certainly have toppled. In 1198, clocks were temporarily installed on the third floor of the unfinished construction.

Fig. 4-10 the baptistry

在 1178 年建造第三层时斜塔开始下沉。这是由于斜塔只有仅仅 3 米的基础，却建立在柔软的、不稳定的地基土上。这意味着设计从一开始就是有错误的。建造随之暂停了几乎一个世纪，因为当时比萨人几乎不断地在与热那亚、卢卡和佛罗伦萨进行战争。这就使得斜塔下面的土壤有时间稳定沉降直至静止。否则，斜塔绝对会倾倒。1198 年，大钟暂时放在了未完成的斜塔的第三层上。

In 1272, construction resumed under Giovanni di Simone, architect of the Camposanto. In an effort to compensate for the tilt, the engineers built higher floors with one side taller than the other. This made the tower begin to lean in the other direction. Because of this, the tower is actually curved. Construction was halted again in 1284, when the Pisans were defeated by the Genoans in the Battle of Meloria.

1272 年，在纳骨室的建筑师乔瓦尼·西蒙的指导下，斜塔恢复建造。为努力恢复斜塔垂直，工程师们修建了一边高过另一边的地面。这使得斜塔开始向另一个方向倾斜。因此，斜塔其实是弯曲的。1284 年建造工作再次停止，当时比萨人在麦洛里亚战役中被热那亚人击败。

The seventh floor was completed in 1319. The bell-chamber was not finally added until 1372. It was built by Tommaso di Andrea Pisano, who succeeded in harmonizing the Gothic elements of the bell-chamber with the Romanesque style of the tower. There are seven bells, one for each note of the musical scale. The largest one was installed in 1655.

1319 年完成了第七层。钟室最终于 1372 年才加上。钟室是由皮萨诺修建的，他在钟室的哥特元素和罗马风的塔体之间取得了和谐。钟室共有 7 座大钟，每个都有独特的音律。最大的一个在 1655 年安放于此。

Galileo Galilei is said to have dropped two cannon balls of different masses from the tower to demonstrate that their descending speed was independent of their mass. This is considered an apocryphal tale, and the only source for it comes from Galileo's secretary.

传说伽利略曾从斜塔上扔下两个不同重量的球体，以证明它们的下降速度和重量无关。这被认为是虚假的传说，唯一来源是伽利略的秘书。

6. Claustrophobia Agoraphobia　幽闭恐惧症　广场恐惧症

Claustrophobia is the fear of enclosed spaces. The word originates from claustro meaning closed. It is typically classified as an anxiety disorder and often results in panic attacks. One study indicates that anywhere from $2\% \sim 5\%$ of the general world population is affected by severe claustrophobia. However, only a small percentage of these people re-

ceive some kind of treatment for the disorder.

幽闭恐惧症是对封闭空间产生恐惧。这个词语来源于"claustro"，意为封闭。一般认为它是一种焦虑健康障碍，并且常常导致恐慌。研究表明，全球人口中2%～5%的人都有严重的幽闭恐惧症。然而，这些人中只有一小部分人接受治疗。

Claustrophobia is typically thought to have two key symptoms: fear of restriction and fear of suffocation. A typical claustrophobic will fear restriction in at least one, if not several, of the following areas: small rooms, locked rooms, tunnels, cellars, elevators, subway trains, and crowded areas. Additionally, the fear of restriction can cause some claustrophobics to fear trivial matters such as sitting in a barber's chair or waiting in line at a grocery store simply out of a fear of confinement to a single space. This is not to say, however, that claustrophobics are necessarily afraid of these areas themselves, but, rather, they fear what could happen to them should they become confined to said area. Often, when confined to an area, claustrophobics begin to fear suffocation, believing that there may be a lack of air in the area to which they are confined. Any combination of the above symptoms can lead to severe panic attacks. However, most claustrophobics do everything in their power to avoid these situations.

幽闭恐惧症有两个关键症状：对受限制的恐惧和窒息的恐惧。如果不严重的话，有幽闭恐惧症的人将对下列场所中的至少一处产生恐惧：小房间，上锁的房间、隧道、地下室、电梯、地下铁和人流拥挤的场所。另外，对限制的恐惧可能引起某种幽闭恐惧症，就会害怕平常的事情，比如坐在理发师的椅子上或者排队等待的杂货店，只是由于对禁锢在一个简单空间感到恐惧。然而，这不是说有幽闭恐惧症的人就必须对这些场所本身产生恐惧，而是他们害怕将要发生什么会把自己禁锢在前面所说的场所中。往往当有幽闭恐惧症的人被限制在一处场所中时，会开始害怕、窒息，相信限制他们的场所会缺少空气。以上症状的结合可以导致严重的恐慌。然而，绝大多数有幽闭恐惧症的人可以在自我控制下做出避免这些情况发生的事。

Agoraphobia 广场恐惧症

Agoraphobia is an anxiety disorder, often precipitated by the fear of having a panic attack in a setting from which there is no easy means of escape. As a result, sufferers of agoraphobia may avoid public and/or unfamiliar places. In severe cases, the sufferer may become confined to their home, experiencing difficulty traveling from this"safe place."

广场恐惧症是一种焦虑性健康障碍，常常是由于在一处没有易于逃生手段的环境中感到恐慌而引起。结果，广场恐惧症的患者可能会避免出现在公共和/或不熟悉的场所。在严重的情况下，患者可能变得限制在家中，感觉到从这个"安全场所"中离开很困难。

The word"agoraphobia"is an English adaptation of the Greek words agora (αγορά) and phobos (φόβος), and literally translates to"a fear of the marketplace."

"agoraphobia"是英语将古希腊语市场(αγορά)and趋避性(φόβος)结合产生的，用来描述对"市场的恐惧"。

Agoraphobia is a condition where the sufferer becomes anxious in environments that are unfamiliar or where he or she perceives that they have little control. Triggers for this

anxiety may include crowds, wide open spaces or traveling, even short distances. This anxiety is often compounded by a fear of social embarrassment, as the agoraphobic fears the onset of a panic attack and appearing distraught in public.

广场恐惧症是指患者变得对不熟悉或者他或她感到无法控制的环境感到焦虑。这种焦虑的触动因素可能包括人群、宽阔的开放空间或者旅行，甚至是短距离的旅行。这种焦虑常常混合着社交困难，因为有广场恐惧症的人害怕在公共场合自己会开始恐慌和看起来像发疯了。

Agoraphobics may experience panic attacks in situations where they feel trapped, insecure, out of control or too far from their personal comfort zone. In severe cases, an agoraphobic may be confined to his or her home. Many people with agoraphobia are comfortable seeing visitors in a defined space they feel they can control. Such people may live for years without leaving their homes, while happily seeing visitors in and working from their personal safety zones. If the agoraphobic leaves his or her safety zone, they may experience a panic attack.

有广场恐惧症的人可能在他们觉得有陷阱、不安全、无法控制或离自己舒适区域过远的地方感到恐慌。在严重的案例中，一位广场恐惧症患者可能会禁闭在他或她的家中。许多有广场恐惧症的人在他们感到可以控制的限定空间中会见他人会感到舒适。这些人可能多年没有离开过家，而喜欢看到有人来看自己，并在他们的个人安全区域工作。如果有广场恐惧症的人离开他或她的安全区域，他们可能感到恐慌。

Research has uncovered a linkage between agoraphobia and difficulties with spatial orientation. Normal individuals are able to maintain balance by combining information from their vestibular system, their visual system and their proprioceptive sense. A disproportionate number of agoraphobics have weak vestibular function and consequently rely more on visual or tactile signals. They may become disoriented when visual cues are sparse as in wide open spaces or overwhelming as in crowds. Likewise, they may be confused by sloping or irregular surfaces.

研究发现在广场恐惧症和空间定位困难之间存在联系。正常的人可以通过从前庭系统——视觉系统和本能——合成的信息来保持平衡。广场恐惧症的比例失调弱化了前庭功能，于是人们更多依赖于视觉或触觉信号。当视觉线索由于空间宽阔开放或人流拥挤而变得稀少时，他们就可能变得失去方向。同样，他们可能对于混乱或不整齐的表面而感到困惑。

Vocabulary

1. evollution *n.* ①进化，演化，进化论：study the evolution of man 研究人类的进化 ②发展，发育，开展：the evolution of the modern car 近代汽车的发展 ③放出，散出，放出物，散出物：The evolution of heat from the sun is inestimable. 从太阳中放射出的热是无法估计的。

［近义词］development, advance, growth, increase, progress, progression, expansion, ripening, derivation, descent, Darwinism

［辨析］evolution 发展、开发：指自然而逐步的发展。

We noticed the evolution of the modern steamship from the first crude boat. 我们注意到最初原始简陋的小船是如何演变为现代化轮船的。

development 发展、成长：系普通的用词。

He is engaged in the development of his business. 他正努力发展业务。

advance 前进、进展：指向一个固定目标或目的地推进。

The advance of our troops was not noticed by the enemy. 敌人没有发现我们的军队在前进。

growth 生长：指成长发展的过程。

Childhood is a period of rapid growth. 幼年是生长迅速的时期。

2. perception　*n.* ①感觉，知觉，感受，体会：visual perception 视觉　②知觉作用；知觉过程；感性认识；观念，概念　③理解力，洞察力，直觉；了解　④［法］地租的征收；（农作物的）收获

［近义词］awareness,feeling,grasp,consciousness,sense,apprehension,comprehension,judgment,understanding,recognition,impression　*n.* 感觉，知觉

conception,concept,idea,image,notion,thought,view,belief,conviction,supposition　*n.* 概念，观念

3. shelter　*n.* ①避难所；庇护物，遮蔽物；庇护所：an air-raid shelter 防空洞　②庇护，掩护；遮挡：a shelter from the sun. 避免日晒处　③百叶箱；棚

［近义词］refuge,asylum,cover,protection,shield,haven,safety

［辨析］shelter 庇护所：指躲避风雨或危险等侵害的场所，有临时性的含义。

We took a shelter under a tree. 我们在树下躲雨。

asylum 收容所、救济院：指收容、保护病人或罪犯的场所。

There stands an asylum for the blind. 那里有一所盲人院。

refuge 避难所：指避免危险、灾祸等的场所。

It is made for refuge from floods. 这里可作为躲避洪水的场所。

4. dimension　*n.* ①尺寸：A line has one dimension and a square has two. 线是一度空间，平面是两度空间。②［数］次元，度（数），维（数）：Time is sometimes called the fourth dimension. 时间有时被称为第四度空间。③容积，面积，大小，规模，范围：What are the dimensions of this language laboratory? 这个语言实验室的容积是多少？④女性的腰胸臀：The girl's dimensions were 38-24-36. 女孩的标准腰胸臀尺寸是 38-24-36 英寸。

［近义词］size,mass,volume,measurements,length,width,height,thickness,physical extent　*n.* 尺寸，面积，体积

scope,range,extent,magnitude,volume,weight,greatness,massiveness,importance　*n.* 范围，重要性

5. measurement　*n.* ①测量，度量：We take the measurements of sth. to see how long,tall,or wide it is. 我们量东西以便知道它有多长、多高或多宽。②（量得的）尺寸，大小，长、宽、深度，面积，容积：the measurements of a room 房间的面积　③度量制

度：measurement in miles 英里的度量制度 ④容量，容［体］积，计算单位，测量结果 ⑤（按体积、容积计算的）体积货物 ⑥（妇女的）三围（指胸围、腰围和臀围）：My waist measurement is 32 inches. 我的腰围是 32 寸。

［近义词］calculation，evaluation，computation，estimation *n.* 测量，度量

measure，depth，width，height，area，extent，volume，weight，size，dimension，magnitude *n.* （量得的）尺寸，大小，长、宽、深度，面积，容积

system，law *n.* 度量制度

6. idiom *n.* ①成语；习语，惯用语：To be"hard up"is an English idiom. "hard up"是英语惯用语。②（一民族或国家的）语言特性；语言的特别表达方式：the idiom of the young 年轻人的习惯用语 ③方言，土语 ④风格，特色以某个个人、学派、时代或媒介为代表的艺术风格：the idiom of the French impressionists 法国印象主义风格

［近义词］speech，dialect，language，tongue，colloquialism，expression，jargon，phrase，style，usage *n.* 习语

［辨析］idiom 成语、惯用语：指一门语言中的单词、片语或句子的特殊表现法。

The use of preposition is a striking feature of English idioms. 前置词是英语惯用法的一个显著特色。

speech 语言：指人类所特有的、有音节的语言。

He is thick in his speech. 他说话时发音不清楚。

dialect 方言：指某一地区特有的语言形式。

He speaks several dialects. 他会说好几种方言。

anguage 语言：指构成一个民族，国家或几个民族语言的字、形、音或结构。

The French people speak French language. 法国人说法语。

tongue 语言：指一国或一民族的语言。

He speaks nothing but his mother-tongue. 他只说他本国的语言。

7. perspective *adj.* 透视的，透视画法的，配景的：a perspective glass 望远镜 *n.* ①透视画法，配景：aerial perspective 空中透视画法 ②远景，眼界，景色，前景：a perspective of lakes and hills 湖山远景 ③适当比例，配合 ④洞察力，眼力：tried to keep my perspective throughout the crisis 试图在整个危机中保持我的洞察力 ⑤看法，观点：see thing in perspective 正确地观察事物 ⑥透镜；望远镜

［近义词］viewpoint，outlook，angle，aspect，point，consideration，standpoint，position，side，focus *n.* 观点，看法

outlook，panorama，vista，overview，view，look，scene，prospect，bird's-eye view，panoramic view *n.* 远景，景观

［辨析］perspective 前景、远景：原指透视法，即远近的配合，现指被观察的天然景色。

The villa he bought last year held a perspective of lakes and hills. 从他去年购的别墅里可以领略湖山的远景。

outlook 景色、展望：指尽目力所能看到的风景，也可指对事情发展的看法。

The hotel has a good outlook on the lake. 这旅馆有很好的湖景。

panorama 全景：指宽广的、无阻挡的景色。

He enoyed the panorama of London life. 他欣赏着伦敦形形色色的生活全景。

vista 景色、远景：指在狭窄通道的末端所见到的景色。

The opening between the two rows of trees afforded the vista of the lake. 从两行树木间的通道中露出了湖的远景。

8. territory *n.* ①领土，版图，领地：This island is our territory. 这个岛是我国的领土。②领域；地盘；地域：in the territory［sphere,field,domain,area］of science and technology 在科学技术的领域内 ③［商］势力范围；区域；地区 ④［动］生活范围

［近义词］region,area. zone,sphere,scope,sector

n. 领域，范围

domain,jurisdiction,terrain,realm,province,dominion,kingdom,empire,land,bounds

n. 领土，地区

［辨析］territory 领土：指在某个政府统治下的土地。

Gibraltar is British territory. 直布罗陀是英国的领土。

domain 领土、领域：原意指领土，现可喻指思想、知识、活动的领域或范畴。

They touched upon questions in the domain of literature. 他们谈到了文学领域的一些问题。

jurisdiction 管辖权：指实施司法、裁判、审判的权力。

The courts have jurisdiction not only over our own citizens but over foreigners living here. 法庭的裁判权不仅及于我们的公民，而且及于侨居此地的外国人。

terrain 地域、地势、地形：指大块土地，尤指从军事角度而言的地势、地形。

The terrain is difficult for tanks. 这种地形对坦克很难通行。

Sentence

Yet on the inner walls of these caves man produced the first painting-incredibly beautiful and lifelike-more than 70000 years ago. From the picture plane,man translated what he had perceived into three dimensions,thus creating free-standing structures. With these structures,as with every other human creation,people strove to communicate with their fellow creatures and with their god/s/.

然而在这些七万多年前的洞穴室内墙上，人类创造出了令人无法相信的美丽和逼真的图画。通过画面，人类将所感知的一切转换为三维，于是创造出了独立于外的建筑。通过这些建筑，也通过所有人类创造，人们力求与共同生存的生物和神灵产生交流。

Architectural language,however,is not a strictly visual communication but a combination of perception understanding and emotional response. Architectural awareness is learned so early in life that it becomes partly intuitive. Architecture is perceived as a compressed statement of our varied external environment,and it is valued according to our internal environments.

然而，建筑语言严格说来并不是视觉上的联系，而是感知的理解和情感反应的结合。建筑意识早在人类历史早期就已经被认识到，于是它很大部分都是靠直觉。人们把建筑作

为各种各样外部环境的压缩体来感受，并根据我们的内部环境来加以评价。

Once measurements were based on various parts of the body and allusions to them remain in the language as idioms rule-of-thumb, arm's length, a head taller or shorter. The system of inches and feet, which assume that the measure of the thumb's breadth was 1 inch was gauged by people with wide thumbs and big feet/1 foot＝12 inches/.

曾经尺寸都是以各个身体部位来确定的，并且在留传下来的语言中仍有所暗示，比如经验法则、公平的、高一头或低一头这些词。假定大拇指的宽度为 1 英寸的英制尺寸系统，就是人们以较宽的大拇指来制定标准：1 英尺＝12 英寸。

A modern definition, taken from behavioral psychology, is that architecture is the manipulation of space to accommodate the movement of people（behavioral psychology itself being the manipulation of people to accommodate an existing space, an idea that is behind a large portion of building-construction economics）. Our senses have learned to accurately interpret perceived space; that is, lines of perspective symbolize distance on the picture plane.

现代的定义，从行为心理学出发，认为建筑是对空间进行控制以满足人类运动的需要（行为心理学自身就是控制人类以适应存在的空间，这一理论支持了大部分建筑构造经济学）。我们研究人类的感觉是为了准确地解释所感受的空间；也就是图面上表现透视距离的线条。

Persons who invade one's personal space are perceived as potential enemies. If an invasion is accidental, as in a crowded elevator we remain quiescent and avert our eyes from others to avoid provoking of seeming to exhibit aggressive or defensive attack. On the other hand, we interpret a deliberate invasion, such as an attempted sales pitch or sexual seduction, as an actual attack on our physical selves, and we respond according to our social conditioning.

侵入私人空间的人就会被认为是潜在的敌人。如果侵入是偶然的，比如在拥挤的电梯中，我们会保持静止并且避开眼睛与他人接触，以避免产生似乎在展示侵略性或防御性攻击感觉。另一方面，我们认为是有意地侵入，比如一个销售员搭住你或性的引诱，就是对我们身体本身的实际侵犯，我们会根据我们的社交习惯来有所反应。

Translation

第 4 课　感 知 的 进 化

最早的"建筑"是纯功能性的；它们只是遮蔽物。然而在这些七万多年前的洞穴室内墙上，人类创造出了令人无法相信的美丽和逼真的图画。人类将其从画中所感知的事物转换为三维的时候，就创造出了独立于外的建筑。通过这些建筑，也通过所有的人类创造，人们力求与共同生存的生物和神灵产生交流。当人们认识到死亡是必然的时候，建筑的设计就呈现出更为宏伟、永久的一面，联系着未来。金字塔就是为了永恒而建造。保护体变成了形式。

然而，建筑语言严格说来并不是视觉上的联系，而是感知的理解和情感反映的结合。建筑意识早在人类历史早期就已经被认识到，很大程度上人们都是靠直觉。人们把建筑作为各种各样外部环境的压缩体来感受，并根据内部环境来加以评价。

既然几乎每个人工制品都是为了人们的使用——特别是建筑——在人类身体和建筑物之间就存在直接联系。人们曾经都是以各个身体部位来确定尺寸的，在留传下来的语言中仍有所暗示，比如经验法则、公平、高一头或低一头这些词。假定大拇指的宽度为1英寸的英制尺寸系统，就是人们以较宽的大拇指来制定标准：1英尺＝12英寸。因此人们在运用身体/空间体验时，需要判断建筑的空间可承受性。

建筑和雕塑都是"静止的"。因为人类身体静止时是"平衡的"，那么一个不平衡的建筑就会显得正在移动或下降（比如著名的比萨斜塔）。类似的，一间与人体尺度协调的房间会让人觉得是和谐的，而一幅扭曲的图像会扰乱你的思想。我们的美学判断受到下列基本感受的影响：视界是一条水平的线；下落的重力是一条垂直线；两者之间的角度是直角。

空间。和过去一样，人们习惯上将建筑认为是改进自然环境的体量。建筑的现代定义从行为心理学出发，认为建筑是对空间进行控制以满足人类运动的需要（行为心理学就是研究控制人类以适应存在的空间，这一理论支持了大部分建筑构造经济学）。我们研究人类的感觉是为了准确地解释所感受的空间，也就是图面上表现透视距离的线条。

身处缺少通风或光照、或者是限制行动自由的空间里，人们就会产生受管制或不舒服的感觉；然而如果必要的话，一个人可以在这种封闭空间中生活许多年，因为生存空间的要求要比令人愉悦的舒适空间低得多。依据个人空间需求的不同，一间低顶棚、没有窗户、门很窄、墙质地粗糙、地板凹凸不平的房间可能是舒适的，也可能是压抑的。狭窄、高顶棚的房间可能给人以置身于巨大峡谷之中的感觉。扭曲或弯曲的墙壁可能会使人失去方向感。对限定空间的恐惧被称为幽闭恐惧症，对开放空间的恐惧被称为广场恐惧症。一些人也害怕高度或深度。游乐场"娱乐屋"就是有意设计成能引起这些恐惧。

甚至在二维图面中的空间也能影响人们对其内涵的理解。被分成小段的素材更易于理解，对许多人来说，更"愿意"去理解。

对空间巧妙的处理和利用，可以唤起每一种人类情感反应。人们通过安排空间和空间中的自己能够揭示自己的心理。人们在教堂和棒球场的行为当然不同。空间的形态对人们预想其中的行为提供一些指导。行为常常受空间允许的运动限度支配。在矩形房间中男人可以更好地定向，在正方形或圆形房间里就会感觉失去方向感。而女人则刚好相反。在我们的社会中，矩形房间被认为是最普遍的生活或工作空间；正方形或圆形房间则认为是或者非常古老，或者非常现代的，与艺术、文化、宗教相关的空间。

我们的空间界限并不是我们的皮肤；它们根据我们对于空间领域的个体需要而延伸，超越实际距离。侵入私人空间的人就会被认为是潜在的敌人。如果侵入是偶然的，比如在拥挤的电梯中，我们会保持静止并且避开眼睛与他人接触，以避免产生似乎在展示侵略性或防御性攻击感觉。另一方面，如果我们认为是有意的侵入，比如一个销售员搭住你或性的引诱，就是对我们身体本身的实际侵犯，我们会根据我们的社交习惯来有所反应。因此我们可以感知到实际空间中的一部分私人空间。

Extensive Reading

Art Of The Fifteenth Century

For Hundreds of years, the church was the most important institution in Europe. Artists spent all their time working on decoration for these great buildings. We quite often do not even know the names of the artists.

As the cities became larger and people traveled more, some of the citizens became richer. They wanted better places in which to live and work. Artists were hired to plan and decorate buildings other than the churches. Since artists were often hired because they were well-known, they started signing their names to many of their art works.

The de Medici family, a rich and powerful group in Florence, Italy, hired many artists to work for them. One of these artists, Benozzo Gozzoli (1420~1497) , painted a fresco called "The Journey of the Magi". A fresco is a painting made directly in the wet plaster of a wall.

Although this fresco was about a religious subject, the people in it were really members of the de Medici family, wearing their own rich clothing. Artists were still supposed to paint only religious subjects, but we can see in this fresco that they were beginning to be more interested in life around them.

Leonardo da Vinci (1452~1519) was known especially for his interest in man and nature. He kept a notebook of detailed drawings of the things he saw. He even studied human bones and muscles in order to draw people better. He was a scientist, an engineer, and an artist, all in one. The Leonardo drawing shown in this lesson is a good example of his careful study of every detail.

Two of Leonardo's most famous paintings are "The Last Supper" and "The Mona Lisa". The first is in Milan, Italy, and the second in Paris, France. They have been studied carefully by lovers of art from all over the world.

Although Leonardo will live forever through his paintings, he is equally well-known for his scientific ideas and inventions. Some of these included drawings for a flying machine and a machine gun. Some drawings predicted the coming of propellers and helicopters.

A curious fact about this artist was that he wrote his notes backwards. He then read them in a mirror.

The Last Supper

The Mona Lisa

Journey of the Magi

Translation

十 五 世 纪 艺 术

　　数百年来，教堂一直是欧洲最重要的建筑。艺术家们所有的工作就是装饰这些伟大的建筑物。我们甚至不知道这些艺术家的名字。

　　随着城市越来越大，交通越来越发达，一些市民变得更加富有。他们希望有更好的生活和工作的环境。艺术家们除了教堂之外，也开始设计和装饰这些生活建筑。由于人们常常是以名气来决定请哪位艺术家，所以艺术家们开始在作品上标示出自己的名字。

　　美地奇家族，是意大利佛罗伦萨的一个非常富有且有名望的家族，雇佣了很多艺术家

为其服务。其中之一，贝纳佐·戈佐利，绘了一幅名为"三圣贤之旅"的壁画。壁画是在趁墙上的灰泥还未干时直接在其上绘画。

虽然这幅壁画的主题是宗教，但是画得却是穿着豪华服装的美地奇家族。艺术家们仍坚持只画宗教题材，但是我们从这幅壁画中可以看出他们开始对周围的世俗生活感兴趣。

里奥纳多·达·芬奇以其对人类和自然的兴趣而闻名。他坚持用一本笔记本详细绘下他所见到的一切。他为了将人画得更好，甚至研究人类骨骼和肌肉。他集科学家、工程师、艺术家于一身。这一课所展示的里奥纳多绘画就是他仔细研究每一个细节的很好说明。

里奥纳多最著名的两幅画是"最后的晚餐"和"蒙娜丽莎"。"最后的晚餐"收藏在意大利的米兰，"蒙娜丽莎"收藏于法国的巴黎。全世界的艺术爱好者都对这两幅画进行过研究。

里奥纳多的绘画很出名，而他的科学理念和发明也很出色，其中有飞行器和机械枪支的设计图。一些图纸预示了螺旋桨和直升机的出现。

有趣的是，这位艺术家从后向前倒着记录笔记。他通过镜子来读这些笔记。

Art After The Renaissance

The art of the Renaissance is orderly and calm probably because the times were orderly. Art usually shows something about the period of history in which it was made.

Soon the times became less calm. The powerful Roman Catholic Church split, and the Protestants also became powerful. Great arguments began as to which group was right, and people everywhere argued and fought over their religion. These struggles and changes began to affect artist's works, too.

For one thing, artists had become so good at using their tools, that this skill became an end in itself. Sculptors tried to make more difficult carvings, painters tried to show how great their skills were, and architects invented daring ways of building. These styles in art are called Mannerism and Baroque.

The Church of St. Charles of the Four Fountains in Rome was purposely built off-center in balance. Its architect, Francesco Borromini, made its outer and inner walls seem to curve and twist and turn right before your eyes. Some people feel a kind of swaying motion as they look at them. The curving decorations and walls make an exciting pattern of dark and light because of their shadows.

Painters also tried to get this kind of feeling into their art. Tintoretto used dramatic darks and lights in his painting, "The Last Supper" He also used asymmetry; the most important figures are at the sides, rather than in the center. This arrangement and the gestures of the people cause one's eyes to shift back and forth and up and down as one looks at it. The angels seem to be leaving the painting, which causes a flowing movement upward. The lighting and colors are mysterious. Everything combines to make a feeling of excitement that was not seen in the paintings of the Renaissance.

Tintoretto The Last Supper

The Church of St. Charles of the Four Fountains in Rome

Translation

文艺复兴后艺术

　　文艺复兴时期艺术是有条理的和平静的。可能因为这个时代就是强调秩序性的。艺术常常展现出绘成画作的历史时期的某些方面。

　　很快时代变得不再平静。强大的罗马天主教分裂了,新教变得强大。就哪一派是正确

的这个问题产生了激烈的争论，人们都在为了自己的信仰相互争斗。这些斗争和改变也开始影响到艺术家的作品。

一方面。艺术家变得如此善于使用工具，这一技能也终结了自身。雕塑家费尽心机地创造更有难度的雕塑，画家努力表现自己的绘画技能多么高超，建筑师发明了大胆的建筑风格。人们称之为矫饰主义和巴洛克。

罗马四喷泉圣卡罗教堂在设计时有意产生一种偏离中心的平衡。设计它的建筑师，弗兰西斯科·波洛米尼，将室外和室内的墙设计为扭曲的，并在你的眼前具有向右的动势。有些人在看到这座教堂时能感到建筑在左右摇摆。曲线动态的装饰和墙面产生了强烈的光影效果。

画家也尝试将这种手法加入到他们的绘画中。丁托列托在他的绘画中创造了戏剧化的光影效果。"最后的晚餐"中，他也使用了不对称的手法；最重要的人物被放在了边缘，而不是中心。人物的位置和姿势使人们在观看这幅画时视线从前到后、从左到右不断移动。天使们似乎马上要离开画框，产生了向上的动势。画中充满了神秘的光线和色彩。所有一切产生了以往文艺复兴时期绘画所没有的强烈感受。

Abstract And Expressionistic Art

Painters of our own times have become less concerned with painting real things than were artists of long ago. They are more interested in painting to show their feelings about things. When they do this with art that doesn't have any objects in it, we call these paintings abstract or non-objective. Abstract art uses color, line, shape, texture, and dark and light to show ideas; there are no figures in it. Expressionistic art uses objects that can be recognized, but they are changed to show the artist's feelings. The shaped of the objects can be changed, they may overlap strangely, or they may be missing certain parts.

Piet Mondrian, a Dutchman, painted abstract works. Some of his works use only horizontal and vertical lines, with shapes and carefully chosen colors, to make an exciting, original painting.

Jackson Pollock was an American painter who worked by splashing and dribbling paint on canvas. He is well-known for this method of painting both here and in Europe.

Jean Rene Bazaine is a French painter who uses rich, softened colors arranged in a strong, flowing way. While it may appear very free in its desigh, his work has been carefully thought out. Bazaine's "Dawn" is a good example of what is sometimes called abstract-expressionism. Can you think of why his painting can be thought of as both abstract and expressionistic? What do you feel when you look at it?

Try to make an abstract painting. Think of a subject in colors, lines, shapes, and textures. Don't draw it; just paint how you feel about it.

Piet Mondrian

Jean Rene Bazaine Jackson Pollock

Translation

抽象艺术和表现主义艺术

我们这个时代的画家已经变得不再如很久以前的画家那样关注真实的事物。他们对展现自己对于事物的感受更感兴趣。在他们的艺术作品中不再有任何实际对象，我们称这种类型的绘画为抽象的或非客观的。抽象派用色彩、线条、形体、质感和明暗来展现理念，却没有实物。表现主义艺术使用可被认知的物体，但是却加以改变以表现艺术家的感受。物体的形体被加以改变，它们可能很奇怪地相互重叠，或缺少某一部分。

蒙得里安，荷兰人，抽象派画家。他的一些作品仅仅用水平线和垂直线，通过形体和仔细选择的色彩来创造令人兴奋的、具有创造性的绘画。

杰克森·波洛克是位美国画家，他将颜料飞溅和滴落在画布上而绘成一幅画。他以这种绘画方式而闻名。

尚·勒内·巴赞是法国画家，他通过丰富、柔软的色彩产生强烈、流动的效果。虽然看起来他的绘画非常随便，实际上却是经过仔细的思考。巴赞的"黄昏"是抽象-表现主义很好的范例。你能想到为什么他的绘画被认为既是抽象的又是表现主义的？当看他的画时会有怎样的感受？

尝试画一幅抽象画。思考一个物体的色彩、线条、形体和质感。不要画它实际的样子；只画你对它们的感受。

Part Ⅱ Basic Theory

Intensive Reading

Lesson 5 The Role of the Landscape Designer

Landscape design is an unusual profession, mixing as it does both the arts and the sciences. Landscape designers are holistic, working with both poles of human culture, the practical and analytical as well as the artistic and innovative.

Landscape designers can have an immense impact on our lives, improving the richness and beauty of our surroundings. The landscape practitioner should be able to take ideas, whims, impressions, feelings and notions and convert them into reality in "bricks and plants" The landscape designer is, however, working with someone else's land and someone else's money.

There are many elements to consider in landscape design, such as function, materials, aesthetics and context. Functions, such as the provision of shelter, privacy, security and even delight, must be provided for. Materials, used to achieve these aims, might be planting, paving bricks and slabs, stonewalls, iron railings, water and so on. Aesthetics is about the principles of composition and beauty. Context is a term used to describe the circumstances of the site.

The subject of landscape design is a massive one, requiring knowledge about many related subjects, it also requires the social skills to deal with both the client and the contractor, as well as statutory authorities and technical experts. Landscape design involves detailed data collection and assessment, it pays regard to the utility, durability and aesthetics of the proposed landscape. Furthermore, much attention must be given to the overall co-ordination of the design elements to create a unified whole. The landscape designer must consider the fourth dimension too: the change or evolution of the scheme through time. Time is an important consideration to a new living landscape, which is likely to require both management and maintenance to reach a satisfactory maturity.

Designing effectively for people's many and diverse needs demands a wide palette of knowledge and a landscape designer may find it beneficial to have some knowledge of horticulture, civil engineering, history, architecture, botany, geography, geology, soil science, meteorology, aesthetics, graphics, psychology and sociology, and a working knowledge of the uses and construction techniques for materials such as stone, water, wood, concrete, brick and metal.

All landscape practitioners have a professional responsibility to act in the best interest

of their client, that is to say they have a duty of care to act as the client's adviser, and based on a thorough assessment of the client's requirements. If the designer is commissioned to provide an administrative role during a contract between client and landscape contractor, then there also exists a duty for the consultant to act fairly between these two parties.

Furthermore, it is vital that the designer gleans all the relevant information about the site itself, the client's needs and indeed the client's budget. This will be achieved both by direct liaison with the client and by a full site examination and assessment. Client liaison will be successful only where it is possible to build a relationship of trust and goodwill.

Inevitably with a subject so vast there are specialist areas requiring specialist training, including the disciplines of both landscape managers (who possess a greater expertise in specifying maintenance and management practices and works) and scientists (who specialize in analyzing and providing data on soils, plant and animal communities and other ecological and environmental factors). Above all, good landscape designers know how to source the specialist information that they require quickly, accurately and efficiently. Getting on with other people and having an effective chain of contacts is a great asset to a landscape designer whose work touches so many disciplines.

Notes

1. Landscape Architecture and Landscape Design　景观建筑学和景观设计
Landscape architecture　景观建筑学

Landscape architecture involves the investigation and designed response to the landscape. The scope of the profession includes architectural design, site planning, environmental restoration, town or urban planning, urban design, parks and recreation planning. A practitioner in the field of landscape architecture is called a landscape architect.

Fig. 5-1　Central Park, like most city parks, is an example of landscape architecture

景观建筑学包括针对景观的调研和设计。专业领域涵盖建筑设计，基地设计，环境恢复，城镇或城市规划，城市设计，公园和休闲空间设计。景观建筑学领域的从业者被称为景观建筑师。

Landscape architecture is a multi-disciplinary field, which includes: geography, mathematics, science, engineering, art, horticulture, technology, social sciences, politics, history, philosophy and more recently, ecology. The activities of a landscape architect can range from the creation of public parks and parkways to site planning for corporate office buildings, from the design of residential estates to the design of civil infrastructure and the management of large wilderness areas or reclamation of degraded landscapes such as mines or landfills.

景观建筑学是一个多学科领域，包括：地理学、数学、科学、工程学、艺术、园艺学、技术、社会科学、政治、历史、哲学，还有最近的生态学。景观建筑师的活动范围可以从公共公园和绿地的设计到办公建筑群的基地设计，从居住区的设计到城市基础设施的设计和大型野生区域的管理，又或者是被破坏景观的恢复，比如矿井或垃圾填埋场。

The breadth of the professional task that landscape architects collaborate on is very broad, but some examples of project types include：

需要景观建筑师合作的专业领域范围是非常广泛的，典型范例包括：

- The planning, form, scale and siting of new developments；
- 新发展区域的规划、形式、尺度和位置；
- Civil design and public infrastructure；
- 城市设计和公共基础设施设计；
- Stormwater management including rain gardens, green roofs and treatment wetlands；
- 洪水控制，包括雨水花园、屋顶花园和湿地；
- Campus and site design for institutions；
- 校园和机构的基地设计；
- Parks, botanical gardens, arboretums, greenways, and nature preserves；
- 公园、植物园、树木园、绿地和自然保护；
- Recreation facilities like golf courses, theme parks and sports facilities；
- 休闲娱乐设施，像高尔夫球场、主题公园和运动设施；
- Housing areas, industrial parks and commercial developments；
- 居住区、工业园和商业发展区；
- Highways, transportation structures, bridges, and transit corridors；
- 高速公路、交通构筑物，桥梁和交通廊道；
- Urban design, town and city squares, waterfronts, pedestrian schemes, and parking lots；
- 城市设计、城镇和城市广场、滨水空间，步行区和停车场；
- Large or small urban regeneration schemes；
- 大型或小型城市再生设计；
- Forest, tourist or historic landscapes, and historic garden appraisal and conservation studies；
- 森林、旅游区或历史景观，以及历史花园的评定和保护研究；
- Reservoirs, dams, power stations, reclamation of extractive industry applications or major industrial projects；
- 蓄水池、水坝、发电站，耗费资源的工业设施或重要的工业建设项目；
- Environmental assessment and landscape assessment, planning advice and land management proposals；
- 环境评估和景观评估，规划建议和土地管理方案；
- Coastal and offshore developments；

- 海岸和滨海区域的发展；
- Ecological Design any form of design that minimizes environmentally destructive impacts by integrating itself with living processes.
- 任何形式的生态设计，这些设计通过以天然过程整合设计将环境破坏影响降至最低。

Landscape design 景观设计

Landscape design is similar to landscape architecture. Landscape Design focuses more on the artistic merits of design, while Landscape Architecture encompasses the artistic design as well as structural engineering. Landscape design and Landscape Architecture, both take into account soils, drainage, climate and other issues, because the survival of selected plants depends on those. Landscape Architecture may require a license depending on the country and region. Landscape designers may be required to have a license, depending on the level and detail in the design plan, as well as the location. The establishment of landscape plants over a period of time is not landscape design, but is considered "landscape management". Landscape design is almost synonymous with garden design. Landscape architecture and landscape design can, and should, embrace garden design, landscape management, landscape engineering, landscape detailing, landscape urbanism, landscape assessment and landscape planning.

景观设计类似于景观建筑学。景观设计更注重设计的艺术品质，而景观建筑学强调艺术设计也强调结构工程。景观设计和景观建筑学，都涉及土壤、排水、气候和其他问题，因为所选择植被的生存依赖于那些问题。景观建筑学可能要求获取职业资格，这取决于国家和地区的规定。景观设计师也被要求获取职业资格，这取决于设计的等级和细节，以及位置。一段时间内景观种植并不属于景观设计，而被认为是"景观管理"。景观设计几乎是造园设计的同义词。景观建筑学和景观设计能够，而且也应该，包含造园设计、景观管理、景观工程、景观细节、景观城市设计、景观评估和景观设计。

Practically speaking, landscape architecture and landscape design are almost one in the same, if done properly according to the science, knowledge and skill. Some Landscape Designers are licensed Landscape Architects. Sometimes, professionals must call themselves "Landscape Designers" because local laws and rules prevent advertising as "Landscape Architects" without that level of license.

事实上，如果就科学、知识和技能进行恰当处理的话，景观建筑学和景观设计几乎是同义词。一些景观设计师就有景观建筑师的资格。有时，这些专家必须将他们自己称为"景观设计师"，因为当地法律法规不允许在没有职业资格的情况下宣称自己为"景观建筑师"。

In the landscape design profession, "Landscape Architecture" is generally the name of the more advanced level of college education pertaining to landscape design.

景观设计教学中，"景观建筑学"一般是附属于景观设计的更高级的学院教学层次。

2. Landscape Designer 景观设计师

Bernard Tschumi 伯纳德·屈米

Bernard Tschumi (born January 25, 1944 Lausanne, Switzerland) is an deconstructivist

architect, writer, and educator. He works and lives in New York and Paris.

伯纳德·屈米(1944 年 7 月 25 日生于瑞士洛桑)是解构主义建筑师、作家和教育家。他在纽约和巴黎生活和工作。

Since the 1970s, Tschumi has argued that there is no fixed relationship between architectural form and the events that take place within it. The ethical and political imperatives that inform his work emphasize the establishment of a proactive architecture which engages balances of power through programmatic and spatial devices. In Tschumi's theory, architecture's role is not to express an extant social structure, but to function as a tool for questioning that structure and revising it.

Fig. 5-2 Bernard Tschumi

从 20 世纪 70 年代开始，屈米就提出建筑形式与建筑内部发生的活动之间没有明显关系。他的作品所表达的道德和政治规则强调一种积极建筑的建立，这种建筑通过项目和空间设计形成了权力的平衡。在屈米看来，建筑的角色并不是表达现有的社会结构，而是作为对现有结构提出疑问和修改的工具。

Tschumi's winning entry for the 1982 Parc de la Villette Competition in Paris became his first major public work. Landscaping, spatial sequences in the park were used to produce sites of alternative social practice.

屈米在 1982 年赢得了巴黎的拉·维莱特公园竞赛，这成为了他首个重要公共作品。在拉维莱特公园设计中，景观和空间序列成为各种社会活动的基地。

Tschumi's critical understanding of architecture remains at the core of his practice today. By arguing that there is no space without event, he designs conditions for a reinvention of living, rather than repeating established aesthetic or symbolic conditions of design. Through these means architecture becomes a frame for "constructed situations," a notion informed by the theory, city mappings and urban designs of the Situationist International.

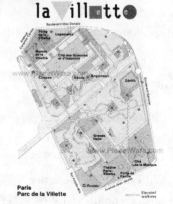

直到今天，屈米的设计核心仍是其对建筑的重要理解。他认为没有活动就没有空间，因此提出了生活重演的设计，而不是重复已建立的设计美学或符号。通过这些方法，建筑成为了"构造环境"的框架，一

Fig. 5-3 Parc de la Villette

种由情境主义国际的理论、城市地图和城市设计来传达的理念。

Mario Schjetnan　马里奥·谢赫楠

Mario Schjetnan is a Mexican architect and landscape architect that manages to "unite social concerns, aesthetics and, increasingly, ecology-all by way of interpreting and celebrating Mexico's rich and diverse culture. "He is co-founder of the interdisciplinary firm Grupo de Diseno Urbano in Mexico City known for designs in which the building is subordinate to the landscape. Among his numerous awards are the Prince of Wales/Green Prize in Urban Design for Xochimilco Ecological Park and the ASLA President's Award for Excellence for Parque El Cedazo.

Fig. 5-4　Mario Schjetnan

马里奥·谢赫楠是一位墨西哥建筑师和景观建筑师，提倡"将社会影响、美学和不断发展的生态相结合——所有一切都通过了解和赞美墨西哥丰富和多样的文化来实现。"他是墨西哥多学科团体 Grupo de Diseno Urbano 的创立人之一，这一团体以建筑从属于景观的设计而著名。在他的无数奖项中，赫霍奇米尔科生态公园获得了威尔士王子城市设计绿色大奖，阿圭斯林特斯城柴达座公园以其优秀的设计获得了的美国景观设计师协会荣誉奖。

Schjetnan was born in 1945 in Mexico City, a climate that gave him an immense appreciation for water that would appear in his later works. His father was an architect, professor and golf course designer while his mother had a degree in history and was interested in literature and theater. His parents' professions helped to inspire his own interests in 20th century modern architecture, pre-columbian myth, and colonial history.

谢赫楠1945 年出生于墨西哥城，那里的气候给予了他对水的极其偏爱，这一切都显示在了他随后的作品中。他的父亲是一位建筑师、教授和高尔夫球场设计师，而他的母亲获得了历史学位，并对文学和戏剧感兴趣。父母的职业帮助他对 20 世纪现代主义建筑、发现美洲之前的神话和殖民地历史产生了兴趣。

Mario Schjetnan views public parks as an expression for environmental justice—an extension of the public housing work he did at INFONAVIT. He works with low budgets, basic materials and modest details while gaining financial and political support by linking public spaces with infrastructure improvement. He acknowledges the importance of landscape to both individual memory and public history by utilizing "critical regionalism": self-reflective adaptation or transformation of both modernist and traditional design languages. The result is a "metropolitan ecology" in which architecture, urbanism, and nature coexist in a dynamic mosaic.

马里奥·谢赫楠将公共公园看作是对环境公正的表达——他在 INFONAVIT（墨西哥工人住宅部）所做的公共居住设计的进一步延伸。他的低预算、原始材料和适度细节的设计，通过将公共空间和基础设施改良联系在一起而获得了财政和政治支持。通过运用"批判性地域主义"（现代主义和传统设计语言自我反省的适应和转变），他认识到景观对于个

体记忆和公共历史的重要性。结果是一种"大都市生态",建筑、城市生活和自然以动态的马赛克共存在城市中。

Ian McHarg 伊恩·麦克哈格

Ian McHarg (November 20, 1920-March 5, 2001) was born in Glasgow, Scotland and became a landscape architect and a renowned writer on regional planning using natural systems. He was the founder of the department of landscape architecture at the University of Pennsylvania in the United States. His 1969 book Design with Nature pioneered the concept of ecological planning. It continues to be one of the most widely celebrated books on landscape architecture. In this book, he set forth the basic concepts that were to develop later in Geographic Information Systems.

Fig. 5-5 Ian McHarg

伊恩·麦克哈格(1920 年 11 月 20 日—2001 年 3 月 5 日)出生在苏格兰的格拉斯哥,最终成为了一名运用自然系统进行地域设计的景观建筑师和著名作家。他是美国宾夕法尼亚大学景观建筑学系的创立者。他 1969 年出版的《设计结合自然》首次提出了生态设计的概念。这本书随后成为了景观建筑学最成功的著作之一。在这本书中,他建立了随后发展为全球地理信息系统的基本概念。

In 1969, he published, *Design with Nature*, which was essentially, a book of step-by-step instructions on how to break down a region into its appropriate uses. McHarg also was interested in garden design and believed that homes should be planned and designed with good private garden space.

1969 年,他出版了《设计结合自然》,从本质上说这本书是在逐步教授人们如何以适合的用途来划分区域。麦克哈格也对花园设计感兴趣,并相信应该以良好的私人花园空间来设计住宅。

McHarg said his book, *Design with Nature* is sharply critical of the French style of garden design, which he saw as a subjugation of nature, and is full of praise for the English style of garden design, which he saw as a precursor of his 'design with nature' philosophy.

麦克哈格在他的《设计结合自然》一书中尖锐地批评了法国花园设计风格,他将其视作对自然的征服,同时对英国花园设计风格大加赞扬,将其视为他的"设计结合自然"哲学的先行者。

McHarg's own plans for urban expansion projects also were more "English" than "French" in their geometry. He favored what became known as 'cluster development' with relatively dense housing set in a larger natural environment.

麦克哈格的城市扩张项目设计也更为"英国化"而非"法国化"的几何学。他欣赏相对较高密度的住宅位于更广阔自然环境中的"丛式发展"。

3. Aesthetics

Asethetics 美学

Aesthetics is commonly known as the study of sensory or sensori - emotional val-

ues, sometimes called judgments of sentiment and taste. More broadly, scholars in the field define aesthetics as "critical reflection on art, culture and nature." Aesthetics is a subdiscipline of axiology, a branch of philosophy, and is closely associated with the philosophy of art. Aesthetics studies new ways of seeing and of perceiving the world.

普遍认为美学是对感官或感官情绪价值的研究，有时称为情感或品味的判断。更广泛地说，该领域的学者将美学定义为"对艺术、文化和自然的批判性反映"。美学是价值论学科和哲学的分支，与艺术哲学联系密切。美学研究看待和体验世界的新方法。

Aesthetic judgment 审美

Judgments of aesthetic value clearly rely on our ability to discriminate at a sensory level. Aesthetics examines our affective domain response to an object or phenomenon. Many see natural beauty folded within petals of a rose.

很明确，审美取决于我们感官层次上的区别能力。美学检验我们对一个物体或现象的情感反映。许多人从一枝玫瑰的花瓣中看到了自然的美。

It is not uncommon to find aesthetics used as a synonym for the philosophy of art, although it is also not uncommon to find thinkers insisting that we distinguish these two closely related fields. In practice we distinguish between aesthetic and artistic judgements, one refers to the sensory contemplation or appreciation of an object (not necessarily an art object), while the other refers to the appreciation or criticism of an art work.

使用美学作为艺术哲学同义词的情形非常普遍，虽然思想家坚持我们应该区分这两个紧密相关的领域。在实践中我们将美学和艺术审美区分开来，一个是指对一个问题（而不必是艺术作品）的感官思考或欣赏，而另一个是指对艺术作品的欣赏或批评。

Aesthetic universals 美学共识

The philosopher Denis Dutton identified seven universal signatures in human aesthetics:
哲学家丹尼斯·杜顿列出了人类美学的七个普遍特征：

1. Expertise or virtuosity. Technical artistic skills are cultivated, recognized, and admired.

专业知识或鉴赏力。经过培养、认识和期望的技术性艺术技巧。

2. Non-utilitarian pleasure. People enjoy art for art's sake, and don't demand that it keep them warm or put food on the table.

非功利性的愉悦。人们为了艺术而欣赏艺术，不要求它保持温暖或提供食物。

3. Style. Artistic objects and performances satisfy rules of composition that place them in a recognizable style.

风格。艺术品和工作满足构成规则，将其置于一种可识别的风格中。

4. Criticism. People make a point of judging, appreciating, and interpreting works of art.

批评。人们可以形成判断、欣赏和理解艺术作品的观点。

5. Imitation. With a few important exceptions like music and abstract painting, works of art simulate experiences of the world.

模仿。除了一些重要的例外情况以外（像音乐和抽象绘画），艺术品模拟世界中的体验。

6. Special focus. Art is set aside from ordinary life and made a dramatic focus of experience.

特殊的焦点。艺术将日常生活放在一边，创造出体验的戏剧化焦点。

7. Imagination. Artists and their audiences entertain hypothetical worlds in the theater of the imagination.

想象。艺术家和他们的听众沉浸在充满想象力的虚拟世界中。

4. horticulture, civil engineering, history, architecture, botany, geography, geology, soil science, meteorology, graphics. 园艺学、土木工程学、历史学、建筑学、植物学、地理学、土壤学、气象学、图形学。

Horticulture 园艺学

Horticulture is the art and science of plant cultivation. **Horticulturists** work and conduct research in the disciplines of plant propagation and cultivation, crop production, plant breeding and genetic engineering, plant biochemistry, and plant physiology. The work particularly involves fruits, berries, nuts, vegetables, flowers, trees, shrubs, and turf. Horticulturists work to improve crop yield, quality, nutritional value, and resistance to insects, diseases, and environmental stresses.

园艺学是研究植物种植的艺术和科学。园艺家从事植物繁殖和种植，作物生产，植物育种和基因工程，以及植物方面的生物化学和生理学领域的工作和研究。工作对象包括水果、浆果、坚果、蔬菜、花朵、树木、灌木和草地。园艺学的工作目的是为了改善作物产量，品质和营养价值，以及抵制虫害、病害和环境压力。

The word **horticulture** is a 17th century English adaptation of the Latin *hortus* (garden) and *cultura* (culture). Horticulture is the art of gardening or plant growing, in contrast to agronomy (the cultivation of field crops such as cereals and animal fodder), forestry (cultivation of trees and products related to them), or agriculture (the practice of farming).

园艺学这个词是在 17 世纪英语将拉丁语 *hortus*（花园）和 *cultura*（文化）结合而成。园艺学是布置花园或植物生长的艺术，与农学（谷类和动物饲料等作物的耕作）、森林学（树木和相关产品的耕种）或是农业（农业耕作的实践）不同。

Horticulture involves eight areas of study, which can be grouped into two sections——ornamentals and edibles:

园艺学包括八个研究领域，这八个领域可以分成两个部分——装饰和食用

- Arboriculture the study and selection, planting, care, and removal of individual trees, shrubs, vines, and other perennial woody plants.
- 树木栽培的研究和选择、种植、照顾，以及单体树木、灌木、藤本植物和其他多年生木本植物的采伐。
- Floriculture (includes production and marketing of floral crops).
- 花卉栽培（包括开花作物的生产和销售）。
- Landscape horticulture (includes production, marketing and maintenance of land-

scape plants).

- 景观园艺学(包括景观植物的生产、销售和维护)。
- Olericulture (includes production and marketing of vegetables).
- 蔬菜栽培(包括蔬菜的生产和销售)。
- Pomology (includes production and marketing of fruits).
- 果树栽培(包括果实的栽培和销售)。
- Viticulture (includes production and marketing of grapes).
- 葡萄栽培(包括葡萄的生产和销售)。
- Postharvest physiology (involves maintaining quality and preventing spoilage of horticultural crops).
- 观赏植物(包括园艺作物的品质维护和防止损害)。

Civil engineering 土木工程学

Civil engineering is a professional engineering discipline that deals with the design, construction and maintenance of the physical and naturally built environment, including works such as bridges, roads, canals, dams and buildings. Civil engineering is the oldest engineering discipline after military engineering, and it was defined to distinguish it from military engineering. It is traditionally broken into several sub-disciplines including environmental engineering, geotechnical engineering, structural engineering, transportation engineering, water resources engineering, materials engineering, coastal engineering, surveying, and construction engineering. Civil engineering takes place on all levels: in the public sector from municipal through to federal levels, and in the private sector from individual homeowners through to international companies.

土木工程学是涉及人工和自然环境的设计、建造和维护的专业工程学科，比如桥梁、道路、隧道、水坝和建筑。土木工程学是军事工程学之后最古老的工程学学科，它的定义也与军事工程学有所不同。传统上将它分为一些分支学科，包括环境工程、土质工程、结构工程、运输工程、水资源工程、材料工程、海岸工程测量和建筑工程。土木工程学在所有层次中出现：如公共方面从城市到整个国家，私人方面从私人业主到跨国公司。

Fig. 5-6 The Archimedes' screw was operated by hand and could raise water efficiently.

History 历史学

History is the study of the past, particularly the written record and oral traditions passed down from generation to generation verbally. New technology, such as photography, sound recording, and motion pictures now complement the written word in the historical record. History is a field of research producing a continuous narrative and a systematic analysis of past events of importance to the human race. Those who study history as a profession are called historians.

历史是对过去的研究，特别是书写下来的记录和口头代代相传的传统。摄影、录音，动画等新技术，现在已经现在成为历史书写记录的补充。历史是对人类以往重要事件进行连续记述和系统分析的研究领域。将研究历史作为职业的人被称为历史学家。

Architecture 建筑学

The term **architecture** (from Greek αρχιτεκτονική, architektoniki) can be used to mean a process, a profession or documentation.

建筑学这个词（来源于古希腊的 αρχιτεκτονική, architektoniki）可用来表示一个过程、一种职业或记录。

Fig. 5-7 Most early history was passed on through oral tradition

Fig. 5-8 Section and elevation of the dome of Florence Cathedral.

As a process, architecture is the activity of designing and constructing buildings and other physical structures by a person or a machine. A wider definition often includes the design of the total built environment, from the macro level of how a building integrates with its surrounding man made landscape to the micro level of architectural or construction details and, sometimes, furniture. Wider still, architecture is the activity of designing any kind of system.

作为一个过程，建筑学是指通过人或机器来设计和建造建筑物以及其他现实构筑物的活动。更宽泛的定义常常包括整个建筑环境的设计，从建筑物和周围人造景观如何融合的宏观尺度到建筑或构筑物细节，有时还包括家具的微观尺度。更宽泛的定义提出，建筑学就是设计任何系统的活动。

As a profession, architecture is the role of those persons or machines providing architectural services.

作为一种职业，建筑学是指那些提供建筑服务的人或机器的角色。

As documentation, usually based on drawings, architecture defines the structure and/or behavior of a building or any other kind of system that is to be or has been constructed.

作为记录，常以绘图为基础，建筑学是指一座建筑物的结构和/或行为，或者任何将

要或者已经建成的其他类型系统。

Architects have as their primary object providing for the spatial and shelter needs of people in groups of some kind (families, schools, churches, businesses, etc.) by the creative organization of materials and components in a land-or city-scope, dealing with mass, space, form, volume, texture, structure, light, shadow, materials, program, and pragmatic elements such as cost, construction limitations and technology, to achieve an end which is functional, economical, practical and often with artistic and aesthetic aspects. This distinguishes architecture from engineering design, which has as its primary object the creative manipulation of materials and forms using mathematical and scientific principles.

建筑师的主要目标是通过基地内(或城市范围内)材料和构成的创造性组织，为一定类型群体(家庭、学校、教堂、商业大楼，等等)提供空间和遮蔽物。建筑师需要处理体量、空间、形式、容积、质感、结构、照明、阴影、材料、规划，以及费用、建造限制和技术等实际问题，而最终得到具有功能性、经济性、可行性，常常还有艺术性和美观性的结果。这一目标就将建筑学与工程设计区分开来，工程设计主要目的是运用数学和科学原则对材料和形式的创造性处理。

Architectural works are perceived as cultural and political symbols and works of art. Historical civilizations are often known primarily through their architectural achievements. Such buildings as the pyramids of Egypt and the Roman Colosseum are cultural symbols, and are an important link in public consciousness, even when scholars have discovered much about a past civilization through other means. Cities, regions and cultures continue to identify themselves with their architectural monuments.

建筑作品被认为是文化和政治的象征，是一件艺术品。历史中的文明常常主要通过它们的建筑成就为人所知。比如埃及金字塔、意大利罗马大斗兽场都是文化的象征，也是公众意识的重要联系，甚至当学者们已经通过其他方式发现许多过去文明的其他成就的时候也是如此。城市、地区和文化继续通过它们的建筑纪念碑标识着自身。

Botany　植物学

Botany is a branch of biology and is the scientific study of plant life and development. Botany covers a wide range of scientific disciplines that study plants, algae, and fungi including: structure, growth, reproduction, metabolism, development, diseases, and chemical properties and evolutionary relationships between the different groups. Botany, the study of plants, began with tribal efforts to identify edible, medicinal and poisonous plants, making botany one of the oldest sciences. From this ancient interest in plants, the scope of botany has increased to include the study of over 550000 kinds or species of living organisms.

Fig. 5-9　*Pinguicula grandiflora*
commonly known as a Butterwort

植物学是生物学的分支，是对植物生命和发育的科学研究。植物学覆盖广泛的研究植物、藻类和菌类的科

学学科，包括：构造、生长、繁殖、新陈代谢、发育、病害和化学特性，以及不同群体之间的进化关系。植物学对植物的研究，从鉴别可食用、有疗效和有毒的植物的努力开始，成为最古老的科学之一。从这种对植物的古老兴趣，植物学的范围扩展到包括对超过 550000 种类或物种的天然有机体的研究。

The study of plants is vital because they are a fundamental part of life on Earth, which generates the oxygen, food, fibres, fuel and medicine that allow humans and other higher life forms to exist. Through photosynthesis, plants also absorb carbon dioxide, a greenhouse gas that in large amounts can affect global climate, they prevent soil erosion and impact the water cycle. Paleobotanists study ancient plants in the fossil record. It is believed that early in the earth's history, the evolution of photosynthetic plants altered the global atmosphere of the earth, changing the ancient atmosphere by oxidation. A good understanding of plants is crucial to the future of human societies as it allows us to:

对植物的研究是至关重要的，因为它们是地球生命的基础部分，它们制造氧气、食物、纤维和药品，人们和其他高层次生命形式因此而存在。通过光合作用，植物还能吸收二氧化碳———一种大量存在的会影响全球气候的温室气体，植物能够阻止水土流失和影响水循环。古植物学通过化石研究古老的植物。人们相信在地球历史的早期，光合植物的演化改变了地球的大气层，而氧化作用也同样改变了远古的空气。对植物的充分理解对于人们社会的未来是至关重要的，因为它让我们能够：

- Produce food to feed an expanding population;
- 生产食物供给不断扩展的人口；
- Understand fundamental life processes;
- 理解基本的生命过程；
- Produce medicine and materials to treat diseases;
- 生产药品和材料来处理疾病；
- Understand environmental changes more clearly.
- 更为清晰地理解环境的改变。

Geography 地理学

Geography is the study of the Earth and its lands, features, inhabitants, and phenomena. A literal translation would be "to describe or write about the Earth". The first person to use the word "geography" was Eratosthenes (276-194 B. C.). Four historical traditions in geographical research are the spatial analysis of natural and human phenomena (geography as a study of distribution), area studies (places and regions), study of man-land relationship, and research in earth sciences. Nonetheless, modern geography is an all-encompassing discipline that foremost seeks to understand the Earth and all of its human and natural complexities———not merely where objects are, but how they have changed and come to be. As "the bridge between the human and physical sciences," geography is divided into two main branches-human geography and physical geography.

地理学是对地球及其土地、特征、居住者和现象的研究。文字上的翻译应该是"描述和书写有关地球的知识"。第一个使用"地理学"这个词的是埃拉托色尼（276-194 B. C. ）。

Fig. 5-10 Map of the Earth

地理学研究的四个基本领域是自然和人类现象的空间研究（地理学作为现象分布研究），领域研究（场所和区域），人类—土地关系研究，以及地球科学研究。此外，现代地理学是所有学科的综合，寻求理解地球和所有人类及自然的复合体——不仅仅是对象在哪里，还有它们如何变成现在的样子。作为"人类和物理科学之间的桥梁，"地理学被分成两个主要分支——人类地理学和物理地理学。

Traditionally, geographers have been viewed the same way as cartographers and people who study place names and numbers. Although many geographers are trained in toponymy and cartology, this is not their main preoccupation. Geographers study the spatial and temporal distribution of phenomena, processes and feature as well as the interaction of humans and their environment. As space and place affect a variety of topics such as economics, health, climate, plants and animals, geography is highly interdisciplinary.

传统上，地理学家被看作制图员及研究场所名称和数量的人。虽然许多地理学家在地名研究和地图学方面都有研究，但这不是他们的主要工作。地理学家所研究的是现象、过程和特征在空间和时间上的分布，以及人类和环境之间的相互作用。由于空间和场所将创造出各种各样的主题，比如经济、健康、气候、植物和动物，所以地理学是一个高度综合的跨学科领域。

Soil science 土壤学

Soil science is the study of soil as a natural resource on the surface of the earth including soil formation, classification and mapping; physical, chemical, biological, and fertility properties of soils; and these properties in relation to the use and management of soils.

土壤学是将土壤作为一种位于地球表面的自然资源来研究的科学，研究内容包括土壤信息，分类和绘图；土壤的物理、化学、生物学和肥力特性；与土壤使用和管理相关的特性。

Sometimes terms which refer to branches of soil science, such as pedology (formation, chemistry, morphology and classification of soil) and edaphology (influence of soil on

Fig. 5-11 Soil science

organisms, especially plants), are used as if synonymous with soil science. The diversity of names associated with this discipline is related to the various associations concerned. Indeed, engineers, agronomists, chemists, geologists, geographers, biologists, microbiologists, sylviculturists, sanitarians, archaeologists, and specialists in regional planning, all contribute to further knowledge of soils and the advancement of the soil sciences.

有时一些土壤学分支，比如 pedology(研究土壤的形成、化学特性、形态和分类)和 edaphology(研究土壤对生物体的影响，特别是植物)，用作 soil science(土壤学)的同义词。这个学科名称的多样性是因为研究关注的侧重点各有不同。事实上，工程师、农学家、化学家、地质学家、地理学家、生物学家、微生物学家、森林学家，卫生学家、考古学家和区域规划的专家，都对土壤的更深入了解和土壤科学的发展做出过贡献。

Meteorology　气象学

Meteorology is the interdisciplinary scientific study of the atmosphere that focuses on weather processes and forecasting (in contrast with climatology). Meteorological phenomena are observable weather events which illuminate and are explained by the science of meteorology. Those events are bound by the variables that exist in Earth's atmosphere. The majority of Earth's observed weather is located in the troposphere.

气象学是对大气层的多学科交叉研究，重点是天气过程和预报(与气候学相比较)。气象学现象是指阐明值得观察的天气事件并用气象科学来解释。那些事件必然是以各种各样形态存在于地球大气层中。在地球上所观察的天气大多位于对流层。

Meteorology, climatology, atmospheric physics, and atmospheric chemistry are sub-disciplines of the atmospheric sciences. Meteorology and hydrology compose the interdisciplinary field of hydrometeorology.

气象学、气候学、大气物理和大气化学都是大气科学的分支科学。气象学和水文学构成了水文气象学的跨学科领域。

Graphics　图形学

Graphics are visual presentations on some surface, such as a wall, canvas, computer screen, paper, or stone to brand, inform, illustrate, or entertain. Examples are photographs, drawings, Line Art, graphs, diagrams, typography, numbers, symbols, geometric designs, maps, engineering drawings, or other images. Graphics often combine text, illustration, and color. Graphic design may consist of the deliberate selection, creation, or arrangement of typography alone, as in a brochure, flier, poster, web site, or book without any other element. Clarity or effective communication may be the objective, association with other cultural elements may be sought, or merely, the creation of a distinctive style.

图形学是一些表面的视学表达，比如墙体、画布、计算机屏幕、纸张或岩石，目的是标示、传达、描述或接受。图形学范例有照片、绘图、艺术线条、图表、图解、印刷品、编号、符号、几何学设计、地图、工程图或者其他图像等等。图形学常常与文本、图解和色彩相结合。图形学设计可能是由印刷品的审慎选择、创造或布置构成，就像是手册、补充目录、海报、网页、或者没有任何其他元素的书籍。图形学的目标是清晰或有效地传达信息，寻求结合其他文化元素，或者仅仅是独特风格的创造。

Graphics can be functional or artistic. The latter can be a recorded version, such as a photograph, or an interpretation by a scientist to highlight essential features, or an artist, in which case the distinction with imaginary graphics may become blurred.

图形学可以是功能性的或艺术性的。后者可能是一种记录版本，比如照片，或者是科学家强调本质特征的解释，或者是一件艺术品，图形的真实与否可能变得不再清晰。

In art, "graphics" is often used to distinguish work in a monotone and made up of lines, as opposed to painting.

艺术方面，"图形"常用来指风格单调和线条构成的作品，为的是和绘画相区别。

5. Assessment 评估

Landscape should be recognized as a resource and is therefore a variable to be considered in land use decisions. When evaluating landscapes one should use an interdisciplinary approach, communicate with other evaluators and, importantly, recognize the academic respectability of the elementary.

应该将景观作为一种资源来加以认识，因此它是在土地使用决策中需要考虑的变量。当评价景观时，一个人应该使用多学科交叉的方法，与其他评估者合作，重要的是认识到初步工作的学术价值。

A method of landscape assessment, linking description, classification, analysis and assessment, will provide an integrated framework within which decisions on land use management and advice can be debated. One of the biggest problems in developing quantitative assessment methods is that of measuring the contributions of specific landscape elements to overall preference.

景观评价和描述、分类、分析与评估一起，将提供一个整体性的框架，在这个框架内就可以讨论土地使用管理的决策和建议。发展定量评价方法的最大问题之一就是判定特定景观元素对于整体特性的重要程度。

During the late 1960's through to the 1970's, there was an emphasis in landscape assessment to produce "objective" and quantitative methods of attaching a numerical value for the "subjective" responses to aesthetic or scenic quality. These methods were developed to act as evaluative tools to enable an assessment to be repeated by different observers, or carried out in different areas and still produce comparable results that is they were expected to give reliable and consistent information about the observers' responses to landscape quality.

在 20 世纪 60 年代后期到 70 年代，在景观评价中强调创造 "客观的" 和定量的方法，对美或景色品质的 "主观" 反映进行一种数字评定。这些方法被认为是可以被不同观察者重复使用的，或者在不同领域都成立的评价工具，并将创造出可比较的结果，人们期望它们能给予可靠的和一致的有关观察者对景观特性反应的信息。

Unwin (1975) describes three phases of landscape assessment.

昂温(1975)描述了景观评估的三个阶段：

- Landscape measurement: an inventory of what actually exists in the landscape;
- 景观测量：为真实存在于景观中的事物编制目录；
- Landscape value: an investigation and measurement of value judgments or prefer-

ences in the visual landscape;

- 景观评估：对视觉景观的价值判断或偏好的调查和测量。
- Landscape evaluation：an evaluation of the quality of the objective visual landscape in terms of individual or societal preferences for different landscape types.
- 景观评价：根据不同景观类型的个体或社会背景，对客观的视觉景观品质进行评价。

Landscape assessment methods　景观评价方法

Numerous techniques of landscape assessment have been devised in recent years. They form a spectrum in which the extremes are represented on the one hand by techniques based unequivocally on the subjective assessments of landscape quality by individuals or groups and on the other by techniques using physical attributes of landscape as surrogates for personal perception.

最近几年提出了无数的景观评价方法。它们形成了一个系列，而两个极端表现在：一方面是明确基于个人或群体对景观特性的主观评价，另一方面使用景观的物理属性作为个人概念的代替品。

Landscape assessment　景观评估

Landscape assessment is a sub-category of environmental assessment（or EIA）concerned with quality assessment of the landscape. Landscape quality is assessed either as part of a strategic planning process or in connection with a specific development which will have an impact on the landscape.

景观评估是环境评估(或 EIA)中关注景观特性评估的一支。景观特性评估或者作为总体规划过程的一部分，或者与影响景观的特定发展相联系。

The term'landscape assessment'can be used to mean either：

"景观评估"意味着：

- *visual* assessment. This would look at the nature and extent of visual impacts and qualities relating to locations and proposals.
- 视觉评估。将审视有关地域和方案的视觉影响和特性的本质和范围。
- *character* assessment. This includes assessments of each aspect of the landscape：geology,hydrology,soils,ecology,settlement patterns,cultural history,scenic characteristics,land use etc. It typically includes distinct descriptive and evaluative components.
- 特征评估。景观各个方面的评估：地质、水文、土壤、生态、居住模式，文化历史、景观特性，土地使用等等。一般包括明确的描述性和评价性内容。

Vocabulary

1. **immense** *adj*. ①极大的；巨大的：an immense territory 广大的领土　*n*. ①广大；巨大；无限；无际：the dark immense of air 黑暗无边的天空

［近义词］enormous,gigantic,great,huge,large,massive,monumental,tremendous,vast　*adj.* 巨大的

［辨析］**immense** 巨大的：指各方面都极大，非一般标准所能衡量。

The distance between the earth and the sun may be said to be immense. 太阳和地球间的距离可以说是巨大的。

vast 广大的：通常指范围的巨大。

There is a vast expanse of desert in Sinkiang. 新疆有一片广阔的沙漠。

gigantic 巨大的：指有如巨人一般巨大。

He has a gigantic appetite and eats gigantic meals. 他的食量很大，能吃很多东西。

enormous 巨大的：指超出比例的、异常的和过分的巨大。

The fat man in the circus is enormous. 马戏团里的那个胖子太胖了。

huge 巨大的：通常指体积的巨大。

I saw a huge dog in the street. 我在街上看到一条很大的狗。

2. practitioner　*n.*　①专业人员，老手　②（律师，医生）开业者：a general practitioner 全科医生　③从事者；实践者：pedagogical practitioner 教育实践家

3. composition　*n.*　①作文（法），作诗（法），作曲（法），作品，文章，乐曲，文体，措辞：to write a composition 写作文　②编制，结构，构造，组成，组织，成分，合成物：Scientists study the composition of the soil. 科学家研究土壤成分。③素质，性格：He has a touch of madness in his composition. 他在素质上有点神经病。④结构；构图；布置，布局：a painting masterful in composition 布局巧妙的绘画

［近义词］writing, work, paper, document, script, article, essay, dissertation, theme, thesis, treatise　*n.*　作文，习作

music, musical composition, musical pieces　*n.*　乐曲

structure, construction, formation, constitution, fabric, form, systemization, organization, mechanics　*n.*　组成，结构

4. subject　*n.*　①（谈话，论文，文章等的）主题，题目；问题：a subject of conversation 谈话的主题　②学科，科目：the main subject in our school curriculum 我们学校课程中的主要科目　③主旨，主人翁　④原因，理由：a subject for complaint 抱怨的理由　*adj.*　①受……支配的，附属的：subject to the law of the land 受国家法律管辖的　②易受［遭，患］……的，动不动就……的：be subject to damage 易受损伤

［近义词］vulnerable, open, liable, prone, exposed, in danger of　*adj.*　易遭受……的

under the control of, ruled by, in the power of, bound theme, topic, issue, concern, gist, subject matter, point at issue　*n.*　主题，题目

［辨析］**subject** 题目：普通的用词。

We are the subject of their conversation. 我们是他们谈话的主题。

theme 题目：指文章、演说等的题目。

"Patriotism" was the speaker's theme. 这演讲者的题目是"爱国主义"。

topic 题目：指用于与当时事件或问题有关的题目。

Newspapers discuss the topics of the day. 报纸讨论时事问题。

5. diverse　*adj.*　①不同的；相异的：diverse interests 不同的兴趣　②形形色色的，多种多样的：diverse interpretations of these ideas 对这些思想所作的多种多样的解释

［近义词］assorted, different, manifold, many, miscellaneous, numerous, several, sundry, various, varied, multiform *adj.* 多变化的

various, different, unkike, distinct, dissimilar, disparate, divergent, distinctive, peculiar, individual *adj.* 不一样的

［辨析］**diverse** 不同的：指性质和种类上的显著不同。

The word is now used in a sense diverse from the original meaning. 这字现在的用意与最初的意义明显不同。

various 不同的：指各式各样的。

Men's tastes are various. 人们的嗜好是各式各样的。

different 不同的：普通的用词。

His second book is different from his first. 他的第二本书和第一本书不同。

Sentence

Landscape designers can have an immense impact on our lives, improving the richness and beauty of our surroundings. The landscape practitioner should be able to take ideas, whims, impressions, feelings and notions and convert them into reality in "bricks and plants".

景观设计师对我们的生活产生极大的影响，改善了周围环境的丰富性和美观性。景观师能够提出观点、奇思妙想、概念、感受和想法，并把它们转换为现实中的"砖头和植物"。然而，景观设计师其实是在与某些人的土地和金钱打交道。

Furthermore, much attention must be given to the overall co-ordination of the design elements to create a unified whole. The landscape designer must consider the fourth dimension too：the change or evolution of the scheme through time. Time is an important consideration to a new living landscape, which is likely to require both management and maintenance to reach a satisfactory maturity.

此外，更重要的是将各设计元素进行整合以创造出统一的整体。景观设计师也必须考虑第四维尺度：时间所造成的设计改变和发展。时间对于新建成的景观来说是一个非常重要的考虑因素，新的景观很可能需要进行管理和维护，以达到令人满意的效果。

Furthermore, it is vital that the designer gleans all the relevant information about the site itself, the client's needs and indeed the client's budget. This will be achieved both by direct liaison with the client and by a full site examination and assessment. Client liaison will be successful only where it is possible to build a relationship of trust and goodwill.

此外，至关重要的是，设计师要收集所有与基地本身、业主需要和实际预算相关的信息。这可以通过直接与业主交流和全面的基地调研来获得。与业主的交流只能在建立信任和良好意愿的基础上才能实现。

Above all, good landscape designers know how to source the specialist information that they require quickly, accurately and efficiently. Getting on with other people and having an effective chain of contacts is a great asset to a landscape designer whose work touches so many disciplines.

总之，好的景观设计师知道如何快速、准确和有效地获得所需要的专业信息。与其他人合作并保持有效联系是一位景观设计师在接触如此多专业学术门类时最宝贵的财富。

Translation

第 5 课　景观设计师的角色

景观设计是一个不同寻常的职业，融合了艺术与科学。景观设计师是综合性的工作，要研究人类文明、实践和解析学，以及美学和创新这两个完全相反的极端。

景观设计师对我们的生活产生极大的影响，他们改善了周围环境的丰富性和美观性。景观设计师能够提出观点、构思、概念、感受和想法，并把它们转换为现实中的"砖头和植物"。然而，景观设计师其实是在与某些人的土地和金钱打交道。

在景观设计中需要考虑很多因素，比如功能、材料、美学和项目背景。功能，比如提供遮蔽性、私密性、安全性以至所必须提供的光照。材料，是用来达成这些目的，也许是植被、铺地砖和板材、石墙、铁栏杆、水等等。美学是有关构成和美观的原则。项目背景是用来描述基地的周围环境。

景观设计这一学科所包含的范围非常广泛，需要掌握许多相关学科的知识，景观设计师也要有处理与客户和承建者，以及相关部门和技术专家之间关系的社会技能。景观设计包括详细资料的收集和评价，需要考虑景观方案的实用性、持久性和美观性。此外，更重要的是将各设计元素进行整合，以创造出统一的整体。景观设计师也必须考虑第四维尺度：时间所造成的设计改变和发展。时间对于新建成的景观来说是非常重要的考虑因素，新景观很可能需要进行管理和维护，以达到令人满意的效果。

针对人们众多不同需要进行设计，景观设计师就要有将广泛的知识相互融通的能力。他们会发现，掌握一些园艺、市政工程、历史、建筑、植物学、地理学、地质学、土壤学、气象学、美学、图形学、心理学、社会学的知识，以及如石料、水、木材、混凝土、砖和金属等材料的使用和建造技术，对于提高这种能力是非常有用的。

所有景观设计师们都有责任做出最能满足业主要求的设计，这就是说他们有责任对业主的需要进行全方面考量，再提出自己的建议。如果设计师受雇成为业主和景观承建者之间合作的管理者，那么他也有义务成为这两方公正的顾问。

此外，至关重要的是，设计师要收集所有与基地本身、业主需要和实际预算相关的信息。这可以通过直接与业主交流和全面的基地调研来获得。与业主的交流只能在建立信任和良好意愿的基础上才能实现。

如此广泛的学科，不可避免地就有许多专业领域需要经过专业的培训，包括景观管理学家(负责景观项目的维护和管理工作)和科学家(专门分析和提供有关土壤、植物、动物以及其他生物和环境因素)等学术门类。首先，好的景观设计师知道如何快速、准确和有效地获得所需要的专业信息。与其他人合作并保持有效联系是一位景观设计师在接触如此多专业学术门类时最宝贵的财富。

Lesson 6　Hard Landscape Design

Hard landscape simply means brick or slab paving, timber fencing, metal railings, structures and any other non-living external landscape element.

Once the initial design layout has been completed and approved by the client, the designer can then begin to work out the detailed choice and arrangement of fencing types, walling, paving pattern, edging and street furniture. Some of the early detailed hard landscape design may be carried out before working drawings are commenced, because it is often important to know, for example, the fencing types, wall design and the paving patterns required, even at the sketch design stage. Just like the initial design stage, the starting point for choosing and detailing hard landscape elements must take account of the context and mood of both the general area and of the immediate site.

The character of a place is defined by the relative proportion of hard elements (such as dwellings and other buildings) to soft elements (such as farm land). Recreational space and street furniture are all indicative of these character definitions. It can be useful to pin down such contexts when choosing materials in order to avoid specifying inappropriate ones, which then look incongruous on site. Metal detailing may look very smart in an urban area but appear brutal in a rural and rustic setting.

Listed below are some of the indicator factors that define the more measurable landscape contexts, so that the right decisions can be made on choice of hard landscape detailing. The character and choice of various hard elements and street furniture will vary widely between the following contextual categories. For example, a railing chosen for a country house or market town might well be the curved top continuous bar railing, which is often found around paddocks in such areas; in the inner city, railings might vary between traditional vertical bar railings with ornate finials to modern architectural metalwork in its various forms.

Urban

- High proportion of hard space;
- High density of buildings;
- High quantity of shops, financial centres, public buildings and offices;
- High quantity of street furniture;
- High proportion of public space and low quantity of private outside space;
- Low quantity of agricultural activity.

Rural

- Low proportion of hard space;
- Low density of buildings;

- Low numbers of shops, offices, financial centres, public buildings;
- Low quantity of street furniture;
- Low proportion of public space and high quantity of private land;
- High quantity of agricultural activity.

Suburban

- Medium proportion of hard space;
- Medium density of buildings; a few shops, but low numbers of public/Financial buildings and offices;
- Medium amount of street furniture;
- High quantity of private land but some public space;
- Low to medium agricultural activity; some paddocks.

This simplification of the subject can act as a rough guide. For a more subtle assessment of context and mood, the individual landscape designer must rely on more subjective findings. Often, though, such assessments which precede hard landscaping decisions cannot be undertaken in isolation, but are formed by a consensus of local planning officers, conservation officers, architects, local residents, councilors and members of professional advisory bodies such as English Heritage, the Countryside Commission and so on.

Notes

1. Hard Landscape

The term **hard landscape** is used by practitioners of landscape architecture and garden design to describe the construction materials which are used to improve a landscape by design. The corresponding term *soft landscape* is used to describe plant materials. A wide range of hard landscape can be used, such as brick, gravel, stone, concrete, timber, bitumen, glass, metals, etc. For the designer, it is important to choose hard landscape products and materials which "go together"——as must be done for interior design, architecture, fashion design and other categories of design. "Hard landscape" can also describe outdoor furniture and other landscape products.

景观建筑学和造园设计的从业者使用硬质景观这个概念来描述通过设计改善一处景观的建筑材料。与之相对应的概念软质景观，用于描述植物材料。可使用的硬质景观的范围很广，比如砖、砾石、岩石、混凝土、木材、沥青、玻璃、金属，等等。对于设计师来说，选择"相互融合"的硬质景观产品和材料是很重要的——就如室内设计、建筑设计、时尚设计和其他类型设计所做的一样。"硬质景观"也可以用来描述室外家具和其他景观产品。

The key to incorporating hard landscaping successfully into the design is to consider all the elements——hard and soft——in relation to each other and never losing sight of the wider plan or how they all need to fit together. The overall landscape design may make some choices simple; the informal look of a picket fence or rustic rose-arch, for instance, is never going to sit happily in an otherwise entirely "formal" environment.

在设计中成功融合硬质景观的关键是考虑所有的元素——硬质或软质——相互之间的关系，并且从不忽视更宽泛的设计或者是它们怎样才需要相互适合。整体景观设计可能做出一些简单的选择。例如，栅栏或乡村蔷薇拱廊的日常生活外观，绝不会在完全不同的"正式"环境中会显得合适。

Avoiding clashes of this kind with your selection of hard landscaping structures and materials is one of the most important principles to bear in mind. Get your choice right and it will feel perfect——although almost no one will notice; get it wrong and everyone will, even if they cannot quite put their finger on why.

避免这种硬质景观结构和材料选择相互冲突是头脑中要时时浮现最重要的原则之一。做出正确的选择，就会感觉非常完美——虽然几乎没有人将会注意到；做出错误的选择，每个人都将注意到，即使他们没能确切地指出为什么。

2. Paving, Fencing, Railing　铺装，围栏，栏杆

Paving　铺装

Paving may refer to:

Paving 可能是指:

- material, the durable surfacing of roads and walkways ("*road surface*" in British English);
- 铺地（材料），道路和步行通道坚固耐用的表面（在英语中用"*road surface*"）；
- Sidewalk, a walkway along the side of a road, in American English ("*pavement*" in British English and Philadelphia dialect);
- 人行道，在美式英语中指沿着道路一边的步行通道（在英语和费城方言中使用"*pavement*"）；
- architecture, a floor-like stone or tile structure;
- 建筑学，一层地面似的石材或瓦制结构；
- Road surface marking, highway surface markings intended to convey information.
- 道路表面标记，传递信息的高速公路表面标记。

Fig. 6-1　Cobblestone paving in Santarém, Portugal

Fencing　围栏

A **fence** is a freestanding structure designed to restrict or prevent movement across a boundary. It is generally distinguished from a wall by the lightness of its construction: a wall is usually restricted to such barriers made from solid brick or concrete, blocking vision as well as passage (though the definitions overlap somewhat).

围栏是用来限制或阻挡穿越边界运动的独立构筑

Fig. 6-2　A fence in Westtown Township, Pennsylvania

物。一般通过其结构的透光度与墙体相区分：墙体往往局限于指由固体砖或混凝土制成的障碍物，阻挡视野和通路（虽然这两个定义有时相互重叠）。

Fences are constructed for several purposes, including:

建造围栏的目的有许多，包括：

- Agricultural fencing, to keep livestock in or predators out;
- 农业围栏，保持家蓄在其内部或者阻止食肉动物进入；
- Privacy fencing, to provide privacy;
- 私密性围栏，提供私密性；
- Temporary fencing, to provide safety and security, and to direct movement, wherever temporary access control is required, especially on building and construction sites;
- 临时围栏，在任何需要临时入口管理的地方，特别是在建筑物和构筑物基地内，提供安全性和安全感；
- Perimeter fencing, to prevent trespassing or theft and/or to keep children and pets from wandering away;
- 周边围栏，阻止侵入或盗窃，并且/或者让周围的孩子和宠物远离此地；
- Decorative fencing, to enhance the appearance of a property, garden or other landscaping;
- 装饰性围栏，为地产、花园或其他景观的外观增加美观；
- Boundary fencing, to demarcate a piece of real property.
- 边界围栏，划定一块不动产的界限。

Fig. 6-3　Split-rail fencing common in timber-rich areas.

Fig. 6-4　Typical agricultural barbed wire fencing.

Fig. 6-5　Typical perimeter fence with barbed wire on top.

Fig. 6-6　A typical urban fence.

Fig. 6-7 Decorative palace fence

Fig. 6-8 When provided with a railing,
a fence may be an attractive
place for animals to sit

Railing 栏杆

- Guard rail, for safety or support;
- 安全栏杆，为了安全或支撑；
- Handrail, on a stairway.
- 扶手，在楼梯上。

Guard rail 防护栏

Guard rail, sometimes referred to as **guide rail**, is a system designed to keep people or vehicles from (in most cases unintentionally) straying into dangerous or off-limits areas. A handrail is less restrictive than a guard rail and provides both support and the protective limitation of a boundary.

防护栏，有时又叫引导栏杆，是为了让人们或车辆避免（在绝大多数情况下是在无意中）进入危险或禁止进入的区域。扶手比防护栏的限制程度要小，并能提供支撑以及边界的保护性限制。

Most public spaces are fitted with guard rails as a means of protection against accidental falls.
绝大多数公共空间都设有防护栏，作为防止意外坠落的方法。

Fig. 6-9 Fall Prevention Railing
System is suitable
for flat roofs

Fig. 6-10 residential handrail

Examples of this are both architectural and environmental. Environmental guard rails are placed along hiking trails where adjacent terrain is steep. Railings may also be located at scenic overlooks.

在建筑和环境中都有这方面的范例——沿着旅行路线在邻近地形较陡的地方设置环境防护栏。也可能在鸟瞰景观的位置设置护栏。

An architect who was famous for creative use of handrails was Alvar Aalto. The guard rails of an observation tower such as the Space Needle or Eiffel Tower become exaggerated to the point of becoming a fence or cage. This is also done on bridges and overpasses to prevent accidents and suicides.

建筑师阿尔瓦·阿尔托以对扶手的创造性使用而闻名。像太空针塔或是埃菲尔铁塔这些观察塔的防护栏夸大到了变成警戒网或笼子。避免意外或自杀的大桥或天桥上也有这样做的。

Fig. 6-11 A staircase with metal handrails

Handrail 扶手

Handrails are railings used on stairways and escalators. They are designed to be grasped by the hand while ascending or descending the stairs. They are supported by posts or fixed directly to a wall.

扶手是用在楼梯或自动扶梯上的栏杆。它们被用来在楼梯上升或下降时方便手抓。它们由柱体支撑，或由固定物直接钉在墙上。

3. Street Furniture 街道家具

Street furniture is a collective term for objects and pieces of equipment installed on streets and roads for various purposes, including benches, bollards, post boxes, phone boxes, streetlamps, street lighting, traffic lights, traffic signs, bus stops, tram stops, taxi stands, public lavatories, fountains and memorials, and waste receptacles. An important consideration in the design of street furniture is how it affects road safety.

街道家具是指为了各种目的安装在街道和道路上的物体和设施的集合，包括长椅、矮栏、邮箱、电话亭、街灯、街道照明、交通信号灯、交通标志、公交车站、电车站、出租车停靠点、公共洗手间、喷泉和纪念碑以及垃圾箱。街道家具设计的重要考量就是它如何影响街道安全。

Street name signs identify streets, for the benefit of visitors, especially postal workers and the emergency services. They may also indicate the district in which the street lies.

街道名称标志可以区分各个街道，方便了参观旅游者，特别是邮政工人和紧急服务。它们也可以表示街道所处的地区。

Fig. 6-12 Street name signs on Birdbrook Road, Birmingham, England

A **bench** is essentially a chair made for more than one person, usually found in the central part

of any settlement (such as plazas and parks). They are often provided by the local councils or contributors to serve as a place to rest and admire the view. Armrests in between are sometimes provided to prevent people lying down and/or to prevent people from sitting too close to someone who likes to keep some distance.

长凳实质上是为了多人使用的椅子，在任何居住地的中心部分（比如广场和公园）都可以找到。它们常常由当地的委员会或部门提供，作为休息和欣赏景观之地。长凳中间的扶手有时是用来阻止人们躺下和/或者阻止有人会太靠近喜欢保持一定距离的人。

Bollards are posts, short poles, or pillars, with the purpose of preventing the movement of vehicles onto sidewalks or grass etc.

矮栏是指标杆、短杆、或者柱子，目的是阻挡车辆开到步行道或者草地上等等。

Post boxes, are found throughout the world, and have a variety of forms: round pillar style found in Japan and the U. K. (the two feature a difference in that the Japanese version has a round lid while the UK version is flat); rectangular blue boxes in the United States; red and yellow boxes with curved tops in Australia. The Canadian version is a red box with a slanted back top.

在整个世界都可以找到邮箱，它们有各种各样的形式：在日本和英国是圆柱形风格（两者并不相同，在日本有一个圆形的盖子，而英国的盖子是平的）；在美国是矩形蓝色盒子；在澳大利亚是有着弯曲顶部的红色和黄色盒子。在加拿大是有着倾斜后顶部的红色盒子。

Phone boxes are prominent in most cities around the world, and while ranging drastically in the amount of cover they offer users, e. g. many only cover the phone itself while others are full booths. The widespread use of mobile phones has resulted in a decrease in their numbers.

全世界绝大多数城市中电话亭都是非常突出的，而它们提供给使用者的覆盖范围差别很大，比如有些只覆盖电话本身，而有些则全部封闭。移动电话的广泛使用已经导致了电话亭数量的减少。

Fig. 6-13　Street furniture can reflect local issues. The ammonite-design streetlamps reflect the town's location on the Jurassic Coast, a World Heritage site.

Fig. 6-14　K2 and K6 (left) telephone boxes stand next to each other on St John's Wood High Street, London, England.

Street lamps are designed to illuminate the surrounding area at night, serving not only as a deterrent to criminals but more importantly to allow people to see where they're going. The color of streetlamps' bulbs differ, but generally are white or yellow.

街灯用来在夜晚照亮周围区域，不仅作为对犯罪行为的威慑，更为重要的是让人们看到将要去的地方。街灯灯泡的颜色各有不同，但一般都是白色或黄色。

Traffic lights usually include three colours: green to represent "go", amber to inform drivers that the color will alternate shortly and red to tell drivers to stop. They are generally mounted on poles or gantries or hang from wires.

交通信号灯常常包括三个色彩：绿色代表"通过"，黄色告知司机交通信号灯的色彩很快就会改变，红色告诉司机停。它们一般安装在电线杆或者柱台上，或者挂在电线上。

Traffic signs warn drivers of upcoming road conditions such as a "blind curve", speed limits, etc. Direction signs tell the reader the way to a location, although the sign's information can be represented in a variety of ways from that of a diagram to written instructions. Direction signs are usually mounted on poles. Recently, illumination has started to be added in order to aid nighttime users.

交通标志警告司机即将出现的道路情况，比如"看不到的转弯"、速度限制等。方向标志告诉人们到达某地的道路，标志信息可以以各种方式表达，从图表到书写的指令。方向标志常常安装在电线杆上。最近，开始在交通标志上附设照明设施，目的是帮助夜晚的使用者。

Public lavatories allow pedestrians the opportunity to use restroom facilities, either for free or for a per-use fee.

公厕使得步行者有机会使用厕所设施，或者免费或者收费。

Local significance 地域重要性

Street furniture itself has become as much a part of many nations' identities as dialects and national events, so much so that one can usually recognize the location by their design; famous examples of this include:

街道家具本身已经变得和方言及国家大事一样成为许多国家同一性的一部分。它们是如此重要，以至于一个人常常通过它们的设计来认识地域；著名范例包括：

- the red telephone boxes of Britain;
- 英国的红色电话亭；
- the residential post boxes of the United States;
- 美国居民的邮箱；
- the streetlamps and metro entrances of Paris.
- 巴黎的街灯和地下铁入口。

Fig. 6-15 The Tiergarten park in Berlin has a collection of antique streetlamps from around the world, both gas and electric.

4. Public Space 公共空间

Public space is and has been an integral part of communities for centuries. It serves as a location for people to meet, relax, and exchange ideas. Historically, public open space has been

the infrastructure for healthy physical and contemplative relaxation. Locations such as the reflecting pool in Washington D. C. and Library Mall in Madison have been the staging points of important movements and protests. To understand the importance of public space, it is vital to know what constitutes a public area. One definition of public space states"a place where anyone can come without paying an entrance or other fee". Typical examples are most roads, including the pavement, and public parks. The idea of public space has changed quite radically in the past millennia. In Roman and Greek times, public space was not nearly as accessible as what we have grown accustomed to. Women did not usually leave the home, while men dominated most public space (e. g. the modern Middle East). The architects of the Renaissance

Fig. 6-16 the reflecting pool in Washington D. C.

derived their forms in part from a revived interest in Roman and Greek ruins. In the process, the architects, humanists, and painters of the Renaissance invented a new idea of public space in which civic pride and organization would be organized on a city-wide scale. This method of spatial organization has been replicated throughout the world. Allusions to this philosophy on public space can be seen in most public areas even in Madison; from the Greek inspired capitol building to the numerous parks.

许多世纪以来，公共空间都是社会不可分割的一部分。公共空间是人们会见、放松和相互交换理念的场所。历史中，公共开放空间一直是身体锻炼和精神放松的基础设施。比如华盛顿特区的福雷克汀池塘和麦迪逊的图书馆广场等公共空间，已经成为举行重大运动的场所。理解公共空间的重要性，关键是了解什么构成公共空间。公共空间的一种定义是："任何人不支付门票或其他费用就可以进入的场所"。典型范例有绝大多数道路，包括铺地和公共公园。公共空间的理念在过去的几千年中已经发生了极大的改变。在古罗马和古希腊时期，公共空间并不像现在我们已经习惯的那样易于进入。妇女常常不能离开家，而男人占据了绝大多数公共空间(就如现代的中东地区)。部分来说，文艺复兴时期的建筑是在对古罗马和古希腊废墟复兴的兴趣中得出了他们的形式。在这个过程中，文艺复兴时期的建筑师、人文主义者和画家发明了一种新的公共空间理念——在城市范围尺度上进行城市的规划和组织。这种空间组织方法传遍整个世界。这种公共空间理念的暗示甚至在麦迪逊的绝大多数公共空间中仍可以看到；从来自古希腊灵感的国会大厦到无数的公园。

Socio-cultural problems are related to public space through many different ideas. If there is a place where everyone can get together without barriers of class, race, or ethnicity the sense of community is strengthened. Lisa Peattie has argued that"while planners usually seem to be obsessed with creating or restoring a sense of community, they have given very little attention to conviviality, the sense of welcoming and cohesion, as a planning goal". If space were planned in a way that welcomed the entire public, there would be a stronger sense of unity among community members. Public areas need to have conviviality about

them so as to eliminate societal divisions, making them truly public.

社会文化问题与公共空间通过许多不同理念相互联系。如果人们都可以居住在一起，没有阶级、种族或人种的划分障碍，社会感就会增强。丽莎·皮阿迪认为"当设计师常常似乎沉迷于创造和恢复社会感时，他们极少注意到心情的愉快，欢迎和亲和的感受，将其作为设计目标。"如果空间以欢迎整个公众的方式来设计，在社会成员之间将有更强烈的整体感受。公共空间需要具有令人心情愉快的能力，来消除社会划分，使人们真正成为公众。

In other words, many stereotypes have been developed because there are not enough experiences shared by the different cultures in the city. "The idea of public space questions class, ethnicity, and income inequality. Social contact, especially with people of different backgrounds is acknowledged as one of the values of open space". For example, "many communal public actions typically happen in existing public spaces-streets, squares, parks and other open spaces or in such public buildings as school auditoriums or community centers". "The expectation was that if we design the space, activities will happen. This type of physical determinism proved wrong time and again, but the practice still continues in the urban design of civic centers and similar public spaces". Public space needs to be designed for the citizens, rather than for the government. After all, it is the citizens who utilize the public space and determine how it affects the city.

换句话说，因为城市文化各有不同，因此发展出许多公共空间模式。"公共空间理念对阶级、人种和收入的不平等提出怀疑。社会联系，特别是与不同背景的人，被认为是开放空间的价值之一。"例如，"许多社区公共活动常常在现有公共空间举行——街道、广场、公园和其他开放空间，或者是学校礼堂、社区中心这些建筑物中。""人们所期望的是如果我们设计公共空间，在其中就会发生活动。这种现实决定论证明是错误的，但是在城市中心和类似公共空间的城市设计中这种做法仍在继续。"公共空间需要为市民做设计，而不是为政府做设计。毕竟，是市民来使用公共空间并决定它会如何影响城市。

5. English Heritage　英国历史遗产部

　　English Heritage is the Government's statutory adviser on the historic environment. Officially known as the Historic Buildings and Monuments Commission for England, English Heritage is an Executive Non-departmental Public Body sponsored by the Department for Culture, Media and Sport (DCMS). Its powers and responsibilities are set out in the National Heritage Act (1983) and today we report to Parliament through the Secretary of State for Culture, Media and Sport.

　　英国历史遗产部是政府法定的历史环境顾问。正式名称是"英国历史建筑和遗迹委员会"，英国历史遗产部是独立的非政府公共机构，受文化、媒体和运动部资助。英国历史遗产部的权力和责任是实施国家

Fig. 6-17　English Heritage Headquarter in London

历史遗产法(1983年),并通过文化、媒体和运动部向国会做报告。

It meets those responsibilities by:

相关工作:

- acting as a national and international champion for the heritage;
- 国家和国际历史遗产的维护者;
- giving grants for the conservation of historic buildings,monuments and land-scapes;
- 对历史建筑物、遗迹和景观进行保护的授权工作;
- maintaining registers of England's most significant historic buildings,monuments and landscapes;
- 持续记录英国最重要的历史建筑物、遗迹和景观;
- advising on the preservation of the historic environment;
- 对历史环境的保护提出建议;
- encouraging broader public involvement with the heritage;
- 鼓励公众更广泛地参与到历史遗产保护工作中;
- promoting education and research;
- 推动教育和研究;
- caring for Stonehenge and over 400 other historic properties on behalf of the nation;
- 代表国家关注巨石阵和超过400年的历史遗产;
- maintaining the National Monuments Record as the public archive of the heritage;
- 设立国家遗迹记录中心,作为公共历史遗产资料室;
- generating income for the benefit of the historic environment.
- 为历史环境的保护投入资金。

6. The Countryside Commission 乡村委员会

The Countryside Commission was a statutory body in England,originally established in 1949 as the National Parks Commission to coordinate government activity in relation to national parks.

乡村委员会是英国的法定机构,1949年成立,作为等同政府行为的国家公园委员会,管理全国的公园。

It became the Countryside Commission in 1968,when its duties were expanded to cover the countryside as a whole.

1968年更名为乡村委员会,它的工作也延伸到整个乡村。

It ceased to exist in 1999 when it was merged with the Rural Development Commission to form the Countryside Agency.

1999年该委员会与乡村发展委员会合并为乡村署。

The Countryside Commission has been a leader in helping to redefine the purposes of agricultural policy. The Commission has been influential,both in policy development at the national and European level,and in practical implementation through schemes such as Cou-

ntryside Stewardship. The Cork Declaration, setting out a new vision for agriculture and rural development in Europe.

乡村委员会是帮助政府重新制定农业政策方面的领导者。委员会对英国和欧洲的政策发展，以及如乡村管理计划等主题的政策实施方面具有影响力。《寇克宣言》提出了欧洲农业和乡村发展的新观点。

Vocabulary

1. structure *n.* ①结构；构造；组织；纹理：grammer structure 语法结构 ②设备，装置 *vt.* 构造；组织；建造［立，筑］，配制设计：structure a teaching program 拟订教学大纲

［近义词］arrangement, form, make-up, organization, configuration, formation, pattern, conformation *n.* 结构，构造

building, edifice, construction *n.* 建筑物

［辨析］**structure** 建筑物：侧重指建筑物构造的形式。

The new library is a fireproof structure. 新图书馆是一座有防火设备的建筑物。

building 建筑物：最普通的用词，它并不说明建筑物的式样、用途和大小。

From the hill, we could see the buildings in the city. 在山上我们可以看见城市里的建筑物。

edifice 大建筑物、大厦：正式的用词，指巨大宏伟的建筑物。

The cathedral is a handsome edifice. 这教堂是一座美丽的建筑物。

2. external *adj.* ①外部的；外面的，外界的，客观的：the external walls of a house 一座房屋的外墙 ②［医］皮肤的，外用的：This medicine is for external use only, not for drinking. 此药只供外用，不可内服 ③外用的；外来的：external paints 外用涂料 ④表面上的，浮浅的，浅薄的 ⑤对外的，外国的，偶然的：external trade 国外贸易 *n.* ①外部，外面 ②外形，外貌，形式：judge by externals 从外观上判断

［近义词］alien, foreign, exotic, exterior, extramural, extraneous, extrinsic, outermost, outside, outward, surface, superficial, visible, independent, outer, exterior, outside *adj.* 外部的

［辨析］**external** 外部的：指全部外面的，系 internal 的反义词。

The external features of the building are very attractive. 这幢建筑物的外观很吸引人。

outer 外部的：指离开中心或内部较远的，系 inner 的反义词。

He spent hours in adorning the outer body. 他花了好几个小时来装扮外表。

exterior 外部的：指物的较外部分，系 interior 的反义词。

The exterior wall of the house was of brick. 这屋子的外墙是砖砌的。

outside 外边的：指外面的部分或表面的部分，系 inside 的反义词。

The ship is painted black on the outside and white on the inside. 这船外面漆的是黑颜色，里面漆的是白颜色。

3. layout *n.* ①形式，轮廓，外形 ②设计图，草图，线路图，设备布置图，规划图，流程图：the layout of a factory 工厂的布局 ③模样，总体布置(实际尺寸)总图；(报纸等的)版面编排 ④(一套)工具，全套装备 ⑤陈列，布置，布局，安排，规划，划分，

镶砌

[近义词] arrangement,design,draft,formation,geography,map,outline,plan,sketch
n. 布局，陈设，安排，设计

4. relative *adj.* ①相对的；比较的：After his troubles,he's now in relative comfort. 困境过后，他现在比较舒服了。②关于……的；有关……的(与 to 连用)：the facts that are relative to this question 与这个问题有关的事实　③相对的，相比较的，相应的，成比例的(to)：the relative quiet of the suburbs 郊区的相对安静　④附条件的：a different yet relative reason 虽不同但有连带关系的理由　⑤相互的：the relative duties of employer and employee 雇主与雇工之间的相互责任　*n.* ①亲人，亲戚；家人　②有关事物　③相对物

[近义词] relation,family,kin,kindred,cousin,kinfolk　*n.* 亲属，亲戚

pertinent,appropriate,pertaining,relevant,respective,applicable,related　*adj.* (与……)相关的

comparative,comparable,approximate,close,rough　*adj.* 相对的，比较的

5. subject *n.* ①(谈话，论文，文章等的)主题，题目；问题：a favourite theme for poetry 诗里喜欢用的主题　②学科，科目：the main subject in our school curriculum 我们学校课程中的主要科目　③主旨，主人翁　*adj.* ①受……支配的，附属的：a subject state 附属国　②易受[遭，患]……的，动不动就……的：be subject to damage 易受损伤　③以……为条件[转移]的；须经[有待于]……的(to)：The treaty is subject to ratification. 此条约经批准后才能生效。*vt.* ①使服从，使隶属(to)：subject another's will to one's own 使别人的意志服从己意　②使受到，使遭到(to)；加(to)：subject a metal to great heat 给金属加高热　*adv.* ①(与 to 连用)依据；随着

[近义词] vulnerable,open,liable,prone,exposed,in danger of　*adj.* 易遭受……的

under the control of,ruled by,in the power of,bound by,at the mercy of　*adj.* 受……支配的

expose,submit,make liable　*v.* 使遭受

theme,topic,issue,concern,gist,subject matter,point at issue　*n.* 主题，题目

[辨析] **subject** 题目：系普通的用词。

We are the subject of their conversation. 我们是他们谈话的主题。

theme 题目：指文章、演说等的题目。

"Patriotism"was the speaker's theme. 这演讲者的题目是"爱国主义"。

topic 题目：指用于与当时事件或问题有关的题目。

Newspapers discuss the topics of the day. 报纸讨论时事问题。

Sentence

HARD landscape simply means brick or slab paving,timber fencing,metal railings,structures and any other non-living external landscape element.

硬质景观简单来说就是砖或石材铺地，木质围栏，金属栏杆、构筑物和其他任何无生命的外部景观要素。

Once the initial design layout has been completed and approved by the client, the designer can then begin to work out the detailed choice and arrangement of fencing types, walling, paving pattern, edging and street furniture.

一旦最初的平面设计完成并被客户所接受，设计师就可以开始设计栏杆样式、墙体、铺地类型，道路镶边和街道家具。

The character of a place is defined by the relative proportion of hard elements (such as dwellings and other buildings) to soft elements (such as farm land). Recreational space and street furniture are all indicative of these character definitions.

一个地域的特征是通过硬质元素（比如住宅和其他建筑物）与软质元素（比如农场的土地）之间的相互比例关系来定义的。消遣娱乐空间和街道小品都是这些特征的表达。

Listed below are some of the indicator factors that define the more measurable landscape contexts, so that the right decisions can be made on choice of hard landscape detailing.

下面所列是一些可估量的景观背景的指标因素，在选择硬质景观细部方面就可以做出正确的决定。

This simplification of the subject can act as a rough guide. For a more subtle assessment of context and mood, the individual landscape designer must rely on more subjective findings.

这种主题的简化可以作为一个大致的指导。对于更为微妙的背景和情感的评价，景观设计师必须依靠更为主观的判断。

Translation

第 6 课 硬 质 景 观 设 计

硬质景观，简单来说就是砖或石材铺地、木质围栏、金属栏杆、构筑物以及其他任何无生命的外部景观要素。

一旦最初的平面设计完成并被客户所接受，设计师就可以开始设计栏杆样式、墙体、铺地类型、道路镶边和街道小品。可以在着手绘制图纸之前就完成一些早期的详细硬质景观设计。因为即使在草图设计阶段，了解所需要的栏杆样式、墙体设计和铺地类型等常常是非常重要的。就像在最初的设计阶段，开始选择和细化硬质景观元素时，就必须思考大众的看法和当时基地所处的背景。

一个地域的特征是通过硬质元素（比如住宅和其他建筑物）与软质元素（比如农场的土地）之间的相互比例关系来定义的。消遣娱乐空间和街道小品都是这些特征的表达。在选择材料时，找出这些背景可以避免因为选择不适当而造成与环境的不协调。金属材质的细部在城市会看起来非常地轻快，但在乡村就会显得粗鲁。

下面所列是一些可估量的景观背景的指标因素，在选择硬质景观细部方面就可以做出正确的决定。各种各样硬质元素和街道小品的性质与选择，在下列背景分类中变化很大。例如，为乡村住宅或市镇选择的栏杆很可能是弯曲的、顶杆连续的栏杆，这种栏杆常常在牧场、围场这种地方出现；而在城市，栏杆可能在传统的、有华丽尖叶饰的垂直栏杆和现

代建筑金属制品的各种各样形式之间来回变化。

城市

- 高比例的硬质空间；
- 高密度的建筑物；
- 大量的商店、金融中心、公众建筑物和办公楼；
- 大量的街道小品；
- 高比例的公共空间和缺少私人外部空间；
- 少量的农耕活动。

乡村

- 低比例的硬质空间；
- 低密度的建筑物；
- 少量的商店、办公楼、金融中心、公共建筑物；
- 少量的街道小品；
- 低比例的公共空间和大量的私人领地；
- 大量的农耕活动。

郊区

- 中等比例的硬质空间；
- 中密度的建筑物；有一些商店，但是公共/金融建筑物和办公楼很少；
- 中量的街道小品；
- 大量的私人领地但仍有一些公共空间；
- 中等偏少的农耕活动；有一些牧场。

这种主题的简化可以作为一个大致的指导。对于更为微妙的背景和情感的评价，景观设计师必须依靠更为主观的判断。虽然这种先于硬质景观决策的评价常常并不能孤立地进行，但是可以通过当地规划部门、保护部门、建筑师、当地居民、顾问和专业咨询机构的人员达成共识而形成，比如英国历史遗产部、乡村委员会等机构。

Lesson 7 Soft Landscape Design

Soft landscape is the term used for all living landscape elements such as grass, herbaceous and woody plants and trees. Soft works are those required to make living landscape elements grow and flourish in perpetuity.

Strategic landscape planting

Planners in local authorities will identify strategically important trees, groups of trees, woods and hedgerows, which contribute to the quality and character of the wider locality. These can be protected by a specific mandatory protection order called a tree preservation order (TPO). When a development is proposed, planners will impose landscape conditions on any outline planning permission granted. Such conditions will seek to preserve strategically important trees, tree groups and hedges, regardless of whether or not they were already protected under TPO legislation. The planners may well seek such protection, their conditions will demand protection of the trees throughout the construction process, and may also require enhancement of the trees or tree groups by additional tree planting. Such strategic planting will preserve the wider character and skyline of the neighborhood and retain and enhance notable landscape landmarks in perpetuity.

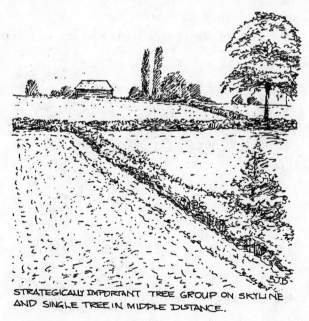

STRATEGICALLY IMPORTANT TREE GROUP ON SKYLINE
AND SINGLE TREE IN MIDDLE DISTANCE.

STRATEGIC RLANTING. Strategically important
trees, grougs of trees, woods and hedgerows contribute to the
quality and character of the wider locality.

Structural and ornamental planting

Structural and ornamental planting are terms that refer to the more intricate detail of specific locations within the site, they are considered after strategically important existing landscape features and strategic planting have been considered. The landscape designer will concentrate on these individual areas, using the basic design principles used for landscape design in general, such as space creation and definition and so on. In applying such principles the planting will fall into either structural or ornamental categories. Structural planting can be summarized to mean space-creating and space-shaping masses of foliage, which create a framework or structure to the site. Ornamental planting is the detail, adding individual character and distinctiveness by the use of colour, flower, texture, etc.

Enclosure of space: mass and forms

Plant mass

One of the most important principles when approaching soft landscape design is space creation and plant form. Plants are materials that have a definable mass. A group of plants of one species will present a mass or solid character of a given height and width. By bringing together a series of plant groups, you are able to arrange different masses to encircle spaces or unite different blocks to form the overall mass that defines and encircles the space itself. The use of planting to form space-defining masses is known as structural planting. The more intricate arrangement of plants against such structural masses can be defined as ornamental planting.

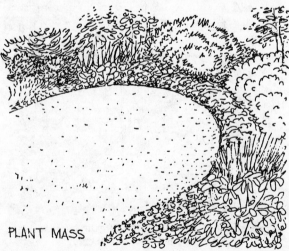

PLANT MASS. Mass is the term given to the size of the particular plant type being used, the bulk or space taken up by the plant or plant group. The further back the plant layer the larger its mass needs to be because the tall back layers are structural and the front layers decorative.

Spaces are like outside rooms, which must be large enough and comfortable enough for the functions and activities (or inactivities) the client wishes to provide for. The size of each block of the enclosing planting mass will be determined by the numbers of plants in each group. The species of plant chosen will determine the eventual height and width of each mass enclosing the space.

Plant form

Each variety of plant also has a definable form. When a group of one species is planted, the presence of this form becomes larger and more dominant. The form determines the character of a particular mass of foliage.

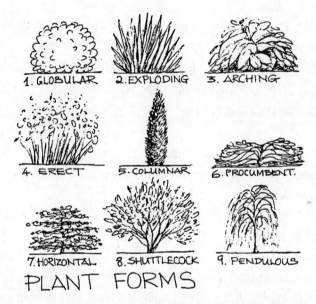

1. GLOBULAR　2. EXPLODING　3. ARCHING
4. ERECT　5. COLUMNAR　6. PROCUMBENT.
7. HORIZONTAL　8. SHUTTLECOCK　9. PENDULOUS
PLANT FORMS

PLANT FORM. The many different plant forms should be juxtaposed and contrasted as much as possible to achieve the best effect. Form and habit are traditionally separated but when looking at individual plants it is usually one of the two that dominates the plant's character and determines how it should be used.

Types of form

Some varieties will be "procumbent", others "erect" or "fastigiate". Some will be "globular" while others will be "pendulous" or of rectangular form. Many plants grow from a single stem and branch out in an up-ended shuttlecock effect. Others grow from the base and may sprawl along the ground or arch, while some shoot out spear-like leaves in a rosette pattern.

Notes

1. Soft Landscape　软质景观

The term soft landscape is used by practitioners of landscape architecture and garden de-

sign to describe the vegetative materials which are used to improve a landscape by design. The corresponding term hard landscape is used to describe construction materials. The range of soft landscape materials includes each layer of the ecological sequence: aquatic plants, semi-aquatic plants, field layer plants (including grasses and herbaceous plants), shrubs and trees.

软质景观是指景观建筑学和造园设计师通过设计改善景观的植物材料。相对的专业术语是用于描述建筑材料的硬质景观。软质景观材料的范围包括生态序列的每个层次：水生植物、半水生植物、草本层植物（包括草地和草本植物）、灌木和树木。

Soft Landscaping gives space, character, interest and color all the year round. It adds a dimension that is always changing with the seasons, with each day's weather and as the plants mature.

软质景观一年到头都在形成空间、特征、兴趣和色彩。它常常随着季节、每天的气候和植物生长的变化而增加尺度。

It provides a breath of fresh air for mind and body. It is also of educational value, offering a home or feeding place for wildlife.

软质景观为大脑和身体提供新鲜的空气。软质景观也有教育价值，为野生生物提供栖息地或喂养场所。

The successful establishment and continuing provision of public open space in cities and towns require the services of efficient plant management and maintenance professionals, as well as inspired designers.

城市和城镇公共开放空间的成功建立和持续发展，需要由高效的植被管理和维护专家以及充满灵感的设计师来实现。

Incorporating water drainage, catchment and storage; the conservation of wildlife, scenic, historic and cultural features; field sports.

与排水沟、集水区和仓库结合；与野生生物保护、风景、历史和文化特征结合；与场地运动结合。

Soft landscaping provides a positive advertising medium for the borough, attracts new business and brings quality of life; generating a sense of well-being.

软质景观为城市提供积极的广告媒介，吸引新商业的到来，提高生活品质；创造健康感受。

Well-designed and maintained soft landscape areas and parks can have a significant effect on improving the quality of life for residents.

设计和维护得很好的软质景观区域和公园能够对改善居住者生活质量产生重大影响。

2. Tree Peservation Order（TPO）　**树木保护法令**（TPO）

A Tree Preservation Order (TPO) is an order made by a Local Planning Authority (LPA) in respect of trees. The order makes it an offence to cut down, uproot, prune, damage or destroy the tree or trees in question. A TPO can apply to a single tree, a group of trees or a woodland. TPO can only apply to trees, they can not apply to bushes, shrubs or hedges (unless the hedge has reverted back to a line of individual trees). The tree under

order can be of any size,species or age.

树木保护法令(TPO)是由当地规划部门(LPA)制定的关于保护树木的法令。法令规定未经许可砍伐、迁离、修建、损害或破坏树木或树群属于违法行为。TPO 可以应用于单个树木、一组树群或一片森林。TPO 可能只应用于树木，而不包括矮树丛、灌木或树篱（除非树篱已经回复到一排单体树木）。法令保护下的树木可以是任何尺度、物种或年龄。

The LPA may make a TPO if it is deemed that the tree offers amenity value to the surrounding area,and that its loss would have a significant impact on the environment and its enjoyment by the public. To this end,the tree（s）would normally be visible from a public place and would contribute to the landscape in some way. The LPA has to justify the placement of a TPO and the tree owner can object against the placement of such an order.

如果认为树木为周围区域提供舒适价值，失去它将对环境产生重要影响，并且公众享受它的存在，当地规划部门就可能制定一条 TPO 法令。出于这一目的，树木（树群）通常是可以从公共场所就能看见的，并能够以某种方式对景观做出贡献。当地规划部门必须不断调整 TPO 的规定，而树木的所有者可能反对这种法令的安排。

A TPO does not mean that the LPA now owns the tree nor does it mean that they are responsible for the cost of its maintenance!

TPO 并不意味着当地规划部门拥有树木，也不意味着他们负责维护树木的费用。

It is important not to confuse trees subject to TPO's with trees located within Conservation Areas; the legislation is completely different.

重要的是不要把 TPO 规定下的树木和位于历史保护区的树木混淆起来；法规是完全不同的。

The removal of trees from within Woodlands & Forests may also require permission from the Forestry Commission.

在森林中采伐树木可能也需要从森林委员会那里获得许可。

3. Landmark　场地标志

Webster's 1913 Dictionary：韦氏词典(1913 年版)中 landmark 的定义：

① A mark to designate the boundary of land; any mark or fixed object（as a marked tree,a stone,a ditch,or a heap of stones）by which the limits of a farm,a town,or other portion of territory may be known and preserved.

① 指定土地边界的标志；任何标志或固定物体(如作为标志的树、岩石、水沟，或者是岩石堆)，通过这些标志可以明确和保留一座农场、一座城镇，或者是地区的任何部分的界限。

② Any conspicuous object on land that serves as a guide; some prominent object,as a hill or steeple.

② 任何作为一种指导的土地上引人注目的物体，一些突出的物体，如小山或尖塔。

③ A structure that has special significance,such as a building with historical associations.

③ 有着特殊重要性的建筑，比如有历史意义的建筑物。

④ An event or accomplishment of great significance; as,Brown v. Board of Education

was a landmark of the civil rights movement.

④ 极其重要的事件或成就；如布朗诉教育委员会案是民权运动的里程碑。

WordNet Dictionary 语义分布词典中 Landmark 的定义：

① the position of a prominent or well-known object in a particular landscape; "the church steeple provided a convenient **landmark**".

① 特定景观中的主导或著名物体的位置；"教堂的尖塔成为了方便的地标"。

② an event marking a unique or important historical change or one on which important developments depend; "the agreement was a watershed in the history of both nations"

② 突出事件——产生独特或重要历史改变的事件，或者重要发展依赖的事件；"协议是两个国家历史的分水岭。"

③ a mark showing the boundary of a piece of land.

③ 展现一块土地边界的标志。

④ an anatomical structure used as a point of origin in locating other anatomical structures (as in surgery) or as point from which measurements can be taken.

④ 标志——解剖学组织，用作确定其他解剖学组织（在外科手术中）位置的开始点，或者手术开始实施的点。

4. Structural Planting 结构种植

A number of plants have a striking architectural or sculptural impact; some from their foliage, stems or flowers, others from their natural growth habit. There is a great variety of forms and effects, ranging from the arching, thistle-like leaves and stately, upright flower to the low, spreading mass of a prostrate juniper.

许多植物具有建筑或雕塑般的突出影响力；一些来自于它们的树叶、枝干或花朵；一些来自于它们的自然生长习性。植物有各种各样的形式和效果，从拱形、飞帘般的树叶和静态的向上花朵，到匍匐桧属植物的低矮的向外蔓延的体量。

Structural plants are often used singly as a focal point, but they are also effective as part of the design framework. Placing a pair of structural plants, one on either side of a path or doorway, acts as an enhancing frame, while a single plant at the end of a border provides a visual full stop.

结构种植常常只是作为一种焦点，但它们也可以成为设计框架的一部分。在道路或走廊两边各放置一对结构种植，就能够强调整体结构，而位于边界结束处的单个植物提供了视觉的终点。

Architectural plants are excellent for visually linking the house (or other hard feature) with the garden, the sculptural, but living forms bridge the transition from hard materials to soft planting. Including a few strongly shaped plants in an otherwise informal and unstructured scheme contrasts well with the soft lines of the free planting and helps to give the design a focus.

结构种植对于建立住宅（或者其他硬质元素）和花园之间的视觉联系非常重要，雕塑般的自然形式建立起从硬质材料到软质材料之间转变的桥梁。以一种与众不同的随意、非结构主题构建的形态强烈的植物，可以与自由种植的柔软线条形成很好的对比，以此形成设

计的焦点。

5. Ornamental Planting 装饰种植

Ornamental plants are typically grown in the flower garden or as house plants. Most commonly they are grown for the display of their flowers. Other common ornamental features include leaves, scent, fruit, stem and bark. In some cases, unusual features may be considered ornamental, such as the prominent and rather vicious thorns of Rosa sericea. In all cases, their purpose is the enjoyment of gardeners and visitors. Ornamental plants may also be used for landscaping, and for cut flowers.

装饰种植一般是指生长在花园或住宅中的植物。绝大多数情况下它们的生长是为了展示它们的花朵。其他普遍的装饰元素包括树叶、香味、果实、枝干和树皮。在一些范例中，不常见的元素可能也被认为具有装饰性，比如绢毛蔷薇（即使它有尖刺）。在所有范例中，装饰种植的目的都是为了给花匠和参观者带来享受。装饰种植也可以用于园林设计，以及切花。

Similarly trees may be called ornamental trees. This term is used when they are used as part of a garden setting, for instance for their flowers, their shapes or for other attractive characteristics. By comparison, trees used in larger landscape effects such as screening and shading, or in urban and roadside plantings, are called amenity trees.

类似地，树木可以称为装饰树木。当树木作为花园环境的一部分的时候，就可以使用这个术语，例如树木的花、形体或者其他吸引人的特征。与装饰种植相比，树木用于较大的景观效果，比如遮蔽和形成阴影，或者是城市和道路种植中提供舒适的树木。

Fig. 7-1 beautiful gardens and
public landscape plantings

For plants to be considered as ornamental, they may require specific work and activity by a gardener. For instance, many plants cultivated for topiary and bonsai would only be considered as ornamental by virtue of the regular pruning carried out on them by the gardener, and they may rapidly cease to be ornamental if the work was abandoned.

对于装饰性植物来说，它们可能需要园丁进行特定的工作和活动。例如，许多植物和盆景需要修剪才能被认为是装饰性植物，园丁要对它们进行有规律的修剪枝叶，如果停止工作，它们可能很快就不再具有装饰性。

6. Plant Form 植物形状

The form of a plant is its three-dimensional shape. It can be seen from various directions and distances and these different viewpoints and scales affect our comprehension of

the form. A plant's form can be explored at close quarters, or rather, the space around the form of the plant can be explored. This space can become intricate and entangled with the solid form of the plant.

植物的形状是指其三维形体。可以从各种角度和距离来观看植物形状,不同的视点和尺度都会影响我们对形状的理解。可以非常靠近地研究一棵植物的形状,又或者植物形状周围的空间都可以被研究。这个空间可能变得错综复杂,并且与植物的固态形状难以分离。

Form is an important aesthetic criterion for species selection. The plant forms that we will consider link the visual phenomena of mass and line with the biological properties of growth form and habit.

形状是物种选择的重要美学标准。我们考虑将植物形状、体量和线条的视觉现象以及植物生长形状和习性联系起来。

Although plant form is wonderfully varied, it is possible to describe major types, and each of these can have a particular role in planting composition. These types will be described with a view to their design potential rather than as a vigorous horticultural classification of plants. However, while authors in the landscape architecture field, such as Florence Robinson (1940) and Theodore Walker (1990), have often treated form as a purely visual property, its horticultural role is at least as important to the success of plant combinations.

虽然植物形状变化多端,却能够进行大体地分类。每个类型都可能在植物构成中具有特殊的作用。这些类型将通过植物在视景中的设计潜力来进行描述,而非清晰的植物园艺分类。然而,在景观建筑学领域中,比如佛罗伦萨·罗宾逊(1940)和西奥多·沃克(1990),常常将植物形状作为一种纯粹的视觉特性,它的园艺作用至少与植物构成的成功一样重要。

Lastly, we should always keep it in mind that a plant's inherited form can be dramatically affect by environmental factors, including the presence of other plants and light levels and wind exposure.

最后,我们应该常常记住,植物的形状可能受到环境因素的极大影响,这些影响包括其他植物的存在,以及光照和风的强度。

Vacabulary

1. herbaceous *adj.* ①草本的,草本植物的:We have a herbaceous border round our garden. 我们的花园四周种有草本植物。②(颜色、纹理、形状等)似绿叶的

2. authority *n.* ①权威,权力,权势:a reference book often cited as an authority 一本常被引为权威的参考书 ②[*pl.*]当局,负责人,官方:the local authorities 地方当局 ③职权;许可的权力:Deputies were given authority to make arrests. 代表们被授予拘捕权。④根据,凭据,引证:On what authority do you make such a claim? 你的指控有何理由? ⑤权威,专家:Who is in authority here? 谁是这里的主管?

[近义词] powers,police,government,administration *n.* (常用复数)当局,官方

influence,control,effect,power,force,weight,domination,strength,might,importance,command,rule,respect,esteem,administration　*n.* 权利，权威

［辨析］**authority** 权利：指一个人因其地位官职而得以命令他人服从。

A father possesses authority over his children. 父亲有权管教他的儿女们。

influence 影响：指一个人以其品格或地位而获得影响他人的力量。

Some teachers have great influence over young people. 有些教师对年轻人的影响力极大。

control 控制：指一个人运用其地位和权利控制或指导他人或其他事物。

Parents have control over their children. 父母对他们的孩子有管制监督的权利。

effect 影响：指影响的程度或范围。

Our arguments had no effect on them. 我们的讨论对他们没有用。

3. identify　*vt.* ①认出；识别；鉴定：identify handwriting 鉴定笔迹　②认为同一（常与 with 连用）：He identifies beauty with goodness. 他认为美与善是一致的。

［近义词］make out, pinpoint, single out, designate, distinguish, know, label, nail, name, place, recognize, spot, tag, tell　*v.* 确定；认出

［辨析］**identify** 认出、认明：说出、表明、证明某人或某物。

Could you identify your umbrella among a hundred others? 你能从一百把伞中认出你的伞吗？

make out 辨认出：努力认出或认明。

I make out a bamboo thicket over there. 我隐约看见那边有一片竹林。

pinpoint 确定：原意为插针于地图上以指示正确的位置，现指确定或精确显示。

The planes bombed objectives pinpointed by ground-to-air radio. 飞机根据地对空无线电精确指示的目标进行轰炸。

single out 选出：指从众人或物中挑选出来。

He was singled out for special training. 他被选拔出来接受专门训练。

4. intricate　*adj.* ①复杂的；难懂的：an intricate design 难懂的设计

［近义词］complex, complicated, knotty, convoluted, difficult, elaborate, fancy, involved, perplexing, rococo, sophisticated, tangled, tortuous　*adj.* 复杂的，错综的

［辨析］**intricate** 复杂的：指复杂而使人疑惑不解。

It is an intricate piece of machinery. 这是一部复杂的机器。

complex 复杂的：指由许多部分组成，难以理解或解释的。

Life is getting more complex and difficult. 生活变得更复杂而困难。

complicated 复杂的：指在理解、解决和处理问题上发生困难。

I must confess that this is the most complicated case I have ever handled. 我必须承认这是我所处理的最复杂的案子。

knotty 使人困惑的：指由于复杂而使解决或理解问题不太可能。

It is a knotty problem. 这是个难题。

5. block　*n.* ①块，片(木、石等)：a block of wood 一块木头　②一组；一批；一套③［美］两条街间的距离；由四条马路围成的方形楼房区：Turn left after 2 blocks. 走过

两个街区后往左拐。④障碍物；阻塞：There was a block in the pipe and the water couldn't flow away. 水管里有块东西塞住了，水流不出。

〔近义词〕bar, cube, square, chunk, brick *n.* 木块，块料

obstruction, barrier, obstacle, blockade, bar, impediment, hindrance, interference, blockage *n.* 阻碍物

〔辨析〕**block** 阻塞：指受东西所阻以致行动困难或不可能。

All roads were blocked by the heavy snowfall. 所有的道路均为大雪所阻塞。

congest 充塞：指过分充满而拥塞。

The streets are often congested at Christmas and New Year. 圣诞节和新年时，街上经常拥挤不堪。

jam 塞满：指把东西紧紧地挤压在一起。

He jammed his clothes into a small box. 他把衣服塞到一个小箱子里。

clog 阻塞：指被废物、污物、油腻等塞住以致活动受阻。

The machinery was clogged with thick oil and dirt. 这架机器被厚厚的油垢阻塞了。

Sentence

Soft landscape is the term used for all living landscape elements such as grass, herbaceous and woody plants and trees. Soft works are those required to make living landscape elements grow and flourish in perpetuity.

软质景观是指所有有生命的景观元素，比如草地、草本及木本植物和树木。软质景观设计就是必须使具有生命力的景观元素永远地生长和繁荣下去。

When a development is proposed, planners will impose landscape conditions on any outline planning permission granted. Such conditions will seek to preserve strategically important trees, tree groups and hedges, regardless of whether or not they were already protected under TPO legislation.

当提出一项发展计划时，规划者们将这些景观限制条件施加于任何概要规划的许可之上。这些限制条件寻求在总体上对重要的树木、树群、树篱得到保护，不管它们是否已经在 TPO 法令的保护之下。

The landscape designer will concentrate on these individual areas, using the basic design principles used for landscape design in general, such as space creation and definition and so on.

景观的设计者将所有的精力都集中于一个个单独领域之中，使用的是与总体景观设计一样的设计原则，比如空间创造和定义等等。

One of the most important principles when approaching soft landscape design is space creation and plant form. Plants are materials that have a definable mass.

软质景观设计最重要的原则之一就是空间的创造和种植的形式。植物是可以形成体量的。一片同一物种的植物呈现出一定高度和宽度的体量或固态特征。

By bringing together a series of plant groups, you are able to arrange different masses to encircle spaces or unite different blocks to form the overall mass that defines and encir-

cles the space itself.

将不同的植物结合在一起，你就可以将不同的体量围绕空间排列开来，或是将不同的体块组织到一起形成一个整体，这一整体定义和围绕空间本身。

Some varieties will be"procumbent", others"erect"or"fastigiate". Some will be"globular"while others will be"pendulous"or of rectangular form.

各种各样的植物有的是"爬地的"，有的是"锥形的"，有的是"球形的"，有的是"悬垂的"或是"矩形的"。

Translation

第7课 软质景观设计

软质景观是指所有有生命的景观元素，比如草地、草本及木本植物和树木。软质景观设计就是要使具有生命力的景观元素永久地生长和繁荣下去。

概要景观种植

有关当局的规划师们将在总体上标识出有助于表现广阔地域特征和品质的重要树木、树群、森林和篱笆。这些树木可以通过一部称为树木保护法令（TRO）的强制保护法令而得以保护。当提出一项发展计划时，规划者们将这些景观限制条件施加于任何概要规划的许可之上。这些限制条件寻求在总体上对重要的树木、树群、树篱提供保护，不管它们是否已经在 TPO 法令的保护之下。规划师们可能很善于寻求保护，这些保护措施要求在整个建造过程中都对树木加以保护，也要求通过继续种植树木来增加树木或树群的数量。这种概要景观种植使得当地的地域特征和天际线得到了保护，著名的景观标识得到了永久地保留和延续。

结构和装饰种植

结构和装饰种植是指在基地内某一特定位置的更为复杂的细节，设计师在考虑、研究过总体存在的重要景观特征后才会考虑它们。景观设计师将所有的精力都集中于一个个单独领域之中，使用的是与概要景观设计一样的设计原则，比如空间创造和定义等等。在应用这些原则时，种植就成为了结构或装饰种植。结构种植是指用大量的树木创造和形成空间，它所产生的是基地的轮廓或结构。装饰种植是指通过色彩、花卉、质感等等来创造有个性和特色的细部。

空间的界限：体量和形式

种植体量

软质景观设计最重要的原则之一就是空间的创造和种植的形式。植物是可以形成体量的。一片同一物种的植物呈现出一定高度和宽度的体量或固态特征。将不同的植物结合在一起，就可以将不同的体量围绕空间排列开来，或是将不同的体块组织到一起形成一个整体，这个整体定义和围绕空间。运用种植来形成定义空间的体量就是结构种植。与结构体量相反，排列更复杂的种植就是装饰种植。

空间就像是外部的房间一样，必须足够大和舒适以满足委托人所希望提供的功能和活动（或者不活动）的需要。围绕空间的种植体量每一个部分的尺度都将由种植植物的数量来决定。植物的物种选择将决定围绕空间的每一体量的高度和宽度。

种植形式

 每种植物都有自己的形状。当种植一片单一物种时，这种形式的存在就变得更大和更具支配性。形式决定着树木体量的特征。

形式的类型

 各种各样的植物有的是"爬地的"，有的是"垂直的"或"锥形的"、有的是"球形的"，有的是"下垂的"或是"矩形的"。许多植物是从一个枝茎生长后向两边分岔形成向上的左右辐射效果。有些则是从根基沿着地面或架子蔓生，而有些则是像光线向外散射一样一<u>丛丛</u>的。

Lesson 8　Visible Landscape

A view is a scene observed from a given vantage point. Often an outstanding view is reason enough for the selection of a property. Once the site has been attained, however, the view is seldom used to full advantage. Indeed, the proper treatment of a view is one of the least understood of all the planning arts. A view must be analyzed and composed with keenly perceptive artistry to utilize even a fraction of the full dramatic potential. Like other Landscape features, the view by its handling may be preserved, neutralized, modified, or accentuated to deal with the view, we must learn more of its mature.

A view is a picture to be framed, an evolving panorama of many blending facets.

A view is a theme. Its proper realization resembles the musical creation of variation on a theme.

A view is a constantly changing mood conveyed by association, light, and color.

A view is a limit of visual space. It transcends the boundaries of the site. It has directional pull. It may evoke a feeling of soaring freedom.

A view is a backdrop. It may serve as the wall of a garden or as a mural in a room.

A view is the setting for architecture.

Design treatment of a view

A view has landscape character. This will of course determine those areas or functions with which it should be combined. If the view is a dominant landscape feature, the related use areas and spaces should be developed in harmony with the view as it exists or as it may be treated.

A view need not be seen full front or be approached from a fixed direction. It is a panorama or a segment of a panorama to be seen from any or all angles. It may be viewed on the oblique, on the sweep, or broadside.

A view is an impeller. A powerful magnet, it will draw one far and from one position to another, for the opportunity of better commanding its limits or of seeing some part in a new and intriguing way. The skilled planner will let a view develop as the viewer moves across it, just as a mountain climber experiences more and more of a view in the ascent until it is seen in the total.

A view may be subdivided. It may be appreciated facet by facet, with each bit treated as a separate picture and so displayed as to best capture its special qualities. By design, a view may be deftly modulated as one moves from area to area. Each area or framing or by the function of the space, relate one to some new aspect of the scene until, at last, it is fully revealed.

A view gains in effectiveness when certain plan areas are developed as a counterpoint

or foil. If we stand for long at one vantage point comprehending a view in its entirety, it begins to lose its first fresh appeal and stiles the senses with less impact. The interest of the open view may be sustained and much accentuated when certain plan areas are developed in balanced opposition. Such an area might be enclosed, with a narrow slot or a constructed aperture opening on some absorbing detail of the scenery. It might be a chaste volume kept simple and severe in form and neutral in tone, so that the colorful sector of view might glow more vividly. It might be a recessive area, leading one away from the view into some cave like interior space for contrast, so that, emerging to the expansiveness of the view, one senses an emotional response of great release and freedom. A designed space may incorporate some feature subtly or powerfully rebated to the view.

Some areas, to give respite, might best be planned without apparent relationship. For a heady view, like a heady drink, should be absorbed slowly and in moderation.

Split interest is a hazard in the treatment of a view. Light detail placed in front of scene is usually lost or distracting-an element of annoyance. If the broad view is used as a backdrop, the object or objects placed before it must, singly or as a compositional group, either recede or dominate.

Notes

1. A view is a picture to be framed, an evolving panorama of many blending facets. 视景是一幅框起的画面，一幅变化多端的全景。

Taj Mahal 泰姬·马哈尔陵

The Taj Mahal, is a mausoleum located in Agra, India, that was built under Mughal Emperor Shah Jahan in memory of his favorite wife, Mumtaz Mahal.

泰姬·马哈尔陵，是莫卧儿王朝国王沙杰汗为了纪念他深爱的妻子慕塔芝·马哈尔在印度阿格拉修建的陵墓。

The focus of the Taj Mahal is the white marble tomb, which stands on a square plinth consisting of a symmetrical building, an arch-shaped doorway, topped by a large dome. Like most Mughal tombs, basic elements are Persian in origin.

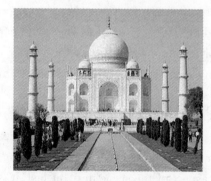

Fig. 8-1 The Taj Mahal

Fig. 8-2 The base of the Taj is a large, multi-chambered structure

泰姬·马哈尔陵的焦点是白色的大理石陵墓，它矗立在一个由对称建筑构成的正方形基座之上，拱形走廊的顶部是一个巨大的穹顶。就像绝大多数莫卧儿王朝的陵墓一样，建筑的基本元素都是源于波斯。

The design is completely symmetrical on all sides of the building. Four minarets, one at each corner of the plinth, frame the tomb.

建筑四面完全对称。四座尖塔每个基座角落一个，框起了陵墓。

The marble dome that surmounts the tomb is its most spectacular feature. Its height is about the same size as the base of the building, about 35 meters, and is accentuated as it sits on a cylindrical "drum" of about 7 metres high. Because of its shape, the dome is often called an onion dome. The top is decorated with a lotus design, which serves to accentuate its height as well. The shape of the dome is emphasised by four smaller domed chattris (kiosks) placed at its corners. The chattri domes replicate the onion shape of the main dome. Their columned bases open through the roof of the tomb and provide light to the interior. Tall decorative spires (guldastas) extend from edges of base walls, and provide visual emphasis to the height of the dome. The lotus motif is repeated on both the chattris and guldastas. The dome and chattris are topped by a gilded finial, which mixes traditional Persian and Hindu decorative elements.

陵墓顶上覆盖的大理石穹顶是它最壮观的特征。穹顶的高度和建筑基础高度基本一致，大约 35 米。但是穹顶通过一个大约 7 米高的圆柱形"鼓座"而进一步强调出其高度。穹顶常常因为其形状而被称为洋葱顶。穹顶顶部用莲花饰装饰，这也强调出它的高度。穹顶的形体通过四个位于角部的 *chattri*（小亭子）穹顶加以突出。Chattri 穹顶重复了主穹顶的洋葱形体。高高的具装饰性的涡旋线（*guldastas*）从基础墙体的边缘延伸出来，提供了穹顶高度在视觉上的强调。莲花饰图案在小亭子和涡旋线上都有重复。穹顶和小亭子都覆以镀金的叶尖饰，这种做法融合了波斯和印度的传统装饰元素。

Fig. 8-3　360° panoramic view of the Chahar Bagh gardens

The complex is set around a large 300-meter square charbagh, a Mughal garden. The garden uses raised pathways that divide each of the four quarters of the garden into 16 sunken parterres or flowerbeds. A raised marble water tank at the center of the garden, halfway between the tomb and gateway, with a reflecting pool on North-South axis reflects the image of the Taj Mahal. Elsewhere, the garden is laid out with avenues of trees and fountains.

建筑周围是一个 300 米×300 米的大型 *charbagh*——一座莫卧儿花园。花园使用凸起的通路，将花园的四个部分分成 16 个下沉的花坛或花圃。凸起的大理石水池位于花园的

中心，位于陵墓和大门的正中，沿着南北轴线成为泰姬·马哈尔陵的反射水池。

Ever since its construction, the building has been the source of an admiration transcending culture and geography, and so personal and emotional responses to the building have consistently eclipsed scholastic appraisals of the monument.

从开始建造起，这座建筑得到超越文化和地理界限的人们的赞美，对这座建筑的个人和情感反应都一致地超越了对纪念建筑风格流派的评价。

Taj Mahal is regarded as one of the eight wonders of the world, and some Western historians have noted that its architectural beauty has never been surpassed. The Taj is the most beautiful monument built by the Mughals, the Muslim rulers of India. Its stunning architectural beauty is beyond adequate description, particularly at dawn and sunset. The Taj seems to glow in the light of the full moon.

泰姬·马哈尔陵被认为是世界八大奇迹之一，一些西方历史学家认为它的建筑之美是永远无法超越的。泰姬陵是莫卧儿王朝——印度的穆斯林统治者们所建造的最美纪念建筑。特别是在黎明和黄昏的时候，它惊人的美已经无法用语言描述。泰姬陵在满月的照射下似乎闪闪发光。

2. A view is a theme. Its proper realization resembles the musical creation of variation on a theme. 视景是一个主题，恰如其分地处理就像是主题变化的音乐创造。

Gardens of Versailles 凡尔赛宫花园

Fig. 8-4 Plan of Versailles

The gardens of Versailles occupy part of what was once the Domaine royale de Versailles. Situated to the west of the palace, the gardens cover some 800 hectares of land, much of which is landscaped in the classic French Garden style.

凡尔赛宫花园占据了曾作为凡尔赛宫殿的一部分。花园位于宫殿的西边，覆盖大约800公顷的土地，是以古典法式花园风格建造的景观。

Orangerie 橘园

The Orangerie, which was designed by Louis Le Vau, was located south of the chateau, a situation that took advantage of the natural slope of the hill. The Orangerie provid-

ed a protected area in which orange trees were kept during the winter months.

橘园由勒沃设计，位于城堡的南面，这是一处利用小山丘自然坡度的场所。橘园为那里的橙树提供了一处受保护的区域，在冬季这些橙树仍不会落叶。

Bassin de Latone　拉朵娜喷泉

Located on the east-west axis just west and below the Parterre d'Eau,is the Bassin de Latone. Designed by André Le Nôtre,sculpted by Gaspard and Balthazar Marsy,and constructed between 1668～1670,the fountain depicted an episode from Ovid's Metamorphoses. Latona and her children,Apollo and Diana,being tormented with mud slung by Lycian peasants,who refused to let her and her children drink from their pond,appealed to Zeus who responded by turning the Lycians into frogs. This episode from mythology was chosen as an allegory to the revolts of the Fronde,which occurred during the minority of Louis XIV.

东西轴线的西侧，碧水潭的下方就是拉朵娜喷泉。拉朵娜喷泉由勒诺特设计，嘉斯帕和巴萨扎·玛希设计雕塑，建造于 1668～1670 年，喷泉描述奥维德《变形记》中的一段插曲。拉朵娜和她的孩子——阿波罗和戴安娜，受到了吕西亚农民的泥石弹弓的攻击。这段神话插曲被选择作为路易十四统治时期发生的投石乱党的讽刺比喻。

Fig. 8-5　The *Orangerie* in the gardens
of the Palace of Versailles

Fig. 8-6　the Bassin de Latone

Bassin d'Apollon　阿波罗喷泉

Further along the east-west axis is the Bassin d'Apollon——the Apollo Fountain. The Apollo Fountain,which was constructed 1668～1671,depicts the sun god driving his chariot to light the sky. The fountain forms a focal point in the garden.

沿着东西轴线再往前就是阿波罗喷水池。阿波罗喷水池建于 1668～1671 年，描述了太阳神驱赶他的马车飞向天空。喷泉形成了花园的焦点。

Grand Canal　大运河

With a length of 1500 meters and a width of 62 meters,the Grand Canal,which was built between 1668～1671,physically and visually prolongs the east-west axis.

1500 米长、62 米宽的大运河建于 1668～1671 年，在现实上和视觉上延长了东西轴线。

Fig. 8-7　Bassin d'Apollon　　　　　　　　Fig. 8-8　Grand Canal

Above the beyond the decorative and festive aspects of this garden feature, the Grand Canal also served a practical role. Situated at a low point in the gardens, the Grand Canal collected water as it drained from the fountains in the garden above. Water from the Grand Canal was pumped back to the reservoir via a network of windmill-powered and horse-powered pumps (Thompson 2006).

除了用作花园的装饰和举行庆祝活动之外，大运河也具有实际意义。它位于花园的较低点，大运河可以收集上面喷泉流出的水。从大运河流出的水经过一个风动力和马拉动力的泵再抽到储水池中。

3. A view is a constantly changing mood conveyed by association, light, and color. 视景是空间联系、光线和色彩所产生的不断变化的情绪。

Abu Simbel 埃及阿布辛贝神庙

Abu Simbel is an archaeological site comprising two massive rock temples in southern Egypt on the western bank of Lake Nasser about 290km southwest of Aswan. It is part of the UNESCO World Heritage Site known as the "Nubian Monuments", which run from Abu Simbel downriver to Philae (near Aswan).

阿布辛贝神庙是位于埃及南部纳瑟湖西岸、亚斯文西南 20 公里处的两座巨大的岩石庙宇。它被联合国教科文组织作为"努比亚遗址"而列为世界文化遗产。

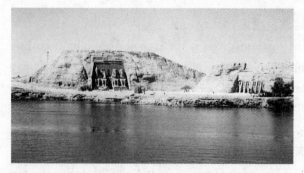

Fig. 8-9　Abu Simbel

The twin temples were originally carved out of the mountainside during the reign of Pharaoh Ramesses II in the 13th century BC, as a lasting monument to himself and his queen Nefertari, to

commemorate his alleged victory at the Battle of Kadesh, and to intimidate his Nubian neighbors. However, the complex was relocated in its entirety in the 1960s, on an artificial hill made from a domed structure, high above the Aswan dam reservoir.

两个庙宇最初是在公元前 13 世纪法老王拉美西斯二世统治时期从山腰处雕刻而成，作为他自己和王后纳菲尔塔莉的永久纪念碑，纪念他在卡叠什之战的胜利，威胁他的邻居努比亚人。然而，这座建筑在 20 世纪 60 年代被整体搬迁到由一个半球形结构形成的人工山上，这样就处于纳瑟水库之上。

The Great Temple 大神庙

The Great Temple at Abu Simbel, which took about twenty years to build, was completed around year 24 of the reign of Ramesses (which corresponds to 1265 BC). It is generally considered the grandest and most beautiful of the temples commissioned during the reign of Ramesses II, and one of the most beautiful in Egypt.

阿布辛贝神庙的大神庙，花费了二十年的时间建造，大约在拉美西斯统治了 24 年时完工（公元前 1265 年）。普遍认为它是拉美西斯二世统治时期最宏伟和美观的神庙，是整个埃及最美的神庙之一。

Four colossal 20 meter statues of the pharaoh with the double crown of Upper and Lower Egypt decorate the facade of the temple, which is 35 meters wide and is topped by a frieze with 22 baboons. The colossal statues were sculptured directly from the rock in which the temple was located before it was moved. All statues represent Ramesses II, seated on a throne and wearing the double crown of Upper and Lower Egypt.

四个高达 20 米、戴着上下埃及王冠的法老巨大雕像装饰神庙立面，四个雕像的总宽度达 35 米，顶部是装饰有 22 个风格奇特图案的横饰带。巨大的雕像直接在神庙未搬迁前所在岩石上雕刻而成。所有雕像都代表拉美西斯，他坐在王位上，带着上下埃及的双层王冠。

Fig. 8-10 Close-up of one of the colossal statues of Ramesses II, wearing the double

Fig. 8-11 Entrance of Great Temple

The inner part of the temple has the same triangular layout that most ancient Egyptian temples follow, with rooms decreasing in size from the entrance to the sanctuary.

神庙的寺庙部分有着三角形的平面，从入口到圣殿房间尺度越来越小，从那时起绝大多数神庙都沿用这种平面。

The axis of the temple was positioned by the ancient Egyptian architects in such a way that twice a year, on October 20 and February 20, the rays of the sun would penetrate the sanctuary and illuminate the sculpture on the back wall, except for the statue of Ptah, the god connected with the Underworld, who always remained in the dark. These dates are allegedly the king's birthday and coronation day respectively, but there is no evidence to support this, though it is quite logical to assume that these dates had some relation to a great event, such as the jubilee celebrating the thirtieth anniversary of the pharaoh's rule.

古埃及建筑师以这种方式设置神庙的轴线：一年中有两次——11 月 2 日和 2 月 20 日，太阳的光线将穿透圣殿照在后墙的雕塑上，只有普塔神——这个掌管地下世界的神除外，他永远保持在黑暗中。这两个日期据说分别是法老王的生日和加冕日，但是没有证据支持，虽然假定这些日期与重要事件有一定关系是非常符合逻辑的，比如五十周年纪念，庆祝法老王统治三十周年。

The Small Temple　小神庙

The temple of Hathor and Nefertari, also known as the Small Temple, was built about one hundred meters northeast of the temple of Ramesses II and was dedicated to the goddess Hathor and Ramesses II's chief consort, Nefertari. This was in fact the second time in ancient Egyptian history that a temple was dedicated to a queen. The first time, Akhenaten dedicated a temple to his great royal wife, Nefertiti.

Fig. 8-12　Ra-Horakhty, the gods Amun Ra and Ptah　　Fig. 8-13　The Small Temple's facade.

哈索尔和纳菲尔塔莉的神庙也被称为小神庙，建造在拉美西斯神庙东北方向约 100 米处，用来祭祀哈索尔女神和拉美西斯的正妻纳菲尔塔莉。事实上这是古埃及历史上第二次建一座神庙来祭祀王后。第一次是阿赫那吞为他伟大的王后奈费尔提蒂建造了一座神庙。

This exception to such a long standing rule bears witness to the special importance attached to Nefertari by Ramesses, who went to Abu Simbel with his beloved wife in the 24th year of his reign.

传统上，王后的雕塑站在法老王的旁边，但是她们决不能高过法老王的膝盖。这个神庙异常的站立尺度见证了纳菲尔塔莉对于拉美西斯特殊的重要性，在他统治的第 24 年，他和自己深爱的妻子一起进入了阿布辛贝神庙。

4. A view is a limit of visual space. It transcends the boundaries of the site. It has directional pull. It may evoke a feeling of soaring freedom. 视景是视觉空间的限定。它超越了场地界线且有方向上的吸引力，可让人产生翱翔的感觉。

Alhambra　阿尔罕布拉宫

The Alhambra is a palace and fortress complex of the Moorish rulers of Granada in southern Spain, occupying a hilly terrace on the southeastern border of the city of Granada.

阿尔罕布拉宫是位于西班牙南部格兰纳达省摩尔统治者的宫殿和城堡建筑群，占据了格兰纳达城东南边界上一处丘陵阶地。

Once the residence of the Muslim rulers of Granada and their court, the Alhambra is now one of Spain's major tourist attractions exhibiting the country's most famous Islamic architecture.

格兰纳达的穆斯林统治者和他们的国会曾经居住于此，现在的阿尔罕布拉宫成为了西班牙最著名的伊斯兰建筑，吸引无数旅游者来此参观。

The decorations within the palaces typified the remains of Moorish dominion within Spain and ushered in the last great period of Andalusian art in Granada. The isolation with the rest of the Islam, and the commercial and political relationship with the Christian kingdoms also influenced in the space concepts. Columns, muqarnas and stalactite-like ceiling decorations, appear in several chambers, and the interiors of numerous palaces are decorated with arabesques and calligraphy.

宫殿群内的装饰具有摩尔人统治西班牙时期的特征，并展示出格兰纳达的安达路西亚艺术最后的伟大时期。与伊斯兰其他地域的隔离，与基督教王国的商业和政治关系也都对当地的空间概念产生了影响。柱子、壁龛和钟乳石般的天花装饰出现在一些房间中，无数宫殿的室内用阿拉伯图饰和书法来装饰。

Fig. 8-14　Alhambra

Fig. 8-15　A room of the palace and a view of the Court of the Lions.

The majority of the palace buildings are, in ground-plan, quadrangular, with all the rooms opening on to a central court; and the whole reached its present size simply by the gradual addition of new quadrangles, designed on the same principle, though varying in dimensions, and connected with each other by smaller rooms and passages. Alhambra was added onto by the different Muslim rulers who lived in the complex. However, each new section that was added followed the consistent theme of "paradise on earth." Column arcades, fountains with running water, and reflecting pools were used to make add to the aesthetic and functional complexity. In every case, the exterior is left plain and austere. Sun and wind are freely admitted. Blue, red, and a golden yellow, all somewhat faded through lapse of time and exposure, are the colors chiefly employed.

在地平面上，宫殿建筑主体是四方形，所有的房间都开向一个中庭；只是通过逐渐增加以相同原则设计的、大小不一的中庭，整个建筑群达到了现在的规模。生活在此的穆斯林统治者们都曾增建阿尔罕布拉宫。然而，每个增加的新部分都追随"地球上的天堂"同一主题。柱子拱廊、流水的喷泉和反射的水池用来增加建筑的美学和功能的复杂性。每个建筑的室外是平坦和简朴的。太阳和风自由穿入。蓝色、红色和金黄色——所有使用的主色调随着时间流逝和暴晒，都有点褪色。

Court of the Lions 狮子宫

The Patio de los Leones (Court of the Lions) is an oblong court, 116 ft (35m) in length by 66 ft (20m) in width, surrounded by a low gallery supported on 124 white marble columns. A pavilion projects into the court at each extremity, with filigree walls and light domed roof. The square is paved with colored tiles, and the colonnade with white marble; while the walls are covered 5 ft (1.5m) up from the ground with blue and yellow tiles, with a border above and below enamelled blue and gold. The columns supporting the roof and gallery are irregularly placed. In the centre of the court is the Fountain of Lions, an alabaster basin supported by the figures of twelve lions in white marble, not designed with sculptural accuracy, but as symbols of strength and courage.

Fig. 8-16 Canopy with stonework

Fig. 8-17 Court of the Lions

狮子宫是一处长方形庭院，116 英尺(35 米)长，66 英尺(20 米)宽，周围是低矮的长廊，由 124 个白色大理石柱子支撑。庭院的每个端点都有一个亭子，用金银细丝饰品装饰墙体和轻质的穹顶。广场用色彩斑斓的地砖和白色大理石列柱铺就；而从地面到 5 英尺(1.5 米)高处的墙体都用蓝色和黄色的瓷砖铺砌，上下用镶珐琅的蓝色和金色镶边。支撑屋顶和长廊的柱子不规则地放置。在庭院的中心是狮子喷泉，12 只白色大理石狮子雕像支撑起一个雪花石水池，这些狮子并不是追求雕塑般的准确性，而是作为力量和勇气的象征。

5. A view is a backdrop. It may serve as the wall of a garden or as a mural in a room.
视景是一种背景，可成为园墙或房中的一幅壁画。

The Church of the Water　水的教堂

The Church on the Water is located in Tomamu, east of the city of Sapporo on the northern Japanese island of Hokkaido. It was designed by Tadao Ando between 1985 and 1988, and it was built in an astonishingly quick five months in 1988. The site is in a clearing in a beech forest, and slopes down towards a small river.

水的教堂位于北海道札幌东部的新得滑雪度假中心，它是安藤忠雄在 1985～1988 年间设计的，1988 年用了惊人的仅仅 5 个月就建成了。基地位于山毛榉森林中的一块空地上，向下朝向一条小河倾斜。

The church faces a large pond, 80m by 42.7m in size. The pond steps down in five stages towards the small river. At the high end of the pond is the building, the shape of which is basically a pair of overlapping cubes. The larger of the two faces the pond directly, and serves as the chapel. It is connected to the smaller cube entrance by means of a semi-circular, spiral stairway. Finally, a long, L-shaped wall runs alongside the south and east of the pond-building grouping, separating the church from the hotel behind it.

Fig. 8-18　the chapel of Church　　　　Fig. 8-19　Church on the water

教堂面对一个 80 米×42.7 米的巨大水池，水池有 5 个踏步伸向小河。在水池的制高点是建筑，建筑的形体基本上是一对相互交叠的立方体。两个立方体中较大的那个直接面对水池，作为礼拜堂使用。两个立方体通过半圆形的螺旋楼梯和小立方体入口联系起来。最终，一面长长的、L 形的墙体沿着水池——建筑群的南面和东面伸向远方，将教堂和后面的酒店分隔开来。

The visitor gains access to the church by rounding the wall at the northernmost end. The entry door is set under a glass and steel cube, and as one enters, four large, concrete crosses set inside the glass cube direct the view upwards. Once visitors enter the chapel space, they are confronted with a view of the pond. A steel cross placed in the middle of the water, and the entire view is framed by the open face of the chapel; in fact, the chapel has only three concrete walls. The fourth side is made by a glass wall, which can slide open.

Fig. 8-20 Church model

参观者通过围绕最北面的墙体进入教堂。入口大门位于一个玻璃和钢铁制成的立方体下，人们进入后，玻璃立方体中 4 个巨大的混凝土十字架指引人的视线向上移动。一旦参观者进入到礼拜堂空间，他们会直接面对水池。一座钢铁十字架站立在水中间，入口景观通过礼拜堂的开放面形成；事实上，礼拜堂只有三面混凝土墙体。第四面就是一面玻璃墙，可以滑动打开。

6. A view is the setting for architecture.　视景是建筑的环境。

Tuath na Mara Residence　Tuath na Mara　住宅

Standing vigilant over a northern Fjord in Ireland, the Tuath na Mara Residence, by MacGabhann Architects appears solid as a rock. The low slung house blends seamlessly into the heather-covered rocky landscape. The roof line warps and twists upwards like wonderful grey weathered seaweed, revealing the surrounding views to the living areas.

麦克格本汉建筑事务所设计的 Tuath na Mara 住宅守卫着爱尔兰的北峡湾，这座住宅就像岩石般坚固。低矮的住宅毫无痕迹地融合在石南花覆盖的岩石景观中。屋顶线向上弯曲和扭曲，就像奇妙的灰色风化的海藻，揭示着朝向生活区域的周围景观。

The site is hidden from the public road and is accessed from high ground on the landward side where the first experience is of an elevated view of the site and the sea beyond. Therefore the importance of the roof, or fifth façade, dictated a metal zinc cladding which is suitable for both walls and roof. Said façade, mimicking the seaweed found on the shores beyond. The anthracite color of the zinc makes the building camouflage itself into the heather landscape.

Fig. 8-21 Roofline of house

Fig. 8-22 House in the heather landscape

基地从公路上是看不到的，从朝向陆地一边的高地上才能进入基地。来到这里的第一个体验就是基地和海岸之上的上升视景。因此屋顶，或者称为第五个立面，非常重要，设计选用了一种金属锌包层，非常适用于墙体和屋顶。说到立面，在海岸之上的建筑立面在模仿海藻。锌暗淡的色彩使建筑本身完全融合进石南花景观中。

The roof of both living areas is flipped and directed in opposite directions. Both living areas are fully glazed, thus embracing nature and developing a conversation with it. By way of contrast the sloped slit windows of the bedrooms act as a counter point to the absolute horizontal of the ocean horizon.

两个生活区域的屋顶向内倾斜，指引相反的方向。两个生活区域完全是玻璃的，因此将自然引入建筑，并发展出建筑和自然的对话。通过对比的方法，卧室的狭长窗户成为了海洋水平线的对照点。

In order to emphasize the fact that the owners were embarking on a holiday each time they entered the house, the step and entry ramp at the front door is disconnected from the building thus making the visitor step over a gap not unlike stepping from the static platform onto a passing train.

为了强调业主每次进入住宅是来度假这一事实，前门的踏步和入口坡道与建筑相分离，因此使参观者在一个裂缝中迈步，非常像从静止的站台踏上一列正在开动的火车。

The plan form was inspired by the traditional narrow cottage and is orientated towards warm southern sun. It contains three sleeping cells and auxiliary spaces in the middle with two living areas, one at each end, connected by a library.

平面形式的灵感来源于传统的狭窄村舍，以及朝向温暖太阳的需求。建筑平面包括三个卧室和两个生活区域中间的辅助空间，每边一个，通过一间图书室联系起来。

The roof rain water is drained by way of gargoyles making one aware of the elements even in the lightest of showers, thus reinforcing the connection between inhabitant and nature.

屋顶的雨水通过出水口排干，使人意识到甚至最小的阵雨也成为了建筑可利用的元素，因此加强了居住和自然之间的联系。

MacGabhann Architects have made, as the client describes, a wonderful modern escape. With integrated reference to vernacular buildings and the landscape, without compromising aesthetics and impressive modern design.

麦克格本汉建筑事务所创造出了一处完美的现代隐居所，就如业主所描绘的。建筑师完整参考了当地的本土建筑和景观，没有向美学和令人印象深刻的现代设计妥协。

Fig. 8-23　Exterior and Interior of house

Vocabulary

1. utilize　*vt.* ①利用　②光通利用率；室内利用率

[近义词] use, consume, employ, expoit, make use of, put to use, take advantage of, capitalize on, put into service, bring into play, profit by, resort to　*vt.* 利用

[辨析] **utilize 利用：**指使之有用或用之于有益的方面。

She utilizes every scrap of food. 她利用每一点食物。

use 使用：普通的用词，指通过使用达到一定的目的或满足需要。

When I write, I always use a pen. 我总是用钢笔写字。

consume 用尽：指为达到某一目的而耗尽其所有。

He consumed much time and energy in writing this book. 他写这本书耗费了很多时间和精力。

2. panorama　*n.* ①回转画，活动画景　②全景照片 [装置]；风景的全貌　③一连串的现象　④概观，概论：a panorama of American history 美国通史

[近义词] outlook, perspective, vista, lookout, scene, sight　*n.* 全景

[辨析] **panorama 全景：**指宽广的、无阻挡的景色。

He enioyed the panorama of London life. 他欣赏着伦敦形形色色的生活全景。

outlook 景色、展望：指尽目力所能看到的风景，也可指对事情发展的看法。

The hotel has a good outlook on the lake. 这旅馆有很好的湖景。

perspective 前景、远景：原指透视法，即远近的配合，现指被观察的天然景色。

The villa he bought last year held a perspective of lakes and hills. 从他去年购买的别墅里可以领略湖山的远景。

vista 景色、远景：指在狭窄通道的末端所见到的景色。

The opening between the two rows of trees afforded the vista of the lake. 从两行树木间的通道中露出了湖的远景。

3. setting *n.* ①安放，置放；沉落：the setting of the sun 落日 ②环境；（书的）背景；电影的场景：the social setting 社会环境 ③调整：This machine has two settings：fast and slow. 这种机器有两种可调的速度：快速和慢速。④剧景；布景；舞台面

［辨析］**setting 背景、环境**：指文学、艺术、戏剧作品中，角色出现的时间、地点和条件。

The author chose a 19th century setting for her novel. 这位作家选择 19 世纪作为她小说的背景。

background 背景：指人的经历、教育与环境，包括当时的社会、政治环境。

He is a man of high cultural background. 他是受过高等教育的人。

environment 环境：指对人的身体、思想或品德发展有影响的所有外部因素。

The house itself is not particular to my mind, but I like its environment. 这幢房子本身我并不特别中意，但我喜欢它周围的环境。

surroundings 环境：指周围的事物，用复数形式。

The house is in beautiful surroundings. 这所房屋处于优美的环境中。

4. dominant *adj.* ①支配的，统治的：a dominant position 统治地位 ②发配的；有统治权的：a dominant person in the team 队里最有权威的人 ③（身体成对部分中的）较有力的：The right hand is dominant in most people. 大多数人右手比左手有力。④超群出众的，显著的

［近义词］essentials,key,part,element,factor,VIP *adj.* 主因，要素，主要的人（或物）

paramount,predominant,governing,ruling,controlling,conducting,assertive,authoritative,chief,commanding,influential,leading,main,powerful,managing,predominant,paramount,preponderant,preponderating,sovereign,prevailing,prevalent,preeminent,supreme,transcendent,surpassing,outstanding,senior,prominent,important *adj.* 支配的，统治的

［辨析］**dominant 有统治权的、有支配力的**：指有统治权的、有优势的，具有最大影响力、权力或权威。

Efficiency is the dominant idea in many businesses. 在许多种业务中，效率是最重要的。

paramount 最高的、至高无上的：指在重要性、权威、阶级等方面均居于首位，因而是最高的、至高无上的。

It is of paramount importance that we finish the work on time. 我们按时完成这项工作是非常重要的。

predominant 主要的、优越的：指在影响力、权力和权威方面超越其他，因此是主要的或优越的。

Love of liberty is the predominant feeling of many people. 热爱自由是如今许多人的主

要感情。

5. harmony n. ①和睦；和谐；和平相处：In a beautiful picture there is harmony between the different colors. 美丽的画面中，不同色彩相协调。②一致点（对不同题目的不同叙述中的相同处）

［近义词］melody,note,tone,accord,agreement,amicability,balance,compatibility,concord, conformity,consonance,coordination,correspondence,parallelism,peace,rapport,suitaability, symmetry,sympathy,tune,tunefulness,unanimity,understanding,unity n. 和谐，和睦，融洽

［辨析］**harmony** 和谐，和声：指不同的音调和谐一致。

He is a master of harmony. 他是一位精于和声的人。

melody 曲调、旋律：指一首歌或一部乐曲的曲调。

This song is based on old lrish melodies. 这首歌是根据古老的爱尔兰曲调改编的。

note 音调：指乐器发出的具有一定音度的单音，又可称音符。

He striked a false note on the instrument. 他在乐器上奏错了一个音符。

tone 音调：指音的高低、性质、强弱等。

He sings in a flute-like tone. 他用笛子般的音调唱歌。

6. aperture n. ①孔；缝隙：The only light came through a narrow aperture. 仅有的光来自一个小孔。②（照相机的）孔径；光圈，快门：What aperture are you using? 你使用多大的光圈？ ③［光］（望远镜等的）镜径

［近义词］leak,drip n. 孔、洞

［辨析］**aperture** 孔、洞：指允许光线进过的小孔。

The only light came through a narrow aperture. 仅有的光是来自一个小孔的。

leak 漏洞：指由于损坏而漏液体、水或气的洞隙。

There is a leak in the gasbag of a balloon. 飞行气球的袋囊上有一处漏气。

drip 水滴：指液体、水一滴一滴地落。

We heard the drip,drip,drip of the rain. 我们听到滴答滴答的雨声。

7. scenery n. ①布景，道具布置 ②自然景物，天然风光：The scenery in the mountains is very beautiful. 山里的景色非常美。③背景

［近义词］scene,landscape,view,sight n. 风景，景象

scene,view,landscape,prospect,backdrops,bankground,setting,sets n. 舞台布景

［辨析］**scenery** 景色、风景：指某一地区全部的天然景色，不必指眼中所见的。

The scenery along the river was beautiful. 沿江的风景非常美丽。

scene 景色：指展现在眼前的风景或景物。

We have a fine view of the mountain scene. 我们能看到优美的山景。

view 景色：普通的用词，指从某一位置所能见到的景色或物体。

Here you have a good view of the stage. 从这里你可以很清楚地看到舞台。

landscape 风景：指山水及自然界的其他景色。

The spring landscape in Hangzhou is beautiful. 杭州的春景非常美丽。

prospect 景色：指从高处眺望远处所见到的景色。

The prospect from the mountain was grand. 从山上看到的景色很壮观。

Sentence

A view is a scene observed from a given vantage point. Often an outstanding view is reason enough for the selection of a property.

视景是从一个给定视点所能见到的景致。通常，一个绝佳的视景就足以成为选址的理由。

Once the site has been attained, however, the view is seldom used to full advantage. Indeed, the proper treatment of a view is one of the least understood of all the planning arts.

然而场地一经获得后，大部分视景的优势都不能得以充分利用。实际上，对视景的恰当处理是最有待理解的视觉艺术之一。

It may be appreciated facet by facet, with each bit treated as a separate picture and so displayed as to best capture its special qualities. By design, a view may be deftl modulated as one moves from area to area.

视景是可以细分的，它可一小幅一小幅地观赏，每一局部都可作为一个独立的画面且这样能更好地领略其特殊本质。

The interest of the open view may be sustained and much accentuated when certain plan areas are developed in balanced opposition.

当某些规划区域发展构成平衡的对立面时，开放视景的吸引力才能持久且得以强化。

Split interest is a hazard in the treatment of a view. Light detail placed in front of scene is usually lost or distracting-an element of annoyance.

视景处理中兴趣分散是灾难性的。场景前的细枝末节常常令人迷惑或心烦意乱——一个恼人的因素。

Translation

第8课　视　觉　景　观

视景是从一个给定视点所能见到的景致。通常，一个绝佳的视景就足以成为选址的理由。然而场地一经获得后，大部分视景的优势都不能得以充分利用。实际上，对视景的恰当处理是最有待理解的视觉艺术之一。必须以敏锐和富有洞察力的艺术手法分析和组合视景，以利用其中极为细微但却充满潜在生机的部分。同其他景观特征一样，视景可以通过处理得以保护、弱化、缓和和强化。但在试图处理视景之前，必须更多地了解其本质。

视景是一幅框起的画面，一幅变化多端的全景。

视景是一个主题，恰如其分地处理类似于主题变化的音乐创造。

视景是情绪不断变化的诱导。

视景是视觉空间的限定。它超越了场地界限且有方向上的吸引力。它可让人产生延展自由的感觉。

视景是一种背景，可成为园墙或房中的一幅壁画。

视景是建筑的环境。

视景的设计处理

视景具有景观特征。这一点势必会决定与之相结合的那些区域或功能。如果视景是主导的景观特征，那么相关的用地区域或空间就应与该视景的现状或可能状况取得和谐。

视景无需完全从正面或从固定的方向观察。它是从各个角度都能观察到的一幅全景或全景的一部分。它可斜看、可环视、可侧观。

视景是一个驱动装置。它把人们的目光拉远，从一点拉到另一点，为的是更好地掌控其界限或者以一种新奇有趣的方式来观看某些部分。技高一筹的规划师会让视景步移景异，如同登山者在攀登过程中越向上就越能体会到更多的景致，直至看到全景。

视景是可以细分的，它可一小幅一小幅地观赏，每一局部都可作为一个独立的画面且这样能更好地领略其特殊本质。通过设计，视景能随人的移动而不断变幻。在每一个地域，利用方向、前景、景框，或空间的功能，使人接触到视景的一些新貌，直到最后完全展现在人们面前。

当某些规划区域发展为对景或衬景时，视景会给人更深刻的印象。如果我们长时间地站在一个视点上，全面领略一视景，它将开始失去最初新奇的吸引力，其震撼力也将大减弱。只有当某些规划区域发展构成平衡的对立面时，开放视景的吸引力才能持久且得以强化。这类区域可以是封闭的，仅有一条狭长的通道或构筑物设置的缝隙透出景色诱人的细节。它可以是一个纯朴的空间，形式简洁质朴，色调平和，这样视景色彩明快的部分才能生动。它可以是一个隐蔽区域，为了对比，将人从一处视景引到一些洞穴状的内部空间，这样当视域豁然开朗时，人们会感到莫大的放松和自由。经过设计的空间可组合一些巧妙地或强有力地与视景相关联的物体。

一些地域为了留有余地，规划时最好没有明显的联系。因为像醇酒般醉人的视景，应该慢慢吸收、细细品味。

视景处理中兴趣分散是灾难性的。场景前的细枝末节常常令人迷惑或心烦意乱——一个恼人的因素。如果把辽阔的视景用作背景，置于其前的景物必须是独立的或呈组群状，要么作陪衬，要么占主导地位。

Lesson 9 The Defined Open Space

Open spaces assume an architectural character when they are enclosed in fall or in part by structural elements. Such a space may be an extension of a building. Sometimes it is confined within the limits of a single building or endorsed by a building group. Sometimes such a space surrounds a structure or serves as its foreground, or as a foil, or as a focal point. Each such defined open space is an entity, complete within itself. But more, it is an inseparable part of each adjacent space or structure. It can be seen that such related spaces, structures, and the landscape that surrounds them must all be considered together in the process of design.

A defined outdoor volume is a well of space. Its very hollowness is its essential quality. Without the corresponding void a solid has no meaning. Is it not then quite evident that the side, shape, and quality of the negative space will have a powerful retroactive effect upon the adjacent positive masses?

Each structure requires for its fullest effective expression a satisfying balance of mass and void. The same void may not only satisfy two or more solids and relate them to each, it may also relate them as a group to some further structures or spaces beyond.

Whatever its function. When the hollowness of a volume is a quality to be desired, this concavity is to be meticulously preserved and emphasized by letting the shell read dearly, by revealing enclosing members and planes, by incurving, by belling out the sides, by the use of recessive colors and forms, by letting the bottom fall away visually, by terracing or sloping down into and up out of the base, by digging the pit, or by depressing a water basin or reflective pool and thus extending the apparent depth of the space to infinity. A cleanly shaped space is must to be choked or clogged with plants or other standing objects. This is not to imply that the volume should be kept empty, but rather that its hollowness should be in all ways maintained. A well-placed arrangement of elements or even a clump or grove of high-crowned trees might well increase this sense of shell-like hollowness.

The defined space, open to the sky, has the obvious advantages of flooding sunlight, shadow patterns, airiness, sky color, and the beauty of moving clouds. It has disadvantages too, but we need only plan to minimize these and to capitalize on every beneficial aspect of the openness. Let us not waste one precious yard of azure blue, one glorious burst of sunshine, or one puff of welcome summer breeze that can be caught and made to animate, illuminate, or aerate this outdoor volume that we plan.

If the volume defined by a structure is open to the side, it becomes the focal transition between the structure and landscape. If open to the view, it is usually developed as the best possible viewing station and the best possible enframement for the view seen from the various points of observation.

The defined open space is normally developed for some use. It may extend the function of a structure, as the motor court extends the entrance hall or as the dining court extends the dining room or kitchen. It may serve a separate function in itself, as does a recreation court in a dormitory grouping military parade ground flanked by barracks. But whether or not it is directly related to its structure in use, it must be in character. Such spaces, be they patios, courts, or dominant and focal in most architectural groupings that the very essence of the adjacent structures is distilled and captured there.

Notes

1. Architectural Character 建筑特征
A Three-Step Process to Identify A Building's Character 辨别建筑特征的三个步骤
Step 1: Identify the Overall Visual Aspects 第一步：识别整体视觉外观
Identifying the overall visual character of a building is nothing more than looking at its distinguishing physical aspects without focusing on its details. The major contributors to a building's overall character are embodied in the general aspects of its setting; the shape of the building; its roof and roof features, such as chimneys or cupolas; the various projections on the building, such as porches or bay windows; the recesses or voids in a building, such as open galleries, arcades, or recessed balconies; the openings for windows and doorways; and finally the various exterior materials that contribute to the building's character.

识别建筑的整体视觉特征通常只不过是看它独特的某些方面，并没有关注细节。建筑整体特征的主要决定因素体现在建筑环境之中；建筑形体；屋顶和屋顶特征，比如烟囱或圆屋顶；建筑物上的突出部分，比如走廊或凸窗；建筑物的凹进或空隙，比如开敞的地下通道，拱廊或凹进的阳台；窗户和走廊的开口；以及构成建筑物特征的各种各样室外材料。

Step One involves looking at the building from a distance to understand the character of its site and setting, and it involves walking around the building where that is possible. Some buildings will have one or more sides that are more important than the others because they are more highly visible. This does not mean that the rear of the building is of no value whatever but it simply means that it is less important to the overall character. On the other hand, the rear may have an interesting back porch or offer a private garden space or some other aspect that may contribute to the visual character. Such a general approach to looking at the building and site will provide a better understanding of its overall character without having to resort to an infinitely long checklist of its possible features and details.

第一步，从远处观看建筑，目的是理解其基地和环境的特征，包括尽可能环绕建筑步行。一些建筑会有一边或多个边比其他边更为重要，因为它们更具可视性。这不是说建筑剩下的面不重要，而只是说它可能不如整体特征那么重要。另一方面，剩下的面可能有一个有趣的后廊，或提供私人花园空间，或者一些其他可能构成视觉特征的方面。这种观看建筑和基地的方法将提供对其整体特征的更好的理解，没有必要无限长地列出它可能的特

征和细节。

Step 2: Identify the Visual Character at Close Range　第二步：近距离识别视觉特征

Step Two involves looking at the building at close range or arm's length, where it is possible to see all the surface qualities of the materials, such as their color and texture, or surface evidence of craftsmanship or age. In some instances, the visual character is the result of the juxtaposition of materials that are contrastingly different in their color and texture. The surface qualities of the materials may be important because they impart the very sense of craftsmanship and age that distinguishes historic buildings from other buildings. Furthermore, many of these close up qualities can be easily damaged or obscured by work that affects those surfaces. Examples of this could include painting previously unpainted masonry, rotary disk sanding of smooth wood siding to remove paint, abrasive cleaning of tooled stonework, or repointing reddish mortar joints with gray portland cement.

第二步，在近距离观察建筑，在那里观看所有材料的表面特性是可能的，比如它们的色彩和质感，或者技术或年代的外观表达。在一些范例中，视觉特征是色彩和质感完全不同的材料并置的结果。材料的表面特性可能很重要，因为它们给予对建筑技术和年代方面的正确感受，这种感受能够使历史建筑从其他建筑中脱颖而出。此外，许多近距离建筑特性可能被影响那些表面的工作轻易地破坏或掩饰掉。典型范例包括在没油漆过的砖石建筑上绘画，在旋转盘上打磨去掉光滑木材上的油漆，石雕工艺的研磨清洁，或者用灰色的波特兰水泥重嵌红色灰浆。

There is an almost infinite variety of surface materials, textures and finishes that are part of a building's character which are fragile and easily lost.

表面材料有无数种，质感和装饰是脆弱和易于失去的建筑特征。

· Step 3: Identify the Visual Character of Interior Spaces, Features and Finishes　第三步：识别室内空间的视觉特征，特征和装修

Perceiving the character of interior spaces can be somewhat more difficult than dealing with the exterior. In part, this is because so much of the exterior can be seen at one time and it is possible to grasp its essential character rather quickly. To understand the interior character, Step Three says it is necessary to move through the spaces one at a time. While it is not difficult to perceive the character of one individual room, it becomes more difficult to deal with spaces that are interconnected and interrelated. Sometimes, as in office buildings, it is the vestibules or lobbies or corridors that are important to the interior character of the building. With other groups of buildings the visual qualities of the interior are related to the plan of the building, as in a church with its axial plan creating a narrow tunnel-like space which obviously has a different character than an open space like a sports pavilion. Thus the shape of the space may be an essential part of its character.

感受室内空间特征可能比室外空间困难点。部分来说，这是因为同时可以看见如此多的室外空间，抓住其基本特征可能就相当快。为了理解室内特征，第三步就必须在一段时间内穿越空间。感受单个房间的特征并不困难，而处理相互联系和相互关联的空间更为困难。有时，作为一个办公建筑，前庭或者大厅或者走廊对于建筑的室内特征就很重要。室

内的视觉特性通过建筑其他部分与建筑平面相关，就如狭窄通道般的空间、平面轴线对称的教堂和运动场的开放空间有完全不同的特征。因此，空间的形体是其特征的基本部分。

The importance of interior features and finishes to the character of the building should not be overlooked. In relatively simple rooms, the primary visual aspects may be in features such as fireplace mantels, lighting fixtures or wooden floors. In some rooms, the absolute plainness is the character-defining aspect of the interior. So-called secondary spaces also may be important in their own way, from the standpoint of history or because of the family activities that occurred in those rooms.

室内特征和装修对于建筑特征的重要性不应被忽略。在相对简单的房间中，主要的视觉因素可能存在于比如壁炉架、照明质感或木地板这些特征中。在一些房间中，绝对的平坦就是室内特征的定义。所有的次要空间也可能以其自己的方式表现重要性——从历史的角度，或者因为发生在那些房间中的家庭活动。

2. Structural Element　结构元素

Arches　拱

Arches are a common type of architectural structural element originally used in underground structures such as tombs, drains, and vaults. The first recorded use of the arch was in the Indus Valley around 2500bc. The arch was used because of its strong design able to bear enormous loads. In general an arch is a semi-circular design of odd number parts coming to an apex at the keystone where the majority of the weight is applied. 2000 years after its first use the arch was brought above ground by the Greeks and Romans. The common uses were doorways and bridges. There are a number of arch styles including triangular, round, segmental, rampant, lancet, inflexed, and a number of others.

拱是最初普遍用于地下结构的建筑结构元素，比如陵墓、排水沟和穹顶。存有记录的首次使用拱大约是在公元前 2500 年左右的印度河流域。使用拱是因为它能够承受巨大的负载。一个拱一般是由奇数个部分构成的半圆形设计，在拱心形成一个顶点来承载主要的重量。首次使用的 2000 年后，拱被古希腊和古罗马人带到了地上。一般用于大门和桥梁。拱有许多形式，包括三角形、圆形、切片、跃立的动物、尖拱、内折，等等。

Ceilings　顶棚

The ceiling is another important architectural structural element serving both the need for cover and stability as well as aesthetics. There are a number of ceiling styles including domed, cathedral, dropped, and coffered. Cathedral ceilings are any ceiling that is a term that refers to any high ceiling. A dropped ceiling tends to be constructed below the apex of the structure typically for aesthetics or for piping and ventilation. Coffered ceilings are barrel shaped ceilings divided into various panels typically for acoustics or aesthetics.

顶棚是另一个重要的建筑结构元素，满足覆盖、稳定和美观的需求。顶棚有许多形式，包括穹顶、教堂式、斜顶和藻井。教堂式顶棚这个词是指任何形式的高天花。斜顶顶棚倾向于在建筑的顶点建造，一般是为了美观或者安置管道和通风。藻井是分成各种层次的桶形顶棚，一般是为了满足声学或美观的需要。

Columns 柱子

Columns are a common architectural structural element used for support as well as decoration. The first use of columns was in ancient Egypt beginning around 2500bc. The main categories of columns are divided into what are termed orders. There are five major orders including Doric, Tuscan, Ionic, Corinthian, and Composite. Columns can be erected as a single piece or in components. The Doric and Tuscan columns are similar and are the most common structural columns being basic cylindrical structures. Ionic columns tend to incorporate a fluted shaft and a scroll top. Corinthian columns are typically thinner and are more aesthetic than weight bearing with leaves carved in the top. Composites are a mix between Ionic and Corinthian columns.

柱子是普遍用于支撑和装饰的建筑结构元素。柱子的首次使用大约是在公元前2500年的古埃及。柱子的主要分类被称为柱式，五个主要的柱式包括多立克式、托斯卡纳式、爱奥尼式、科林斯式和混合式。柱子可以作为一个单体或者组件来竖立。多立克式和托斯卡纳式相类似，是最普遍的基本圆柱体结构柱。爱奥尼柱融合刻槽的柱身和涡卷柱头。科林斯柱较细长，在顶部雕刻叶子，美观比承重更为重要。混合式是爱奥尼柱和科林斯柱的混合。

Windows 窗户

There are a variety of window styles used as architectural structural elements that serve a number of purposes including airflow, increased light, and decoration. Common windows in the United States and Europe are sash windows. These overlap slightly at the edges so that they can be opened and closed. Some windows are in place mainly for light including bay and picture windows, skylights, and oriel windows. For decorative purposes stained glass can be used and this is found mostly in churches and cathedrals.

各种各样风格的窗户也是建筑结构元素，用于许多目的，包括通风、增加光照和装饰。在美国和欧洲普遍使用的窗户是推拉窗。这种在边缘轻微相互重叠的窗户便于打开和关闭。一些主要用于光照的窗户包括海景窗、天窗和凸窗。为了装饰的目的，可以使用染色玻璃，这种玻璃大多在教堂和大教堂中使用。

3. Focal Point 焦点

A **focal point** may mean：

focal point 是指：

- Focus (optics), the point at which initially collimated rays of light meet after passing through a convex lens, or reflecting off of a concave mirror.
- 焦点（光学），光线穿过一面凸透镜，或者从一面凹透镜中反射出来后最初瞄准的点。
- In mathematics：
- 数学：
 - Focus (geometry), a special point used in describing conic sections.
 - 焦点（几何学），用来描述圆锥剖面的特殊点。
 - Focal point is a critical point of a distance function.

 ○ 焦点是距离函数的关键点。

- Focal point used in art design principles (contrast, size & placement, lines & visual rhythms)

- 焦点，用于艺术设计原则（对比，尺度 & 位置，线条 & 视觉韵律）

- In computer programs, Telelogic Focal Point is a configurable Web-based decision support platform for requirements management, product management and project portfolio management.

- 在计算机程序中，电子逻辑焦点是结构网络基础决定支持平台，用于需求管理，产品管理和项目文件管理。

- In a work of art, the center of visual attention, often different from the physical center of the works.

- 艺术作品中，视觉注意力的中心，常常不同于作品的构图中心。

- In business, the person or organization responsible for the coordination of activities and tasks among several groups or networks.

- 商业中，负责众多群体或网络的活动和任务协调的人或机构。

4. The Negative Space 负空间

Rubin's vase is an optical illusion in which the negative space around the vase forms the silhouettes of two faces in profile.

鲁宾司的花瓶是一种视觉错觉，花瓶周围的负空间在剖面图中形成了两个脸的侧影。

Spaces Between Moth is another example of the optical illusion where the faces and arms reveal a moth in the white.

飞蛾之间的空间是另一个视觉错觉的范例，用人的脸和胳膊表现出了白色的飞蛾。

Negative space, in art, is the space around and between the subject (s) of an image. Negative space may be most evident when the space around a subject, and not the subject itself, forms an interesting or artistically relevant shape, and such space is occasionally used to artistic effect as the "real" subject of an image. The use of negative space is a key element of artistic composition. The Japanese word "ma" is sometimes used for this concept, for example in garden design.

Fig. 9-1 Rubin's vase Fig. 9-2 Spaces Between Moth

在艺术上，负空间是指一幅图像的主题周围和之间的空间。当主题周围的空间（不是主题本身）形成一种有趣的或者和艺术有关的形体的时候，负空间可能最明显。这种空间偶尔用于艺术效果，如一幅图像的"真实"主题。负空间的使用是艺术构图的关键元素。日本语"ma"有时用来指这个概念，例如在造园设计中。

The use of equal negative space, as a balance to positive space, in a composition is considered by many as good design. This basic and often overlooked principle of design gives the eye a "place to rest", increasing the appeal of a composition through subtle means. The term is also used by musicians to indicate silence within a piece.

许多好的设计都在构图中有所考虑平等负空间的使用，将其作为正空间的平衡。这种基本的，却常常被忽视的设计原则让眼睛"有地方休息"，通过巧妙的方法增加构图的感染力。音乐家们也使用这个术语来表达一部作品中的静止。

Negative Space Can Have a Positive Effect 负空间能够产生积极效果

Many elements work together to create a pleasing photograph. One such elements is negative space. Negative space is all the space inside the picture that is not the subject. The edges of any picture form a frame for that picture. Within that frame, the subject is considered the positive area; the rest is called negative space.

许多元素一起创造出一幅令人愉快的照片。其中元素之一就是负空间。负空间是画面中所有非主题的空间。任何图片的边界形成图像的框架。在框架内，主题被认为是正区域（积极空间）；剩下的就是负空间（消极空间）。

The word negative is used descriptively; it is not a value judgment. Negative space is not something to be avoided. However, it is something to be considered, because it is an important part of a picture's composition. It is a design element in your image.

Fig. 9-3 the brass object

负这个词是描述性使用；它不是一种价值判断。负空间不是指要避免的事物。反而，它是需要考虑的事物，因为它是一幅图画构图的重要部分。它是你的想象中的设计元素。

A stencil can help you recognize this importance. Here the subject is the brass object, but the negative space that forms the letter is equally if not more important.

一张模板可以帮你认识这种重要性。这里的主题是一个黄铜物体，但是形成字母的负空间同等或者更为重要。

Negative space has several functions. It helps define a subject. In many cases, it also provides a vital element in the design of your image. Since a photo is two-dimensional, the space around a subject appears on the same plane as the subject. Negative and positive spaces are side by side. The balance between them should be pleasing.

负空间有许多功能。它帮助确定主题。在许多范例中，它也为你的想象提供至关重要的设计元素。既然一幅图像是二维的，主题周围的空间就和主题出现在同一平面。负和正空间是并列的。它们之间的平衡应该是令人愉快的。

Negative space can appear anywhere in a picture. If your subject is in the center of a

picture, the negative space is at the edges. It could also be in the center, as in the this striking image of the Golden Gate Bridge by photographer Michael Fletcher.

负空间可以出现在图片中的任何地方。如果主题位于一张图片的中心，负空间就在边缘。它也可以在中心，就如这张由摄影师麦可·佛雷切拍摄的金门大桥的醒目图片。

5. Mass and Void　实与虚

The two extremes of vision are those of light and dark. Highlights are a reflection of light back at the viewer, and shadows are the presence of dark due to the diffusion or obstruction of light. Mass and void are physically opposites in form, and this is reflected in the interaction with light:

Fig. 9-4　Negative space of the Golden Gate Bridge

图像的两个极端是光明和黑暗。光明是对观察者背后的光线的反映，阴影是光线漫射或阻碍所造成的黑暗的存在。实和虚是形式的现实对立面，反映在光线的相互作用中：

when mass is highlighted, voids will be in shadow; when voids are in light, the mass will be dark. Under normal circumstances, the two can never exist in the same plane of light, they *must* be in opposition. This begins to suggest that mass and void are not simply physical opposites, but complete fundamental opposites—they are not just different in their tangible properties, but also in their intangible properties.

当实被照亮时，虚在阴影中；当虚被照亮时，实就会是黑暗的。在正常的环境中，两者决不可能在光线的同一平面存在，它们必须是对立关系。这说明实和虚不只是现实的对立，而且是完全的功能对立——它们不只是在实体属性中不同，而且在无形属性中也不同。

Physically, mass is defined as a coherent, typically large body of matter with no definite shape; similarly, void is defined as an unfilled space in a structure.

现实中，实被定义为一种连贯，一般是体量较大的、没有固定形体的物质；类似的，虚被定义为建筑中未被填充的空间。

This describes a mass and voids physical presence in the world, however it does not describe the way the most people perceive these forms in their daily lives.

然而这种对现实世界中实和虚的描述，并不是绝大多数人们在日常生活中感受这些形式的方法。

Through their physical definitions, it is obvious that mass and void are polar opposites—a void is literally a hole, perforation, or fluctuation carved out of a mass. A mass then can be viewed similarly, as a region"carved"out of a void so as to obstruct it, to bring presence to absence. In this way, one can think of void as the anti-mass, and mass conversely as the anti-void. They are complete and total opposites. But how do we know this if we are not in physical contact with the form?

通过它们的现实定义，很明显实和虚是对立的两面——虚在字意上是指在实体上雕刻

出来的空洞、孔,或起伏。那么相似地,实就可以被视为从虚中"雕刻"出来的区域以便可以阻碍虚的延伸,形成虚的存在。以这种方法,一个人可以将虚视为反-实,实反过来可以视为反-虚。它们是完全和整体的对立。但是我们如何知道,如果我们没有与形式进行真实的接触?

Vocabulary

1. endorse *vt.* ①在(支票)背面签字,背书 ②签署,签注,批注(公文等);(在驾驶执照上)注明违章记录:The application was endorsed by the governers' board. 申请书已由董事会批准。③赞同;认可:endorse one's opinions 同意某人的意见 ④保证,担保;承认,赞成

[近义词] countersign,sign,subscribe,indorse,back,affix *v.* 背书,签署

certify,ratify,validate,adopt,advocate,affirm,approve,favour,authorize,support,sustain,warrant,sanction,recommend,confirm *v.* 赞同,认可,担保

[辨析] **endorse 赞同、认同**:指对言论、要求等表示赞同或认可。

Parents heartily endorsed the plan for a school playground. 家长们都热心支持学校修建运动场的计划。

certify 证明:通常以出具证明书来证明某事是真实、正确、合格的。

That certified the account was correct. 那就证明了这账目没错。

ratify 批准:正式的用词,表明正式的赞同或认可。

The club council ratified the by laws. 俱乐部行政会议通过了这些章程。

validate 确认:指由事实或权威支持证明某一事件或观念的真实性。

Time validated our suspicion. 时间证实了我们的怀疑。

2. adjacent *adj.* 邻近的;毗邻的;附近的;交界的;前后紧接着的;对面的:the city and adjacent suburbs 城市和附近的郊区

[近义词] adjoining,neighbouring,bordering,near,conjoining,next door to,right beside *adj.* 邻近的,毗邻的

[辨析] **adjacent 毗邻的**:指位置上相近或毗邻,但不一定连接在一起。

The garden is adjacent to a church. 这花园与教堂毗邻。

adjoining 贴近的、毗连的:指位置上相连。

They are adjoining farms. 它们是相连的农场。

neighbouring 相邻的、接壤的:指在地理位置上互相靠近或接壤。

China and Burma are neighbouring countries. 中国和缅甸是邻国。

3. volume *n.* ①卷,册 ②(大部头的)书,书籍 ③体积,容量(与 of 连用):The volume of this container is 2 cubic meters. 这个容器的容量是两立方米。④(工商业的)额,量(与 of 连用):the volume of sales 销售量 ⑤音量;响度:She turned down the volume on the radio. 她关小了收音机的音量。⑥(*pl.*)大量:volumes of smoke 大量的烟

[近义词] quantity,amount,mass *n.* 数量 sound,loudness *n.* 音量,响度

bulk,magnitude,size,capacity,measure,cubic content *n.* 体积,容积

[辨析] **volume 大量**:指容积,常指滚动或流质的物体。

He drank a great volume of water. 他喝了很多水。

bulk 巨大：指立体的体积，且常形容大象、船等大的东西。

The built a ship of great bulk. 他们建造了一艘巨大的船。

magnitude 巨大、广大：指非常大的东西，如空间、重量、力量等的巨大。

The engineers are measuring the magnitude of current. 工程师们在测算电流量。

size 大小：普通的用词，指物体的体积、面积或数量。

The book is the same size as that. 这本书的大小和那本书一样。

4. apparent *adj*. ①明显的；显而易见的(to)：It was apparent that he knew nothing about how to repair cars. 很明显，他一点儿也不知道怎样修理小汽车。②貌似的；表面的，外观上的：Her apparent indifference mad him even more mervous. 她表面上若无其事反而使他更加紧张。③[物] 表观的；视在的，外显的：apparent indifference 表面上显得冷淡。④外表的；表面上的

[近义词] seeming, likely, probable, according to appearance *adj*. 表面的，看起来像，貌似

visible, distinct *adj*. 可见的

distinct, evident, manifest, plain, obvious, evident, plain, conspicuous, clear, open, marked, self-evident, clear-cut, clear as day, understandable, unmistakable *adj*. 明显的

[辨析] **apparent 明显的、显而易见的**：指容易被看见或认识的东西。

It is apparent to all bystanders. 这是所有旁观者都明了的。

distinct 清晰的：侧重于物体的清晰度。

The earth shadow on the moon was quite distinct. 地球在月球上的阴影是十分清晰的。

evident 明显的、显然的：指从可见的现象中引向肯定的结论，多用于推理方面，如事实、证据、错误等。

This is too evident to require proof. 这事太明显了，根本不需要证明。

manifest 明白的、明显的：指外部现象十分明显以致无须推理即可得出结论，其意思较 evident 强烈。

That could be manifest at a glance. 那是一目了然的。

plain 显而易见的：指简单明白，易于让人了解。

His essays are plain in language. 他的文章浅显易懂。

5. animate *vt*. ①使活起来，赋予……以生命：A smile animated her face. 一丝笑容使她脸上平添了生气。②给……以生气；使有生气；使活泼 ③鼓舞，激励，激发：animate sb. to greater efforts, with a desire to succeed：激励某人更加努力、争取胜利 *adj*. ①有生命的，有生气的：The dog lay so still it scarely seemed animate. 那条狗卧着一动也不动，简直不像活的。②生气蓬勃的，活泼的

[近义词] activate, excite, rouse *v*. 刺激

[辨析] **animate 激励**：指给予活力并使之有生气。

The soldiers were animated by their captain's brave speech. 连长慷慨激昂的演说激励了士兵。

activate 刺激：指使产生活动。

His work was not final, but it attracted and activated others. 他的工作并非是决定性的，但毕竟吸引并刺激了别人。

excite 鼓舞：指激励人的感情，使之感到有力量。

The news excited everybody. 消息传来，人人为之鼓舞。

rouse 激励：指从怠惰状态或缺乏信任的状态中活动过来。

The dog roused a deer from the bushes. 狗惊起了丛林中的一只鹿。

Sentence

Open spaces assume an architectural character when they are enclosed in fall or in part by structural elements. Such a space may be an extension of a building.

当开放空间整个或部分被结构元素围合时，表现出一种建筑特性。这种空间可能是一座建筑物的延伸。

Without the corresponding void, a solid has no meaning. Is it not then quite evident that the side, shape, and quality of the negative space will have a powerful retroactive effect upon the adjacent positive masses?

被限定出的室外空间是空间的"井"。它的空洞就是它的本质。没有所谓的空，实体就没有意义。难道这不是很明显吗？消极空间的边界、形体和性质对于邻近的积极体量会产生反作用。

When the hollowness of a volume is a quality to be desired, this concavity is to be meticulously preserved and emphasized by letting the shell read dearly, by revealing enclosing members and planes, by incurving, by belling out the sides, by the use of recessive colors and forms, by letting the bottom fall away visually, by terracing or sloping down into and up out of the base, by digging the pit, or by depressing a water basin or reflective pool and thus extending the apparent depth of the space to infinity.

当人们期望空间中有空洞时，这种凹陷就通过让外观深入人心，通过揭示围绕它的要素和平面，通过弯曲，通过与各个面的隔离，通过消极色彩和形式的应用，通过让底部无法看到，通过阶梯或倾斜向下进入并最终立于基础之上，通过挖坑，或通过设置一个平静的水面或是反射阳光的水池，无限大地延伸了空间的表面深度。

The defined space, open to the sky, has the obvious advantages of flooding sunlight, shadow patterns, airiness, sky color, and the beauty of moving clouds. It has disadvantages too, but we need only plan to minimize these and to capitalize on every beneficial aspect of the openness.

限定的空间，向天空开敞，拥有显而易见的优点：流动的阳光、强烈的阴影、流畅的通风、天空的色彩，以及流云的美丽。它也会有缺点，但是我们需要设计以使这些缺点最小化，并利用开敞空间的每一个有利方面。

But whether or not it is directly related to its structure in use, it must be in character. Such spaces, be they patios, courts, or dominant and focal in most architectural groupings that the very essence of the adjacent structures is distilled and captured there.

但不管它是否与建筑相连，它都必须与建筑相适应。这种空间，不管是作为天井、庭院，还是众多建筑群的焦点，附近建筑的最为本质的东西都可以在那里提炼并捕捉到。

Translation

第 9 课　限定的开放空间

当开放空间整个或部分被结构元素围合时，表现出一种建筑特性。这种空间可能是一座建筑物的延伸。有时它位于一座单体建筑之内，或是由一组建筑围绕。有时这种空间包围着一座建筑物，或作为建筑的背景，或作为前景，或作为衬景，或作为一个焦点。这种加以限定的空间都是一个整体，其自身是完整的。但是，它更是每一个邻近空间或建筑不可分割的部分。这种相关的空间、建筑及其围绕它们的景观都必须在设计过程中一起考虑。

被限定出的室外空间是空间的"井"。它的空洞就是它的本质。没有所谓的空，实体就没有意义。难道这不是很明显吗？消极空间的边界、形体和性质对于邻近的积极空间会产生反作用。每一个建筑都需要在表达上产生出令人满意的体量和空虚之间的平衡。相同的空虚可能不仅能使两个或更多体量产生平衡并相互取得联系，也可以它们作为一个整体与一些更远的建筑或空间取得联系。

不论它的功能是什么。当人们期望空间中有空洞时，这种下沉就通过让外观深入人心，通过揭示围绕它的要素和平面，通过弯曲，通过与各个面的隔离，通过消极色彩和形式的应用，通过让底部无法看到，通过阶梯或倾斜向下进入并最终立于基础之上，通过挖坑，或通过设置一个平静的水面或是反射阳光的水池，无限大地延伸了空间的表面深度。一个具有明确形体的空间必须是被植物或其他直立物体所围合的。这并不就暗示说只能由体量来孕育空，而是说应该以所有方式产生空。使人满意的元素布置，甚或是一丛或一小片高树冠的树木都可以很好地增加这种壳体似的空洞感。

限定的空间，向天空开敞，拥有显而易见的优点：流动的阳光、强烈的阴影、流畅的通风、天空的色彩，以及流云的美丽。它也会有缺点，但是我们只需要通过设计使这些缺点最小化，并利用开敞空间的每一个有利方面。让我们不要浪费每一抹珍贵的蔚蓝，每一束灿烂的阳光，每一阵吹来的夏日微风，它们可以使我们设计的室外空间鲜活起来、明亮起来、生气勃勃。

如果由一座建筑物加以限定的空间在一边是开放的，它就变成了建筑和景观之间的集中过渡点。如果朝向某一视景，常常发展为各种各样观察视点中最佳视点和最佳视框。限定的开放空间通常有许多用途。它可能成为建筑功能的延续，比如汽车旅馆入口大厅的延伸，或是餐馆餐室或厨房的延伸。它可能具有自己独有的功能，比如作为两侧是兵营的军官宿舍的娱乐休息空间。但不管是否为建筑所用，它都必须与建筑相适应。这种空间，不管是作为天井、庭院，还是众多建筑群的焦点，附近建筑的最为本质的东西都可以在那里提炼并捕捉到。

Lesson 10 The Process of Programming

Webster's Dictionary defines programming as a process leading to the statement of an architectural problem and requirements to be met in offering a solution. Programming is basically a problem-seeking process. It defines the problem that the design must solve. An architect can become involved with architectural programming in many ways. For instance, an architect must recognize and analyze major influences that may give form to, hence directly determine, the physical design. It is the architect's responsibility to convert raw data and the client's wishes into negotiable information. He or she must also be aware of missing information, must evaluate the implications of various data, and must distinguish between pertinent facts and irrelevant details.

A major aspect of programming is to establish realistic requirement and explore alternatives in order to find the uniqueness of a building project. Once the simplest, clearest, and most definitive form of the building's problems is stated, design can begin.

To summarize, architectural programming refers to the architect's ability to do the following:

1. Turn raw date into negotiable, useful information.
2. Evaluate date for design and analyze their influences on major design elements.
3. Compare alternatives and establish requirements.
4. Abstract all program"uniqueness".

Programming establishes the uniqueness of a design problem by identifying the task and explaining its task. Since this work is partly based on the evaluation of quantitative information, computers can be very helpful in the process. Many factors, however, cannot be expressed readily in numbers, and in this field.

Before the architect concentrates on particular assignment, he or she will research similar building types and organization. To obtain an idea of the specific program will be the effort of a team, which usually includes the architect, the owner future occupants and users of the building proposed and specialists and consultants. The main responsibility for communication among team members will lie with the architect. In using graphic tools such as diagrams and renderings task, however the architect must be aware that the average individual's capacity for understanding and visualizing a graphic presentation is not as developed as that of the professional.

Generally speaking the safest and most efficient approach to programming is to work from the broad concept and big blocks of information toward more detailed and specific points. Thus it is best to begin by establishing a schematic or conceptual program, which is graphically expressed in a schematic design. If this schematic program satisfies the major criteria, the architect can proceed with a more detailed preliminary program, which leads to

the design development phase. In this way the architect avoids the danger of losing the overview of a problem by becoming overly concerned with one detail. Both stages of programming follow the same process, which can be structured in five steps.

1. Definition of the Client's objectives. The architect evaluates the client's goals in terms of the building program and the space, time, and money available. This leads to a series of discussions with the client that permits the clear establishment of his or her goals.

2. Collection, Organization, and Analysis of Facts. All information gathered is classified in terms of its relevance to the specific problem and the basic functions of the project. The data should cover the building's future use and obsolescence, and the relationship of the project to the surrounding environment. A major organizing factor in this process is the characteristics of the site-its physical as well as legal and community-related aspects. Money of course, is the prime organizer in every business enterprise, and budgetary considerations are omnipresent in every step of programming.

3. Evaluation of Alternative Concepts. Such concepts include centralization versus decentralization, compartmentation versus open-space plans, and flexibility versus explicit functionality. These alternative must be tested in their performance against the needs and preferences of the users.

4. Determination of Space Requirements. When the minimum space required and the optimum amount of space for each function of the project have been determined, the efficiency of the building can be tested with ratios such as the net usable space divided by the gross building space. Whether the building programs in line with the preliminary budget is also ascertained in this phase; the amount of space allowances above the minimum largely depends on these financial evaluation.

5. Statement of the Problem. In the conceptual program this statement should be quite broad. It should not specify the individual forms of buildings but rather their functions and performances. Detailed information concerning the site, cost, time, and specific design solutions should be kept to a minimum in favor of a clear overall picture of all factors involved.

Throughout this process the architect should incorporate the feedback from the owner and user in every step, to ensure that the program clearly reflects their intentions. If this is done, the program itself can be used as a basis for arbitration if disagreements occur later between parties. A good program will reduce the amount of future changes, thus reducing predevelopment and construction cost.

The term "program guide" refers to a format outline for the preparation of master plan program on big projects. It is intended to help owner/users express their concepts, and it classifies information into three general categories:

Goals and objectives;

Functional needs;

Basic space requirements.

According to the program instrument, the project must be defined starting from the general and moving toward more detailed considerations. Thus the first step is the development of the master plan for the "total complex," including data regarding access, circulation parking, servicing of the project, fire protection, and similar matters.

Next to be developed is the "total building" program. It focuses on a single building in the project and defines all its functions, their interrelationship, their space requirements, and the environment qualities needed.

The next smaller program unit is the "activity center"; this includes several rooms and related spaces that are all supposed to serve the same general activity. In a hospital, for instance, an outpatient clinic would be such an activity center, and the program would include a list of its staff and their activities.

The smallest unit of the program is called "individual space". In this part, the data are detailed enough to include the exact amount of square feet of floor space, as well as furniture, fixtures, and so on.

When the completed program instrument is revised and approved by both architect and owner, it can serve the designer as a guideline throughout the job, and it is indispensable in arriving at realistic cost estimates.

Notes

1. Webster's Dictionary 韦氏词典

Webster's Dictionary is the name given to a common type of English language dictionary in the United States. The name is derived from American lexicographer Noah Webster and has become a genericized trademark for this type of dictionary.

Fig. 10-1 An 1888 advertisement for *Webster's Unabridged Dictionary*

韦氏词典是一种美国普遍使用的英语词典。词典名称来源于美国词典编纂者诺厄·韦伯斯特，并且这一名称成为了这类型词典的通用名称。

Although Merriam-Webster dictionaries are descended from the original work of Noah Webster, many other dictionaries bear his name, such as those published by Random House and by John Wiley & Sons.

虽然新版韦氏词典是从最初的诺厄·韦伯斯特的版本沿传下来的，但是许多其他词典也使用了他的名称，比如由兰登书屋和约翰威立股份有限公司出版的词典。

Noah Webster, the author of immensely popular readers and spelling books for schools, published his first dictionary, A Compendious Dictionary of the English Language, in 1806. In it, he introduced features that would be a hallmark of future editions such as American spellings (center rather than centre, honor rather than honour, program rather than programme, etc.) and including technical terms from the arts and sciences rather than confining his dictionary to literary words. He spent the next two decades working to expand his dictionary.

诺厄·韦伯斯特，是学校非常流行的阅读和拼写书籍的作者，1806 年出版了他的首个词典——《英语简明字典》。在这本词典中，他引入了将成为未来的韦氏词典标志的内容，比如美式拼写（是 *center* 而不是 *centre*，是 *honor* 而不是 *honour*，是 *program* 而不是 *programme*，等等），并包含了来自艺术和科学的技术术语，并没有把他的词典限定在文学词汇之内。在这以后的 20 年间他一直为扩展他的词典而工作。

Fig. 10-2　Noah Webster

2. Building Type　建筑类型

A building's function strongly influences its design and construction. For each general Building Type there is a discussion of the attributes and requirements of the type as well as links to information on more specific uses.

一座建筑的功能对其设计和建造具有强大的影响力。对于各种普遍的建筑类型，都需要对类型的属性和需求，以及与特定用途信息的联系进行讨论。

- Archives；
- 档案馆；
- Community Services；
- 社会服务；
- Educational Facilities；
- 教育设施；
- Health Care Facilities；
- 保健设施；
- Libraries；
- 图书馆；
- Office Building；
- 办公建筑；
- Parking Facilities；
- 停车设施；
- Research Facilities.
- 研究设施。

Archives and Record Storage Building　档案馆和记录储存建筑

Archives and Record Storage Buildings are facilities that provide a proper environment for the purpose of storing records and materials that require permanent protection for historic and lifetime storage, upkeep, and preservation. Archives and Record Storage Buildings must be high-performance buildings whose systems must be designed to operate permanently at a very high level with zero tolerance for failure. The often irreplaceable nature of the materials to be permanently stored and preserved in this type of building requires a life-cycle analysis and approach to its design and construction, with extensive redundancy in its

building systems.

　　档案馆和记录储存建筑是为了存储记录和材料而提供的适当环境，这些建筑需要对历史悠久的和长期的存储、维持和保存提供永久性保护。档案馆和记录存储建筑必须是高性能建筑，它的系统必须被设计成永远保持高水平运行，不允许任何失误。材料常常具有不可恢复的本质，决定了这类型建筑的永久性存储和保护需要以生命循环的分析和方法来进行设计和建造，在其建筑系统中有大量的附加内容。

　　This building type must be designed to accommodate the loads of the materials to be stored; the sensitive environmental needs of different materials to be permanently stored and preserved; the functional efficiency, safety, security, and comfort of the visiting public and operating personnel; and the protection of the archived materials from fire, water, and man-made threat.

　　这种建筑类型必须被设计成满足被存储的材料的负载；需要永久存储和保护的不同材料的敏感环境需求；参观公众和工作人员的功能有效性、预防性、安全性和舒适性；对已存档材料的防火、防水和防止人造威胁。

　　To accomplish this complex mission, these buildings benefit from an inclusive, holistic, integrated or whole building design approach that optimizes and balances the various design objectives to achieve the desired high-performance building. This process involves all building stakeholders and design professionals from the beginning of the project.

　　为完成这种复杂的使命，这些建筑得益于一种范围广阔的、整体的、全面的或完整的建筑设计方法，尽可能完善和平衡各种各样的设计目标，来达到期望的高性能建筑。这个过程的参与者从项目一开始就包括所有的建筑保管者和设计专家。

Community Services　社区服务

　　The Community Services building type is distinguished by the wide range of different facility types that fall under it. While all Community Services facilities share a common purpose in the service of public needs, each facility is very specialized and the functional requirements are extremely varied. For example, facilities such as museums, visitor centers, and youth centers are recreational in nature, accommodate the general public, and are open and welcoming in design character. However, facilities such as police and fire stations, while sometimes being partially open to the public, comprise many spaces that are intended to be occupied only by highly trained professionals.

　　社区服务建筑由于不同设施类型的广泛范围而显得与众不同。而所有的社区服务设施共享的同一目的就是服务于公众需求，每个设施都非常专业，功能需求极端不同。例如，博物馆、游客中心和青年中心，这些设施本质上是娱乐性的，满足普通大众的需求，在设计特点上是开放和欢迎人的到来。然而，警察局和消防站这些设施，有时是部分向公众开放的，包括许多倾向于只由经过严格训练的专业人员使用的空间。

　　The range of Community Services facility types is vast and varied：

　　社区服务设施类型的范围是广泛和多样的：

- Auditoriums;
- 礼堂；

- Banks/Credit Unions；
- 银行/信贷联盟；
- Central Laundry/Dry-Cleaning Facilities；
- 中心洗衣房/干洗设施；
- Community Centers；
- 社区中心；
- Fire Stations；
- 消防站；
- Fitness Center；
- 健美中心；
- Museums；
- 博物馆；
- Police Stations；
- 警察局；
- Post Offices；
- 邮局；
- Visitor Centers；
- 游客中心；
- Youth Centers.
- 青年中心。

Educational Facilities　教育设施

Educational facilities are becoming increasingly specialized. For example, we have come to understand that classrooms intended for pre-schoolers are fundamentally different from those that best serve high school seniors or the training of mid-career professionals. Today, even the traditional idea of "classroom" as an instructor-focused learning space is changing. The growth of computer-based instruction, video projection, and other telecommunication requirements is causing us to rethink traditional educational patterns and spatial relationships.

教育设施变得越来越专业化。例如，我们已经开始理解，为了学龄前儿童服务的课堂根本上不同于那些为高中高年级或者职业人员培训提供服务的课堂。今天，甚至"课堂"作为以教师为中心的学习空间这一传统理念也正在改变。计算机教育、视频投影以及其他远程通信需求的增长正在使我们重新思考传统的教育类型和空间关系。

From an environmental perspective, concerns for the health and well-being of students—particularly young students—are increasing interest in the improved performance and fabric of school

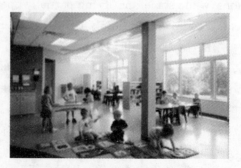

Fig. 10-3　Child development center in Des Moines, IA.　Architects：Wells, Kastner, Schipper

structures. Strategies including daylighting, the specification of sustainable and non-toxic building materials, and the use of renewable energy sources are gaining attention in school design. At the same time, resources for the construction, maintenance, and upkeep of educational facilities remain in short supply.

从环境角度来看，对学生的健康和安全的关注——特别是年幼的学生——使人们对学校建筑的性能和结构改良越来越感兴趣。所运用策略包括日光照明，可持续和无毒建筑材料的详细说明，可更新能源的使用，这些都在学校设计中得到了注意。同时，教育设施的建造、维护和保养问题仍然得不到足够的重视。

Education is a lifelong process. This is reflected in the range of educational facility types:

教育是持续一生的过程。这一点反映在教育设施类型的范围上：

- Child Development Centers, including preschool and day-care;
- 幼儿发展中心，包括学前和日间托儿；
- Elementary;
- 小学；
- Secondary;
- 中学；
- University, including college and post-graduate education;
- 大学，包括学院和研究生教育；
- Training, including computer centers and teleconference facilities.
- 培训，包括计算机中心和远程会议设施。

Health Care Facilities　保健设施

Health care facilities encompass a wide range of types, from small and relatively simple medical clinics to large, complex, and costly, teaching and research hospitals. Large hospitals centers may include all the various subsidiary health care types that are often independent facilities. The facility conveys a message to patients, visitors, volunteers, vendors, and staff. The facility also communicates a torrent of clues about the organization and the medical care being provided there. The clues start at the approach to the facility, the drop-off area, the parking lots, and the street signs. Ideally, that message is one that conveys welcoming, caring, comfort, and compassion, commitment to patient well-being and safety, where stress is relieved, refuge is provided, respect is reciprocated, competence is symbolized, wayfinding is facilitated, and families are accommodated. The facility also influences employee service attitudes and behaviors. Finishes, signage, and artwork must be carefully selected, well coordinated, and integrated. Security can be balanced with some features apparent to patients/visitors, while conveying a message of safety. Thoughtful design can help ensure the proper first impression is created and sustained.

保健设施有许多类型，从小型和相对简单的医学门诊到大型、复杂和昂贵的教学和研究医院。大型医学中心可能包括各种各样的附属保健类型，这些保健设施常常是相互独立的。设施向病人、参观者、志愿者和工作人员传达信息。设施也传达在那里提供治疗的一

系列线索。从接近设施就开始传达线索——下沉区域、停车场和街道标志。理想中，信息是在传达：欢迎、充满爱心、舒适和同情，向病人的健康和安全做出承诺，压力被减轻了，提供避难处，尊重是相互的，体现能力，道路的寻找是方便的，接纳家庭。设施也影响工作人员的服务态度和行为。装修、标牌和艺术品必须经过仔细地选择，很好地对位和整合。安全感可以和一些表现给病人/访客的特征平衡，同时传达安全的信息。经过深思熟虑的设计可以确保产生和维持适当的第一印象。

The design of health care facilities is governed by many regulations and technical requirements. It is also affected by many less defined needs and pressures.

保健设施的设计受许多法规和技术需求的规定，也受到许多不太明确的需求和压力的影响。

Flexibility must be a basic feature of any new health care facility to keep it from rapid obsolescence in the face of changing needs and

Fig. 10-4　VAMC Dallas, TX

technologies. Health care facility needs are evolving rapidly, and the direction of that evolution is difficult to forecast with any certainty. New equipment technologies, new treatment methodologies, changes in diseases, and changes in the patient population base all impact the facilities that house them. Inpatient care is steadily being reduced while outpatient services are growing. There is increasing emphasis on special-care units and smaller satellite facilities rather than large, centralized facilities.

灵活性必须是任何新建保健设施的基本特征，以避免面对不断改变的需求和技术快速发展而出现空间的废弃。保健设施需要快速发展，发展的方向是很难确定的。新的设备技术、新的治疗方法、疾病的改变和病人人数的改变都影响到容纳它们的设施。住院病人的治疗在稳固减少，而门诊服务正在增加。人们正在越来越重视特定治疗单元和更小的附属设施，而不是大型的、集中的设施。

Sustainability must be a consideration for the design of all health care facilities. Many sustainable design features can be incorporated into health care facility design, including daylighting, energy and water conservation, nontoxic materials and finishes, and sustainable operations and maintenance.

所有保健设施必须考虑可持续性。许多可持续性设计的特征可以整合到保健设施设计中，包括日光照明、能源和水资源保护，无毒材料和装修，可持续性运行和维护。

Libraries　图书馆

The primary goal of effective library design and space planning is that the facility must respond to the needs of its service population. The library building must include flexibility in the design of its interior and exterior spaces and elements in order for the library to effectively address the immediate and future needs of its design population.

高效图书馆设计和空间规划的主要目标是，设施必须反映它所服务的人群的需要。图

书馆建筑必须具有室外空间和元素的灵活性，目的是可以高效适应设计服务人群当时和未来的需求。

Since the late 1970s, advanced technologies and alternative methods of how libraries deliver services, i. e. , distance learning, electronic media, continue to develop rapidly. Before the late 1970s, housing print media was the main function of a library. Today, Internet access, electronic media, computer technology, and other forms of modern-day advancements have had a profound effect on the function and design of libraries. As a result, library design must take into account all of the issues that may affect its use in the future.

Fig. 10-5 Denver Public Library—Denver, CO
(Michael Graves Architects)

20 世纪 70 年代以来，先进的技术和图书馆传递服务的各种方法，即远程学习、电子媒介，继续快速发展。在 20 世纪 70 年代后期之前，容纳印刷媒体是图书馆的主要功能。今天，因特网的接入、电子媒介、计算机技术以及其他现代先进方式对图书馆的功能和设计产生了深刻的影响。结果，图书馆设计必须考虑所有可能影响其未来使用的问题。

Several types of libraries:

一些图书馆类型：

- Public Libraries;
- 公共图书馆;
- Academic Libraries (including college and university libraries);
- 大学图书馆(包括学院和大学图书馆);
- School Libraries (including public and private schools);
- 学校图书馆(包括公立和私立学校);
- Special Libraries.
- 特殊图书馆。

Office Building 办公建筑

Fig. 10-6 Federal Building—Oakland, CA

The office building is the most tangible reflection of a profound change in employment patterns that has occurred over the last one hundred years. In present-day America, northern Europe, and Japan, at least 50 percent of the working population is employed in office settings as compared to 5 percent of the population at the beginning of the 20th century.

办公建筑是前一百年中工作模式深刻变化的最切实反映。在今天的美国、北欧和日本，至少 50％的工作人群在办公环境中工作，而这一数字在

20 世纪初期只有 5%。

Through integrated design, a new generation of high-performance office buildings is beginning to emerge that offers owners and users increased worker satisfaction and productivity, improved health, greater flexibility, and enhanced energy and environmental performance. Typically, these projects apply life-cycle analysis to optimize initial investments in architectural design, systems selection, and building construction.

通过全面的设计，新的高性能办公建筑正在出现，帮助业主和使用者提高工作满意度和生产力，改善健康状况，提高灵活性，以及增强节能和环境性能。这些项目大多应用全过程分析来最优化建筑设计、系统选择和建筑建造的初期投入。

An office building must have flexible and technologically-advanced working environments that are safe, healthy, comfortable, durable, aesthetically-pleasing, and accessible. It must be able to accommodate the specific space and equipment needs of the tenant. Special attention should be made to the selection of interior finishes and art installations, particularly in entry spaces, conference rooms and other areas with public access.

办公建筑必须拥有灵活、技术先进的工作环境，这个环境是安全、健康、舒适、持久、美观和易于接近的。它必须能够满足承租人的特定空间和设备需求。对室内装修和艺术装饰的选择必须给予特殊的注意，特别是在入口空间、会议室和其他公众可以进入的区域。

Parking Facilities　停车设施

Parking as part of an overall transportation system is one of the crucial issues of our times. As the number of automobiles increases exponentially, the need to house them in close proximity creates a challenging design problem. The parking garage or lot must foremost deal with the Functional/Operational-as in providing for safe and efficient passage of the automobile. This is a very complex challenge as automotive, engineering and traffic issues relative to site locations must be integrated to create the appropriate solution. Therefore designing the parking garage requires an integrated design approach of many professionals. Parking has often been reduced to the construction of the most minimal stand-alone structure or parking lot without human, aesthetic or integrative considerations. This has given parking a poor public perception and has frequently disrupted existing urban fabric. However, many architects, engineers, and planners have envisioned and constructed far more complex, aesthetic, and integrative structures. This should be the goal of good parking design.

停车作为整体交通系统的一部分，是我们这个时代的关键问题。由于汽车数量每年递增，在邻近区域容纳它们的需求产生了极具挑战性的设计问题。车库或停车场必须最先处理功能/运行问题——就如为汽车提供安全和高效的通路一样。这是非常复杂的挑战，因为必须全面整合与基地位置有关的停车、工程技术和交通问题，以创造适当的解决方案。因此，车库的设计需要许多专家共同合作。停车区域常常被减至最低限度的单体结构，或者没有考虑人群、美观和综合使用的停车场。这常常使公众对停车区域感觉很差，停车场还常常破坏城市肌理。然而，许多建筑师、工程师和规划师希望建造更加复杂、美观和全面的建筑。这应该是优秀停车设施设计的目标。

Fig. 10-7 Hermosa Beach Parking Structure
(Courtesy of Gordon H. Chong
& Partners Architecture)

Fig. 10-8 Bryan Street Garage

Research Facilities 研究设施

As symbols of the Nation's technological progress, research facilities are essential to the discoveries and breakthroughs of yesterday, today, and tomorrow. Thousands of public and private sector scientists and engineers from industries such as pharmaceutical, biomedical, manufacturing, and biotechnology use all types of laboratories and instruments to advance the frontiers of knowledge. At times, an entire facility may be built to support the specialized instruments required for research, including accelerators, light sources, research reactors, neutron beam facilities, plasma, fusion science facilities, genome centers, advanced computational centers, wind tunnels, model testing facilities, hot cells, and launch facilities.

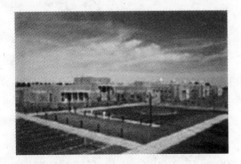

Fig. 10-9 William R. Wiley Environmental
Molecular Sciences Laboratory (EMSL),
at DOE's Pacific Northwest National
Laboratory has unique and state-of-the-art
research resources. Richland, WA.

Fig. 10-10 The Mark O. Hatfield Clinical
Research Center on the National Institutes
of Health campus in Bethesda, Maryland,
provides a crucial link in rapidly moving
research findings from the laboratory to
mainstream medical practice.

作为国家技术发展的象征，研究设施是昨天、今天和明天的发现和突破所必需的。数以千计的公共和私人机构中的工业科学家和工程师，比如医药、生物医学、制造业和生物工程，使用各种类型的实验室和设备来发展前沿知识。有时，一个完整的设施可能包括支持研究所需的专门设备，包括加速器、光源、研究反应装置、中子光束设施、等离子体、熔解科学设施、基因中心、先进的计算机中心、风洞、模型测试设施、热室以及发射设施。

There are many kinds of research facilities. They are divided into two major groups: Animal Research Facilities and Research Laboratories. Research Laboratories are further categorized by type (e. g. , wet labs and dry labs), and by sectors (e. g. , academic, corporate, and government labs).

有许多类型的研究设施。它们主要分为两类：研究设施和研究实验室。研究实验室更进一步按类型(比如，潮湿实验室和干燥实验室)和按分属(比如学校、公司和政府实验室)来分类。

Research facilities present a unique challenge to designers with their inherent complexity of systems, health and safety requirements, long-term flexibility and adaptability needs, energy use intensity, and environmental impacts. There are many different types of research facilities. :

研究设施以其固有的系统复杂性、健康和安全需求，长期灵活性和适应性需求，能源使用密度和环境影响，呈现出对设计师的特殊挑战。

A new model of laboratory design is emerging, one that creates lab environments that are responsive to present needs and capable of accommodating future demands. Several key needs are driving the development of a new model.

新的实验室设计模式正在出现，其中之一是创造反应现有需求和能够满足未来需求的实验室环境。许多关键需求正在推动新模式的发展。

3. Rendering 渲染

Rendering may refer to:

Rendering 是指：

- In the visual arts:
- 在视觉艺术中：
 - Artistic rendering, the process by which a work of art is created.
 - 艺术渲染，是艺术作品创造的过程。
- In computer science:
- 在计算机科学中：
 - Rendering (computer graphics), the process of producing an image from a higher-level description of its components.
 - 渲染(计算机图形)，是创造一幅高水平描述其构成的图像的过程。

Rendering (computer graphics) 渲染(计算机图形)

Rendering is the process of generating an image from a model, by means of computer programs. The model is a description of three-dimensional objects in a strictly defined language or data structure. It would contain geometry, viewpoint, texture, lighting, and shad-

ing information. The image is a digital image or raster graphics image. 'Rendering' is also used to describe the process of calculating effects in a video editing file to produce final video output.

Fig. 10-11　An image created by using POV-Ray 3. 6.

渲染是通过计算机程序从模型中产生图像的过程。模型是对严格明确语言或数据结构的三维物体的描述。它包含几何学、视点、质感、照明和阴影信息。图像可能是数字图像或光栅图形图像。"渲染"也用来描述在视频编辑文件中计算效果的过程，来创造最终的视频输出。

Rendering has uses in architecture, video games, simulators, movie or TV special effects, and design visualization, each employing a different balance of features and techniques. As a product, a wide variety of renderers are available.

渲染在建筑学、视频游戏、模拟系统、电影或电视特效中广泛使用，每个领域都运用特性和技术之间的不同平衡。作为一种产品，有各种各样的渲染程序可供使用。

Artistic rendering　艺术渲染

Rendering in visual art and technical drawing means the process of creating, shading and texturing of an image, especially a photorealistic one. It can also be used to describe the quality of execution of that process.

Fig. 10-12　An example of a rendered image

视觉艺术和技术绘图中的渲染意味着一幅图像的创造、调整色光和赋予质感的过程，特别是照片般真实效果的图像。它也用于描述过程实施的规格。

The emphasis of the term is on the correct reproduction of light-and-shadow and the surface properties of the depicted objects, not on the emotional impact, composition, or other more generic qualities.

"渲染"这个词强调的是描述物体的光影效果和表面特性的正确重现，不受情感、构图或其他更为普遍的特性影响。

4. Clinic　门诊

A clinic (or an outpatient clinic) is a small private or public health facility that is devoted to the care of outpatients, often in a community, in contrast to larger hospitals, which also treat inpatients. Some grow to be institutions as large as major hospitals, whilst retaining the name clinic. These are often associated with a hospital or medical school.

门诊是一种小型的私人或公共健康设施，用于接待门诊病人，常常位于社区中。与更大的医院相比，医院的不同之处在于能够接待住院病人。一些门诊发展成为和医院一样的大机构，但是同时保留了门诊的名称。这些门诊常常与一所医院或医学学校有联系。

Function 功能

The function of clinics will differ from country to country. For instance, a local general practice run by a single general practitioner will provide primary health care, and will usually be run as a for-profit business by the owner whereas a government specialist clinic may provide subsidized specialized health care.

门诊的功能随着国家的不同而不同。例如，由一位普通医师坐诊的当地普通门诊将提供私人的保健服务，常常作为追求利润的商业由所有者运行，而政府的专家门诊可能提供政府资助的专业保健。

Some clinics function as a place for people with injuries or illnesses to come and be seen by triage nurse or other health worker. In these clinics, the injury or illness may not be serious enough to warrant a visit to an emergency room, but the person can be moved to one if required. Treatment at these clinics is often less expensive than it would be at a casualty department.

一些为受伤或得病的人们提供医治的门诊，通过实习护士或其他健康工作者建立和照看。在这些门诊中，受伤或疾病可能没有严重到必须送达急救室的程度，但是如果需要的话可以转到那里。在这些门诊中的处理常常要比在严重伤亡部门要便宜一些。

Types 类型

- In the United States, a free clinic provides free or low cost health care for those without insurance.
- 在美国，免费门诊为那些没有保险的人提供免费或所费低廉的保健。
- A Retail Based Clinic is housed in supermarkets and similar retail outlets providing walk in health care, which may be staffed by nurse practitioners.
- 零售门诊常常位于超市以及类似的零售场所中，提供保健的零售工作，可能配备护士。
- A **general out-patient clinic** is a clinic offering a community general diagnoses or treatments without an overnight stay.
- 普通门诊是为社区提供普通的诊断或处理，没有过夜留观。
- A polyclinic is a place where a wide range of health care services (including diagnostics) can be obtained without need of an overnight stay
- 综合门诊是从事广泛的保健服务的场所(包括诊断)，可以接待不需要整夜留观的病人。
- A **specialist clinic** is a clinic with in-depth diagnosis or treatment on diseases of specific parts of the body. This type of clinic contrasts with **general out-patient clinics**, which deal with general diseases.
- 专家门诊是深层次诊断或处理身体特定部分疾病的门诊。这类门诊和处理一般疾病的普通门诊不同。

5. Individual Space 个体空间

Establishing Individual Space Requirements 建立个体空间需求

The establishment of individual space requirements will require a detailed analysis of

the operating, habitability and environmental support needs of specific functional activities. The functional area requirements of each space will generally be determined from an understanding of the staff, furniture, equipment and circulation space required by the activity. Appropriate allocations of space should be developed for repetitive functional areas which vary in number with the intensity of operational activities. Such functional areas as private offices, open clerical space, interview and conference rooms are repetitive in nature and require similar enclosures with varying qualities. Actual requirements will determine specific enclosure characteristics; however, for repetitive type activities, acoustic and/or visual privacy requirements are noted with other special requirements where these requirements are essential to achieving a generally accepted standard of effectiveness.

个体空间需求的建立将需要详细分析特定功能活动的运行、习惯能力和环境支持需求。每个空间的功能一般通过对人员、家具、设备和活动所需要的流通空间的理解来决定。适当的空间分配应该以随运行活动强度变化而改变的重复性功能区域来决定。这些功能区域，如私人办公、开放办公空间，面谈和会议室在本质上是重复、需要类似的不同特性的围合。真实需求将决定特定围合的特性。然而，对于重复性类型的活动来说，需要一起考虑声学和/或视觉私密性需求以及其他特定需求，这些需求必须获得普遍接受的有效性标准。

Individual Space Standards 个体空间标准

1. The functional activity standards which are illustrated should be reviewed in conjunction with the descriptions of individual space requirements. The illustrated standards are based on function-specific"optimum"space-planning criteria and are used for descriptive purposes only. Specific standards should be identified by local using service. Unique standards should be based on and integrated with space organization principles that reflect mission-peculiar and location-specific requirements of a project.

1. 描述的功能活动标准应该结合个体空间需求来评价。所描述的标准是以功能—特定"最佳"空间设计标准为基础，并且只用于描述性目的。特定标准应该通过当地使用部门来确定。独特的标准应该与反映项目特殊使命和特定位置需求的空间组织原则相结合。

2. The principal application of space standards is in determining detailed functional requirements. The application of the"optimum"space standards to existing functional areas also may prove to be a useful tool in evaluating the efficiency and effectiveness of existing space utilization. This use of space standards, particularly in evaluating the effects of existing conditions on mission-performance, may, consequently, underscore both the initial determination of project need and the identification of operational and functional deficits in many existing facilities.

2. 空间标准主要用来判定详细的功能需求。现有功能区域的"最佳"空间标准也可以是评价现有空间使用的有效性和效率的工具。空间标准的使用，特别在现有环境使命—性能效果的评价中，可能会强调项目需求的最初判定，以及许多现有设施运行和功能的不足。

Vocabulary

1. offer　*vt.* ①提出，提议：offer a few ideas 提出几点意见　②出价，开价：pounds for the house 出价一千镑买这所房子　③贡献：offer sth. up (to God) 将某物奉献给(上帝)　④企图　⑤表示愿意：offer to help sb. 表示愿意帮助某人　⑥演出：offer a new comedy 上演一出新的喜剧　*vi.* ①出现，发生：Take the first opportunity that offers. 机会一出现，就要抓住它。②供奉；献祭　③提议；求婚　*n.* ①提出，提议：make an offer of help [support、food] 提出给以帮助 [支持、食品]　②出价，开价：an offer of ＄250,000 for the house 出价 25 万美元买这所房子　③贡献　④企图：an offer to catch the ball 想要把球接住　⑤求婚

　　[近义词] suggestion,proposal,tender,overture,attempt　*n.* 提议，提供

　　propose,advance,move,suggest,bid,put forward,put forth　*v.* 提出，提议

　　proffer,tender,present,provide,voluteer,afford,extend,give　*v.* 提供

　　[辨析] **offer 提供**：普通的用词，指给某物予某人，至于对方是否接受，则听其自便。She offered him coffee. 她请他喝咖啡。

　　proffer 提供：自愿供给，并有亲切、谦恭或极其诚恳的意思。

　　He refuaed the proffered hospitality. 他拒绝了给予他的宽待。

　　tender 提供：正式的用词，指正式提供某物，主要为服务，不是实物。

　　He tendered his apologies. 他正式提出道歉。

2. responsibility　*n.* ①责任；职责；任务；负担：the person with overall responsibility in the locality 一个地区的总负责人　②履行能力，(指财务等方面的)可靠性；可信赖性；偿付能力

　　[近义词] accountability,dependability,reliability,trustworthiness,culpability,answerability,conscientiousness,maturity　*n.* 责任，责任心

　　obligation,duty,charge,function,trust,task,burden,order,onus　*n.* 职责，任务

　　[辨析] **responsibility 责任**：指一个人所负责的事物，他有责任去完成它。

　　You should take up your responsibility. 你应该担负起你的责任。

　　obligation 义务：指自己对社会应尽的义务。

　　A good citizen has certain obligations to society. 好公民要对社会尽一些义务。

　　duty 责任：指对于他人应尽的职责，或根据道德或法律应尽的义务。

　　Everyone has a duty to his country. 每个人对自己的国家都有责任。

3. convert　*vi.* ①转变；变换(常与 into 连用)　②兑换：At what rate does the dollar convert into pounds? 美元以什么汇率兑换成英镑？③改变信仰、党派或意见等：John has converted to Buddhism. 约翰改信佛教。*vt.* ①把……改变为，变换成，兑换：to convert an old house into a new one 把旧房改成新房　②使转而信仰，使改属(某政党)，使转变：Many Africans were converted to Christianity. 许多非洲人都改信基督教。

　　[近义词] change one's religion,change one's belief,cause a change of opinion　*v.* 使改变信仰，转变信仰

　　change,alter,modify,vary,transform　*v.* 转变，改变

［辨析］**convert** 改变、转变：指从一种状态或情况改变为另一种状态或情况。

They converted boxes into furniture. 他们把箱子改制成家具。

change 改变：普通的用词，指一个人或一件东西在改变前后完全不同。

She used to be shy, but has changed a lot since she went to college. 她以前很害羞，但自从进大学后，她已经改变了很多。

alter 改变：指部分地改变，但并非是整个人或物的改变。

We have altered the house into a barn. 我们已经把这屋改成谷仓了。

modify 变更、修改：指部分地改变，但不能用于物质方面，通常指变更计划、方法、制度、条款等。

He won't modify his demands. 他不会改变他的要求。

vary 改变：指不规则地或断断续续地改变。

The prices of vegetables vary with the season. 蔬菜的价格随着季节的变化而变化。

4. Compare　*vt.* ①比较；对照：compare one thing with another 将一物与另一物比较　②比喻；显出相同之处；比作：Man's life is often compared to a candle. 人生常被喻为蜡烛。③与……比较；比得上（常与 with 连用）：The police compared the forged signature with the original. 警察将伪造的签名与原来的作比较。*vi.* ①相比，匹敌（with）：My English cannot compare with his. 我的英文水平不如他。②不相上下，竞争：It is hard to compare. 很难比较。*n.* 比较：a musician beyond compare 无与伦比的音乐家

［近义词］liken, equate, correlate, relate, describe as similar, draw a parallel between, identify with　*v.*（＋to）比作，比喻

match, equal, approach, be comparable, be as good as, bear comparison, be up to, hold a candle to, be in a class with　*v.* 比得上，相比

contrast, parallel, resemble, approximate, approach, note the differences of, note the similarities of, balance against　*v.*（＋with）比较

［辨析］**compare** 比较：指研究人与人、事物与事物之间相同或相异的程度。

The physician compared my height with that of John. 医生将我和约翰的身高作了个比较。

contrast 对比：指仅对相异之处作比较。

His actions contrasted badly with his promises. 他的言行相差太远。

parallel 与……相似：指提出相似或可比较之物。

His experiences parallel mine in many instances. 他的经历在许多方面与我相似。

resemble 相似：普通的用词。

They resemble each other in shape but not in color. 它们的形状相似，但颜色不同。

5. identify　*vt.* ①认出；识别；鉴定：The markings are so blurred that it is difficult to identify. 标记模糊不清，难以识别。②认为同一（常与 with 连用）：Never identify opinions with facts. 永远不要把意见混同于事实。*vi.* ①（成为）一致（with）　②打成一片；融为一体（with）：The play was so gripping that the audience quickly identified with the actors. 那出戏如此扣人心弦，以致观众很快和演员融为一体。③同情：Reading this book, we can identify with the main character's struggle. 读这本书时，我们会同情主要人

物的斗争。④与……有关系（常与 with 连用）：That politician is too closely identified with the former government to become a minister in ours. 那位政客被认为与上届政府关系过于密切，不能成为本届政府里的部长。

［近义词］make out,pinpoint,single out,designate,distinguish,know,label,nail,name, place,recognize,spot,tag,tell *v.* 确定；认出

［辨析］**identify** 认出、认明：指说出、表明、证明某人或某物。

Could you identify your umbrella among a hundred others? 你能从一百把伞中认出你的伞吗？

make out 辨认出：指努力认出或认明。

I make out a bamboo thicket over there. 我隐约看见那边有一片竹林。

pinpoint 确定：原意为插针于地图上以指示正确的位置，现指确定或精确显示。

The planes bombed objectives pinpointed by ground-to-air radio. 飞机根据地对空无线电精确指示的目标进行轰炸。

single out 选出：指从众人或物中挑选出来。

He was singled out for special training. 他被选拔出来接受专门训练。

6. preliminary ①预备的；初步的，初级的：a preliminary trial 初审，初试 ②序言性的，绪言的：preliminary remarks 开场白，序言 ③在前的：a preliminary investigation 事先调查 *n. pl.* ①初步，开端；预备行为［步骤，措施］，准备：engineering preliminary 工程准备事项 ②入学初考，预考 ③预赛；淘汰赛；次要比赛 *adv.* 预先

［近义词］preexamination,preliminary exam,first attempt,first try *n.* 预考，初试

introductory,prefatory,preparatory,initiatory,preparative,prelusive,primary,prelusory, first,inaugural,opening,test,trial,experimental *adj.* 预备的，初步的

［辨析］**preliminary** 预备性的、初步的：指在某种情况或活动开始前所必须做的或准备的事情。

They held a preliminary discussion to set up the agenda for the meeting. 他们作了初步的讨论以确定会议日程。

introductory 介绍的、导引的：指在一个活动、工作或程序启动前的开始步骤。

The chairman's introductory remarks established his point of view. 主席的开幕词明确地表明了他的观点。

prefatory 序言的、开端的：指书籍、讲演的序言或开场白。

The chairman made some prefatory remarks before introducing the speaker. 主席在介绍演讲者之前先来了一段开场白。

Sentence

Webster's Dictionary defines programming as a process leading to the statement of an architectural problem and requirements to be met in offering a solution.

韦氏词典将设计定义为一个过程，其最终成果为所遇到问题和需求提供解决方案。设计基本上是问题寻求解决的过程。

It is the architect's responsibility to convert raw data and the client's wishes into ne-

gotiable information. He or she must also be aware of missing information, must evaluate the implications of various data, and must distinguish between pertinent facts and irrelevant details.

将原始资料和业主需求转换成可相互流通的信息是建筑师的责任。他或她也必须抓住这些正在失去的信息，必须研究各种各样资料的含义，必须区分出有用的资料和无关的细节。

A major aspect of programming is to establish realistic requirement and explore alternatives in order to find the uniqueness of a building project.

设计的主要方向是确定现实需要和研究可采用的方法，目的是寻求建筑项目的唯一性。

Generally speaking the safest and most efficient approach to programming is to work from the broad concept and big blocks of information toward more detailed and specific points.

一般说到最安全和最有效的设计方法，就是从宽泛的概念和大量的信息到更细致和确切的点。

Thus it is best to begin by establishing a schematic or conceptual program, which is graphically expressed in a schematic design.

因此最好一开始就建立一个总体的概念设计，就是用图示表达概念设计。

Translation

第 10 课　设　计　过　程

韦氏词典将设计定义为一个过程，其最终成果是为所遇到问题和需求提供解决方案。设计基本上是问题寻求解决的过程，它决定了设计必须解决的问题。一位建筑师可以通过许多方式从事建筑设计。例如，建筑师必须认识和分析那些决定建筑形式、并因此直接决定实际设计的主要因素。将原始资料和业主需求转换成可相互流通的信息是建筑师的责任。他或她也必须抓住这些正在失去的信息，必须研究各种各样资料的含义，必须区分出有用的资料和无关的细节。

设计的主要方向是确定现实需要和研究可采用的方法，目的是寻求建筑项目的唯一性。一旦建筑物最简单、最清晰、最具决定性的形式被确定下来，设计就可以开始了。

总的来说，建筑设计要求建筑师具有下列能力：

1. 将原始资料转换成可流通的有用信息。

2. 评价设计资料并分析它们对于主要设计元素的影响。

3. 比较可采用的方法并确定需求。

4. 将所有的设计抽象为"唯一"。

设计通过确定以及解释所面临的任务建立起设计问题的唯一性。既然这一工作部分上是基于对一定数量的信息的评估，那么计算机就会非常有帮助。然而，许多因素，并不能很容易地通过数字和计算机来表达。

建筑师在进行特定的设计任务之前，他或她将研究相类似建筑的类型和构成。产生特

定项目的构思将会是团队努力的结果，其中常常包括建筑师、建筑的拥有者、建筑未来的居住者和使用者、专家和顾问。团队成员之间的交流主要由建筑师负责。然而，在使用绘图表现手法比如图表和透视图时，建筑师必须意识到，一般人对于图示表达的理解能力和视觉化能力并不能达到专家水平。

一般说到最安全和最有效的设计方法，就是从宽泛的概念和大量的信息到更细致和确切的点。因此，最好一开始就建立一个总体的概念设计，就是用图示表达概念设计。如果这个概要设计符合主要标准，建筑师就可以继续进行更为详细的初期设计，最终进入设计发展阶段。使用这种方法，建筑师会避免由于过于纠缠某一细节而忽略问题大局的危险。这一过程可以分为五个步骤：

1. 确定客户的目标。建筑师根据建筑项目、场地、时间和可用资金来评估客户的目标。这就要与客户进行一系列的讨论，清晰地确立他或她的目标。

2. 选择、组织和分析各个方面。所有收集到的信息根据与特定问题和项目功能的关联性加以分类。资料应涵盖建筑物未来的使用和废弃，以及项目与周围环境的关系。过程中一个主要的组织因素就是基地特征——它的实际情况，与法规和社会相关的各方面。当然，资金是每个经营企业的主要组织者，在设计的每一步骤中都是无所不在的。

3. 评价可做选择的意向。这些意向包括中心化与分散化，整齐分区与开放空间，以及灵活性与明显的功能性。这些选择必须就其特性加以考量，根据使用者的需要和喜好加以对照。

4. 确定空间的需求。当项目每一功能的最小空间和最佳空间确定下来时，建筑物的效率就可能用各种系数来加以检验，比如净可用空间除以总建筑空间。建筑设计是否与最初预算一致也是在这一阶段要确定的；大于最小值之上的超额空间数量在很大程度上依赖于这些资金评估。

5. 问题的陈述。在概念性设计中这种论述应非常宽泛。应该不要指定建筑物某一特定形式，而是指定其功能和特性。有关基地、费用、时间和特定的设计解决方案的详细信息应保持在最低限度，以有利于包含其中的要素的整体清晰呈现。

整个过程中建筑师应将每一步骤中从业主和使用者那里反馈回来的信息融合起来，确保设计清晰反映出他们的意图。如果这样做了，随后各方之间如出现争论，设计本身就可以用作判断的依据。好的设计将减少未来改变的程度，并因此减少前期和建造的费用。

"设计导则"指的是大型建筑项目为前期设计准备的一个格式化大纲。它被用来帮助业主/使用者表达他们的想法，它将信息分成三类：

目标和宗旨；

功能需求；

基本的空间需求。

根据设计导则，设计项目必须从一般原则开始，逐渐向更细致的考虑前进。因此第一步是"整体"的总平面设计，包括有关入口、循环停车、项目服务设施、防火等资料。

下一步要做的是"整体建筑"设计。主要集中在项目中的单一建筑物身上，确定它所有功能，确定功能间的相互关系，空间需求，以及所需环境质量。

进一步更小的设计单元是"活动中心"；包括一些房间和有关的空间，大多用于相同的一般性活动。例如医院门诊就是这样的活动中心，设计应包括一系列工作人员及其

活动。

　　设计的最小单元是"私人空间"。在这一部分，资料要足够详细，包括房间的面积是多少平方英尺，以及家具、设备等等。

　　完成的设计在加以修改并得到建筑师和业主的赞同后，就可以作为整个设计工作的指导方针，也是计算现实费用预算所不可缺少的。

Extensive Reading

Pablo Picasso

Picasso, whose full name was Pablo Ruizy Picasso, received his first lessons in painting from his father, a drawing master in Barcelona. He entered the Barcelona School of Art in 1895, where he proved himself an unusually precocious student, and later spent a brief period at the Madrid Academy, from 1897 to 1898. In 1900 he paid his first visit to Paris and settled there years later. Between 1917 and 1924 Picasso designed the costumes and décor for several Diaghilev ballets. He became interested in Surrealism about 1925, though he was never an official member of the group.

During the early years in Spain, Picasso's painting followed the academic tradition. About 1900, however, he felt the impact of Lautrec and of the currently fashionable Art Nouveau sweeping Europe. In Paris, Picasso did not at once break away from his Barcelona style; for several years he remained a part from the Parisian avant grade, his work appearing closer in spirit to the Symbolist-Synthetist circle, which had been headed by Gauguin at the end of the previous century. The literary content was important and the style essentially linear, tending toward a rather mannered elegance. In 1905 he began to paint with a new strength, his drawing becoming less mannered, the mood less melancholy. Circus theme became a favorite subject, and pink replaced blue as the predominant color, as in the Family of Saltimbanques.

Up to this time Picasso's work had been basically naturalistic in style. During the winter of 1906-7, however a newly-formed interest in primitive sculpture of Negro, Iberian, and other types provoked an abrupt change.

In his early Cubist works, such as the landscapes painted at Horta de Ebro in 1909. Picasso was strongly influenced by Cezanne. His color was subdued to an almost monochromatic color range, thus leaving the emphasis on structure. During the next two years Picasso's compositions became increasingly complex and difficult to comprehend, their images broken down to smaller and smaller planes, their relationship to each other and to the background increasingly ambiguous. During World War I Picasso, the working by himself, continued to expand and to elaborate the Cubist idiom, introducing a more decorative quality. He used areas of pattern (particularly dots), brighter colors, and freely curving shapes. As a foil to this new ornateness the compositions generally became simpler. At the same time he returned in some of his pieces to a naturalistic style.

In the mid-1920's, Picasso's paintings came near to Surrealism in spirit. These canvases were disquieting in tone, heir forms were metamorphic in character and distorted for emotional rather than formal reasons, as in The Three Dancers, 1925. This style varied continually in the following years. After the war, when he had moved to Antibes, Picasso's style became more lighthearted in character.

He was also devoting considerable time to ceramics at Vallauris. His tremendously imaginative and original treatment of shapes, particularly their transfiguration by decoration had a great influence on pottery. His work in sculpture was widely influential.

In his paintings during the late 1950's Picasso became particularly interested in composing series of free variations (always of a strongly personal nature) on great masterpieces of the past, such as Velazquez's Las Meninas and Manet's Dejeuner sur I'herbe, showing in these works both his great respect for the long tradition behind him and his powers of reinterpretation.

Translation

帕布洛·毕加索

毕加索，他的全名是帕布洛·Ruizy·毕加索，从他的父亲那里平生第一次接受了美术教育，他的父亲是巴塞罗那的一位绘画教师。毕加索于 1895 年进入了巴塞罗那艺术学校，在那里他证明了自己是不同平常的早熟的学生，随后的他在马德里学院渡过了一段很短的时间(1897～1898 年)。1900 年他第一次到了巴黎并在那里待了 3 年。

1917 年到 1924 年毕加索为多个佳吉列夫的芭蕾舞团设计服装和装饰品。1925 年左右他开始对超现实主义感兴趣，虽然他从未成为这一团体的正式一员。

在西班牙的早期，毕加索的画仍保持了学院派风格，然而，1900 年左右，他受到劳特雷克和当时席卷整个欧洲的新艺术影响。在巴黎，毕加索并没有立即脱离他原有的巴塞罗那风格；他多年都是巴黎先锋派的一员，他的作品表现出与象征—合成派的精神较接近(它是 19 世纪高更所领导的派别)。他的画作非常重视文化内容而风格是线性的，倾向于一种相当矫饰的雅致。1905 年他开始以一种新的力量绘画，他的画不再矫揉造作，情绪也不再忧郁。熙熙攘攘的热闹场面成了受他喜爱的主题，粉红色代替蓝色成为了主色调，就如"卖艺者一家"。

"saltimbanco"是意大利语，法语则在尾音稍作修改、变成"saltimbanque"，指的都是"街头杂耍、卖艺者"的意思(编者注)。

直到这个时期毕加索的作品在样式上基本上是自然主义。然而，在 1906～1907 年的冬天，他开始对黑人和伊比利亚人以及其他类型的原始雕塑感兴趣，这唤起了毕加索风格的一次突然改变。

在他早期的立体派作品中，比如 1909 年在奥而塔(Horta de Ebro)画的风景画。毕加索受到塞尚的极大影响。他的色彩减少到几乎成了单色渲染，因此将重点放在了构图上。在以后的两年中，毕加索画作的构图变得越来越复杂和难以理解，画中的图像分解成越来越小的平面，它们之间以及与背景的相互关系也变得越来越模糊。在第二次世界大战期间，他的绘画继续发展了立体主义风格，引入了更具装饰性的特点。他用大面积的图案(特别是点)、明亮的色彩以及自由弯曲的形体来作画。作为这种新装饰的衬托，构图逐渐变得简单。同时他的一些作品回到了自然主义。

在 20 世纪 20 年代中期，毕加索的画风开始接近超现实主义。这些画作在色调上是忧郁的，它们所描绘的都是变形的事物，这些扭曲与其说是为了形式上的原因，不如说是为了精神上的原因，正如绘于 1925 年的《三个舞蹈者》这幅画。这一画风在随后的几年中

仍继续多变。战后，当他搬到安提贝时，其画风变得比较明快。

毕加索也花费了大量时间在瓦洛里研究陶瓷。他所做的陶瓷极具想象力和独特处理，特别是由装饰造成的变形，对陶器的发展有极大的影响。他的雕塑作品也有广泛的影响。

Henry Moore——The World's Grandest Old Man of Sculpture

Do you know who Henry Moore is? His slight frame supported by two black canes, sculptor Henry Moore inched through the English mist to oversee the arrival by truck of a 22-foot, seven-ton bronze, "Today we say hello to a new piece," he explained, and see how it looks against the cold metal, he approves its placement among the bronze and marble pieces arranged about his 55-acre estate. Henry Moore is the greatest sculptor in the world today and a multimillionaire as well. His work has been the subject of 392 exhibitions, and his represented in 150 museums with more than 800 sculptures and 5000 drawings, lithographs and etchings. Last year, at a New York auction, a reclining figure he carved from elm in 1946 sold for a record $1.2 million, more than the work if any other living artist. This month the Metropolitan Museum of Art opens a retrospective titled "Henry Moore Sixty Years of His Art." Recently LIFE had a rare opportunity to watch Moore at work on his Much Hadham, Herfordshire estate, 30 miles north of London. The artist was sketching, carving and overseeing new sculptures——larger than ever-destined for places as far-flung as Illinois and Singapore.

After breakfast with Irina, His wife of 53 years, Moore begin his day drawing. "It is my physical exercise" he says. After coffee at 11, he is off "to see how the boys are doing on the big piece"——a 30-foot figure for a Singapore building. Moore starts by making a small plaster model. Then Woodward and Muller, in a barn like studio, create a full-size version in polystyrene so "the master," as Woodward calls him, can see what the piece will look like. After lunch and a catnap, Moore goes next door to his foundation offices. He answers mail. Tea with Irina is at four.

Each studio is cluttered with sticks, rocks, shells, bones and old maquettes. "I like to feel that wherever I am in my little setup," he says, "I shall have to look far to find an inspiration."

The seventh of eight children of a Yorkshire miner, Henry Spencer Moore knew at the age of 11 that he wanted to be a sculptor. "As a child," he says, "I used to rub my mother's back for her rheumatism, and I discovered so many different hardness and softness, to many little mountains and valleys which I got to know the way a sculptor needs to get to know things-through touch." Working as an abstract sculptor when the prevailing style was realistic (this man has been feeding on garbage, wrote one of his teachers at the Royal College of Art in 1922), Moore developed variations on the two central themes that have been his preoccupation——the relining female and the mother and child. He even made large holes to show that space itself can suggest form. "A hole," Moore explains, "connects one side of a sculpture to another, making it immediately more three-dimensional. And the three-di-

mensions are what sculpture is all about."Although he had his first one-man exhibit in 1931,Moore was not wall known to the public until the early 1940s,when his moving war-time drawings of British citizens huddled in bomb shelters were shown. The birth of his only child,Mary,in 1946,inspired an even greater interest in family figures. A landmark show that year at the Museum of Modern Art in New York earned Moore an international reputation. Significant public commissions followed notably for the Paris UNESCO building in 1957 and later for Lincoln center in New York. In 1976 he set up his foundation to promote exhibits,finance young sculptors and turn his fields and studios into a kind of sculpture park. Henry Moore's primary obsession has always been the same：his work. "We have so little,"he says,"and so much left to do."

Translation

世界上最伟大的雕塑家——亨利·摩尔

你知道亨利·摩尔吗？用两个黑色手杖支撑起轻盈的身躯，亨利·摩尔在英国的薄雾中缓慢移动，观察这个由卡车运来的22英尺高、7吨重的青铜雕塑，"今天我们看到一件新的作品"，他解释到，"并观察它在开放的天空中会是什么样"。摩尔，在他84岁的时候，很仔细地检查了这个大体量的雕塑。接着用手杖敲打着冰冷的金属，他认为是这个雕塑在他大约55英亩土地上的位置应该在青铜雕塑和大理石雕塑之间。亨利·摩尔是今天世界上最伟大的雕塑家，也是一个千万富翁。他的作品进行了392次展览，有150家博物馆收藏了他超过800件雕塑和5000幅绘画。去年，在纽约的拍卖中，亨利·摩尔1946年用榆木雕刻的一个倾斜人像拍出了120万美元，超过了任何至今在世的艺术家。在这个月，纽约大都会艺术博物馆举办了命名为"亨利·摩尔六十年艺术展"的回顾展。最近《生活》杂志获得极难得的机会，参观亨利·摩尔是如何在他位于伦敦北部30里的，Much Hadham的Herfordshire产业中的工作室是如何工作的。艺术家在那里绘图、雕刻和审视着最新设计的雕塑——比伊利诺伊州和新加坡设计的雕塑更大。

在与伊瑞娜的妻子用过早餐后，摩尔开始他一天的绘画。他说："这是我的身体锻炼"。在11点喝过咖啡后，他下来"看孩子们是如何工作的"——为一座新加坡建筑物设计的30英尺高的雕塑。摩尔做一个小比例石膏模型，接着伍德沃德和穆勒在一个像仓库般的建筑中，用聚苯乙烯制造一个全比例尺度的摹本，接着"师傅"（伍德沃德这样称呼摩尔)仔细观察作品将看起来如何。在吃完午饭和小睡后，摩尔到旁边的办公室中回复信件。在四点与伊瑞娜喝茶。

每个工作室都非常杂乱地堆着砖块、石头、框架、骨架和旧模型。摩尔说："我喜欢任何时候都处于创造状态。""我必须将目光投向远方，去寻找灵感。"

作为一个约克郡矿工的八个孩子中的老七，亨利·摩尔在11岁时就知道他的愿望是成为一名雕塑家。他说："在孩提时代，我常常为母亲按摩背部来治疗风湿，我发现竟然有如此多不同程度的硬度和柔软度，我也到过许多山脉和村庄，了解到一个雕塑家应该通过触觉来感知事物。"在写实主义流行的时期，作为一名抽象派雕塑家(在皇家艺术学院一位教师的信中，他说摩尔是以制造垃圾艺术品为生)，在他正专注所作的两个雕塑主

题——斜倚的妇女和母亲与孩子上，摩尔做了多种变化。他甚至做了一个大洞来展现空间。"一个孔洞"，亨利·摩尔解释到，"联系雕塑的一边和另一边，使雕塑立即成为三维的。而三维正是雕塑的全部所在。"虽然在 1931 年举办了自己的首次个人展览，但是直到 20 世纪 40 年代早期，摩尔展出了他令人感动的描绘英国市民在防空洞中相互拥护场面的绘画后，才为公众所熟知。1946 年，他唯一的孩子玛丽出生了，更激发了他对家庭的兴趣。纽约现代艺术博物馆时期是标志着摩尔获得国际声望的里程碑。重大的公共委托接踵而至，特别是 1957 年为巴黎的联合国教科文组织大楼以及随后为纽约林肯中心所做的设计。1976 年，他建立了自己的基金会以推动展览举办和资助年轻雕塑家，并将他的地产和工作室改为雕塑公园。亨利·摩尔最大的困扰常常只有一个：他的作品。他说："我们做的是如此之少，该做的却如此之多。"

Henry Matisse

Henri Matisse (1869—1954) was born in Le Cateau in the north of France. His plans to enter the law profession were interrupted by an attack of appendicitis. During a long convalescence, Matisse's attempts at painting encouraged him to study art. He was twenty-two when he arrived in Paris to study with Bougereau at the Beaux-Arts and to work also with Gustave Moreau. Matisse's early paintings were dark, naturalistic works, but by 1896 he had become a Neo-Impressionist, working in light color and short strokes. By 1905, he was the leader of the Fauve movement and by 1908 he had embarked on the course that was to influence all contemporary painting after that date: an exploration of the possibilities of painting as a decorative and sensuous art. Cezanne who expressed depth through color, was Matisse's primary influence. Gauguin and Van Gogh influenced his use of color to express emotion, his simplified or distorted drawing and his sacrifice of realistic illusions of depth to an emphatic surface pattern. Retaining volume within the limits of color and design, Matisse juxtaposes intense colors, varied patterns and a rhythmic line. The results are dynamic paintings that are sometimes serene, constantly changing and always more than merely decorative. Throughout his long and successful career, Matisse sought to improve his work and to find the perfect manner of expression. By 1918, he had a world-wide reputation and besides is paintings and line drawings was commissioned to do book illustrations, ballet sets and murals. His most famous mural, La Danse, painted for the Barnes Foundation in Philadelphia (1931-33), achieves its effect by an extreme simplification of figures in a moving pattern of graceful lines. His last great public work was the complete decoration——stained-glass, furniture, murals, chasubles——for the Dominican Chapel in Venice, Matisse died in Venice, in the south of France, in 1954.

Translation

亨利·马蒂斯

亨利·马蒂斯(1869—1954)出生于法国北部的勒卡杜。他从事法律行业的计划被一次

阑尾炎给打断了。在恢复期间，马蒂斯尝试绘画并最终走上了学习艺术的道路。在 22 岁那年他来到巴黎，和布格霍一起在巴黎美术学院学习，他也曾和古斯塔夫·莫罗一起工作。马蒂斯的早期作品是灰暗的，自然主义的。但是到了 1896 年，他成为了一位新印象主义画家，以轻快的色彩和短笔触作画。1905 年，他成为了野兽派的领导者，1908 年他开创了影响之后所有现代绘画的发展方向：将绘画作为一种装饰和感官艺术的可能性。通过色彩表达深度的塞尚对马蒂斯影响最为深刻。高更和梵高对他运用色彩表达情感方面也有影响，他用简化或扭曲的绘画和放弃对深度的真实描述来强调表面图案。保留了在色彩和设计限制下的体量，马蒂斯把强烈的色彩、多变的图案和充满韵律的线条混合在一起。结果，动态的绘画有时平静，有时不断变化，常常不仅仅只具有装饰性。在他整个成功和漫长的职业生涯中，马蒂斯努力提高自己的作品，希望发现表达的完美表现方式。1918 年，他拥有了享誉世界的声望，经常邀请他为书、芭蕾舞剧、墙壁绘制图画和线条图。他最著名的壁画《舞蹈》，是为费城的巴恩思基金会绘制的，通过极为简化的事物、优美的线条创造出运动感的画面。他最后一件重要公共作品是完全装饰性的——染色玻璃、家具、壁画、礼服——为威尼斯的多米尼加小教堂所绘，马蒂斯于 1954 年逝于法国南部的威尼斯（并不是意大利的威尼斯）。

Part III Academic Frontiers

Intensive Reading

Lesson 11 Urban Publicspace: The Role of Squares

The public square has played a central role in the evolution of all societies. From the ancient Greek agora to its modern-day manifestations across the world, urban public spaces such as the square have taken on a variety of functions, ranging from security and trade to relaxation and entertainment, in every society. For example, in ancient Greece the public square acted as a meeting place for residents, a venue for Socrates, a forum for public debate, and a marketplace. Setha M. Low writes in her book, On the public Plaza: The Politics of Public Space and Culture, that the plaza is the "ultimate architectural expression of social and moral freedom. " Whether used for leisure, protection, or the development of social capital, squares have been, and continue to be, essential in the development of all societies, especially open, free, democratic ones.

In the 20th century, however, the function of the square has been transformed and the concept of the square has become inherently political. Whereas in the past the square had been a place that society, and perhaps even the government, provided for people to come as individuals to socialize, the functions of a square have been transformed. In many nations today, the square no longer represents a citizen-owned locale for relaxation or group interactions; the modern square, in nations across the world, now symbolizes order, conformity, and the power of the state.

By definition, countries attempt to control the actions of their people. The modern square, however, represents both the state and the anti-state. It symbolizes order and the power of the state, yet in some instances acts as a venue for publicly protesting that power. When comparing squares in an authoritarian setting to squares in a democratic one, citizens in democracies have far more latitude and control in determining how public spaces are used. In either setting, however, the square is a public space that the state, to varying degrees, has an interest in regulating. This presents a paradox——a space set aside for public use, yet regulated by the government. In democratic countries, this oversight or regulation may be very subtle. For example, the government may require protestors to obtain permits granting permission to rally or march, or it may post troops or guards to prevent violence from occurring. By contrast, public spaces in authoritarian countries are regulated to a far more serious degree, especially during extremely repressive periods, meaning that the

squares are only used for state sanctioned purposes, such as the symbolic mobilization of the masses. No unsanctioned use of that "public" space is permitted.

To a certain degree, urban public spaces such as squares and plazas are where a city's residents congregate and interact with one another, and where the city's visitors and tourists come to observe local customs. Urban places such as these often symbolize the heart of a city, perhaps even the nation, and are the heartbeat of its people, as well. Beyond ideology and politics, in these places one can sense the vibrancy of a culture and feel its energy.

For a historic example of such an urban public space, one could look at Moscow's Red Square in the 1950s and 1960s, while New York City's Times Square or Washington, D. C.'s Mall, are examples of such an urban public space located in a more democratic setting. By spending time in each place, observing its inhabitants and their interactions, one can view patterns and behaviors that help us better understand a city, and a nation, in general. For instance, a few moments spent in Times Square could tell an observer a great deal, not only about American culture, but about poverty, class/race issues, and capitalism, as well. In this way, open public spaces provide a window onto a society, a brief glimpse at the bigger picture. Essentially, urban public spaces are microcosms analogous to the larger societies in which they are located.

Notes

1. The Public Square　公共广场

A public square is an open area commonly found in the heart of a traditional town used for community gatherings. Other names for public square are civic center, city square, urban square, market square, town square, plaza (from Spanish), piazza (from Italian), and place (from French).

公共广场是指往往在传统城镇中心就可以找到的、用于社会聚会的开放区域。公共广场的其他名称还有 civic center, city square, urban square, market square, town square, plaza（源自西班牙语），piazza（源自意大利语）和 place（源自法语）。

Most public squares are hardscapes suitable for open markets, music concerts, political

Fig. 11-1　A celebration in the square of the Catalan city of Sabadell

Fig. 11-2　Market square with 142 tenement houses in Piotrków Trybunalski, Poland

rallies, and other events that require firm ground. Being centrally located, public squares are usually surrounded by small shops such as bakeries, meat markets, cheese stores, and clothing stores. At their center is often a fountain, well, monument, or statue. Many of those with fountains are actually named Fountain Square.

绝大多数公共广场被建成硬质景观，适合于开放市场、音乐会、政治集会，以及其他需要坚实地面的活动。中心的地理位置，使得公共广场常常有一些小商铺围绕，比如面包店、肉店、乳酪店以及服装店。在广场的中心是喷泉、水井、纪念碑或雕像。许多中心有喷泉的公共广场就叫喷泉广场。

- Red Square in Moscow was originally used as an outdoor marketplace and later became the stage for Soviet military parades and May Day demonstrations.
- 莫斯科的红场最初是作为室外市场，随后成为前苏联军队展演和五一游行的场所。
- Palace Square in St Petersburg was designed to be the central square of Imperial Russia and ironically became the setting of revolutionary protests that led to the overthrow of monarchy during the February Revolution of 1917.
- 圣彼得堡的宫廷广场被设计成为俄罗斯帝国的中心广场，讽刺的是它变成了革命者的抗议场所，最终导致了 1917 年二月革命中君主政体被推翻。
- John-F. -Kennedy-Platz was the site of the West Berlin town hall and John F. Kennedy's famous Ich bin ein Berliner speech.
- 约翰·肯尼迪广场是西柏林市政厅的所在地，约翰·肯尼迪著名的"我是柏林人"演讲的发生地。
- New York City's Times Square as well as Bryant Park and Washington, D. C. 's National Mall often fill this role for the United States.
- 纽约的时代广场、布莱恩特公园和华盛顿特区的国家广场都是美国的公共广场。
- Trafalgar Square in London does the same for the United Kingdom.
- 英国伦敦的特拉法加广场。
- Dam Square in Amsterdam for the Netherlands.
- 荷兰阿姆斯特丹的达姆广场。
- Three squares: Main Market Square, Kraków, Town Square in Piotrków Trybunalski and Castle Square, Warsaw for Poland.
- 波兰的三个广场：克拉科夫—中央广场、雷布纳尔斯基的城市广场和华沙的城堡广场。
- Radhuspladsen, Copenhagen for Denmark.
- 丹麦哥本哈根的市政厅广场。

 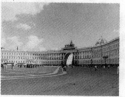 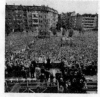

Red Square in Moscow Palace Square in St Petersburg John-F.-Kennedy-Platz New York City's Times Square

Fig. 11-3　squares of world(一)

Bryant Park

Trafalgar Square in London

Dam Square in Amsterdam

Rådhuspladen

Fig. 11-3 squares of world(二)

2. The Ancient Greek Agora 古希腊时期的市场

The Agora in ancient Greek cities was an open space that served as a meeting ground for various activities of the citizens. The name, first found in the works of Homer, connotes both the assembly of the people as well as the physical setting; it was applied by the classical Greeks of the 5th century BC to what they regarded as a typical feature of their life: their daily religious, political, judicial, social, and commercial activity. The agora was located either in the middle of the city or near the harbour, which was surrounded by public buildings and by temples. The general trend at this time was to isolate the agora from the rest of the town.

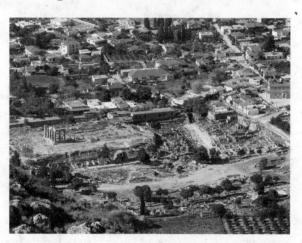

Fig. 11-4 View of the ancient agora

古希腊时期的城市市场是指作为各种各样市民活动场所的开放空间。在荷马的著作中首次使用这一名称，意思是人民和现实环境的汇集。公元前 5 世纪，古希腊用这个词汇来指他们所认为的生活重要因素：日常生活中的宗教、政治、法律、社会和商业活动。市场或者位于城市的中心，或者靠近港口，市场的周围是公共建筑和寺庙。当时的普遍倾向是将市场和城镇的其他部分隔离。

The use of the agora varied at different periods. Even in classical times the space did not always remain the place for popular assemblies. In Athens the ecclesia, or assembly, was moved to the Pnyx (a hill to the west of the Acropolis), though the meetings devoted to ostracism were still held in the agora.

不同时期，市场的用途也各有不同。即使是古典时期，市场也并不一定是公众集会的

场所。雅典的古国民大会，或者集会，就被搬到了普尼克斯（雅典卫城西面的小山），虽然专门进行放逐判决的会议仍在市场举行。

In the highly developed agora, like that of Athens, each trade or profession had its own quarter. Many cities had officials called agoranomoi to control the area.

在高度发达的市场中，就如雅典的市场，每类贸易或职业都有其自己专属的角落。许多城市都有称为 agoranomoi（市场管理员）的官员来管理市场。

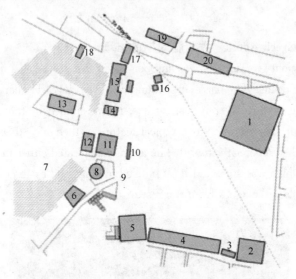

Fig. 11-5 Plan showing major buildings and structures of the agora of Athens as it was in the 5th century BC

1—Peristyle Court；2—Mint；3—Enneacrounos；4—South stoa Ⅰ and South Stoa Ⅱ；5—Heliaea；6—Strategeion；
7—Colonos Agoraios；8—Tholos；9—Agora stone；10—Monument of the Eponymous Heroes；11—Metroon
(Old Bouleuterion)；12—New Bouleuterion；13—Temple of Hephaestus (Hephaestion)；14—Temple
of Apollo Patroos；15—Stoa of Zeus；16—Altar of the Twelve Gods；17—Stoa Basileios (Royal stoa)；
18—Temple of Aphrodite Urania；19—Stoa of Hermes；20—Stoa Poikile

3. Ancient Greece 古希腊

The term ancient Greece refers to the period of Greek history lasting from the Greek Dark Ages ca. 1100 BC and the Dorian invasion, to 146 BC and the Roman conquest of Greece after the battle of Corinth. It is generally considered to be the seminal culture which provided the foundation of Western civilization. Greek culture had a powerful influence on the Roman Empire, which carried a version of it to many parts of Europe. The civilization of the ancient Greeks has been immensely influential on the language, politics, educational systems, philosophy, science, and arts, giving rise to the Renaissance in Western Europe and again resurgent during various neo-Classical revivals in 18th and 19th century.

Fig. 11-6 The Parthenon is the one of the most representative symbols of the culture and sophistication of the ancient Greeks

　　古希腊是指从公元前 1100 年的黑暗时代和多利亚人入侵，到公元前 146 年科林斯战争后罗马人征服希腊的这段历史时期。普遍认为古希腊是建立西方文明基础的初期文化。古希腊文化对古罗马帝国产生了巨大的影响，而古罗马帝国将这种影响带到了欧洲的许多地方。古希腊文明对语言、政治、教育系统、哲学、科学和艺术产生巨大影响，通过西方欧洲的文艺复兴，古希腊文明在 18、19 世纪各种各样的新古典主义中再次重生。

　　The ancient Greek period is subdivided into four periods on pottery styles and political events. The Greek Dark Ages (c. 1100—c. 750 BC) features the use of geometric designs on pottery; it is followed by the Archaic period (c. 750—c. 480 BC), in which artists made larger free-standing sculptures in stiff, hieratic poses with the dreamlike 'archaic smile'. The Archaic period is often taken to end with the overthrow of the last tyrant of Athens in 510 BC. The Classical period (c. 500—323 BC) is characterised by a style which was considered by later observers to be exemplary (i. e. 'classical')—for instance the Parthenon. The death of Alexander in 323 BC is used to mark the beginning of the Hellenistic period, when Greek culture and power expanded into the near and middle east; a period which finishes with the Roman conquest of 146 BC.

　　古希腊时期按陶器风格和政治事件被分成四个时期。黑暗时代（公元前 1100—前 750）的特征是陶器的几何图案设计；接着是古风时期（公元前 750—前 480），那时的艺术家创造更大的独立雕塑，这些雕塑摆着僵硬的、神圣的姿势，展开梦幻般的 "古风式微笑"。古风时期在公元前 510 年推翻雅典最后一位暴君时结束。古典时期（公元前 500—前 323）的独特风格被随后的观察者认为是模范的（即 "古典的"）——例如帕提农神庙。公元前 323 年亚历山大的去世成为晚希腊时期开始的标志，当时古希腊文化和权利扩展到中东附近；这段时期结束于公元前 146 年罗马人征服希腊。

　　Ancient Greece consisted of several hundred more-or-less independent city states (poleis). This was a situation unlike that in most other contemporary societies. Undoubtedly the geography of Greece, divided and sub-divided by hills, mountains and rivers contributed to the fragmentary nature of Ancient Greece. However, there is also a degree to which the situation was something peculiar to Ancient Greece. On the one hand, the ancient Greeks had no doubt that they were 'one people'; they had the same religion, same basic culture, and same language. Furthermore, the Greeks were very aware of their tribal origins; Herodotus was able to extensively categorizes the city-states by tribe. Yet, they seem to have rarely had a major role in Greek politics. The independence of the poleis was fiercely defended; unification was something rarely contemplated by the Ancient Greeks. Even when, during the second Persian invasion of Greece, a group of city-states allied themselves to defend Greece, the vast majority of poleis remained neutral, and after the Persian defeat, the allies quickly returned to infighting.

　　古希腊是由数百个或大或小的独立城邦组成的。这种社会状态与同时代其他社会不同。毫无疑问，希腊的地形由小山、大山和河流分隔，形成了古希腊碎片状的自然地貌。然而，古希腊也有一定程度的特殊性。一方面，古希腊人对他们是 "一个人" 毫无疑问；他们有相同的宗教，相同的文化基础和相同的语言。此外，古希腊人非常重视他们种族的

起源；希腊历史学家能够通过种族来给城邦分类。然而，它们却几乎没有对古希腊的政治产生什么影响。人们坚持城邦的独立；古希腊人几乎完全不考虑统一。甚至在波斯第二次入侵希腊期间，绝大多数城邦仍保持中立，在波斯人被击败后，盟邦很快就回到了相互作战的态势。

4. Socrates　苏格拉底

Socrates (469 BC—399 BC) was a Classical Greek philosopher. Credited as one of the founders of Western philosophy, in reality he is an enigmatic figure known only through other people's accounts. It is Plato's dialogues that have largely created today's impression of him.

苏格拉底（公元前 469—前 399）是一位古希腊哲学家，被尊称为西方哲学的创立者之一。事实上，苏格拉底是通过其他人的记录才为人所知的神秘人物。与柏拉图的对话在很大程度上决定了今天的人们对于苏格拉底的印象。

Through his portrayal in Plato's dialogues, Socrates has become renowned for his contribution to the field of ethics, and it is this Platonic Socrates who also lends his name to the concepts of Socratic irony and the Socratic method. The latter remains a commonly used tool in a wide range of discussions. It is Plato's Socrates that also made important and lasting contributions to the fields of epistemology and logic, and the influence of his ideas and approach remains strong in providing a foundation for much western philosophy.

Fig. 11-7　Socrates

通过柏拉图对话中对他的描述，苏格拉底以其对伦理学领域的贡献而闻名，纯理性的苏格拉底也将他的名字留在了苏格拉底反讽和苏格拉底问答法概念中。而后者至今仍是各种各样讨论普遍使用的工具。柏拉图式的苏格拉底也对认识论和逻辑学领域做出了重要和持久的贡献，他的理念和方法为绝大多数西方哲学建立了基础。

5. Moscow's Red Square　莫斯科红场

Red Square is the most famous city square in Moscow, and arguably one of the most famous in the world. The square separates the Kremlin, the former royal citadel and currently the official residence of the President of Russia, from a historic merchant quarter known as Kitay - gorod. As major streets of Moscow radiate from here in all directions, being promoted to major highways outside the city, the Red Square is often considered the central square of Moscow and of all Russia.

红场是莫斯科最著名的城市广场，也是全世界最著名的城市广场之一。红场将克里姆林宫（以前是皇家城堡，现今作为俄罗斯总统的正式居所）和被称为格罗城的历史商贸区分隔开来。由于莫斯科主要的街道都从这里向各个方向辐射，与城市外延主要高速公路连接，红场常常被称为莫斯科的中心，乃至俄罗斯的中心。

The rich history of Red Square is reflected in many artworks, including paintings by Vasily Surikov, Konstantin Yuonand others. The land on which Red Square is situated was

originally covered with wooden buildings but cleared by Ivan III's edict in 1493, as those buildings were dangerously susceptible to fires. The newly-opened area (originally known simply as the Pozhar, or "burnt-out place") gradually came to serve as Moscow's primary marketplace. Later, it was also used for various public ceremonies and proclamations, and occasionally as the site of coronation for Russia's czars. The square has been gradually built up since that point and has been used for official ceremonies by all Russian governments since it was established.

红场的丰富历史反映在许多艺术作品中，包括苏里科夫，康斯坦丁·尤纳德等人的绘画。红场所处的位置最初是一些木制建筑，1493 年在伊凡三世的命令下这些建筑被拆除，因为它们易发生火灾。新建的开放空间（最初只叫做 *Pozhar*，或者"烧坏的地方"），逐渐成为了莫斯科主要的市场。随后，它也用于各种公众庆典和宣言仪式，偶尔还成为俄国沙皇举行加冕典礼的场所。广场从那时逐渐建成，并从建成伊始所有俄罗斯政府都在此地举行官方典礼。

The name of Red Square derives neither from the colour of the bricks around it nor from the link between the colour red and communism. Rather, the name came about because the Russian word красная (krasnaya) can mean either "red" or "beautiful". The word was originally applied (with the meaning "beautiful") to Saint Basil's Cathedral and was subsequently transferred to the nearby square. It is believed that the square acquired its current name (replacing the older Pozhar) in the 17th century. Several ancient Russian towns, such as Suzdal, Yelets, and Pereslavl-Zalessky, have their main square named Krasnaya ploshchad, namesake of Moscow's Red Square.

Fig. 11-8 *Morning of execution of streltsy by Tsar Peter I* in Red Square (1881, Vasily Ivanovich Surikov)

红场这个名字的来源既不是它周围的砖石色彩，也不是红色和共产主义的联系。而是因为俄语 красная（*krasnaya*）的意思或者是"红色"或者是"美观"。最初这个词被用于（用的是"美观"的意义）瓦西里升天大教堂，随后被转到了教堂附近的广场上。相信是在 17 世纪广场获得了它现在的名称（取代了原有的 *Pozhar*）。许多古老的俄罗斯城镇，比如苏兹达利，叶利兹和札列斯基，都有和莫斯科红场一样名称（*Krasnaya ploshchad*）的主广场。

In 1990, the Kremlin and Red Square were among the very first sites in the USSR added to UNESCO's World Heritage List.

1990 年，克里姆林宫和红场成为前苏联首批被联合国教科文组织列为世界遗产名录的基址。

Each building in Red Square is a legend in its own right. One of these is Lenin's Mausoleum, where the embalmed body of Vladimir Ilyich Lenin, the founder of the Soviet Union, is displayed. Nearby is the elaborate brightly-domed Saint Basil's Cathedral and also the palaces and cathedrals of the Kremlin.

Fig. 11-9　Victory Parade on
Red Square

Fig. 11-10　Red Square, with Lenin's Tomb (left)
and Historical Museum (right)

红场中的每个建筑都是一部传说。其中之一就是列宁墓，在那里安放着经过防腐处理的弗拉基米尔·伊里奇·列宁——这位苏联的缔造者的遗体。附近是精致的有着明亮穹顶的瓦西里升天大教堂，以及克里姆林宫的宫殿和教堂。

On the eastern side of the square is the GUM department store, and next to it the restored Kazan Cathedral. The northern side is occupied by the State Historical Museum, whose outlines echo those of Kremlin towers. The Iberian Gate and Chapel have been rebuilt to the northwest.

在广场的东边是古姆百货商店，再往后是重建的喀山大教堂。北边是国家历史博物馆，它的轮廓是对克里姆林宫塔楼的回应。伊比利亚之门和教堂在广场的西北方重建。

The only sculptured monument on the square is a bronze statue of Kuzma Minin and Dmitry Pozharsky, who helped to clear Moscow from the Polish invaders in 1612, during the Times of Trouble. Nearby is the so-called Lobnoye Mesto, a circular platform where public ceremonies used to take place. Both the Minin and Pozharskiy statue and the Lobnoye Mesto were once located more centrally in Red Square but were moved to their current locations to facilitate the large military parades of the Soviet era.

广场的唯一雕塑纪念碑是米尼和德米特里·波扎尔斯基大公的青铜雕像，他们在困难时

期帮助莫斯科人在 1612 年击退了波兰入侵者。附近是所谓的罗波诺耶梅思托平台(一个圆形平台)，在那里举行公众庆典。米尼和德米特里·波扎尔斯基大公雕像和罗波诺耶梅思托平台曾位于广场中心，但后来被移到了现在的位置，为前苏联时期的大型阅兵仪式提供方便。

6. New York City's Times Square 纽约时报广场

Times Square is a major intersection in Manhattan, New York City at the junction of Broadway and Seventh Avenue and stretching from West 42nd to West 47th Streets. The Times Square area consists of the blocks between Sixth and Eighth Avenues from east to west, and West 40th and West 53rd Streets from south to north, making up the western part of the commercial area of Midtown Manhattan.

时报广场是纽约市曼哈顿重要交叉路口，位于百老汇和第七大道的交汇点，从西第 42 大街向西第 47 大街延伸。时报广场区域由从东到西的第六大街和第八大街，从南到北的西第 40 大街和西第 53 大街之间的街区组成，组成了曼哈顿中心商业区域的西部。

Formerly Longacre Square, Times Square was re-named after the Times Building, the former offices of the New York Times, in April 1904. Times Square has achieved the status of an iconic world landmark and has become a symbol of its city. Times Square is principally defined by its animated, digital advertisements.

Fig. 11-11 The southern end of Times Square, New Year's Eve, December 31, 2007

广场的原名叫朗埃克广场，在 1904 年时报大楼建成后更名为时报广场。时报大楼曾是《纽约时报》的办公楼。时报广场成为了梦想世界的标志，也是这座城市的标志。时报广场最重要的特征就是其热闹的数字广告。

Times Square is the site of the annual New Year's Eve ball drop. On December 311907, a ball signifying New Year's Day was first dropped at Times Square, and the Square has held the main New Year's celebration in New York City ever since. On this night hundreds of thousands of people congregate to watch the Waterford crystal ball being lowered on a pole atop the building (though not to the street, as is a common misconception), marking the new year. It replaced a lavish fireworks display from the top of the building that was held from 1904 to 1906. Beginning in 1908, and for more than eighty years thereafter, Times Square sign maker Artkraft Strauss was responsible for the ball-lowering. During World War Ⅱ, a minute of silence, followed by a recording of church bells pealing, replaced the ball drop because of wartime blackout restrictions. Today, Countdown Entertainment and One Times Square handle the New Years' Eve event in conjunction with the Times Square Alliance. A new energy-efficient LED ball, celebrating the centennial of the ball drop, debuted for the arrival of 2008.

时报广场每年都举行跨年水晶球整点落下的仪式。1907 年 12 月 31 日，画着新年好的气球首次在时报广场放飞。广场从那时起成为了举行纽约市新年庆典之处。在这一夜，数以万计的人们聚集在此，观看沃特福德水晶球降落在建筑顶部（并不是落在街道，这是一个普遍的误会），庆祝新年。它取代了 1904 到 1906 年举办的、耗费巨大的建筑顶部焰火展示。从 1908 年开始的 80 多年中，时报广场标牌制作公司史特劳斯负责水晶球的降落。第二次世界大战期间，由于战时灯火限制，教堂钟声播放之后一分钟的静默取代了球体落下。今天，倒数嘉年华、时报广场大厦和时报广场联盟一起举行新年庆典。在 2008 年举行的百年庆典水晶球下落中首次使用了新的节能 LED 灯泡。

Fig. 11-12　The lights and advertising at the southern end of Times Square

The theaters of Broadway and the huge number of animated neon and LED signs have long made it one of New York's iconic images, and a symbol of the intensely urban aspects of Manhattan. The density of illuminated signs in Times Square now rivals that of Las Vegas.

百老汇的戏院、众多热闹非凡的氛气和 LED 标志使它成为了纽约商业图像之一，曼哈顿热情城市景象的象征。现今时报广场的照明标志密度可以与拉斯维加斯匹敌。

Notable examples of the signage include the Toshiba billboard directly under the NYE ball drop and the curved seven-story NASDAQ sign at the NASDAQ MarketSite on 43rd Street. The Toshiba sign will be the newest, most energy efficient sign in Times Square and capable of broadcasting images to 1080p resolution. The Nasdaq sign was unveiled in January 2000 and cost $37 million to build. NASDAQ pays more than $2 million a year to lease the space for this sign.

著名标牌包括直接位于新年庆典球体落下下方的东芝广告牌和第 43 大街纳斯塔克证券总部上七层高的曲线纳斯达克标牌。东芝标志成为时报广场中最新、最节能的标牌，能以 1080p 的精度来播放图像。纳斯达克标志在 2000 年 1 月公布，建造标牌共花费 3700 万美元。纳斯达克每年需要花费超过 200 万美金用来租赁放置标牌的空间。

Fig. 11-13　View of the northern part of Times Square, with the Renaissance New York Times Square Hotel (Two Times Square) in the center

7. Washington, D. C. 's Mall 华盛顿国家广场

The National Mall is an open-area national park in downtown Washington, D. C. , the capital of the United States. Officially termed by the National Park Service the National Mall & Memorial Parks, the term commonly includes the areas that are officially part of West Potomac Park and Constitution Gardens to the west, and often is taken to refer to the entire area between the Lincoln Memorial and the Capitol, with the Washington Monument providing a division slightly west of the center.

Fig. 11-14 Facing east across the Mall in front of the Lincoln Memorial

国家广场是位于美国首都华盛顿市中心的开放国家公园。国家公园管理局命名的官方名称是国家广场 & 纪念公园，包括西波托马克公园的部分区域，向西到达宪法花园。国家广场常常用来指林肯纪念堂和国会大厦之间的整个区域，而其中的华盛顿纪念碑成为了稍微偏西的划分两个区域的标志。

Fig. 11-15 This USGS satellite image of the National Mall (proper) was taken April 26, 2002. The Capitol and surrounding grounds on the right were pixellated before release, presumably for security reasons

1—Washington Monument; 2—National Museum of American History; 3—National Museum of Natural History; 4—National Gallery of Art Sculpture Garden; 5—West Building of the National Gallery of Art; 6—East Building of the National Gallery of Art; 7—United States Capitol; 8—Ulysses S—Grant Memorial; 9—United States Botanic Garden; 10—National Museum of the American Indian; 11—National Air and Space Museum; 12—Hirshhorn Museum and Sculpture Garden; 13—Arts and Industries Building; 14—Smithsonian Institution Building; 15—Freer Gallery of Art; 16—Arthur M. Sackler Gallery; 17—National Museum of African Art

The National Sylvan Theater, southeast of the Washington Monument, is also part of the Mall, although it is not numbered in the image. As popularly understood, the National Mall also includes the following areas west of the Washington Monument: the Lincoln Memorial and Reflecting Pool, the National World War II Memorial, the Korean War Veterans Memorial, and the Vietnam Veterans Memorial.

国家西尔万剧院位于华盛顿纪念碑的东南方，也是国家广场的一部分，虽然它没有纳入到图片中。一般人所理解的国家广场也包括华盛顿纪念碑西边的下列区域：林肯纪念堂和国会映象池，二战纪念碑，朝战纪念碑和越战纪念碑。

The Martin Luther King, Jr. National Memorial, is located on a 4 acre (16000m²) site that

borders the Tidal Basin and within the sightline of the Jefferson and Lincoln memorials.

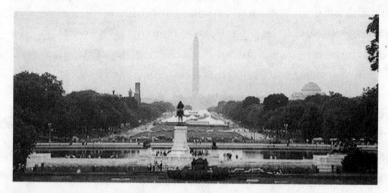

Fig. 11-16 View from the back of the United States Capitol, facing west across the Mall

马丁·路德·金纪念园，位于潮汐湖畔边界的 4 英亩（16000m²）基址处，在杰斐逊和林肯纪念堂就可以看到。

Other attractions within walking distance of the Mall include the Library of Congress and the United States Supreme Court building east of the Capitol; the White House (on a line directly north of the Jefferson Memorial), the National Archives, the Old Post Office, the National Theatre, Ford's Theater, and the Albert Einstein Memorial to the north; the National Postal Museum, and Union Station to the northeast; and the Jefferson Memorial (on a line directly south of the White House), the Franklin Delano Roosevelt Memorial, the George Mason Memorial, the United States Holocaust Memorial Museum, and the Bureau of Engraving and Printing to the south.

步行在广场中，其他吸引人之处包括国会图书馆和国会大厦东面的美国最高法院大楼；白宫（在杰斐逊纪念堂正北）、国家档案馆、旧邮政局、国家剧院、福特戏院；北面的爱因斯坦纪念碑、国家邮政博物馆；东北面的联邦车站、杰斐逊纪念堂（白宫的正南）、罗斯福纪念堂、乔治梅森纪念堂、华盛顿大屠杀纪念馆；南面的铸印局。

8. American Culture 美国文化

The development of the culture of the United States of America has been marked by a tension between two strong sources of inspiration: European sophistication and domestic originality.

美国文化发展的标志是两个强大灵感来源之间的紧张关系：欧洲的温文尔雅和本国的创造力。

American music is heard all over the world, such as through Channel V, VH1 and by singers such as Michael Jackson, Tina Turner, Madonna, Whitney Houston, Cyndi Lauper, Mariah Carey, and the Backstreet Boys; American movies and television shows can be seen almost anywhere, including icons like Star Wars, Titanic and The Matrix; American sports figures are widely known, such as Michael Jordan, Tiger Woods, Venus Williams, Mike Tyson and Michael Johnson; and American movie actors and actresses are widely recognized such as Tom Hanks, Julia Roberts, Brad Pitt, Marilyn Monroe, Leonardo DiCaprio and Tom Cruise. This is in very stark contrast to the early days of the American republic, when the country

was generally seen as an agricultural backwater with little to offer the culturally advanced world centers of Europe and Asia. At the beginning of her third century, nearly every major American city offers classical and popular music; historical, scientific and art research centers and museums; dance performances, musicals and plays; outdoor art projects and internationally significant architecture.

美国音乐流行于全世界，比如 Channel V, VH1 和迈克尔·杰克逊、蒂娜·特纳、麦当娜、惠特尼·休斯敦、辛迪·劳博尔、玛丽亚·凯利、后街男孩等；美国的电影和电视秀几乎可以在全世界任何地方都可以看到，像《星球大战》、《泰坦尼克号》和《黑客帝国》等影片；美国运动员为全世界所知，比如迈克尔·乔丹、泰格·伍兹、大威廉姆斯、迈克·泰森和迈克尔·杰克逊；美国电影演员很有名，比如汤姆·汉克斯、朱丽亚·罗伯茨、布拉德·皮特、玛丽莲·梦露、莱昂纳多·迪卡普里奥和汤姆·克鲁斯。这与美国公众的早期生活完全相反，当时美国被普遍认为是一个农业社会，无法与欧洲和亚洲的先进文化中心相媲美。在建国三百年之后，几乎每个美国城市都有古典和流行音乐；历史、科学和艺术研究中心和博物馆；舞蹈表演，音乐片和音乐剧；室外艺术项目和国际知名建筑。

The main content of American culture is the emphasize on individuals' value, the pursue of democracy and freedom, the promotion of deploitation and competition and the need of realistic and practicality. Its core is individualism: self first, personal need first, pursue of individual benefit and enjoyment, emphasize on achieving individual value by self-strive and self-design. This type of intentionally build up of personality and pursue customized individualism has its pros and cons, it gives incentives to people and make them exert on their potential and wisdom and as a result accelerate the development of the entire race and nation; on the other hand it is difficult to keep good relationship among people if everyone is egocentric thus make the entire society lack of unity.

美国文化的主要内容是强调个人价值，追求民主自由，崇尚开拓和竞争，讲求理性和实用，其核心是个人中心主义：个人至上、私欲至上、追求个人利益和个人享受，强调通过个人奋斗、个人自我设计，追求个人价值的最终实现。这种刻意塑造自我、追求个性化的个人主义有其积极的一面，也有消极的一面。它调动了个人的积极性，使许多人的智慧和潜力得以充分发挥，从而促进整个民族与国家的振兴和发展。然而，人人以我为中心，人际关系就难以融洽，整个社会也会缺乏凝聚力。

American citizens emphasize on achievements and respect heroes. They have great sense in their hearts to praise success and heroes. Personal achievements are one of those with the highest value in Americans mind. Americans have very strong senses of success. Success is the pursuit of most Americans, it is their attractive future and the incentives for moving forward. They believe that one's personal value is equivalent to his achievements in his career. Some high achievers in their career such as entrepreneurs, scientists, artists and all kinds of super starts became modern heroes. The process and result of how they strived have become the frame of reference of social culture value and the real life text book for parents to educate their children.

美国公众注重成就，仰慕英雄，有深厚的成就崇拜和英雄崇拜的心理积淀。个人成就是所有美国人价值观中评价最高的价值之一。美国人有很强的成就（或成功）意识。成功是所有美国人的追求，是诱人的前景，前进的动力。他们坚信，一个人的价值就等于他在事业上的成就。一些事业有成的企业家、科学家、艺术家和各类明星，成了新时代的英雄。他们个人奋斗的过程和结果，成了社会文化价值取向的参照系，父母教育子女的活教材。

American society has great movements within itself. These movements are shown in two aspects: movements amongst locations and movements inside the society. The United States are relatively more open and have more freedom. Developed transport and the tradition of adventure and sporty makes a lot of American migrate from countryside to cities, from downtown to uptown; and from north to the southern sunny land, from one city to another. Unlike European countries, the social classes in America is not so stable. Further more, with the advocation of public education, movements upwards along the social ladder have become possible. Many people living in the states, no matter whether they are Native American or immigrants from overseas, have the same dream of changing their social class and make their lifetime dream come true through their own efforts. This is what they often called "American dream".

美国是流动性很大的社会。这种流动体现在两个方面：地域性流动和社会性流动。相对开放自由、发达的交通和冒险好动的传统，使许多美国人从乡村流到城市，又从市中心流向郊区；从北方流到南方阳光地带，从一个城市流到另一个城市。美国的社会阶级不像欧洲国家那样固定，加上公共教育的普及，使美国人沿着社会阶梯向上流动成为可能。许多生活在美国的人，无论是土生土长的美国人，还是漂洋过海来到美国的外国移民，都有一个梦想，即通过自己的努力，改变自己的社会地位，实现自己的人生梦想，这就是人们常津津乐道的"美国梦"。

Vocabulary

1. evolution n. ①进化；演化，进化论：study the evolution of man 研究人类的进化 ②发展，发育，开展：the evolution of a story 故事情节的发展 ③进化论 ④放出，散出，放出物，散出物：The evolution of heat from the sun is inestimable. 从太阳中放射出的热是无法估计的。

［近义词］development, advance, growth, increase, progress, progression, expansion, ripening, derivation, descent, Darwinism n. 进展，发展，进化

［辨析］**evolution** 发展、开发：指自然而逐步的发展。

We noticed the evolution of the modern steamship from the first crude boat. 我们注意到最初原始简陋的小船是如何演变为现代化轮船的。

development 发展、成长：普通的用词。

He is engaged in the development of his business. 他正努力发展业务。

advance 前进、进展：指向一个固定目标或目的地推进。

The advance of our troops was not noticed by the enemy. 敌人没有发现我们的军队在前进。

growth 生长：指成长发展的过程。

Childhood is a period of rapid growth. 幼年是生长迅速的时期。

2. ancient *adj.* ①以往的，古代的：ancient Rome 古罗马，an ancient city 古城 ②古来的，古老的，旧式的：a very ancient-looking dress 一件式样很古旧的衣裳 *n.* ①古（代的）人 ②［the ancients］古文明国的国民；(希腊、罗马时代的)古典作家［艺术家］

［近义词］ancient people *n.* 古时的人

old,aged,antique,timeworn,archaic *adj.* 老的，年高的

antique,old,archaic,aged,remote,early,primitive,prehistoric *adj.* 古老的，古代的

［辨析］**ancient 古代的**：庄重的用词，指今已不存在的时代。

They study ancient history. 他们研究古代的历史。

antique 古代的：指古代传下来的。

It is an antique trade route to the Orient. 这是一条古代通往东方的经商路线。

old 年老的：普通的用词。

He is quite happy in his old ages. 他老来很快乐。

3. entertainment *n.* ①招待，款待；招待会：give an entertainment to sb. 招待某人。②娱乐；消遣，乐趣：A cinema is a place of entertainment. 电影院是公众娱乐场所。

［近义词］amusement,recreation,diversion,enjoyment,fun,pastime,play,cheer,pleasure,show,spectacle,sport,satisfaction *n.* 招待，款待，表演会，文娱节目

banquet,feast,dinner *n.* 招待会，宴会

［辨析］**entertainment 游艺会**：指目的在于使来宾快乐的集会，也有饮料或食物招待。

Last night we held a farewell entertainment. 昨晚我们举行了欢送会。

banquet 宴会、酒宴：指食物丰盛或正式的宴请。

We gave them a splendid banquet yesterday. 昨天我们设盛宴招待他们。

feast 宴会：普通的用词。

They sang at a wedding feast. 他们在婚宴上唱歌。

4. paradox *n.* ①似是而非的议论；乍听正确实则自相矛盾的话："More haste,less speed"is a paradox. "欲速则不达"是似是而非的隽语。②矛盾的事；有矛盾之处的人(事)：It is a paradox that in such a rich country there should be so many poor people. 这样一个富国中有那么多穷人，这是一种矛盾的现象。

［近义词］absurdity,ambiguity,enigma *n.* 似是而非的论点

［辨析］**paradox 似是而非的论点**：指表面上看来似乎与事实或一般常理相背，但实际上却蕴含着真理，或至少有一半是真实的。

"More haste less speed"and"The child is father to the man"are paradoxes.

"越急越慢"与"儿童乃成年人之父"都是似是而非的论点。

absurdity 荒谬：指不合理的和可笑的，显然与常识、理性相悖的行为或言论。

This book contains multitudinous absurdities. 这本书有许多荒谬之处。

ambiguity 意义含糊：指可能有两种以上含义的词句或意义含糊的话。

In making a contract,ambiguities should be avoided. 订合同时应避免使用意义含糊的词。

enigma 谜：指令人迷惑的问题、人物、事物或情况。

To most of the audience, the philosopher seemed to speak in enigmas. 对于大部分的听众来说，那哲学家所说的似乎是谜语。

5. sanction *n.* ①批准；允许；认可：without the sanction of the author 未经作者同意 ②制裁：moral sanction 道德制裁 ③约束力：Poetry is one of the sanctions of life. 诗是一种人生道德的影响力。*vt.* ①接受；批准；认可：The wrong use of the word is sanctioned by usage. 这词的误用已约定俗成了。②支持，赞许，鼓励

［近义词］penalty, pressure, punitive measure *n.* 法令，制裁

admit, allow, permit, concede, permit, approve, accept, support, endorse, authorize, ratify *v.* 认可，批准，支持

［辨析］**sanction 认准、批准**：一般指权力机关赋予的权利。

Official sanction has not yet been given. 尚未获得官方批准。

admit 允许进入：普通的用词。

Children not admitted. 儿童免进。

allow 允许、许可：它的意思不强烈，有默许之意。

Allow me to introduce Mr. Zhang. 请允许我介绍张先生。

concede 承认、容许：表示客气的用语。

I conceded to his demands. 我容许他的要求。

permit 允许、准许：正式的用词。

Smoking is not permitted here. 此处不准抽烟。

Sentence

From the ancient Greek agora to its modern-day manifestations across the world, urban public spaces such as the square have taken on a variety of functions, ranging from security and trade to relaxation and entertainment, in every society.

从古希腊的市场到现今遍布世界，广场这种城市公共空间在每个社会中都呈现出各种各样的功能，从安全和贸易到休闲和娱乐。

In the 20th century, however, the function of the square has been transformed and the concept of the square has become inherently political. Whereas in the past the square had been a place that society, and perhaps even the government, provided for people to come as individuals to socialize, the functions of a square have been transformed.

然而在 20 世纪，广场的功能已经转变，广场的概念已经变得政治化。过去的广场是社会、甚至政府为人们实现个体社会化的场所，而现今广场的功能已经转变了。

When comparing squares in an authoritarian setting to squares in a democratic one, citizens in democracies have far more latitude and control in determining how public spaces are used. In either setting, however, the square is a public space that the state, to varying degrees, has an interest in regulating.

当比较在专制背景下和民主背景下的广场时，民主背景下的市民在决定公共空间如何使用时有更多的言论自由。然而在另一种背景中，广场是国家有不同程度的兴趣去控制的

公共空间。

To a certain degree, urban public spaces such as squares and plazas are where a city's residents congregate and interact with one another, and where the city's visitors and tourists come to observe local customs.

许多时候，就如广场是城市居民集合和相互交流的场所一样，这种城市空间也是城市参观者和游客来观察当地民俗的场所。

By spending time in each place, observing its inhabitants and their interactions, one can view patterns and behaviors that help us better understand a city, and a nation, in general.

漫游在每个场所，观察居民的相互交流，可以帮助我们更好理解一座城市、一个国家的大众的生活模式和行为。

Translation

第 11 课　城市公共景观：广场的角色

公共广场在所有社会的发展中都扮演了重要角色。从古希腊的市场到现今遍布世界，广场这种城市公共空间在每个社会中都呈现出各种各样的功能，从安全和贸易到休闲和娱乐。例如，在古希腊，公共广场成为了市民的集会场所、苏格拉底的审判地、公众争论的讨论地以及交易的市场。塞思·M·劳尔在《公共广场：公共空间和文化政治》中写到，广场是"社会和道德自由的主要建筑表达。"不管是为了休闲、安全，还是为了社会资本的发展，广场从过去到未来都将是所有社会，特别是开放、自由和民主社会中最基本的内容。

然而在 20 世纪，广场的功能已经转变，广场的概念已经变得政治化。过去的广场是社会、甚至政府为人们实现个体社会化的场所，而现今广场的功能已经转变了。今日的许多国家，广场不再是所有市民用来讨论修宪或群体交流的场所。在全世界，现代的广场代表着国家的秩序、遵从和权力。

通过广场空间的限定，国家尝试控制人们的行为。然而，现代广场成为了国家和反国家的象征。它代表着国家的秩序和权力，在一些范例中，广场成为了公众抗议的场所。当比较在专制背景下和民主背景下的广场时，民主背景下的市民在决定公共空间如何使用时有更多的言论自由。然而在另一种背景中，广场是国家有不同程度的兴趣去控制的公共空间。这表现出一种矛盾——为公众使用的空间，却由政府控制。在民主国家，这种监督或控制可能非常巧妙。例如，政府可能需要抗议者获得许可才能集会或游行，或者可能安排军队或警卫来避免暴力的发生。通过对比，专制国家的公共空间受控制的程度更为严重，特别是极端压制的时期，这意味着广场只为了国家制裁的目的来使用，比如作为全民动员的象征。不允许未经认可使用"公共"空间。

许多时候，就如广场是城市居民集会和相互交流的场所一样，这种城市空间也是城市参观者和游客来观察当地民俗的场所。城市场所，比如往往象征城市、甚至整个国家中心的广场，也是人民的中心。超越了意识形态和政治，一个人可以在这些场所中感受到文化的活跃和能量。

20 世纪 50、60 年代的莫斯科红场就是专制背景下城市公共空间的历史范例，而纽约

的时代广场或华盛顿特区的国家广场是更为民主背景下的城市公共空间。漫游在每个场所，观察居民的相互交流，可以帮助我们更好地理解一座城市、一个国家的大众生活模式和行为。例如，在时代广场呆一段时间就会告诉观察者许多，不只是有关美国文化，还有关于贫穷、等级/人种问题、资本主义。以这种方式开放公共空间提供开向社会的窗户——巨大图像的简单一瞥。实质上，城市公共空间是对它们所在的广大社会的微缩。

Lesson 12　John Notman and Landscape Gardening in Philadelphia

America in the 1830s was an artistically awkward nation. Having outgrown colonial subordination, she was acutely sensitive of her cultural relationship to England and Europe in general. Her writers were anxiously searching for their position in world literature. Her painters were trapped between their European training and their American patrons. All her artists were looking for that quality which made America different. One outgrowth of this cultural search was the glorification and celebration of America's untamed landscape; another was the rise of American landscape design.

John Notman (1810—1865) was a leading Philadelphia architect who also became one of America's first landscape gardeners, the contemporary name for a landscape architect. Typical of the decades before the Civil War, Notman's commissions included rural cemeteries, country residences, and public pleasure grounds.

When John Notman arrived in Philadelphia in 1831, he found a city and a region that was uncommonly interested in horticulture and gardening; this was not a recent development. As one modern writer explains:

This horticultural preeminence is not due to a sudden discovery of the suitability of the climate to gardening, but it was revealed to the colonists, who recognized the possibilities of the country at an early date.

From its inception, Philadelphia had been planned by Penn to be a "green country town" where each house was surrounded by a small garden. The original plan, comprising a central square and four equidistant outlying squares, was unfortunately never fully executed. In 1801, the city waterworks in Center Square was completed and the grounds landscaped according to the designs of Benjamin Henry Latrobe (1756—1833). Carved wood figures of Nymph and Bittern by William Rush (1756—1833) decorated the fountain in front of the pump house. In 1812, the city purchased five acres at the base of Fairmount along the Schuykill River, and the waterworks and Rush's statue were moved to this new site. Franklin Square, the northeast one of the four peripheral squares, was laid out in 1824 with a fountain, gravel walks, and various plantings, as designed by Rush. This square was maintained until 1883 when direct cement walks replaced the more intricate pattern devised by Rush. Examples such as these show that there was some interest in landscape planning on the part of the City of Philadelphia.

The private sector shared official Philadelphia's enthusiasm for landscape planning. Several men had demonstrated and interest in horticulture and gardening as early as the 1730s. Probably the first important colonial American horticulturalist was John Bartram who began to collect American plants and seeds around 1730. Bratram sent many of these

specimens from is farm on the eastern bank of the Schuylkill River below Philadelphia to his friend and fellow botanist, Peter Collinson, in England.

Both John Bartram and James Logan, Secretary of the Province, did experimental planting at the request of European scientists. Bartram's garden remained the only major horticultural garden in Philadelphia until the time of John Notman. Other fine gardens in the Philadelphia area included those built by Henry Pratt at the head of Fairmount Bay and by William Hamilton at the Woodlands, also along the banks of the Schuylkill River. A contemporary of Bartram, Henry Pratt developed a fine garden with the aid of his gardener, Robert Buist. Known as "Pratt's garden" or Lemon Hill, the name of the house, the grounds were considered the finest example of a formal or "geometric" style in America. A greenhouse was also located on the grounds. The gardens around the Woodlands, the estate of William Hamilton, were begun in 1786 and improved in 1802—1805 when the botanist, Frederick Pursh, live there briefly and introduced many forms of American plants. These three gardens and several others in the vicinity were still maintained and open to the public when Notman arrived in Philadelphia in 1831.

In the area of Pennsylvania near Philadelphia, several other important examples of horticulture and gardening were in existence in the 1830s. John Bartram's cousin, Humphry Marshall, established in 1773 an arboretum on his farm near Marshalltown, Pennsylvania. In 1785 Marshall published in Philadelphia his Arbustrum Americanum——the American Grove, or an Alphabetical Catalogue of Forest Trees and Shrubs, native to the American United States. Influenced by Marshall, Samuel and Joshua Pierce established Longwood Arboretum in 1800 at Longwood, Pennsylvania. Finally, in 1832, a group of contributors met to discuss the planting of the grounds of Haverford College, which was opened the following year. Under the direction of William Carvill, an English gardener, 495 trees were planted on the grounds in the form of an orchard and ornamental plantings for the college building. Thus, when John Notman arrived in Philadelphia, he found an enthusiasm for gardening and horticulture and many citizens eager to employ his talents as a landscape gardener.

Notes

1. John Notman　约翰·诺特曼

John Notman (1810—1865), a well known American architect, was born in Scotland and educated at the Royal Scottish Academy. Prior to immigrating to the United States in 1831, Notman worked for the office of William Henry Playfair. After arriving in America, he eventually settled in the City of Philadelphia, Pennsylvania where one of his first commissions was the Laurel Hill Cemetery in 1835. Notman was also a founding member of the American Institute of Architects and was committed to establishing professionalism in

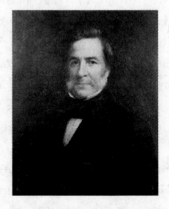

Fig. 12-1　John Notman

the practice of architecture in the United States.

约翰·诺特曼(1810—1865)，美国著名建筑师，出生于苏格兰，在苏格兰皇家学院接受教育。1831 年移民美国之前，诺特曼为威廉·亨利公正事务所工作。在抵达美国之后，他最终定居在宾夕法尼亚的费城，他在那里的首个设计任务是 1835 年的劳来丘墓园。诺特曼也是美国建筑师协会的创立者之一，并为在美国建筑师行业的职业化做出贡献。

Some of Notman's notable commissions were for the Episcopal Church and include:

诺特曼设计的著名项目是为圣公会而做，其中包括：

St. Mark's Church, Philadelphia, 1849;

圣马克教堂，费城，1849;

Emmanuel Church, Cumberland, Maryland, 1851;

灵光堂，坎伯兰，马里兰州，1851;

St. Peter's Church, Pittsburgh, 1851;

圣彼得教堂，匹兹堡，1851;

St. Clement's Church, Philadelphia, 1857;

圣克来孟教堂，费城，1857;

The Cathedral Church of St. John the Evangelist, Wilmington, Delaware, 1858;

圣若望主教座堂，维明顿，特拉华州，1858;

The Church of the Holy Trinity, Philadelphia, 1859;

圣三一教堂，费城，1859;

St. Thomas Episcopal Church, Glassboro, New Jersey;

圣托马斯主教教堂，葛拉斯堡罗，新泽西;

Chapel of the Holy Innocents, Saint Mary's Hall, Burlington, New Jersey;

圣洁无罪堂，圣玛丽堂，柏林顿，新泽西;

St. Paul's Episcopal Church, Trenton, New Jersey.

圣保罗主教教堂，特伦顿，新泽西。

2. Philadelphia 费城

Philadelphia is the largest city in Pennsylvania and the sixth most populous city in the United States. It is the fifth largest metropolitan area and fourth largest urban area by population in the United States, the nation's fourth largest consumer media market as ranked by the Nielsen Media Research, and the 49th most populous city in the world. A popular nickname for Philadelphia is The City of Brotherly Love.

费城是美国宾夕法尼亚州最大的城市，也是美国第六人口多的城市。在美国，费城都市区域面积排第五，城市区域排第四，尼尔森媒介研究将费城列为美国第四大消费市场，人口在全世界城市中排第 49 位。费城最流行的别称是友爱之市。

Philadelphia's architectural history dates back to Colonial times and includes a wide range of styles. The earliest structures were constructed with logs, but brick structures were common by 1700. During the 18th century, the cityscape was dominated by Georgian architecture, including Independence Hall. In the first decades of the 19th century, Federal architecture and Greek Revival architecture were popular. In the second half of the 19th

century, Victorian architecture was common. In 1871, construction began on the Second Empire-style Philadelphia City Hall. Despite the construction of steel and concrete skyscrapers in the 1910s, '20s and '30s, the 548 ft (167m) City Hall remained the tallest building in the city until 1987 when One Liberty Place was constructed. Numerous glass and granite skyscrapers were built from the late 1980s onwards. In 2007, the Comcast Center surpassed One Liberty Place to become the city's tallest building.

 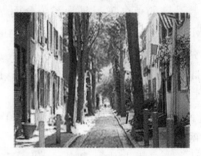

Fig. 12-2 Philadelphia　　Fig. 12-3 A street in the Washington Square West neighborhood

费城的建筑历史可以追溯到殖民时代，包括各种各样的风格。最早的建筑是用木材建造的，但到 1700 年砖石建筑变得很普遍。在 18 世纪，城市景观主要是乔治式建筑，其中就包括独立厅。在 19 世纪的头十年里，联邦建筑和希腊复兴建筑变得流行起来。19 世纪后半叶，维多利亚式建筑变得普遍。1871 年，开始建造第二帝国风格的费城市政厅。尽管在 20 世纪头十年到 20 世纪 20、30 年代建造了许多钢铁和混凝土的摩天大楼，但是 548 英尺（167 米）的市政厅仍是城市最高建筑，直到 1987 年自由广场一号大厦建成。无数玻璃和花岗岩的摩天楼从 20 世纪 80 年代开始陆续建造。在 2007 年，康卡斯中心超过了自由广场一号大厦成为了城市最高的建筑。

Philadelphia contains many national historical sites that relate to the founding of the United States. Independence National Historical Park is the center of these historical landmarks. Independence Hall, where the Declaration of Independence was signed, and the Liberty Bell are the city's most famous attractions. Other historic sites include homes for Edgar Allan Poe, Betsy Ross, and Thaddeus Kosciuszko, early government buildings like the First and Second Banks of the United States, Fort Mifflin, and the Gloria Dei (Old Swedes') Church National Historic Site.

Fig. 12-4 Row houses in West Philadelphia　　Fig. 12-5 Independence Hall in Philadelphia

费城有许多有关美国建国的国家历史遗产。国家独立公园是这些历史遗迹的中心。独立厅是签署独立宣言的场所，自由钟是费城最著名的名胜。其他历史遗迹包括埃德加·爱伦·坡，贝齐·罗斯和萨丢斯·科什乌兹科的居住地；第一和第二国家银行、密夫林堡垒等早期政府办公建筑；荣耀(古瑞典语)教堂国家历史遗址。

Philadelphia's major science museums include the Franklin Institute, which contains the Benjamin Franklin National Memorial, the Academy of Natural Sciences, and the University of Pennsylvania Museum of Archaeology and Anthropology. History museums include the National Constitution Center, the Atwater Kent Museum of Philadelphia History, the National Museum of American Jewish History, the African American Museum in Philadelphia, the Historical Society of Pennsylvania. Philadelphia is home to the United States' first zoo and hospital.

费城的主要科学博物馆包括收藏了富兰克林国立纪念像的富兰克林学院，以及自然科学院和宾夕法尼亚州大学考古与人类博物馆。历史博物馆包括国家宪章中心、阿特沃特·肯特费城历史博物馆、美国犹太人历史国家博物馆、费城非裔美国人博物馆以及美国宾州历史学会。费城是美国首个动物园和医院的所在地。

3. Philadelphia Had Been Planned by Penn 潘对费城的规划

Penn's conceptions of Philadelphia may be characterized as one of the earliest attempts at utopian city planning, and they certainly represented the most extensively 'pre-planned' American city at that time. Paradoxically, Penn's early plans grew from his love of the country estate, as opposed to the metropolis. Much of his wealth was derived from rents from his rural properties in England and Ireland. Perhaps self-exculpatory, he viewed moneys gained from the as land less morally tainted than those gained in trade. Thus his original vision of a "greene Country Towne" seeks to replicate this model of life in the New World. The first plan called for individual houses to be separated from their neighbors by sizable areas of green, thus replicating the gentleman's farm that he so loved.

潘对费城的构思是乌托邦式城市规划的最早尝试之一，它们绝对是那个时代经过大规模"前期规划"的美国城市的代表。相矛盾的是，潘的早期规划来源于他对乡村地区的热爱，而不是大都市。他的财富大部分来自英格兰和爱尔兰的乡村资产获得的租金。可能是自我开脱，他认为从土地获得的金钱要比从贸易中获得的金钱干净。因此，他最初的"绿色乡村城镇"的观点是要寻求在新世界中复制这种生活模式。首个规划提倡以大小相当的绿色面积来相互分隔个体住宅，因此复制出他所喜爱的绅士农场的效果。

Though Penn envisioned country estates, he could scarcely ignore the occupation of most of his colony's investors. They were tradesmen, and trade would be the economic engine of the new city. So, in addition having to fertile farm lands, the "towne" would still have to be accessible to trading ships. It would be situated "in the most convenient place upon the river for health & Navigation. "

虽然潘预想的是乡村产业，但是他并没有忽视投资者这个最主要的居住者。他们是商人，而商业将成为新城市的经济动力。于是，除了有可以耕作的土地，"城镇"仍必须是商贸船只可以直接到达之处。它将"为了健康和通达性而位于河流最方便的之处。"

Centered in the 10000 acres that Penn set aside for his 'great towne' was the 1200 acre site of Philadelphia. This land formed a rectangle joining the Schuylkill and Delaware rivers, and would form the commercial heart of his towne, while 80 acre gentleman's estates would surround this core. Each of these mansions was to be set at least 800 feet from its neighbor and be surrounded by fields and gardens. He also kept the concept of a greenbelt encircling the metropolis, itself a forerunner of the modern suburb. In his revised plan Penn provided a generous amount of room for expansion, far more than in any other contemporary American city. Penn thus anticipated two major trends in city development: rampant growth, and the desire for a bourgeois semi-urban enclave. As well, his plans for the towne proper assume that each house will have its own space for a garden. His plans certainly varried from the cramped cities of Europe, and have garnered much praise, condemnation, and speculation ever since he first published them.

潘的"伟大城镇"的 10000 英亩土地的中心是费城的 1200 英亩基址。这块土地呈矩形，连接起司库河和特拉华河，形成他的城镇商贸中心，而 80 英亩的绅士房产将围绕这个核心。每个高楼都至少和它的邻居保持 800 英尺的距离，并有场地和花园围绕。他也保持了绿化带围绕大都市的理念，其本身就是现代市郊的先行者。在他经过修改的规划中，潘提供了大量的空间用于城市扩展，超越了其他任何同时代的美国城市。因此潘在城市发展中主要有两个倾向：快速增长；对中产阶级半城市围合领土的期望。还有，他的城市规划为每个住宅都设计了自己的花园空间。他的规划当然与欧洲空间狭窄的城市不同，在他首次公布规划开始，就受到了许多的赞扬、批评和审核。

Penn first advertised the layout of his town in Thomas Holme's Portraiture of the City of Philadelphia, published in 1683. As one can see, Penn designed the city as a rectangular gridiron. Broad and High streets cross each other at 'centre square' and divide the city into four quadrants.

潘首次在 1683 年出版的汤玛斯·荷姆所著的《费城城市描绘》中公布了他的城市规划平面。就如下图所示，潘将城市设计成了一个矩形网格结构。宽而高的两条大街在"中心广场"周围穿越，并将城市分成 4 个部分。

Fig. 12-6 Penn's plan of the City of Philadelphia

These 100 foot wide avenues were at broader than the other street, and broader than any street in London. Penn may have been influenced by Richard Newcourts plans for rebuilding burnt out parts of London, or perhaps by new garrison towns like Londonberry Ireland. In any case, his wide, open, rectilinear design was somewhat revolutionary, though today seems 'normal' for most American cities.

这两条 100 英尺宽度的街道比其他街道宽，比伦敦的任何街道都宽。潘可能受到了理查德·纽考茨的伦敦火后重建规划的影响，或者可能受到新驻军城镇的影响，像是伦敦德里县爱尔兰。任何情况下，他的宽阔、开放的矩形设计都有几分革命性，虽然对于今天的大多数美国城市来说似乎"很正常"。

Penn planned for the city's principal public buildings, the meeting house, school, state house, to border centre square. As the map indicates, lots were evenly spread across the width of the city, with the prime real estate facing first the Delaware, and second the Schuylkill river. Penn originally planned to situate his own house near the Schuylkill, at Fairmount, close to the place where the city's famed Water Works, and then Museum of Art would stand. The lots marked off on the map were either one acre or half an acre in size, plenty large enough for all to plant their own gardens. Even the city dweller could live in a country-esque manner. Additionally, each quadrant contained additional green-space in the form of a small park.

潘为城市规划了主要的公共建筑，从会议建筑、学校、州政府到宽阔的中心广场。就如地图所示，街区最终分布在整个城市宽度内，主要居住地面对的首先是特拉华河，其次是司库河。潘最初将自己的住宅规划在费尔蒙特靠近司库河的地方，那里靠近最终成为艺术博物馆的所在地，著名的城市供水工程离那里也很近。地图上标示出的、一英亩或半英亩的街区尺度，足够所有人种植自己的花园。即使城市的居住者也能以乡村生活方式来生活。另外，每四分之一城市区域内都有以小型公园形式出现的附属绿色空间。

Penn was so interested in parks and gardens in part because he realized some of the dangers inherent in the 17th century city. He had lived through London's bubonic plague of 1665 and great fire of 1666. And so it is not surprising that he envisioned his "greene towne" as one "which will never be burnt, and always be wholesome." Sadly, a little over one hundred years after Penn established his city, Philadelphia would be devastated by a series of yellow fever epidemics. The dream of a "wholesome" city was seriously compromised by the "stinking miasmas" of disease. Though like Penn, city leaders once again found salvation in both "greening" and "cleaning" the towne with the establishment of the Fairmount Water Works, and its surrounding park. His contributions in planning the city were far reaching, both locally and nationally. His likeness atop City Hall (at Centre Square) was deemed to be the limit for building height until the mid 1980s; then Penn's statue always looked down on his city. As well, his rectilinear street layout, his interest in 'suburban' development, and his desire to plan the perfect city, all foreshadowed many future city planning 'innovations'.

潘对公园和花园如此感兴趣，部分是因为他认识到 17 世纪城市固有的一些危险。他经历了 1665 年鼠疫灾难和 1666 年的大火。他将自己的"绿色城镇"想象成一个"决不会被烧毁，永远洁净"的地方就毫不奇怪了。不幸的是，在潘建立他的城市一百年后，费城

就遭受了一系列黄热病的侵害。"洁净"城市的梦想受到了疾病的"非常讨厌的臭气"的破坏。虽然像潘一样，城市的领导者曾经再一次努力通过蒙城供水工程的建立来"绿化"和"清洁"城镇。威廉·潘对城市规划的影响是深远的，不管是对当地还是对整个国家。他设计的位于顶部的市政厅（在中心广场）直到 20 世纪 80 年代都是建筑高度的最高限度；潘的雕像一直俯视着他的城市。还有，他的矩形街道平面，他对"郊区"发展的兴趣，以及他对规划完美城市的期望，都预示了许多未来城市规划的"改革"。

4. Fairmount 费尔蒙特

Fairmount is a United States neighborhood in the North Philadelphia area of Philadelphia, Pennsylvania. The name "Fairmount" itself derives from the prominent hill on which the Philadelphia Museum of Art now sits, and where William Penn originally intended to build his own manor house. Later, the name was applied to the street originally called Hickory Lane that runs from the foot of Fairmount hill through the heart of the neighborhood. The area is sometimes referred to as the "Art Museum Area", for its proximity to the Art Museum.

Fig. 12-7 Fairmount Park—Water Works Looking Upstream on the Schuykill River

费尔蒙特是位于美国宾夕法尼亚州费城北区的街区。"费尔蒙特"这个名称来源于现今费城艺术博物馆所在的小山，威廉·潘最初是想在那里建造自己的庄园。随后，这个名称被用于原名为山核桃巷的街道，这条街道从费尔蒙特山一直到达街区的中心。这个区域有时被称为"艺术博物馆区"，因为它靠近艺术博物馆。

Definitions of the boundaries of Fairmount vary. A more intimate definition of the neighborhood, and the one most commonly used, places the boundaries at Fairmount Avenue to the south, Poplar Avenue to the north, the Schuylkill River to the west, and 19th Streets to the east.

费尔蒙特的边界有各种各样的定义。最明确的街区限定，也是最普遍使用的，是南到费尔蒙特街，北到白杨街，西到司库河，东到第 19 大街。

A handful of European settlers farmed the area in the 17th, 18th and early 19th centuries, when Fairmount was still outside Philadelphia's city limits. Prominent city families established countryseats there as well, including Bush Hill, White Hall, and Lemon Hill, the last of which still stands overlooking the Schuylkill.

一些来自欧洲的定居者在 17、18 和 19 世纪早期来到这里耕种土地，当时费尔蒙特仍位于费城城市区域之外。城市中显赫的家族在那里建立了乡间别墅，包括布什·希尔庄园，怀特厅和雷蒙·希尔庄园，而雷蒙·希尔庄园至今仍在那里俯视着司库河。

During the American Revolution, British soldiers occupying Philadelphia built defensive works starting on the hill of Fairmount and continuing several miles along a line just south of present-day Fairmount Avenue to the Delaware River. Their purpose was to prevent American troops under George Washington from attacking them from the north——

the only side of the city not protected by water.

在美国独立战争期间，英国士兵开始在费城费尔蒙特的小山上建造防御工事，工事沿着现今费尔蒙街以南的线路绵延数里，一直到达特拉华河。他们的目的是阻止乔治·华盛顿领导的美国军队从北面攻击他们——城市唯一没有河流保护的一面。

It was also an architectural and scenic attraction. Its buildings, which included a restaurant, are among the earliest examples of Greek Revival architecture in the United States. Protection of the municipal drinking water that the Water Works pumped was the impetus for the purchase of lands along the Schuylkill that later became Fairmount Park, one of the world's largest municipal park systems.

费尔蒙特也吸引了建筑师和科学家的注意。它的建筑，包括一座餐馆，是美国古希腊复兴建筑的最早范例。供水工程的城市饮水保障成为了人们购买司库河岸土地的推动力，这片区域随后成为费尔蒙特公园——世界最大的城市公园系统之一。

Fairmount continues to be one of Philadelphia's most desirable neighborhood owing its location near the Philadelphia Museum of Art, its famous "Rocky Steps" (immortalized in the 1976 Academy Award film, "Rocky"), Fairmount is located at the end of the Benjamin Franklin Parkway, a broad 1.5 mile tree and flag-lined avenue that connects City Hall to the Philadelphia Museum of Art. This stretch is known as the "Museum District" since most of the city's cultural attractions and museums are located here. Along the Parkway are the Rodin Museum, Philadelphia's Central Library, the Franklin Institute of Science, the Academy of Natural Sciences and the soon to be relocated Barnes Museum. The city's panoramic skyline is best viewed from the steps of the Art Museum.

费尔蒙特继续发展成为费城最理想的街区要归功于它靠近费城艺术博物馆的地理位置，和著名的"洛基之路"（以 1976 年奥斯卡获奖电影"洛基"而闻名于世）。费尔蒙特位于富兰克林大道的终点，富兰克林大道是一条宽 1.5 英里、树木和旗帜成行排列的大道，联系起市政厅和费城艺术博物馆。因为绝大多数费城的文化设施和博物馆都位于此，所以这条大道的周围区域被称为"博物馆区"。沿着富兰克林大道依次是罗丹博物馆、费城中心图书馆、富兰克林科学研究所、自然科学院以及很快会重新在此地建造的巴尼斯博物馆。

Fig. 12-8　Fairmount Park, 1870

Fig. 12-9　The Fairmount Water Works on the Schuylkill River were once the source of Philadelphia's water supply and are now an attraction in Fairmount Park

Behind the Philadelphia Museum and along the Schuylkill River are the historic Fairmount Water Works and picturesque Boat House Row. These boathouses and rowing clubs host several regattas each year. Atop one of the bluffs overlooking the river is the historic Lemon Hill Mansion.

在费城博物馆后面，沿着司库河是古老的费尔蒙特供水工程和景色如画的联排船屋。这些船屋和成排的俱乐部每年都举行许多赛船会。在俯视河流的悬崖顶部，就是古老的雷蒙·希尔庄园。

Fairmount's homes were generally smaller row or town houses and the residents were generally working class. Here row houses were interspersed with lumber yards, coal yards, lime yards, iron foundries, bakeries, dry goods stores, as well as several wagon works and stables. Many of these were built in the second half of the 19th century to support small factories and later the large breweries that located there in the late 1800's and reached their zenith in the early 1900's. One of these breweries with its many ancillary buildings has been painstakingly preserved and turned into fashionable condominiums. Of architectural note is Aspen Street's "Centennial Block".

费尔蒙特的住宅一般是较小的联排或复式住宅，居民一般是工人阶级。这里的联排住宅中间点缀有木材场、煤炭场、石灰场、铸造车间、面包房、干燥食品仓库，以及许多车辆工厂和马房。其中许多都是在 19 世纪后半期建造，以方便小型工厂使用，18 世纪建于此地的大型酿酒厂在 19 世纪早期达到顶峰。一座附属建筑众多的酿酒厂被保存下来，变成了时尚的公寓。著名的建筑景点是白杨街的"百年街区"。

Fig. 12-10 Centennial Block Built by the National Bank of Bellows Falls in 1875

5. The Schuykill River 司库河

The Schuylkill River, is a river in the U.S. Commonwealth of Pennsylvania. It is a designated Pennsylvania Scenic River.

司库河位于美国宾夕法尼亚州。它被指定为宾夕法尼亚河流风景区。

The river is about 130miles (209km) long. Its watershed of about 2000 square miles (5000km²) lies entirely within the state of Pennsylvania. The source of its eastern branch is in the Appalachian Mountains at Tuscarora Springs, near Tamaqua in Schuylkill County. The west branch starts near Minersville and joins the eastern branch at the town of Schuylkill Haven. Wissahickon Creek joins it in northwest Philadelphia. Other major tributaries include the Little Schuylkill River, Maiden Creek, French Creek, and Perkiomen Creek. The Schuylkill joins the Delaware River, of which it is the largest tributary, at the site of the former Philadelphia Navy Yard, now the Philadelphia Naval Business Center, just northeast of Philadelphia International Airport.

Fig. 12-11　The Schuylkill River, looking
south toward the skyline of Philadelphia,
through which the river flows

Fig. 12-12　The Strawberry Mansion
Bridge over the river at dusk

河流大约 130 英里(209 公里)长。它的流域大约 2000 平方英里(5000 平方公里)，全部位于宾夕法尼亚州之内。它东部支流的源头位于塔斯卡洛拉温泉区的阿巴拉契亚山脉，靠近司库郡的塔马奎。西部支流开始于麦诺斯维尔附近，并在司库哈文镇和东部支流汇合。维萨肯河在费城的西北部汇入。其他主要支流包括小司库河、梅登河、法国河、伯科曼河。司库河是特拉华河最大的支流，刚好将费城国际机场东北面的费城海军商业中心(以前的费城海军基地)和特拉华河连接。

6. Franklin Square　富兰克林广场

Franklin Square is one of the five original open-space parks planned by William Penn during the late 17th century in central Philadelphia, Pennsylvania.

富兰克林广场是 17 世纪后期威廉·潘规划的 5 个最初的开放空间之一，位于宾夕法尼亚州的费城。

Originally called Northeast Square, Franklin Square was renamed in 1825, to honor Benjamin Franklin, one of the most prominent Founding Fathers of the United States and a leading printer, scientist, inventor, civic activist and

Fig. 12-13　Franklin Square

diplomat. The myth persists that Franklin conducted his famous (though misunderstood) "kite and key" experiment on this spot, no doubt encouraged by the presence of Bolt of Lightning, Isamu Noguchi's the massive steel sculpture that faces the Square and erected in 1984.

最初被称为东北广场，富兰克林广场在 1825 年更名，是为了纪念本杰明·富兰克林——最杰出的美国创立者之一，也是著名的作家、科学家、发明家、活动家和外交家。传说富兰克林在这里进行了他著名的(虽然是误解)"风筝"试验，毫无疑问是因为"一道闪电"——野口勇创作的面朝广场、树立于 1984 年的雕塑——所产生的误解。

In its early years, the square was an open common used for grazing animals, storing gun powder (during the American Revolution) drilling soldiers (during the War of 1812). From 1741 to 1835, a portion of the Square was used as a cemetery by the German Reform Church; some of the graves still remain.

早期，广场是大多用于放牧动物、储存武器(在美国独立战争期间)、演练士兵(在

1812 年战争期间）的开放区域。1741～1835 年，广场的一部分用作德国改革教会的墓地；一些坟墓保留至今。

In the 1920s, a series of events corresponding with the rise of the automobile initiated the decline of the Square and its surrounding neighborhood. The construction of the Ben Franklin Bridge, from 1922～26, leveled blocks of buildings; the Bridge begins at the Square's eastern boundary, 6th Street. The steady flow of cars over the bridge made the Square's northern boundary, Vine Street, into one of the city's busiest thoroughfares, effectively cutting off pedestrian access on two of the Square's sides. The neighborhood's residential character was further eroded by the federal government's plans to establish Independence Mall: in the 1950s and 1960s, the government acquired the private land below Race Street. The construction of the Vine Street Expressway in the late 1980s exacerbated the problem. Franklin Square had become the least-used of Penn's original five squares, mainly an encampment for the homeless.

20 世纪 20 年代，随着汽车出现所引起的一系列问题造成了广场和周围区域的衰落。1922～1926 年，富兰克林大桥的建造提升了这片区域的价值；大桥开始于广场的东部边界——第六大街。

Fig. 12-14　the Living Flame Memorial

桥上稳定的车流使广场的北部万安街成为了城市最繁忙的干道，有效地分离出了广场两边的步行入口。街区的居住特征被联邦政府建造独立厅的规划进一步侵蚀：20 世纪 50 年代和 60 年代，政府获得了礼士街以下的私人土地。20 世纪 80 年代后期建造的万安街高速公路加剧了问题的严重性。富兰克林广场已经变成了潘的最初五个广场中使用率最低的广场，成为了无家可归者的宿营地。

In 1976, the city dedicated the Living Flame Memorial to the city's fallen policemen and firefighters, centered on a sculpture by local sculptor Reginald E. Beauchamp.

1976 年，城市下令建造生命光辉纪念碑来纪念城市牺牲的警察和消防员，由当地雕塑家雷金纳德・E・伯查创作。

The square was refurbished and rededicated in July 2006, Franklin's tercentenary year. Complete with the Philadelphia Park Liberty Carousel, Philly Miniature Golf, new playgrounds and a restored 19th-century fountain, Franklin Square is now touted as an entertainment destination near Independence National Historical Park.

广场在 2006 年——富兰克林诞辰三百周年——进行了更新和重新开放。广场由费城公园自由酒会、菲力迷你高尔夫、新运动场和保留下来的 19 世纪喷泉组成。富兰克林广场现在成为了靠近国家独立历史公园的一处娱乐场所。

7. Woodlands　伍德兰

The Woodlands is a National Historic Landmark District on the western banks of the Schuylkill River

Fig. 12-15　The Woodlands Mansion

in Philadelphia. It includes a magnificent federal style mansion, a matching carriage house and stable, and a garden landscape that in 1840 was transformed into a "rural" Victorian cemetery with an arboretum of over 1000 trees.

伍德兰是位于费城司库河西岸的国家历史保护区。一座宏伟的联邦风格大厦，以及相匹配的车房和马厩；一所 1840 年被转变成"乡村"维多利亚式公墓的花园景观（其中的植物园种植了超过 1000 棵树），都位于此地。

The Woodlands was originally purchased in 1735 as a 250 acre tract on the west bank of the Schuylkill River by the famous Philadelphia lawyer Andrew Hamilton. When he died in 1741, he willed his lands to his son, also named Andrew, who survived his father but six years. He devised what became a 300 acres estate to his son, William (1745—1813), who acquired it at the age of twenty-one. He built a Georgian style mansion with a grand, two-storied portico overlooking the river. Following a trip to England after the American Revolution, Hamilton doubled the size of the dwelling into a 16-room manor with kitchens and service rooms in a windowed ground floor. The rebuilt Woodlands mansion became one of the greatest domestic American architectural achievements of the 18th century, recognized as a leading example of English taste and presaging architectural trends in the following century.

伍德兰最初是著名的费城律师安德鲁·汉密尔顿在 1735 年购买的司库河西岸 250 英亩土地。当他在 1741 年去世时，把土地留给了也叫安德鲁的儿子，他只比自己的父亲多活了 6 年。他遗赠给他的儿子威廉（1745—1813）的时候变成了 300 英亩地产，威廉在他 21 岁时获得了这片土地。他建造了一座乔治风格的公馆，有宏伟的两层高的门廊俯视河流。在美国独立战争后，威廉·汉密尔顿到英格兰旅行后，把住所扩大成原来的两倍，变成一座有 16 个房间的庄园，在开窗的地面层中有厨房和服务房间。重建的伍德兰公馆成为了 18 世纪美国本土建筑最大的成就之一，被认为是英国品味的主导范例，预示了下一个世纪的建筑倾向。

Following Hamilton's death in 1813, his heirs sold off much of the Woodlands estate for institutional and residential development. By the first quarter of the 19th Century, the West Philadelphia district was becoming a fashionable suburb. In 1840, The Woodlands Cemetery Company of Philadelphia purchased the last 92 acres, which included the mansion, carriage house, greenhouse, as well as extensive plantings. The founders concluded The Woodlands' isolated location, its array of exotic trees and its commanding view of the Schuylkill River provided an ideal site for a rural cemetery.

随着 1813 年汉密尔顿去世，他的继承人把大部分伍德兰地产出售，用于机构和居住建筑发展。在 19 世纪的前 25 年里，西费城区域正在变成一个时尚的郊区。1840 年费城伍德兰公墓公司购买了最后 92 英亩土地，其中就包括公馆、车房、温室以及室外种植。伍德兰公墓公司创办者结束了伍德兰与世隔绝的位置，它的外国树种阵列和司库河的俯瞰视景提供了一处乡村公墓的理想场地。

8. Haverford College　哈沃福特学院

Haverford College is a highly selective, private, coeducational liberal arts college located in Haverford, Pennsylvania, a suburb of Philadelphia.

哈沃福特学院是位于宾夕法尼亚州费城郊区哈沃福特的一所具有高度选择性、私立的、男女同校的文理学院。

The college was founded in 1833 by area members of the Religious Society of Friends (Quakers). It is the oldest college or university in the United States with Quaker origins. Although the college no longer has a formal religious affiliation, the Quaker philosophy still influences campus life. Originally an all-male institution, Haverford began admitting female transfer students in the 1970s, and became fully co-ed in 1980 when the board of managers came to consensus on a proposal initiated by former president John R. Coleman. The reason for the delay was not because of a lack of interest in coeducation in prior years, but rather a concern for how such a change would impact Haverford's relationship with neighboring, all-female Bryn Mawr College. As of 2007, more than half of Haverford's students are women.

Fig. 12-16　Haverford College

学院成立于 1833 年，由贵格会（教友派）的地区成员创立。它是美国教友派起源的最古老学院或大学。虽然学院不再有正式的宗教附属关系，但是教友派哲学仍影响到了学校生活。最初是男校，哈沃福特于 20 世纪 70 年代开始接收女性交换学生，并于 20 世纪 80 年代成为完全的男女同校，当时管理委员会就前主席约翰·R·科尔曼提出的方案达成一致。有所耽搁的原因不是因为在前几年对男女同校教育缺乏兴趣，而是担心这种改变将会对哈沃福特和他的邻居女校布林茅尔学院的关系产生怎样的影响。到 2007 年，有超过一半的哈沃福特的学生是女生。

All students at the college are undergraduates, and almost all live on campus. Haverford remains one of the smallest of the nation's elite liberal arts colleges. For most of the 20th century, Haverford's total enrollment was kept below 300. It went through two periods of expansion after 1970's, and its current enrollment is 1168 students.

学院所有学生都是大学生，几乎全都住在校园。哈沃福特仍是最小的国家精英文理学院之一。20 世纪的绝大多数时间里，哈沃福特全部在册学生人数保持低于 300 人。在 20 世纪 70 年代后他经历了两个扩张时期，现在的在册学生人数是 1168 人。

Haverford has been described as "quietly prestigious", and has been classified by Princeton Review as one of most difficult schools to get into-ranked 18 among all US colleges and universities in "The Toughest to Get Into" category. It placed ninth in the U. S. News and World Report rankings of U. S. liberal arts colleges in both 2006 and 2007, and tenth in 2008.

哈沃福特被描述为"安静的、声望很高的"学校，被"普林斯顿评论"列为为最难以进入的学校之一——在所有美国学院和大学的"最难进入"排名中排第 18 名。它在《美国新闻与世界报道》2006 年和 2007 年的美国文理学院排名中列第 9，2008 年列第 10。

The Haverford College Arboretum (216 acres) is an arboretum located across the campus of Haverford College, in Haverford, Pennsylvania. It is open daily without charge.

哈沃福特学院植物园（216 英亩）是位于宾夕法尼亚州哈沃福特学院校园的植物园，每天免费开放。

The arboretum's beginnings stretch back to 1831, when the campus property was purchased. The college itself was founded two years later. In 1834 William Carvill laid out the campus in a style influenced by noted landscape architect Sir Humphry Repton.

植物园的开放可以追溯到 1831 年，当时刚购买了校园地产。学院本身在两年后建立。1834 年，威廉·卡维在著名景观建筑师亨弗利·雷普顿爵士的影响下规划校园。

Vocabulary

1. **patron** *n.* ①(对某人，某活动，某艺术等的)赞助人，支持者；保护人；恩主：a patron of the arts. 艺术事业的赞助者 ②主顾；(旅店等的)老板；(慈善协会等的)主席 ③［宗］保护圣徒；守护神；(英国教会中)有授予牧师职权的人：patron saint 保护圣徒，守护神 *adj.* 守护的

［近义词］guardian, protector, defender, custodian, benefactor, benefactress, backer, supporter, helper *n.* 保护人

buyer, client, shopper, frequenter, purchaser *n.* 老顾客，主顾

sponsor, subseriber, contributor, promoter, financier, guarantor, underwriter, surety, philanthropist, angel *n.* 赞助人，资助人

［辨析］**patron** 赞助人：指对某人、某种目标、艺术等予以资助的人。

Modern artists have difficulty in finding wealthy patrons. 现代艺术家们很难找到富有的赞助人。

sponsor 保证人：指能对某人或某项事业负责的人。

He is the sponsor of the firm. 他是该公司的保证人。

subseriber 捐助者、订阅者：指向某项基金捐助或订阅报刊的人。

I have put down my name as a subscriber for the newspaper. 我已经报名订了这份报。

2. **commission** *n.* ①命令，训令；委任，委托；任务，职权：If you are going to Hong Kong, I have two or three small commissions for you. 你如去香港，我有两三件小事托你办。②委员，委员会；调查团：The Federal Trade Commission investigates false advertising. 联邦贸易委员会调查不实广告。③［商］代办，经纪，手续费，佣金：commission agency 代办业，经纪业 *vt.* ①给予……以职权，委任，任命，命令：I have commissioned the bank to pay my taxes. 我授权银行代我缴税。②委托

［近义词］empower, appoint, assign, name, delegate, charge, bid, order, director, engage, employ, hire, contract, charter *v.* 委任，任命

board, agency, council, committee, delegation, deputation, representatives *n.* 委员会

rank, position, appointment, office, document, certificate, officer's rank, appointment papers, written orders *n.* 军衔，委任状

committing, act, performance, doing, transacting, exercise, conduct, acting out, carrying out *n.* 犯(罪)

bonus, dividend, premium, percentage, cut, portion, piece, fee *n.* 佣金

［辨析］**commision** 佣金、回扣：指请人销售货物，按销量所付的佣金或回扣。

Some salesman in big shops receive a commision of 10% on everything they sell as well

as a salary. 大商店里有些店员除了薪金外，还将得到所售货物金额百分之十的佣金。

bonus 红利：指分给股票持有者额外的利息。

The shareholder receives a bonus every year. 股东每年得到一份红利。

dividend 股息：指商业公司对股东的债款，每股利润定期支付的利息。

The company paid a 10% dividend last year. 该公司去年付出一成股息。

premium 奖金：指为鼓励某种行为或行动所给予的奖金。

Some magazines give premiums for obtaining subscriptions. 有些杂志以奖金招揽新订户。

3. specimen *n.* ①范例，典范 ②样品，样本；标本：He collects specimens of all kinds of rocks and minerals. 他采集各种岩石和矿物的标本。③供检查用的材料，试料；供实验的尿：wool specimens for staple testing 供检验纤维长度用的羊毛试料

adj. 作为样品的

［近义词］sample,pattern,model,representative *n.* 样本；标本

［辨析］**specimen 标本、样品**：指动植物标本或能够代表整体的部分。

He collects specimens of all kinds of rocks and minerals. 他采集各种岩石和矿物的标本。

sample 样品：指足以表示某一事物性质的样品。

This is a collection of samples for museum display. 这是为博物馆展出而收集的样品。

pattern 货样：指布样或做衣服的式样。

It is modelled after the same pattern. 这是照着样子仿制的。

4. Grove *n.* 小树林；树丛：an orange grove 小桔林

［近义词］wood,forest *n.* 森林

［辨析］**grove 小树林**：指地域较小的树林，通常是由人工种植的。

There is a dense grove of evergreen trees. 那儿有一片浓密的常绿树林。

wood 森林：类似 forest，但地域较小且近人烟。

We are living in a house in the middle of a wood. 我们住在林间的一座房屋里。

forest 森林：通常指地域较广，保持有原始的树木，且有野兽栖息的森林。

He lost himself in the forest. 他在森林里迷了路。

5. Catalogue *n.* ①(图书或商品)目录，目录册：catalogue of article for sales 待售品目录 ②［美］(大学的)学校周年大事表，学校便览 *vt.* ①(为……)编目录，(把……)编目：Can you catalogue the VCD sets you sell and send me a copy? 你能不能把你们出售的 VCD 机编成目录送我一份？②(把……)按目录分类 *vi.* ①编目录，编目 ②按目录分类

［近义词］list,group,classify,record,file,index *v.* 为……编目

list,directory,roll,index,listing,record,file,roster,register,inventory *n.* 目录

［辨析］**catalogue 目录**：指有系统的表，一般按字母顺序或其他的系统编制而成。

This article is placed in the catalogue. 这件货物被列在目录里。

1ist 目录、名单：普通的用词，适用于一串名字、数字等。

His name stands first on the list. 他名列第一。

directory 姓名住址录：按字母顺序编成。

I've got a recent issue of telephone directory. 我有一本新出版的电话号码簿。

roll 人名簿：指一个团体的全体名单。

His name is on the honor roll. 他的名字上了光荣榜。

Sentence

Her writers were anxiously searching for their position in world literature. Her painters were trapped between their European training and their American patrons. All her artists were looking for that quality which made America different.

她的作家急切寻求在世界文学中的地位。她的画家陷入学习欧洲和美国顾客之间的尴尬境地。所有的艺术家都在寻求可以使美国与众不同的品质。

One outgrowth of this cultural search was the glorification and celebration of America's untamed landscape; another was the rise of American landscape design.

这种文化寻求的结果之一就是对美国野性景观的赞赏和庆祝；另一个就是美国景观设计的出现。

John Notman (1810—1865) was a leading Philadelphia architect who also became one of America's first landscape gardeners, the contemporary name for a landscape architect.

约翰·诺特曼（1810—1865）是著名费城建筑师，他也成为了美国首批景观园艺家，现在叫景观建筑师。

This horticultural preeminence is not due to a sudden discovery of the suitability of the climate to gardening, but it was revealed to the colonists, who recognized the possibilities of the country at an early date.

这种园艺优势并不是由于对造园气候的适应性而突然出现，而是要向殖民者展现，让他们认识到更早建立国家的可能性。

The private sector shared official Philadelphia's enthusiasm for landscape planning. Several men had demonstrated and interest in horticulture and gardening as early as the 1730s.

私人和费城官方一样对景观设计投入了极大的热情。许多人早在 18 世纪 30 年代就表达出对园艺和造园的兴趣。

Translation

第 12 课　约翰·诺特曼和费城景观造园艺术

19 世纪 30 年代的美国在艺术上处于很尴尬的地位。已经强大到不适合殖民地从属地位，她尖锐地对英国和欧洲大众文化敏感。她的作家急切寻求在世界文学中的地位。她的画家陷入学习欧洲和美国顾客之间的尴尬境地。所有的艺术家都在寻求可以使美国与众不同的品质。这种文化寻求的结果之一就是对美国野性景观的赞赏和宣扬；另一个就是美国景观设计的出现。

约翰·诺特曼(1810—1865)是著名费城建筑师，他也成为了美国首批景观园艺家，现

在叫景观建筑师。在内战前的几十年中，诺特曼的项目包括乡村墓地、乡村住宅以及公共娱乐场地。

当约翰·诺特曼在1831年到达费城时，他发现这个城市和地区对园艺和造园极感兴趣；这并不是最近才有的发展。就如一位现代作家解释到：

这种园艺优势并不是由于对造园气候的适应性而突然出现，而是要向殖民者展现，让他们认识到更早建立国家的可能性。

从一开始，费城就被潘规划成为"绿色乡村城镇"，那里的每个住宅都被小型花园围绕。最初的规划包括一个中心广场和四个等距离向外的广场，不幸的是从未完全实施。1808年，中心广场的城市供水系统完成，根据本杰明·亨利·拉特罗布(1756—1833)的设计建造景观。威廉·罗许(1756—1833)雕刻的"仙女和鸬鹚"木制雕像装饰泵房前的喷泉。1812年，城市在沿着司库河的费尔蒙特基地购买了5英亩的土地，供水系统和罗许的雕像被移到这个新位置。富兰克林广场——四个外围广场之一——在1824年建成，有喷泉、碎石步道和各种各样的植被，就如罗许所设计的。直到1883年，水泥步道取代了广场中罗许设计的更复杂图案。这些范例展现出费城开始对景观规划感兴趣。

私人和费城官方一样，对景观设计投入了极大的热情。许多人早在18世纪30年代就表达出对园艺和造园的兴趣。美国殖民地时期首个重要园艺家可能就是约翰·巴特兰姆，他在1730年就开始收集美国植物和种子。巴特兰姆把从费城下方的司库河东岸农场收集到的许多物种送给了他的朋友和同事——英国植物学家彼得·克林森。

约翰·巴特兰姆和詹姆士·罗根——州长的秘书，都在欧洲科学家的要求下进行了实验性种植。巴特兰姆的花园直到约翰·诺特曼时代一直是费城重要的园艺花园。其他费城的优秀花园包括亨利·普安在费尔蒙特海湾顶端建造的花园，以及威廉·汉密尔顿也沿着司库河河岸在伍德兰建造的花园。巴特兰姆的同时代人，亨利·普安在他的园丁罗伯特·布斯特的帮助下修建了一处美丽的花园，被称为"普安花园"或雷蒙·希尔庄园——住宅的名称，这个花园被认为是美国风格或"几何"风格的最佳范例。花园中还有一个温室。围绕伍德兰威廉·汉密尔顿房产的花园于1786年开始修建，1802～1805年改建，当时植物学家弗雷德里克·普什曾短期生活在那里，并引入了许多美国植物。这三个花园和附近的其他花园，在诺特曼1831年到达费城时仍在向公众开放。

费城附近的宾夕法尼亚地区，一些园艺和造园的重要范例一直保存到19世纪30年代。约翰·巴特兰姆的堂兄汉弗莱·马歇尔于1773年在他的宾夕法尼亚州马歇尔镇附近的农场上修建了一座植物园。1785年马歇尔在费城出版了他的《Arbustrum Americanum》(美国树林，或者美国本地的森林树木或灌木的字母表目录)。受到马歇尔的影响，撒母耳和约书亚·皮尔斯于1800年在宾夕法尼亚州的朗伍德修建了朗伍德树木园。1832年，一群专业人士聚在一起讨论哈弗福德学院的种植，这所学院在下一年开放。在英国园艺师威廉·卡维的指导下，495棵树木被以果园和校园建筑装饰种植的形式种植在地面上。因此，当约翰·诺特曼到达费城时，他发现了费城人对造园和园艺的狂热，许多市民渴望雇他作景观园艺师。

Lesson 13 Garden Cities: Sustainable Design: Past, Present, Future

The history of the sustainability concept, from the industrial revolution to present, was researched and examined to isolate relevant quantifiable and measurable principles that would be useful in architectural, planning, and engineering design. Indicators of sustainability were also researched and found to often lack interrelatedness between each other. A deeper analysis led to the realization that natural flows of nutrients and energy connected these indicators and that an understanding of these cycles and transformations would be necessary to begin to understand their connections.

Several seminal planners and architects dealt with the challenge of incorporating technology and the environment and the work of one, Ebenezer Howard, is examined in detail. Howard's original schematics for Garden City showed that he established an order of community that was tightly integrated with the environment. While Howard's genius appeared directed largely at the urban development, less insight was evident in the open space that separated his proposed matrix of many such Garden Cities.

Even though a great bogy of knowledge has been created concerning countless ecological relationships, we do not, yet, have the knowledge to reproduce a healthy model that is sustainable. It is possible, however, to examine components of such a model, not in isolation or to see simply how it is held in balance by other components, but to determine how the cycles of nature and the naturally occurring flows of energy can be used to heal other damages to an ecosystem while sustaining its own health and growth.

The relationship between the natural environment and the built environment is often viewed as adversarial. The Bible finds God giving man dominion over the animals and at least one well-known environmentalist views man as the most devastating and insidious of parasites. This work develops a view of integrating these environments into a whole that is self-perpetuating and healthy, defined herein as sustainable. It also shows that the designers of the built environment, the architects, engineers, and planners, can assume responsibility for protecting the complex and fragile ecologies that have been damaged in the past if they understand and work with the forces of nature.

Essentially, this work deals with sustainability and defines it as a function of a complex, healthy environment. It examines the environmental damage caused by humans and the actions and concepts that are the current expression of concern. The history of the concept of sustainability is reviewed to introduce both its global and local implications. Indicators of sustainability are quantifiable effects of non-sustainable human activity such as pounds of phosphorus discharged into a stream of parts per million of nitrous oxide expelled into the air. These are

examined because they are often measured individually and not part of the natural flows of nutrients and energy that are shown to be essential in a healthy environment. These flows support the web of life that exists in the natural environment. The designers of the built environment are in a place of responsibility because their structures and infrastructure can be designed in a way that promotes sustainability concepts. The architects, planners, and engineers (APEs), then, will benefit from an unique perspective of sustainable design that is integrated with the natural flows of nutrients and energy.

Current definitions of sustainability and the use of indicators are not directly helpful to APEs. With a general idea of what sustainability is (and isn't), we turn to other sources, based on the typical tri-partite concept of social, environmental, and economic concerns. Nature, community, and energy are familiar areas to the APEs that lead to a useful definition of sustainability. To determine this definition's validity, several city forms and theories are discussed in general terms leading to a closer examination of a definition that has endured for over one hundred years.

Looking at the work of Ebenezer Howard aids in the understanding of the concept of sustainability for APEs. Portions of his book, Garden Cities of Tomorrow, are examined and principles that are useful for APEs. Although written over one hundred years ago, the insights he presented have been referred to and used in many town planning theories and actual constructs around the world. Howard's theories were developed in Victorian England and predated the impact of the automobile and the general employment shift from manufacturing to service industries.

While his understanding of relationship of the variables in the town section of his Garden City was clearly defined, Howard does not describe the country portion with the same detail. The point is made, herein, that the integration of, and harmonious balance between, town and country, urban and rural, built and natural environments more fully defines sustainability. The criteria for a complex model that accommodates the large number of variables required to balance the built and natural environments are developed. As the desired result is a self-sustaining healthy environment (integration of both built and natural).

Notes

1. Sustainability　可持续性

Sustainability, in the broadest sense, is the ability to sustain a certain process or state at a certain rate or level, hence the term: sustain-ability. The concept of sustainability applies to all aspects of life on Earth, however it is commonly defined within ecological, social and economic contexts for clarity. Due to factors such as overpopulation, lack of education, inadequate financial circumstances and the actions of past generations, sustainability can be difficult to achieve.

就广义来说，可持续性是指持续某个过程或保持某种速度或水平的能力，因此由持续—能力组成。可持续性的概念应用于地球生活的所有方方面面，而它在生态学、社会学

Fig. 13-1 Blue Marble composite images generated by NASA in 2001 (left) and 2002 (right)

和经济学领域中有明确定义。由于各种因素，比如人口过剩、缺乏教育、不充分的资金环境和前代人的行为，可持续性很难达到。

To be sustainable, regardless of context, the Earth's resources must be used at a rate at which they can be replenished. There is now clear scientific evidence that humanity is living unsustainably, and that an effort is needed to keep human use of natural resources within sustainable limits. This has brought sustainability to the forefront of public consciousness and is seen by many as being a natural progression in human evolution. Due to its broad definition, sustainability has become a complex term that can be applied to almost every facet of life on Earth, particularly the many different levels of biological organization, such as: wetlands, prairies and forests and is expressed in human organization concepts, such as: ecovillages, eco-municipalities, sustainable cities, and human activities and disciplines, such as: sustainable agriculture, sustainable architecture and renewable energy.

Fig. 13-2 Before flue gas desulfurization was installed, the air-polluting emissions from this power plant in New Mexico contained excessive amounts of sulfur dioxide

不管背景如何，为了获得可持续性，必须在资源可以重生的速度下使用地球的资源。现在，明确的科学证据表明人类生存不可持续，需要做出努力使人类对资源的使用保持在可持续限度内。这就把可持续性带到了公众意识的最前沿，被许多人视为是人类演化的自然发展过程。由于其广泛的定义，可持续性已经变成了一个复杂的词汇，可以被应用于地球生活的方方面面，特别是生物组织的不同层次（比如沼泽、草原和森林）；人类组织概念（比如生态村落，生态城市，可持续城市）和人类活动与学科（比如可持续农业、可持续建筑和可再生能源）。

The skeptics have pointed out that infinite economic growth is impossible on a finite planet, and that Earth's limits also define the limits of all material-based activities. Some contend that the term itself is an oxymoron. In reality, sustainable development has tended to mean nothing more than ecologically more sensitive growth——a slightly reformed status.

怀疑者已指出，有限地球上无限的经济增长是不可能的，地球的限度也决定了所有以材料为基础的活动的限度。一些人主张这个术语本身就是一种矛盾修辞法。现实中，可持续发展倾向于只是对生态更为敏感的增长———一种轻微的改革状态。

Some of the advocates of sustainable development have argued it is best understood as qualitative improvement. In that case, development means "better" rather than "more" and an emphasis on quality of life, rather than material living standards. They call for better, not faster, lives and for a focus on values, not things. These advocates of a new paradigm urge a movement away from the dogma that the only wealth is material wealth, with the resulting development being recognized formally by an improvement in the quality of life indicators.

一些可持续发展的倡导者提出最好把它理解成一种质量的提高。在这种情况下，发展意味着"更好"而不是"更多"，重点是生活的品质，而不是物质生活标准。他们号召更好而不是更快的生活，重点是价值，而不是事物。这些新模式的倡导者主张远离物质财富是唯一财富的教条，结果是将发展理解为生活品质指数的提高。

Environmental sustainability is the process of making sure current processes of interaction with the environment are pursued with the idea of keeping the environment as pristine as possible.

环境可持续性是在尽可能保持自然原有状态的理念下确保与环境相互作用的过程。

An "unsustainable situation" occurs when natural capital (the sum total of nature's resources) is used up faster than it can be replenished. Sustainability requires that human activity only uses nature's resources at a rate at which they can be replenished naturally. Inherently the concept of sustainable development is intertwined with the concept of carrying capacity. Theoretically, the long-term result of environmental degradation is the inability to sustain human life. Such degradation on a global scale could imply extinction for humanity.

当自然资本(自然资源的总合)的使用比重新补足资源的速度更快时，就出现了"不可持续状态"。可持续性要求人类活动只在可以自然重新补足的速度下使用自然资源。可持续发展的概念必然与容纳量相互纠缠在一起。理论上讲，环境恶化的长期结果就是不能维持人类的生活。这种全球范围的恶化就意味着人类的灭绝。

2. Nutrient 营养物

A nutrient is food or chemicals that an organism needs to live and grow or a substance used in an organism's metabolism which must be taken in from its environment. Non-autotrophic organisms typically acquire nutrients by the ingestion of foods. Methods for nutrient intake vary, with animals and protists having an internal digestive sys-

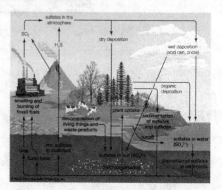

Fig. 13-3 General paths of energy flow and nutrient cycling in the biosphere

tem, but plants externally digesting nutrients before ingesting them.

营养物是指生物体生存和生长所需要的食物或化学物质，或者必须从其环境中获取的生物体新陈代谢的物质。不能自给营养的生物体大多通过食物摄取来获取营养。营养物输入的方法各有不同，动物和原生生物有内部消化系统，但是植物在吸收营养物之前就外部消化了营养物。

Organic nutrients include carbohydrates, fats, proteins (or their building blocks, amino acids), and vitamins. Inorganic chemical compounds such as minerals; water and oxygen may also be considered nutrients. A nutrient is essential to an organism if it cannot be synthesized by the organism in sufficient quantities and must be obtained from an external source. Nutrients needed in relatively large quantities are called macronutrients and those needed in relatively small quantities are called micronutrients.

有机营养物包括碳水化合物、脂肪、蛋白质(或者它们的构筑物——氨基酸)和维生素。无机化学营养物包括矿物、水和氧气。营养物对于生物体是基本的，如果不能通过生物体合成充分的数量，就必须从外部来源获得。需求数量相对较大的营养物被称为常量营养元素，那些需求数量相对较小的营养物被称为微量营养元素。

- The chemical elements humans consume in the largest quantities are carbon, hydrogen, nitrogen, oxygen, phosphorus, and sulfur.
- 人类消耗最大数量的化学元素是碳、氢、氮、氧、磷和硫。
- The classes of chemical compounds humans consume in the largest quantities and which provide bulk energy are carbohydrates, proteins, and fats. Water and atmospheric oxygen also must be consumed in large quantities, but are not always considered "food" or "nutrients".
- 人类消耗数量最大并提供能量的化合物是碳水化合物、蛋白质和脂肪。人类也必须大量消耗水和空气中的氧气，但是它们并不常常被认为是"食物"或"营养物"。
- Calcium, salt (sodium and chloride), magnesium, and potassium (along with phosphorus and sulfur) are sometimes added to the list of macronutrients because they are required in relatively large quantities compared to other vitamins and minerals. They are sometimes referred to as the macrominerals.
- 钙、盐(钠和氯化物)、镁和钾(和磷和硫一起)有时被增加到常量营养元素中，因为与其他维生素和矿物相比人们需要这些矿物的数量较大。它们有时被称为常量矿物。

The remaining vitamins, minerals, or elements, are called micronutrients because they are required in relatively small quantities.

剩下的维生素、矿物或元素，被称为微量营养元素，因为所需要的数量相对较少。

3. Ebenezer Howard　埃比尼泽·霍华德

Sir Ebenezer Howard (29 January 1850—May 1, 1928)　Fig. 13-4　Sir Ebenezer Howard

was a prominent British urban planner.

埃比尼泽·霍华德爵士是杰出的英国城市规划师。

Howard read widely, including Edward Bellamy's 1888 utopian novel Looking Backward and thought deeply about social issues.

霍华德阅读广泛，包括贝拉密 1888 年乌托邦小说《回顾》，并深度思考了社会问题。

One result was his book (1898) titled To-Morrow: A Peaceful Path to Real Reform, which was reprinted in 1902 as Garden Cities of To-Morrow. This book offered a vision of towns free of slums and enjoying the benefits of both town (such as opportunity, amusement and high wages) and country (such as beauty, fresh air and low rents). He illustrated the idea with his famous Three Magnets diagram, which addressed the question "Where will the people go?", the choices being "Town", "Country" or "Town-Country"——the Three Magnets.

他的重要成就就是《明日：一条通向真正改革的和平道路》（1898），这本书在 1902 年以《明日的田园城市》的名称重新出版。这本书提出了摆脱了贫民窟、享受城镇（比如机会、交际和高工资）与乡村（比如美观、新鲜空气和低租金）的双重好处的城镇景象。他用著名的"三磁极"图表来阐述理念，图表中探讨了"人们将往哪里去"的问题，答案是"城镇"、"乡村"或"城镇—乡村"——三磁极。

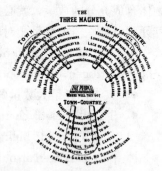

Fig. 13-5　Howard's 'three magnets' diagram

It called for the creation of new suburban towns of limited size, planned in advance, and surrounded by a permanent belt of agricultural land. These Garden cities were used as a role model for many suburbs. Howard believed that such Garden Cities were the perfect blend of city and nature.

他号召建立提前规划、尺度有限的新郊区城镇，并用永久的农业用地来环绕。这些花园城市成为许多郊区的基本模式。霍华德相信这种花园城市是城市和自然的最完美结合。

In 1899 he founded the Garden Cities Association, now known as the Town and Country Planning Association and the oldest environmental charity in England.

1899 年他创立了花园城市协会，现在被称为城乡规划协会，它是英格兰最古老的环境机构。

His ideas attracted enough attention and financial backing to begin Letchworth Garden City, a suburban garden city north of London. A second garden city, Welwyn Garden City, was started after World War I. His contacts with German architects Hermann Muthesius and Bruno Taut resulted in the application of humane design principles in many large housing projects built in the Weimar years. Hermann Muthesius also played an important role in the creation of Germany's first garden city of Hellerau in 1909, the only German garden city where Howard's ideas were thoroughly adopted.

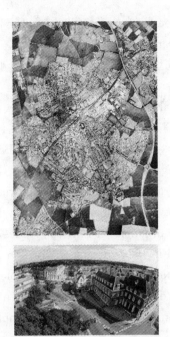

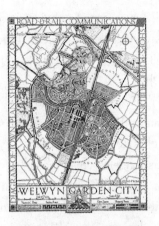

Fig. 13-6 Letchworth Garden City Fig. 13-7 Welwyn Garden City

他的理念吸引了足够的注意力和财政支持，从而开始莱奇沃思花园城市的修建，这是一处位于伦敦北部的郊区花园城市。第二个花园城市——威尔文花园城市在第一次世界大战后开始建造。他和德国建筑师赫曼·慕特修斯、布鲁诺·陶特的接触导致了许多魏玛时期修建的大型住宅项目采用了人性设计原则。赫曼·慕特修斯也在 1909 年德国海勒劳首个花园城市产生中扮演了重要角色，这个城市是唯一完全采纳霍华德理念的德国花园城市。

4. Garden City 花园城市

The garden city is an approach to urban planning that was founded in 1898 by Sir Ebenezer Howard in the United Kingdom. Garden cities were to be planned, self-contained communities surrounded by greenbelts, and containing carefully balanced areas of residences, industry, and agriculture.

花园城市是于 1898 年由埃比尼泽·霍华德爵士在英国创立的城市规划方法。花园城市是经过规划的、自给自足的、由绿化带围绕的社区，包含经过仔细设计的居住、工业和农业的平衡区域。

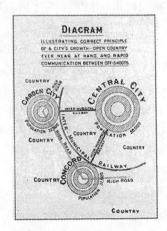

Fig. 13-8 Ebenezer Howard's 3 magnets diagram which addressed the question'Where will the people go?', the choices being'Town', 'Country'or'Town-Country'

Two cities were founded based on Howard's ideas: Letchworth Garden City and Welwyn Garden City, both in England.

两个城市是基于霍华德的理念建立：莱奇沃思花园城市和威尔文花园城市，这两个城市都位于英格兰。

Howard's successor as chairman of the Garden City Association was Sir Frederic Osborn, who extended the movement into regional planning.

霍华德的继任者，田园城市协会的主席弗雷德里克·奥斯本爵士，把花园城市理念延伸到区域规划中。

The idea of the garden city was influential in the United States (in Newport News, Virginia's Hilton Village; Pittsburgh's Chatham Village; Radburn, New Jersey; Jackson Heights, Queens; Garden City, New York; Forest Hills, NY, and Baldwin Hills Village in Los Angeles), in Canada (in Kapuskasing, Ontario and Walkerville, Ontario) and in Argentina. The first German garden city, Hellerau, a suburb of Dresden, was founded in 1909. Scandinavian examples include the garden city of Bromma in Stockholm, built 1910~1940. The garden city also influenced the Scottish urbanist Sir Patrick Geddes in the planning of Jerusalem's expansion and Tel-Aviv, Israel in 1920s during the British mandate period. Contemporary town planning charters like New Urbanism and Principles of Intelligent Urbanism find their origins in Garden City. Today, there are many garden cities in the world. Most of them, however, exist as just dormitory suburbs, which completely differ from what Howard wanted to create.

花园城市理念在美国(希尔顿村、匹兹堡的查塔姆村、新泽西的雷特邦、纽约皇后区的杰克逊高地、纽约的花园城、纽约的森山和洛杉矶的鲍德温山村)、加拿大(安大略的卡普斯卡辛和沃克威尔)和阿根廷是很有影响力的。首个德国花园城市海勒劳是德累斯顿的郊区，建于1909年。斯堪的纳维亚的范例包括建于1910~1940年的斯德哥尔摩的布劳玛。花园城市也影响了苏格兰城市规划学家帕特里克·格迪斯爵士的耶路撒冷市扩张规划和20世纪20年代英国委任统治时期的以色列特拉维夫的规划。当代的城镇规划理论，像是新城市主义和智能城市主义理念都对花园城市有所借鉴。今天，全世界有许多花园城市。然而，它们大多数都只是郊外居住区，完全不同于霍华德当时所设想的那样。

The Town and Country Planning Association recently marked its 108th anniversary by calling for Garden City and Garden Suburb principles to be applied to today's New Towns and Eco-towns.

城乡规划协会最近举行了它第108次年会，号召将花园城市和花园郊区原则应用于今天的新城镇和生态城镇中。

5. The Bible 圣经

Bible refers to respective collections of religious writings of Judaism and of Christianity. The exact composition of the Bible is dependent on the religious traditions of specific denominations. Modern Judaism generally recognizes a single set of canonical books known as the Tanakh, or Hebrew or Jewish Bible. It comprises three parts: the Torah (also known as the Pentateuch or "Five Books of Moses"), the Prophets, and the Writings. It was primarily written in He-

Fig. 13-9 An American family Bible dating to 1859 A. D

brew with some small portions in Aramaic.

圣经是指犹太教和基督教各自宗教作品的集合。圣经的准确构成依赖于特定的宗教传统。现代犹太教一般把一套规范书籍称为《塔纳赫》、《希伯来圣经》或《犹太圣经》。它由三个部分构成：教律(也被称为"摩西五书")、《先知书》和《圣书卷》，主要是用希伯来语和一小部分亚拉母语写成。

The Christian Bible includes the same books as the Tanakh, but usually in a different order, together with twenty-seven specifically Christian books collectively known as the New Testament. Those were originally written in Greek. Among some traditions, the Bible includes books that were not accepted in other traditions, often referred to as apocryphal.

基督教圣经包括和《塔纳赫》相同的书籍，但顺序常常不同，还有 27 本特定的基督教书籍，这 27 本书被称为新约全书。这些书最初用希腊语所写。在一些传统中，圣经包括其他传统不接受的书本，常常被认为是冒充的。

6. The Environmental Damage Caused by Humans 人类对环境的破坏

Experts have released a report that measures damage to the environment from human activities. The report measures the damage to the services that nature provides for people.

专家们已经发布了一份有关人类活动对环境破坏的报告。报告测定了为人类服务的自然所遭受的破坏。

The report says people have changed ecosystems to meet growing demands for food, fresh water, and energy. These changes have helped improve the lives of thousands of millions of people. But they have weakened the ability of nature to provide important services for people.

报告声称人类已经改变了生态系统，来满足不断增长的对食物、新鲜水和能源的需求。这些改变已经帮助数以千万计的人们改善了他们的生活。但也削弱了自然为人类提供重要服务的能力。

The report identified several problems. They include reduced numbers of fish in the world's oceans and dangers to people living in dry areas. Another problem is a growing threat to ecosystems from climate change and pollution.

报告提出了许多问题。包括世界海洋中鱼的数量的减少和生活在干旱地区的人们所面临的危机。另一个问题是气候改变和污染对生态环境越来越严重的威胁。

The study found that sixty percent of the world's ecosystems are being harmed by human actions. These include fishing too much and clearing land to grow crops.

研究发现全世界 60% 的生态系统正在由于人类的活动而受到伤害。这些伤害包括过度捕鱼和清理耕地来生长作物。

The study considered many kinds of services that an ecosystem provides. These include things like a forest's ability to store water and cool the air. It also includes cultural services, like providing a place for recreation. And, it includes life-support services like soil formation and the process by which plants make food.

研究考虑了生态系统提供的许多类型的服务。包括森林可以蓄养水和冷却空气的能力。也包括文化服务，例如提供娱乐场所。以及生命支持服务，例如土壤形成和植物创造

食物的过程。

The scientists say many of the areas where the environment is most quickly being damaged are among the world's poorest areas. As a result, damaged environments are likely to harm efforts to help poor people and reduce disease in developing countries.

科学家提出，环境被损害最快的区域大部分是世界最贫穷的区域。结果，被破坏的环境很可能对帮助发展中国家的穷人和减少疾病的努力有所损害。

The report said rich countries also were responsible for some problems. One of them is the increased use of chemical fertilizers. The fertilizers are washed into rivers and coastal waters. Nitrogen in the fertilizers creates areas in the water where nothing can live.

报告表明，富有的国家也要对一些问题负责。问题之一是越来越多地使用化学肥料。肥料被水冲到河流和海岸的水中。肥料中的氮产生了任何生物无法生存的水域。

Many earlier studies examined loss of forests and other wild places on land and in the oceans.

许多早期研究检视了大地和海洋中森林和其他野生环境的损失。

The report says action is needed to prevent additional damage to the environment. It says："We must learn to recognize the true value of nature——both in an economic sense and in the richness it provides to our lives."

报告提出，需要行动起来阻止对环境的进一步破坏。"我们必须学会认识到自然的真实价值——既要从经济的角度，也要从它提供给我们生活的丰富性角度。"

The protecting the environment should no longer be seen as something a country considers after more important concerns are dealt with. It said measures to protect natural resources are more likely to be successful if local communities are involved in decisions and share the gains.

保护环境应该不再被国家视为在更重要问题处理后所需要考虑的事情。如果当地居民参与决策和分享收获，保护自然资源的措施更可能取得成功。

7. Victorian England　英格兰的维多利亚

The Victorian era of the United Kingdom was the period of Queen Victoria's rule from June 1837 to January 1901. This was a long period of prosperity for the British people, as profits gained from the overseas British Empire, as well as from industrial improvements at home, allowed a large, educated middle class to develop. Some scholars would extend the beginning of the periodback five years to the passage of the Reform Act 1832.

英国的维多利亚时代是指维多利亚女王的统治时期（1837.7—1901.1）。这是英国人从海外大英帝国和本国的工业发展获得利益的繁荣时期，造成了大量受过教育的中产阶级的出现。一些学者将这个时期的起始时间向前推了五年，也就是 1832 年改革法令获通过的时刻。

Fig. 13-10　Queen Victoria, after whom the era is named. 1837—1901

The era is often characterized as a long period of peace, known as the Pax Britannica, and economic, colonial, and in-

dustrial consolidation, although Britain was at war every year during this period. Domestically, the agenda was increasingly liberal with a number of shifts in the direction of gradual political reform and the widening of the voting franchise.

这个时代的特征常常被定义为长期的和平，称为英国强权下的世界和平，这个时期的英国经济、殖民地和工业稳定，尽管英国几乎每年都有战争。国内政策越来越宽容，有大量的阶段性政治改革方向的改变，并拓宽了公民的投票表决权。

The Victorian fascination with novelty resulted in a deep interest in the relationship between modernity and cultural continuities. Gothic Revival architecture became increasingly significant in the period, leading to the Battle of the Styles between Gothic and Classical ideals. Charles Barry's architecture for the new Palace of Westminster, which had been badly damaged in an 1834 fire, built on the medieval style of Westminster Hall, the surviving part of the building. It constructed a narrative of cultural continuity, set in opposition to the violent disjunctions of Revolutionary France, a comparison common to the period, as expressed in Thomas Carlyle's The French Revolution: A History and Charles Dickens'A Tale of Two Cities. Gothic was also supported by the critic John Ruskin, who argued that it epitomized communal and inclusive social values, as opposed to Classicism, which he considered to epitomize mechanical standardization.

Fig. 13-11　The medieval
Westminster Hall

维多利亚时代对新奇事物的迷恋导致了人们对现代性和文化连续性之间的关系非常感兴趣。哥特复兴建筑在那个时代越来越突显出来，引起了哥特式和古典主义风格之间的风格之争。巴里爵士为新威斯敏斯特宫所作的设计（1834 年由于大火被严重损坏）中，建筑残留的部分——威斯敏斯特议会大厅以中世纪风格建造。它构筑了对文化连续性的叙述，来反对法国大革命时期对文化的明确分隔，人们总是拿法国大革命时期和维多利亚时代相比较，就如托马斯·卡莱尔的《法国大革命史》和查尔斯·狄更斯的《双城记》。哥特式也得到了批评家约翰·拉斯金的支持，拉斯金认为它概括了群体和包容的社会价值，与追求机械标准化的古典主义形成对比。

The middle of the century saw The Great Exhibition of 1851, the first World's Fair and showcased the greatest innovations of the century. At its centre was the Crystal Palace, an enormous, modular glass and iron structure—the first of its kind. It was condemned by Ruskin as the very model of mechanical dehumanization in design, but later came to be presented as the prototype of Modern architecture. The emergence of photography, which was showcased at the Great Exhibition, resulted in significant changes in Victorian art. John Everett Millais was in-

Fig. 13-12　The Crystal Palace

fluenced by photography (notably in his portrait of Ruskin) as were other Pre-Raphaelite artists. It later became associated with the Impressionistic and Social Realist techniques that would dominate the later years of the period in the work of artists such as Walter Sickert and Frank Holl.

在19世纪中期的1851年举办了大英博览会，这是首次世界性展览会，并展示了那个世纪最伟大的发明。展览会中心是水晶宫，一个巨大的、模数化的玻璃和钢铁结构——这类型建筑的首例。它被拉斯金评价为非人性机械设计的最佳范例，但是水晶宫随后成为了现代主义建筑的原型。摄影也在大英博览会中出现，这导致了维多利亚时代艺术的巨大改变。约翰·艾佛雷特·米莱和其他前拉斐尔派艺术家都受到了摄影的影响（著名的是他所画的拉斯金肖像）。随后摄影和印象主义、社会唯实论技法一起占据了那个时代后期艺术家作品的主流，比如沃尔特·希科特和弗兰克·霍尔。

8. Sustainable Development　可持续发展

Sustainable development is a pattern of resource use that aims to meet human needs while preserving the environment so that these needs can be met not only in the present, but in the indefinite future. The term was used by the Brundtland Commission which coined what has become the most often-quoted definition of sustainable development as development that "meets the needs of the present without compromising the ability of future generations to meet their own needs. "

可持续发展是指在保护环境的同时满足人类需求的资源利用模式，这些需求不仅现在可以满足，在永恒的未来也可以满足。联合国布伦特兰委员会对这个术语的使用成为了现在最经常被引用的可持续发展的定义：“既满足当代人的需求又不危害后代人满足其需求的”发展。

Sustainable development ties together concern for the carrying capacity of natural systems with the social challenges facing humanity. As early as the 1970s "sustainability" was employed to describe an economy "in equilibrium with basic ecological support systems". Ecologists have pointed to the "limits of growth" and presented the alternative of a "steady state economy" in order to address environmental concerns.

可持续发展把对自然系统的承载能力的关注和人类的社会挑战紧密联系在一起。早在20世纪70年代，“可持续性”就用来描述一种“和基本生态支持系统平衡”的经济。生态学家已经指出“增长的限度”，并提出“稳定状态经济”的替代方案，目的是探讨对环境的关注。

The field of sustainable development can be conceptually broken into three constituent parts: environmental sustainability, economic sustainability and sociopolitical sustainability.

可持续发展领域可以在概念上分为三部分：环境可持续性、经济可持续性和社会政治可持续性。

The concept has included notions of weak sustainability, strong sustainability and deep ecology. Sustainable development does not focus solely on environmental issues. The United Nations 2005 World Summit Outcome Document refers to

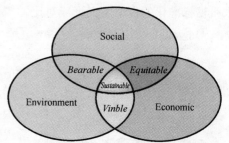

Fig. 13-13　Scheme of sustainable development：at the confluence of three constituent parts

the"interdependent and mutually reinforcing pillars"of sustainable development as economic development, social development, and environmental protection.

可持续性概念又包括弱可持续性、强可持续性和深层生态学。可持续发展不是单一地聚焦于环境问题。2005 年纪念联合国成立 60 周年首脑会议中的《成果文件》提到"可持续发展是经济发展、社会发展和环境保护相互依存、相互增强的支撑。"

People have argued, through various international forums such as the United Nations Permanent Forum on Indigenous Issues and the Convention on Biological Diversity, that there are four pillars of sustainable development, the fourth being cultural. The Universal Declaration on Cultural Diversity (UNESCO, 2001) further elaborates the concept by stating that"… cultural diversity is as necessary for humankind as biodiversity is for nature"; it becomes"one of the roots of development understood not simply in terms of economic growth, but also as a means to achieve a more satisfactory intellectual, emotional, moral and spiritual existence". In this vision, cultural diversity is the fourth policy area of sustainable development.

各种各样的国际论坛上，比如世界原住民事务大会和《生物多样性公约》，人们提出可持续发展的四个支柱，而第四个就是文化。《国际文化多元性宣言》（UNESCO, 2001）进一步阐述了这一概念："…文化多样性就如自然的生物多样性一样，是人类所必需的"；"人类发展的根基不只是经济增长，同样也包括更令人满意的智能、情感、道德和精神存在"。这种观点下，文化多样性是可持续发展的第四个政策领域。

The United Nations Division for Sustainable Development lists the following areas as the scope of sustainable development:

联合国就可持续发展分类列出了下列领域作为可持续发展范畴：

- Agriculture 农业
- Atmosphere 大气圈
- Biodiversity 生物多样性
- Biotechnology 生物技术
- Capacity-building 能力建设
- Climate Change 气候变化
- Consumption and Production Patterns 消费和生产模式
- Demographics 人口分布
- Desertification and Drought 沙漠化和干旱
- Disaster Reduction and Management 减灾和灾难控制
- Education and Awareness 教育和意识
- Energy 能源
- Systems ecology 系统生态
- Finance 财政
- Forests 森林
- Fresh Water 淡水
- Health 健康
- Human Settlements 人类定居点
- Indicators 指数
- Industry 工业
- Information for Decision Making and Participation 决策制定和参与的信息
- Integrated Decision Making 全面的决策制定
- International Law 国际法律
- International Cooperation 国际合作
- Land management 土地管理
- Major Groups 主要种群
- Mountains 山脉
- National Sustainable Development Strategies 国家可持续发展策略
- Oceans and Seas 海洋
- Poverty 贫穷
- Sanitation 公共卫生

- Science 科学
- Sustainable tourism 可持续旅游
- Technology 技术
- Toxic Chemicals 有毒化学物质
- Trade and Environment 商贸和环境
- Transport 交通
- Waste（Hazardous）废弃物（危险）
- Waste（Radioactive）废弃物（放射性）
- Waste（Solid）废弃物（固态）
- Water 水

Vacabulary

1. cycle　*n.* ①周期，循环，周而复始；一个操作过程：a vicious cycle 恶性循环　②周时，周年　③（诗、故事等的）始末或专集；全本，全套，全集：the cycle of events 一系列事件　④自行车，摩托车，机器脚踏车　⑤［植］（从枯凋到再生的）一轮回；天体运转的轨道；天体循环期；轨道：A year constitutes a cycle of the seasons. 一年由四季的周期循环组成　*vi.* ①骑自行车（或摩托车）：He cycles to school every day. 他每天骑车上学。②循环；旋转：the life cycle of insects 昆虫的生活周期　*vt.* ①使循环，使轮转：cycled the heavily soiled laundry twice 把那件肮脏无比的衣物洗两遍

［近义词］period, circle, revolution, recurrence, cycling, circulation, rotation, recursion　*n.* 周期，循环

　　bicycle, bike　*n.* 自行车

　　ride, ride a bike　*v.* 骑自行车

2. ecosystem　*n.* 生态系统：agricultural ecosystem 农业生态系统 anaerobic ecosystem 厌氧生态系统　aquatic ecosystem 水生生态系统　artificial ecosystem 人工生态系统（指城市，空间飞行器等）　community ecosystem 群落生态系（统） dynamic ecosystem 动态生态系　fresh-water ecosystem 淡水生态系（统）　local ecosystem 局部生态系（统）　man-made ecosystem 人为生态系（统）　marine ecosystem 海洋生态系（统）　natural ecosystem 自然生态系（统）　primordial ecosystem 原始生态系统　protective ecosystem 保护性生态系统

3. dominion　*n.* ①统治权；主权；管辖，支配（over）：the governments claim of dominion over the resources of the marginal sea 政府对于领海资源的管辖权　②［*pl.*］疆土，领土，版图（封建地主的）领地　③（D～）（英帝国的）自治区域；加拿大　④［法］所有权：Dominion Day 加拿大自治纪念日（7 月 1 日）Dominion of Canada 加拿大自治区域［俗简称 the dominion］exercise［have, hold］dominion over 对……行使统治［管辖，支配］权　the Old Dominion［美］弗吉尼亚的别名

4. infrastructure　*n.* ①基础；基础结构［设施］（尤指社会、国家赖以生存和发展的，如道路、学校、电厂、交通、通讯系统等）　②［建］基［底］层结构，下部结构　③［军］永久性防御设施，永久性基地：economic infrastructure 经济基础结构部门　infrastructure of city 城市内部结构　physical infrastructure 物质基础设施　transportation infrastructure 运输基本设施

5. unique　*adj.* ①唯一的，独一无二的：unique opportunity 极难得的机会　②无与伦比的；独特的：That building is unique because all the others like it were destroyed. 那座建筑很独特，因为所有像它那样的其他建筑都毁坏了。③珍奇的：unique copy 珍本 *n.* 独一无

二的人〔物〕

〔近义词〕alone,only,single,sole,singular,distinctive,incomparable,unrivaled,unparalleled,peerless,matchless　*adj.* 唯一的，独一无二的

〔辨析〕**unique** 唯一的、无与伦比的：这是最为强烈的用词，有无双的含意。

His talent is quite unique.　他的才能是无人可比的。

alone 单独的、独一的：常形容人是孤身一个。

I'm not alone in this opinion.　不只我一个人有这个想法。

only 唯一的：普通的用词。

The only thing to do is to go on.　前进是唯一的办法。

single 唯一的：指数个中的唯一，常用于加强语气。

There was not a single person at the party that I know.　这集会上我一个人都不认识。

sole 唯一的：这是比 only 更为强烈的用词，又是比较庄严的用词，如 sole heir 为唯一的继承人，sole reason 为唯一的原因。

He is the sole heir to the estate.　他是该产业的唯一继承人。

Sentence

The history of the sustainability concept,from the industrial revolution to present,was researched and examined to isolate relevant quantifiable and measurable principles that would be useful in architectural,planning,and engineering design.

从工业革命到现在可持续概念一直被人们加以研究和检验，以求分离出用于建筑、规划和工程设计的相关定量和重要原则。

While Howard's genius appeared directed largely at the urban development,less insight was evident in the open space that separated his proposed matrix of many such Garden Cities.

而霍华德的天赋大部分直接表现在城市发展上，很少关注分割他提出的众多花园城市模型中开放空间的设计。

Even though a great bogy of knowledge has been created concerning countless ecological relationships,we do not,yet,have the knowledge to reproduce a healthy model that is sustainable.

关注无数生态关系是很困难的，然而即使这样做我们仍没有掌握实现可持续发展的健康模式。

It also shows that the designers of the built environment,the architects,engineers,and planners,can assume responsibility for protecting the complex and fragile ecologies that have been damaged in the past if they understand and work with the forces of nature.

这一概念也存在于建筑环境的设计者、建筑师、工程师和规划师之中。如果可以理解自然并以自然力量来工作的话，他们就可以承担保护在过去曾被破坏复杂脆弱的生态的责任。

The case is presented that the designers of the built environment are in a place of responsibility because their structures and infrastructure can be designed in a way that pro-

motes sustainability concepts.

这个案例是在表达建筑环境的设计师是有责任的，因为他们的建筑和设施能够以推动可持续性概念的方式来设计。

As the desired result is a self-sustaining healthy environment（integration of both built and natural）.

就如所期望的那样，结果是自给自足的健康环境（建筑和自然环境的融合）。

Translation

第 13 课　花园城市（可持续设计）：过去、现在、未来

从工业革命到现在，可持续概念不断被加以研究和检验，以求分离出能够用于建筑、规划和工程设计的相关定量和重要原则。人们也研究可持续性指数，并发现指数之间常常缺乏相关性。深层分析发现，营养物质、能源的自然流动和这些指数相关，对这些循环和转化的理解是开始理解指数之间相互联系所必需的。

许多规划师和建筑师都寻求解决技术和环境相互融合的问题，埃比尼泽·霍华德就是其中之一，他对这一问题进行了详细深入的研究。霍华德最初的花园城市规划图展现出寻求建立一种紧密结合环境的社会秩序。而霍华德的天赋大部分直接表现在城市发展上，很少关注他提出的众多花园城市模型中开放空间的设计。

关注无数的生态关系是很困难的，即使这样做我们仍没有掌握实现可持续发展的健康模式。然而，检验这样一种模式的组成部分是可能的：并不是孤立的分析，或者只是简单的观察它如何同其他构成元素保持平衡，而是判断自然循环和自然发生的能源流动如何在用于改善人类对生态系统的破坏的同时又维持其本身的健康和发展。

自然环境和建筑环境之间的相互关系常常被视为敌对关系。《圣经》中写到：上帝赋予人类统治动物的权利，许多著名的环保论者将人类视为最具毁灭性和危险性的寄生生物。这种观点发展出将环境整合为一个自我永存和健康的整体理念，因此被称为可持续性。这一概念也存在于建筑环境的设计者、建筑师、工程师和规划师之中。如果可以理解自然并以自然力量来工作的话，他们就可以承担保护在过去曾被破坏、复杂脆弱的生态的责任。

实质上，设计涉及可持续性，并将其定义为复杂、健康环境的功能。它研究人类引起的环境破坏，以及现今表达所关注问题的方式和概念。回顾可持续性概念的历史是为了引入全球和当地的可持续内涵。可持续性指标可以用来计量不可持续人类行为的影响，比如每一百万亚硝酸氧化物进入空气后排放出的磷的数量。研究这些指标是因为它们常常被单独测量，而不是作为健康环境所必需的营养物和能源自然流动的一部分。营养物和能源的自然流动支撑起自然环境的生命网络。建筑环境的设计师是有责任的，因为他们的建筑和设施是能够以推动可持续性概念的方式来设计。于是，建筑师、规划师和工程师将受益于融合营养物和能源自然流动的可持续设计的独特前景。

当今可持续性的定义和指标的使用并不能为建筑师、规划师和工程师提供直接的帮助。通过什么是可持续性（和什么不是）普遍理念，我们转向其他来源——涉及社会、环境和经济的三重概念。自然、社会和能源是建筑师、规划师和工程师非常熟悉的领域，并导

致他们对可持续性提出可以善加利用的定义。为了确定这种定义的正确性，许多城市形式和理论都对可持续性概念进行了大体上的讨论，造成了一百多年来对可持续性概念更清晰的检验。

　　研究埃比尼泽·霍华德的设计能够帮助建筑师、规划师和工程师理解可持续性概念。他在《明日的田园城市》一书中，讨论了对建筑师、规划师和工程师非常有用的原则。虽然是在一百年前写的，他的观点已经在许多城镇规划理论和全世界的现实建造中提出和使用。霍华德的理论在维多利亚时代英格兰的进一步发展，要先于汽车的影响，以及就业从制造业向服务产业的改变。

　　霍华德对花园城市城镇部分的变量之间相互关系的理解很明确，但是他没有以相同的细节来描述乡村部分。因此，研究的关键是通过城镇和乡村、城市和乡村、建筑环境和自然环境之间的和谐平衡更完整地定义可持续性，提出包含众多变量的复杂模式，这些变量能够实现建造和自然环境之间的平衡。所期望的结果是自给自足的健康环境（建筑和自然环境的融合）。

Lesson 14 Multi-sensory Experience: the Significance of Touch

Every significant experience of architecture is multi-sensory; qualities of matter, space and scale are measured by the eye, ear, nose, skin, tongue, skeleton and muscle. Maurice Merleau-Ponty emphasizes this simultaneity of experience and sensory interaction as follows: "My perception is [therefore] not a sum of visual, tactile, and audible givens: I perceive in a total way with my whole being: I grasp a unique structure of the thing, a unique way of being, which speaks to all my senses at once".

The task of architecture is to make visible "how the world touches us", as Maurice Merleau-Ponty wrote of the paintings of Paul Cezanne. Paraphrasing another notion of Merleau-Ponty's: architecture concretizes and frames human existence in the "flesh of the world". In developing Goethe's notion of "life-enhancing" in the 1890s, Bernard Berenson suggested that when experiencing an artistic work we imagine a genuine physical encounter through "ideated sensations". The most important of these Berenson called 'tactile values'. In his view, the work of authentic art stimulates our ideated sensations of touch, and this stimulation is life-enhancing. Genuine architectural works, in my view, also evoke similar ideated tactile sensations which enhance our experience of ourselves.

The retinal-biased architecture of our time is clearly giving rise to a quest for a haptic architecture. Our culture of control and speed has favored the architecture of the eye, with its instantaneous imagery and distant impact, whereas haptic architecture promotes slowness and intimacy, appreciated and comprehended gradually as images of the body and the skin. The architecture of the eye detaches and controls, whereas haptic architecture engages and unites. Tactile sensibility replaces distancing visual imagery by enhanced materiality, nearness and intimacy.

We are not usually aware that an unconscious element of touch is unavoidably concealed in vision; as we look, the eye touches, and before we even see an object we have already touched it. "Through vision, we touch the stars and the sun", as Merleau-Ponty writes. Touch is the unconsciousness of vision, and this hidden tactile experience determines the sensuous quality of the perceived object, and mediates messages of invitation or rejection, courtesy or hostility.

"Architecture is not only about domesticating space", writes Karsten Harries, Professor of Philosophy at Yale University, "It is also a deep defense against the terror of time. The language of beauty is essentially the language of timeless reality." Architecture's task to provide us with our domicile in space is recognized by most architects, but its second task in mediating our relation with the frighteningly ephemeral dimension of time is usually disregarded.

In its quest for the perfectly articulated autonomous artifact, the main line of Modernist architecture has preferred materials and surfaces that seek the effect of flatness, immaterial abstractness

and timelessness. Whiteness, in Le Corbusier's words, serves "the eye of truth", mediating thus moral and objective values. The Modernist surface is treated as an abstracted boundary of volume, and has a conceptual rather than a sensory essence. These surfaces tend to remain mute, as shape and volume are given priority; form is vocal, whereas matter remains mute. The aspiration for geometric purity and reductive aesthetics further weakens the presence of matter, in the same way that a strong figure and Contour reading diminishes the interaction of color in the art of painting; all real colorists in painting use a weak Gestalt in order to maximize color interaction. Abstraction and perfection transport us into the world of ideas, whereas matter, weathering and decay strengthen the experience of time, causality and reality.

As a consequence of its formal ideals, the architecture of our time is usually creating settings for the eye which seem to originate in a single moment of time and evoke the experience of flattened temporality. Vision places us in the present tense, whereas haptic experience evokes the experience of a temporal continuum. The inevitable processes of ageing, weathering and wear are not usually considered as conscious and positive elements in design; the architectural artifact exists in a timeless space, an artificial condition separated from the reality of time. The architecture of the modern era aspires to evoke an air of ageless youth and of a perpetual present. The ideals of perfection and completeness further detach the architectural object from the reality of time and the traces of use. Consequently, our buildings have become vulnerable to the effect of time, the revenge of time. Instead of offering positive qualities of vintage and authority, time and use attack our buildings destructively.

A particularly thought-provoking example of the human need to experience and read time through architecture is the tradition of designed and built ruins, a fashion that became a mania in eighteenth-century England and Germany. While engaged in the construction of his own house in Lincoln's Inn Fields - which, by the way, incorporated images of ruins-John Soane imagined his structure as a ruin by writing a fictitious study of a future antiquarian.

There are architects in our time, however, who evoke healing experiences of time. The architecture of Sigurd Lewerentz, for instance, connects us with deep time; his works obtain their unique emotive power from images of matter which speak of opaque depth and

mystery, dimness and shadow, metaphysical enigma and death. Death turns into a mirror image of life; Lewerentz enables us to see ourselves dead without fear, and placed in the continuum of timeless duration, the 'womb of time', to use an expression of Shakespeare's from Othello.

Notes

1. Maurice Merleau-Ponty 莫里斯·梅洛—庞蒂

Maurice Merleau-Ponty (March 14, 1908—May 3, 1961) was a French phenomenological philosopher, strongly influenced by Edmund Husserl and Martin Heidegger in addition

Fig. 14-1 Maurice Merleau-Ponty

to being closely associated with Jean-Paul Sartre and Simone de Beauvoir. At the core of Merleau-Ponty's philosophy is a sustained argument for the foundational role that perception plays in understanding the world as well as engaging with the world. Like the other major phenomenologists Merleau-Ponty expressed his philosophical insights in writings on art, literature, and politics; however Merleau-Ponty was the only major phenomenologist of the first half of the Twentieth Century to engage extensively with the sciences, and especially with descriptive psychology. Because of this engagement, his writings have become influential with the recent project of naturalizing phenomenology in which phenomenologists utilize the results of psychology and cognitive science.

莫里斯·梅洛—庞蒂(1908 年 3 月 14 日—1961 年 5 月 3 日)是法国现象学哲学家。庞蒂除了和让—保罗·萨特、西蒙娜·德·波伏娃联系紧密外，还受埃德蒙德·胡塞尔和马丁·海德格尔的影响。梅洛—庞蒂哲学的核心是针对感觉在理解世界和改造世界中的基础作用的持续争论。就像其他现代哲学家一样，梅洛—庞蒂在艺术、文学和政治著作中表达他的哲学观点。然而，梅洛—庞蒂是 20 世纪前 50 年中唯一与科学广泛结合，特别是以描述心理学来研究哲学的现象学家。因此他的著作对现象学家运用心理学和认知科学的结果来研究自然化现象很有影响力。

In his Phenomenology of Perception (first published in French in 1945), Merleau-Ponty developed the concept of the body-subject as an alternative to the Cartesian"cogito." This distinction is especially important in that Merleau-Ponty perceives the essences of the world existentially, as opposed to the Cartesian idea that the world is merely an extension of our own minds. Consciousness, the world, and the human body as a perceiving thing are intricately intertwined and mutually"engaged". The phenomenal thing is not the unchanging object of the natural sciences, but a correlate of our body and its sensorimotor functions. Taking up and"communing with" (Merleau-Ponty's phrase) the sensible qualities it encounters, the body as incarnated subjectivity intentionally elaborates things within an ever-present world frame, through use of its preconscious, prepredicative understanding of the world's makeup. The elaboration, however, is"inexhaustible". The world and the sense of self are emergent phenomena in an ongoing"becoming".

在他的《知觉现象学》(1945 年在法国首次出版)中，梅洛—庞蒂提出身体主体作为笛卡尔哲学"自我的思维作用"的替换物这一概念。这种变化在梅洛—庞蒂感受现实世界的本质时显得特别重要，和笛卡尔哲学认为世界仅仅是自我意识的一种延伸的理念形成对比。意识、世界和人类身体作为可以感知的事物，杂乱地相互纠缠和互相"契合"。现象物体不是自然科学中不可改变的物体，而是一种和我们的身体及其感觉运动功能相关的事物。身体"拿起"和"交流"(梅洛—庞蒂使用的词)它所遇到的可感知性质，身体故意将主观具体化，通过其世界构成的潜意识和前判断，详细说明世界框架内永恒存在的事物。然而，详尽阐述是"无穷无尽的"。世界和自我感受是不断进行中的"改变"突显出的现象。

Some critics have remarked that while Merleau-Ponty makes a great effort to break away from Cartesian dualism, in the end Phenomenology of Perception still starts out from

the opposition of consciousness and its objects. Merleau-Ponty himself also acknowledged this and in his later work attempted to proceed from a standpoint of our existential unity with what he called the"flesh"of the world.

一些批评家认为，虽然梅洛—庞蒂努力脱离笛卡尔哲学的二元论，但是《知觉现象学》仍是从意识和物体的对照法出发。梅洛—庞蒂他本身也承认这一点，并在他后期的作品中尝试从人类存在和他称之为世界"物质"的一致性观点出发。

2. Sense 感觉

This is no firm agreement among neurologists as to the number of senses because of differing definitions of what constitutes a sense. The traditional five senses are sight, hearing, touch, smell, taste：a classification attributed to Aristotle. Humans also have at least six additional senses (a total of eleven including interoceptive senses) that include：nociception (pain), equilibrioception (balance), proprioception & kinesthesia (joint motion and acceleration), sense of time, thermoception (temperature differences), and in some a weak magnetoception (direction).

神经学领域就感官的数量并没有达成完全一致，原因是对什么构成一种感觉的定义不同。传统的五种感觉是亚里士多德提出的：视觉、听觉、触觉、嗅觉、味觉。人类也至少还有额外的六种感觉(一共就有 11 种，包括内感受性感觉)，包括：痛苦、平衡感、本体感受和肌肉运动知觉(关节运动和加速)、时间感、热感(温度的不同)，有些人还有微弱的方向感。

Sight 视觉

Sight or vision is the ability of the brain and eye to detect electromagnetic waves within the visible range (light) interpreting the image as"sight."There is disagreement as to whether this constitutes one, two or three senses. Neuroanatomists generally regard it as two senses, given that different receptors are responsible for the perception of color (the frequency of photons of light) and brightness (amplitude/intensity-number of photons of light). Some argue that stereopsis, the perception of depth, also constitutes a sense, but it is generally regarded as a cognitive (that is, post-sensory) function of brain to interpret sensory input and to derive new information.

视觉是大脑和眼睛在视觉范围内(光)发现电磁波，将图像解释为"视觉"。就这一过程是否构成一种、两种或三种感觉存有争论。神经解剖学者一般认为它是两种感觉，有不同感受器负责色彩感受(光线中光子的频率)和亮度感受(波幅/亮度—光线中光子的数量)。一些人提出视觉深度——深度的感受——也构成一种感觉，但是它一般被认为是一种大脑认知功能(那就是说，在感觉之后)，这种功能解释感官输入的信息并推导出新的信息。

Hearing 听觉

Hearing or audition is the sense of sound perception. Since sound is vibrations propagating through a medium such as air, the detection of these vibrations, that is the sense of the hearing, is a mechanical sense akin to a sense of touch. In humans, this perception is executed by tiny hair fibres in the inner ear which detect the motion of a membrane which vibrates in response to changes in the pressure exerted by atmospheric particles within a

range of 20 to 22000Hz, with substantial variation between individuals. Sound can also be detected as vibrations conducted through the body. Lower and higher frequencies than that can be heard are detected this way only.

听觉是声音感受的感觉。既然声音是通过媒介(比如空气)的振动来传播,那么这些振动的测定,也就是听觉,是一种机械感觉,和触觉相类似。人类的听觉通过微小的内耳纤维来实现,这些纤维检测到振动耳膜的运动,耳膜的振动是为了响应20~22000Hz范围内的大气微粒所施加的压力改变,每个人的情况也各有不同。声音也可以作为通过身体传导的振动来发现。低于和高于可以听到的频率范围时就只能用这种方法来检测。

Taste 味觉

Taste or gustation is one of the two main "chemical" senses. There are at least four types of tastes that "buds" (receptors) on the tongue detect, and hence there are anatomists who argue that these constitute five or more different senses, given that each receptor conveys information to a slightly different region of the brain.

味觉是两个主要的"化学"感觉之一。至少有四种味觉可以由舌头上的"味蕾"(感受器)来察觉,因此有解剖学者认为这些构成了五种或更多不同的感觉,因为每种感受器传达信息的大脑区域都稍有不同。

The four well-known receptors detect sweet, salt, sour, and bitter, although the receptors for sweet and bitter have not been conclusively identified. A fifth receptor, for a sensation called umami, was first theorized in 1908 and its existence confirmed in 2000. The umami receptor detects the amino acid glutamate, a flavour commonly found in meat and in artificial flavourings such as monosodium glutamate.

四个著名的感受器检测甜、咸、酸和苦,虽然检测甜和苦的感受器并没有最后确定。第五种感受器,是对于一种称之为鲜味的感觉,首先在1908年被推想出,并在2000年证明其存在。鲜味感受器检测氨基酸谷氨酸盐——一种普遍用于肉类和人工调味料的食用香料,比如味精。

Note that taste is not the same as flavor; flavor includes the smell of a food as well as its taste.

要注意味觉并不等同于滋味;滋味包括食物闻起来的和吃起来的味道。

Smell 嗅觉

Smell or olfaction is the other "chemical" sense. Unlike taste, there are hundreds of olfactory receptors, each binding to a particular molecular feature. Odour molecules possess a variety of features and thus excite specific receptors more or less strongly. This combination of excitatory signals from different receptors makes up what we perceive as the molecule's smell. In the brain, olfaction is processed by the olfactory system. Olfactory receptor neurons in the nose differ from most other neurons in that they die and regenerate on a regular basis.

嗅觉是另一种"化学"感觉。与味觉不同,它有数百个嗅觉感受器,每个都结成特定的分子特性。臭味分析拥有各种各样的特性,因此或多或少都强烈地激发特定的感受器。这种不同感受器激发信号的组合构成了我们所感觉到了分子的气味。在大脑中,嗅觉由嗅

觉系统处理。鼻子里的嗅觉感受神经元和绝大多数神经元不同之处在于它们有规律的死亡和重生。

Touch 触觉

Touch, also called mechanoreception or somatic sensation, is the sense of pressure perception, generally in the skin. There are a variety of nerve endings that respond to variations in pressure (e. g. , firm, brushing, and sustained). The inability to feel anything or almost anything is called anesthesia.

触觉，也被称为机械感应或者身体感觉，是对压力感受的感觉，一般是通过皮肤。人体有各种各样的神经终端来反映压力的变化（比如坚固、刷过和维持）。无法感觉到任何事物或者几乎任何事物被称为感觉缺失。

Balance and acceleration 平衡感

Balance, or Equilibrioception, is the sense which allows an organism to sense body movement, direction, and acceleration, and to attain and maintain postural equilibrium and balance. The organ of equilibrioception is the vestibular labyrinthine system found in both of the inner ears. Technically this organ is responsible for two senses, angular momentum and linear acceleration (which also senses gravity), but they are known together as equilibrioception.

平衡，或平衡感，是一种使生物体感受到身体运动、方向和加速，以此达到和维持姿势平衡的感觉。平衡感的器官是在两个内耳中都可以发现的前庭系统。在技术上，这个器官负责两种感觉，角动量和直线加速（也感觉重力），但是它们一起被称为平衡感。

Temperature 热感

Thermoception is the sense of heat and the absence of heat (cold) by the skin and including internal skin passages. The thermoceptors in the skin are quite different from the homeostatic thermoceptors in the brain (hypothalamus) which provide feedback on internal body temperature.

热感应是一种通过皮肤对热量和缺乏热量（寒冷）的感觉，包括人体内部的皮肤通道。皮肤中的热感受器与大脑中提供内在身体温度反馈的自我平衡热感受器（下丘脑）不同。

Kinesthetic sense 动觉

Proprioception, the kinesthetic sense, provides the parietal cortex of the brain with information on the relative positions of the parts of the body. Neurologists test this sense by telling patients to close their eyes and touch the tip of a finger to their nose. Assuming proper proprioceptive function, at no time will the person lose awareness of where the hand actually is, even though it is not being detected by any of the other senses. Proprioception and touch are related in subtle ways, and their impairment results in surprising and deep deficits in perception and action.

本体感受，肌肉运动感觉，为大脑的腔壁皮层提供身体各部分相对位置的信息。神经学家通过告诉病人闭上眼睛用手指尖触摸他们的鼻子来测试这种感觉。假定本体感受功能良好，人就没有任何时间会失去对手实际在那里的意识，即使在没有发现任何其他感觉的情况下。

Pain 疼痛

Nociception (physiological pain) signals near-damage or damage to tissue. The three types of pain receptors are cutaneous (skin), somatic (joints and bones) and visceral (body organs). It was believed that pain was simply the overloading of pressure receptors, but research in the first half of the 20th century indicated that pain is a distinct phenomenon that intertwines with all of the other senses, including touch. Pain was once considered an entirely subjective experience, but recent studies show that pain is registered in the anterior cingulate gyrus of the brain.

生理疼痛表示快要伤害或已经伤害到组织。三种类型的疼痛感受器是表皮(皮肤)、躯体(关节和骨骼)以及内脏(身体器官)。以前人们相信疼痛只是简单的压力感受器负载过大,但是在 20 世纪前 50 年中的研究表明,疼痛是独特的现象,和所有其他感觉相互纠缠,其中就包括触觉。疼痛曾经被认为是一种完全主观性体验,但是最近的研究表明,疼痛在大脑的扣带回前部内被记录下来。

3. Paul Cézanne 保罗·塞尚

Paul Cézanne (19 January 1839—22 October 1906) was a French artist and Post-Impressionist painter whose work laid the foundations of the transition from the 19th century conception of artist to a new and radically different world of art in the 20th century. Cézanne can be said to form the bridge between late 19th century Impressionism and the early 20th century's new line of artistic enquiry, Cubism.

Fig. 14-2 Self portrait c. 1875 Fig. 14-3 *Femme au Chapeau Vert* (Woman in a Green Hat. Madame Cézanne.) 1894~1895

保罗·塞尚(1839 年 1 月 19 日—1906 年 10 月 22 日)是法国艺术家和后印象主义画家,他的作品奠定了从 19 世纪艺术家概念到 20 世纪完全不同的新艺术世界转变的基础。可以说塞尚在 19 世纪后期的印象主义和 20 世纪艺术追求的新路线之间搭起了桥梁。

Cézanne's work demonstrates a mastery of design, color, composition and draftsmanship. His often repetitive, sensitive and exploratory brushstrokes are highly characteristic and clearly recognizable. He used planes of color and small brushstrokes that build up to form complex fields, at once both a direct expression of the sensations of the observing eye

and an abstraction from observed nature. The paintings convey Cézanne's intense study of his subjects, a searching gaze and a dogged struggle to deal with the complexity of human visual perception.

塞尚的作品表现出他对设计、色彩、构图和制图术的掌握。他的常常重复、感性和探索的笔法非常具有特征，很容易辨别。他使用色彩面和短笔触来构建复杂的画面，立刻直接表达出观看的眼睛的感受，以及被观察者的本质抽象。绘画传达出塞尚对主题的强烈感受，一种对人类视觉感受复杂性的探索和顽固的斗争。

4. Goethe 歌德

John Wolfgang von Goethe (28 August 1749—22 March 1832) was a German writer. Goethe's works span the fields of poetry, drama, literature, theology, humanism, and science. Goethe's magnum opus, lauded as one of the peaks of world literature, is the two-part drama Faust. Goethe's other well-known literary works include his numerous poems, the Bildungsroman Wilhelm Meister's Apprenticeship and the epistolary novel The Sorrows of Young Werther.

约翰·沃尔夫冈·冯·歌德(1749年8月28日—1832年3月22日)是德国作家。歌德的作品涉及广泛的领域：诗歌、戏剧、文学、神学、人文主义以及科学。歌德被称赞为世界文学的巅峰之作，就是两幕戏剧《浮士德》。歌德的其他著名文学作品包括大量的诗，教育小说《威廉·迈斯特的学习年代》和书信小说《少年维特之烦恼》。

Fig. 14-4 Johann Wolfgang von Goethe

Goethe was one of the key figures of German literature and the movement of Weimar Classicism in the late 18th and early 19th centuries. The author of the scientific text Theory of Colours, he influenced Darwin with his focus on plant morphology. He also served at length as the Privy Councilor ("Geheimrat") of the duchy of Weimar.

歌德是德国文学和18世纪后期到19世纪早期魏玛古典主义运动的关键人物。作为科学论文《色彩理论》的作者，他影响了达尔文去关注植物形态学。他最后也成为了魏玛公国的枢密院顾问官("Geheimrat")。

Goethe is the originator of the concept of Weltliteratur ("world literature"), having taken great interest in the literatures of England, France, Italy, classical Greece, Persia, Arabic literature. His influence on German philosophy is virtually immeasurable, having major effect especially on the generation of Hegel and Schelling.

歌德是 Weltliteratur("世界文学")概念的创立者，他对英国、法国、意大利、古希腊、波斯、阿拉伯等地的文学都有着浓厚的兴趣。他对德国哲学的影响是无法估量的，特别是对黑格尔和谢林那一代哲学家。

Goethe's influence spread across Europe, and his works were a major source of inspiration in music, drama, poetry and philosophy. Goethe is considered by many to be the most important writer in the German language and one of the most important thinkers in West-

ern culture as well.

歌德的影响遍及整个欧洲，他的作品成为了音乐、戏剧、诗歌和哲学的主要灵感来源。歌德被许多人认为是最重要的德语作家，以及西方文化最重要的思想家之一。

5. Yale University 耶鲁大学

Yale University is a private university in New Haven, Connecticut. Founded in 1701 as the Collegiate School, Yale is the third-oldest institution of higher education in the United States and is a member of the Ivy League.

耶鲁大学是位于纽黑文康乃狄格州纽黑文市的私立大学。始创于 1701 年，初名为"大学学院"。耶鲁大学是美国历史上建立的第三所大学，今为常青藤联盟的成员之一。

Particularly well-known are its Yale Graduate School of Arts and Sciences; the undergraduate school, Yale College; and the Yale Law School; the two latter of which have produced a number of U. S. presidents and foreign heads of state. In 1861, the Graduate School of Arts and Sciences became the first U. S. school to award the Ph. D. Also notable is the Yale School of Drama, which has produced many prominent Hollywood and Broadway actors and writers, as well as the art, divinity, forestry and environment, music, medical, management, nursing, and architecture schools.

著名的学院包括耶鲁艺术和科学研究生学院、耶鲁学院（本科学院）以及法学院；后两个学院培养了多位美国总统和其他国家的国家领导人。1861 年，艺术和科学研究生学院成为了首个授予博士学位的美国学校。著名学院还有耶鲁戏剧学院，这所学院培养许多杰出的好莱坞和百老汇演员和作家，以及艺术、神学、森林学与环境、音乐、医学、管理、护理和建筑学院。

Fig. 14-5　Ingalls Rink by Eero Saarinen,
thin-shell and tensile structure

Fig. 14-6　Harkness Tower

Yale and Harvard have been rivals in almost everything for most of their history, notably academics, rowing, and American football. In sports, the Harvard-Yale Regatta and The Game are annual contests.

耶鲁和哈佛在他们的大部分历史中都在为每件事竞赛，特别在学术、划船和美式橄榄球方面。在运动方面，哈佛与耶鲁的划船赛和竞赛每年都举行一次。

Yale is noted for its harmonious yet fanciful Collegiate Gothic campus as well as for several modern buildings commonly discussed in architectural history survey courses: Lou-

is Kahn's Yale Art Gallery and Center for British Art, Eero Saarinen's Ingalls Rink and Ezra Stiles and Morse Colleges, and Paul Rudolph's Art & Architecture Building. Yale also owns many noteworthy 19th-century mansions along Hillhouse Avenue.

耶鲁以其和谐而古怪的哥特式校园，以及许多被建筑历史研究课程普遍讨论的现代建筑而闻名：路易斯·康的耶鲁大学美术馆和耶鲁英国艺术中心，埃罗·沙里宁的耶鲁大学冰球馆，莫尔斯和施泰尔斯两个住宿学院，以及保罗·儒道夫的艺术和建筑大楼。沿着耶鲁的山屋大道，也有许多值得注意的 19 世纪大厦。

Many of Yale's buildings were constructed in the neo-Gothic architecture style from 1917 to 1931. Stone sculpture built into the walls of the buildings portray contemporary college personalities such as a writer, an athlete, a tea-drinking socialite, and a student who has fallen asleep while reading. Similarly, the decorative friezes on the buildings depict contemporary scenes such as policemen chasing a robber and arresting a prostitute (on the wall of the Law School), or a student relaxing with a mug of beer and a cigarette. The architect, James Rogers, faux-aged these buildings by splashing the walls with acid, deliberately breaking their leaded glass windows and repairing them in the style of the Middle Ages, and creating niches for decorative statuary but leaving them empty to simulate loss or theft over the ages. In fact, the buildings merely simulate Middle Ages architecture, for though they appear to be constructed of solid stone blocks in the authentic manner, most actually have steel framing as was commonly used in 1930. One exception is Harkness Tower, 216 feet (66m) tall, which was originally a free-standing stone structure. It was reinforced in 1964 to allow the installation of the Yale Memorial Carillon.

耶鲁大多数古建筑都为哥特式风格，多建于 1917~1931 年期间。大量的浮雕展现出当时的大学生活：有作家、运动员、喝茶的交际花、读书时打瞌睡的学生等等。在耶鲁大学法学院大楼(官方名称为史德林法学大楼)的雕刻上，也展现了当时的一些场景，包括警察追逐强盗和逮捕娼妓的场面。建筑师詹姆斯·罗杰斯为了使建筑显得老旧，采用了在石质墙面上泼酸、故意打破玻璃并且使用中世纪的方法补合，还人为地添加了许多空的装饰性壁龛，仿佛雕塑已经失落很久。虽然耶鲁大学中心校园的大多建筑都呈现中世纪的建筑风格，使用大型的石材，但事实上大多都采用的是 1930 年通用的钢结构框架，唯一的例外是哈克尼斯塔，高 216 英尺(66 米)，它最初是一座独立的全石质结构。该塔在 1964 年加固，为的是在其内部安装耶鲁纪念钟。

Ironically, the oldest building on campus, Connecticut Hall (built in 1750), is in the Georgian style and appears much more modern. Georgian-style buildings erected from 1929 to 1933 include Timothy Dwight College, Pierson College, and Davenport College, except the latter's east, York Street façade, which was constructed in the Gothic style.

讽刺的是，校园内最古老的一幢建筑却属于佐治亚风格，而看起来也似乎更为现代。这座称为"康乃迪楼"的建筑建于 1750 年，现坐落于老校园中，为哲学系所在地。校园里其他的建于 1929~1933 年的佐治亚风格的建筑包括杜外特学院、皮尔森学院和达文波特学院。达文波特学院的东部——约克街立面除外，它是哥特风格。

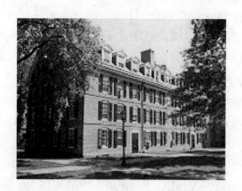

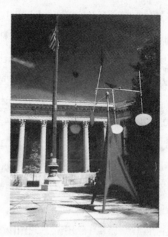

Fig. 14-7　Connecticut Hall　　·　　Fig. 14-8　Beinecke Plaza

The Beinecke Rare Book and Manuscript Library, designed by Gordon Bunshaft, is one of the largest buildings in the world reserved exclusively for the preservation of rare books and manuscripts. It is located near the center of the University in Hewitt Quadrangle, which is now more commonly referred to as "Beinecke Plaza." The sculptures in the sunken courtyard by Isamu Noguchi are said to represent time (the pyramid), the sun (the circle), and chance (the cube).

百内基珍本书图书馆由戈登·邦夏设计，是当今世界上最大的专门收藏古籍善本的图书馆。它坐落于休伊特庭院的旁边（现在多被称作百内基广场）。广场下沉式庭院中的雕塑由野口勇设计，代表了时间（金字塔）、太阳（圆环结构）和几率（斜立的立方）。

6. Le Corbusier　勒·柯布西耶

Charles-Édouard Jeanneret-Gris, who chose to be known as Le Corbusier (October 6, 1887—August 27, 1965), was a Swiss-born architect, designer, urbanist, writer and also painter, who is famous for his contributions to what now is called Modern architecture. In his 30s he became a French citizen.

尔斯—爱德华·让雷内，人们熟知的名字是勒·柯布西耶（1887 年 10 月 6 日—1965 年 8 月 27 日），是瑞士出生的建筑师、设计师、城市规划师、作家和画家，以其对现在被称为现代主义建筑的贡献而闻名。在 30 岁时，他成为了一名法国公民。

He was a pioneer in studies of modern design and was

Fig. 14-9　Le Corbusier

dedicated to providing better living conditions for the residents of crowded cities. His buildings constructed throughout central Europe, India, Russia, and one each in North and South America. He was also an urban planner, painter, sculptor, writer, and modern furniture designer.

他是现代设计研究的先锋者，专注于为拥挤城市的居民提供更好的生活条件。他所设计的建筑遍布欧洲中部、印度、俄国，在北美和南美各有一个。他也是一位城市规划师、

画家、雕塑家、作家和现代家居设计师。

It was Le Corbusier's Villa Savoye (1929—1931) that most succinctly summed up his five points of architecture that he had elucidated in the journal L'Esprit Nouveau and his book Vers une architecture, which he had been developing throughout the 1920s. First, Le Corbusier lifted the bulk of the structure off the ground, supporting it by pilotis-reinforced concrete stilts. These pilotis, in providing the structural support for the house, allowed him to elucidate his next two points: a free facade, meaning non-supporting walls that could be designed as the architect wished, and an open floor plan, meaning that the floor space was free to be configured into rooms without concern for supporting walls. The second floor of the Villa Savoye includes long strips of ribbon windows that allow unencumbered views of the large surrounding yard, and which constitute the fourth point of his system. The fifth point was the Roof garden to compensate the green area consumed by the building. A ramp rising from the ground level to the third floor roof terrace, allows for an architectural promenade through the structure. The white tubular railing recalls the industrial "ocean-liner" aesthetic that Le Corbusier much admired.

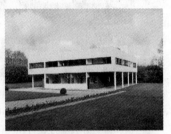
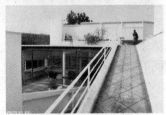

Fig. 14-10 Villa Savoye

勒·柯布西耶的萨伏伊别墅(1929—1931)最能体现他在杂志《新精神》和著作《走向新建筑》阐述的建筑五点，这一理念是他在整个 20 世纪 20 年代所发展形成的。首先，勒·柯布西耶将建筑体量从地面上提升起来，用独立支柱支撑——强化混凝土支柱。这些独立支柱为住宅提供结构支撑，使他又阐明了下面两点：自由立面——意味着墙体可以如建筑师所希望的那样不承重；开放的平面——意味着平面空间可以自由分隔，不需要考虑承重墙。萨伏伊别墅的第二层有长条状窗户，这构成了柯布西耶系统的第四点。第五点是屋顶花园，以补偿建筑所消耗掉的绿色区域。从地面层到第三层的屋顶平台有一条坡道，提供一条穿越建筑的通道。白色的管状扶手使人回想起勒·柯布西耶非常赞赏的工业"外洋轮船"美学。

Le Corbusier was at his most influential in the sphere of urban planning, and was a founding member of the Congrès International d'Architecture Moderne (CIAM).

勒·柯布西耶在城市规划领域最有影响力，他是国际现代建筑协会(CIAM)的创立成员之一。

One of the first to realize how the automobile would change human agglomerations, Le Corbusier described the city of the future as consisting of large apartment buildings isolated in a park-like setting on pilotis. Le Corbusier's theories were adopted by the builders of public housing in Western Europe and the United States.

作为首先认识到汽车将如何改变人类群体的人，勒·柯布西耶将未来城市描述为公寓建筑支撑在巨大的高楼架空底层支柱上，以公园般的种植间隔。勒·柯布西耶的理论被西欧和美

Fig. 14-11　The Open Hand Monument
is one of numerous projects in
Chandigarh, India designed
by Le Corbusier

国的公共住宅建筑者所采纳。

Le Corbusier was heavily influenced by the problems he saw in the industrial city of the turn of the century. He thought that industrial housing techniques led to crowding, dirtiness, and a lack of a moral landscape. He was a leader of the modernist movement to create better living conditions and a better society through housing concepts. Ebenezer Howard's Garden Cities of Tomorrow heavily influenced Le Corbusier and his contemporaries.

勒·柯布西耶受到了他在世纪之交所看到的工业城市问题的深刻影响。他认为工业化居住设施导致了过于拥挤，污秽不堪和缺乏道德伦理的景观。他是现代主义运动的领导者，想要通过居住概念创造更好的生活条件和更好的社会。埃比尼泽·霍华德的《明日的田园城市》对勒·柯布西耶以及和他同时代的人产生了重要影响。

7. Lincoln's Inn Fields　林肯因河广场

Lincoln's Inn Fields is the largest public square in London, England. It is thought to have been one of the inspirations of Central Park, New York. It was opened to the public after its acquisition by London County Council in 1895. It is today managed by the London Borough of Camden and forms part of the southern boundary of that borough with the City of Westminster.

林肯因河广场是英国伦敦最大的公共广场。它被认为是纽约中央公园的灵感来源之一。1895年伦敦市政议会获得这块地的所有权后向公众开放。今天它是由卡姆登区管理，并形成了伦敦威斯敏斯特自治镇南部边界的一部分。

It takes its name from the adjacent Lincoln's Inn, but should not be confused with the private gardens of Lincoln's Inn itself. Lincoln's Inn is separated from Lincoln's Inn Fields by a perimeter wall and a large gatehouse.

它的名字来源于附近的英国林肯律师学院，但是不能把它和英国林肯律师学院本身的私有花园相混淆。英国林肯律师学院通过四周的墙体和巨大的门房从林肯因河广场中分隔出来。

At number 13, on the north side of the square, is Sir John Soane's Museum, home of the architect. Organizations with premises on the south side of the square include Cancer Research UK, the Royal College of Surgeons (including the Hunterian Museum exhibiting the intriguing medical collections of John Hunter) and HM Land Registry. There is a blue plaque marking the home of the surgeon William Marsden at number 65. On the west side, the Lon-

Fig. 14-12　Lincoln's Inn
Fields in Spring 2006

Fig. 14-13 Sir John Soane's Museum

don School of Economics and Political Science has new premises at Stuart House, which opened in September 2008, as well as offices at Queen's House. There is a statue by Barry Flanagan, an abstract called *Camdonian*, in the North East corner of the square.

广场北面的 13 号是索恩爵士博物馆——建筑师的住宅。广场南面的机构包括英国癌症研究院、皇家外科医学院(包括展示英国医生约翰·亨特有趣收藏品的亨特利安博物馆)和英国土地注册局。65 号有一个蓝色徽章,标示着外科医生威廉·马尔斯登的住宅。在西面,有伦敦政治经济学院的斯图尔特住宅(于 2008 年 9 月开放),以及女王官邸办公室。在广场的东南角还有巴里·弗拉纳根创作的雕塑,一座名为"Camdonian"的抽象雕塑。

The grassed area in the centre of the Fields contains a court for tennis and netball and a bandstand. It was previously used for corporate events, but these are no longer permitted.

广场中心的草地有一片包括网球、篮球和演奏台的场地。它以前是用于集会,但是这些活动现在不再允许了。

The Lincoln's Inn Fields Theatre was located in the Fields from 1661 to 1848 when it was demolished. Originally called the Duke's Theatre, it was created by converting Lisle's Tennis Court, to become the Lincoln's Inn Fields Theatre in 1695. The theatre presented the first paid public performances of Purcell's Dido and Aeneas in 1700, most importantly John Gay's The Beggar's Opera in January 1728, and Handel's final two operas in 1740 and 1741.

伦敦林肯律师学院菲尔兹剧院从 1661 年到 1848 年一直位于广场之中,到 1848 年被拆毁。最初名称是公爵剧院,它由林希网球场改建而来,1695 年成为了伦敦林肯律师学院菲尔兹剧院。剧院在 1700 年举行了普塞尔的《珀塞尔狄多与埃涅阿斯》首场收费公众演出,最著名的是 1728 年 1 月约翰·盖伊的《乞丐歌剧》,以及 1740 年和 1741 年韩德尔的最后两部歌剧。

Fig. 14-14 Handmade oil painting reproduction of Lincolns Inn Fields Theatre, 1811

Since 2007, Lincolns Inn Fields is also home to the Centre for Commercial Law Studies, Queen Mary, University of London.

从 2007 年开始，林肯因河广场也成为了伦敦大学玛丽女王学院的商业法律研究中心所在地。

8. Shakespeare 莎士比亚

William Shakespeare (baptised 26 April 1564—23 April 1616) was an English poet and playwright, widely regarded as the greatest writer in the English language and the world's preeminent dramatist. He is often called England's national poet and the "Bard of Avon" (or simply "The Bard"). His surviving works consist of 38 plays, 154 sonnets, two long narrative poems, and several other poems. His plays have been translated into every major living language, and are performed more often than those of any other playwright.

Fig. 14-15 The Chandos portrait, artist and authenticity unconfirmed. National Portrait Gallery, London

威廉·莎士比亚(1564 年 4 月 26 日受洗—1616 年 4 月 23 日)是英国诗人和剧作家，被广泛认为是最伟大的英语作家和世界杰出剧作家。他常常被称为英国的民族诗人和"艾冯河畔诗人"（或者简称为"吟游诗人"）。他现存的作品有 38 部戏剧，154 首十四行诗，两部长篇叙事诗和一些诗歌。他的戏剧被翻译成所有至今仍存的语言，比其他任何剧作家的戏剧演出的次数都多。

Shakespeare produced most of his known work between 1590 and 1613. His early plays were mainly comedies and histories, genres he raised to the peak of sophistication and artistry by the end of the sixteenth century. He then wrote mainly tragedies until about 1608, including Hamlet, King Lear, and Macbeth, considered some of the finest examples in the English language. In his last phase, he wrote tragicomedies, also known as romances, and collaborated with other playwrights.

莎士比亚著名作品的绝大多数是在 1590~1613 年间创作的。他早期的戏剧主要是喜剧和历史剧，这类型作品在 16 世纪末达到了精致性和艺术性的顶峰。这之后直到 1608 年他主要写悲剧，包括《哈姆雷特》、《李尔王》和《麦克白》，这些作品被认为是英语文学的最佳范例。在他最后的日子里，他开始写悲喜剧（也被称为浪漫诗）并和其他剧作家合作。

Shakespeare was a respected poet and playwright in his own day, but his reputation did not rise to its present heights until the nineteenth century. The Romantics, in particular, acclaimed Shakespeare's genius, and the Victorians hero-worshipped Shakespeare with a reverence that George Bernard Shaw called "bardolatry". In the twentieth century, his work was repeatedly adopted and rediscovered by new movements in scholarship and performance. His plays remain highly popular today and are constantly performed and reinterpreted in diverse cultural and political contexts throughout the world.

在莎士比亚所生活的时代，他是受人尊敬的诗人和剧作家，但是他的声望直到 19 世纪才达到现今的高度。特别是浪漫主义者开始为莎士比亚的天赋和维多利亚时代的英雄崇拜而欢呼。乔治·伯纳德·肖称之为"莎士比亚崇拜"。20 世纪，它的作品被学术和表演的新运动重复采纳和重现。他的戏剧至今仍非常流行，不断在全世界不同的文化和政治背景中上演和重新阐释。

Shakespeare's work has made a lasting impression on later theatre and literature. In particular, he expanded the dramatic potential of characterisation, plot, language, and genre. Until Romeo and Juliet, for example, romance had not been viewed as a worthy topic for tragedy. Soliloquies had been used mainly to convey information about characters or events; but Shakespeare used them to explore characters' minds. His work heavily influenced later poetry. The Romantic poets attempted to revive Shakespearean verse drama, though with little success.

莎士比亚的作品对随后的戏剧和文学有持久的影响。特别是他扩展了人物、情节、语言和题材风格的戏剧潜力。例如，直到《罗密欧和朱丽叶》，浪漫主义才被视为有价值的悲剧主体。独白才被用来传达有关人物和事件的信息。莎士比亚将它们用来展现人物的思想。他的作品对后期的诗歌产生了重要的影响。浪漫主义诗人尝试复兴莎士比亚的韵文戏剧，虽然极少有成功之作。

Shakespeare influenced novelists such as Thomas Hardy, William Faulkner, and Charles Dickens. Dickens often quoted Shakespeare. The American novelist Herman Melville's soliloquies owe much to Shakespeare; his Captain Ahab in Moby-Dick is a classic tragic hero, inspired by King Lear. Scholars have identified 20000 pieces of music linked to Shakespeare's works. These include two operas by Giuseppe Verdi, Otello and Falstaff. Shakespeare has also inspired many painters, including the Romantics and the Pre-Raphaelites. The Swiss Romantic artist Henry Fuseli, a friend of William Blake, even translated Macbeth into German. The psychoanalyst Sigmund Freud drew on Shakespearean psychology, in particular that of Hamlet, for his theories of human nature.

莎士比亚影响了如威廉·福克纳和查尔斯·狄更斯等小说家。狄更斯常常引用莎士比亚的名句。美国小说家赫尔曼·梅尔维尔的独白很多都是模仿莎士比亚；他的《白鲸》中的亚哈船长是经典的悲剧式英雄，灵感源于《李尔王》。学者们认为有 20000 件音乐作品和莎士比亚的作品有联系。其中包括朱赛琵·威尔第的两部歌剧——《奥赛罗》和《法斯塔夫》。莎士比亚也是许多画家的灵感来源，其中就包括浪漫主义和前拉斐尔派。瑞士浪漫主义艺术家亨利·弗赛利是威廉·布莱克的朋友，他甚至把《麦克白》翻译成德文。心理分析学者西格蒙德·弗洛伊德将莎士比亚戏剧中的心理学，特别是哈姆雷特的心理用来研究人类本质。

9. Othello　《奥赛罗》

Othello, the Moor of Venice is a tragedy by William Shakespeare, believed to have been written in approximately 1603, based on the short story "Moor of Venice" by Cinthio. The work revolves around four central characters: Othello, his wife Desdemona, his lieutenant Cassio, and his trusted advisor Iago. Attesting to its enduring popularity, the play appeared

in 7 editions between 1622 and 1705. Because of its varied themes—racism, love, jealousy and betrayal—it remains relevant to the present day and is often performed in professional and community theatres alike. The play has also been the basis for numerous operatic, film and literary adaptations.

《奥赛罗》是威廉•莎士比亚所写的悲剧，大约写于 1603 年，以钦提奥的短故事《威尼斯的摩尔人》为基础创作而成。作品围绕四个中心人物展开：奥赛罗、他的妻子苔丝狄蒙娜、他的副官凯西奥和他信任的顾问伊阿古。它持续流行的证明是戏剧在 1622~1705 年出版了 7 个版本。因为不同的主题——种族主义、爱情、嫉妒和背叛——它留传至今，常常在专业和社会剧院等地表演。这部戏剧也成为无数歌剧、电影和文学改编的基础。

Fig. 14-16　Poster for an 1884 American production starring Thomas Keene

Vocabulary

1. mode　*n.* ①方式，方法：modes of thought 思想方法　mode of life 生活方式　②(事情发生的)情况：This fever will return from time to time, if it follows its usual mode. 一般情况，这种热病每隔一阵子就会再发作。③样式，款［模］式，体裁，习惯种类　④风尚，流行；时髦　⑤［语］(= mood)语气

［近义词］fashion, style, trend, vogue, prevalence, currency, rage, fad, popularity, ton　*n.* 风尚，流行

method, fashion, manner, process, way, procedure, means, custom, form, technique, approach　*n.* 方式，样式

［辨析］**mode 方法、方式**：指一定的、习惯的或独特的方式方法。
We abide by civilized modes of living.　我们遵循文明的生活方式。

method 方法：指有系统的方法，按照步骤或系统做适宜的处理。
Follow her method for cooking.　学学她的烹饪法。

fashion 方式、式样：指做事或行动的方式。
He walks in a peculiar fashion.　他走路的样子很奇特。

manner 方式、方法：指行动的特殊方式或独特的方法。
He rides in the western manner.　他采用西方的姿势骑马。

process 方法、程序：指生产中的制作方法。
The new process has yielded good results.　新的方法已经产生了好的结果。

way 方式、方法：普通的用词。
The way she spoke hurts me.　她讲话的态度伤了我的心。

2. genuine　*adj.* ①真正的；真实的；名副其实的：All genuine knowledge origi-

nates in direct experience.　一切真知都是从直接经验发源的。②真实的，诚恳的；非伪装的：a genuine person 诚恳的人　③纯的，纯血统的；用天然原料制成的：a genuine Hawaiian 纯正的夏威夷人

　　[近义词] sincere,heartfelt,straightforward,actual,authentic,candid,earnest,frank,honest,legitimate,natural,originalm prue,real,sound,true,veritable　*adj.* 真正的，诚恳的，真诚的

　　[辨析] **genuine 真正的、诚恳的**：指正如所说的一样，不是伪造的。

It is a genuine picture by Rubens.　这是鲁宾斯的真迹(画)。

sincere 真诚的：指感情、行为诚挚的。

He is a sincere friend.　他是一个诚挚的朋友。

heartfelt 诚意的：指发自内心的、真诚的。

I give you my heartfelt thanks.　我向你表示衷心的感谢。

straightforward 直率的：指诚实而直率。

He gave us a straightforward explanation of his long absence from home.
他很直率地向我们解释了他长期离家的原因

　　3. authentic　*adj.*　①可信的，可靠的，确实的，有根据的：authentic news 可靠消息　②真的，真正的：Is that an authentic painting from Piccaso,or a modern copy? 那幅油画是毕加索的真迹还是现代仿制品？

　　[近义词] reliable,authoritative,dependable,solid,sound,trustworthy　*adj.* 可靠的，权威性的，有根据的

　　actual,positive,real,genuine,legitimate,true,solid　*adj.* 真正的

　　[辨析] **authentic 真实的、可信的**：它的意思更为强烈，可作为法律上的正式用词。

It is an authentic signature.　这是真实的签名。

actual 实际的、现实的：表示实际存在的意思，是"假定"的反义词。

The actual conditions aren't very good.　实际情况并不理想。

positive 确实的：表示确定无疑的意思，是 doubtful(可疑的)的反义词。

The leader gave him a positive answer.　领导给了他一个肯定的答复。

real 真实的：指事实存在的，并非虚构的事物，是 imaginary(想象的)的反义词。

It is a real pleasure to meet you.　真高兴和你见面。

　　4. detach　*vt.*　①分开；拆开；分离；移开(常与 from 连用)：detach a check from the checkbook 从支票簿上撕下一张支票　②[军]指派担任特种任务，分遣，派遣(军队等)：Men were detached to defend the pass.　已经派遣了人员去防守关隘。

　　[近义词] dispatch,assign,apportion,send on a special mission,assign to special service　*v.* 派遣，分派

　　isolate,cut off,seclude,separate,disconnect,disengage,sever,unhitch,loosen　*v.* 分开，分离，拆开

　　[辨析] **detach 分离、分开**：指解开、拆开的意思。

He detached a watch from a chain.　他将表与表链分开。

isolate 使隔离、使孤立：指与其他人或物分离。

When a person has an infectious disease,he is usually isolated.

当某人患传染病时，他通常会被隔离起来。

cut off 隔离、使孤立：指切断、阻断而导致隔离或孤立。

The enemy was cut off from all help. 敌军陷入孤立无援的境地。

seclude 隔离、隔绝：指使人、自己与他人隔离。

The old lady secluded herself from society. 这老妇人过着隐居生活。

5. hostility n. ①敌对状态；敌对行动：feelings of hostility 敌意　②反对［抗］；抵抗　③(*pl.*)战斗；战争：open [suspend] hospitalities 开［停］战

[近义词] animosity, feud, brawl, quarrel, antagonism, aversion, abhorrence, enmity, antipathy, rancor, dislike, hate, hatred, illwill, malice, opposition, resentment　*n.* 敌意，敌视，敌对状态

[辨析] **hostility 敌意、敌视**：指公开地与某人或某物表示敌对的意思。

I feel no hostility towards anyone. 我对任何人都没有敌意。

animosity 仇恨、敌意：指强烈的敌意以致形成仇恨。

There exist animosities between classes. 阶级间存在着仇恨。

feud 争执、宿仇：指群体间持续很久的恩怨，有时继之以谋杀性的攻击和报仇。

The two families have been at feud with each other for many generations. 这两家已经有几代的冤仇了。

brawl 口角：指大声的争吵。

A family brawl kept the neighbors awake all night. 这场家庭争吵搞得邻居们一个晚上都没睡着。

quarrel 争吵、争论：指吵嘴、吵架，吵过后就算了，或是吵后继之以打架。

We had a voilent quarrel. 我们发生了剧烈的争吵。

6. originate *vt.* ①使产生；创始；创办；发明；originated the practice of monthly reports. 开创了每月报告的惯例　②发起；引起：They originated the plan. 他们首先提出这一计划。*vi.* 发源；开始，发生；The quarrel originated in a misunderstanding. 争吵是由于误解而引起的。

[近义词] pionner, introduce, launch, invent, create, initiate, start, instigate, set up　*n.* 首创，发明

cradle, generate, arise, begin, derive, develop, emerge, evolve, inaugurate, issue, emanate, result from, stem from, be born　*n.* 起源，发生

[辨析] **originate 创始**：指开始或发端。

Coal of all kinds has originated from the decay of plants. 各种煤都是由植物腐烂而变成的。

cradle 摇篮：指婴儿用的摇篮，常比喻为发源地。

Greece is the cradle of western culture. 希腊是西方文化的发源地。

generate 产生：指促使产生或存在。

Much electricity is generated. 发了很多电。

7. enigma *n.* ①谜，难解的话［文章］②不可思议的事物［人物］

[近义词] paradox, absurdity, ambiguity, mystery, problem, puzzle, riddle, stumper　*n.* 谜

［辨析］**enigma** 谜：指令人迷惑的问题、人物、事物或情况。

To most of the audience, the philosopher seemed to speak in enigmas. 对于大部分的听众来说，那哲学家所说的似乎是谜语。

paradox 似是而非的论点：指表面上看来似乎与事实或一般常理相背，但实际上却蕴含着真理，或至少有一半是真实的。

"More haste less speed" and "The child is father to the manv are paradoxes". "越急越慢"与"儿童乃成年人之父"都是似是而非的论点。

absurdity 荒谬：指不合理的和可笑的，显然与常识、理性相背的行为或言论。

This book contains multitudinous absurdities. 这本书有许多荒谬之处。

ambiguity 意义含糊：指可能有两种以上含义的词句或意义含糊的话。

In making a contract, ambiguities should be avoided. 订合同时应避免使用意义含糊的词。

Sentence：

The task of architecture is to make visible 'how the world touches us', as Maurice Merleau-Ponty wrote of the paintings of Paul Cezanne.

建筑的任务是创造"世界如何触知我们"的可见形式，正如莫里斯·梅洛—庞蒂为保罗·赛尚的绘画的评论。

In developing Goethe's notion of "life-enhancing" in the 1890s, Bernard Berenson suggested that when experiencing an artistic work we imagine a genuine physical encounter through 'ideated sensations'.

伯纳德·贝伦森发展了 19 世纪 90 年代歌德的"生命扩展"的概念，指出当我们体验一种艺术作品的时候，我们通过"设想知觉"想象一种真正的身体上的接触。

We are not usually aware that an unconscious element of touch is unavoidably concealed in vision; as we look, the eye touches, and before we even see an object we have already touched it.

我们并没有经常意识到在视觉中不可避免地隐藏着一种无意识的触摸成分；当我们观看的时候，眼睛就在触摸，甚至在我们看清一个物体之前我们就已经在触摸它了。

In its quest for the perfectly articulated autonomous artifact, the main line of Modernist architecture has preferred materials and surfaces that seek the effect of flatness, immaterial abstractness and timelessness.

在追寻完美表达明确的人工制品的过程中，现代主义建筑大都更偏爱那些追求平面化、非物质抽象性和永恒性的材料和表面。

As a consequence of its formal ideals, the architecture of our time is usually creating settings for the eye which seem to originate in a single moment of time and evoke the experience of flattened temporality.

作为理想形式的结果，我们时代的建筑常常为视觉创造出环境布景，它似乎产生于某个独特的瞬间，并唤起人们对暂时性的体验。

There are architects in our time, however, who evoke healing experiences of time. The architecture of Sigurd Lewerentz, for instance, connects us with deep time; his works ob-

tain their unique emotive power from images of matter which speak of opaque depth and mystery, dimness and shadow, metaphysical enigma and death.

然而，我们的时代中有些建筑师召唤人们去恢复对时间的体验。例如，西古德·莱伟伦茨的建筑，将我们与时间联系起来；他的作品从物质的意象中获得了使人动情的独特力量，讲述了无法洞悉的深刻与神秘，模糊与朦胧，玄奥谜题与死亡。

Translation

第 14 课　多重感官体验：触觉的意义

任何有意义的建筑体验都是可多重感知的：物质、空间和尺度的意义是通过眼睛、耳朵、鼻子、皮肤、舌头、骨骼和肌肉来衡量的。莫里斯·梅洛—庞蒂是这样来强调这种体验的同时性和感官相互作用的："我的感受（因此）并非是视觉、触觉和听觉带来的总和，我用我的整个身体来感知：我体会到一种独特的事物结构，一种独特的存在方式，它们通过我所有的感官同时向我传达信息。"

建筑的任务是创造"世界如何触知我们"的可见形式，正如莫里斯·梅洛—庞蒂对保罗·赛尚的绘画的评论。梅洛—庞蒂另一个对建筑概念的解释是：建筑凝聚和塑造了人类在"世界中"的存在。伯纳德·贝伦森发展了 19 世纪 90 年代歌德的"生命扩展"的概念，指出当我们体验一种艺术作品的时候，我们正在通过"设想知觉"想象一种真正的身体接触。贝伦森称其中最重要的一点为"触觉评价"。按照他的观点，真正的艺术刺激我们触摸的设想知觉，而这种刺激正是生命扩展。我认为，真正的建筑作品也会唤起类似的强化我们自身体验的设想触摸知觉。

我们时代中带有视觉偏好的建筑，无疑正在引发一种对可触知建筑的寻求。快速、控制力强的文化喜爱为眼睛而设计的建筑，拥有瞬时的图像和疏远的影响，而为触觉设计的建筑减缓了速度，带来了亲密感，逐渐作为身体和皮肤的想象而获得欣赏和理解。视觉的建筑带来隔离和控制，而可触知的建筑带来参与和联合。触觉的敏感性通过材料、接近和亲密，取代了远观的视觉印象。

我们并没有经常意识到在视觉中不可避免地隐藏着一种无意识的触摸成分。当我们观看的时候，眼睛就在触摸，甚至在我们看清一个物体之前我们就已经在触摸它了。正如梅洛—庞蒂所写的那样："通过视觉，我们触摸到星星和太阳"。触摸是视觉的一种下意识，而这种隐藏其中的触觉体验确定了被观察物体的感官质量内涵，包括吸纳或排斥、礼遇或敌视等媒介信息。

"建筑并非仅仅涉及通俗易懂的空间"，耶鲁大学的哲学教授谢尔斯滕·哈里斯这样写道："它也是人们抵御对时间的恐惧的深层防线。优美的语言本质上就是永恒现实的"。建筑的任务就是为我们在空间中提供居所这一概念已经获得了大多数建筑师的承认，但它的第二项任务，在我们与使人恐惧的、朝生暮死的时间维度之间进行调节，却经常受到漠视。

在追寻表达完美明确的人工制品过程中，现代主义建筑大都更偏爱那些追求平面化、带有非物质抽象性和永恒性的材料和表面。按照勒·柯布西耶的说法，洁白为"真实的视觉"服务，影响道德和目标的价值。现代主义者将表面视为物体被分离出来的边界，因而

具有概念性而非感官性的本质。由于外观和体量被给予了优先权，这些表面便趋向于保持缄默：形式突出，而物质保持缄默。对纯粹几何和简化美学的渴望，进一步弱化了物质的现实感；以同样的方式，绘画艺术中强有力的外形和轮廓的表现削弱了色彩的交互作用；而所有真正的善用色彩者在绘画中使用一种淡薄的格式塔完成形式，使色彩的交互作用达到最大化。抽象和完美将我们送入思想的世界，然而物质、侵蚀和衰败加强了我们对时间、因果和现实的体验。

作为理想形式的结果，我们时代的建筑常常为视觉创造出环境布景，它似乎产生于某个独特的瞬间，并唤起人们对暂时性的体验。时间决定我们在现在时态中的位置。然而触觉体验唤起我们对时间连续统一体的体验。不可避免的老化、侵蚀和磨损的过程，在设计中并没有常常当作自觉和积极的因素来认识；建筑的人造物存在于一个永恒的空间中，是一种从时间现实中分离出来的人工环境。现代建筑渴望唤起一种永远年轻和永远保持在现在时刻的气氛。尽善尽美的理想，进一步使建筑的目标从时间现实和使用轨迹中分离出来。结果，我们的建筑物已经在时间的作用和复仇之下变得十分脆弱。时间和使用，不再为我们的建筑物提供寿命和权威的积极特性，而是去破坏性地攻击它们。

人类需要通过建筑体验来理解时间的一个特别发人深省的实例，就是设计和建造废墟遗迹的传统，这在 18 世纪的英国和德国曾经成为一种狂热的时尚。当约翰·索恩投身于他在林肯郡因菲尔德住宅的建造中时——顺便说明一下，这栋住宅中包含着对废墟的想象——将他的建筑想象成为一处废墟遗迹，并写下了一篇假想的未来考古学家的研究报告。

然而，我们的时代中有些建筑师召唤人们去恢复对时间的体验。例如，西古德·莱伟伦茨的建筑，将我们与时间联系起来；他的作品从物质的意象中获得了使人动情的独特力量，讲述了无法洞悉的深刻与神秘，模糊与朦胧，玄奥谜题与死亡。死亡转变成生命的镜像；莱伟伦茨使我们能够毫无惧色地理解我们的死亡，使我们置身于无限持续的连续统一体之中——按照莎士比亚在《奥赛罗》中的表达方式——"时间的坟墓"。

Lesson 15　Landscape Planning: a History of Influential Ideas

In the 16th century, the Medici were the most powerful family in Italy. They had houses in cities as well as sixteen villas in the Tuscan countryside. The Medici villas were decorated with paintings that express the idea that the landscape was the basis of the wealth of the family, and also that it was also a beautiful place (Fig. 15-1). Over the next two or three hundred years the idea that a productive agricultural landscape was a beautiful landscape became very powerful. However, the owners of the villas were not the working farmers. The owners did not directly create the landscape, the peasant farmers did. Unlike the peasant farmer, the aristocracy had the leisure to recognize and enjoy the beauty of the productive landscape. It is only for the past 100 years or so, as education and leisure have increased, that appreciation of the beauty of the productive landscape has been shared by all kinds of people.

Many of the great English landscape gardeners and improvers had the same idea, that the landscape can be both productive and beautiful. A good example is Stowe, a work by Charles Bridgeman, William Kent, and Lancelot "Capability" Brown. The landscape was productive, with sheep, cattle and deer grazing among scattered clumps of trees. This sort of English landscape has become idealized as a beautiful landscape, and has formed the image that has inspired much of Western landscape design (Fig. 15-2).

Fig. 15-1　The Medici villas　　　　Fig. 15-2　Western landscape design

Perhaps the most famous English landscape gardener was Humphry Repton (1752—1818) (Fig. 15-3). For the large landscapes, he had one very important good idea, and is associated with another, bad idea. His good idea is that each project should be described using two drawings, one of "before" (Fig. 15-4) and one of "after" (Fig. 15-5) the design is carried out. Reptons watercolor illustrations of his designs have flaps that fold over the areas where changes are planned. When you lift the flap, the new design appears. Repton used the only direct way to show the effect of proposed changes to the existing landscape. The second idea, the

Fig. 15-3　Humphry Repton

bad one, is a broad cultural idea. It comes from Burkes idea of the sublime. "Designs that are vast only by their dimensions are always the sign of a common and low imagination. No work of art can be great, but as it deceives. To be otherwise is the prerogative of nature only". In other words, a design must be artificial: it must deceive. And to plan a large landscape implies a lack of imagination.

Fig. 15-4　landscape of "before"　　　　Fig. 15-5　landscape of "after"

At almost in the same time, in France, Jean Marie Morel (1728—1810) (Fig. 15-6) wrote his book, "Theorie des jardins" (1776). His basic position was that design is managing the natural processes of the landscape. He worked on the famous landscape at Ermenonville, near Paris. This is a designed landscape (Fig. 15-7) that respects and takes advantages of the natural processes of the site, its hydrology, vegetation, and drainage. As early as the 1770s, there was a great debate, which survives today in landscape architecture, "Are we creating artificial landscapes or managing natural processes?"

Fig. 15-6　Jean Marie Morel　　　　Fig. 15-7　landscape at Ermenonville

Thomas Jefferson (1743—1826) was the third President of the United States of America (Fig. 15-8). He decided that the middle part of the United States should be surveyed and sub-divided by using a square grid. His aim was to encourage settlement of what is now the Midwest (Fig. 15-9). In the 1780s. he needed an inexpensive way to define the boundaries of homesteads for new settlers. His idea, that the landscape should be surveyed as a grid, was extended westward as the country grew. It can still be seen today by anyone who flies over the country. The shaping of the American landscape owes more to Jefferson than to any other individual.

Fig. 15-8　Thomas Jefferson　　　　Fig. 15-9　square grid of America

Our German colleagues might claim that landscape planning began with Prince Leopold Ⅲ Friedrich Franz von Anhalt-Dessau (1740—1817). In 1740 he inherited one of the many German principalities, and was concerned with its improvement. England was then the most advanced and prosperous nation in the world. English literature, economics, government, and landscape were regarded as the model for most of Europe. Prince Franz made extended visits to England to study English ways, and returned home to introduce English ideas and to remake his lands in the way of the English landscape. The landscape of Worlitz was developed between 1765 and 1817. It functioned both to educate in the advanced agricultural techniques of England, and to exemplify English liberalism: it was a didactic landscape (Fig. 15-10). Many learned the new social, physical, economic, governmental, and landscape ideas from the Dessau-Worlitz"Garden Kingdom". Prince Franzs great idea was not to copy a style, but to use the landscape to teach.

John Claudius Loudon (1783—1843), in the 1830s was the most important landscape designer in Britain. He made his reputation by designing parks and gardens for wealthy people and as a thinker and writer on landscape gardening and architecture. Loudon made a regional landscape plan for the entire region of London (Fig. 15-11). He proposed that there should be alternating rings of city and countryside, centered on the Palace of Westminster on the River Thames. Loudon made a series of example designs that showed how a garden could be different in the middle of the city, in a suburban area or in the countryside.

Fig. 15-10　Dessau-Worlitz"Garden Kingdom"　　　Fig. 15-11　the entire region of London

This concentric diagram was his way of saying that people cannot live only in the city, and they cant live only in the countryside. It was the same idea as Yin and Yang. Both are necessary. This was a very important idea in the 1830s, and it is still relevant today, for example, in Shanghai or Beijing.

Notes

1. The Medici 美第奇家族

The Medici family was a powerful and influential Florentine family from the 13th to 17th century. The family produced three popes (Leo Ⅹ, Clement Ⅶ, and Leo Ⅺ), numerous rulers of Florence (notably Lorenzo the Magnificent, patron of some of the most famous works of Renaissance art), and later members of the French and English royalty. Like other families they dominated their city's government. They were able to bring Florence under their family's power, allowing for an environment where art and humanism could flourish. They led the birth of the Italian Renaissance along with the other great families of Italy like the Visconti and Sforza families of Milan, the Este of Ferrara, the Gonzaga of Mantua, and others.

Fig. 15-12 Coat of arms
of Medici

美第奇家族是从 13 世纪到 17 世纪强大和有影响力的佛罗伦萨家族。这个家族产生了三位教皇(里欧十世、克莱门特七世和里欧十一世)无数的佛罗伦萨统治者（特别是慷慨的洛伦佐——最著名的文艺复兴艺术作品的赞助者）和随后的法国和英国皇室成员。就像其他家族一样，他们统治了整个城市。他们将佛罗伦萨置于家族权利之下，营造一种艺术和人文主义繁荣的环境。他们与米兰的维斯康提和斯福尔扎家族，费拉拉的埃斯特家族，曼图亚的龚萨格家族等等其他意大利家族一起，带来了意大利文艺复兴。

The biggest accomplishments of the Medici were in the sponsorship of art and architecture, mainly early and High Renaissance art and architecture. The Medici were responsible for the majority of Florentine art during their reign. Their money was significant because during this period, artists generally only made their works when they received commissions in advance. Giovanni di Bicci de'Medici, the first patron of the arts in the family, aided Masaccio and commissioned Brunelleschi for the reconstruction of the Basilica of San Lorenzo, Florence in 1419. Cosimo the Elder's notable artistic associates were Donatello and Fra Angelico. The most significant addition to the list over the years was Michelangelo Buonarroti (1475—1564), who produced work for a number of Medici, beginning with Lorenzo the Magnificent, who was said to be extremely fond of the young Michelangelo, inviting him to study the family collection of antique sculpture. Lorenzo also served as patron to Leonardo da Vinci (1452—1519) for seven years. Indeed Lorenzo was an artist in his own right, and author poetry and song; his support of the arts is seen as a high point in Medici patronage.

美第奇家族最大的成就是在文艺复兴早期和盛期对艺术和建筑的赞助。美第奇家族在他们的统治期间占据了佛罗伦萨艺术的主体。他们的金钱是重要的，因为在这个时期的艺术家们一般只在提前接收委托后才创造作品。乔凡尼·迪比奇·德·美第奇，家族中首位艺术赞助者，资助马萨乔并委托伯鲁乃列斯基在1419年重建了佛罗伦萨的圣洛伦佐教堂。老科西莫赞助的著名艺术家有多纳太罗和弗拉·安杰利科。多年后又增加了一位最杰出的艺术家，他就是米开朗琪罗·勃那罗蒂（1475—1564），他从慷慨的洛伦佐开始就为美第奇家族创作作品。洛伦佐非常欣赏年轻的米开朗琪罗，邀请他研究家族的古雕塑收藏。洛伦佐也赞助了莱奥纳多·达芬奇（1452—1519）七年。事实上洛伦佐自己就是一位艺术家，他精通诗歌和歌唱；他对艺术的支持被视为美第奇赞助事业的最高点。

In addition to commissions for art and architecture, the Medici were prolific collectors and today their acquisitions form the core of the Uffizi museum in Florence. In architecture, the Medici are responsible for some notable features of Florence; including the Uffizi Gallery, the Boboli Gardens, the Belvedere, and the Palazzo Medici.

除了为委托艺术家创作艺术和建筑，美第奇家族还收藏了大量的作品，他们的收藏在今天形成了佛罗伦萨乌菲兹美术馆的核心。在建筑方面，美第奇家族建造了许多著名的佛罗伦萨建筑，包括乌菲兹美术馆、博波尔花园、柏华丽和美第奇宫。

Later, in Rome, the Medici Popes continued in the family tradition of patronizing artists. Pope Leo X would chiefly commission works from Raphael (1483—1520)—"the Prince of Painters." Pope Clement VII commissioned Michelangelo to paint the altar wall of the Sistine Chapel.

随后，美第奇家族教皇在罗马延续了资助艺术家的家族传统。里欧十世教皇委托拉斐尔（1483—1520）创作了作品《拉斐尔》。教皇克莱门特七世委托米开朗琪罗在西斯廷教堂的神坛墙壁上绘画。

2. Tuscany Countryside, Italy　意大利托斯卡纳的乡村

It's impossible to divorce Tuscany from our preconceptions. A row of cypress trees breaking the blue sky on a rolling hilltop. Olive groves and grapevines marching tidily down the side of a slope. Little medieval hill towns gazing down upon a country that has been carefully cultivated since the time of the Romans. It has been said indeed, that rather than take a photo of the modern landscape, you can gaze into a painting by Michelangelo, Donatello, Raphael or Piero della Francesca. Much of the scenery is simply unchanged in 500 years.

将托斯卡纳从我们的想象中消除是不可能的。一排排柏树在起伏的小山顶上插进蓝色天空。橄榄树林和葡萄藤整齐地在斜坡边缘铺设。几座古老山顶城镇俯视着从古罗马时代就仔细耕种的乡村大地。事实上，可以说这不是现代景观师的照片，你可能是在凝视米开朗琪罗、多纳太罗、拉斐尔或是皮耶罗·德拉·弗朗西斯卡的绘画。许多景色500年以来从未改变。

Where to start with Tuscany though? We have the 'art cities' of Florence, Pisa and Siena, the galleries and museums, devotional buildings and architecture of Florence (Firenze) could swallow your entire vacation in Tuscany. Another week would just about deal with Pisa and its Campo dei Miracoli around the Leaning Tower and Baptistery. There is lesser

Fig. 15-13 Landscape of Tuscan countryside

known Lucca, a perfect medieval city within its unbreached medieval walls.

　　从哪里开始托斯卡纳？佛罗伦萨、比萨和锡耶纳这些"艺术城"，画廊和博物馆、宗教建筑和佛罗伦萨建筑(Firenze)可能就花掉你在托斯卡纳的整个假期。只是参观比萨、比萨斜塔附近的奇迹广场和礼拜堂就可能花掉另一个星期的时间。卢卡的名气较小，这是一所保留有完整中世纪城墙的完美古老城市。

　　Siena is a superb medieval city, which depopulated a few hundred years ago due to the Black Death and never quite filled up again. Indeed parts of this opulent and stylish town, around the stunning black-and-white marble Duomo, retain a semi-rural air. Cobbled streets spiral toward the central 'Campo' site of the twice yearly horse race. There are dozens of little hill towns south and west of Siena, with San Gimignano (the city of towers) being best known.

锡耶纳是一个壮观的中世纪城市，由于几百年前的黑死病造成人口减少，再也没有达到原有人数。事实上这个富有和时尚的城镇中，迷人的黑白大理石大教堂的周围保留了半乡村的空气。鹅卵石铺砌的街道弯弯曲曲地通向每年举行两次赛马的"广场"基地。锡耶纳的南部和西部有许多小山上的城镇，其中圣吉米纳诺（美塔之城）最著名。

Between Florence and Siena we have Chianti, superb wine country and a popular retreat for British and American expats. The main towns of"Chiantishire"are Greve in Chianti and Radda in Chianti. See too the medieval cloth town of Prato, with the Castello Imperator and a fine Pisan—Romanesque Duomo. Another undiscovered gem is Pistoia, with a well preserved medieval core. Heading towards the coast we have Pisa, Lucca. The most famous of the resorts is Viareggio, a fashionable resort in Victorian times, and still a fun seaside town, with restaurants, beaches and the huge February carnival. Livorno is often dismissed as a bombed and uninspiringly rebuilt port town, but there is a lovely old town of canals and humpback bridges, a 'little Venice' indeed. Offshore we have the isle of Elba, once home to a defeated Napoleon.

在佛罗伦萨和锡耶纳之间是康帝，那里有壮观的葡萄酒乡村，是英国和美国难民的大众避难所。"康帝郡"的主要城镇是康帝的格雷沃和拉达。也可以去参观普拉托的中世纪纺织重镇，那里有皇帝的城堡和很好的比萨——罗曼风格的大教堂。另一个未被发觉的珍宝是皮斯托亚，中世纪城镇中心保留至今。面朝海岸有比萨、卢卡。最著名的胜地就是危阿雷觉——维多利亚时代非常流行的旅游胜地，至今仍是一处好玩的海滨城镇，那里有餐馆、海滩和盛大的2月狂欢节。利沃诺作为被炸毁的、丝毫不鼓舞人心的重建港口城镇常常被放弃了，但是那里的运河边有一处很可爱的古老城镇和拱桥，事实上是一处"小威尼斯"。靠海处有艾尔巴岛，这里曾经是被打败的拿破仑的住处。

The southern Tuscan coast becomes the Maremma, once a malaria-ridden backwater but now home to the famed Maremma cattle and the 'butteri', cowboys who tend them. The countryside rises to the hills of Monte Argentario and the rather lovely and very ancient town of Orbetello. South of Siena come to the remarkable San Gimignano, a little town that became a powerful republic, albeit briefly. And south of Siena spreads the countryside of the Crete Senese.

南托斯卡纳海岸变成了马雷马——曾经是受疟疾困扰的穷乡僻壤，但现在成为了著名的马雷马牛和照顾它们的牛仔——"butteri"的居所。乡村延伸到亚坚塔里欧山的山丘——相当可爱和非常古老的城镇奥尔贝泰洛。锡耶纳的南面到达著名的圣吉米纳诺———一座成为强大共和国（虽然短暂）的小城镇。锡耶纳的南面延伸到科雷特—色内西地区的乡村。

We can't leave southern Tuscany without visiting the Abbazia dei San Galgano, one of Italy's most stunning Gothic buildings, and the Abbazia di Monte Oliveto Maggiore, with its superb Renaissance frescoes. On to Montepulciano, at 600 metres above the sea it's the highest hill town in Tuscany. Another lovely hill town nearby is Montalcino——wine buffs will know the name.

我们在没有参观圣加尔加诺修道院之前是不能离开南托斯卡纳的，那里有意大利最迷人的哥特建筑；还有马乔雷蒙特奥里维托修道院，那里有壮观的文艺复兴壁画。高于海岸

线 600 米的蒙特普恰诺，是托斯卡纳最高的山丘城镇。这附近另一个可爱的山丘城镇是蒙塔奇诺——葡萄酒的爱好者都会知道这个名字。

Eastern Tuscany's main towns are Arezzo——a beautiful Etruscan, Roman and medieval city, and the home of movie clown Roberto Benigni (much of 'La Vita e Bella' was filmed here). Finally on to Cortona, from whose heights you gaze down upon Lake Trasimeno. The town has the Museo dell'Accademia Etrusca, a fine Duomo.

东托斯卡纳的主要城镇是阿列佐——一处美丽的伊特鲁里亚、罗马和中世纪城市，也是电影丑角罗伯托·贝尼尼的家乡（"美丽人生"大部分场景是在这里拍摄）。最后来到科多纳，从它的高度你可以向下凝视特拉西梅诺湖。城镇中有伊特鲁里亚学院博物馆——一座保存很好的圆顶教堂。

3. Watercolor 水彩

Watercolor (US) or Watercolour (UK) is a painting method. A watercolor is the medium or the resulting artwork, in which the paints are made of pigments suspended in a water soluble vehicle. The traditional and most common support for watercolor paintings is paper; other supports include papyrus, bark papers, plastics, vellum or leather, fabric, wood, and canvas. In East Asia, watercolor painting with inks is referred to as brush painting or scroll painting. In Chinese and Japanese painting it has been the dominant medium, often in monochrome black or browns. India, Ethiopia and other countries also have long traditions. Fingerpainting with watercolor paints originated in China.

水彩是一种绘画方法。水彩画是一种媒介或最终的艺术作品，其中的颜料是由可以在水溶性载色剂中悬浮的色素。传统和最普遍的水彩画是画在纸上的；还有草纸、树皮纸、塑料、牛皮纸或皮革、织物、木材和画布等都可以作画。在东亚，用墨画出的水彩画被称为毛笔画或卷轴画。在中国和日本绘画中，水彩画是主要的媒介，常常是单色调的黑色或棕色。印度、埃塞俄比亚和其他国家也有很悠久的水彩画传统。用手指画水彩画起源于中国。

Fig. 15-14　Artist working on a watercolor using a round brush　　Fig. 15-15　Mädchen, Egon Schiele 1911

Among the many 20th century artists who produced important works in watercolor, mention must be made of Wassily Kandinsky, Emil Nolde, Paul Klee, Egon Schiele and Raoul Dufy; in America the major exponents included Charles Burchfield, Edward Hop-

per,Charles Demuth,Elliot O'Hara and John Marin,80% of whose total output is in watercolor. In this period American watercolor (and oil) painting was often imitative of European Impressionism and Post-Impressionism,but significant individualism flourished within "regional"styles of watercolor painting in the 1920s to 1940's,in particular the"Cleveland School"or"Ohio School"of painters centered around the Cleveland Museum of Art,and the "California Scene"painters,many of them associated with Hollywood animation studios or the Chouinard Art Institute (now CalArts Academy).

在众多创作了著名水彩画作的 20 世纪艺术家中，必须提到的有瓦西里·康定斯基、埃米尔·诺尔德、保罗·克利、埃贡·席勒和拉乌尔·杜菲；在美国主要是查尔斯·伯奇菲西德、爱德华·霍普、查尔斯·德穆斯、埃利奥特·奥哈拉以及约翰·马林(他 80%的作品是水彩画)。在这一时期，美国水彩画(和油画)常常是模仿欧洲的印象主义和后印象主义，但是 20 世纪 30 年代到 40 年代在水彩画的"地域"风格中，有重要意义的个人主义繁荣起来，特别是画家集中在克利夫兰美术馆周围的"克利夫兰画派"或"俄亥俄画派"，以及"加利福尼亚风景"画家，他们中许多人都和好莱坞动画工作室或是乔纳德艺术学院(现名加利福尼亚艺术学院)有联系。

4. Ermenonville　埃默农维尔

Ermenonville is a town and commune 45 kilometers North-East of Paris.

埃默农维尔是距巴黎东北部 45 公里的城镇和社区。

Ermenonville is notable for its park named for Jean-Jacques Rousseau,whose tomb designed by the painter Hubert Robert is on the Isle of Poplars in its lake.

埃默农维尔以让-雅各·卢梭公园而闻名，让-雅各·卢梭的坟墓是由画家休伯特·罗伯特设计的，位于公园湖面上的白杨岛上。

Fig. 15-16　Tomb of Jean-Jacques Rousseau

The garden at Ermenonville was one of the earliest and finest examples of the English garden in France. The garden at Ermenonville was planned by Count Louis-René Girardin,friend and final patron to Jean-Jacques Rousseau. Girardin's master plan drew its inspiration from Rousseau's novels and philosophy of the nobility of Nature. Louis-René Girardin was probably assisted in the design by the painter Hubert Robert. Created with care and craft,the garden came to resemble a natural environment,almost a wilderness,appearing untouched by any human intervention. Girardin admired the work of William Shenstone at The Leasowes and made a ferme ornee at Ermenonville. An imitation of Rousseau's Island at Ermenonville was produced in Dessau-Wörlitz Garden Realm,Germany.

埃默农维尔的花园是英式花园在法国的最早和最完美的范例。埃默农维尔的花园是由吉拉丹侯爵——让·雅各·卢梭的朋友和最后一位赞助者——规划设计的。吉拉丹的总平面灵感来自卢梭的小说和自然高贵的哲学。吉拉丹侯爵在设计中可能接受了画家休伯特·罗伯特的帮助。经过仔细的设计和构思，创造出的花园就如同一种自然环境，几乎是一种野生的、看起来似乎没有任何人类干预的状态。吉拉丹非常欣赏威廉·申斯通的利索斯田庄，在埃默

农维尔创作了一个乡村园林农场。埃默农维尔的卢梭岛是模仿德国的沃利茨园。

It was much visited and admired during the early nineteenth century. The garden at Ermenonville was described by Louis-René's son in 1811 in an elegant tour-book that reveal Girardin's love of diverse vistas that capture painterly landscape effects.

19 世纪早期许多人都到花园参观和表示钦佩。吉拉丹的儿子在 1811 年的精美旅行手册中把埃默农维尔的花园描述为揭示了吉拉丹对绘画般景观效果的各种狭长景色的喜爱。

5. Thomas Jefferson 托马斯·杰斐逊

Thomas Jefferson (1743—1826) was the third President of the United States (1801—1809), the principal author of the Declaration of Independence (1776), and one of the most influential Founding Fathers for his promotion of the ideals of republicanism in the United States.

托马斯·杰斐逊(1743—1826)是第三任美国总统(1801—1809)，独立宣言的主作者(1776)，最有影响力的国父之一，他推动了美国共和政体理念。

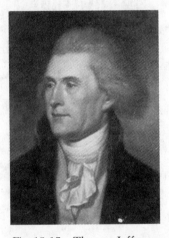

Fig. 15-17 Thomas Jefferson Fig. 15-18 The Lawn, University of Virginia

A polymath, Jefferson achieved distinction as, a horticulturist, statesman, architect, archaeologist, paleontologist, author, inventor, and founder of the University of Virginia. Jefferson has been consistently ranked by scholars as one of the greatest U. S. Presidents.

作为一名知识广博者，杰斐逊获得了各种身份，园艺家、政治家、建筑师、考古学家、古生物学家、作家、发明家和弗吉尼亚大学的创立者。杰斐逊被学者们一致认为是最伟大的美国总统之一。

Jefferson is widely recognized for his architectural planning of the University of Virginia grounds, an innovative design that is a powerful representation of his aspirations for both state sponsored education and an agrarian democracy in the new Republic. His educational idea of creating specialized units of learning is physically expressed in the configuration of his campus plan, which he called the "Academical Village." Individual academic units are expressed visually as distinct structures, facing a grassy quadrangle, with each Pavilion housing classroom, faculty office, and residences. Though unique, each is visually equal in importance, and they are linked together with a series of open air arcades that are the front

facades of student accommodations. Gardens and vegetable plots are placed behind sur-
rounded by serpentine walls, affirming the importance of the agrarian lifestyle.

　　杰斐逊以他对弗吉尼亚大学的规划而为大众所认识，这个创新设计强有力地表现出他
对各州教育和新共和国的农业民主政体的期望。杰斐
逊创造的学习专业单元的教育理念在他的校园规划构
成中得到表现，他将这种规划称为"大学村"。单个的
学术单元在视觉上表达为独特的建筑，面朝绿草茵茵
的四边形场地，每个建筑都容纳教室、教师办公室和
居所。虽然独特，但每个建筑在视觉上都同等重要，
它们用一系列开放拱廊联系在一起，这些拱廊是学生
住所的前立面。花园和菜地被放置在后面，用蜿蜒的
墙体围绕，以此来强调耕种生活方式的重要性。

His highly ordered site plan establishes an ensem-
ble of buildings surrounding a central rectangular
quadrangle, named The Lawn, which is lined on either
side with the academic teaching units and their linking
arcades. The quad is enclosed at one end with the li-
brary, the repository of knowledge. The remaining side
opposite the library remained open-ended for future
growth. The lawn rises gradually as a series of stepped
terraces, each a few feet higher than the last, rising up
to the library set in the most prominent position at the
top, while also suggesting that the Academical Village

Fig. 15-19　An ensemble of buildings

facilitates easier movement to the future.

　　他所设计的具有高度秩序性的基地平面建立了一种建筑围绕中心矩形中庭的组合体，
命名为"草坪"，它沿着学术教学单位和之间相互联系的拱廊排列。这种四边形组合一端
以图书馆围合——知识的储藏馆。和图书馆对应的一边保持开放是为了未来的发展。草地
作为一系列分级的台地逐渐上升，每个都比前一个高几英尺。最后，图书馆位于顶部最显
著的位置，同时也说明大学村在未来易于移动。

　　Stylistically, Jefferson was a proponent of the Greek and Roman styles, which he be-
lieved to be most representative of American democracy by historical association. Each aca-
demic unit is designed with a two story temple front facing the quadrangle, while the library
is modeled on the Roman Pantheon. The ensemble of buildings surrounding the quad is an
unmistakable architectural statement of the importance of secular public education, while
the exclusion of religious structures reinforces the principle of separation of church and
state. The campus planning and architectural treatment remains today as a paradigm of the
ordering of manmade structures to express intellectual ideas and aspirations. A survey of
members of the American Institute of Architects identified Jefferson's campus as the most
significant work of architecture in America.

在风格上，杰斐逊是古希腊和古罗马风格的倡导者，他认为这两种风格通过和历史的联系最能代表美国的民主。每个学术单位都以两层的神庙前立面设计，面朝中庭，而图书馆是以古罗马万神殿为模型设计的。建筑围绕中庭的组合是对不受宗教束缚的大众教育重要性的最正确的建筑阐释，而对宗教建筑的排斥加强了教会和国家分离的原则。校园规划和建筑设计保持至今，作为人类建筑秩序表达知识理念和期望的范例。美国建筑师协会成员认为杰斐逊的校园是美国建筑最重要的作品。

Fig. 15-20 The Dessau-Wörlitz
Garden Realm

Fig. 15-21 View from a gondola on
one of the numerous canals

6. Dessau-Worlitz 德绍—沃利茨园

The Dessau-Wörlitz Garden Realm, also known as the English Grounds of Wörlitz, is one of the first and largest English parks in Germany and continental Europe. It was created in the later part of the 18th century under the regency of Duke Leopold Ⅲ Friedrich Franz of Anhalt-Dessau. The park lies on the anabranch of the Elbe, making it rich in water and diversity.

德绍—沃利茨园，也被称为英式沃利茨园，是德国和欧洲大陆第一个和最大的英式公园。10 世纪后期，公园在安哈尔特—德骚亲王利奥波德二世统治下建成。公园位于易北河的支流，这给它带来了丰富的水源和风景。

The park had its origin in the 17th century, when the marriage of Prince John George Ⅱ to the Dutch princess Henriette Catharina, daughter of Frederick Henry of Orange, brought a team of engineers and architects from the Low Countries to lay out the town and park of Oranienbaum.

Fig. 15-22 Rock island "Vesuvius"
and Villa Hamilton

Fig. 15-23 Wörlitzer Lake

公园的起源可以追溯到 17 世纪，约翰·乔治二世亲王和奥兰治公爵的女儿荷兰公主

亨妮丽特·凯塔林纳的婚姻，从低地国家带来了一批工程师和建筑师来设计规划奥拉宁鲍姆的城镇和公园。

The lake featured an island which was a model of Mount Vesuvius. The duke would stage fireworks that seemed to issue from an erupting volcano to entertain his guests.

湖面中有一座岛屿，是维苏威火山的微缩版。公爵会在那里放焰火，就好像从一座喷发的火山中放出，以此来愉悦他的客人。

The Dutch influence remained prevalent in Anhalt-Dessau for many decades, until the Anglophile Prince Leopold Ⅲ engaged Friedrich Wilhelm von Erdmannsdorff to build Schloss Wörlitz (1769~1773), the first Neoclassical building in Germany. Johann Friedrich Eyserbeck, a garden architect who designed the English Park for Leopold, was obviously indebted to such British antecedents as Claremont, Stourhead, and Stowe.

荷兰的影响在安哈尔特—德骚保持了数十年，直到亲英派利奥波德三世亲王请弗里德里西·威廉·冯·埃德曼斯多夫来修建沃利茨宫(1769~1773)，这是德国首个新古典主义建筑。园艺建筑师约翰·弗里德里希·艾瑟贝克为利奥波德设计的英式花园，很明显是借用了克莱蒙、斯杜海和斯道园等英国前辈的设计。

The philosophy of Jean-Jacques Rousseau and the aesthetic of Johann Joachim Winckelmann underlie the design of the park in Dessau-Wörlitz. Rousseau saw in agriculture the basis of everyday life and pointed out to educational functions of the natural landscape. Unsurprisingly, the most elegant landscape in the area is Rousseau Island, scored to imitate the island in Ermenonville where the philosopher was buried.

让—雅各·卢梭的哲学和约翰·亚奥布姆·温克尔曼的美学隐藏在德绍—沃利茨的公园设计之中。卢梭将农业视为日常生活的基础，并指出自然景观的教育功能。理所当然，在这里最优美的区域是卢梭岛，力图仿效埃默农维尔中埋葬哲学家卢梭的岛。

The grounds, which had been divided into four parts since the constructions of a railway line and highway in the 1930s, were designated a World Heritage Site by UNESCO in 2000. The ICOMOS, however, noted that "the overall structure of the landscape has undergone a good deal of deterioration". Currently, a major road passes only meters away from Rousseau Island.

20世纪30年代铁路线和高速公路建成后，公园被分成了四个部分。2000年德绍—沃利茨园被联合国教科文组织指定为世界文化遗产。然而，国际古迹遗址理事会注意到"景观的整个结构经历了多次恶化。现在，一条主公路距离卢梭岛只有几米远。"

7. The Palace of Westminster 威斯敏斯特宫

The Palace of Westminster, also known as the Houses of Parliament or Westminster Palace, in London, England, is where the two Houses of the Parliament of the United Kingdom (the House of Lords and the House of Commons) meet. The palace lies on the north bank of the River Thames in the London borough of the City of Westminster, close to the buildings of Whitehall.

威斯敏斯特宫，也被称为国会大厦或西敏宫，位于英国伦敦，是英国国会（包括上议院和下议院）的所在地。威斯敏斯特宫位于英国大伦敦自治区威斯敏斯特市的泰晤士河北

岸，距离白厅很近。

Fig. 15-24 The Palace of Westminster

The palace contains around 1100 rooms, 100 staircases and 4. 8 kilometres of corridors. Although the building mainly dates from the 19th century, remaining elements of the original historic buildings include Westminster Hall, used today for major public ceremonial events such as lyings in state, and the Jewel Tower.

宫殿有大约 1100 间房间，100 部楼梯和 4.8 公里的走廊。建筑大多建于 19 世纪，最初建造时期保留下来的历史建筑是：今天用于外交等重要公众庆典的威斯敏斯特议会大厅和珠宝塔。

After a fire in 1834, the present Houses of Parliament were built over the next 30 years. They were the work of the architect Sir Charles Barry (1795—1860) and his assistant Augustus Welby Pugin (1812—1852). The design incorporated Westminster Hall and the remains of St Stephen's Chapel.

在 1834 年的一次大火后，大约用了 30 年的时间建造了国会大厦。由建筑师巴里爵士 (1795—1860)和他的助手普金(1812—1852)完成此项设计。设计将威斯敏斯特议会大厅和圣斯蒂芬小教堂的残余部分合并在一起。

Fig. 15-25 Westminster Hall in
the early 19th century

Fig. 15-26 George Ⅳ's coronation banquet
was held in Westminster Hall in 1821;
it was the last such banquet held

Westminster Hall, the oldest existing part of the Palace of Westminster, was erected in 1097, at which point it was the largest hall in Europe, though it was subsequently overtaken by the Palais de la Cité in Paris (1301—1306) and a hall in Padua of similar date. The roof

was probably originally supported by pillars, giving three aisles, but during the reign of King Richard II, this was replaced by a hammerbeam roof by the royal carpenter Hugh Herland, "the greatest creation of medieval timber architecture", which allowed the original three aisles to be replaced with a single huge open space, with a dais at the end. Richard's architect Henry Yevele left the original dimensions, refacing the walls, with fifteen life-size statues of kings placed in niches. The rebuilding had been begun by Henry III in 1245, but had by Richard's time been dormant for over a century.

威斯敏斯特议会大厅是威斯敏斯特宫最古老的现存部分，建立于 1097 年，当时它是欧洲最大的大厅，虽然随后被巴黎的西岱宫(1301—1306)和差不多同一时期的帕多瓦大厅所超越。屋顶可能最初是用柱子支撑，形成三个走廊，但是在里查二世国王统治期间，被御用木匠休·赫兰德制作的橡尾梁屋顶所取代——"中世纪木建筑的最伟大创造"，使得最初的三个走廊变成了一个单一的巨大开放空间，在终点处有一个华盖。理查二世的建筑师亨利·耶维尔保持了最初的尺度，重修了墙体外观，15 座真人大小的国王雕像被放置在壁龛中。1245 年亨利三世开始了重建，但是直到理查时代，重建整整停滞了一个多世纪。

Westminster Hall has served numerous functions. It was primarily used for judicial purposes, housing three of the most important courts in the land: the Court of King's Bench, the Court of Common Pleas and the Court of Chancery. In 1873, these courts were amalgamated into the High Court of Justice, which continued to meet in Westminster Hall until it moved to the Royal Courts of Justice in 1882. In addition to regular courts, Westminster Hall also housed important trials, including impeachment trials and the state trials of King Charles I at the end of the English Civil War.

威斯敏斯特议会大厅有许多功能。主要是用于司法用途，容纳王国最重要的三个法院：王室法院，民诉法院和大法官法院。1873 年，这些法院合并为最高法院，它继续在威斯敏斯特议会大厅中开会，直到在 1882 年搬到英国皇家法院。除了固定的法院活动，威斯敏斯特议会大厅也举行重要的审判，包括弹劾审判和在英国内战结束时对国王查理一世的审判。

Westminster Hall has also served ceremonial functions. From the twelfth century to the nineteenth, coronation banquets honouring new monarchs were held here. The last coronation banquet was that of King George IV, held in 1821; his successor, William IV, abandoned the idea because he deemed it too expensive. The Hall has been used for lyings-in-state during state and ceremonial funerals. Such an honour is usually reserved for the Sovereign and for their consorts; the only non-royals to receive it in the twentieth century were Frederick Sleigh Roberts, 1st Earl Roberts (1914) and Sir Winston Churchill (1965). The most recent lying-in-state was that of Queen Elizabeth The Queen Mother in 2002.

威斯敏斯特议会大厅也举行仪式。从 12 世纪到 19 世纪，庆祝新国王的加冕典礼宴会在这里举行。最后一次加冕典礼宴会是 1821 年为乔治四世国王举行的；他的继任者威廉四世废弃了这一想法，因为他认为这过于昂贵。大厅在国家重要葬礼期间用作瞻仰遗容之处。这种荣誉常常留给君主和他们的配偶；20 世纪唯一非王室成员受到这一礼遇的是弗

雷德里克·斯雷·罗伯茨伯爵(1914)和温斯顿·丘吉尔爵士(1965)。最近的一次瞻仰遗容是 2002 年为了伊丽莎白王太后。

8. The River Thames 泰晤士河

The Thames is a major river flowing through southern England. Its lower reaches flow through central London, the river flows through several other towns and cities, including Oxford, Reading and Windsor.

泰晤士河是流经南部英格兰的重要河流。它的下游穿越伦敦中心，河流经过许多其他城镇和城市，包括牛津、雷丁和温莎。

Fig. 15-27 The River Thames

The River Thames is the second longest river in the United Kingdom and the longest river entirely in England, rising at Thames Head in Gloucestershire, and flowing into the North Sea at the Thames Estuary. It has a special significance in flowing through London, the capital of the United Kingdom, although London only touches a short part of its course. The river is tidal in London with a rise and fall of 7 metres and becomes non-tidal at Teddington Lock. The catchment area covers a large part of South Eastern and Western England and the river is fed by over 20 tributaries. The river contains over 80 islands, and having both seawater and freshwater stretches supports a variety of wildlife.

泰晤士河是联合王国的第二大河，也是英格兰最长的河流，从格鲁斯特郡的泰晤士黑德起源，在泰晤士河口流入北海。流经联合王国的首都伦敦使它具有了特殊的重要性，虽然伦敦只是占据了它整个流域的很小一部分。河流在伦敦的潮涨潮落相差 7 米，在特丁顿水闸却没有任何潮汐。它的流域覆盖英格兰东南和西部的大部分。河流有 20 多条支流，80 多个岛屿，既有咸水也有淡水流域，为流域带来了各种各样的野生生物。

The river has supported human activity for thousands of years providing habitation, water power, food and drink. It has also acted as a major highway both for international trade through the Port of London, and internally along its length and connecting to the British canal system. The river's strategic position has seen it at the centre of many events and fashions in British history, earning it a description by John Burns as "Liquid History". It has been a physical and political boundary over the centuries and generated a range of river crossings. In more recent time the river has be-

Fig. 15-28 River Thames Flood

come a major leisure area supporting tourism and pleasure outings as well as the sports of rowing, sailing, skiffing, kayaking, and punting. The river has had a special appeal to writers, artists, musicians and film-makers and is well represented in the arts. It is still the subject of various debates about its course, nomenclature and history.

数千年来，泰晤士河一直为人类活动提供居住地、水力、食物和饮料。泰晤士河通过伦敦港和流经国土的路线联系起英国的运河系统，成为了国际贸易的主要通路。泰晤士河的战略位置使它成为了英国历史中许多事件和时尚的中心，约翰·博斯把它描述为"流动的历史"。数百年里它成为了现实和政治的界限，也创造出河流交汇的区域。现在，河流已经成为了支持旅游业和娱乐郊游，以及划船、航行、小艇、独木舟和踢球等运动的主要休闲区域。作家、艺术家、音乐家和电影创作者对泰晤士河有特殊的感染力，也在艺术中进行了很好的表现。关于其流域、命名原则和历史仍有各种各样的争论。

In the early 1980s a massive flood-control device, the Thames Barrier, was opened. It is closed several times a year to prevent water damage to London's low-lying areas upstream (as in the 1928 Thames flood for example). In the late 1990s, the 7-mile (11 km) long Jubilee River was built, which acts as a flood channel for the Thames around Maidenhead and Windsor.

Fig. 15-29 The Thames passes by some of the sights of London, including the Houses of Parliament and the London Eye

Fig. 15-30 Swan Upping-skiffs surround the swans

在 20 世纪 80 年代早期，巨大的洪水控制装置——泰晤士水闸开始运行。它每年关闭许多次，以阻止河水对伦敦上游低洼区域的破坏（就如 1928 年的泰晤士河洪水）。在 20 世纪 90 年代后期，7 英里(11 公里)长的吉百利河道建造起来，作为梅登黑德和温莎周围的泰晤士河泄洪通道。

Vocabulary

1. decorate *vt.* ①装饰；点缀：to decorate a street with flags 用旗帜装饰街道 ②油漆；粉刷 ③授以勋章：was decorated for bravery 因为英勇而被授勋 *vi.* 装饰；布置
［近义词］honour, award a decoration to, confer distinction upon *v.* 授勋(章)给……
adorn, embellish, ornament, beautify, trim, bedeck, deck, mount, fix up, set off *v.* 装饰，装潢，布置
［辨析］**decorate** 装饰：指加装饰品于某物之上，以使其更美丽。

The room was decorated with pictures. 房间是用画装饰起来的。

adorn 装饰：指美化或增加荣耀，多侧重于精神方面。

They adorned the building with multicolored lamps and flags. 他们用彩灯和彩旗装饰大楼。

embellish 装饰、修饰：此词使用较少，除与 decorate 意义相同外，可用于修饰精神方面的东西。

Mark Twain was heavily embellished by his biographers. 马克·吐温由于其传记作者的渲染而竟增其光辉。

ornament 装饰：指用一物装饰另一物的表面，也可作装潢解。

They ornament a hall with paintings. 他们用画来装饰大厅。

2. **basis** *n. pl.* bases ①基础；基底；台座：on a production basis 在大规模生产的基础上 ②基本原理，根据，算法：What is the basis of your opinion? 你的观点的根据是什么？ ③起点；起源 ④原则；制度 ⑤主要部分：The basis of this drink is orange juice. 这种饮料的主要成分是橘子汁。

［近义词］ foundation, ground, base, cause, reason, rationale, root, source *n.* 根据，基础

［辨析］ **basis** 基础：主要用于比喻、学说、讨论等的根据。

The basis of his opinion is some thing he saw in the paper. 他意见的根据是从报纸上看来的东西。

foundation 基础：原义及比喻又皆适用，强调基础的稳固及坚固。

This report has no foundation. 这项报告毫无根据。

ground 基础：多用在比喻的意义上

There is no ground for alarm. 没有惊恐的理由。

3. **aristocracy** *n.* ①贵族政府，贵族统治的国家 ②贵族的派头 ③贵族政治 ④上流社会；特殊阶级；［the aristocracy］［集合词］贵族，贵族阶层，上层阶级；第一流人物 ［近义词］ elites, gentry, nobility *n.* 贵族，统治集团

［辨析］ **aristocracy** 贵族、统治集团：指贵族阶级的统治集团或任何阶级的优秀代表。

They are ladies and gentlemen of the aristocracy. 他们是贵族阶层的绅士淑女。

elites 精英、社会名流：指社会中或行业中最杰出的代表。

The elites of the city were present at the reception for the governor. 本城的知名人士都出席了州长欢迎会。

gentry 绅士、上等人：指有良好社会地位但无世袭称号的人，或在英国仅次于贵族的人。

The private school is favored by generations of the gentry.

这所私立学校为好几代绅士所偏爱。

nobility 贵族：指在帝王之下，赋有世袭特权的人。

The duke ranks highest in British nobility. 在英国，公爵是贵族中最高的爵位。

4. **productive** *adj.* ①生产的，生产性的；有生产能力的：a very productive writer 多产作家 ②（与 of 连用）可能产生……的：policies productive of much harm 带来许多害处的政策 ③有生产价值的，富有成效的，效益好的：productive labour 有价值的劳动 ④多产的，

富饶的，肥沃的：a productive farm 肥沃的农场

［近义词］constructive,effective,efficacious,useful,worthwhile,profitable,gainful,paying, moneymaking,rewarding,lucrative *adj.* 富有成效的，效益好的

producing,creating,constructive,creative,manufacturing *adj.* 生产的，生产性的

fertile,rich,fruitful,prolific,proliferous,fecund,yielding,plentiful,copious,teeming *adj.* 多产的，丰饶的

［辨析］**productive 多产的**：指出产丰富。

Those fruit trees are very productive. 那些果树结的果子很多。

fertile 多产的、肥沃的：指本身含有养分，能滋养或培养种子，并维持其生命的发展。

The seed fell on fertile ground. 种子落在肥沃的土地上。

rich 肥沃的：指土地肥沃，丰饶多产。

This country is rich in agricultural products. 这个国家农产品非常丰富。

5. flap *vt.* ①拍打；拍击：The birds flapped its wings. 小鸟拍动双翼。②使(帆、帘子等)拍动，摆动，飘动；(鸟)振(翅)：an eagle flapping its wings 振翅飞翔的鹰 ③焦虑；紧张；不安；激动：Don't get in a flap. 别紧张。④唤起……注意；鼓动 ⑤合上；叠起；扔，掷：flap a book down hastily 急忙把书合上 *n.* ①拍打；拍击声：a flap in the face 打在脸上的一巴掌 ②航 ③襟翼，阻力板 ④垂下物；衣服的口袋盖；前襟；(帽)边；信封口盖：a flap pocket 有盖衣袋 ⑤［口］激动；慌乱；恐慌；紧急情况：Don't get in a flap. 别紧张。

［近义词］agitation,commotion,dither,fluster,flutter,fuss,state,tizzy *n.* 拍打，飘动，振动

dangle,swing,agitate,beat,flutter,fuss,shake,swish,thrash,vibrate,wag,wave *v.* 拍打，飘动，振动

［辨析］**flap 飘动**：指上下或左右移动。

The bird flapped its way up the stream. 鸟儿振翅向河的上游飞去。

dangle 摇摆：指悬吊着或摇摆不停。

The leaves dangled in the wind. 树叶迎风摇摆着。

swing 摇摆，摆动：指一端固定，另一端摆动。

The lantern hanging overhead swung in the wind. 吊在高处的灯在风中摇摆着。

6. deceive *vt.* ①诈骗；欺骗：deceive sb. with fair words 用花言巧语欺骗某人 ②使弄错，使失望：deceive sb's hopes 辜负某人的希望

vi. 欺诈，欺骗

［近义词］cheat,defraud,impose,swindle,trick,mislead,fool,hoax,hoodwink,dupe,humbug, beguile *v.* 欺骗，蒙蔽

［辨析］**deceive 欺骗**：最普通的用词，指使人相信虚假之事以隐瞒事实。

He deceived the teacher by lying. 他说谎话欺骗老师。

cheat 欺骗：指通过不诚实的手段换取所需要的东西。

They cheated him at cards. 他们玩牌的时候骗他。

defraud 诈取：指用欺诈的手段去获取。

That man was defrauded of his estate. 那人的产业被人骗去了。

impose 欺骗：指通过虚伪的借口欺骗人。

He imposed a false article upon a person. 他把假货卖给别人。

swindle 诈取：指以获取财物为目的而欺骗人。

Honest merchants do not swindle their customers. 诚实的商人不会欺骗顾客。

trick 欺骗：指用狡猾的手段骗取所需之物。

He tricked the poor girl out of her money. 他骗走了那可怜女孩的钱。

7. extraordinary *adj.* ① 异常的；非凡的，非常的，卓绝的：Her strength of will is extraordinary. 她意志的力量是不平常的。②特别的，意外的：an envoy extraordinary 特使 ③临时的；额外的：an extraordinary session 临时会议

［近义词］special，peculiar，exceptional，rare，striking，unusual，amazing，fantastic，notable，marvelous，noteworthy，particrlar，significant，surprising，strange，unique，unimaginable *adj.* 非常的，非凡的，特别的

noteworthy，outstanding，remarkable *adj.* 显著的，特别的

［辨析］**extraordinary 特别的**：指超乎寻常的、惊人的。

He is a man with extraordinary strength. 他力气惊人。

noteworthy 值得注意的：指显著的。

He has made noteworthy achievement. 他取得了显著的成就。

outstanding 显著的：指引人注意的或著名的人或事。

The boy who won the scholarship was quite outstanding. 那个获奖学金的男孩是相当杰出的。

remarkable 值得注意的：指由于不平常而值得注意。

These animals are remarkable for the fineness of their fur. 这些动物由于皮毛的精美而著名。

Sentence

The Medici villas were decorated with paintings that express the idea that the landscape was the basis of the wealth of the family, and also that it was also a beautiful place. Over the next two or three hundred years the idea that a productive agricultural landscape was a beautiful landscape became very powerful.

美第奇家族的别墅里到处都是风景画，这些画表现出景观是家族财富的基础，景观也可以成为非常美丽的场所。在以后的二、三百年里，"获得收获的农业景观是美丽的"这一思想逐渐盛行。

Many of the great English landscape gardeners and improvers had the same idea, that the landscape can be both productive and beautiful.

许多著名的英国园艺师有同样的理念，即景观可以同时具有观赏性和生产性。

Repton used the only direct way to show the effect of proposed changes to the existing landscape.

雷普顿以此来表达规划对原有景观所做的改造。

This is a designed landscape that respects and takes advantages of the natural processes of the site, its hydrology, vegetation, and drainage. As early as the 1770s, there was a great debate, which survives today in landscape architecture, "Are we creating artificial landscapes or managing natural processes?"

他在巴黎附近的阿蒙农维拉做了很多著名的景观设计。这幅图是他所做的一个景观设计，该设计充分利用场地的水文、植被等自然过程。早在 18 世纪 70 年代，景观规划设计领域就有一个很大的争议，即"景观设计是一个创造人工景观的过程还是管理自然的过程"。这个争论一直延续到今日。

The shaping of the American landscape owes more to Jefferson than to any other individual.

杰斐逊对美国大地景观的形成做出了独一无二的贡献。

Prince Franzs great idea was not to copy a style, but to use the landscape to teach.

法兰兹王子的重要贡献在于他不是简单复制一个景观，而是利用景观来教育民众。

He made his reputation by designing parks and gardens for wealthy people and as a thinker and writer on landscape gardening and architecture.

他以替有钱人设计花园而出名，同时他也是著名的景观造园和建筑的著名思想家、作家。

Translation

第 15 课　景观规划：具影响力理念的历史

在 16 世纪，美第奇家族是意大利最有权势的家族，他们不仅在大城市拥有住宅，在托斯卡纳郊外还有 16 幢别墅。美第奇家族的别墅里到处都是风景画，这些画表现出景观是家族财富的基础，景观也可以成为非常美丽的场所(图 15-1)。在以后的二、三百年里，"获得收获的农业景观是美丽的"这一思想逐渐盛行。然而，别墅的主人并不是农夫。别墅的主人们并没有直接创造景观，与终日耕作的农夫不同。贵族有闲情逸致欣赏农业景观之美丽。过去 100 年中，随着教育和休闲活动的普及，对农业生产景观的欣赏逐渐被各阶层所接受。

许多著名的英国园艺师有同样的理念，即景观可以同时具有观赏性和生产性。一个很好的例子就是查尔斯·布里奇蒙、威廉·肯特和"万能的布朗"设计的斯多庄园。这个景观是生产性的——人们在疏林草地放养牛羊和鹿。这类英国田园风光被很多人视作理想景观，启迪了许多西方的景观设计(图 15-2)。

英国最著名的园艺师可能是亨弗利·雷普顿(1752—1818)(图 15-3)。就大尺度景观规划来讲，他有一个非常好的理念，但同时又有一个非常糟糕的理念。好理念是他认为每一个项目应采用两幅图片来展示，一张图片是改造之前的景观(图 15-4)，另一张图片是改造后的景观(图 15-5)。雷普顿用水彩画做成折页来表现所做的设计，当你翻过一页，设计后的结果就会显现出来。雷普顿以此来表达设计对原有景观所做的改造。他非常糟糕的理念是关于文化理念，其来源是博克的清高思想。他认为"设计作品如果只是尺度比较大的话，往往意味着设计师缺乏想象力，所有艺术品都只是某种形式的欺骗而已。"换言之，

他认为设计必须是假的、人造的，而大规模的规划只是缺乏想象力的表现。

大约在同一时期，法国人让·马利·莫罗(1728—1810)(图 15-6)完成了著作《花园理论》。他的基本立场是认为设计是对自然过程进行管理。他在巴黎附近的阿蒙农维拉做了很多著名的景观设计。这张图片(图 15-7)是他所做的一个景观设计，该设计充分利用场地的水文、植被等自然过程。早在 18 世纪 70 年代，景观规划设计领域就有一个很大的争议，即"景观设计是创造人工景观的过程还是管理自然的过程"。这个争论一直延续到今日。

托马斯·杰斐逊(1743—1826)是美国的第三任总统(图 15-8)。他当时决定在美国中部采用方格网进行土地测量(图 15-9)，其目的在于鼓励民众到中西部定居。18 世纪 80 年代，他需要一种简便的方式来确立定居者所拥有土地的边界。他采用方格网测量土地的想法随着疆域向西部扩展而推广。这样的景观现在任何人坐飞机的时候还能够看到。杰斐逊对美国大地景观的形成做出了独一无二的贡献。

在德国，可能认为景观规划起源于弗雷德里奇·法兰兹·范·恩哈特—德骚王子(1740—1817)。1790 年他继承了一个小公国，于是便着手改进它。当时英国是世界上最强盛的国家，英国的文学、经济、政治和景观被整个欧洲视为模范。法兰兹王子在英国广泛游历，回国后引进了英国的思想，并以英国的方式改造景观。沃里兹庄园建于 1765～1817 年。这是一个具有教育意义的景观，它不仅成了传授先进农业技术的基地，还成为了英国自由主义精神的象征(图 15-10)。许多人从这个"花园王国"学到了社会、经济、政治和景观方面的先进理念。法兰兹王子的重要贡献在于他不是简单复制一个景观，而是利用景观来教育民众。

约翰·克劳迪斯·路登(1783—1843)是 19 世纪 30 年代英国最重要的园艺师。他以替有钱人设计花园而出名。同时，他也是景观造园和建筑的著名思想家、作家。路登为整个大伦敦区作了一个区域景观规划(图 15-11)。规划建议以泰晤士河边的威斯敏斯特宫为圆心，四周是交替的都市和郊区环带。路登作了一系列的设计来证明城市中心、近郊区和郊区花园的不同之处。这种同心圆的布局方式体现了他的观点，即人们不能总是生活在城市或郊区中，城市与郊区对人来说都是非常重要的。这一点与中国的阴阳观非常类似。在 19 世纪 30 年代，这是一个重要的思想。即使在今天，这个思想对北京和上海这样的大城市来说仍然具有借鉴意义。

Extensive Reading

How to Write a Data Sheet

A data sheet is a list of your most important achievements, talents, and skills.

The first step in writing a data sheet is to gather personal information. This includes your education and experience, and other facts such as activities or hobbies. You then decide which of these facts are important enough to include on the data sheet. Each person is unique. Therefore, there is no single list of information to include. There is also no single right way to organize a data sheet. You must carefully choose the facts you fell will help your chance of getting a particular job. Exclude anything you feel would not be of help. Most data sheets include the following information in some order.

1. personal data;
2. education;
3. work experience;
4. activities;
5. reference.

Your strongest points should get the most emphasis. These points should be placed first on the data sheet. For example, if you do not have much work experience, then stress educational experience or activities by placing them first on the data sheet. If you have more related work experience, then place this fact first. Usually, facts placed at the beginning get the most attention from the reader. If the facts listed first are not impressive, the employer may not read any further.

Personal Data

Following are types of personal data that you may wish to include in a data sheet.

1. your name;
2. address and telephone number;
3. job objective.

It is helpful to the employer to know as much as possible about you. However, laws prohibit personal questions that might be used to discriminate. You may want to include the following on your data sheet:

1. data of birth;
2. sex;
3. health;
4. marital status.

Education

A student with more education than work experience should place the education information before work experience on the data sheet. Include the following information in the education section:

1. name, location, dates of attendance, and degree awarded for all schools attended;
2. special honors received;
3. Major area of study;
4. courses pertinent to the job, if they will strengthen your case.

Work Experience

For applicants who have had many related jobs, the work experience section is the most important part of the data sheet. Most applicants have at least some paid work experience they can list. List your work experience even if it does not seem related to the job for which you are applying. The fact that you have held some kind of job is a recommendation. List all paid jobs, beginning with the last job and moving backward in time.

Employment information should include:

1. name and location of company;
2. job title and type of work performed;
3. dates of employment and/or length of time employed Indicate part-time work where appropriate to avoid confusion.

Activities

Include activities on your data sheet if you have held positions of responsibility or gained work related experience from them. Do not list all your activities. List only those which increase your chances for the job. Include the name of the activity and any offices that you have held. Also, list the purpose of the activity.

Reference

Name at least two people who can recommend your skills. Former employers or teachers are often good choices. Also, give the name of a friend of good reputation who can provide a good character reference for you. In addition to stating what type of reference the person can supply (professional, character), include the following:

1. full name and address of the reference;
2. telephone number (include area code);
3. title (if the person has one).

Good manners dictate that you ask the people for permission before listing their names on your data sheet.

Presentation

The data sheet should be well organized and neatly typed so that it is easy to read and nice to look at. The employer may consider the way the data is presented as a sign of your ability to organize material. Use parallel constructions in presenting each part of the data sheet. Use short phrases rather than long, complete sentences to give the information.

Data sheets should be no longer than one typewritten page. If you have many jobs and schools to list, include only the most relevant.

Use good quality white bond paper and a dark typewriter ribbon when typing the data sheet. Make corrections neatly. There should be no grammatical, punctuation, or spelling

errors in the data sheet. The employer may form a first impression of you from the looks of the data sheet. This first impression could be the deciding factor when the hiring decision is made.

Translation

如 何 写 简 历

个人简历是你最重要的业绩、才干和技能的一份表格。

写简历的第一步是收集个人资料。它包括你所受的教育和社会经历，以及其他诸如社会活动与业余爱好等材料。然后，你决定哪些事实重要，应将它们写入简历。个人的情况都是不一样的。所以，写个人简历没有单一的模式，也没有组织编写的固定单一的方法。你必须仔细选择那些你认为能够帮助你赢得某份工作的事实材料，并且删除那些你认为无益的东西。绝大多数个人简历包括如下内容：

1. 个人资料；

2. 教育；

3. 工作经历；

4. 社会活动；

5. 推荐人。

你的强项应予以大力强调，应写在个人简历的最前边。例如：如果你没有多少工作经历，那就要强调你的教育程度或社会活动，把它们置于简历的最前列。如果你有相关的工作经历，那就把它放在前面。通常，放在开头的资料最能得到阅读者的注意。如果列在前面的资料不吸引人，雇主可能就不会读下去。

个人资料

以下是一些你可能要列入简历中的个人资料类别。

1. 你的姓名；

2. 地址和电话号码；

3. 求职目标。

让雇主尽量详细地了解你是大有益处的。然而，法律禁止列入那些可能被利用来进行歧视的个人问题。你可能需要在简历中列入如下内容：

1. 出生日期；

2. 性别；

3. 健康状况；

4. 婚姻状况。

教育

一个接受教育较多且缺乏工作经历的学生，在简历中应该先写教育状况，后写工作经历。教育部分应列入如下内容：

1. 所入各学校的名称、校址、入学日期、学位；

2. 获得的特别奖励；

3. 主修课程；

4. 与所申请工作有关的能增加你实力的课程。

工作经历

对于那些有过多种有关工作经历的应聘者，工作经历部分是简历中最重要的部分。多数应聘者至少要列出某项有薪水的工作经历。你还应列上那些即使看起来与你的应聘工作无关的工作经历，因为你曾从事过某项工作这一事实也是一种推荐参考。列出所有的有酬工作，从最近一项工作开始，按时间倒着排列。

就业经历方面的资料应包括：

1. 公司名称及地址；

2. 所担任的工作职位及类型；

3. 受聘日期和(或)工作期限。

社会活动：

你简历上所列入的社会活动，应是那些你所担任的某些负责工作或从中获得了相关的工作经验的活动。不要列出所有的社会活动。只需列出那些能增强你应聘机会的活动。其中应写明活动的名称和你所担任的职务。如果有不清楚的地方，你还需介绍一下该项活动的宗旨。

推荐人：

至少写明两名可以推荐你的技能的人。前雇主或老师常常是最好的人选。此外，还要写上能证明你人品好的有声望的朋友的名字。除了要写明推荐人对你专业和人品可提供哪种推荐材料外，还要写入下列内容：

1. 推荐人的全名和地址；

2. 电话号码；

3. 职务(如果推荐人有的话)。

在将他们的姓名列入你的简历前，最好先征得他们的同意。

陈述和格式

个人简历应组织有序，打印整洁，悦目易读。雇主可能把提交的简历看作是你组织材料能力的表现。在陈述每个部分时要采用统一的结构形式，用短语而不要用完整的长句。

个人简历不可太长，不要超过一张打印纸。如果你有多种工作经历和学历，只需列出最有关的即可。

打印个人简历时需用优质上乘白纸与黑色打印机打印。修改要干净整洁。不应存在语法、标点或拼写错误。雇主可能从你简历的外观形成对你的第一印象，而这第一印象可能是雇用与否的决定性因素。

Tactics for Job-Hunt Success

If you're finding it tough to land a job, try expanding your job-hunting plan to include the following tactics: **Set your target.** While you should always keep your options open to compromise, you should also be sure to target exactly what you want in a job. A specific job hunt will be more efficient than a haphazard one. **Schedule ample interviews.** Use every possible method to get interviews——answering ads, using search firms, contacting companies directly, surfing the Web, and networking. Even if someone dose not hire you, write

them a thank-you note for the interview. Then, some weeks later, send another brief letter to explain that you still have not found the perfect position and that you will be available to interview again if the original position you applied for——or any other position, for tat matter——is open. Do this with every position you interview for, and you may just catch a break! **Make it your full-time job.** You can't find a job by looking sporadically. You have to make time for it. If you're unemployed and looking, devote as much time as you would to a full-time job. If you have a job while you're looking, figure out an organized schedule to maximize your searching time. **Network vertically.** In the research phase of your job hunt, talk to people who are on a level abouve you in your desired industry. They'll have some insights that people at your own level won't have, and will be in a good position to hire you or recommend you to be hired. **Keep your spirits up.** Looking for a job is one of the toughest things you will ever have to do. Maintain your confidence, stay persistent, and think positively, and eventually you will get a job that suits you.

Translation

如何找到理想的工作

如果你觉得找工作是件棘手的事情，不妨扩展你找工作的计划，纳入以下策略：**确定目标。**尽管自己应该永远给自己的选择留有妥协余地，你也应确切知道你到底想从某份工作中获取什么。明确地寻找工作要比漫无目的地碰机会有效得多。**安排尽可能多的面谈。**尽量利用一切办法去争取面试机会——汇入招聘广告、求助猎头公司、直接与公司联系、网上搜寻、利用各种关系网，等等。即便某份工作对你不是最为理想的，但每次面谈都可以是一次有积极作用的经历。**继续努力！**即便人家没有雇用你，给他们写张感谢卡，对给你安排了一次面试就表示感谢。数周之后，如果你申请的原职位——或与此相关的其他职位——尚无人选落实，你不妨在寄去一封简短的信说你还未找到理想的职位，如有机会再面试一次将随叫随到。你每次应聘面试求职都应这样，没准儿你就会抓住一个机会。**将工作视为全职工作。**你偶然随便地找，不可能找到一份理想的工作，必须去花时间找。如果你失业了想再找份新工作，尽可能多地付出时间，就像你在全职工作一样。如果你有工作，但还想找新的机会，制定一个有序的计划，尽可能多地安排出时间去搜寻。**纵向发展关系。**在找工作的研究阶段，找机会去和你渴望进入的行业中比你高一层次的人物交谈。他们会有你这层次人物所不具备的视野，会有能力雇用你或将你推荐给其他雇主。**心情愉快，充满希望。**找工作是你必须做的最为棘手的事情之一。保持信心，坚持不懈，态度乐观，最终你会找到适合你的工作的。

Top Ten Tips for Career Fair Success

1. **Develop a commercial.** You have30 seconds to get an employer interested in you. If you can't, they'll move on. Practice a 30-second commercial to introduce yourself and your career goals. Be short and concise, but add a specific instance to grab attention. The following is how an American student"sells"herself at a career fair.

"Hello, Ms. Smith. I'm Samantha Ward and I've been interested in OmegaTron ever since I read that *Business Week* article about your new multimedia software program. I'm a computer science major with an art minor, and I'm really excited about combing these two interests. I've actually developed an interactive educational program to teach children how to draw. Would you like to see a copy of the website I designed?"

2. **Look professional.** Always remove tongue or eyebrow piercings (no more than one earring in each ear), and hide tattoos. Once you know the culture of the company, then you can start to add (or not) these items to your morning toilette! It's always better to err on the side of caution and be more conservative than less!

3. **Bring at least 50 resumes.** Cover letters are not necessary at the fair, but don't risk running out of resumes.

4. **Bring a bag, a notebook and a pen.** The bag is to carry literature and giveaways. The notebook should be professional with space for safekeeping of those resumes (no crumbled, copies, please!) and a pad for motes. Bring two pens—just in case.

5. **Get enough rest.** Get a good night's sleep so you're rested and energized for the fair. Eat a good meal before you go to prevent tummy grumbles while you chat!

6. **Do your homework.** Check out the websites of the participating companies so you're familiar with them and what they are looking for.

7. **Arrive early.** Career fairs attract hundreds, sometimes thousands of people. Get there early, grab the directory, and plan your attack!

8. **Start in the back.** Many people get stuck in the stampede at the front. Make your way to the back where there are representatives waiting for someone to appear.

9. **Pick up literature and a business card.** Take literature you know you'll read from companies you're interested in. Otherwise your arm will ache carrying around all that stuff. Don't forget a business card so you can follow up with the recruiter later. Jot down on the back some notes about your conversation.

10. **Show your interest.** Give a firm handshake and smile with eye contact. That's a great first impression that shows confidence. Ask questions. Nothing is more boring that a one-sided conversation. Send a thank-you note. To make a real impression, send it soon after the fair to the companies that most piqued your interest. Follow up. Don't wait for companies to call—call them first. Set up informational interviews or a company tour.

Translation

在人才招聘会上获得成功的 10 项技巧

1. **做商业广告。** 你有 30 秒的时间让某位雇主对你感兴趣。如果你不能，他们会另寻他人。准备一个 30 秒的广告介绍自己和事业目标。简洁明了，但要有具体的例子抓住对方的注意力。以下例子是一位美国学生如何在人才招聘会上"推销"自己。

"您好，史密斯女士。我是萨曼莎·沃德。自从在《商业周刊》上读到那篇有关你们

新的多媒体软件程序的文章后，我一直对贵公司感兴趣。我主修计算机科学，辅修艺术，而将这两种兴趣结合会让我兴奋不已。实际上我已设计了一个互动教育程序，教孩子如何画画。您想不想看看我设计的网页？"

2. **看上去具有职业形象。** 把舌环或眉环拿掉（每只耳朵上只戴一个耳环），遮盖住纹身。一旦你清楚了某公司的文化后，你才可以在早晨化妆时增加（或不增加）这些装饰。因谨慎出岔总比因胆大出岔好，保守总比过于开放稳妥。

3. **带上 50 份个人简历。** 首页介绍在招聘会上并非必备，但也不能冒缺少简历的危险。

4. **携带一个书包，一个笔记本和一支笔，** 书包用来装文献和赠品。笔记本应该是办公用的，有足够的地方妥善保存你的个人简历（请不要递上皱巴巴的简历!），还有一个便签簿，带两支笔以备万一。

5. **休息好。** 头天晚上睡好觉让自己得到充分休息，以便精力充沛地赴人才招聘会。去之前还要吃好饭，以免与雇主交谈时你的肚子会饿得咕咕叫。

6. **做好应聘准备。** 上网搜寻参加招聘会的那些公司的资料，以便熟悉它们，知道它们在寻找怎样的雇员。

7. **提前到达。** 人才招聘会往往会吸引数以百计，乃至千计、万计的人前往。争取早到、抢得一份目录单，计划你的主攻目标。

8. **"反其道而行之"。** 许多人陷入前门拥挤慌乱的人群中难以脱身。你不妨径直走向后门，那里有代表们在等候来访者的出现。

9. **拿宣传品和商务名片。** 只拿那些你感兴趣的公司的宣传品，因为你会阅读它们，否则背着一书包各个公司的宣传品走来走去会让你胳膊酸痛。不要忘记拿商务名片，因为日后你可以跟招聘人士联系，在名片背面记下一些你们交谈的内容。

10. **表达你的兴趣。** 握手要有力，直视对方带以微笑。这是表现信心极好的第一印象。要问问题。没有什么比一方侃侃而谈，一方沉默无语的交谈更没意思了。会后寄份感谢卡。若想真给人家留下印象，招聘会后马上将感谢卡寄给那些激起你兴趣的公司。主动做后续工作，不要等着公司给你打电话——先给他们打，商定情况介绍或参观公司等事宜。

Part Ⅳ Design Project

Intensive Reading

Lesson 16 Office Landscape

"**Office landscape**" is a literal translation of the German *buro-Landschaf*, describes a system of office planning developed during the last few years in Europe. An "office landscape" interior tends to be quite shocking to most designers on first exposure, because in plan it appears that furniture and portable screens have been thrown into a space at random with a chaotic absence of pattern. On closer examination, however, it becomes clear that the originators of office landscape have some very specific and reasonable ideas, which lead to these unusual results.

Atyplcal office Landscape plan. Office for Orenstein Koppel near
Dortmund, Germany. Qulckborner Team, planners

The developers of this method, the Quickborner Team of Hamburg, are, in fact, office management consultants rather than designers. Their study of office operation has led them to the belief that office planning should be based on patterns of communication, with all other values (such as appearance, status recognition, and tradition) either ignored or given a very minor status. Placement of work stations is determined by the flow of communication, which is the vital part of daily office functioning.

It is also basic to the "landscape" idea that partitioning be avoided. Without partitio-

ning, change to accommodate changing work patterns becomes both quick and inexpensive. Communication is always easy in an office space without subdivision, and the reduction in emphasis on the symbolic values of status turns out to be helpful to office morale and work efficiency.

Without partitions, loss of privacy becomes most bothersome in terms of noise. For this reason, an office landscape requires complete carpeting of floors and elaborates acoustical treatment of all ceilings. It is also a part of the system that all massive furniture with solid surfaces must be avoided, because these are also a source of sound reflection. Noisy office machines are removed from the general office space to special isolated locations. Permanent files are also placed in remote locations so that only small open file baskets are used in the regular office space.

The office landscape planning method begins with a survey of all communication in the office organization—whether by conversation, written memo, or telephone. Every staff member keeps a fog of communications conducted for a period of two weeks. These data are then analyzed. This leads to a plan placing each workstation so as to minimize the length of the most active lines of communication. People who must be in frequent contact are placed close together; those who have little need for contact end up far apart.

Once the basic plan has been arrived at, a scale model is built with movable furniture and portable screen elements placed according to the proposed plan. This model is made available to representatives of the working staff who will occupy the office, so that criticisms and changes can be considered. There is also a routine continuing study of needed changes, with a general rearrangement taking place approximately every six months, this rearrangement deal with all the accumulated needs for revision that have developed during that time. Since there are no fixed, architectural elements, such change is quick and inexpensive.

Up to now, most experience with this planning system has been developed in Europe. Reports indicate that there is an increase in work efficiency, and that office workers tend to like the "landscape" office better than conventional offices. There can be no question that the cost of construction will be low (because of the omission of partitioning), and the cost of changes is so low as to be almost negligible.

Notes

1. Office　办公室

An **office** is generally a room or other area in which people work, but may also denote a position within an organization with specific duties attached to it; the latter is in fact an earlier usage, office as place originally referring to the location of one's duty. When used as an adjective, the term **office** may refer to business-related tasks. In legal writing, a company or organization has **offices** in any place that it has an official presence, even if that presence consists of, for example, a storage silo rather than an office.

Office 一般是指人们工作的房间或者其他领域，但是也可以表示隶属于特定职责组织

内的职位；事实上后者是早期的使用惯例，Office 最初是指一个人的职责定位。当用作形容词时，Office 是指和商业相关的任务。在法律文件中，一个公司或组织可以把在任何地方拥有的正式场所称为 Office，即使这种场所是个如地下仓库的地方，而不是办公室。

Fig. 16-1　A typical messy
North American office

An office is an architectural and design phenomenon and a social phenomenon, whether it is a tiny office such as a bench in the corner of a "Mom and Pop shop" of extremely small size and including massive buildings dedicated entirely to one company. In modern terms an office usually refers to the location where white-collar workers are employed.

办公室既是一种建筑学和设计学现象，也是一种社会现象，不管是"Mom and Pop shop"那样只有拐角处一条长凳的微型办公室，还是整个巨大建筑完全都属于一家公司。在现代词汇中，办公室常常是指白领工作的场所。

There are many different ways of arranging the space in an office and whilst these vary according to function, managerial fashions and the culture of specific companies can be even more important. Choices include, how many people will work within the same room. At one extreme, each individual worker will have their own room; at the other extreme a large open plan office can be made up of one main room with tens or hundreds of people working in the same space. Open plan offices put multiple workers together in the same space, and some studies have shown that they can improve short term productivity. At the same time, the loss of privacy and security can increase the incidence of theft and loss of company secrets. A type of compromise between open plan and individual rooms is provided by the cubicle, which solves visual privacy to some extent, but often fails on acoustic separation and security. Most cubicles also require the occupant to sit with their back towards anyone who might be approaching; workers in walled offices almost always try to position their normal work seats and desks so that they can see someone entering, and in some instances, install tiny mirrors on things such as computer monitors.

有各种各样的方法布置办公室空间，这些方法的功能各有不同，而特定公司的管理方式甚至更为重要。作出的选择包括多少人将在同一个房间中工作。一种极端案例就是每个工作人员都有自己的房间；另一种极端案例就是一间巨大的开放平面办公室里有数十个乃至数百个人在其中工作。一些研究表明，这样的空间可以提高短期的生产力。同时，私密性和安全性的失去将会增加盗窃的发生率，还会泄露公司机密。工作台提供了一种开放平面和私人房间之间的折衷方法，在一定程度上解决了视觉私密性的问题，但是在声学隔离和安全性方面常常失效。绝大多数工作台需要占用者坐着，后背朝向任何会接近他的人；工作人员在四面都是墙壁的办公室中几乎都会把他们的工作座椅和办公桌放到他们可以看到什么人进来的位置。在一些案例中，工作人员会在一些物品上安放小型镜子，比如计算机显示器。

While offices can be built in almost any location in almost any building, some modern requirements for offices make this more difficult. These requirements can be both legal (i. e. light levels must be sufficient) or technical (i. e. requirements for networking). Alongside such other requirements such as security and flexibility of layout, this has led to the creation of special buildings which are dedicated only or primarily for use as offices. An office building, also known as an office block, is a form of commercial building which contains spaces mainly designed to be used for offices.

办公室几乎可以建在任何建筑中的任何位置，但是办公室的一些现代需求使这一点变得更为困难。这些需求可能是法律规范方面的（比如照明必须充足）或者技术方面的（比如对互联网的需求），以及平面布置的安全性和灵活性等需求，这导致了专用于或主要用于办公的特定建筑的产生。一座办公建筑，也被称为办公大楼，就是一种商业建筑形式，它主要包含经过设计可以用作办公室的空间。

Fig. 16-2 An office building

2. Office landscape 景观办公室

Office landscape (Bürolandschaft in German) was an early (1950s) movement in open plan office space planning.

景观办公室是开始于 20 世纪 50 年代的开放平面办公室空间规划运动。

Large open office environments have existed for a very long time. However, these frequently consisted of many identical rows of desks or long tables where clerks, typists, or engineers sat and performed repetitive functions. This layout was rooted in the work of industrial engineers and efficiency experts such as Frederick Winslow Taylor and Henry Ford. The office landscape approach to space planning was pioneered by the Quickborner Team led by Eberhard and Wolfgang Schnelle based in the Hamburg suburb of Quickborn. It was intended to provide a more collaborative and humane work environment.

巨大的开放办公室环境存在了相当长的一段时期。然而，这些办公室常常由一排排相同的桌子或长条桌来组成，办事员、打字员或者工程师都坐在那里完成不断重复的工作。这种平面布置源于工业工程师和效率专家弗雷德里克·温斯洛·泰勒和亨利·福特的研究。景观办公室空间规划方法是由位于奎克伯恩郊区的汉堡、由埃伯哈德和沃尔夫冈兄弟领导的奎克伯恩团队开创的。倾向于提供一种更利于合作和更具人性化的工作环境。

The post-WWII socialist environment in many Northern European countries engendered an egalitarian management approach. Office landscape encouraged all levels of staff to sit together in one open floor to create a non-hierarchical environment that increased communication and collaboration.

第二次世界大战后，在许多北欧国家的社会主义环境下产生了一种平等主义管理方式。景观办公室中所有级别的工作人员在开放空间中坐在一起，以此来创造一种无等级差

别的环境，这种环境可以增进交流和合作。

Typical designs used contemporary but conventional furniture which was available at the time. Standard desks and chairs were used, with lateral file cabinets, curved screens, and large potted plants used as visual barriers and space definers. Floor plans frequently used irregular geometry and organic circulation patterns to enhance the egalitarian nature of the plan. Many designs used slightly lower than normal occupancy density to mitigate the acoustical problems inherent in open designs.

典型景观办公室设计使用现代家具而不是当时常常使用的传统家具。标准化的桌椅，桌子侧面有文件篮，弯曲的屏风和巨大的盆栽植物用来阻挡视线和限定空间。地面常常使用不规则的几何形体和有机循环图案来增强设计的平等主义本质。许多设计使用比正常稍低的占有密度来减少开放设计固有的声学问题。

Office furniture companies quickly developed panel-hung systems and other types of systems furniture which sought to provide some of the advantages of office landscape, but with slightly greater privacy, density, and storage capacity. Initially, the layouts typical of these systems imitated the irregular, organic forms of office landscape. However, they qu-ickly degenerated into the regimented sea of cubicles common in modern offices and reminiscent of earlier Taylorism. The sea of cubicles effectively replaced office landscape by the mid-1960s.

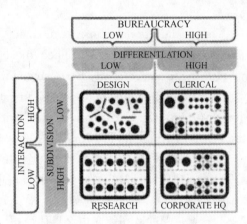

Fig. 16-3 Office type organisational diagram

办公室家具公司很快发展了挂板式和其他类型的办公家具，寻求体现景观办公室的优势，同时拥有更多的私密性、密度和存储能力。起初，这些设计的典型平面布置仿效景观办公室的不规则、有机的形式。然而，它们很快退化到现代办公室普遍的系统化和更早的泰勒主义中。到 20 世纪 60 年代中期，格子间办公室完全取代了景观办公室。

3. The Quickborner Team of Hamburg 汉堡的奎伯恩团队

The history of the Quickborner Team is the history of successful evolution. Since its founding in 1956, They have constantly regenerated themselves in terms of staff, organization and strategy and have grown from their beginnings as the adjunct to a Hamburg-based office furniture manufacturer to a holistically oriented consultancy backed by a great number of qualifications. Their claim, however, has remained the same: to furnish people with the most effective, productive and pleasant working environments possible.

奎克伯恩团队的历史是成功发展的历史。从 1956 年成立起，他们不断更新工作人员、组织和策略，从一开始作为总部位于汉堡的办公室家具制造商的附属机构，变成了获得许多资格的全盘定向咨询顾问。而他们的目标是永远一致的：给人们提供最有效、生产效能最高和最令人愉悦的工作环境。

The origins of the Quickborner Team go back to Velox-Organization Hermann Dunst

GmbH, a company headed by brothers Eberhard and Wolfgang Schnelle, and Hermann Dunst. Its first office, opened in 1956 on Hamburg linked the sale of office furniture from the Velox works with consultation on office organization and utilization. In 1959 the company completely detached itself from the Velox works under the new name of Eberhard und Wolfgang Schnelle GmbH. One of its first major contracts was to plan a communication-friendly administrative office for the Mannheim-based pharmaceutical concern Boehringer.

奎克伯恩团队的起源要追溯到沃拉克斯和希尔曼·邓斯特有限公司，一家由埃伯哈德和沃尔夫冈·施奈尔兄弟以及希尔曼·邓斯特管理的公司。1956 年在汉堡成立了第一间办公室，把沃拉克斯生产的办公室家具的销售和办公室组织与使用顾问结合在一起。1959年，公司完全和沃拉克斯工厂脱离，使用新的名称：埃伯哈德和沃尔夫冈元规划有限公司。最初主要是为总部在曼海姆的勃林格殷格翰医药企业规划设计一种促进交流的管理办公室。

The organizational consultants made a name for themselves around the country in planning office environments. Their most important new building projects in these years included the media company Bertelsmann in Gütersloh (1960/1961), Krupp in Rheinhausen (1962), BBC in Mannheim (1963), Orenstein & Koppel in Dortmund (1964), Osram in Munich (1965), the Ford works in Cologne (1966), Deutsche Lufthansa in Cologne (1967) and Texas Instruments in Munich (1969).

同时，组织顾问的成绩为他们在全国的办公室环境设计中赢得了声望。这段时期他们最重要的新建筑项目包括居特斯洛的贝塔斯曼媒体公司(1960/1961)、莱茵豪森的蒂森克虏伯公司(1962)、曼海姆的英国广播公司(1963)、多特蒙德的欧伦史坦 & 柯沛公司(1964)、慕尼黑的欧司朗光电半导体公司(1965)、科隆的福特工厂(1966)、科隆的德国汉莎航空公司(1967)和慕尼黑的德州仪器半导体公司(1969)。

Rapid growth followed QT's move. By this time, the Quickborner Team had already made a name for itself in office landscaping in the U. S. In 1967/1968 the company established Quickborner Team Incorporated in Milburn, New Jersey, its own U. S. subsidiary. The first office landscape planned by the Quickborner Team was created at E. I. du Pont de Nemours & Co in Delaware, followed by others at Eastman Kodak in Rochester, the Mercedes Benz headquarters in New York, the Department of Labor in Washington, as well as in Canada——the 20-storey office landscape for Ontario Hydro in Toronto, for example. At the beginning of the 1970s, QT was even active in Venezuela, where the Cia Shell de Venezuela in Caracas was planned, among others.

搬到奎克伯恩后公司快速发展。这时，奎克伯恩团队早已在美国景观办公室设计中获得了名望。在 1967～1968 年，公司在新泽西州的墨尔本成立了奎克伯恩团队股份有限公司，这是其在美国的分公司。奎克伯恩团队设计的首个景观办公室是在特拉华的杜邦公司，接着是在罗切斯特的伊斯曼—柯达公司、纽约的梅赛德斯—奔驰总部、华盛顿的劳工部以及在加拿大的设计——例如多伦多安大略水电集团的 20 层景观办公室。20 世纪 70 年代初，奎克伯恩团队甚至活跃在委内瑞拉，在那里设计了加拉斯加的委内瑞拉制铁公司，等等。

The 1970s were the Quickborner Team's decade of foreign activities: From Postbanken und Svenska Handelsbanken in Stockholm to Nederlandsche Persil, IBM Nederland and Shell Petrol Company Ltd. in Brunei to Singapore Airlines in Singapore, the Hamburg planners' designs were in demand around the world. Only the company's U. S. activities were scaled back before they were finally discontinued altogether.

20 世纪 70 年代是奎克伯恩团队的海外发展时代：从斯德哥尔摩的挪威邮政银行和瑞典商业银行到荷兰宝莹公司，IBM 尼德兰分公司，汶莱的壳牌石油化工有限公司，到新加坡的新加坡航空公司，汉堡设计师们的设计遍布全世界。公司只有在美国的活动有所减少，直至最终完全结束。

QT was active at the highest levels in 1971 when it planned the optimization of the Chancellor's Office in Bonn, based on Metaplan. In 1973, the company moved to its Hamburg office on Mittelweg, a year that also saw the departure of the Schnelle brothers and Hermann Dunst.

奎克伯恩团队在 1971 年达到顶峰，当时它为波恩的联邦德国总理府设计了最优化方案。1973 年，公司搬到在米特威克的汉堡办公室，那一年施奈尔兄弟和希尔曼·邓斯特拆伙。

At the dawn of the 1990s, the QT was involved in one of the most ambitious projects ever attempted in Germany: the relocation of the federal government from Bonn to Berlin. Commissioned by the Federal Ministry for Regional Planning, Building and Urban Development, the QT developed programs and studies on floor space requirements, occupancy and sites. At the same time, a new principle of office organization was tested at the offices of Eschborn, and at Boehringer. New working forms such as teleworking, the non-territorial office, desk sharing and the increasing mobility of office technologies (e. g. e-mail, internet and notebooks) changed the requirements of planning consulting.

20 世纪 90 年代一开始，奎克伯恩团队参与了德国最雄心勃勃的项目之一——将联邦政府从波恩搬到柏林。受联邦地区规划部、建设和城市发展部委托，奎克伯恩团队进行了地面空间需求、使用者和基地等内容的研究项目。同时，在勃林格的埃施伯恩办公室测试了办公组织的新原则。比如电传工作、不占地的办公室、办公桌分享等新的工作形式，以及改变了对设计顾问要求的越来越具灵活性的办公技术（比如电子邮件、因特网和笔记本）。

Faster competition, new technologies and changing workstyles require entirely new working environments. QT therefore relies increasingly on flexible and customized combinations of different models. Open plan offices and shared spaces are becoming ever more important, as well as direct communication, creativity and the quality of the office experience. Recent examples of this include projects such as the new building for the European Central Bank in Frankfurt, the new RTL headquarters in Cologne and the German offices of T-Systems.

更快速的竞争、新技术和不断改变的工作方式需要全新的工作环境。奎克伯恩团队因此越来越重视灵活的、专门为客户定制的不同模式的结合。开放平面办公室和分享空间，

以及直接的交流模式、创造性办公室体验，正在变得越来越重要。这方面最近的范例包括法兰克福欧洲中央银行的新大楼、科隆的新 RTL 电视台总部和德电信息通信集成系统有限公司的德国办公室。

4. Office Design　办公室设计

Clients are often impressed when they enter a luxurious office. Well-designed offices create an image that the company is doing well. Good office design must not merely be pleasant to look at, it must be comfortable for the employees who spend most of their waking hours at their desks.

Fig. 16-4　BBH's reception area looks exceptionally modern

客户们常常对豪华的办公室印象深刻。设计得很好的办公室给人以公司运行良好的印象。好的办公室设计必须不仅仅看起来令人愉悦，也必须让一天中大部分时间都花费在工作桌前的雇员们感到舒适。

Teh office environment affects people enough to increase their productivity. Because we spend more than 10 hours a day in the office, it needs to be comfortable. If possible, the majority of workers should have a window view.

办公室环境对人们的影响程度大到了可以增加他们的生产力的程度。因为我们每天有超过 10 小时都呆在办公室里，所以那里就需要是个舒适的地方。如果可能，大部分工作人员应该都有一扇窗户可以看到外面。

When visiting clients who are fortunate enough to be located in skyscrapers along Shenton Way, I often envied the marvellous view they have of the waterfront and the cityscape. What I fail to understand is that invariably their desks are positioned in such a way that they have their backs to the windows. Perhaps they are so burdened with work that they have little time to enjoy the vista or they want to face the door in case the boss spies on them.

当客户很幸运可以参观位于珊顿大道的摩天大楼时，常常羡慕他们所拥有的奇异的滨水和城市景观。我无法理解的是，他们的办公桌常常以人们背对窗户的方法来布置。可能他们的工作负担重到了没有时间欣赏景色的地步，或者他们想面对老板，可以发现老板是否监视他们。

A poor level of satisfaction with the workplace and low morale that results often leads to a greater amount of job-hopping. Research has shown that such dissatisfaction often results in increased absenteeism that affects performance.

对工作场所的不满和士气很低就会常常导致经常跳槽的情形出现。研究表明，这种不满常常导致影响工作业绩的旷工现象越来越多。

The office ambiance should provide impetus for task motivation. It should not be too distractive so that work is the last thing on one's mind. Neither should it be as sombre as an undertaker's office.

办公室氛围应该提供完成任务的动力。它不应过于纷杂，以免工作成了一个人头脑中最后想到的一件事。也不能像殡仪事务承办人办公室那样昏暗。

The workstations should be adjustable to suit each worker's preferences. Some workers who are left-handed would appreciate this. Heights of desks and chairs must be adjustable as the wrong heights can lead to backaches and poor posture. Some people are particular about the direction they face when seated because of good geomancy. It would be wonderful if each worker can orientate his desk to the most lucky direction rather than aligned in straight rows as in a cemetery.

应该调整工作站来适应每个工作人员的偏好。一些习惯使用左手的工作人员将非常欣赏这一点。办公桌和椅子的高度必须是可以调节的，因为不适合的高度可能会导致背痛和坐姿不正确。一些人因为迷信，对于他们就座时面对的方向非常敏感。如果每个工人都可以把他们的办公桌朝向最幸运的方向，而不是就像在墓地一样排成一列，那该是多么精彩！

Employees should be allowed to express themselves perhaps in the form of a family photo, a daily dose of fresh flowers, or special decorative stationery as long as they do not encroach on the neighbouring workspace. The bosses may frown on the display of personal photographs at the workstation as they feel that the office is the place for work and there should be no family distractions.

应该允许雇员表现自我，可能是家庭的照片，可能是一打鲜花，或者是经过特别装饰的文具，只要这些东西没有侵入附近的工作空间。老板可能看到在工作站展示个人的照片会皱眉头，因为他们感到办公室是工作的场所，不应该有任何家庭的分心之事。

Modern workstations come with hidden panels for all the ugly wiring of the infocommunication equipment.

现代工作站用面板隐藏了信息交流设备所有丑陋的接线。

From the health point of view, workers expect offices to be air conditioned but not so cold that they have to wear winter clothing all day. A reasonable temperature is from 24 to 26 degrees Celsius.

从健康角度来看，工作人员希望办公室有空气调节设施，不要冷到全天都得穿厚重的冬季衣物的地步。合理的温度应该是 24～26℃。

To improve the looks of blank walls and corridors, it is a good idea to decorate them with art pieces. An art programme for the office must be planned in the early stages so that budgets can be set aside and the finishes and lighting can be worked into the office design.

为了改善墙壁和走廊空空的外观，用艺术作品来装饰是很好的想法。办公室的艺术品规划必须在早期阶段就进行，以便可以留出一定的预算用来购买艺术品，装饰和照明可以融入到办公室设计中。

It is important that art in the office is well displayed. The size should be appropriate

for the wall it is on. The colors should harmonize with those of the interior spaces. Artificial light must not be allowed to distort the original colors.

重要的是应该很好地展现办公室的艺术品。艺术品的尺度应该和挂它的墙相适合。色彩应该和室内空间的其他元素相和谐。人工照明不能扭曲原作的色彩。

Give special attention to the lighting. Avoid high contrasts. The work you are doing should be the most brightly lit surface in the room. Hot spots of glare in other parts of the room reflect light into your eyes. These hot spots compete with the task at hand for your attention and may cause fatigue. Select non-reflective desktops to reduce glare.

应给予照明以特殊的注意。避免过大的对比。你正在做的工作应该是房间中最明亮之处。房间其他部分过亮的闪光点会反射到你的眼中。这些闪光点会分散你对手头工作的注意力，还有可能产生疲劳感。选择光线的非反射桌面可以减少眩目的闪光。

If you can take advantage of daylight make full use of it. It could help to reduce power consumption and add some cheer into the office. Lighting helps to make design come alive. Lighting can add an air of elegance to common materials. Expertly planned lighting can create the right ambiance in the workplace.

如果你可以利用自然光照明，那就要充分利用它。它可以帮助减少能源消耗，并且在办公室中鼓舞人心。照明使设计生动起来。照明可以给普通的材料增加一种优雅感。经过深思熟虑设计的照明可以在工作场所中创造适当的氛围。

Flat LCD monitors have freed up precious desk space. In future, the monitor screens can be as thin as a sheet of paper.

LCD平面显示器解放了以前的桌面空间。在未来，显示器的屏幕将可以像一张纸那样薄。

The steel filing cabinets are an eyesore and take up valuable space as well. With electronic filing of documents, such cabinets can be consigned to the museum. Closed filing and storage components become relics of the historical office as many believe that items that are put away are often forgotten.

钢铁的存档箱是碍眼的东西，也占据了有利用价值的空间。随着电子存档文件的普及，这些存档箱可以送到博物馆了。封闭的存档和储存空间已经成为了古老办公室的遗迹，当时许多人相信放太远的东西常常会被人们遗忘。

For offices without window views, the walls become huge LCD screens with photos of mountains, blue skies, and white beaches. These projected photos change with each passing hour and help to break the monotony of office life.

对于没有窗户景观的办公室来说，墙壁变成了展示山脉、蓝天和白色沙滩的巨型LCD显示屏。这些投射到屏幕上的照片每个小时都改变，可以帮助打破办公室生活的单调。

5. Communication　交流

Communication is the process to impart information from a sender to a receiver with the use of a medium. Communication requires that all parties have an area of communicative commonality. There are auditory means, such as speaking, singing and sometimes tone of voice, and nonverbal, physical means, such as body language, sign language, paralanguage, touch, eye contact, or the

use of writing. Communication is defined as a process by which we assign and convey meaning in an attempt to create shared understanding. This process requires a vast repertoire of skills in intrapersonal and interpersonal processing, listening, observing, speaking, questioning, analyzing, and evaluating. Use of these processes is developmental and transfers to all areas of life: home, school, community, work, and beyond. It is through communication that collaboration and cooperation occur.

交流是发送者通过媒介向接受者传递信息的过程。交流需要所有参与者拥有一定的交流共性。交流方式包括听觉，比如谈话、歌唱，有时声调也可以，以及不用语言的身体方式，比如身体语言、符号语言、准语言、触觉、眼睛接触或者书写。交流被定义为一种过程，通过交流我们在创造共享理解的尝试中制定和传达意义。这种过程需要人体内和人与人之间处理、聆听、观察、谈论、提问、分析和评价的巨大能力系统。这些过程的运用是不断发展的，并涉及所有生活领域：家庭、学校、社区、工作等等。通过交流能够产生生合作和协同。

Communication is the articulation of sending a message through different media, whether it be verbal or nonverbal, so long as a being transmits a thought provoking idea, gesture, action, etc. Communication is a learned skill. Most people are born with the physical ability to talk, but we must learn to speak well and communicate effectively. Speaking, listening, and our ability to understand verbal and nonverbal meanings are skills we develop in various ways. We learn basic communication skills by observing other people and modeling our behaviors based on what we see. We also are taught some communication skills directly through education, and by practicing those skills and having them evaluated.

交流是通过不同媒介传递信息的表达，不管是口头上的还是不用语言的，只要能够传递一种引发想法、姿势、行动等的思想。交流是一种需要学习的能力。绝大多数人在一出生就有说话的能力，但是我们必须学习如何很好地表达和有效地交流。我们需要以各种方式发展谈话、聆听和理解语言及非语言意义的能力。我们通过观察其他人学习基本的交流能力，基于我们所看到的，建立我们的行为模式。我们也通过教育直接接受一些交流能力的培养，并通过实践来评价那些能力。

Nonetheless, communication is usually described along a few major dimensions: Content (what type of things are communicated), source, emisor, sender or encoder (by whom), form (in which form), channel (through which medium), destination, receiver, target or decoder (to whom), and the purpose or pragmatic aspect. Between parties, communication includes acts that confer knowledge and experiences, give advice and commands, and ask questions. These acts may take many forms, in one of the various manners of communication. The form depends on the abilities of the group communicating. Together, communication content and form make messages that are sent towards a destination. The target can be oneself, another person or being, another entity (such as a corporation or group of beings).

此外，常常在一些主要维度内描述交流：内容（交流的事物类型）、来源、发出者、传达者或者编码者（通过谁）、形式（形成交流的形式）、通道（通过哪种媒介）以及目的或

实用。在团体之间，交流包括赋予知识和经验、给予建议和命令以及提问的行为。这些行为可能有许多形式，以各种各样的交流方式来进行。总之，交流内容和形式使信息向目的地传递。目标对象可能是自身、另一个人或者是生物、另一个实体（比如一间公司或一群生物）。

Communication can be seen as processes of information transmission governed by three levels of semiotic rules：

交流可以被视为受三个层次符号学规则支配的信息传递：

Syntactic (formal properties of signs and symbols)；

语法（符号和象征的形式属性）；

pragmatic (concerned with the relations between signs/expressions and their users)；

实用（涉及符号/表达和其使用者之间的关系）；

semantic (study of relationships between signs and symbols and what they represent).

语义（符号和象征与所表达内容之间关系的研究）。

In a simple model, information or content (e. g. a message in natural language) is sent in some form (as spoken language) from an emisor/sender/encoder to a destination/receiver/decoder. A particular instance of communication is called a speech act. In the presence of "communication noise" on the transmission channel (air, in this case), reception and decoding of content may be faulty, and thus the speech act may not achieve the desired effect. One problem with this encode-transmit-receive-decode model is that the processes of encoding and decoding imply that the sender and receiver each possess something that functions as a code book, and that these two code books are, at the very least, similar if not identical. Although something like code books is implied by the model, they are nowhere represented in the model, which creates many conceptual difficulties.

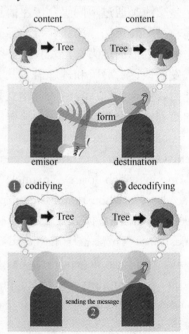

Fig. 16-5　a simple model of communication

在一个简单模型中，信息或内容（如大自然语言中的信息）以某种形式（如口语）从一个发起者/传递者/编码者传达到目的地/接收者/译码者。一种特殊的交流范例就是言语行为。在传达通道有"通信噪声"的情况下（在这个案例中是指空气），内容的接收和译码可能失败，因此言语行为可能无法获得期望的效果。这种编码—传达—接收—译码模式的问题之一就是编码和译码的过程暗示着传达者和接收者都拥有某些译码本的功能，而这两本译码本即使不同也至少是类似的。虽然这个模式暗示着某些类似译码本的事物，它们却没有在模式中表现出来，这创造了许多概念上的困难。

There are only 3 major parts in any communication which are body language, voice tonality, and words. According to the research, 55% of impact is determined by body language——postures, gestures, and eye contact, 38% by

the tone of voice, and 7% by the content or the words used in the communication process. Although the exact percentage of influence may differ from variables such as the listener and the speaker, communication as a whole strives for the same goal and thus, in some cases, can be universal. System of signals, such as voice sounds, intonations or pitch, gestures or written symbols which communicate thoughts or feelings. If a language is about communicating with signals, voice, sounds, gestures, or written symbols, can animal communications be considered as a language? Animals do not have a written form of a language, but use a language to communicate with each another. In that sense, an animal communication can be considered as a separate language.

任何交流只有 3 个主要部分，它们是身体语言、声调和言辞。根据研究，55%的效果是由身体语言——体态、手势和眼睛的接触决定的，38%是由声调决定的，7%是由交流过程中的内容和言语决定的。效果的准确百分比可能根据变量各有不同，比如聆听者和谈话者，以及追求相同交流目标的整体努力程度。因此在一些案例中交流可以是通用的。符号系统，比如声音、声调或间隔，姿势或书写的符号，都可以交流思想或感受。如果说语言是关于符号、声音、声调、姿势或书写符号的交流，那么动物的交流就可以被视为一种相互交流的语言。就这方面来说，动物的交流就可以被视为独立的语言。

6. Tradition　传统

The word tradition means "handing over, passing on", and is used in a number of ways in the English language:

Tradition（传统）这个词意味着"移交，传递"，在英语中以许多种方式使用：

1) Beliefs or customs taught by one generation to the next, often orally. For example, we can speak of the tradition of sending birth announcements.

1）一代人教给下一代的信念或习惯，常常是口述的。例如，我们可以谈论邮寄出生声明的传统。

2) A set of customs or practices. For example, we can speak of Christmas traditions.

2）一套习俗或惯例。例如，我们可以谈论圣诞节的传统。

3) A broad religious movement made up of religious denominations or church bodies that have a common history, customs, culture. For example, one can speak of Islam's Sufi tradition or Christianity's Lutheran tradition.

Fig. 16-6　Ways to celebrate holidays may be passed down as traditions, as in this Polish Christmas meal and decorations

3）广泛的宗教运动，由拥有共同历史、习俗、文化的宗教派别或教会机构组成。例如，一个人可以谈论伊斯兰教的苏菲教派或基督教的路德教派。

However, on a more basic theoretical level, tradition(s) can be seen as information or composed of information. For that which is brought into the present from the past, in a particular societal context, is information. This is even more fundamental than particular acts or practices even if repeated over a long sequence of time.

然而，在更为基本的理论层面中，传统可以被视为信息或者由信息组成。因为在特定社会背景中，从古代传到今天的就是信息。这甚至比在漫长时光中不断重复的特定行为或实践更为基本。

A tradition is a practice, custom, or story that is memorized and passed down from generation to generation, originally without the need for a writing system. Tools to aid this process include poetic devices such as rhyme and alliteration. The stories thus preserved are also referred to as tradition, or as part of an oral tradition.

传统是一代代记录和传递下来的实践、习俗或故事，最初并没有书写下来的必要。诗歌就是帮助传统向下传递的工具之一，比如韵律和押韵。因此保留下来的故事也被视为传统，或者是口述传统的一部分。

Fig. 16-7　Olin Levi Warner, *Tradition* (1895). Bronze tympanum over the main entrance, Library of Congress Thomas Jefferson Building, Washington, D. C

Tradition is a knowledge system (a means of transferring knowledge). Economists Friedrich Hayek and Thomas Sowell explain that tradition is an economically efficient way to transfer and obtain knowledge of all kinds. Sowell, for example, notes that decision-making consumes time (a valuable resource), and cultural traditions offer a rich, low-cost, consensually authenticated way to economize on the resources required to make decisions independently.

传统是一种知识系统(传输知识的方式)。经济学家弗里德里希·海耶克和托马斯·索威尔这样解释传统：传输和获得所有类型知识的最经济、高效的方法。例如，索威尔注意到决策制定耗费时间(一种有价值资源)，而文化传统提供丰富、低成本、双方一致认定的方法，能够节省独立做决定所需要的资源。

Traditions are often presumed to be ancient, unalterable, and deeply important, though they may sometimes be much less "natural" than is presumed. Some traditions were deliberately invented for one reason or another, often to highlight or enhance the importance of a certain institution. Traditions may also be changed to suit the needs of the day, and the changes can become accepted as a part of the ancient tradition. A famous book on the subject is The Invention of Tradition, edited by Eric Hobsbawm and Terence Ranger.

传统常常被认定为是古老的、不可改变的以及非常重要的，虽然它们可能有时不像所认定的那么"自然"。常常由于一个或另一个原因故意杜撰出某种传统，为的是强调或增

加某种制度的重要性。传统可能也被改变以适应今天的需要，而这些改变被人们作为古老传统的一部分所接受。埃瑞克·霍布斯鲍姆和特伦斯·兰格编著的《被发明的传统》是讨论这一主题的权威著作。

Vocabulary

1. random *adj.* ①任意的：a random guess 随意乱猜 ②随机的；无规则的；不齐的：a random sample 随意取样 ③偶然遇到的

［近义词］desultory,capricious,erratic,unintentional,unplanned,undesigned,unintended,unpremeditated,chance,accidental,casual,occasional,fortuitous,hit-or-miss,off-hand *adj.* 随机的，任意的

［辨析］**random 随便的、无目的的**：指某事物的发生或完成纯属偶然，并非有计划的。

He fired a shot at random. 他毫无目标地放了一枪。

desultory 散漫的、不连贯的：指无秩序、无方法地从一件事情跳到另一件事情，导致不连贯和无系统。

The careful study of a few books is better than the desultory reading of many. 精心研究几部书胜过散漫地读许多部书。

capricious 多变的、反复无常的：指无明显理由而突然改变心意或行动。

He is a man of capricious temper. 他是个性情多变的人。

2. vital *adj.* ①极为重要的；关系重大的：a vital examination 至关重要的考试 ②充满生命力的；生气勃勃的；生动的：vital style 生动的文体 ③致命的，生死攸关的；严重的：a vital question 生死攸关的问题 ④生命的，生机的；维持生命所必需的：vital energies 生命力 *n.* ①要害；命脉，命根子；核心；紧要处 ②(身体的)重要器官；(机器的)主要部件

［近义词］vigorous,lively,energetic,animated,vibrant,forceful,mighty *adj.* 有生命力的，充满活力的

critical,crucial,grave,important,urgent,pressing,essential,indispensable,foremost,fundamental,necessary *adj.* 重要的，紧要的，必不可少的

［辨析］**vital 极重要的、不可缺少的**：指维持生命所必需的或与生命有关的。

Perseverance is vital to success. 忍耐是成功的重要条件。

critical 危急的：指在危机中的。

We are at a critical time in our history. 我们处于历史的危急时期。

crucial 关键的：指决定性的和关系重大的。

He made a crucial decision. 他作了一个极重要的决定。

grave 严肃的：指在容貌、面容、行为和态度方面严肃且缺乏愉快，或表示心上有重大问题。

His expression was grave. 他表情严肃。

3. massive *adj.* ①又大又重的：a massive piece of furniture 一件大而重的家具 ②结实的；实心的；大规模的；大量的：We must make massive efforts to improve things. 我们必

须作出极大的努力去改善一切。③有力的，坚定的；（心胸）宽大的　④巨大的，雄伟的，庄严的

［近义词］big,enormous,great,heavy,huge,substantial,bulky,giant,jumbo　*adj.* 粗大的，大面重的

bulky,voluminous,vast,immense,colossal,monstrous,gigantic,monumental,large - scale　*adj.* 巨大的，大规模的

［辨析］**massive** 巨大的：含有大而重，并且坚实的意思。

There is a massive pillar in the park. 公园里有一根大柱子。

bulky 庞大的：含有笨重、不灵活的意思。

It is a bulky parcel. 这是一件庞大的包裹。

voluminous 巨大的：常形容占据空间大的东西。

A voluminous cloak covered him from head to foot. 一件大衣把他从头到脚罩住了。

4. Permanent　*adj.* ①永久的，耐久的，经久的；固定不变的：permanent address 永久地址

［近义词］eternal,everlasting,perpetual,constant,lasting,everlasting,infinite,endless,never - ending,immortal,imperishable,unalterable,unfailing,enduring,durable,stable,unfading,unchanging　*adj.* 永久的，持久的

［辨析］**permanent** 永久的、不变的：指在相同的情况下，永远不会改变。

What is your permanent address? 你的永久通信地址在哪里？

eternal 永久的：强调没有开始，也没有结束。

Because a circle has no beginning or end,the wedding ring is a symbol of eternal love. 因为圆既无起点，也无终点，所以结婚戒指是爱情永久的象征。

everlasting 永久的：强调没有止境，永远继续下去。

We wish for everlasting peace. 我们希望永久的和平。

perpetual 永久的：指继续下去，永远不会停止，尤指未来的情况。

It is a perpetual punishment for him. 对他来说，这是永久的惩罚。

5. conventional　*adj.* ①因袭的；传统的，习惯的：a conventional design 传统图案 ②常规的；普通平凡的：conventional weapon 常规武器　③受俗套束缚的，按习惯办事的，陈旧的：conventional opinions 旧观念　④约［协］定的；会议的：conventional duties 协定关税

［近义词］customary,routinely,habitual,usual　*adj.* 惯例的，常规的，传统的

agreed,accordant　*adj.* 协定的

ceremonial,ceremonious,formal　*adj.* 正式的

［辨析］**conventional** 习俗的、传统的：指依照公认的形式或习俗，缺乏独特性。

The chairman made a few conventional remarks. 主席说了几句客套话。

ceremonial 正式的、礼貌的：指与礼仪或习俗有关的礼貌，可指合乎礼仪的或有关礼节的。

She received me in a ceremonial way. 她非常礼貌地接待了我。

ceremonious 好礼的，隆重的：指礼节周到的或拘泥于礼节的，用于形容人或事。

The banquet was a ceremonious affair. 那宴会是一件很拘泥于形式的事。

formal 正式的：指遵守惯例与习俗，强调正确性，坚定不移，缺乏亲切与自然。

A judge has a formal manner in a law court. 在法庭上法官应有符合礼俗的举止。

6. negligible　*adj.*　①可以忽视的；无足轻重的；不足取的；很小的，微不足道的：a negligible quantity 可忽略的量〔因素〕

〔近义词〕paltryt, trivial, insignificant, minor, minute, small, unimportant, trifling, imperceptible　*adj.* 很小的，微不足道的

〔辨析〕**negligible 很小的、可忽略的**：指由于量小而无关紧要，可以不加以考虑的。

In buying a suit, a difference of ten cents in price is negligible.

买一套衣服时，价钱只相差一角是无所谓的。

paltryt 无价值的：指不重要的和微不足道的。

Pay no attention to the paltry gossips. 不必注意那些琐碎的流言。

trivial 琐碎的：指由于不重要而无足轻重的。

They suffered a trivial loss. 他们只遭受了轻微的损失。

Sentence

　　"Office landscape" is a literaltranslation of the German *buro-Landschaf*, describes a system of office planning developed during the last few years in Europe. An "office landscape" interior tends to be quite shocking to most designers on first exposure, because in plan it appears that furniture and portable screenshave been thrown into a space at random with a chaotic absence of pattern.

　　"景观办公室"是由德语 buro-Landschaf 翻译而来，用来描述最近几年欧洲发展起来的办公室规划系统。绝大多数设计师在第一次看到"景观办公室"的室内时都会非常震惊。因为在平面上它看起来像是家具和轻便挡板随意地放置在空间中，非常混乱，没有任何组合形式。

　　Without partitions, loss of privacy becomes most bothersome in terms of noise. For this reason, an office landscape requires complete carpeting of floors and elaborates acoustical treatment of all ceilings.

　　没有划分，失去私密性，就会由于噪声而变得非常令人烦扰。由于这一原因，景观办公室就需要地板铺满地毯，对顶棚进行精心的声学设计。

　　These data are then analyzed. This leads to a plan placing each workstation so as to minimize the length of the most active lines of communication. People who must be in frequent contact are placed close together; those who have little need for contact end up far apart.

　　再对这些数据加以分析。最终得出在平面上能够最大限度缩小最活跃交流通路的工作点距离。必须常常相互联系的人们放在一起；几乎没有联系需要的人们相隔很远。

　　Once the basic plan has been arrived at, a scale model is built with movable furniture and portable screen elements placed according to the proposed plan. This model is made available to representatives of the working staff who will occupy the office, so that criti-

cisms and changes can be considered.

一旦基本的平面布置确定了，就要根据设计平面等比例做一个有可移动家具和便携式电脑的模型空间。由办公室工作人员的代表来使用，这样就可以评判优劣和加以改变。

Up to now, most experience with this planning system has been developed in Europe. Reports indicate that there is an increase in work efficiency, and that office workers tend to like the "landscape" office better than conventional offices. There can be no question that the cost of construction will be low (because of the omission of partitioning), and the cost of changes is so low as to be almost negligible.

直到现在，这种类型的规划系统绝大多数都在欧洲进行。报告表明，可以增加工作效率，办公室工作人员都倾向于喜欢"景观"办公室超过喜欢传统办公室。毫无疑问，建造费用将非常低廉（因为不用分区），改动的费用也低到几乎可以忽略的程度。

Translation

第 16 课　景 观 办 公 室

"景观办公室"是由德语 buro-Landschaf 翻译而来的，用来描述最近几年欧洲发展起来的办公室规划系统。绝大多数设计师在第一次看到"景观办公室"的室内时都会非常震惊。因为在平面上它看起来像是家具和轻便挡板随意地放置在空间中，非常混乱，没有任何组合形式。然而，更仔细一点看就会很清楚，景观办公室的设计者有非常特别和合理的想法，这些想法产生了不寻常的结果。

事实上，这一方法的始创者是汉堡的奎克伯恩团队，他们是办公室管理顾问而非设计师。他们研究办公室的运转，得出这样的结论：办公室规划应基于交流的模式，其他因素（比如外观、状态识别和传统）应该被忽视或者置于次要地位。工作位置的安排是由交流的流动性决定的，它是日常办公室工作至关重要的部分。

避免分区也是"景观办公室"理念的基础。没有分区，那么工作模式改变造成的区域划分就变得快速和经济。在没有区域划分的办公空间中交流常常非常容易，减轻对地位象征意义的强调对提高办公士气和工作效率很有帮助。

没有划分，失去私密性，就会由于噪声而变得非常令人烦扰。由于这一原因，景观办公室就需要地板铺满地毯，对顶棚进行精心的声学设计。作为设计的一部分，所有大体量家具必须避免有坚硬的表面，因为它们也是声音反射的来源。嘈杂的办公机器要从一般办公空间中移到特定的隔离区域。长期不用的文件也要放在远处，在一般办公空间中只用小型的文件篮。

景观办公室设计以调查办公机构所有交流方式开始——交谈、写备忘录或是打电话。每个工作人员都在两个星期内被置于交流非常困难的状况中。再对这些数据加以分析。最终得出在平面上能够最大限度缩小最活跃交流通路的工作点距离。必须常常相互联系的人们放在一起；几乎没有联系需要的人们相隔很远。

一旦基本的平面布置确定了，就要根据设计平面等比例做一个有可移动家具和便携式电脑的模型空间。由办公室工作人员的代表来使用，这样就可以评判优劣和加以改变。还

要对所需改变进行常规的、持续的研究，每六个月重新组织一次，以此来处理那段时间所累积下来的改动需求。既然没有固定的建筑元素，这种改动是快速和廉价的。

直到现在，这种类型的设计系统绝大多数都是在欧洲进行。报告表明，景观办公室可以提高工作效率，办公室工作人员都倾向于更喜欢"景观"办公室而非传统办公室。毫无疑问，建造费用将非常低廉（因为不用分区），改动的费用也低到几乎可以忽略的程度。

Lesson 17 Recreate Nature From Debris—Third Millennium Park in Bogotá, Columbia

Bogotá, the capital city of Columbia, has experienced in the last eight years a series of changes that, driven and financed from the national and city government under a holistic land-use plan named Plan de Ordenamiento Territorial or POT, led to a remarkable positive urban transformation. This plan had many action programs whose main objectives were the enhancement and revalorization of public space and the reconnection of the original natural structure of the city with the urban grid. What primarily propelled these actions was the quite chaotic and environmentally degraded state in which the city had fallen into, during the last decades. Today, with the renovation of many spaces, the restoration of existing wetlands, the reforestation of the streets and the construction of new parks and green spaces, the city possesses a different and much refreshed image.

master plan of Third Millennium Park in Bogotá

Among the new constructions, Parque del Tercer Milenio or Third Millennium Park appears as an example of a social urban project that completely changed the face of a historically very problematic area. This project was framed into the "Plan for an urban parks system revitalization and reforestation", one of the POT's main action programs, and was put into action after a quite controversial decision.

The area, just a few blocks away from the capital's major governmental institutions, used to be one of the most dangerous spots in Bogotá's, rife with drugs, prostitution, and crime. The city government demolished almost 50 acres of squalid housing, relocated residents and moved elderly people and children into care centers, all of which was pretty questioned but, in the end, turned into the reborn of a central area and the generation of

landscape of Third Millennium Park in Bogotá

new green open spaces for a neglected neighborhood.

The building approach of this new park was shaped, as a chief priority, as a low cost and low maintenance project, thus applying sustainable materials and techniques.

One of the first decisions was that of recycling and reusing the debris and rests of the site's demolition works. In fact, the most relevant landscape strategy for this park consisted on the optimization of the existing soils' management as well as of those resulting from the demolition and readapting them for the site's new profile.

The edges of the new park were thought of as green slopes that would act as sound and wind barriers. These slopes, built from construction debris, have two different finishing treatments on their two sides; a concrete panel, facing the street, retains the soil that, sloping down towards the inner side of the park, is planted with groundcovers and flowering vines. The slopes, of approximately nine-foot-high, achieve a 10-decibel reduction of street noise and, on the other hand, generate a microclimate inside the park that allows planting tree species which are more sensitive to the winds than those planted on the surrounding streets.

Third Millennium Park in Spring

In addition, this artificial topography creates a visual frame for the distant landscape of the Guadalupe and Montserrat hills, so typical of the urban image of Bogotá city.

The planting plan also relies heavily on low-maintenance species, featuring native trees to provide shady retreats, large groups of shrubs, and colorful vines and groundcovers. In Bogotá, the Cerros Orientales or East Hills (a ridge that unfolds from the Andes Mountains and rise to almost 12000 feet) are covered with an extensive native flora that goes from large trees to different kinds of mosses, lichens and grasses at the highest levels. In order to create a natural green connection with this local formation, the planting plan for Third Millenium Park is characterized with the use of those same trees.

In the first place, the two major streets and the two avenues that outline the site were planted

with large species that create a green framing network for the area. This connection has both a visual and an environmental purpose; in fact, these planted streets were named "environmental axis" in the project. With time, these planted streets together with the strong presence of groups of cedros (Cedrela Montana) associated with pinos romerones (Podocarpus oleifolius) and gaques (Ciusia spp), inside the park, have proven to be natural attractors for local birds and avifauna. As a result, the sounds inside the park are more related with the natural image of Bogotá than with that of the chaotic surrounding urban life.

Also as part of the planting plan, the park features some "Memory Gardens" that want to thematically allude to some historical grounds and landscaping arrangements of houses of Bogotá; those original places but that disappeared through local urban degradation processes. The "agrarian garden", for instance, exhibits fruit trees very emblematic of private gardens in Bogotá, papaya (Carica papaya), tree tomatoes (Cyphomandra betracea) and cherries (Prunus sp) are some of the chosen varieties; the "foggy garden" is planted with tree species with which water creates a very special effect, such as alisos (Alnus jorullensi), gaques (ciusia sp) and caucho (Hevea brasiliensis or rubber tree) and the "grasses garden" shows Cortaderias, Festucas and Paspalum species.

The use of natives not only creates a very significant link with the local landscape of the city but with its environmental interactions. In this way, growing and maintenance conditions become less exigent and general costs are considerably reduced.

The finishing materials for paths and large surfaces of the park were also an object of attention to keep costs low. Crushed-clay was chosen for the footpaths and groundcovers and grasses for the slopes and some open areas; homogeneous beds of shrubs complete the surfaces of the park which, following with the low maintenance planting plan, were selected for their easy development conditions.

Water is another meaningful incorporation to the Third Millennium Park. Actually, water has always been a key element of the original structure of Bogotá; wetlands, streams and rivers, which with time and unplanned urban development were respectively fragmented and transformed into underground canals, and initially constituted the natural face of the city.

For this reason, the project incorporated contemporary water features that recall natural and cultural associations within the site. In the past, two rivers——Río San Francisco and Río San Agustin——met at the exact location where the first section of the park was built and now, at this same spot, the park offers two shallow rectilinear pools. The pools, of approximately 75 feet long and 15 feet wide, have a simple layout and were built with concrete, eliminating any other expensive finishing materials; there are aligned end to end within a crushed-clay plaza and, in each pool, water flows down a series of shallow steps. The place is usually crowded with kids that walk around and try to get wet.

Third Millennium Park revives traces of old Bogotá and is iconic scenery while keeping the social component with which was originated and implemented. Local residents, from

adjacent areas and nearby neighborhoods, now have access to an open area and a number of recreational activities that weren't even possible to imagine in the past. Moreover, the complete eradication of one of the most negative urban spots of the city provides the option of generating new ties, new meanings and new behaviors deeply related with a positively shaped public space. Although the project is still being settled and the building process was quite controversial, this new possibility of public life turns into the most important project's achievement.

Third Millennium Park in summer

Notes

1. Bogotá 波哥大

Bogotá—officially named Bogotá, D. C. , formerly called Santa Fe de Bogotá—is the capital city of Colombia, as well as the most populous city in the country, with 6776009 inhabitants (2005). In terms of land area, Bogotá is also the largest in Colombia, and its altitude (2640m) makes it the third-highest major city in the world, after La Paz and Quito. With its many universities and libraries, Bogotá has become known as "The Athens of South America".

波哥大，正式名称波哥大特区（以前被称为圣菲波哥大），是哥伦比亚人口最多的城市，一共有6776009市民（2005年）。就土地面积而言，波哥大也是哥伦比亚最大的城市，它的海拔（2640米）使它成为了世界第三高都市，紧跟在拉巴斯和基多之后。由于波哥大大学位于此地和图书馆众多，波哥大被称为"南美洲的雅典"。

Fig. 17-1 Bogotá at night

Bogotá has over one thousand localities, forming an extensive network of neighborhoods. Areas of higher economic status tend to be located to the north and north-east, close to the foothills of the Eastern Cordillera. Poorer neighborhoods are located to the south and south-east, many of them squatter areas. The middle classes usually inhabit the central, western and north-western sections of the city.

波哥大有一千多个街区，形成了广阔的邻里网络。靠近科迪勒拉东部山脉的城市北部和东北部是经济较为发达的区域。较贫困的区域位于城市的南部和东南部，其中许多都是居民擅自占有土地。中产阶级常常定居在城市的中心、西部和西北部。

The urban layout in the center of the city is based on the focal point of a square or plaza, typical of Spanish-founded settlements, but the layout gradually becomes more modern in outlying neighborhoods.

市中心规划以一座广场的中心点为基础，属于典型的西班牙定居模式，但是城市外围区域的规划逐渐变得更为现代。

There are many parks, many with facilities for concerts, plays, movies, and other activities.

波哥大有许多公园，配备了音乐会、戏剧、电影和其他活动的服务设施。

- "Simón Bolívar Metropolitan Park" is a large park regularly used to stage free concerts (such as the annual Rock al Parque, a festival in which new and popular Latin rock bands play free of charge). Kites are flown in the park.
- "西蒙·玻利瓦尔都市公园"是定期举办免费音乐会（比如每年举行的 Rock al Parque——新成立和流行的拉丁摇滚乐队免费表演的盛会）的大型公园。人们在公园里放飞风筝。
- The public *Parque Nacional* (National Park) has many trees and green spaces, ponds, games for children, many foot and bicycle paths, and venues for entertainment.

Fig. 17-2 Ibero-American Theater Festival of Bogota, The biggest festival of theatre in the world

- 公共国家公园有许多树木及绿色空间、水池、孩童游戏空间、步行和自行车道路，以及娱乐休闲的林荫大道。
- The Bogotá Botanical Garden (*Jardín Botánico de Bogotá*).
- 波哥大植物园。
- "Parque de la 93" is located between 93rd and 93Ath street, and 12th and 13th avenue, and has day-time leisure activities and nightlife. Several

Fig. 17-3 Neusa Park in Bogotá

of the top restaurants and bars in the city are in this park.
- "波哥大93公园"位于第93和第93A大街以及第12和第13大道之间,那里有丰富的白天休闲活动和夜生活。波哥大许多顶级的餐厅和酒吧都位于这个公园内。
- Maloka is an interactive museum of sciences.
- 马洛卡是一座交互式科学博物馆。
- Bogotá Savannah Railway, on weekends a sightseeing train, popular with Bogotá residents, runs to outlying towns Zipaquirá, Cajicá and Nemocón along the lines of the former. Another line goes towards the north for 47km and ends at Briceño.
- 波哥大萨凡纳铁路,在周末会有观光火车,很受波哥大市民欢迎,火车沿着以前的线路到达城市外围的锡帕基拉、卡奇卡和尼莫孔镇。另一条火车线路长47公里,最后到达北部的布里塞尼奥。

Bogotá is known for its vibrant night life. It has a wide variety of restaurants, bars, clubs and cultural activities to please anyone's preference. Places range from fine cuisine from all over the world to night clubs that offer different types of music. There is a curfew for most night places at 3：00am although some clubs still operate after hours.

波哥大以充满活力的夜生活而闻名。那里有各种各样的餐馆、酒吧、夜总会和文化活动来满足任何人的需要。从来自全世界的精致烹饪到提供各种音乐的夜总会应有尽有。虽然宵禁规定绝大多数夜生活场所必须在3点前关门,但是有一些夜总会在此后仍然开门迎客。

Fig. 17-4 View of Downtown Bogotá

2. Columbia 哥伦比亚

Colombia, officially the Republic of Colombia, is a country in north-western South America. Colombia is bordered to the east by Venezuela and Brazil; to the south by Ecuador and Peru; to the north by the Caribbean Sea; to the north west by Panama; and to the west by the Pacific Ocean. Colombia also shares maritime borders with Jamaica, Haiti, the Dominican Republic, Honduras, Nicaragua and Costa Rica. Colombia is the 26th largest nation in the world and the fourth largest in South America (after Brazil, Argentina, and Peru), with an area more than twice that of France. It also has the 29th largest population in the world and the second largest in South America, after Brazil. Colombia has the third largest Spanish-speaking population in the world after Mexico and Spain.

哥伦比亚,正式名称是哥伦比亚共和国,位于南美洲西北部。哥伦比亚的东部与委内

瑞拉和巴西接壤；南部与厄瓜多尔和秘鲁接壤；北面是加勒比海，西北方向是巴拿马；西面是太平洋。哥伦比亚也和牙买加、海地、多米尼加共和国、洪都拉斯、尼加拉瓜、哥斯达黎加共享海洋边界。哥伦比亚是世界第 26 大国家，南美洲第 4 大国家（位于巴西、阿根廷和秘鲁之后），国土面积是法国的两倍多。它在全世界国家人口排名中列第 29 位，是南美洲人口第二大国家，排在巴西之后。哥伦比亚是全世界第三大西班牙语国家，排在墨西哥和西班牙之后。

Colombia is a standing middle power with the fourth largest economy in South America. It is very ethnically diverse, and the interaction between descendants of the original native inhabitants, Spanish colonists, African slaves and twentieth-century immigrants from Europe and the Middle East has produced a rich cultural heritage. This has also been influenced by Colombia's incredibly varied geography. The majority of the urban centres are located in the highlands of the Andes mountains, but Colombian territory also encompasses Amazon rainforest, tropical grassland and both Caribbean and Pacific coastlines. Ecologically, Colombia is one of the world's 17 megadiverse countries.

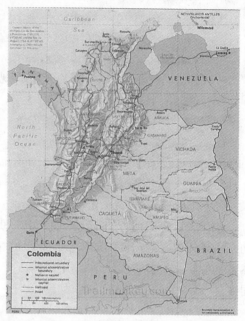

Fig. 17-5　Shaded relief map of Colombia

哥伦比亚是南美洲的中间力量，第四大经济体。它的种族形形色色，原住民的后代、西班牙殖民者、非洲裔奴隶、来自欧洲的 20 世纪移民和中东人之间的相互影响产生了丰富的文化遗产。这个国家也受到差异极大的地理现象的影响。城市中心位于安第斯山脉的高原上，但哥伦比亚的领土也包括亚马逊雨林、热带草原以及加勒比海和太平洋海岸。生态方面，哥伦比亚是世界 17 个超级生物多样性国家之一。

Part of the Pacific Ring of Fire, a region of the world subject to earthquakes and volcanic eruptions, Colombia is dominated by the Andes mountains. Beyond the Colombian Massif (in the south-western departments of Cauca and Nariño) these are divided into three branches known as cordilleras (from the Spanish for "rope"): the Cordillera Occidental, running adjacent to the Pacific coast and including the city of Cali; the Cordillera Central, running between the Cauca and Magdalena river valleys (to the west and east respectively) and including the cities of Medellín, Manizales and Pereira; and the Cordillera Oriental, extending north east to the Guajira Peninsula and including Bogotá, Bucaramanga and Cúcuta. Peaks in the Cordillera Occidental exceed 13000ft (4000m), and in the Cordillera Central and Cordillera Oriental they reach 18000ft (5500m). At 8500ft (2600m), Bogotá is the highest city of its size in the world.

哥伦比亚位于环太平洋火山带——世界上容易发生地震和火山爆发的区域，安第斯山

脉占据了这个国家的大部分。在哥伦比亚断层地块之上(考卡省和拿里诺省的西南部)，分为三个被称为科迪勒拉(西班牙语，意思是"绳索")的支脉：西科迪勒拉山脉，邻近太平洋海岸，包含卡利城；中科迪勒拉山脉，位于考卡省和梅格达莱纳河流山谷之间(分别向西和向东)，包括麦德林、马尼萨莱斯和佩雷拉城；以及东科迪勒拉山脉，北部延伸到瓜希拉半岛东面并包括波哥大、布卡拉曼加和库库塔。西科迪勒拉山脉的最高处海拔超过13000 英尺(4000 米)，中科迪勒拉山脉和东科迪勒拉山脉达到 18000 英尺 (5500 米)。海拔 8500 英尺(2600 米)的波哥大是全世界同等大小的城市中海拔最高的。

The environmental challenges faced by Colombia are caused by both natural hazards and human agency. Many natural hazards result from Colombia's position along the Pacific Ring of Fire and the consequent geological instability. Colombia has 15 major volcanoes, the eruptions of which have on occasion resulted in substantial loss of life, such as at Armero in 1985, and geological faults that have caused numerous devastating earthquakes, such as the 1999 Armenia earthquake. Heavy floods both in mountainous areas and in low-lying watersheds and coastal regions regularly cause deaths and considerable damage to property during the rainy seasons. Rainfall intensities vary with the El Niño Southern Oscillation which occurs in unpredictable cycles, at times causing especially severe flooding.

　　哥伦比亚面临的环境挑战可能是自然危机和人类行为的共同结果。自然危机大多是由哥伦比亚地处环太平洋火山带的位置以及随之产生的地理不稳定性而产生的。哥伦比亚有15 座火山，火山偶尔爆发导致了真实生命的消失(比如 1985 年的阿梅罗火山爆发)，火山爆发还会引起许多毁坏性地震(比如亚美尼亚地震)。山区、低洼流域以及海岸地区的雨季洪水经常造成人员伤亡和对财产的巨大破坏。随着以不可预知周期发生的厄尔尼诺—南方涛动现象，降雨强度有所改变，也可能引起严重的洪灾。

Fig. 17-6 The Magdalena River at
Santa Cruz de Mompox

　　Human induced deforestation has substantially changed the Andean landscape and is creeping into the rainforests of Amazonia and the Pacific coast. However, compared to neighbouring countries rates of deforestation in Colombia are still relatively low. In urban areas industry, the use of fossil fuels, and other human produced waste have contaminated the local environment, and demand from rapidly expanding cities has placed increasing stress on the water supply. Participants in the country's armed conflict have also contributed to the pollution of the environment. Illegal armed groups have deforested large areas of land to plant ille-

Fig. 17-7 View of Bogota from
Monserrate Colombia

gal crops, with an estimated 99000 hectares used for the cultivation of coca in 2007, while in response the government have fumigated these crops using hazardous chemicals. Insurgents have also destroyed oil pipelines creating major ecological disasters.

Fig. 17-8　View of mountains in Melgar Colombia

人类对森林的砍伐已经改变了安第斯山脉的景观，正在缓慢进入亚马逊雨林和太平洋海岸中。然而和邻近国家相比，哥伦比亚砍伐森林的速度仍相对较低。在城市工业中，矿物燃料的使用和人类产生的垃圾污染了当地的环境。快速扩张的城市需求对水供应施加了越来越大的压力。哥伦比亚武装斗争的参与者也对环境产生了污染。非法武装力量砍伐了大面积的森林来种植非法作物。2007年，估计有99000公顷土地用于古柯的种植，而作为回应，政府使用有毒的化学品来熏蒸这些作物。叛乱者也破坏输油管，这产生了重大生态灾难。

The varied and rich geography, flora and fauna of Colombia has also developed an ecotourist industry, mostly developed in the National Natural Parks of Colombia which include the areas of Amacayacu Park in the Department of Amazonas, Colombian National Coffee Park in the town of Montenegro, Quindío.

哥伦比亚多种多样和丰富的地貌、植物群和动物群也发展出生态旅游业，绝大多数成为了哥伦比亚国家自然公园、包括亚马逊省的阿马咖胭骨公园、金迪奥省内哥罗镇的哥伦比亚国家咖啡公园等。

Colombia lies at the crossroads of Latin America and the broader American continent, and as such has been marked by a wide range of cultural influences. Native American, Spanish and other European, Afric-an, American, Caribbean, and Middle Eastern influences, as well as other Latin American cultural influences, are all present in Colombia's modern culture. Urban migration, industrialization, globalization, and other political, social and economic changes have also left an impression.

哥伦比亚位于拉丁美洲和更广阔的美洲大陆的"十字路口"，受到了广泛的文化影响。美洲、西班牙、欧洲国家、非洲、美国、加勒比海、中东以及其他拉丁美洲国家的影响，都表现在哥伦比亚的现代文化之中。城市移民、工业化、全球化和政治、社会和经济的改变也产生了影响。

The mixing of various different ethnic traditions is reflected in Colombia's music and dance. The most well-known Colombian genres are cumbia and vallenato, the latter now strongly influenced by global pop culture. Television has also played a role in the development of the local film industry.

各种民族传统的混合反映在了哥伦比亚的音乐和舞蹈中。最著名的哥伦比亚音乐和舞蹈类型是伦巴和瓦伽娜多，后者受到了全球波普文化的强烈影响。哥伦比亚强大、统一的文化媒体是电视。电视业对当地电影业发展也起到了一定作用。

3. Groundcover　地被植物

Groundcover：of growing over an area of ground to hide it or to protect it from erosion or drought. In an ecosystem, the ground cover is the layer of vegetation below the shrub layer.

地被植物：紧贴地面生长，为的是隐藏或保护自己避免腐蚀或干旱。在生态系统中，地被植物是指低于灌木的植被层。

Fig. 17-9　Fiesta in Palenque. Afro-Colombian
tradition from San Basilio de Palenque, a
Masterpiece of the Oral and Intangible
Heritage of Humanity since 2005

Fig. 17-10　Groundcover of Vinca major

Strictly speaking, the most widespread groundcover are grasses of various types. In gardening terms, however, the term groundcover refers to non-grass plants that are used in place of grasses.

严格来说，分布最广泛的地被植物就是各种各样的草。然而，就造园而言，地被植物指的是在草地中使用的非草植物。

Four general types of plants are commonly used as groundcovers：

普遍作为地被植物使用的四种植物类型是：

- Vines, which are woody plants with slender, spreading stems；
- 藤本植物，有着纤细、四面扩展茎干的木本植物；
- Herbaceous plants, or non-woody plants；
- 草本植物，或者非木质植物；
- Shrubs of low-growing, spreading species；
- 向四周生长的低矮灌木物种；
- Moss of larger, coarser species.
- 较为粗大的苔藓物种。

4. Microclimate　微气候

A microclimate is a local atmospheric zone where the climate differs from the surrounding area. The term may refer to areas as small as a few square feet (for example a garden bed) or as large as many square miles (for example a valley). Microclimates exist, for example, near bodies of water which may cool the local atmosphere, or in heavily urban

areas where brick, concrete, and asphalt absorb the sun's energy, heat up, and reradiate that heat to the ambient air: the resulting urban heat island is a kind of microclimate.

Fig. 17-11　Microclimate and plant

微气候是指与周围区域气候有所不同的局部气候带。这个词可以指几平方英尺那么小的地方(例如一处花床)或者数平方英里那么大的区域(例如一处河谷)。例如,水体周围的微气候可能比当地的大气凉爽,或者拥挤不堪的城市区域里砖、混凝土和沥青柏油吸收太阳热量、温度上升,并将热量辐射到周围的空气中,导致了城市热岛成为一种微气候。

Another contributory factor to microclimate is the slope or aspect of an area. South-facing slopes in the Northern Hemisphere and north-facing slopes in the Southern Hemisphere are exposed to more direct sunlight than opposite slopes and are therefore warmer.

影响微气候的另一个因素是区域的坡度或方向。在北半球向南的斜坡和南半球向北的斜坡能够比相反面接受更多的阳光直射,因此更温暖。

Fig. 17-12　Tree ferns thrive in a protected dell at the Lost Gardens of Heligan, in Cornwall, England, latitude 50° 15'N

The area in a developed industrial park may vary greatly from a wooded park nearby, as natural flora in parks absorb light and heat in leaves, that a building roof or parking lot just radiates back into the air. Solar energy advocates argue that widespread use of solar collection can mitigate overheating of urban environments by absorbing sunlight and putting it to work.

发达工业园区的微气候可能和附近树木繁茂的公园非常不同,因为公园中植物群的叶子可以吸收光线和热量,而建筑物的屋顶或停车场却向大气辐射热量。太阳能倡导者提出太阳能收集系统的广泛使用可以通过吸收太阳光来降低过热的城市环境,并对这部分能量加以利用。

A microclimate can offer an opportunity as a small growing region for crops that cannot thrive in the broader area; this concept is often used in permaculture practiced in northern temperate climates. Microclimates can be used to the advantage of gardeners who carefully choose and position their plants. Cities often raise the average temperature by zoning, and a sheltered position can reduce the severity of winter. Roof gardening, however, exposes plants to more extreme temperatures in both summer and winter.

微气候可以为无法在广大区域生长的作物提供小型生长区;常常在北方温和气候的永

冻地区使用这一概念。仔细选择和确定植物种植位置的园丁们可以利用微气候。城市常常通过分区来提高平均温度，有遮蔽的场所可以减轻冬季的严寒。而屋顶花园则把植物暴露在夏季和冬季的极端温度之下。

Microclimates can also refer to purpose made environments, such as those in a room or other enclosure. Microclimates are commonly created and carefully maintained in museum display and storage environments. This can be done using passive methods, such as micro-climate control devices.

微气候也可以指某种人工环境，比如房间或其他封闭体。博物馆展示和储存环境往往创造和仔细控制微气候。可以通过使用积极的措施来实现这一目的，比如微气候控制设备。

5. Guadalupe and Montserrat Hill　瓜达洛普山和蒙塞拉特山

Guadalupe Hill is a hill located in Downtown Bogotá, Colombia. Next to the mountain of Monserrate.

瓜达洛普山是位于哥伦比亚市中心的山脉，靠近蒙塞拉特山。

Monserrate is a mountain that dominates the city centre of Bogotá, the capital city of Colombia. It rises to 3152 metres (10341ft) above the sea level, where there is a church (built in the 17th century) with a shrine, .

蒙塞拉特山占据了哥伦比亚首都波哥大的市中心。它的海拔 3152 米（10341 英尺），在山上有一座圣地教堂（建于 17 世纪）。

The hill is a pilgrim destination, as well as a tourist attraction. In addition to the church, the summit contains a restaurant and many smaller tourist facilities. Monserrate can be accessed by aerial tramway, a funicular or by climbing, the preferred way of pilgrims. The hill also provides spectacular views of the city.

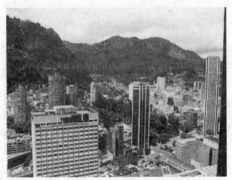

Fig. 17-13　Bogotá Downtown with Monserrate (left) and Guadalupe (right) hills behind

蒙塞拉特山是朝圣者的目的地，也是旅游胜地。除了教堂，顶峰还有一间餐馆和许多更小的旅游设施。可以通过空中缆车、索道或者爬山到达蒙塞拉特山顶，爬山是朝圣者最偏爱的方法。在蒙塞拉特山还可以看到壮观的城市全景。

Both Monserrate and its neighbor Guadalupe Hill are icons of Bogota's cityscape.

蒙塞拉特山和瓜达洛普山都是波哥大市城市景观的标志。

6. Andes Mountains　安第斯山脉

The Andes form the world's longest exposed mountain range. They lie as a continuous chain of highland along the western coast of South America. The range is over 7000km (4400miles) long, 200~700km (300miles) wide, and of an average height of about 4000m (13000ft).

安第斯山脉是陆地上最长的山脉。安第斯山脉位于南美洲西岸的高原上。山脉范围超过 7000 公里长，200~700 公里宽，平均海拔高度大约 4000 米

Fig. 17-14 Aerial photo of a portion of the
Andes between Argentina and Chile

Fig. 17-15 Rift valley near
Quilotoa, Ecuador

The Andean range is composed principally of two great ranges, the Cordillera Oriental and the Cordillera Occidental, often separated by a deep intermediate depression, in which arise other chains of minor importance, the chief of which is Chile's Cordillera de la Costa. The Andes mountains extend over seven countries: Argentina, Bolivia, Chile, Colombia, Ecuador, Peru and Venezuela, some of which are known as Andean States.

安第斯山脉主要由两座群山组成——东科迪勒拉山脉和西科迪勒拉山脉，两座山脉以居中的深谷为分隔，山谷中还有其他不太重要的小山脉，主要是智利的科斯塔山脉。安第斯山脉至少经过了7个国家：阿根廷、玻利维亚、智利、哥伦比亚、厄瓜多尔、秘鲁和委内瑞拉，这些国家被称为安第斯国。

The Andes mountain range is the highest mountain range outside Asia. The highest peak, Aconcagua, rises to 6962m (22841ft) above sea level. The summit of Mount Chimborazo in the Ecuadorean Andes is the point on the Earth's surface most distant from its center, because of the equatorial bulge.

安第斯山脉是除亚洲之外世界上最高的山脉。其最高的顶峰阿空加瓜峰海拔6962米。因为赤道凸起，厄瓜多尔的安第斯山脉中钦博拉索山顶点是地球表面距离地心最远的地方。

The Andes is rich in fauna and flora. About 30000 species of plants live in the Andes with roughly half being endemic to the region, surpassing the diversity of any other hotspot. The Andes is the most important region in the world for amphibians. The numbers are equally impressive: Almost 600 species of mammals (13% endemic), more than 1700 species of birds (c. 1/3 endemic), more than 600 species of reptiles (c. 45% endemic), and almost 400 species of fishes (c. 1/3 endemic).

安第斯山脉是丰富的动植物栖息地。大约有30000种植物在此生长，一半是当地特产，其生物多样性超过了任何热带地区。安第斯山脉是全世界最重要的两栖动物栖息地。统计数字也同样令人深刻：接近600种哺乳动物（13%是本地特

Fig. 17-16 A male Andean Cock-of-the-rock,
a species found in humid Andean forests

产），1700 种鸟类(1/3 为本地特产)，600 多种爬行动物(45%为本地特产)，接近 400 种鱼类(1/3 为本地特产)。

Rainforests used to encircle much of the northern Andes but are now greatly diminished, especially in the Chocó and inter-Andean valleys of Colombia. The small tree Cinchona pubescens, a source of quinine which is used to treat malaria, is found widely in the Andes as far south as Bolivia. Other important crops that originated from the Andes are tobacco and potatoes. The high-altitude Polylepis forests and woodlands are found in the Andean areas of Colombia, Ecuador, Peru, Bolivia and Chile.

雨林曾经环绕大部分安第斯山脉北部地区，但是现在很多雨林都消失了，特别是在哥伦比亚的乔科省和安第斯山内部的山谷。直达玻利维亚的安第斯山脉广大区域中都可以找到小型树大叶鸡纳树——这种树木能够生长用于治疗疟疾的奎宁。安第斯山脉的其他重要作物是烟草和马铃薯。在哥伦比亚、厄瓜多尔、秘鲁、玻利维亚和智利的安第斯山脉区域可以发现高海拔的蝶类森林和林地。

The Andes mountains forms north-south axis of cultural influences, as the geographical extension of the Inca Empire. The Inca Empire developed in the central Andes during the 1400s. The Incas formed this civilization through imperialistic militarism as well as careful and meticulous governmental management.

Fig. 17-17 Map showing cultural influence in the Andes

安第斯山脉形成了从北到南的文化影响轴线，印加帝国也是沿着这条线扩展。15 世纪印加帝国在安第斯中央地带形成。印加人通过军国主义和小心翼翼的政府统治形成了这一文明。

Devastated by deadly European diseases to which they had no immunity, and by a terrible civil war, in 1532 the Incas were defeated by an alliance composed by tens of thousands allies from nations they had subjugated and a small army of 180 Spaniards led by Pizarro. One of the few Inca cities the Spanish never found in their conquest was Machu Picchu, which lay hidden on a peak on the edge of the Andes.

由于印加人对欧洲传入的致命疾病没有免疫力和可怕的内战，印加文明消失了，1532 年印加人被他们曾经征服的、数以万计国家组成的联盟，以及皮萨罗所带领的由 180 个西班牙人组成的小部队所击败。在西班牙人的征服过程中从没被发现的印加城市之一就是马丘比丘，它隐藏在安第斯山脉边缘的顶峰之上。

Several major cities exist in the Andes, among them the capital of Colombia, Bogotá, the capital of Ecuador, Quito, the capital of Bolivia, La Paz, and the famous Peruvian city of Cusco. These and most other cities are now connected with asphalted

roads, while smaller town often are connected by dirt roads. Due to the arduous terrain, localities where vehicles are of little use remain. Locally, Llamas continue to play an important role as pack animals.

安第斯山脉中有许多城市，其中包括哥伦比亚的首都波哥大、厄瓜多尔的首都基多、玻利维亚的首都拉巴斯以及著名的秘鲁城市库斯科。这些城市现在都通过柏油路和其他城市取得联系，而更小的城镇常常用土路相连。由于地形复杂，当地仍然极少使用汽车。在当地，美洲驼继续作为驮畜扮演了重要角色。

7. Wetland 湿地

A wetland is an area of land consisting of soil that is saturated with moisture, such as a swamp, marsh, or bog.

湿地是指由湿度饱和的土壤构成的土地区域，比如沼泽、草本沼泽或低湿地。

As defined in terms of physical geography, a wetland is an environment "at the interface between truly terrestrial ecosystems and aquatic systems making them inherently different from each other yet highly dependent on both". In essence, wetlands are ecotones. Wetlands often host considerable biodiversity and endemism. In many locations such as the United Kingdom, Norway, South Africa and United States they are the subject of conservation efforts and Biodiversity Action Plans.

Fig. 17-18 Small wetland in Marshall County, Indiana in the United States

就如自然地理学所定义的，一处湿地就是"真实的陆地生态系统和水生生态系统之间的分界面，这一点使它们必定不同于这两种生态系统，却仍然高度依赖这两者"。在本质上，湿地是群落交错区。湿地常常容纳了相当范围的生物多样性和特定生物分布。在许多地区，比如英国、挪威、南非和美国，湿地都是生态保护和生物多样性行动计划的主题。

Functions 功能

1) Hydrologic 水文

Hydrologic functions include long term and short term water storage, subsurface water storage, energy dissipation, and moderation of groundwater flow or discharge.

水文方面的功能包括长期和短期的水存储、地下水存储、能源消耗、地下水的流动或排放。

By absorbing the force of strong winds and tides, wetlands protect terrestrial areas adjoining them from storms, floods, and tidal damage.

通过吸收强风和潮汐的力量，湿地保护邻近湿地的陆

Fig. 17-19 Home of water birds in wetland near Tuchlovice, Czech Rep

地区域避免暴风雨、洪水和潮汐的破坏。

2) Biogeochemical　生物地理化学

Nutrient cycling, retention of particulates, removal of imported elements and compounds, and the import and export of organic carbon are all biogeochemical functions of wetlands. Wetlands remove nutrients from surface and ground water by filtering and by converting nutrients to unavailable forms. Denitrification is arguably the most important of these reactions because humans have increased nitrate worldwide by applying fertilizers. Increased nitrate availability can cause eutrophication, but denitrification converts biologically available nitrogen back into nitrogen gas, which is biologically unavailable except to nitrogen-fixing bacteria. Denitrification can be detected in many soils, but denitrification is fastest in wetlands soils.

营养循环、悬浮颗粒物的停留、输入元素和化合物的去除、有机碳的输入和输出，这一切都是湿地的生物地理化学功能。湿地通过过滤和将营养物转变为无法利用形式来去除地表和地下水的营养物。脱氮作用被认为是这些反应中最重要的，因为人类使用化学肥料增加了全世界范围的硝酸盐。增加的硝酸盐可能引起过营养化，但是脱氮作用将生物可用的氮转回到氮气的状态，这是除了使氮固定的细菌以外的生物无法利用的。脱氮作用可以在许多土壤中检测到，但在湿地土壤中脱氮作用最快。

3) Habitat　栖息地

Wetlands provide a safe and lush environment for many different species of fish, birds, and insects.

湿地为鱼类、鸟类和昆虫等许多物种提供安全和丰富的生存环境。

Like animals, there are many plant communities that will only survive in the unique environmental conditions of a wetland. In the continental U. S. wetlands account for only 5% of the total land area, but over 30% of the nation's vascular flora occur in wetlands.

像动物一样，许多植物群落只能在湿地特殊的环境条件下生存。在美国大陆只有5%的土地面积是湿地，但是有30%的导管类植物生长在这些湿地中。

Fig. 17-20　Swans on a marsh in Vermilion County, Illinois

4) Value to humans　对人类的价值

While many of the functions above are directly or indirectly beneficial to humans and society, wetlands are specifically valuable to people as places for recreational and educational activities such as hunting, fishing, camping, and wildlife observation. Wetlands are often filled in to be used by humans for everything from agriculture to parking lots, in part because the economic value of wetlands has only been recognized recently: the shrimp and fish that breed in salt water marshes are generally harvested in deeper water, for example. Humans can maximize the area of healthy, functioning wetlands by minimizing their impacts and by developing management strategies that protect, and where possible rehabilitate

those ecosystems at risk.

以上许多功能都是直接或间接对人类和社会有益，而湿地作为娱乐和教育活动场所对人类有特殊的价值，比如狩猎，钓鱼、露营和野生生物观测。人们常常将任何事物都塞到湿地中，从耕地到停车场，部分是因为人们最近才认识到湿地的经济价值：例如在盐水沼泽中繁殖的鱼虾逐渐在更深的水中培育。我们可以通过人类影响最小化和发展保护策略、在可能的地方修复处于危急的生态系统，来实现健康的、发挥作用的湿地领域最大化。

Wetlands are sometimes deliberately created to help with water reclamation. One example is Green Cay Wetlands in Boynton Beach, Florida, in the United States.

有时我们人工建造湿地，以此来帮助水的再生。一个范例就是美国佛罗里达州博因顿滩市的格林岛湿地。

By 1993 half the world wetlands had been drained.

到 1993 年，世界近一半的湿地消失了。

Historically, humans have made large-scale efforts to drain wetlands for development or to flood them for use as recreational lakes. Since the 1970s, more focus has been put on preserving wetlands for their natural function.

历史上，人们曾经付出巨大努力去排干湿地以满足发展需要，或者淹没湿地用作娱乐的湖水。从 20 世纪 70 年代开始，人们开始更多地关注为了湿地的自然功能而保存湿地。

The creation of the treaty known as the Ramsar Convention (1971), or more properly "The Convention on Wetlands of International Importance, especially as Waterfowl Habitat", demonstrates the global concern regarding wetland loss and degradation. The primary purposes of the treaty are to list wetlands of international importance and to promote their wise use, with the ultimate goal of preserving the world's wetlands.

订立的公约称为《拉姆萨尔公约》（也称为：湿地公约）（1971），或者更恰当的名称是 "国际重要湿地公约，特别是水禽栖息地"，证明全球对湿地损失和退化的关注。这个公约的主要目的是列出具有国际意义的湿地，并推动对它们善加利用，最终的目标是保护全世界的湿地。

Vocabulary

1. Debris *n.* ①残骸；废墟 ②［地］岩硝：glacial debris 冰河的岩屑 ③［矿］尾矿，废石 ④（登山中遇到的崩落的）冰块堆

［近义词］rubbish, trash, wreckage, ruins, wastage, junk, litter, residue, scrap *n.* 瓦砾堆，废墟

［辨析］debris 瓦砾堆：指散乱的碎片。

The street wad covered with debris from the explosion. 街上满是爆炸后的残砾。

rubbish 垃圾：指被丢弃的无用的东西。

The rubbish must be cleaned away. 这垃圾必须清除掉。

trash 废物：指无价值的东西，在美国也指垃圾。

This novel is mere trash. 这本小说毫无价值。

wreckage 残骸：指船舶遭受暴风雨袭击或其他灾难后的残骸。

The shore was covered with the wreckages of a ship. 岸上堆满了一条船的残骸。

2. Propel *vt.* ①推动，推进：propelling power 推进力　②鼓励，驱策：a person propelled by ambition 受野心驱策的人

［近义词］drive,push,shoot,shove,thrust,catapull,eject,send,hurl,launch,push forward,set in motion,drive forward *v.* 推动，推进

［辨析］**propel 推动**：指向前推进。

The ship is propelled by steams. 这轮船是用蒸汽推动的。

drive 赶走、驱逐：指用叫喊、拍打、威胁或其他方式驱赶动物或人去某个方向。

He was driving his cattle to the market. 他正把牛赶往市场。

spur 策励、刺激：原指以刺马钉刺马，使之加快速度，现喻指策励、刺激。

Pride spurred the man to fight. 自尊心激励他去战斗。

3. Possess *vt.* ①具有(能力、性质等)，掌握(知识等)；据有，占有，拥有；财产，房屋等；使占有，使拥有：possessed great tact. 具有非凡的智谋　②(鬼等)缠，附；(情欲等)迷住　③(在身心方面)克制；保持(镇定等)；维持(平衡)：possess oneself 自制　④使沾染，使任意摆布，支配：She was possessed by the desire to be rich. 她被致富的欲望所支配。⑤通知，使熟悉(of,with)：possess sb. of the facts of the case 使某人熟悉该案的事实

［近义词］own,have,acquire,enjoy,hold,obtain,take *v.* 拥有，占有

［辨析］**possess 有**：指占有自己的东西，尤指永久性的房屋、土地等，比 own 更为正式的用词。

He possessed a large fortune. 他拥有大量的财富。

own 有：指具有法律上的所有权的意思。

He owns much land. 他拥有许多土地。

4. Demolition *n.* ①破坏，毁坏，爆破 [pl.] 废墟，爆破的炸药　②爆破

［近义词］destruction,dismantling,ruin *n.* 破坏、毁坏

［辨析］**demolition 破坏、毁坏**：指拆除、推倒已建立之物，如房屋等。

Demolition of old buildings is not an easy task. 拆除旧房并非易事。

destruction 毁坏、毁灭：指由破坏或伤害力量造成的破坏。

The storm caused widespread destruction. 暴风雨造成了很大范围的破坏。

dismantling 拆除、拆卸：指拆除装备等。

The old warship was sent to the docks for dismantling. 这艘旧战舰被送到船坞去拆卸。

ruin 毁灭、破坏：指任何东西部分或整个地倒塌，碎成片状。

The building is in ruins. 那建筑物已经成了废墟。

5. Profile *n.* ①轮廓、外形：draw in profile 画侧面像［轮廓］　②侧面像；侧面；侧影　③传略，人物简介；剪影；(人物)素描：a profile of the new prime minister 新首相传略　④(建筑物的)横断面(图)，纵剖面(图)：soil profile 土壤剖面图　*vt.* ①描……的轮廓　②对……做扼要描写；写……的传略

［近义词］outline,trace,delineate,sketch out,draw a line around *v.* 描……的轮廓

side,silhouette,side view,half face *n.* 侧面（像）

outline,contour,delineation,configuration,form,shape,figure,lineaments,vignette,sk - yline,sketch,drawing,portrait,picture,thumbnail sketch *n.* 外形，轮廓

［辨析］**profile** 轮廓、外形：指外形的侧面像，尤指通过背景所衬托出来的。

Her face was visible in profile only. 只能看见她脸部的侧面。

outline 外形、轮廓：指一个物体、形状或模型的外形轮廓。

We could see the outline of a man. 我们只能看到一个人的轮廓。

contour 轮廓：指轮廓所表示的形象。

The contours of his face are rugged. 他脸部的轮廓高低不平。

6. Eliminate *vt.* ①除去，排［删，消］除，削减（人员）：eliminate the false and retain the true 去伪存真 eliminate the need of ②使不需要：eliminate the possibility of 排除这种可能性；使不可能 ③对消，淘汰；不予考虑：She has been eliminated from she swimming race because she did not win any of the practice races. 她已被取消了游泳比赛，因为她在训练中没有得到名次。

［近义词］delete,exclude,exterminate,annihilate,disregard,eject,extinguish,reject,remove, drop,expel,ignore,kill,omit,cut out,get rid of,do away with,dispose of,knock out *v.* 排除，消除，消灭

［辨析］**eliminate** 驱除、消除：指驱除已存在于某处的事物或使之不受注意。

He eliminated fear from his heart. 他把恐惧从心里驱除了出去。

delete 消去、删除：主要指从文稿中删除无用的字句。

Several words had been deleted by the censor. 有好几个字被新闻检查员删除了。

exclude 驱除、排除：指不让某人或某物进入。

Closing the window excludes street noise. 关上窗户街上的吵闹声就进不来了。

exterminate 消除：主要用于消除疾病、观念、信仰等。

This poison will exterminate rats. 这毒药可以消灭老鼠。

7. Implement *n.* ①工具；器具：farming implements 农具 ②［法］履行（条约等） *vt.* ①实现；履行：implement a contract 履行合同 ②补充 ③使生效，实施，执行：The committee's decisions will be implemented immediately. 委员会的决定将立即执行。④供给器具

［近义词］accomplish,complete,discharge,do,effect,enforce,execute,fulfill,perfect,perform, realize,bring about,carry out *v.* 实现；履行

tool,instrument,apparatus,appliance,device,gadget,utensil *n.* 工具；器具

［辨析］**implement** 工具：最普通的用词，指做某种工作所必需的工具、器械、家庭用具或机械装置等。

Hoes and tractors are agricultural implements. 锄和拖拉机都是农具。

instrument 工具：指科学、美术和音乐上用的器械和器具。

He plays on several musical instruments. 他会奏好几种乐器。

tool 工具：指专业工人和其他劳动者所用的简单的工具。

This tool will serve my turn. 这工具正合我意。

utensil 器皿： 指用于家事或农事等的器皿。

There were hospitals where the most necessary utensils were wanting.

有的医院缺少最必需的器械。

Sentence

This plan had many action programs whose main objectives were the enhancement and revalorization of public space and the reconnection of the original natural structure of the city with the urban grid. What primarily propelled these actions was the quite chaotic and environmentally degraded state in which the city had fallen into, during the last decades.

POT 土地使用计划有多个实施方案，最终目标都是扩展并提升公共空间的价值，将城市原有的生态结构与发展布局联系起来。促使这一系列城市改造方案实施的主要原因是波哥大市在过去几十年间非常混乱且日益恶化的城市环境。

This project was framed into the "Plan for an urban parks system revitalization and reforestation", one of the POT's main action programs, and was put into action after a quite controversial decision.

该项目被纳入了 POT 的主要实施方案之一——"城市公园体系的复兴与绿化计划"的主体框架中，并经过多方商议后开始实施。

The building approach of this new park was shaped, as a chief priority, as a low cost and low maintenance project, thus applying sustainable materials and techniques.

新公园的修建强调了"低成本，低维护"的设计理念，因此项目中多使用可持续利用的材料和工艺。

One of the first decisions was that of recycling and reusing the debris and rests of the site's demolition works. In fact, the most relevant landscape strategy for this park consisted on the optimization of the existing soils' management as well as of those resulting from the demolition and readapting them for the site's new profile.

首先要做出的决定是基地废弃物的回收和再利用。事实上，在新公园的景观设计策略中，与低成本主题最相关的就是现有土地管理方法的优化以及废弃建材的再利用。

In the first place, the two major streets and the two avenues that outline the site were planted with large species that create a green framing network for the area.

首先，设计师在勾勒出公园外形的两条主要街道和两条林荫大道上栽种了高大的树木，形成整个公园的绿色框架。

Also as part of the planting plan, the park features some "Memory Gardens" that want to thematically allude to some historical grounds and landscaping arrangements of houses of Bogotá; those original places but that disappeared through local urban degradation processes.

此外，该公园中种植的植被还起到了"纪念公园"的作用，使人回想起具有历史意义的庭院和波哥大市住宅的景观设计风格。

Water is another meaningful incorporation to the Third Millennium Park. Actually, water has always been a key element of the original structure of Bogotá; wetlands, streams and rivers, which with time and unplanned urban development were respec-

tively fragmented and transformed into underground canals,and initially constituted the natural face of the city.

　　水景一直是波哥大市原有景观结构中的关键部分，但是随着时间的流逝以及无规划的城市发展，最初组成这个城市自然风貌的湿地、小溪和河流在城市整体规划中被隔断而变成地下水道。

　　Although the project is still being settled and the building process was quite controversial,this new possibility of public life turns into the most important project's achievement.

　　虽然这个项目仍处于建设中，而且修建过程也备受争议，但全新的公共生活模式无疑是这个项目最成功之处。

Translation

第 17 课　重建在废墟上的自然——哥伦比亚波哥大市第三千年公园

　　哥伦比亚首都波哥大市在哥伦比亚政府的支持下实行了一项名为 Plan de Ordenamiento Territorial（简称"POT"）的土地使用计划。自计划开始实施的 8 年间，波哥大市经历了一系列的城市改造，成功地实现了城市的转型。POT 土地使用计划有多个实施方案，最终目标都是扩展并提升公共空间的价值，将城市原有的生态结构与发展布局联系起来。促进这一系列城市改造方案实施的主要原因是波哥大市在过去几十年间非常混乱且日益恶化的城市环境。时至今日，随着许多公共空间的重建、现存湿地的修复、街道的绿化以及新的公园和绿色空间的修建，波哥大市已呈现出一派崭新的城市面貌。

　　在众多的新建项目中，第三千年公园的设计彻底改变了波哥大市的形象，并被公认为城市改造项目的典范。该项目被纳入了 POT 的主要实施方案之一——"城市公园体系的复兴与绿化计划"的主体框架中，并经过多方商议后开始实施。

　　该项目距离波哥大市主要政府机构仅几个街区，曾经是波哥大市最混乱的地区之一。为此，政府将居民迁出，拆除了约 20 万平方米的原有住宅区，并将老人和儿童送往看护中心，尽管这些做法在当时受到了质疑，但最终将这里改造成了市中心的一处绿色开放空间。

　　新公园的修建强调了"低成本，低维护"的设计理念，因此项目多使用可持续利用的材料和工艺。

　　首先要做出的决定是基地废弃物的回收和再利用。事实上，在新公园的景观设计策略中，与低成本主题最相关的就是现有土地管理方法的优化以及废弃建材的再利用。

　　该项目设计的一大亮点便是那些可以阻隔噪声和强风的绿色坡地。这些坡地构建在废墟之上，而且内外两侧的坡面并不相同。临街一侧的坡地上覆盖有混凝土板层，用以防止表层土壤流失；内侧坡地上则栽种着地被植物和攀援植物。约 3 米高的坡地可以将街道的噪声降低 10 分贝，还可以在公园内部形成有利于对风力敏感的植物生长的微气候环境。

　　此外，这种人造地形还便于人们眺望远处瓜达洛普山和蒙特塞拉特山的美景，而山地景观正是波哥大市最典型的城市风景之一。

　　植物配置主要选取低维护成本的物种，如可提供大片树荫的本土树种、群生灌木丛以及色彩鲜艳的攀援植物和地被植物等。波哥大市的东山（安第斯山脉中的一个山脊）海拔约

3658 米，地表覆盖着物种丰富的本土植物群，包括高大的乔木和生长在高海拔处的各种藓类、地衣和草坪。为了营造出与本地自然景观相融合的绿色空间，第三千年公园内的植被选取了东山上的原有树种。

首先，设计师在勾勒出公园外形的两条主要街道和两条林荫大道上栽种了高大的树木，形成整个公园的绿色框架。设计兼顾了视觉和环境的需要，设计师将这些经过绿化的街道称为"环境基准"。不久，这些经过绿化的街道与公园中的雪松、罗汉松和克鲁希亚木便成为鸟类的天堂。到那时，公园中的鸟语花香便更加切合波哥大市的自然意境，与昔日嘈杂的都市生活形成鲜明的对比。

此外，该公园中种植的植被还起到了"纪念公园"的作用，使人回想起具有历史意义的庭院和波哥大市住宅的景观设计风格。设计师在这里栽种了曾经繁盛的植物，如在"耕种花园"中展示的波哥大市私人果园的标志性果树，包括番木瓜、树番茄和樱桃树等精选树种；"朦胧花园"中栽种的赤杨、克鲁希亚木和橡胶树等树种。这些植物配以流水便会产生出效果独特的水景；"草地花园"则种植了蒲苇属、羊茅属和雀稗属等物种。

选用本土原生物种不仅可以突出公园与城市景观间的密切联系，同时也是出于对环境的考虑。因为这些植物的生长和维护对环境的要求不是很高，可以大大降低成本。

设计师在选择公园小径和大块地表的铺装材料时也考虑到了降低项目成本的问题——小径的铺装材料选用碎石黏土，绿色坡地和一些开放空间则选用了地被植物和草坪；灌木丛因其低维护的特点也加以使用。

水景一直是波哥大市原有景观结构中的关键部分，但是随着时间的流逝以及无规划的城市发展，最初组成这个城市自然风貌的湿地、小溪和河流在城市整体规划中被隔断而变成地下水道。

为此，项目特意保留了经过现代化的特色水景，既表现了自然风貌，又突出了该地区的文化底蕴。波哥大市的两条河流——里奥圣弗朗西斯科河和里奥圣奥古斯丁河过去的交汇点正是项目所在地，因而该项目在此处设计了两个浅浅的直线型水池，以体现这种历史特征。这两个水池长 23 米、宽 4.5 米，布局简单，使用价格低廉的混凝土材料铺设而成，并在碎石黏土铺设的广场上以首尾相接的形式排列。池中水沿着一系列的阶梯流淌，是孩子们玩耍的乐园。

第三千年公园让人们回忆起波哥大市古老的城市演变痕迹和自然景观。本地及邻近地区的居民都可以进入第三千年公园参加一些娱乐活动，这在过去根本是无法想象的。更为重要的是，在城区全面规划后，在这座城市形成了与具有积极意义的公共空间相联系的新思想、新风气。虽然这个项目仍处于建设中，而且修建过程也备受争议，但全新的公共生活模式无疑是这个项目最成功之处。

Lesson 18 Splendid Sight in the Swedish Estate——Meet the Requirements of Different Group

Until the mid-1990s, Malmö, the third largest city in Sweden, seemed fairly emerged in a long post-industrial decline, its major industries obsolete or surpassed by others elsewhere in Sweden, Europe and the world. Lying in Scania, the southernmost county n Sweden, Malmö lived through one of the earliest national urban booms during the industrial Revolution. Since then, however, the socio-economic fabric of the city deteriorated steadily. It is currently home to 280000 people, or well over 600000 in the Malmö conurbation, significant numbers in a country with just over 9 million inhabitants. With about 27% of its population born outside Sweden, Malmö is also one of the most unequal cities in the country, perennially concerned with high unemployment rates and youth disenfranchisement, among a variety of social problems. These are often reflected in the city's residential districts, roughly segregated along ethno-economic lines. While sections of Malmö are lush and obviously affluent, others lack any evidence of prosperity or color.

But with these prospects on the table, the City of Malmö was not about to concede defeat. Several European Union and government - sponsored revitalization projects targeted the metropolitan area from 1995 onwards. Over the last twelve years, urban renewal became a local motto, with forefront architectural projects mushrooming throughout the city and attracting the attention of specialized international media. The most remarkable of these is arguably Santiago Calatrava's 190m-high HSB Turning Torso residential tower, a sleek, award-winning project that quickly became an easily identifiable symbol of the city. In 2007, Seattle-based online environmental news magazine Grist included Malmö in is coveted '15 Green Cities' list, furthering the impact of this

roof landscape of Nos. 64-66
in Stensjögatan Street

rebirth to the world stage. Malmö has also invested in the attraction of cutting-edge indus-
tries (IT, biotechnology) and on the development of a knowledge-based economy, greatly
fed by the local university and the requirements of neighboring Lund, another major city.
In 2000, the inauguration of the 7845m long Oresund Link, a tunnel/bridge hybrid connect-
ing Malmö to Copenhagen, further enhanced the economic revitalization of the city.

Slowly but steadily, this new urban energy spread through the city, with exciting archi-
tecture, landscape architecture and urban intervention through art peppering the different
sectors. Nos. 64-66 in Stensjögatan Street is one such case. The building is located in the
outskirts of Lorensborg district, a 1950s development that provided large-scale, multistory
residential estates for what was then a growing post-war industrial estates for what was
then a growing post-war industrial population. From its blue-collar origins, Lorentsborg
evolved into what is today a lower-middle class area of the city, surrounded by neighbor-
hoods with severe social issues, such as Kroksbäck, but also modern, more prosperous dis-
tricts like Hyllie, an area now growing fast due to its proximity to the Oresund Link to
Denmark.

The yellow-red brick building, situated next to a major throughway and roundabout
connecting different districts, was a council development aimed at housing mixed groups of
people. The 11-storey building was meant for tenants with different levels and types of im-
pairments, as well as elderly citizens' temporary housing and a full elderly nursing home. A
few floors were also reserved for people without any social problems. In the academic com-
munity, these human geography experiments have both been lauded and denounced, in Swe-
den and in other developed countries with similar social issues.

Monika Gora's GORA art&landscape design team was called to intervene, improving
the project by creating a master plan that reconciled the landscape needs of such diverse
groups of people. Several issues presented themselves as significant obstacles: the heavy
traffic on Lorensborgsgatan street, and the volume and height of neighbouring buildings
were evident from the onset. The budget was another difficulty: at approximately US $
160/m², the total amount was limited (in Swedish terms) for the tasks of clearing the
ground, creating a new landscaped area in the central courtyard that could be used for dif-
ferent effects by all residents, and additionally a roof garden for the exclusive use of the eld-
erly people in the nursing home.

The key features that resulted form this intervention are gradually visible to passers by
and residents. An arts& crafts styled brown brick wall closes off the site from the busy
Lorensborgsgatan street. Form this street, a second feature—the most easily recogniza-
ble—is visible in the roof garden: a magenta, fuchsia and ochre glasshouse in the corner of
the terrace, overlooking the estate and the side street. Once inside the property, the most
striking aspects are the sleek and somewhat uncoordinated stained pine pergolas scattered
suggestively. These features concentrated a large portion of the resources, functioning as
focal points that can be enjoyed by everyone.

On the corner of Lorensborgsgatan and Stensjögatan streets, soil removed when clearing the grounds was 'recycled' onto small, grassed mounds, islands of green circled by paths that create a new point of interest, even if lacking the sheer boldness of other details. The maturing trees will one day provide a more interesting character to this portion of the site, offering pleasant shadows and becoming inviting resting spots. On the south side, and orchard and rose garden suggests a more private experience than assumed in a large estate, and introduces the theme of a sensorial experience to be had.

This theme is brought to a higher level (quite literally!) in the roof garden. Here, spread through the irregular drop-shaped fiber-concrete flowerbeds, the appearance is that of a small archipelago of herbs, scented flowers and wild berries islands, in an attempt to stimulate the minds of the elderly people who are primary users of the space, through scent and flavors. The containers are made of an inexpensive material, sectioned, reassembled on site,. The colorful glass gazebo is undoubtedly the highlight of the terrace, in that it provides color, light games in the sun, but also a privileged observation spot for life going on in the public garden downstairs.

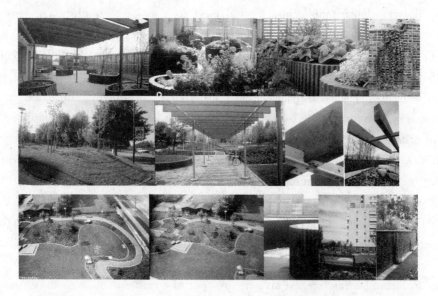

Notes

1. Malmö 马尔默

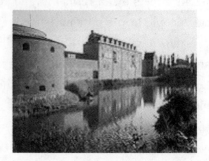

Malmö is the third most populous city in Sweden, situated in its southernmost province of Scania. Malmö is the seat of Malmö Municipality and the capital of Skåne County.

马尔默的人口在瑞典城市中排第三位，这座城市位于斯堪尼亚省的最南边。马尔默是马尔默自治区的所在地和斯康纳省的省会。

Fig. 18-1 Malmöhus Castle, now housing Malmö Museum

The city contains many historic buildings and parks, and is also a commercial center for the western part of Scania. During the last few years a university college (University College of Malmö) has been established and the city is now trying to focus on education, arts and culture.

城市中有许多历史建筑和公园。那里也是斯堪尼亚省西部的商业中心，在最近的几年成立了大学学院(马尔默大学)，马尔默现在正在努力重点发展教育、艺术和文化。

Malmö is part of the transnational Oresund Region and since 2000 the Oresund Bridge crosses the Oresund strait to Copenhagen, Denmark. The bridge was inaugurated July 1, 2000, and measures 8 kilometres (the whole link totalling 16km), with pylons reaching 204.5 metres vertically. Apart from the Helsingborg - Helsingør ferry links further north, most ferry connections have been discontinued.

马尔默是跨国的厄勒地区的一部分。厄勒海峡大桥落成于 2000 年 7 月 1 日，横跨厄勒海峡到达丹麦的哥本哈根，长 8 公里(全长为 16 公里)，桥塔的垂直高度为 204.5 米。除了北面赫尔辛堡到赫尔辛格渡口外，大部分渡口都被废弃了。

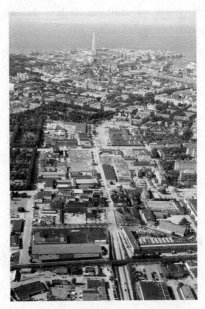

A striking depiction of Malmö was made by Bo Widerberg in his engaging debut film *Kvarteret Korpen* (*Raven's End*) (1963), largely shot to the shabby Korpen working - class district in Malmö. With humour and tenderness it depicts the tensions between classes and generations. The movie was nominated for an Academy Award as Best Foreign Language Movie in 1965.

波·维德伯格的首部电影《乌鸦居民区》(1963年)是对马尔默的生动描写，电影将大量篇幅放在了生活在马尔默底层的工人阶级，用幽默和敏感的手法描绘了阶级的冲突和不同时代人之间的代沟。影片曾被提名 1965 年奥斯卡金像奖最佳外语片奖。

Fig. 18-2 Malmo Urban Photos

Since the 1970s the city has also been home to a rich array of independent theatre groups and some show/musical companies. It also hosts a rich rock/dance/dub culture.

从 20 世纪 70 年代开始，马尔默成为众多独立戏剧团体和一些音乐戏剧公司的聚居地。同时它也是摇滚、舞蹈和音乐活动的主办地。

The Rooseum Center for Contemporary Art, founded in 1988 by the Swedish art collector and financier Fredrik Roos and housed in a former power station which had been built in 1900, was one of the foremost centers for contemporary art in Europe during the 1980s and 1990s. By 2006, most of the collection had been sold off and the museum was on a time-out.

鲁斯当代艺术中心成立于 1988 年，由瑞典艺术收藏者和金融家佛雷德里克·鲁斯创办，位于 1900 年前作为发电所的基地之上。20 世纪 80 年代到 90 年代之间，它成为欧洲

当代艺术最重要的中心之一。2006 年，绝大部分收藏被拍卖，博物馆暂停开放。

The Opera of Malmö (Malmö Opera och Musikteater) is well-known in Sweden and a wide range of operas, musicals and plays have been performed there.

马尔默歌剧院在瑞典很出名，各种歌剧、音乐剧和戏剧在那里演出。

The oldest parts of Malmö were built between 1300～1600 during its first major period of expansion. The central city's layout as well as some of its oldest buildings are from this time. ·Many of the smaller buildings from this time are typical Scanian two story urban houses that show a strong Danish influence.

马尔默最古老城区建于 1300～1600 年之间——第一次城市扩张时期。迄今为止，在城中心仍然保留了街道的布局和一些古老的房子。这一时期建造的较小建筑大多是典型的斯堪尼亚两层城市住宅，这些住宅展现出受丹麦的强烈影响。

Recession followed in the ensuing centuries. The next expansion period was in the mid 19th century and led to the modern stone and brick city. This expansion lasted into the 20th century and can be seen by a number Jugendstil buildings for which the city is known. Malmö was one of the first cities in Sweden to be influenced by modern ideas of functionalist tenement architecture in the 1930s. Around 1965, the government initiated the so called Million Programme, intending to offer affordable apartments in the outskirts of major Swedish cities. But this period also saw the reconstruction (and razing) of much of the historical city center.

经济衰退期过后，19 世纪中期的第二次发展使马尔默变成了一个现代石材和砖瓦的城市。这次发展持续到 20 世纪，当时许多新艺术建筑开始出现，城市因此而闻名。马尔默是 20 世纪 30 年代瑞典首批受功能主义现代建筑风格影响的城市之一。1965 年左右，政府开始了百万工程，在瑞典重要城市的郊区提供舒适的公寓。不过这个时期在城市中心也有很多地方被重建或拆除。

Recent years have seen a bolder more cosmopolitan architecture. *Västra Hamnen* (The Western Harbor), like most of the harbor to the north of the city center, was industrial. In 2001, however, its reconstruction began as an exclusive, albeit secluded, urban residential neighborhood. Among the new buildings towers the Turning Torso, a spectacular twisting skyscraper, 190 metres (623ft) tall, the majority of which is residential. It quickly became Malmö's new landmark.

Fig. 18-3　Turning Torso in Malmö Harbour

近些年在马尔默可以看到更多大胆的建筑。西部港口就像城市北部的大部分港口一样，曾经是重工业的主要场所。虽然地处偏远，但是经过 2001 年重建后，那里成为马尔默最高级的居住区。在新建的建筑塔楼中，HSB 旋转中心是一座特别的螺旋状摩天大楼，高度为 190 米(623 英尺)，主体是住宅。这座塔楼很快成为了马尔默的新市标。

2. Sweden 瑞典

Sweden, officially the **Kingdom of Sweden**, is a Nordic country on the Scandinavian Peninsula in Northern Europe. Sweden has land borders with Norway to the west and Finland to the northeast, and is connected to Denmark by the Öresund Bridge. It has been a member of the European Union since January 1, 1995. Sweden's capital is Stockholm, which is also the largest city in the country. The second and third largest cities are Gothenburg and Malmö.

瑞典，正式名称是瑞典王国，是位于北欧斯堪的纳维亚半岛的日耳曼民族国家。它西临挪威，东北部和芬兰接壤，通过厄勒海峡大桥和丹麦相连。瑞典于 1995 年 7 月 1 日加入欧盟。首都是斯德哥尔摩，那里也是瑞典最大的城市。第二大和第三大城市是哥德堡和马尔默。

Fig. 18-4 The 25 provinces of Sweden

At 449964 square kilometres, Sweden is the third largest country by area in Western Europe and fourth largest in Europe. With a total population of over 9.2 million, Sweden has a low population density of 20 people per km². About 85% of the population live in urban areas.

国土面积为 449964 平方公里，瑞典是西欧第三、欧洲第四大国家。全部人口超过 920 万，瑞典有很低的人口密度(20 人/平方公里)。大约 85%的人在城市生活。

Sweden is the most visited country of the Nordic countries with 5.2 million visitors in 2007.

Fig. 18-5 Traditional Swedish rural house, painted in the traditional Swedish Falu red

瑞典是最受游客欢迎的日耳曼民族国家，2007 年有 520 万游客来到这里。

Sweden has many authors of worldwide recognition including August Strindberg, Astrid Lindgren, and Nobel Prize winners Selma Lagerlöf and Harry Martinson. In total seven Nobel Prizes in Literature have been awarded to Swedes. The nation's most well-known artists are painters such as Carl Larsson and Anders Zorn, and the sculptors Tobias Sergel and Carl Milles.

瑞典有许多世界著名作家，包括奥古斯特·斯特林堡、阿斯特丽德·林格伦以及诺贝尔奖获得者塞尔玛·拉格洛夫和哈里·马丁逊。共 7 位瑞典人获得了诺贝尔文学奖。最有名的艺术家包括画家卡尔·拉森和安德斯·左恩以及雕刻家托比亚斯·舒吉尔和卡尔·米勒斯。

Swedish twentieth-century culture is noted by pioneering works in the early days of cinema, with Mauritz Stiller and Victor Sjöström. In the 1920s—1980s, the filmmaker Ingmar Bergman and actors Greta Garbo and Ingrid Bergman became internationally noted

people within cinema.

瑞典的 20 世纪文化中，早期的先锋派电影作品也有出色表现，莫里兹·斯蒂勒与维克多·斯约史特是代表人物。在 20 世纪 20~80 年代，导演英格玛·伯格曼，演员葛丽泰·嘉宝和英格丽·褒曼成为了电影业的国际著名人物。

Apart from traditional Protestant Christian holidays, Sweden also celebrates some unique holidays, some of a pre-Christian tradition. They include Midsummer celebrating the summer solstice; Walpurgis Night (Valborgsmässoafton) on 30 April lighting bonfires; and Labour Day or Mayday on 1 May is dedicated to socialist demonstrations. The day of giver-of-light Saint Lucia, 13 December, 6 June is the National Day of Sweden and, as of 2005, a public holiday.

除了传统的圣诞节外，瑞典还有很多特殊的节日。如庆祝夏至到来的仲夏节；4 月 30 日为五朔节前夜，要点燃火把；5 月 1 日劳动节是表示社会民主；12 月 13 日是圣露西亚节；6 月 6 日是瑞典的国庆日，直到 2005 年才成为正式假期。

Fig. 18-6　Midsummer's Eve by Anders Zorn

3. Scania　斯堪尼亚

Scania in Swedish and Danish is a geographical region on the southernmost tip of the Scandinavian peninsula, a traditional province (*landskap*) in the Kingdom of Sweden, before 1658 a province in the Kingdom of Denmark and part of the historical lands of Denmark. To the north, it borders the provinces Halland, Småland and Blekinge, to the east and south the Baltic Sea, and to the west the Oresund strait. Around 130km long from north to south, Scania covers less than 3% of Sweden's total area. The population of approximately 1200000 represents 13% of Sweden's total population.

位于瑞典和丹麦的斯堪尼亚是斯堪的纳维亚半岛的最南顶端，瑞典王国一个历史悠久的省份，1658 年前是丹麦王国的一个省和丹麦国土的一部分。斯堪尼亚北部与哈兰省、斯莫兰省和布京省相接，东和南面是波罗的海，西面是厄勒海峡。从北到南共长 130 公里，斯堪尼亚涵盖了接近 3% 的瑞典国土。人口大约 120 万，占瑞典全国人口的 13%。

Scania's historical connection to Denmark, the vast fertile plains, the deciduous forests and the relatively mild climate make the province culturally and physically distinct from the emblematic Swedish cultural landscape of forests and small hamlets.

斯堪尼亚和丹麦在历史上有联系。广阔富饶的土地，落叶的森林和相对温和的气候使斯堪尼亚省的文化和景观不同于象征瑞典文化景观的森林和小山村。

Scania's long-running and sometimes intense trade relations with other communities along the coast of the European continent through history has made the culture of Scania distinct from other geographical regions of Sweden. Its open landscape, of-ten described as a colorful patchwork quilt of corn and rape fields, and the relatively mild climate at the southern tip of the Scandinavian peninsula, have inspired many Swedish artists and authors

to compare it to European regions like Provence in southern France and Zeeland in the Netherlands.

有史以来，斯堪尼亚和欧洲大陆海岸的其他地区之间长期和密集的贸易关系使斯堪尼亚的文化与瑞典其他区域非常不同。那里开放的景观（常常描述为玉米地和油菜地拼成的多彩画面）以及斯堪的纳维亚半岛最南端相对温和的气候，使许多瑞典艺术家和作家将它比作法国南部的普罗旺斯和荷兰的西兰等地。

Fig. 18-7　Nature trail through Scanian beech woods at the public forests of Söderåsen

Traditional Scanian architecture is shaped by the limited availability of wood; it incorporates different applications of the building technique called half-timbering. In the cities, the infill of the façades consisted of bricks, whereas the country - side half - timbered houses had infill made of clay and straw. Unlike many other Scanian towns, the town of Ystad has managed to preserve a rather large core of its half-timbered architecture in the city center——over 300 half-timbered houses still exist today. Many of the houses in Ystad were built in the renaissance style that was common in the entire Oresund Region. Among Ystad's half-timbered houses is the oldest from 1480.

Fig. 18-8　The house of magistrate Jacob Hansen in Helsingborg, Scania, built

斯堪尼亚的传统建筑是在木材有限的条件下形成的；它融合了被称为木骨架建筑技术的不同应用方式。在城市中，建筑立面由砖构成，而乡村的木骨架住宅都是用黏土和稻草填充。和其他斯堪尼亚城镇不同，位于于斯塔德城市中心的大量木骨架建筑被保留了下来——有超过 300 座木骨架住宅保存至今。于斯塔德的许多住宅都是以文艺复兴风格修建的，这一风格在整个厄勒地区非常普遍，于斯塔德最古老木骨架住宅建于 1480 年。

Fig. 18-9　The Old Church of Södra Åsum in the municipality of Sjöbo—a typical example of a Danish medieval

In the northern part of Scania, the architecture was not shaped by a scarcity of wood, and the pre-17th century farms consisted of graying, recumbent timber buildings around a small grass and cobblestone courtyard. Only a small number of the original farms remain today. During two campaigns, the first in 1612 by Gustav Ⅱ Adolf and the second by Charles Ⅺ in the 1680s, entire districts were leveled by fire.

斯堪尼亚北部的建筑并不受缺乏木材的限制，17 世纪前的农场都是用泛灰的横向木建筑围绕一片铺着草地和鹅卵石的庭院构成。只有少量最初的农场保留至今。在两次战役中

（首次是 1612 年由古斯塔夫二世·阿道夫发起，第二次是 17 世纪 80 年代由查尔斯 11 世发动），整个区域都毁于战火。

Many of the old churches in today's Scanian landscape stem from the medieval age, although many church renovations, extensions and destruction of older buildings took place in the 16th and 19th century. From those that have kept features of the authentic style, it is still possible to see how the medieval, Romanesque or Renaissance churches looked like. Many Scanian churches have distinctive Crow - stepped gables and sturdy church porches, usually made of stone.

虽然在 16 和 19 世纪进行了许多古建筑的翻修、扩建和拆除，但是今天斯堪尼亚景观中仍然保留了许多建于中世纪的古老教堂。从那些保持了真实风格特征的教堂身上，仍可能看出中世纪罗马式或文艺复兴教堂当时的外观。许多斯堪尼亚的教堂都有与众不同的阶式山形墙和坚固的教堂走廊，常常用石材建造。

The first version of Lund Cathedral was built in 1050, in sandstone from Höör. The oldest parts of today's cathedral are from 1085, but the actual cathedral was constructed during the first part of the 12th century with the help of stone cutters and sculptors from the Rhine valley and Italy, and was ready for use in 1123. For the next 400 years, Lund became the ecclesiastical power center for Scandinavia and one of the most important cities in Denmark. The cathedral was altered in the 16th century by architect Adam van Düren.

隆德大教堂建于 1050 年，用取自赫尔的砂岩建造。保留至今的最古老部分是建于1085 年的大教堂残余部分，现在保存完整的大教堂是 12 世纪在来自莱茵河谷和意大利的石材切割者和雕塑家的帮助下建造的，于 1123 年投入使用。在以后的 400 年中，隆德成为了斯堪的纳维亚的教会权力中心和丹麦最重要的城市之一。大教堂在 16 世纪由建筑师亚当·凡·迪伦进行了改建。

Fig. 18-10　Lund skyline, with the Cathedral towers

Scania has 240 castles and country estates——more than any other province in Sweden. Many of them received their current shape during the 16th century, when new or remodeled castles started to appear in greater numbers, often erected by the reuse of stones and material from the original 11～15th century castles and abbeys. Between 1840 and 1900, the landed nobility in Scania built and rebuilt many of the castles again, often by mod-

Fig. 18-11　Vittskövle Castle

ernizing previous buildings at the same location in a style that became typical for Scania.

斯堪尼亚有 240 座城堡和庄园——比瑞典任何省份都要多。其中许多建筑都是从 16 世纪保留至今。越来越多的城堡进行重修和改建时，也往往是重新使用取自 11~15 世纪城堡和修道院中的石头和材料来建造的。斯堪尼亚有土地的贵族在 1840 年到 1900 年间建造和重建了许多城堡，常常是以斯堪尼亚典型风格在同一位置将以前的建筑现代化。

4. European Union 欧盟

The European Union (EU) is a political and economic union of 27 member states, located primarily in Europe. It was established by the Treaty of Maastricht in 1993 upon the foundations of the pre-existing European Economic Community. With almost 500 million citizens, the EU combined generates an estimated 30% share of the world's nominal gross domestic product.

欧盟是由大部位于欧洲的 27 个成员国组成的政治和经济统一体。1993 年《马斯垂克条约》在原欧洲经济共同体的基础上建立欧盟。欧盟拥有将近 5 亿城市人口，创造了全世界大约 30%的国内生产总值。

The EU has developed a single market through a standardized system of laws which apply in all member states, guaranteeing the freedom of movement of people, goods, services and capital. It maintains a common trade policy, agricultural and fisheries policies, and a regional development policy. Sixteen member states have adopted a common currency, the euro. It has developed a role in foreign policy, representing its members in the World Trade Organisation, at G8 summits and at the United Nations. Twenty-one EU countries are members of NATO. It has developed a role in justice and home affairs, including the abolition of passport control between many member states under the Schengen Agreement.

欧盟通过应用于所有成员国家的标准化法律系统发展出统一的市场，保证了人力、货物、服务和资金流动的自由。它维护统一的商贸、农业和渔业政策，以及区域发展政策。16 个成员国采用了统一的货币（欧元）。欧盟在外交政策中发挥作用，代表其成员国参加世界贸易组织、八国峰会和联合国。其中 21 个欧盟成员国是北大西洋公约组织成员。欧盟在国际和国内事务中发挥作用，包括废除了《神根协议》中许多成员国之间的护照政策。

The EU operates through a hybrid system of intergovernmentalism and supranationalism. In certain areas it depends upon agreement between the member states. However, it also has supranational bodies, able to make decisions without unanimity between all national governments. Important institutions and bodies of the EU include the European Commission, the European Parliament, the Council of the European Union, the European Court of Justice and the European Central Bank. EU citizens elect the Parliament every five years.

欧盟通过政府间主义和超国家主义的混合系统运行。在某些领域中它依赖于成员国之间的协议。然而，它也有超国家的机构，能够在所有成员国政府未达成一致的情况下做出决议。欧盟重要的机构和部门包括欧盟委员会、欧洲议会、欧盟理事会、欧洲共同体法院和欧洲中央银行。欧盟的公民每五年选举一次议会。

The first environmental policy of the European Community was launched in 1972. Since then it has addressed issues such as acid rain, the thinning of the ozone layer, air quality, noise pollution, waste and water pollution. The Water framework directive is an example of a water policy, aiming for rivers, lakes, ground and coastal waters to be of "good quality" by 2015. Wildlife is protected through the Natura 2000 programme and covers 30,000 sites throughout Europe. In 2007, the Polish government sought to build a motorway through the Rospuda valley, but the Commission has been blocking construction as the valley is a wildlife area covered by the programme.

Fig. 18-12　Mont Blanc in the Alps is the highest peak in the EU

欧洲共同体于 1972 年开始实施首个环境政策。从那时起开始强调如酸雨、臭氧层变薄、空气质量、噪声污染、废弃物和水污染等问题。欧盟水框架指令就是水资源政策之一，目的是使河流、湖泊、地下和沿海的水资源到 2015 年能够有"很好的品质"。野生生物通过 Natura 2000 生态网络项目得到了保护，这个项目覆盖了整个欧洲的 30000 个基地。2007 年，波兰政府要求建造通过罗斯普达山谷的高速公路，但欧盟委员会阻止了这项建设，因为山谷正是这个项目涵盖的野生生物区域。

The REACH regulation was a piece of EU legislation designed to ensure that 30000 chemicals in daily use are tested for their safety. In 2006, toxic waste spill off the coast of Côte d'Ivoire, from a European ship, prompted the Commission to look into legislation regarding toxic waste.

REACH 法规是一项欧盟立法，以确保日常使用的 30000 种化学品都经过安全测试。2006 年有毒废物从欧洲轮船上泄漏到科特迪瓦海岸里，这一事件推动欧盟委员会研究有关有毒废物的立法。

In 2007, member states agreed that the EU is to use 20% renewable energy in the future and that is has to reduce carbon dioxide emissions in 2020 by at least 20% compared to 1990 levels. This includes measures that in 2020, one-tenth of all cars and trucks in EU 27 should be running on biofuels. This is considered to be one of the most ambitious moves of an important industrialized region to fight global warming.

2007 年成员国达成一致——欧盟在未来使用 20% 的可再生能源，并且在 2020 年至少比 1990 年减少 20% 的二氧化碳排放。这包括到 2020 年欧盟 27 国中 1/10 的小汽车和货车应该使用生物燃料。这被认为是重要工业化地区抵抗全球变暖的最雄心勃勃的措施之一。

Fig. 18-13　Renewable energy is one priority in transnational research activities such as the FP7

At the 2007 United Nations Climate Change

Conference, the EU has proposed at 50% cut in greenhouse gases by 2050. The EU's attempts to cut its carbon footprint appear to have also been aided by an expansion of Europe's forests which, between 1990 and 2005, grew 10% in western Europe and 15% in Eastern Europe. During this period they soaked up 126 million metric tons of carbon dioxide, equivalent to 11% of EU emissions from human activities. The ambitious EU goals for the Kyoto Protocols have not been met and there is serious doubt that they can ever be.

在 2007 年的联合国气候变化会议上，欧盟提出了到 2050 年减少 50% 的温室气体排放。欧盟尝试减少其碳足迹的努力似乎也得到了 1990~2005 年间欧洲森林面积扩张(西欧 10%，东欧 15%)的帮助。这段时期内它们吸收了 12600 万吨二氧化碳(等于欧盟 11% 的人类排放)。欧盟雄心勃勃的《京都议定书》的目标从没有实现，很多人怀疑能否实现。

5. Santiago Calatrava 圣地亚哥·卡拉特拉瓦

Santiago Calatrava (born July 28, 1951) is an internationally recognized and award-winning Valencian Spanish architect, sculptor and structural engineer whose principal office is in Zurich, Switzerland.

圣地亚哥·卡拉特拉瓦(出生于 1951 年 7 月 28 日)是国际知名、获得众多奖项的西班牙瓦伦西亚建筑师、雕塑家和结构工程师，他的事务所位于瑞士的苏黎世。

Fig. 18-14 L'Umbracle, City of Arts and Sciences, Valencia

Calatrava's early career was dedicated largely to bridges and train stations, the designs for which elevated the status of civil engineering projects to new heights. His elegant and daring Montjuic Communications Tower in Barcelona, Spain (1991) in the heart of the 1992 Olympic site was a turning point in his career, leading to a wide range of commissions. The Quadracci Pavilion (2001) of the Milwaukee Art Museum was his first US building. Calatrava's entry into high-rise design began with an innovative 54 story high twisting tower, called Turning Torso (2005), located in Malmö, Sweden.

Fig. 18-15 Puente del Alamillo at night, made for the Universal Exposition of Seville, Seville, Spain, (1992)

卡拉特拉瓦的早期职业生涯大部分是修建桥梁和火车站，这些设计将城市工程项目的地位提升到新的高度。他在西班牙巴塞罗纳设计的优雅而大胆的巴塞罗纳通信塔(1991)成为 1992 年奥林匹克基地的核心，也成为了他职业生涯的转折点，为他带来了广泛的委托项目。密尔沃基艺术博物馆新馆(2001)是他在美国设计的首个建筑。卡拉特拉瓦的高层建筑设计开始于 54 层高耸扭曲塔楼的创新设计，被称为旋转大楼(2005)。这座建筑位于瑞典的马尔默。

Calatrava's style has been heralded as bridging

the division between structural engineering and architecture. In this, he continues a tradition of Spanish modernist engineering that includes Félix Candela and Antonio Gaudí. Nonetheless, his style is very personal and derives from numerous studies he makes of the human body and the natural world.

卡拉特拉瓦的风格由于在结构工程和建筑学之间架起桥梁而受到称赞。就这一方面，他继承了费雷克斯·堪迪拉和安东尼·高迪的西班牙现代主义工程技术传统。此外，他的风格非常个性化，这来源于他对人体和自然世界的深入研究。

Calatrava is also a prolific sculptor and painter, claiming that the practice of architecture combines all the arts into one. In 2005, the Metropolitan Museum of Art in New York City held an exhibition of his artistic work, entitled "Santiago Calatrava: Sculpture Into Architecture. "Exhibitions of his work have also taken place in Germany, England, Spain, Italy and elsewhere.

卡拉特拉瓦也是多产的雕塑家和画家，他声称建筑实践将所有艺术形式结合为一体。2005年，纽约市的美国大都会博物馆举行了他的艺术作品展，命名为"圣地亚哥·卡拉特拉瓦：将雕塑融入建筑"。在德国、英格兰、西班牙、意大利和其他地方也都举行过他的作品展。

Auditorio de Tenerife, Santa Gruz de Tenerife, Canary Islands.

L'Umbracle at the Ciutat de les Arts i les Ciències in Valencia, Spain(1996).

Ciutat de les Arts i les Ciències, Valencia, Spain (1996).

Milwaukee Art Museum in Milwaukee, Wisconsin, USA (2001)

Estação do Oriente, Lisbon, Portugal(1998)

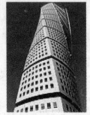
Turning Torso in Malmö, Sweden(2005)

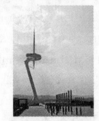
Montjuic Communications Tower in Barcelona, Spain (1992)

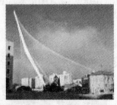
Chords Bridge for Pedestrians and train in Jerusalem, Israel (2008)

Fig. 18-16 Works of Santiago Calatrava

6. HSB Turning Torso Residential Tower HSB 旋转大楼

HSB Turning Torso is a skyscraper in Malmö, Sweden, located on the Swedish side of the Öresund strait. It was designed by the Spanish architect Santiago Calatrava and officially opened on 27 August 2005. The tower reaches a height of 190 metres (623 feet) with 54 stories. Upon completion, it was the tallest building in Scandinavia, the tallest residential building in the EU and the second tallest residential building in Europe, after the 264-metre (870ft)-high Triumph-Palace in Moscow.

HSB 旋转大楼是瑞典马尔默的摩天楼，位于厄勒海峡的瑞典一边。大楼由西班牙建

筑师圣地亚哥·卡拉特拉瓦设计，2005 年 8 月 27 日正式对外开放。塔楼高 190 米，共 54 层。完工后，它成为了斯堪的纳维亚最高的建筑，欧盟的最高居住建筑，欧洲第二高居住建筑，位列莫斯科 264 米高的凯旋宫之后。

The design is based on a sculpture by Calatrava called Twisting Torso. It uses nine segments of five-story pentagons that twist as it rises; the topmost segment is twisted ninety degrees clockwise with respect to the ground floor. Each floor consists of an irregular pentagonal shape rotating around the vertical core, which is supported by an exterior steel framework. The two bottom segments are intended as office space. Segments three to nine house 147 luxury apartments.

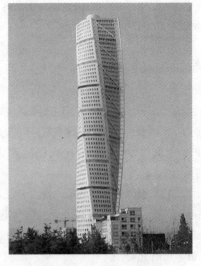

设计是基于卡拉特拉瓦名为《旋转大楼》的雕塑而产生的。它使用了 9 块向上旋转的 5 层高五边形；最顶部一块的角度刚好是地面层顺时针转了 90 度。每一层都是由不规则的五边形围绕垂直线核心旋转，建筑由外部的钢铁框架支撑。底部的两块作为办公空间。第 3～9 块容纳了 147 间奢华的公寓。

Fig. 18-17 Turning Torso

One reason for the building of Turning Torso was to re-establish a recognizable skyline for Malmö since the removal of the Kockums Crane in 2002, which was located less than a kilometre from Turning Torso. The local politicians deemed it important for the inhabitants to have a symbol for Malmö——Kockumskranen, which was a large crane that had been used for shipbuilding and somewhat symbolized the city's blue collar roots.

建造 HSB 旋转大楼的原因之一就是要重建人们所熟悉的马尔默天际线（因为 2002 年位于 HSB 旋转大楼不到一公里处的考库姆起重机拆除之后天际线被改变）。当地政治家认为对于居民来说拥有马尔默的象征——考库姆起重机是非常重要的，考库姆起重机是用于装载轮船货物的大型起重机，象征着城市的蓝领根基。

As Turning Torso is a private residential building there is no access for the general public.

由于 HSB 旋转大楼是私人住宅建筑，所以不接待公众参观。

7. Grist

Grist (originally Grist Magazine) is an American non-profit online magazine that publishes environmental news and opinion articles. Launched in April 1999, Grist is headquartered in Seattle, Washington.

Grist(原名 **Grist** 杂志)是美国非营利性网上杂志，发布环境方面的新闻和观点文章。1999 年 4 月开办，Grist 的总部在华盛顿的西雅图。

Called The Daily Show of the environment by Newsweek and others, Grist has been cited in major media including The New York Times, BusinessWeek, The Washington Post, Outside magazine, Vanity Fair, the Weather Channel, National Public Radio, The Japan Times, Fast Compa-

ny, and ABC News. Opinions by Grist editors have appeared in The Boston Globe and the San Francisco Chronicle. Grist won the Webby People's Voice Award for Best Magazine in both 2005 and 2006 as well as Utne's Independent Press Award for Best Online Political Coverage.

Fig. 18-18　Internet page of Grist

Grist 被《新闻周刊》和其他媒体称为环境的"每日秀"。《纽约每日时报》、《商业周刊》、《华盛顿邮报》、《户外》杂志、《名利场》、天气频道、美国国家公共电台、《日本时报》、《快速公司》和美国广播公司新闻等媒体都曾引用 Grist 的内容。Grist 编辑们的观点在《波士顿环球报》和《旧金山新闻》中出现。Grist 赢得了 2005 年和 2006 年度威比人民之声大奖的最佳杂志奖，以及 Utne 独立传媒大奖的最佳网络政治覆盖奖。

Grist offers in-depth reporting, interviews, opinion pieces, daily news, book reviews, food and agricultural coverage, green advice, and a popular blog——all tailored to inform, entertain, provoke, and encourage its readers to think creatively about environmental problems and solutions.

Grist 提供深度的报道、面谈、观点文章，每日新闻、书评、食物和农业内容、绿色建议以及大众化的短文——所有都是专门传达、引起兴趣、唤起和鼓励其读者有创造性地思考环境问题和解决方案。

Regular features include "Muckraker," a political column by Kate Sheppard, "Ask Umbra," a popular environmental advice column by sage Umbra Fisk, the "Grist List," covering green celebrities and pop culture, as well as "Victual Reality," Tom Philpott's column on food and agricultural issues. Grist also summarizes the day's environmentally related news events in "Daily Grist".

经常性内容包括"探听丑闻者"（凯特·榭波特所写的政治性专栏），由德高望重的安布诺·菲斯克开设的"问安布诺"（针对大众的环境建议专栏），"Grist 目录"涵盖绿色环境方面的名人和流行文化，以及汤姆·费尔波特有关食物和农业问题的"食物的真实"专栏。Grist 也在"每日 Grist"中概述每天和环境相关的新闻事件。

All of Grist's content is available free of charge.

所有 Grist 的内容都是免费的。

8. Oresund Link

The Oresund Bridge is a combined two-track rail and four-lane road bridge across the Öresund strait. The bridge-tunnel is the longest combined road and rail bridge in Europe and connects the two metropolitan areas of the Öres-und Region: the Danish capital of Copenhagen and the Swedish city of Malmö. The international European route E20 runs across the bridge and through the tunnel via the two lane motorway, as does the Öresund Railway Line. The bridge is the longest border crossing bridge in the world, but due to the Schengen Agreement, there are no passport or customs controls.

厄勒海峡大桥是由两条铁路和 4 车道公路组成，横跨厄勒海峡。这座大桥是全欧洲最长的公路铁路两用桥，连接厄勒区的两个大都市：丹麦首都哥本哈根和瑞典城市马尔默。欧洲 E20 公路经过大桥，经两车道高速公路通过隧道，厄勒铁路线也是如此。大桥是全世界最长的跨国界桥梁，而根据《神根协议》，这里没有护照或海关检查。

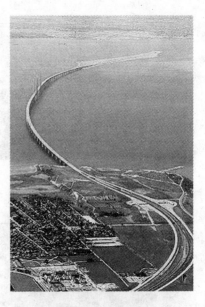

Construction began in 1995. The last section was constructed on 14 August 1999. Crown Prince Frederik of Denmark and Crown Princess Victoria of Sweden met midway to celebrate its completion. The official inauguration took place on 1 July 2000, with Queen Margrethe II, and King Carl XVI Gustaf, presiding. The bridge was opened for traffic later that day. Before the inauguration 79871 runners competed in a half

Fig. 18-19 The Oresund Bridge

marathon (the Bridge Run) from Amager (in Denmark) to Skåne (in Sweden) on 12 June, 2000.

大桥于 1995 年开工，1999 年 8 月 14 日合拢。丹麦王储佛雷德里克和瑞典公主维多利亚在大桥中间相遇，庆祝大桥完工。而官方的落成仪式在 2000 年 7 月 1 日举行，由丹麦皇后玛格丽特二世和瑞典国王卡尔十六世·古斯塔夫主持。翌日，开始向车辆开放使用。大桥落成前，在 2000 年 6 月 12 日举行了有 79871 名参赛选手参加的半马拉松比赛（在桥上竞跑），由丹麦的阿玛盖尔一直跑到瑞典的斯科纳省。

Initially the usage of the bridge was not as high as expected, which was generally attributed to the expense of crossing. However, 2005 and 2006 saw a rapid increase in the volume of traffic on the bridge. This phenomenon may be due to Danes buying homes in Sweden and commuting to work in Denmark, because the price of housing in Malmö is lower than in Copenhagen. In 2008, a single car ride across the bridge cost DKK 260, SEK 325 or €36 (however, discounts of up to 75% are available for regular users). In 2007, almost 25 million people travelled over the bridge, 15.2 million in cars and buses and 9.6 million by train.

最初大桥的使用人数并没有所预期的那样多，主要是因为经过大桥需要收费。但到了 2005 年和 2006 年，大桥的交通流量急剧上升。这主要是因为很多丹麦人在瑞典置业、到丹麦上班，因为马尔默的房屋价格较哥本哈根低很多。2008 年，一辆车经过大桥要收取 260 丹麦克朗，325 瑞典克朗或 26 欧元（但是，经常通过大桥的车辆最多会有高达 75% 的折扣优惠）。2007 年，近 2500 万人穿越大桥，其中 1520 万人使用车辆和公交车，960 万人使用火车。

The bridge has one of the longest cable-stayed main spans in the world at 490 metres (1608ft). The height of the highest pillar is 204 metres (669ft). The total length of the bridge is 7845 metres (25738ft), which is approximately half the distance between the Swedish and

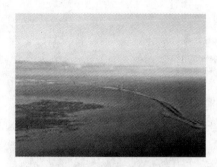

Fig. 18-20　Aerial Photo of
Oresund Bridge

Fig. 18-21　Satellite image of the
Oresund Bridge

Danish landmasses, and its weight is 82000 tonnes. On the bridge, the two rail-tracks are beneath the four road lanes. The bridge has a vertical clearance of 57 metres (187ft). The bridge was designed by Arup.

大桥是全世界主跨最长的斜拉桥(有 490 米)。而桥塔最高处为 204 米。大桥全长 7845 米,大概是瑞典和丹麦陆地长度的一半,大桥重 82000 吨。桥上,大桥的两条铁路线位于四车道公路的下面。大桥桥面和水面间垂直净空高为 57 米。大桥是由奥雅纳事务所设计。

The bridge ends in the middle of Øresund, on an artificially built island, called Peberholm. The island is more than 4km long and a few hundred metres wide, belongs to Denmark and is now an un-populated natural reserve.

大桥结束在位于厄勒海峡中部的人工岛——胡椒小岛之上。这个岛大约 4 公里多长,几百米宽,属于丹麦国土,现在是无人居住的自然保留地。

The connection between Peberholm and the nearest populated part of Denmark is through a tunnel, called the Drogden Tunnel. The tunnel is 4050 metres (13287ft) long, a 3510-metre (11500ft) long buried undersea tunnel plus two 270-metre (890ft) gate-tunnels. The reason for building a tunnel instead of another section of bridge is that the Copenhagen Airport is nearby.

胡椒小岛和最近的丹麦居住地之间的联系是通过一条隧道——杜洛格敦隧道。这条隧道 4050 米长,其中 3510 米的距离是海底隧道,270 米是水闸隧道。在这里修建建筑隧道而不是另一段桥梁的原因是哥本哈根机场就在这附近。

Fig. 18-22　Aerial Photo of
Oresund Bridge

9. Copenhagen　哥本哈根

Copenhagen is the capital and largest city of Denmark. It is situated on the Islands of Zealand and Amager.

哥本哈根是丹麦的首都和最大的城市,坐落于丹麦的西兰岛和阿玛格尔岛。

Copenhagen is described as "The Paris of the North" because of its design, fashion and beauty, and is among the 20 most popular tourist destinations in Europe.

哥本哈根以其设计、时尚和美观而被称为 "北部的巴黎",也是欧洲最受欢迎的 20 个旅游目的地之一。

Suburbs：The Finger Plan 郊区：手指规划

Fig. 18-23 Panorama of The Palace and Fredricks Church

STORKØBENHAVN

Fig. 18-24 The Finger Plan

Suburban Copenhagen is planned according to the Finger Plan, initiated in 1947, dividing the suburbs into five fingers. The strain lines are built according to the Finger Plan, while green wedges and highways are built in-between the fingers

哥本哈根市郊是根据开始于 1947 年德尔 "手指规划" 建设的，将郊区分为 5 个手指。铁路线沿着 "手指规划" 修建，而绿化带和高速公路在手指之间修建。

The Little Finger 小拇指

The northern suburbs form the little finger of the plan, and is traditionally the wealthiest of the suburbs. In popular language, the area is known as "The Whiskey Belt", although the area is mixed between mansions, larger houses, garden cities and mid-size houses. The area has a population of around 270000 inhabitants.

北部郊区形成规划的小拇指，历史上这里是最富裕的市郊。老百姓们把这片区域称为 "威士忌地带"。这片区域混合在高楼大厦之间，大约有 270000 人口。

The Ring Finger 无名指

The North-Northwestern part of the suburbs forms the ring finger. The area is to a large extent formed by detached middle-class dwellings, with some exceptions of housing projects or upper-class areas. The area has a population of around 100000 inhabitants.

郊区的北—西北部形成了无名指。区域大部分是相互分离的中产阶级住宅，还有一些居住项目或上层阶级区域。这片区域的人口大约 100000 人。

The Middle Finger　中指

The northwestern suburbs form the middle finger, and consists of a mixed area of both detached middle-class dwellings, widespread garden cities and large, low-rise public housing projects. The area has a considerable part of the industrial areas of metropolitan Copenhagen, mostly in the traditional sectors of manufacturing. The area has a population of around 110000 inhabitants.

西北部郊区形成了中指，是相互分离的中产阶级住宅、广阔的花园城市和大型低成本公共居住项目相混合的区域。这片区域中有相当可观的面积都属于哥本哈根大都市工业区域，绝大部分是传统的制造业。这里的人口大约 110000 人。

The Index Finger　食指

The index finger forms the western suburbs, which are the suburbs with the lowest income per capita and the highest crime-rate. The suburbs vary from the petit bourgeois area of Glostrup to the widespread low housing projects of Albertslund and Taastrup. Of the total of 145000 inhabitants, some 20% are immigrants of first or second generation.

食指形成了西部郊区，这部分地区人均收入最低，犯罪率最高。这里有少量的格洛斯卓普中产阶级区域和广阔的阿尔伯茨隆德和塔斯特卢普低收入居住项目。全部人口 145000，其中 20% 是首代或第二代移民。

The Thumb　大拇指

The southwest suburbs along the coast form the thumb of the plan. While the central parts of these suburbs are dominated by high-rise housing projects and low-income inhabitants, the distant part is dominated by detached middle-class houses. These suburbs have a population of some 215000 inhabitants and has a sizeable number of immigrants.

沿着海岸的西南郊区形成了规划的大拇指。而这片郊区的中心部分是高层居住项目和低收入居民，外围部分是相互分离的中产阶级住宅。这部分郊区人口大约 215000 人，大部分都是移民。

Copenhagen has a multitude of districts, each representing its time and with its own distinctive character, making up a dense urban febric. Other distinctive features of the Copenhagen of today is the abundance of water, the greenness and the elaborate system of bicycle paths that line almost every major street.

哥本哈根有许多街区，每个街区都表现出时代感和独特特征，形成了密集的城市肌理。今日哥本哈根的独特特征还包括水资源、绿化资源丰富，以及几乎遍布各大主要街道的精致自行车道路系统。

Sometimes referred to as "the City of Spires", Copenhagen is known for its horizontal skyline, only broken by spires at churches and castles. Most characteristic is the baroque spire of Church of Our Saviour with its spiraling and narrowing external stairs that visitors can climb to the very top of the spire. Other important spires are those of Christiansborg

Fig. 18-25 Copenhagen Panorama

Palace, the City Hall and the former Church of St. Nikolaj that now houses a modern art venue. A bit lower are the renaissance spires of Rosenborg Castle and the "dragon spire" of Christian IV's former stock exchange, so named because it is shaped as the tails of four dragons twined together.

Fig. 18-26 View from Rundetårn

　　有时哥本哈根被称为"尖顶之城",以被教堂和城堡的尖顶所打破的天际线而闻名。最有特点的就是救主堂的巴洛克式尖顶,教堂中狭窄的螺旋楼梯使参观者可以爬到尖顶的最顶部。其他重要的尖顶还有克丽斯汀堡宫殿、市政厅和以前的圣尼克拉教堂(现在成为现代艺术馆)。稍低的是文艺复兴时期洛森堡宫的尖顶和克里斯蒂安四世时代前证券交易所的"龙顶"(名称来源于屋顶是用扭曲在一起的四条龙形成)。

　　Recent years has seen a tremendous boom in modern architecture in Copenhagen. For a few hundred years, virtually no foreign architects had worked in Copenhagen but since the mid 1990s the city and its immediate sourroundings have seen buildings and projects from such international star architects as Norman Foster, Hadid, Nouvel and Liebeskind. In the same time, a number of Danish architects have achieved great success both in Copenhagen and abroad. This has led to a number of international architecture awards. Buildings in Copenhagen have won RIBA European Awards four years in a row. At the 2008 World Architecture Festival in Barcelona, Bjarke Ingels Group won an award for the World's Best Residential Building 2008 for a house in Ørestad. The Forum AID Award for Best building in Scandinavia went to Copenhagen buildings both in 2006 and 2008. In 2008 British design magazine Monocle named Copenhagen the World's best design city 2008.

　　最近几年中在哥本哈根可以看到现代建筑的蓬勃发展。数百年来几乎没有任何外国建筑师在哥本哈根设计作品,但从 20 世纪 90 年代中期开始,这个城市及其周围地带可以看到许多如诺曼・福斯特,哈迪德、努维尔和利贝斯金德等国际著名建筑师所设计的建筑和

项目。同时，许多丹麦建筑师在哥本哈根和国外都获得了巨大的成功，带来了许多国际建筑奖项。哥本哈根的建筑连续 4 年获得了英国皇家建筑师协会欧洲奖。2008 年在巴塞罗纳举行的世界建筑节，BIG 建筑师事务所以弗雷斯德住宅项目赢得了 2008 世界最佳居住建筑奖。斯堪的纳维亚的 AID 最佳建筑大奖在 2006 年和 2008 年都颁给了哥本哈根。2008 年英国设计杂志《单片眼镜》授予哥本哈根 2008 世界最佳设计城市。

Fig. 18-27　Østre Anlæg

Copenhagen is a green city with many big and small parks. King's Garden, the garden of Rosenborg Castle, is the oldest and most visited park in Copenhagen. Its landscaping was commenced by Christian IV in 1606. Every year it sees more than 2,5 million visitors and in the summer months it is packed with sunbathers, picknickers and ballplayers. It also serves as a sculpture garden with a permanent display of sculptures as well as temporary exhibits during summer. Also located in the city centre are the Botanical Gardens particularly noted for their large complex of 19th century greenhouses donated by Carlsberg founder J. C. Jacobsen. Fælledparken is with its 58 hectars the largest park in Copenhagen, It is popular for sports and hosts a long array of annual events like a free opera concert at the opening of the opera season, other open-air concerts, carnival, Labour Day celebrations and Copenhagen Historic Grand Prix which is a race for antique cars. Another popular park is the Frederiksberg Garden which is a 32 hectars romantic landscape park. It houses a large colony of very tame grey herons along with other waterfowls. The park also offers views of the elephants and the elephant house designed by world-famous British architect Norman Foster of the adjacent Copenhagen Zoo.

哥本哈根是有许多大大小小的公园的绿色城市。御花园——洛森堡宫的花园，是哥本哈根最古老和参观人数最多的公园。它的景观建设开始于 1606 年的克里斯蒂安四世。每年有超过 250 万的参观者来此游览，公园在夏季到处都是日光浴者、野餐者和玩球的人。它也是进行雕塑永久展示及夏季短期展示的雕塑公园。位于市中心的公园还有植物园——以嘉士伯创立者雅可布森出资建设的 19 世纪大型温室而闻名。人民公园面积达 58 公顷，是哥本哈根最大的公园，人们经常在那里运动和举行历时很长的年度庆典，像是在歌剧季一开始举行的免费歌剧音乐会、露天音乐会、狂欢节、劳动节庆典和哥本哈根举办的超贵、超级跑车大型聚会（古董车竞速）。另一个受人欢迎的公园是 32 公顷的浪漫主义景观公园——腓特烈堡公园。那里有很多非常驯服的灰苍鹭和其他水鸟。从这个公园可以看到附近哥本哈根动物园中的大象和由著名英国建筑师诺曼·福斯特设计的大象屋。

10. Denmark　丹麦

The Kingdom of Denmark, commonly known as Denmark, is a country in the Scandinavian region of northern Europe. It is the southernmost of the Nordic countries. The main-

land is bordered to the south by Germany; Denmark is southwest of Sweden and south of Norway. Denmark borders both the Baltic and the North Sea. The country consists of a large peninsula, Jutland (Jylland) and many islands, most notably Zealand (Sjælland), Funen (Fyn), Vendsyssel - Thy, Lolland, Falster and Bornholm as well as hundreds of minor islands often referred to as the Danish Archipelago. Denmark has long controlled the approach to the Baltic Sea, and these waters are also known as the Danish straits. The Faroe Islands and Greenland are equal countries with Denmark within the Kingdom, but are not members of the European Union.

丹麦王国，一般称为丹麦，位于北欧斯堪的纳维亚地区。它是北欧五国中最靠南端的国家。丹麦南面就是德国。丹麦位于瑞典的西南面，挪威的南面。丹麦濒临波罗的海和大西洋北海。国家由一座巨大的半岛——日德兰半岛和许多岛屿组成，最著名的就是西兰岛、芬岛、文叙瑟尔—许岛、洛兰岛、法尔斯特岛和波恩霍尔姆岛以及数以百计的常常被称为丹麦群岛的小岛屿。丹麦长期控制波罗的海，这片水域也被称为丹麦海峡。法罗群岛和格陵兰岛是王国内和丹麦平等的国家，但是它们不是欧盟成员。

Fig. 18-28 Windmills and yellow brick houses accent the gently rolling meadowlands of Karlebo

There are also many environmental issues that Denmark currently faces. The following are the problems that Denmark faces:

丹麦现在面临着许多环境问题：

Air pollution, principally from vehicle and power plant emissions;

空气污染，主要是机动车和发电站排放；

Nitrogen and phosphorus pollution of the North Sea;

大西洋北海的氮和磷的污染；

Drinking and surface water becoming polluted from animal wastes and pesticides.

饮用水和地表水被动物废弃物和农药所污染。

However the Danish Government has signed many international agreements such as: Antarctic Treaty; Climate Change-Kyoto Protocol; Endangered Species Act; Etc.

然而丹麦政府签署了许多国际协议，如：《南极公约》、《联合国气候变化框架公约》、《濒危物种法案》等等。

Hans Christian Andersen is known beyond Denmark for his fairy tales, such as The Emperor's New Clothes, The Little Mermaid, and The Ugly Duckling. Karen Blixen, Nobel laureate author Henrik Pontoppidan, Nobel laureate physicist Niels

Fig. 18-29 Ærøskøbing, a traditional Danish

Bohr and the philosopher Søren Kierkegaard have also made a name for themselves outside Denmark.

最著名的丹麦人就是童话大师汉斯·克里斯蒂安·安徒生，他的作品有《国王的新衣》、《海的女儿》和《丑小鸭》等。凯伦·布里克森，诺贝尔获奖者作家 H·彭托皮丹，诺贝尔获奖者物理学家尼尔斯·波尔和哲学家齐克果也扬名海外。

The capital city of Copenhagen includes the Tivoli gardens, the Amalienborg Palace (home of the Danish monarchy), and The Little Mermaid sculpture.

Fig. 18-30　Aarhus Cathedral, Aarhus, Denmark

首都哥本哈根的城市景观包括蒂沃利公园、阿美琳堡（丹麦王室的居所）和海的女儿的雕塑。

The second largest city in Denmark is Aarhus. Aarhus is an old Viking Age city and one of the oldest cities in the country. The largest cathedral in Denmark and the second largest cathedral in Northern Europe is Aarhus Cathedral.

丹麦第二大城市是奥胡斯。奥胡斯是古老的维京时代城市，也是丹麦最古老的城市之一。丹麦最大的大教堂和北欧第二大教堂就是奥胡斯大教堂。

Vacabulary

1. emerge　*vi.* ①出现；显露；发生，浮现，暴露：Advanced figures are emerging in multitude in this era of ours. 在我们这个时代先进人物正在大量地涌现出来。②形成，发生　③（自困境中）摆脱；脱颖而出：He emerged from the accident unharmed. 他在这次事故中侥幸脱险没有受伤。

［近义词］emanate, issue, appear, surface, arise, develop, proceed, materialize, transpire, loom, spring, flow, derive, stem, originate, turn up, crop up　*v.* 出现，滔现，显露

［辨析］**emerge 出现**：指从隐蔽处或遮盖之处出现。

The sun emerged from behind the clouds. 太阳从云后出现了。

emanate 发出、流出：用于无形之物，指从某种根源流出。

Heat emanates from fire. 热自火中发出。

issue 冒出：指经一开口便自源流处流出，尤指如水等的流体流出。

Pus issued from the wound. 脓汁从伤口流了出来。

2. decline　*vt.* ①下降；下滑；下倾：an empire that has declined 业已衰落的帝国　②谢绝；婉谢；辞谢：decline an offer 拒绝请求　③列出（名词、代词或形容词的）词尾变化　*n.* ①衰退；衰败：the decline of the Roman Empire 罗马帝国的衰亡　②倾斜　③（物价的）下落　④衰弱（病）　⑤斜坡，下坡　*vi.* ①下倾，下降；跌落：The birth rate in our country has been declining for several years. 我国人口的出生率几年来一直下降。②衰落，衰老：the rotten and declining system 腐朽没落的制度　③堕落，退步；落魄　④接近终了，接近尾声　⑤谢绝，拒绝：She invitsd me to dinner but I declined on account of ur-

gent business. 她请我吃饭，但我因有急事谢绝了。

［近义词］descend,fall,go down　*v.* 倾斜，下降

sink,fail,wither,fall,weaken,flag,diminish,dwindle,decrease,lesson,worsen,ebb　*v.* 衰落，衰弱

drop,slope,descent,slant,downgrade,downward incline　*n.* 斜面，斜坡

decay,deterioration,lapse,fading,recession,retrogression,atrophy,drop off　*v.* 衰落，衰退

repudiate,refuse,reject,spurm,turn down,fail to accept　*v.* 拒绝，谢绝

［辨析］**decline 婉拒**：指对邀请或要求作有礼貌的拒绝。

I invited him to dinner,but he declined on account of urgent bussiness. 我请他吃饭，但他说他有要事而婉言谢绝了。

repudiate 拒绝、驳斥：指拒绝接受或承认。

He repudiated the gift. 他拒绝接受这份礼物。

3. surpass　*vt.* 越过，超过；凌驾；胜过：The task surpassed his skill. 这工作非他的技术所能胜任。

［近义词］exceed,excel,outdo,override,top,best,overtake,outstrip,outrun,outshine,go beyond,leave behind　*vt.* 超过，胜过

［辨析］**surpass 超过**：指在与别人比较或与一个确定标准比较时更好。

Mary surpasses her sister in history. 玛丽的历史成绩比他妹妹好。

exceed 超过：指数量(quantity)或程度(extent)方面的超过。

Some autos exceed the speed limit. 有些汽车超速行驶。

excel 超过、优于：指在精美、价值或做事方面超过别人。

He excels in mathematics. 他擅长数学。

outdo 胜过：指比别人做得多做得好，尤指超过以前所做的事。

The runner outdid his previous record for the race. 这位跑步运动员的成绩超过了他以前的比赛记录。

4. severe　*adj.* ①严厉的；苛刻的；严格的：spoke in a severe voice 以严峻的口吻说话　②剧痛的；剧烈的；严重的；难熬的：a severe storm 强风暴　③困难的，艰难的：a severe competition 艰苦的竞争　④朴素的；不加修饰的：a severe style 朴素的文体　⑤精确的：severe reasoning 精确的推理

［近义词］intense,extreme,violent,bitter,fierce,savage,wild　*adj.* 严重的，严峻的，激烈的

austere,rigid,stern,strict,harsh,rough,demanding,rigorous,cruel　*adj.* 严厉的，严格的

［辨析］**severe 严厉的**：系普通的用词，含有严重而冷峻的意思，多指严厉的规则(rule)和主义(principle)等。

He is severe with his students. 他对学生很严厉。

austere 严肃的：指缺少热情，感情冷漠，也可指严格的自制、俭朴、禁欲等。

He keeps an austere style. 他保持着简朴的风格。

rigid 严格的：比 severe 的意义更强，有不留情面的意思。

He is a rigid coach. 他是个严厉的教练。

stern 严厉的、严格的：指脾气或性格刚正不阿和缺乏灵活性。

He is stern to me. 他对我很严厉。

strict 严格的：指自己严守规则，对于他人也毫不放松，尤指遵守规则（rule）或标准（standard）。

His orders are very strict. 他的命令十分严厉。

5. **mound** *n.* ①宝球，宝珠（用作王权的象征，其顶部常饰有十字架） ②（城堡的）护堤 ③土墩；土堆；古冢；沙堆；石堆；假山：the Indian mounds 美洲印第安人史前时代在密西西比河东岸所筑的土墩子 ④一堆：a mound of hay 一堆干草 *vt.* 筑堤；造土墩子 *vi.* 逐渐成堆，隆起

[近义词] dune, hill, knoll, heap, barrow, bank, hillock, ridge, knoll, embankment, earthwork, rampart *n.* 土墩，土冈，土丘

[辨析] **mound 土墩、土堆**：指逐渐堆起的大土堆，也可指小山。

Many mounds were built for defensive purposes in olden times. 古时候人们为了达到防御的目的建了许多作掩体用的土墩。

dune 沙丘：指海边被风吹积而成的松而干的沙堆。

Dunes dotted here and there near the seashore. 海边到处可看到沙堆。

hill 小山、丘陵：指地面上较山小的自然形成的高地。

I mounted the hill to see the view. 我登山看风景。

knoll 小山、小丘：指圆顶的小山或小丘。

We planted trees around a knoll. 我们沿着小山种了树。

6. **sheer** *adj.* ①极轻薄的，几乎透明的：sheer chiffon 透明的丝织薄纱 ②纯粹的，全然的，真正的：sheer nonsense 毫无意义 ③陡峭的；垂直的：a sheer rock 峻峭的山崖 *adv.* ①峻峭地，笔直地：The rock rises sheer from the water. 崖石矗立水面。②完全，绝对：be torn sheer out by the root 全部连根拔除 ③十足，彻底 *n.* ①透明薄纱，透明布料的衣服 ②偏航，转向，避开 *vi.* 躲开，避开；迅速转向（常与 away, off 连用） You should sheer off the wicked urchin. 你应该躲开这个淘气包儿。*vt.* 使避开，使偏航

[近义词] straight up and down *adv.* 陡峭的

steep, abrupt, bluff, precipitious *adj.* 陡峭的，险峻的

mere, pahry, petty, absolute, utter, pure, total, complete, perfect, one-hundred-percent, out-and-out *adj.* 纯粹的，十足的

[辨析] **sheer 全然的**：指纯粹、完全或绝对的。

It is sheer waste of time. 这完全是浪费时间。

mere 只：指仅仅或只不过。

He is a mere child. 他只是一个孩子。

pahry 无价值的：指不重要的和微不足道的。

Pay no attention to paltry gossips. 不必注意琐碎的流言。

petty 细小的：指小的和不重要的。

It did not exceed petty one fifth. 它还没超过细微的五分之一。

Sentence

Until the mid-990s, Malmö, the third largest city in Sweden, seemed fairly emerged in a long post-industrial decline, its major industries obsolete or surpassed by others elsewhere in Sweden, Europe and the world.

直到 20 世纪 90 年代中期，瑞典第三大城市马尔默才逐渐从漫长的后工业衰退时期中复苏。由于城市的主要工业几乎荒废，马尔默很快被瑞典、欧洲和全世界的其他城市所赶超。

But with these prospects on the table, the City of Malmö was not about to concede defeat. Several European Union and government-sponsored revitalization projects targeted the metropolitan area from 1995 onwards.

然而，马尔默并没有甘于衰败。1995 年，一些欧盟国家和瑞典政府制定了多个针对马尔默都市复兴的计划。

Over the last twelve years, urban renewal became a local motto, with forefront architectural projects mushrooming throughout the city and attracting the attention of specialized international media.

城市复兴在过去的 12 年里成为当地人的目标，各类建筑项目在全城范围内实施，并吸引了众多专业媒体的关注。

Slowly but steadily, this new urban energy spread through the city, with exciting architecture, landscape architecture and urban intervention through art peppering the different sectors.

缓慢而稳定地通过建筑、景观和艺术化的城区改建，新兴城市的活力正在扩散到整个城市。

In the academic community, these human geography experiments have both been lauded and denounced, in Sweden and in other developed countries with similar social issues.

学术界对这种将不同阶层人群聚集在同一地域的行为褒贬不一，在其他发达国家也存在类似的现象。

Several issues presented themselves as significant obstables: the heavy traffic on Lorensborgsgatan street, and the volume and height of neighbouring buildings were evident from the onset. The budget was another difficulty: at approximately US $ 160/m², the total amount was limited (in Swedish terms) for the tasks of clearing the ground, creating a new landscaped area in the central courtyard that could be used for different effects by all residents, and additionally a roof garden for the exclusive use of the elderly people in the nursing home.

设计师需要解决的问题包括：Lorensborgsgatan 大街阻塞沿海交通的状况；邻近建筑物的高度和密度；而如何将预算控制在大约 160 美元/平方米则是另外一个难题。然而不得不令人称奇的是，设计师在此有限的预算内出色地完成了包括场地清理、在中央庭院新建一个能够满足居民日常活动需求的景观区域以及为养老院的老人们专门修建一个屋顶花园在内的所有规划。

Translation

第 18 课　老城新宅——满足多种群体需要的景观设计

直到 20 世纪 90 年代中期，瑞典第三大城市马尔默才逐渐从漫长的后工业衰退时期中复苏。由于城市的主要工业几乎荒废，马尔默很快被瑞典、欧洲和全世界的其他城市所赶超。在工业革命时期，位于瑞典最南端的马尔默在卡车制造商斯堪尼亚等的带动下，迅速成为早期崛起的几大城市之一。然而进入后工业时代，这个城市的社会经济状况每况愈下。马尔默现有人口 28 万，加上卫星城的人口共有 60 万之多，这对一个总人口只有 900 万的国家而言不是一个小数目。马尔默 27％的人口并不是在瑞典本土出生，所以它也是瑞典人口构成最不平衡的城市之一。多年来，马尔默一直受到高失业率和青少年犯罪等社会问题的困扰，按不同种族划分的居住区便已体现了这些问题的严重性。马尔默的一些地方青草茂盛，非常富裕，而剩下的却缺乏任何繁荣或多彩的迹象。

然而，马尔默并没有甘于衰败。1995 年，一些欧盟国家和瑞典政府制定了多个针对马尔默都市复兴的计划。城市复兴在过去的 12 年里成为当地人的目标，各类建筑项目在全城范围内实施，并吸引了众多专业媒体的关注。最为瞩目的是圣地亚哥·卡拉特拉瓦设计的高 190 米，呈 90 度旋转的大楼，这个获奖项目很快便成为了马尔默的城市标志。2007 年，西雅图网络环境新闻杂志 Grist 将马尔默评为"15 座绿色城市之一"，进一步证明了复兴后的马尔默在世界舞台上的影响力。马尔默市还投资了一些前沿产业，如信息技术和生物技术等，并在本地大学和其邻近城市隆德市的支持下开发知识经济产业。2000 年，7845 米长的厄勒干线建成，这项工程结合了桥梁和隧道的功能，将马尔默与哥本哈根紧密地联系起来，进一步加快了马尔默的经济复兴。

缓慢而稳定地通过建筑、景观和艺术化的城区改建，新兴城市的活力正在扩散到整个城市。位于 Lorensborg 区边缘的 Stensjögatan 大街 64-66 号就是一个典型的范例——该建筑始建于 20 世纪 50 年代，是为当时急剧增长的战后工业化人口提供的大规模多层居住区。现在已从最初的贫民居住区发展成为中低阶层居住区，其周围是发展相对滞后、管理混乱的 Kroksbäck 街区和因靠近厄勒干线而迅速崛起的 Hyllie 街区。

靠近主干道并连接不同街区环形路的红黄色砖墙建筑是为安置各个阶层市民而建的居民区。11 层高、用于出租的建筑有各种不同程度和形式的损伤，这里也是老年人的临时居所和养老院。没有任何社会问题的人也居住在这里。学术界对这种将不同阶层人群聚集在同一地域的行为褒贬不一，在其他发达国家也存在类似的现象。

GORA 艺术与景观公司受邀参与设计，并提出一项协调各个群体之间对景观需求的总体规划。设计师需要解决的问题包括：Lorensborgsgatan 大街阻塞沿海交通的问题；邻近建筑物的高度和密度；而如何将预算控制在大约 160 美元/平方米则是另外一个难题。然而不得不令人称奇的是，设计师在如此有限的预算内出色地完成了包括场地清理、在中央庭院新建一个能够满足居民日常活动需求的景观区域以及为养老院的老人们专门修建一个屋顶花园在内的所有规划。

一堵将居民区和繁华的 Lorensborgsgatan 大街隔开的极具艺术效果与特殊工艺的褐色砖墙是该项目的特色之一；另一个更吸引人注意的特色则是屋顶花园。从屋顶洋红、紫红

和赭石色的玻璃阳台可以俯瞰整个居民区和街道。在居民区内,最吸引人的设计莫过于那些表面光滑、色彩明亮的彩色松树凉亭,此处的景观特色是整个项目的重点,同时也为这里的每个人都提供了一处能尽情享受的活动空间。

在清理 Lorensborgsgatan 和 Stensjögatan 大街时挖出来的土被循环再利用,堆砌成小土丘,宛如一座被道路环绕的绿岛,虽然没有特别之处,却也不失为一处醒目的新景观。高大的树木为人们营造一处阴凉和休憩之所,成为这里更为引人注意的风景。在居民区南部有一个果园和玫瑰园,为人们提供了较为私密的生活空间,更突出了"感官体验"这一主题。

设计师将屋顶花园的设计主题提升到一个更高的层面——为这片空间的主要使用者(老人)而设计。不规则的水滴状纤维混凝土种植箱的外壳都是由廉价的材料制作而成,在现场进行划分、组装。五颜六色的玻璃阳台在阳关的照射下色彩斑斓,无疑成为屋顶平台的一大亮点。楼下的公共花园中,设计师还设计了一个专门的观景点。

Lesson 19 Regeneration of Post-industrial Sites on Sydney Harbour

Ballast Point and Former BP Site Public Parkland both have a similar starting point. They are on petroleum based industrial sites that have, for both environmental and economic reasons, been decommissioned from Sydney's harbour foreshore and relocated to areas with an industrial base. The two sites are located directly opposite one another on two promontories that form the gateway to the inner harbour.

In the late nineteen hundreds, both sites were decommissioned in what originally was seen as sites for residential development. Due to their unique location, a strong public voice demanded that the sites would be returned to the people of Sydney as harbour parklands.

The designs for the resulting were based around environmental principals in order to remediate what were highly contaminated sites. The design focus was to clean all stormwater naturally prior to it entering the harbour and to utilize simple, robust materials that would respond to both the natural site yet communicate its past, historical layers.

Former BP Site Public Parkland

Located on Waverton Peninsula, the site is the first of a series of waterfront areas in North Sydney to be transformed from industrial depots into public parklands. The new 2. 5-hectare harbourside park is a result of the New South Wales Government's decision in 1997, to convert Waverton's three waterfront industrial sites for public use and reject their sale for residential development.

The design acknowledges the site's former use through the restrained composition of simple, yet robust structures. The new design celebrates the site's industrial heritage and harbour location with a series of open spaces, wetlands and spectacular viewing decks that embrace the dramatic, semi-circular sandstone cliff cuttings where the oil tanks formally stood. A combination of concrete and metal staircases wrap around the cliffs and project over the water sensitive, wildlife-attracting ecosystem found below.

As a result of the site being used for oil storage for over 60 years, it had become contaminated and in order to create the park, a variety of environmentally sustainable design

master plan of Former BP site public parkland

initiatives were employed. Existing site soil, rather than being excavated and consigned to landfill, was mixed with imported organic matter and reused across the site. Provenance seed stock was collected from nearby Balls Head, propagated and used as plant stock to reinstate the natural flora of the site.

The design incorporated an integrated stormwater collection and filtration system that directs site water into detention ponds planted with aquatic plants. These ponds filter and clean the water prior to it discharging into the harbour. The establishment of this detention system has additional benefits in that it has created new habitats for a variety of frogs as well as ducks and other bird species.

The park's defining material finishes of in-situ concrete and galvanized steel are references to the industrial past and were selected for their low-cost, low-impact and low-maintenance qualities.

Sydney harbour is at a nexus, where post-industrial lands are searching to find uses that go beyond their pure commercial potential. The Former BP Park is emblematic of the moves to reclaim the harbour foreshore for the people of Sydney while recognizing the importance of retaining a site's heritage.

landscape of Former BP site public parkland

Ballast Point Park

Ballast Point is situated at the tip of the Birchgrove Peninsula, on the southern shores of Sydney harbour, approximately 2 kilometres from the Sydney Harbour Bridge. Together with Balls Head on the northern shore, they form the gateway to the inner reaches of Port Jackson, fed by the Parramatta River to the west. Positioned between Ballast Point and Sydney's CBD lies Goat Island, Sydney Har-

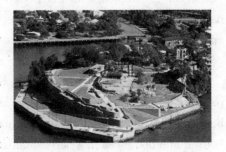

Ballast point park

bour's second largest island.

Ballast Point experienced numerous changes since the arrival of Europeans to Sydney in 1788. The site gained its name during the industrial development of the area, a reference to its role quarrying sandstone to be used as ballast for ships returning to Europe. Thomas Perkins who built a marine villa, Menevia, on the peninsula, bought the land in 1852. In the 1920's, the land changed hands again when Caltex took ownership with Ballast Point becoming the main distribution point for fuel in Sydney. By 1936, Caltex's operational focus shifted as they moved to the manufacturing and storage of lube oil. They continued to run operations at Ballast Point through the mid-1990's, until 2002 when the site was acquired by the Sydney Harbour Foreshore Authority, with the aim of returning the land as parkland to the people of Sydney.

The designer undertook the park with three approach:

(1) Innovative Environmental Initiatives

It was appropriate that sustainability initiatives were one of the underpinning key design considerations to be explored, in light of the site's history as an example of European culture's evolving relationship with the Australian landscape. Initially, the site was seen simply as a resource bank to be carved and cut as required but now, the fact that a park for the people of Sydney is to be constructed on this site, highlights how our perception of the value of the Australian landscape has evolved. To respond to this evolution of the site, it is critical that this new park should make a strong statement about the future of contemporary Australian landscapes.

The focus, therefore, was to use recycled materials and innovative environmental design initiatives wherever possible. Materials such as recycled rubble, aggregate and timber are all to be sourced from nearby rubbish tips and salvage sites and used throughout the park. The park's retaining walls are to be clad with recycled rubble and the concrete mixed with recycled aggregate for the park's paths, giving a legible, unique overall aesthetic. In this way materials otherwise consigned to landfill are to be reused. To counter-balance the extensive areas of concrete, recycled timber is to be utilized for site seating, bridges and decking structures. In addition the park will also produce energy, with wind turbines integrated into the proposed interpretive 'lube ring' structure and positioned at the former site of "tank 101". Coupled with high quality design and detailing these initiatives will create a park for the future, a park that shows that sustainability and design, a place of great beauty and significance.

(2) Interpreting and Integrating the Site's Historic Layers

The site's varied past has given birth to several significant historical layers, which the park's design identifies and incorporates. The footprint of the original Menevia villa is to be traced in the concrete paths with artifacts gathered from archaeological excavations to be housed and displayed in a heritage interpretation wall. The site's industrial past will be acknowledged and reinterpreted through the installation of the 'lube ring', and industrial scale

structure which references the original'tank 101'which formerly crowned the Ballast Point peninsula during the Caltex years. Added to this, the park will also use interpretive signage to tell the story of the site history, with the aim to create a park that has its own language and voice; a park that can speak for itself and reveal its layers and meaning.

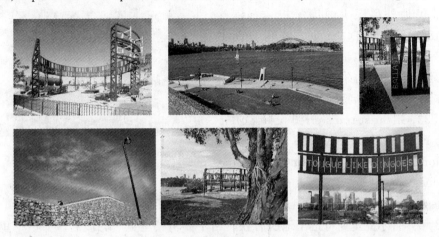

landscape of Ballast Point park

(3) Recognition of the Park as a New Layer over the Site

In addition to attempting to interpret the park's past, the designer has recognized that their park design will add a new layer to the site's already rich tapestry. With this in mind, a conscious effort has bee made to integrate the historic layers of the past with the new layer as an added chapter in the story of Ballast Point. This new layer will reflect our changing social and environmental expectations. It also gives a focus on strong environmental initiatives and expressing new interventions that preserve and celebrate the site rather than exploit it.

Notes

1. Ballast Point 巴拉斯特角

Ballast Point is a 2. 6 hectare area located in Birchgrove at the tip of the Balmain Peninsular in the Municipality of Leichhardt in Sydney, New South Wales, Australia. It is located between Snails Bay and Mort Bay in Port Jackson.

巴拉斯特角位于澳大利亚新南威尔士州悉尼莱卡特自治市波梅茵半岛顶部的白桦果园，面积2.6公顷。它处于杰克逊港的斯奈尔斯湾和莫罗敦湾之间。

Between 1788 and 1800, the point was used as a fishing and hunting ground for European settlers and as a source of ballast for ships returning unladed to Europe, hence the name Ballast Point.

1788～1800年间，巴拉斯特角成为欧洲定居者捕鱼和狩猎的场所，以及货船卸完货后装载压舱物（ballast）回转欧洲的场所，因此被称为巴拉斯特角。

In 1800 the point was part of a 550 acre (2. 2km^2) grant to colonial surgeon Dr Wil-

liam Balmain (1762~1803) made by Governor John Hunter. A year later, Balmain sold his entire holding to John Gilchrist for 5 shillings and the area then became known as Gilchrist's place.

Fig. 19-1　Original Ballast Point
sign from Caltex site

1800 年，巴拉斯特角成为约翰·亨特总督授予殖民地外科医生威廉·巴尔曼医生 (1762~1803)550 英亩(2.2 平方公里)土地的一部分。一年后，巴尔曼把他的土地以 5 先令的价格卖给了约翰·吉尔克里斯特，于是这片领地被称为吉尔克里斯特领地。

In 1833, Gilchrist transferred power of attorney to Frederick Parbury who 3 years later commissioned surveyor John Armstrong to lay out sub divisions. This survey formed the basis of sales between 1836 and 1841.

1833 年，吉尔克里斯特把土地所有权转给了弗雷德里克·帕波利。弗雷德里克·帕波利在 3 年后委托约翰·阿姆斯特朗规划更详细的分区。这次规划形成了 1836~1841 年之间土地出售的基础。

Ballast Point was sold by Parbury to Cooper (NSW Controller of Customs and later Superintendent of Distilleries) and McLean in 1840 but a default in the mortgage saw the land transfer to James Tod Goodsir in February 1841 for 700 pounds. Only 7 months later, Ballast Point was sold to Andrew Smith and Henry Smith for 500 pounds. The land was advertised for sale in 1842 but severe colonial depression forced withdrawal of the sale.

1840 年，帕波利将巴拉斯特角卖给了库珀(新南威尔士的海关官员，随后成为酿酒厂的监督人)和麦克林，1841 年 2 月这块土地又被以 700 镑抵押给了詹姆斯·托德·古德瑟。仅仅在 7 个月后，巴拉斯特角又被以 500 镑的价格卖给了安德鲁·史密斯和亨利·史密斯。这块土地 1842 年又被出售，但是严重的殖民地衰落使得价格下跌了很多。

Merchant and draper Thomas Perkins, purchased the 5-acre (20000m²) site for 300 pounds in 1852 and in 1864 built the only house thought to have existed on the site, Menevia. From this point until 1875 the site was known as Menevia Point, and from 1884 to 1928 was known as Perkins Point after Mrs Perkins who lived in the house.

以商人和裁缝谋生的托马斯·帕金斯，在 1852 年以 300 镑的价格购买了 20000 平方米的土地，并在 1864 年建造了这里唯一的住宅——默勒维亚，人们常常认为这座住宅早在很久之前就存在了。从那时到 1875 年，这里被称为默勒维亚角。1884~1928 年，帕金斯夫人生活在这所住宅中时，这里被称为帕金斯角。

In 1905 the land passed to Henry Thomas Perkins, a barrister living in England, who never took up residence at the site.

1905 年，亨利·托马斯·帕金斯——一位生活在英格兰的律师——继承了这片土地，他从没有在这里居住过。

From 1893 to 1915 Menevia was used as a boarding house and possibly still operated as

such in the early 1920s.

1893～1915 年，默勒维亚被用作海滨度假住宅，可能一直持续到 20 世纪 20 年代。

By 1928, Menevia had fallen into disrepair and the site was purchased by Texaco (later Caltex) who demolished the house to make way for a fuel depot, manufacturing and packaging facility. Ballast Point formed Texaco's major distribution point in Sydney and continued until the 1990s.

到 1928 年，默勒维亚处于年久失修的状态，这块地被德士古公司（随后改为加德士公司）购买，德士古公司拆除了住宅，来修建燃料仓库、车间和打包设施。巴拉斯特角成为了德士古公司在悉尼的主要分装点，直到 20 世纪 90 年代。

In September 2002, the derelict site was returned to public ownership after compulsory purchase by the NSW Government. Caltex had planned to sell the site to the Walker Corporation for development of residential units. A legal disputed ensued over the amount paid for the purchase but an initial win by the developers was overturned by the NSW Court of Appeal.

2002 年 9 月，被人们遗忘的基地由新南威尔士政府强制性购买后又回到了公众的手中。加德士公司原本计划把基地出售给步行者公司用来发展居住单位。跟着发生了对购买价格合法性的争论，由于新南威尔士上诉法院判定发展商败诉，最初的方案取得了胜利。

2. Sydney　悉尼

Sydney is the most populous city in Australia, with a metropolitan area population of approximately 4. 28 million (2006 estimate). It is the state capital of New South Wales, and was the site of the first British colony in Australia.

悉尼是澳大利亚人口最多的城市，市区人口大约 428 万人（2006 年）。悉尼是新南威尔士州的首府，也是英国人在澳大利亚首个殖民地的所在地。

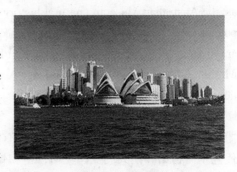

Fig. 19-2　Sydney

Sydney is situated on Australia's south-east coast. The city is built around Port Jackson, which includes Sydney Harbour, leading to the city's nickname, "the Harbour City". It is noted for the Sydney Opera House and the Harbour Bridge, and its beaches. The metropolitan area is surrounded by national parks, and contains many bays, rivers and inlets. The city has hosted international sporting, political and cultural events, including the 1938 British Empire Games, 2000 Summer Olympics and the 2003 Rugby World Cup. In September 2007, the city hosted the leaders of the 21 APEC economies for APEC Australia 2007, and in July 2008 hosted World Youth Day 2008.

悉尼位于澳大利亚的东南海岸。由于是围绕杰克逊港（包括悉尼港）而建的，因此被称为"海港城市"。这里以悉尼歌剧院、港湾大桥和海滩而闻名。市区的四周是国家公园，里面有许多海湾、河流和小内湾。这个城市曾经举行的国际运动会、政治和文化盛事包括 1938 年的大英帝国运动会、2000 年夏季奥运会和 2003 年橄榄球世界杯。2007 年 9 月，悉尼招待了参

加亚太经合组织 2007 澳大利亚峰会的 21 个亚太经济合作组织成员的领导者。

Sydney is one of the most multicultural cities in the world, which reflects its role as a major destination for immigrants to Australia. According to the Mercer cost of living survey, Sydney is Australia's most expensive city, and the 15th most expensive in the world.

悉尼是全世界文化最丰富的城市之一，是移民来到澳大利亚的主要目的地。根据美世生活成本研究，悉尼是澳大利亚生活成本最高的城市，在全世界城市中排名第 15 位。

Sydney's skyline has been ranked as the best in Australia and the 25th best in the world (ahead of such cities as Los Angeles and S ão Paulo).

悉尼的天际线被认为是澳大利亚最美丽的，全世界第 25 美丽（领先于洛杉矶和圣保罗等城市）。

In the year ending March 2008, Sydney received 2. 7 million international visitors. The most well known attractions include the Sydney Opera House, and the Sydney Harbour Bridge. Other attractions include Royal Botanical Gardens, Luna Park, the beaches and Sydney Tower.

截至 2008 年 3 月的一年中，悉尼接待了 270 万国际游客。最著名的旅游胜地包括悉尼歌剧院、悉尼港湾大桥。其他吸引人之处还有皇家植物园、月亮公园、海滩和悉尼塔。

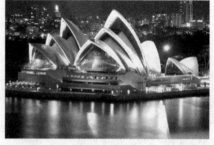

Sydney also has several popular museums such as, the Australian Museum (natural history and anthropology), the Powerhouse Museum (science, technology and design), the Art Gallery of New South Wales, the Museum of Contemporary Art and the Australian National Maritime Museum.

Fig. 19-3　Sydney Opera House at night

悉尼也有许多受人欢迎的博物馆，如澳大利亚博物馆（自然史和人类史）、动力博物馆（科学、技术和设计）、新南威尔士艺术博物馆、当代艺术博物馆和澳大利亚国立海洋博物馆。

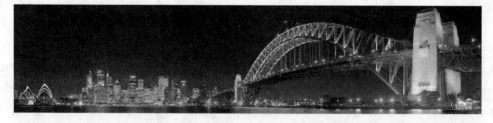

Fig. 19-4　A panorama of Sydney Harbour at night, with the Sydney Opera House on the left, the central business district in the image centre and Sydney Harbour Bridge on the right

3. Waverton Peninsula　威弗敦半岛

Waverton is a suburb on the lower North Shore of Sydney, New South Wales, Australia. Waverton is located 4 kilometres north of the Sydney central business district, in the local government area of North Sydney Council.

威弗敦是澳大利亚新南威尔士州悉尼市地势较低的北岸郊区。威弗敦位于悉尼中央商务区以北 4 公里处，属于北悉尼议会的管理范围。

Waverton was named in 1929 after the Waverton Estate of an early resident, Robert Old. The land once belonged to William Carr, who named it after an English village connected to his family.

威弗敦是在 1929 年以早期居住者罗伯特·欧德的威弗敦庄园来命名的。这片土地曾经属于威廉·卡尔，他用和家族相联系的英国乡村来命名。

Fig. 19-5 View of Sydney from Waverton

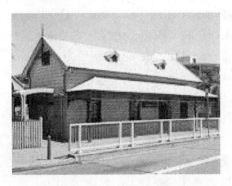
Fig. 19-6 Waverton railway station entrance

The North Shore railway line was extended south from St Leonards to Milsons Point in 1893. The station in this area for nearly forty years was known as Bay Road, after the thoroughfare that crosses the railway line. The local progress association recommended a change and Waverton was chosen in 1929.

北岸铁路线在 1893 年向南从圣莱昂纳多延伸到麦尔森角。40 多年中这一地区的火车站一直被称为海湾路——以穿越铁路的大路来命名。当地的发展协会要求改变名称，于是在 1929 年决定使用"威弗敦"这个名称。

Waverton has a village-like collection of shops around the railway station, including an IGA supermarket, florist, bottle shop, dry cleaner, video store and several restaurants and cafes.

威弗敦的火车站周围是乡村风格商铺的集中地，包括 IGA 超市、花店、酒店、干洗店、音像店以及许多餐馆和咖啡馆。

4. New South Wales 新南威尔士州

New South Wales (abbreviated as NSW) is Australia's oldest and most populous state, located in the south-east of the country, north of Victoria and south of Queensland. It was founded in 1788 and originally comprised much of the Australian mainland, as well as Lord Howe Island and Norfolk Island.

新南威尔士州(简称 NSW)是澳大利亚历史最悠久和人口最多的州，位于澳大利亚东南部，维多利亚州以北，昆士兰州以南。新南威尔士创建于 1788 年，最初领域包括了澳大利亚大陆的大部分，以及豪勋爵岛和诺福克岛。

Inhabitants of New South Wales are referred to as being New South Welsh or New South Welshmen. New South Wales's largest city and capital is Sydney.

新南威尔士州最大的城市和首府是悉尼。

As Australia's most populous state, New South Wales is home to a number of cultural institutions of importance to the nation. In music, New South Wales is home to the Sydney Symphony Orchestra, Australia's busiest and largest orchestra. Australia's largest opera company, Opera Australia, is headquartered in Sydney. Other major musical bodies include the Australian Chamber Orchestra. Sydney is host to the Australian Ballet for its Sydney season (the ballet is headquartered in Melbourne). Apart from the Sydney Opera House, major musical performance venues include the City Recital Hall and the Sydney Town Hall.

Fig. 19-7 The Big Golden Guitar in Tamworth represents the cities country music culture

作为澳大利亚人口最多的州, 新南威尔士州是澳大利亚许多重要文化机构的所在地。在音乐方面, 新南威尔士州是悉尼交响乐团——澳大利亚最繁忙和最大的交响乐团——的所在地。澳大利亚最大的歌剧公司——澳大利亚歌剧团的总部就在悉尼。其他主要音乐机构包括澳大利亚室内乐团。澳大利亚芭蕾舞团在其悉尼演出季期间在悉尼表演(芭蕾舞团总部位于墨尔本)。除悉尼歌剧院之外, 主要的音乐表演地点包括城市演奏厅和悉尼市政府大楼。

New South Wales is home to a number of major art galleries. The Art Gallery of New South Wales (AGNSW), houses a significant collection of Australian art, while the Museum of Contemporary Art, Sydney focuses on contemporary art.

新南威尔士州是许多重要艺术画廊的所在地。新南威尔士艺术博物馆收藏了许多重要的澳大利亚艺术作品, 而悉尼的当代艺术博物馆收藏的重点是当代艺术。

5. Birchgrove Peninsula 伯奇林半岛

Birchgrove is a suburb in the inner-west of Sydney, in the state of New South Wales, Australia. Birchgrove is located 5 kilometres west of the Sydney central business district, in the local government area of the Municipality of Leichhardt.

伯奇林区是位于澳大利亚新南威尔士州悉尼市西部的郊区。伯奇林区位于悉尼中央商务区以西 5 公里处, 处于莱卡特自治市管理范围。

Birchgrove was named after Birchgrove House, built by Lieutenant John Birch of the 73rd regiment, around 1812. He added "grove" to his surname when naming the house because of the large number of orange trees growing on the original site. The house was constructed of stone believed to have been quarried on site.

伯奇林区以伯奇林住宅而得名, 这座建筑是由第 73 军团约翰·伯奇上尉在 1812 年建造的。当命名住宅时他在自己的名字加上了"林", 因为基地中生长了大量的橙树。人们相信住宅是用从基地中开采的石头建造的。

From the 1860s, a number of waterfront businesses appeared in the area including coopers, boat builders and the Morrison & Sinclair shipyard.

从 19 世纪 60 年代起，在这片区域出现了许多沿海岸的商业，包括制桶工人、造船工人和莫里森 & 辛克莱尔造船厂。

The local landmark is Clifton Villa, a three-storey sandstone house in the Gothic style. The house was built in the late 1860s and is surrounded by a covered verandah. In the mid-1870s a ballroom was added. The house's interior features a marble fireplace and cedar woodwork, while the exterior includes a caretaker's cottage that was originally a carriage house. Clifton Villa is now listed on the Register of the National Estate.

Fig. 19-8　Birchgrove park

当地的地标是克利夫顿别墅，一座哥特风格的三层砂岩住宅。这座住宅是在 19 世纪 60 年代后期建造的，住宅四周围以阳台。在 19 世纪 70 年代中期，又增加了一间舞厅。住宅的室内有大理石壁炉和雪松木构件，室外还有一间看管人的小屋，这间屋子最初是马车房。克利夫顿别墅现在被列入国家资产登记。

Landmarks 地标

Fig. 19-9　Yurulbin Park

(1) Ballast Point is a 2. 6 hectare former industrial site located at the tip of the Balmain Peninsular currently under redevelopment as a public open space.

(1) 巴拉斯特角是位于波梅茵半岛顶部的面积 2.6 公顷的前工业基地。

(2) Yurulbin Park is a former shipbuilding site located at the end of Yurulbin Point (Long Nose Point) which has been transformed into an award winning public space.

(2) 长鼻角公园以前是位于长鼻角的造船厂，后来被改造成获得奖项的公共空间。

(3) Pubs——Birchgrove and Balmain are home to many famous drinking establishments, including the Sir William Wallace Hotel, named after the Scottish hero who was the subject of the film *Braveheart*.

(3) 酒吧——伯奇林区和波梅茵区有许多著名的饮酒场所，包括威廉·华莱士爵士酒店，这座酒店以电影《勇敢的心》中的主角——一位苏格兰英雄而命名。

6. Sydney Harbour Bridge　悉尼港湾大桥

The Sydney Harbour Bridge is a steel arch bridge across Sydney Harbour that carries rail, vehicular and pedestrian traffic between the Sydney central business district (CBD) and the North Shore. The dramatic view of the bridge, the harbour, and the nearby Sydney Opera House is an iconic image of both Sydney and Australia. The bridge is locally nick-

named The Coathanger because of its arch-based design.

悉尼港湾大桥是跨越悉尼港的钢拱大桥，承担悉尼中央商务区（CBD）和北岸之间的铁路、机动车和步行交通。大桥、港口和附近的悉尼歌剧院形成的戏剧化景观成为了悉尼和澳大利亚的象征。大桥由于拱形基础的设计而被当地人称为"衣架"。

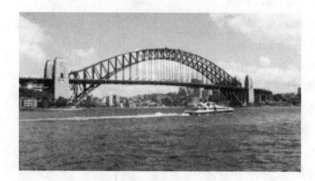

Fig. 19-10　Sydney Harbour Bridge

Fig. 19-11　Flags of New South Wales and
Australia at the top of the bridge

The bridge was designed and built by Dorman Long and Co Ltd, Middlesbrough, Teesside and opened in 1932. Until 1967 it was the city's tallest structure. According to Guinness World Records, it is the world's widest long-span bridge and its tallest steel arch bridge, measuring 134 metres (429. 6ft) from top to water level. It is also the fourth-longest spanning-arch bridge in the world.

大桥是由提兹塞德区米德尔斯布勒市的多门朗工程技术有限公司设计和建造的，1932年对外开放。1967 年前它一直是悉尼市最高的建筑。根据吉尼斯世界纪录，它是全世界最宽的长跨距桥梁与最高的钢铁拱桥，大桥最高处高出水平面 134 米。它也是世界上第 4 长的拱桥。

The Sydney Harbour Bridge is not completely stationary. It can rise or fall up to 18cm depending on whether it is hot or cold.

悉尼港湾大桥并不是完全静止的。她可能上升或下降达 18 厘米，这取决于天气是炎热还是寒冷。

On New Year's Eve, the numbers for the countdown appear on the pylons of the bridge.

在新年前夕，倒计时的数字会出现在大桥的桥塔之上。

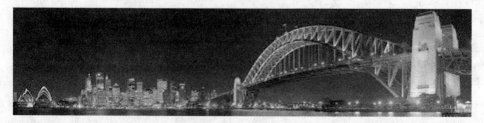

Fig. 19-12　Sydney Harbour Bridge as viewed from Kirribilli on the North Shore

7. Port Jackson 杰克逊港

Port Jackson, containing Sydney Harbour, is the natural harbour of Sydney, Australia. It is known for its beauty, and in particular, as the location of the Sydney Opera House and Sydney Harbour Bridge. The location of the first European settlement in Australia, the Harbour has continued to play a key role in the history and development of Sydney.

杰克逊港（包括悉尼港）是澳大利亚悉尼市的天然海港。杰克逊港以美丽的景观而闻名，特别是悉尼歌剧院和悉尼港湾大桥均坐落于此处。作为澳大利亚首个欧洲移民定居点所在地，港口继续在悉尼的历史和发展中扮演着重要的角色。

It is used during the New Years Eve Fireworks and the start of the Sydney to Hobart yacht race.

这里是新年前夕焰火表演地和悉尼—霍巴特帆船赛的起点。

Geologically, Port Jackson is a drowned river valley, or ria. It is 19km long with an area of 55km^2. The perimeter of the estuary is 317 kilometres.

从地理学角度来看，杰克逊港是被淹没的河谷，或者叫里亚式湾（溺河）。港口长 19 公里，面积为 55 平方公里。海湾的直径达 217 公里。

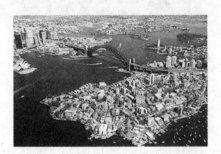

Fig. 19-13 Sydney Harbour and Port Jackson displaying Sydney Harbour Bridge and the Sydney Opera House

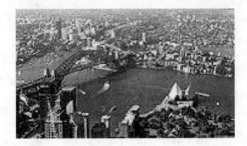

Fig. 19-14 Port Jackson from a helicopter

There are several islands within the harbour, including Shark Island, Clark Island, Fort Denison, Goat Island, Cockatoo Island, Spectacle Island, Snapper Island and Rodd Island. Some other former islands, including Bennelong Island, Garden Island and Berry Island, have subsequently been linked to the shore by land reclamation.

在海港内有许多岛屿，包括鲨鱼岛、克拉克岛、丹尼森堡、山羊岛、鹦鹉岛、奇观岛、斯奈卜岛和罗德岛。一些曾经是岛屿的地方包括本纳隆岛、花园岛和贝利岛，随后通过（填海造田）土地填筑和海岸连接在了一起。

Sydney Ferries is a state-owned corporation of the New South Wales Government providing commuter and tourist passenger ferry services in Sydney Harbour.

悉尼渡船是新南威尔士的国有公司，在悉尼港为乘客和游客提供轮渡服务。

8. Parramatta River 帕拉玛塔河

The Parramatta River is a waterway in Sydney, New South Wales, Australia. The Parramatta River is the main tributary of Sydney Harbour, a branch of Port Jackson, along

Fig. 19-15 Harbour as viewed from Grotto Point Reserve where
Middle Harbour joins the main harbour

with the smaller Lane Cove River and Duck River.

帕拉玛塔河是位于澳大利亚新南威尔士州悉尼市的航道。帕拉玛塔河和较小的兰高夫河与鸭河一起，都是悉尼港(杰克逊港一部分)的重要支流。

The total catchment area of the river is approximately 130km².

河流的整个流域大约130平方公里。

There are five particularly contaminated areas of Sydney Harbour, and that four of them are in the Parramatta river system.

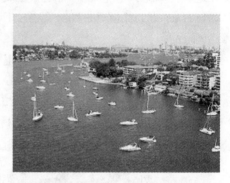

Fig. 19-16 Parramatta River

悉尼港有五个特别严重的污染区域，其中四个位于帕拉玛塔河系统中。

The main contaminated areas of the Parramatta River are：

帕拉玛塔河主要受污染的区域包括：

Homebush Bay——dioxins, lead, phthalates, DDT, PAHs（coal tars）mainly originating from nearby chemical factories of Berger Paints, CSR Chemicals, ICI/Orica, and Union Carbide.

侯姆布什湾——污染主要产自附近的伯爵油漆工厂，CSR气体化学品制造商，多乐士/澳利卡涂料工厂，以及联合碳化物公司的二氧芑、铅、邻苯二甲酸盐、二氯二苯三氯乙烷、多环芳香族碳氢化合物(煤焦油)。

Iron Cove——various metals and chemicals with no clearly defined point source. Pollution may possibly enter through Iron Cove Creek and Hawthorne Canal.

埃若卡夫湾——没有明确来源的各种各样金属和化学元素。污染可能是由埃若卡夫湾河和霍桑运河流入的。

Off former AGL site, now redeveloped as Breakfast Point.

关闭的前格林莱(AGL)国际集团公司基地，现在被重建为巴拉斯特角公园。

Major wetlands include：

重要湿地包括：

Bicentennial Park Wetlands；

比森第内公园湿地；

Newington Wetlands.

纽英顿湿地。

Major foreshore parks include：

主要的海滩公园包括：

Cabarita Park；

卡巴里塔公园；

Kissing Point Park，Ryde；

基斯角公园，赖德；

Meadowbank Park；

密多班克公园；

Putney Park；

普特尼公园；

Bicentennial Park，Homebush Bay；

比森第内公园，侯姆布什湾；

Millennium Parklands，Homebush/Auburn.

千禧年公园，侯姆布什/奥本。

Major heritage buildings on or near the foreshore include：

海滩附近的历史遗产建筑包括：

Thomas Walker Convalescent Hospital；

托马斯·沃克康复医院；

Callan Park，a former psychiatric hospital，with fine sandstone buildings；

卡伦公园，前精神病医院，有非常美的砂岩建筑；

Gladesville Psychiatric Hospital，with many sandstone buildings in parklike surroundings on the southern side of Victoria Road. All the buildings on the Northern side were demolished and sold for redevelopment in about 1990；

格莱兹维尔精神病医院，位于维多利亚路南面，公园般的环境中建有许多砂岩建筑。北面的所有建筑都被拆毁了，并出售给 1990 年开始的新发展项目；

Yaralla，the Italianate mansion of Dame Edith Walker；

雅罗拉，艾迪斯·沃克夫人的意大利式庄园；

the Newington armaments depot with its armaments railway and concrete bunkers.

纽英顿军用仓库、军用铁路和混凝土燃料库。

9. Goat Island　山羊岛

Goat Island is a rocky island in Sydney Harbour，in New South Wales，Australia. The island is some 400m by 200m in size and is located north-west of the Sydney central business district.

山羊岛是澳大利亚新南威尔士州悉尼港中的岩石岛。这座岛屿大约 400 米长，200 米宽，位于悉尼中央商务区的西北部。

Goat Island lies off the shores of the Sydney suburbs of Balmain and Millers Point，at the junction of Darling Harbour with the main channel of Sydney Harbour. Over the years Goat Island has served as a quarry，convict stockade，explosives store，police station，fire station，boatyard and film set. Today the island forms part of the Sydney Harbour National Park.

山羊岛邻近悉尼波梅茵郊区和米勒角，位于达林港和悉尼港主航道的结合处。多年来山羊岛一直作为采石场、监狱、爆炸物仓库，警察局、消防站、制造或修理小船的工场和电影基地。今天，山羊岛成为了悉尼港国家公园的一部分。

Fig. 19-17　Goat Island from Balmain

Confusingly, some early maps of Sydney Harbour show the current Goat Island with the name Cockatoo Island, whilst the current Cockatoo Island is named Banks Island. However by the late 1820s the naming of the two islands had stabilized at the current situation.

令人困惑的是，一些悉尼港的早期地图显示现在的山羊岛当初的名字是鹦鹉岛，而现在的鹦鹉岛的名字却是班克斯岛。然而，到 19 世纪 20 年代后期，这两个岛屿确定为现在的名字。

Whilst the use of Goat Island as both a naval arsenal and a convict stockade were during the late 1820s, the first use of the island was in 1831, as a sandstone quarry. This use set the tone for much of the later life of the island.

虽然山羊岛在 19 世纪 20 年代后期作为海军仓库和罪犯监狱，但是首次使用这个岛是在 1831 年作为砂岩采石场。这种用途确立了随后岛屿大部分生活的主调。

In 1900 all explosives were removed from Goat Island. The island is believed to have been used for a period in that year as a bacteriology station, for the investigation of the major outbreak of bubonic plague in the nearby Rocks district, but firm evidence for this usage is lacking. What is certain is that by 1901 the island had become the depot for the Sydney Harbour Trust, responsible for the maintenance of that body's significant fleet of tugs, dredgers and other floating plant. Over the following years until the mid-1920s, the island saw the construction of a harbour master's house on the highest point of the island, together with four cottages for married members of the fireboat crew stationed on the island, and a barracks for the unmarried members of the same crew.

1900 年，所有的爆炸物都搬离了山羊岛。有人认为在一段时期内这座岛屿成为了细菌学研究基地，为了研究在岩石区附近爆发的淋巴腺鼠疫，但是这一用途缺乏明确的证据。能够确定的是到 1901 年这座岛屿成为了悉尼港信托所的仓库，负责机构重要的拖船、挖泥船和其他浮动装置的维护工作。多年后，直到 20 世纪 20 年代，在岛屿的最高点上建造了一座港口管理人员住宅，和消防艇已婚工作人员居住的四座小屋以及未婚工作人员居住的宿舍一起，位于岛屿之上。

In 1936 the Sydney Harbour Trust was replaced by the New South Wales Maritime Services Board, but the island retained its role.

1936 年，悉尼港信托所被新南威尔士港湾局所取代，但是岛屿仍保留了自己的角色。

The Maritime Services Board finally relinquished control of the island in 1995, and Goat Island became a unit of the Sydney Harbour National Park. During the mid to late 1990s, the island was used as a film-set for the Australian television series Water Rats.

港湾局最终在 1995 年放弃了对岛屿的控制，山羊岛变成了悉尼港国家公园。在 20 世纪 90 年代中后期，岛屿成为澳大利亚电视连续剧《Water Rats》的影片背景。

10. Sydney Harbour Foreshore Authority　悉尼海港管理局

The Sydney Harbour Foreshore Authority is a statutory authority set up by the NSW government of Australia in order to maintain the Port Jackson (Sydney Harbour) foreshore area.

悉尼海港管理局是由澳大利亚新南威尔士州政府建立的法定机构，其目的是为了维护杰克逊港(悉尼港)的沿岸区域。

The Sydney Harbour Foreshore Authority also owns and maintains other land in Sydney, including the Rozelle Marshalling Yards and White Bay Power Station. Some of this land is not waterfront land, and it is quite a quirk of SHFA's history that it is the owner of this land.

悉尼海港管理局也负责和维护悉尼的其他地区，包括罗泽尔区铁路货运编组站和白湾发电站。一些土地并不靠近海岸，对这些土地的拥有是悉尼海港管理局历史中的奇谈。

The Authority is also place manager for a number of culturally significant sites in Sydney, including Luna Park Sydney, the Sydney Conservatorium of Music and the Circular Quay precinct. In previous years, land ownership included the suburbs of Pyrmont and Ultimo, but these have since been redeveloped and sold to the private sector. Proceeds from these land sales were returned to the NSW Treasury.

管理局也负责管理许多悉尼重要的文化基地，包括鲁纳游乐场、悉尼音乐学院和环形码头区域。在前些年，所掌管的土地还包括皮尔蒙特和欧缇莫郊区，但是这些土地已经被重新开发和出售给了私人。这些土地出售的收益又交回了新南威尔士州财政。

The Authority is administered by a seven-member Board, which reports to the NSW Minister for Planning.

由 7 人组成的委员会负责管理局，并向新南威尔士规划部长报告。

Vacabulary

1. gateway　*n.* ①入口；门口；通道：a gateway to success 通往成功之路的大门　②途径；方法：Hard work is the gateway to success. 辛勤工作是通往成功之路。

［近义词］door, entry, opening, portal　*n.* 入口；门口；通道

2. depot　*n.* ①仓库；保管处；库房；补给站：depot ship（随舰队同行的）补给修理船　②［美］火车站；公共汽车站；航空站　③［英］团司令部；新兵训练站；俘虏收容所　*vt.* 把……放在窖内，窖藏　*adj.* ［生理］长效的；起长期作用的：depot penicillin 常效青霉素

［近义词］garage, storehouse, warehouse　*n.* 仓库、库房

［辨析］**depot 仓库、库房**：指堆积货物的场所，尤指储存军用物资的场所。如军械库、补给站等。

The enemy gunfire hit the depot yesterday. 昨天，敌军的炮火击中了军需仓库。

garage 汽车间：指停放或修理汽车的场所。

He had a garage near the railroad station. 他在靠近火车站的地方有一所汽车修理间。

storehouse 仓库、货栈：普通的用词。

This factory has many storehouses for its products. 这家工厂有许多货栈。

warehouse 仓库：指货主储存着向零售商分发货物的仓库。

A lot of goods were stored in the warehouse for wholesale. 仓库中储存了许多供批发的货物。

3. parkland *n.* ①公园用地 ②温带之草木区 *n.* ［生物］稀树草原 *adv.* 公用场地

4. robust *adj.* ①强壮的；健壮的：His robust strength was a counterpoise to the disease. 他身体强壮抵住了这疾病。②粗野的，不文雅的（玩笑）：a robust tale 粗俗的故事 ③（运动等）费力的：robust work 强体力劳动 ④直爽的；坚定的；健全的：a robust young man 一个精力充沛的年轻人 ⑤坚固的，耐用的

［近义词］energetic, vigorous, strong *adj.* 健壮的、刚健的

［辨析］**robust 健壮的、刚健的**：指肌肉发达、身体健康有力的。

Sports make children robust. 运动使孩子们身体强壮。

energetic 精力充沛的：指需要很大的精力去奋力完成。

He is an energetic manager. 他是一位精力充沛的经理。

vigorous 健壮的：指体力健壮或精力旺盛。

The old man is still vigorous and lively. 那老人依然健壮活泼。

strong 强壮的：普通的用词。

He is a strong as an ox. 他壮得像头牛。

5. consign *vt.* ①委托，交付；移交：consign a task to sb. 把一项任务交付给某人 ②寄售；寄存，存（款）：consign a letter to the post 付邮 ③在银行存款 ④用作，当作(to)：be consigned to misery 陷入可悲境地

［近义词］commit, entrust, convey, deliver, hand over, send, transfer *v.* 委托

［辨析］**consign 委托**：正式的用词，指正式委托某人管理或控制某物。

He consigned his share of the bonds to his sister. 他把他的那份债券委托他妹妹处理。

commit 委托：指将某物交付于某人，请其照顾保管。

The court committed the financial affairs of the orphan to a guardian. 法院将有关那孤儿钱财方面的事务交付给一位监护人管理。

entrust 委托：强调对受托人有信心。

I entrusted my door key to my neighbor. 我把我的房门钥匙交给我的邻居。

Sentence

Ballast Point and Former BP Site Public Parkland both have a similar starting point. They are on petroleum based industrial sites that have, for both environmental and economic reasons, been decommissioned from Sydney's harbour foreshore and relocated to areas with an industrial base.

巴拉斯特角公园和 BP 原址公园都有着类似的开始点。它们均是由于环境与经济因素，从石油工业的场址发展而来，悉尼港口上的石油工业已迁移到其他工业基地。

In the late nineteen hundreds, both sites were decommissioned in what originally was seen as sites for residential development. Due to their unique location, a strong public voice demanded that the sites would be returned to the people of Sydney as harbour parklands.

19 世纪末期，两处场地曾被政府规划为住宅区用地，然而最终由于它们独特的地理位置和群众的强烈呼吁将这两处场地规划成悉尼港口对所有市民开放的公共空间。

Located on Waverton Peninsula, the site is the first of a series of waterfront areas in North Sydney to be transformed from industrial depots into public parklands. The new 2. 5-hectare harbourside park is a result of the New South Wales Government's decision in 1997, to convert Waverton's three waterfront industrial sites for public use and reject their sale for residential development.

该项目位于威弗敦半岛，是悉尼北部地区第一个从工业场地改建为公园的项目。早在 1997 年，新南威尔士政府便已决定将威弗敦半岛的三处滨水工业区作为公共用地而不是出售用于住宅发展项目，这个面积约为 25000 平方米的海岸公园终于改建完成。

As a result of the site being used for oil storage for over 60 years, it had become contaminated and in order to create the park, a variety of environmentally sustainable design initiatives were employed.

由于场地作为工业基地的时间已超过 60 年，或多或少都会受到污染，因此在设计公园的过程中，使用了各种各样的环境可持续设计方法。

Ballast Point experienced numerous changes since the arrival of Europeans to Sydney in 1788. The site gained its name during the industrial development of the area, a reference to its role quarrying sandstone to be used as ballast for ships returning to Europe.

自从 1788 年欧洲来到澳大利亚以来，巴拉斯特角便不断经历着历史变革，这一地区最初以采矿业为主，人们将砂岩制成压舱物，以便船只能够顺利返回欧洲，巴拉斯特角的名字也就由此而来。

It was appropriate that sustainability initiatives were one of the underpinning key design considerations to be explored, in light of the site's history as an example of European culture's evolving relationship with the Australian landscape.

巴拉斯特角独特的历史文化使其成为彰显欧洲文化对澳大利亚景观设计影响的范例，设计师也因此将环境的可持续发展作为该项目最主要的设计原则之一。

The focus, therefore, was to use recycled materials and innovative environmental design initiatives wherever possible. Materials such as recycled rubble, aggregate and timber are all to be sourced from nearby rubbish tips and salvage sites and used throughout the park.

因此，重点是在任何可能的地方使用回收材料和创新的环境设计方法。比如循环使用的废石、骨料和木材等材料都是来源于附近的垃圾倾倒处和废物堆积场，并全部用于整个公园。

Added to this, the park will also use interpretive signage to tell the story of the site history, with the aim to create a park that has its own language and voice; a park that can speak for itself and reveal its layers and meaning.

设计师还采用了一些有着特殊意义的标记向人们讲述其历史的变迁，使之成为一座可

以讲述自己故事的公园。

In addition to attempting to interpret the park's past, the designer has recognized that their park design will add a new layer to the site's already rich tapestry.

除了尝试阐述公园的历史，设计师还认识到他们的公园设计将为基地早已丰富的历史增加一个新的阶段。

Translation

第 19 课　悉尼后现代工业场址的复兴

巴拉斯特角公园和 BP 原址公园都有着类似的开始点。它们均是由于环境与经济因素，从石油工业的场址发展而来，悉尼港口上的石油工业已迁移到其他工业基地。两处公园隔海相望，分别位于悉尼港南北两岸的两个岬角之上，形成了悉尼港的大门。

19 世纪末，两处场地曾被政府规划为住宅用地，然而最终由于它们独特的地理位置和群众的强烈呼吁将这两处场地规划成悉尼港口对所有市民开放的公共空间。

最终的设计都坚持环境原则，以修复被污染的场址。设计重点是在暴风雨进入港口之前消除影响，以及简易且坚固的材料的运用。两处公园的设计不仅与周围的自然环境相呼应，还使人们回忆起那里原有的历史特征和文化底蕴。

BP 原址公园

该项目位于威弗敦半岛，是悉尼北部地区第一个从工业场地改建为公园的项目。早在 1997 年，新南威尔士政府便已决定将威弗敦半岛的三处滨水工业区作为公共用地而不是出售用于住宅发展项目，这个面积约为 25000 平方米的海岸公园终于改建完成。

设计师通过保留简单而坚固的建筑物来对基地以前的用途加以认识。为了保留这些地区的工业遗迹及海港特征，设计师设计了一系列的开放空间、湿地以及围绕半圆形砂岩峭壁的观景台。砂岩峭壁的位置曾经是存放储油罐的场所，而今设计师用混凝土及技术制成的阶梯环绕峭壁，并将能够吸引野生生物的水景设置在峭壁之下。

由于场地作为工业基地的时间已超过 60 年，或多或少都会受到污染，因此在设计公园的过程中使用了各种各样的环境可持续设计方法。不只是单纯地将现有的土壤挖出和再填埋，设计混合一些有机物质并在基地中再利用。从附近的宝石头自然保护区一带收集了大量植物作为场地的主要植被，用以恢复该地区的自然植物群落。

设计师还设计了一个综合性的降水采集及过滤系统，该系统能将场地的雨水引入生长有水生植物的滞留池中，使其经过过滤与净化后再流入海港。这种雨水滞留系统也为蛙类、野鸭及其他鸟类创造了新的栖息地。

在建筑材料的选择方面，设计师考虑到公园原址的工业特性，主要采用了混凝土和电镀钢材，这也决定了公园低成本、低损害和低维护的特性。

悉尼海港在不断的发展变化中，那里的后工业土地试图突破其单纯的商业用途，寻求更大的发展空间。BP 原址公园正是悉尼海港突破现状的范例，它不仅将这一海岸区域向悉尼市民开放，也保留了该地区原有的历史特征和文化底蕴。

巴拉斯特角公园

悉尼港南岸的巴拉斯特角位于白桦果园半岛的尖端，距离悉尼港大桥约 2 公里，西面

则是帕拉马塔河，在巴拉斯特角与悉尼商业中心区之间则坐落着悉尼港的第二大海岛——山羊岛。

自从 1788 年欧洲人来到澳大利亚以来，巴拉斯特角便不断经历着历史变革。这一地区最初以采矿业为主，人们将砂岩制成压舱物，以便船只能够顺利返回欧洲，巴拉斯特角的名字也就由此而来。1852 年，托马斯·帕金斯买下了这片区域，并在半岛上建造了一座海滨别墅。1920 年，这一地区又被加德士买下，从此巴拉斯特角成为悉尼主要的燃油配送地。到了 1936 年，由于该地区业务重点的转变，这里开始生产并存储润滑油。直到 20 世纪中期，加德士都在掌管着巴拉斯特角的经济运作。2002 年，悉尼海港管理局收回了该地区的所有权，力求将其改建成为可以向悉尼市民开放的公园。

设计师主要遵循三种设计理念：

（1）创新环境设计

巴拉斯特角独特的历史文化使其成为彰显欧洲文化对澳大利亚景观设计影响的范例，设计师也因此将环境的可持续发展作为该项目最主要的设计原则之一。最初，设计师将这里简单地列为一项亟待大规模改建的项目，但最终决定将这一地区改建为可以向悉尼的广大市民开放的公园，突显人们对澳大利亚景观价值演变的感受。作为对基地发展的回应，关键的是这个新公园应该强烈体现当代澳大利亚景观的未来。

因此，重点是在任何可能的地方使用回收材料和创新的环境设计方法。比如循环使用的废石、骨料和木材等材料都是来源于附近的垃圾倾倒处和废物堆积场，并全部用于整个公园。公园的墙体使用可循环利用的碎石，公园内小路的建筑材料为可循环利用的骨料制成的混凝土，赋予公园一种清晰、独特的整体美感。通过这种方法重新使用了许多会被填埋到垃圾场的材料。设计师为了柔化大规模使用的混凝土结构，使用废旧木材制成了长椅、桥梁以及观景台。还在原场址"101 油罐"的位置上设置了风力涡轮机以制造能源。伴随着高品质的设计和细节，这些创新将带来一处未来的公园，展现可持续性和设计的公园，非常美观和具有重要意义的场所。

（2）诠释和整合基地的各阶段历史

公园的设计力求将不同阶段的历史完美地融合。设计师在通向海滨别墅的混凝土小路上增加了足迹的设计，并在一座历史展示墙上设置了一些古器物。在加德士时代，润滑油环形场地前身的"101 油罐"曾是巴拉斯特角半岛的标志性建筑，如今成为一处展现该地区历史的景观。设计师还采用了一些有着特殊意义的标记向人们讲述其历史的变迁，使之成为一座可以讲述自己故事的公园。

（3）将公园作为该地区的新历史阶段

除了尝试阐述公园的历史，设计师还认识到他们的公园设计将为基地早已丰富的历史增加一个新的阶段。以这种理念，有意识地将过去的历史阶段和新历史阶段融合起来，为巴拉斯特角的故事增加一篇新的章节。这一新阶段将反映不断改变的社会和环境期望。设计师也重视强烈的环境创新性，以及表达保护和展示基地而不是研究基地的新方法。

Lesson 20　Enjoy the Fresh Air in the Limited Space——
Garden in the Slice up House

Historically the"terrace house"or"link house"were introduced during the Dutch coloni-al era in Malaysia, where taxes were based on the width of houses. In respond to this law, the locals started to create long narrow strips of living quarters to avoid paying high taxes. Thus, this created a'link house'typology in urban Malaysia. These old living quar-ters are known as shop houses locally. It is normally punctuated by internal courtyards to allow light and ventilation into the deep plan of the spaces.

In modern times, these types of long and narrow plans are considered the most efficient method of plan-ning residential estates for developers. As geometrical-ly the narrow frontage would required less length of roads to service it, thus saving valuable land. In fact, we could say that majority of urban Malaysia is filled with these link houses and majority of the urban population lives in one.

They are narrow frontage buildings that are squeeze together next to each other in a block of ap-proximately 12～14 units, with windows located only in the front and at the back. These modern link houses do not have the luxury of internal courtyard as their early predecessors do. The only garden spaces are in the front garden (where the inhabitants would proba-bly park their cars in half of it or the whole front gar-den), and at the back yard (some owners would proba-bly have their kitchen extended right to the back, while others would probably utilize it as their service yard).

Therefore if we analyze the planning of the spaces we will find that most of the living spaces and bedro-oms in these link houses do not actually have a garden or sufficient natural light and ventilation. And imagine this is occurring in majority of urban Malaysia's link houses.

In the"slice up house", we were approached by our clients with a 25ft×82ft intermediate link house sand-

Garden in the Slice up House

wiched by other link houses in a row. This house inciden-
tally fronts a major traffic artery and this resulted major
noise pollution to the front of this residential property.
The original building footprint was 25ft wide and 42ft
long. Our clients brief was to have a 3 bedroom house plus
a study.

Thus in this project we decided to challenge the typol-
ogy of the link house in Malaysia with its insufficient light
and ventilation and the lack of a proper garden.

What we have done is to demolish a 7 feet width of the
25×80 foot link house from the line of the shared neigh-
boring wall. A 7 feet wide strip of open to sky garden is
then introduced into this demolished part the link house.
This newly created small pocket garden threw an abun-
dance of daylight and ventilation into the normally stuffy
and dark link house. The bedrooms and all living spaces
now front this garden.

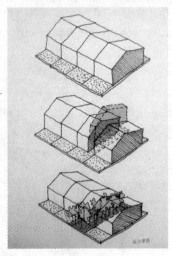

At front of house, a sound barrier wall built out of
standardized components road kerbs was constructed to act
as a sound barrier for the noise pollution from the front.
Climbers were installed and the intention was to have the
climbers creep and fully camouflage this wall. Thus all
bedrooms will now orientates inwards to the garden——
cutting off noise and providing visual privacy, this is where
the residents will be able to truly enjoy their garden.

the Slice up House Design

The external works on the front garden were laid with natural clay brick and lined all
the way up to the neighboring fence. At the entry gate, a small portal were created to allow
thunbergias (a type of local flowering vines) to climb and eventually form a entrance mark-
er. Brick chippings were also used along at the line of trees directing the entry parth-
way, creating a natural red carpet lining the front garden. At the entrance into the
house, one is surprised by the existence of an internal garden in an intermediate link house.
The sight is firstly greeted by a clump of forest trees with day light filtering through from
the above. These pelung trees were planted in a clump as they were naturally found in the
forest.

A series of cengal trees (highly valued tropical hardwood timber) were planted along
the internal garden.

The existing neighboring wall that divides the neighbor and this garden was to be
overgrown with climbers of ficus and ivy.

At the end of the linear garden a spiral stairs became a visual object of the garden and

rises up to access the bedrooms above and the roof terrace.

The creation of this garden challenged the existing unfavorable layout of the link houses. It worked within the constraints of the lot sizes, while fulfilling the owner's spatial requirements. This demonstrates that houses for the middle income need not compromise on their gardens and quality of living. We hope this project could demonstrate to the housing developers that by thinking out of the box, the cookie cutter layout of the link houses can be very much improved.

Though the project was not primarily a landscape project, however it was a project that showed how a garden can make a difference to link house living. Gardens should be created for the enjoyment of all typology of houses and should not be a luxury where only the rich can possess. We believe in gardens as a major component of living and we will create garden spaces where opportunity arises no matter how small they are in our works.

Notes

1. Malaysia　马来西亚

Malaysia is a federation that consists of thirteen states and three federal territories in Southeast Asia with a total landmass of 329847 square kilometres (127355 sq mi). The

capital city is Kuala Lumpur, while Putrajaya is the seat of the federal government. The population stands at over 25 million. The country is separated into two regions——Peninsular Malaysia and Malaysian Borneo——by the South China Sea. Malaysia borders Thailand, Indonesia, Singapore, Brunei and the Philippines. The country is located near the equator and experiences a tropical climate. Malaysia's head of state is the Yang di-Pertuan Agong (conventionally referred to as 'the King' or 'the Agong') and the government is headed by a Prime Minister. The government is closely modeled after the Westminster Parliamentary System.

马来西亚是由位于东南亚的 13 个州和 3 个联邦直辖区组成的联邦体制国家，国土面积 329847 平方公里。首都是吉隆坡，而联邦政府所在地却是布城。马来西亚的人口超过 2500 万。马来西亚共分为两大部分——马来半岛和马来西亚婆罗洲——中间以南中国海相隔。马来西亚和泰国、印度尼西亚、新加坡、文莱和菲律宾接壤。由于马来西亚的地理位置接近赤道，所以属于热带气候。马来西亚的最高领导者是国家元首（传统上被称为"国王"或"the Agong"），而政府受首相的领导。政治体制是沿袭自英国的威斯敏斯特国会体制。

Fig. 20-1　Kota Kinabalu, capital of East Malaysian state of Sabah is located 1600km (1000miles) east across the Beach scenery of Pulau Tioman

The two distinct parts of Malaysia, share a largely similar landscape in that both West and East Malaysia feature coastal plains rising to often densely forested hills and mountains, the highest of which is Mount Kinabalu at 4095. 2 metres (13435. 7ft) on the island of Borneo. The local climate is equatorial and characterised by the annual southwest (April to October) and northeast (October to February) monsoons.

马来西亚主要由东马来西亚及西马来西亚组成，两个独立的地区有非常相似的景观——沿海地区都是平原，平原背后则是森林密集的山丘，最高山峰是位于婆罗洲、海拔4095.2m 的京那巴鲁山。当地气候属赤道多雨气候，每年四月至十月吹西南季候风，十月至二月间吹东北季候风。

The Strait of Malacca, lying between Sumatra and peninsular Malaysia, is arguably the most important shipping lane in the world.

马六甲海峡，位于苏门答腊和马来西亚半岛之间，有人认为是全世界最重要的轮船航线。

Putrajaya is the newly created administrative capital for the federal government of Malaysia, aimed in part to ease growing congestion within Malaysia's capital city, Kuala Lumpur. Kuala Lumpur remains the seat of parliament, as well as the commercial and financial capital of the country. Other major cities include George Town, Ipoh, Johor Bahru, Kuching, Kota Kinaba-

Fig. 20-2　Kuala Lumpur

lu,Miri,Alor Star,Malacca Town,and Petaling Jaya.

布城是新建立的马来西亚联邦政府机构中心，目的主要是为了舒缓马来西亚最大城市吉隆坡越来越严重的交通阻塞。吉隆坡依然是国会所在地及国家商业及经贸中心。其他主要城市包括乔治城、怡保、新山、古晋、哥打基纳巴卢、美里、亚罗士打、马六甲和必打灵查亚。

Malaysia is a multi-ethnic,multi-cultural and multilingual society. The population as of February 2007 is 26.6 million consisting of 62% Malays,24% Chinese,8% Indians,with other minorities and indigenous peoples.

马来西亚是多民族、多文化和多语言的社会。2007 年统计的 2660 万人口中，62% 是马来人，24% 是华裔，8% 是印裔，还有其他少数民族和土著。

Fig. 20-3　Hindus in Kuala Lumpur

Malaysian traditional music is heavily influenced by Chinese and Islamic forms. The music is based largely around the gendang (drum),but includes other percussion instruments (some made of shells); the rebab,a bowed string instrument; the serunai,a double-reed oboe-like instrument; flutes,and trumpets. The country has a strong tradition of dance and dance dramas,some of Thai,Indian and Portuguese origin.

马来西亚传统音乐在很大程度上受中国和伊斯兰音乐的影响。音乐大部分是基于 gendang(鼓)，但是包括其他打击乐器(一些是由贝壳制成)；rebab 是一种弯曲如弓弦的乐器；serunai 是一种类似于双簧管的双簧乐器；笛子和喇叭。马来西亚有悠久的舞蹈和舞蹈剧的传统，其中一些源自泰国、印度和葡萄牙。

2. Ficus　榕树

Ficus is a genus of about 850 species of woody trees,shrubs,vines,epiphytes,and hemiepiphyte in the family Moraceae. Collectively known as fig trees or figs,they are native throughout the tropics with a few species extending into the semi-warm temperate zone. The so-called Common Fig (F. carica) is a temperate species from the Middle East and eastern Europe (mostly Ukraine),which has been widely cultivated from ancient times for its fruit,also referred to as figs. The fruit of most other species are also edible. However,they are extremely important food resources for wildlife. Figs are also of paramount cultural importance throughout the tropics,both as objects of worship and for their many practical uses.

在桑科中，榕树属有大约 850 种树木、灌木、藤本、附生植物和半附生植物。人们共知的如无花果树，

Fig. 20-4　fig trees

它们从热带一直延伸到较温暖的温带区域。所谓的无花果树是源自中东和欧洲东部（大多数是乌克兰）的温带物种，从古时代就因为其果实而被广泛种植，也被称为 figs。绝大多数其他榕树物种的果实也可以食用。它们是野生动物的重要食物来源。无花果树也在整个热带具有非常重要的文化意义，既是礼拜的对象，也有许多实际用途。

Ficus occupy a wide variety of ecological niches. Take, for example, the Common Fig, a small temperate deciduous tree whose fingered fig leaf is well-known in art and iconography; or the Weeping Fig (F. benjamina) a hemi-epiphyte with thin tough leaves on pendulous stalks adapted to its rain forest habitat; or the rough-leaved sandpaper figs from Australia; or the Creeping Fig (F. pumila), a vine whose small, hard leaves form a dense carpet of foliage over rocks or garden walls. In the tropics, it is quite common to find that Ficus is the most species-rich plant genus in a particular forest. In Asia as many as 70 or more species can co-exist.

榕树占据了多种多样的生态地位。例如无花果树——一种小型温带落叶树木，指状的无花果叶在艺术和插图艺术中非常出名；或者垂叶榕——一种半附生植物，下垂枝干上的叶子薄而坚韧，以适应其热带雨林的栖息地；或者澳大利亚枝叶稀疏的锡叶榕；或者薜荔——一种藤本植物，其小而硬的叶子形成了浓密的树叶地毯，覆盖在岩石或花园墙壁之上。在热带，很容易发现在某个森林中榕树是物种最丰富的植物种类。在亚洲有超过 70 种以上的榕树可以共同生存。

Fig. 20-5 A Ficus carica

Fig. 20-6 Leaves of the Sacred Fig (*F. religiosa*)

Ficus are keystone species in many rainforest ecosystems. Their fruit are a key resource for some frugivores including fruit bats, capuchin monkeys, langurs and mangabeys. They are even more important for some birds. Asian barbets, pigeons, hornbills, fig-parrots and bulbuls are examples of which may almost entirely subsist on figs. Many Lepidoptera caterpillars feed on fig leaves. The Citrus long-horned beetle (Anoplophora chinensis), for example, has larvae which feed on wood, including that of fig trees.

榕树是许多雨林生态系统中的关键物种。它们的果实是许多食果动物的重要食物来源，包括狐蝠、僧帽猴、白头叶猴和乌白眉猴。它们对于一些鸟类甚至更为重要。亚洲巨嘴鸟、鸽子、犀鸟、无花果鹦鹉和鹎科都是几乎完全依赖无花果树生存的范例，许多鳞翅目幼虫，都以无花果树叶为食。例如柑橘天牛的幼虫就以树木为食，其中就包括榕树。

Ficus have figured prominently in some human cultures. There is evidence that ficus, specifically the Common Fig (F. carica) and Sycamore Fig (F. sycomorus), were among the first plant species that were deliberately bred for agriculture in the Middle East, start-ing more than 11000 years ago.

榕树在某些人类文化中占据了非常重要的位置。有证据显示，榕树，特别是无花果树和西克莫无花果树，是中东地区农业首批栽种的植物物种之一，从 11000 年前就开始种植了。

Ficus altissima
Figs of a variegated *Ficus aspera*
Mistletoe Fig, *Ficus deltoidea*
Ficus erecta
Ficus ilcina
Ficus luted
Ficus mauritiana
Ficus pseudopalma
Ficus variegata in Mong Kok

Fig. 20-7　Selected species

3. Ivy　常春腾

Hedera (English name ivy) is a genus of 15 species of climbing or ground-creeping evergreen woody plants in the family Araliaceae, native to the Atlantic Islands, western, central and southern Europe, northwestern Africa and across central-southern Asia east to Japan. On suitable surfaces (trees and rock faces), they are able to climb to at least 25～30 metres above the basal ground level.

常春藤属(英文名称 Ivy)是包括 15 种攀爬或爬地常绿木本植物的种属，属于五加科，生长于大西洋岛屿、欧洲西部、中部和南部，非洲西北部和整个中南亚向东到达日本的地区。附着于适合的表面(树木和岩石面)，它们就能够攀爬到至少高出基础地面以上 25～30

米之处。

Ivies are very popular in cultivation within their native range, both for attracting wildlife, and for their evergreen foliage; many cultivars with variegated foliage and/or unusual leaf shape have been selected. They are particularly valuable for covering unsightly walls.

在常春藤的生长范围内，人们非常喜欢种这种植物，既可以用来吸引野生生物，也可以获得永远绿色的树叶来装饰；许多栽培品种有着富于变化的树叶和/或者不同寻常的叶子形体。它们对于覆盖不美观的墙体具有特殊的价值。

Fig. 20-8 Ivy

Ivies have however proved to be a serious invasive weed in the parts of North America where winters are not severe, and their cultivation there is now discouraged in many areas. Similar problems exist in Australia where the plant was originally cultivated in gardens. For example, in the coastal basins of California drought-tolerant Algerian ivy (H. algeriensis or H. canariensis) has been planted as a ground cover around buildings and highways, but it has become an invasive weed in coastal forests, and riparian areas.

Fig. 20-9 Ivy covering the exterior of an apartment near Kips Bay, Manhattan

然而在冬季不是很冷的北美，常春藤成为了一种非常严重的入侵杂草，在许多地区现在不鼓励种植。类似的问题在澳大利亚也存在。在澳大利亚，常春藤最初是种植在花园中的。例如，在加利福尼亚沿海的盆地中，耐旱的阿尔及利亚常春藤作为地面覆盖植物种植在建筑物和高速公路周边，但是它很快变成了沿海森林和岸边区域的入侵杂草。

Much has been argued as to whether or not an ivy climbing a tree will cause harm to it; the consensus in Europe is that they do not harm trees significantly, though they may compete for ground nutrients and water to a small extent, and trees with a heavy growth of ivy can be more liable to windthrow. Problems are greater in North America, where trees may be overwhelmed by the ivy to the extent they are killed; this could be because ivy in North America, being introduced, is without the natural pests and diseases that control its vigor in its native areas. A more serious problem is that ivy creates a vigor-

Fig. 20-10 Ivy berries in Ayrshire, Scotland

ous, dense, shade-tolerant evergreen groundcover that can spread over large areas and out-compete native vegetation.

许多人都在争论，是否一株常春藤爬上树木就会伤害这棵树。在欧洲人一致认为它们不会严重伤害树木，虽然可能在小范围内和树木争夺土地中的营养和水，长着巨大沉重的常春藤的树木可能更容易弯曲。在北美，问题更严重一些，那里的树木可能被常春藤压倒，以致树木因此而死亡；这可能是因为常春藤引入北美，那里的自然界没有害虫和疾病来控制它在自然环境中的生长。更为严重的问题是，常春藤产生了强壮、密集、耐阴的常绿地面覆盖物，可能覆盖过大的面积，并完全排挤掉原有的植物。

Similar concerns are expressed about damage to walls. It is generally considered that a soundly mortared wall is impenetrable to the climbing roots of ivy and will not be damaged, and is also protected from further weathering by the ivy keeping rain off the mortar. Walls with already loose mortar may however be badly damaged, as the ivy is able to root into the weak mortar and further break up the wall. Subsequent removal of the ivy can be difficult, and is likely to cause more damage than the ivy itself. If ivy is allowed to climb wooden structures, then the aerial roots are likely to enter into the wood grain causing the wood to split, allowing moisture and fungus to penetrate the wood and accelerating wet rot.

常春藤对墙体的破坏问题也引起人们类似的关注。一般认为，经过仔细抹灰的墙体是常春藤的攀爬根无法刺入的，就将不会受到破坏，也免受常春藤不断破坏掉灰泥的风化作用。然而灰泥早已松散的墙体可能遭受严重破坏，因为常春藤能够把根系植到松散的灰泥中，并进一步破坏墙体。随后想移走常春藤可能就困难了，可能引起比常春藤本身更严重的破坏。如果常春藤附在了木制建筑之上，那么空中的根系就可能进入到木材之中而引起木材裂开，从而使湿气和真菌渗入木材之中，从而加速木材的腐烂。

4. Spiral Stairs　旋转楼梯

Spiral stairs wind around a central pole. They typically have a handrail on the outer side only, and on the inner side just the central pole. A squared spiral stair assumes a square stairwell and expands the steps and railing to a square, resulting in unequal steps (larger where they extend into a corner of the square). A pure spiral assumes a circular stairwell and the steps and handrail are equal and positioned screw-symmetrically. A tight spiral stair with a central pole is very space efficient in the use of floor area. A user of these stairs must take care to not step too close to the central pole as it becomes more likely that one or more steps may be missed, especially when going down. One should always take care to continuously use the handrail so that additional support is available in the event that a step is missed. Using the handrail will also direct the user to the safer outer portion of the treads.

Fig. 20-11　A spiral staircase inside Cremona's Torrazzo

旋转楼梯围绕中轴旋转。它们一般只在外沿有栏杆，在内沿只是中轴。方形的旋转楼梯有一个方形的梯井并向外扩展踏步和栏杆，从而形成方形楼梯和不相等踏步（在方形角部的踏步较大）。圆形的旋转楼梯有圆形的梯井，踏步和扶手大小相等，位置螺旋对称。在地面区域使用紧密的、有中轴的旋转楼梯可以有效节省空间。这些楼梯的使用者必须小心，踏步太过于接近中轴就很可能错失一级或几级踏步，特别是在下楼梯的时候。一个人应该常常小心地连续使用扶手，就可以在踏错踏步时获得辅助的支持。使用扶手也可以指导使用者到达踏步更为安全的靠外部分。

Spiral stairs in medieval times were generally made of stone and typically wound in a clockwise direction (from the ascendor's point of view, in order to place at a disadvantage attacking swordsmen who were most often right-handed). This asymmetry forces the right-handed swordsman to degrade his mobility compared with the defender who is facing down the stairs. Extant 14th to 17th century examples of these stairways can be seen at Muchalls Castle, Crathes Castle and Myres Castle in Scotland. Exceptions to the rule exist, however, as may be seen in the Palazzo Contarini del Bovolo, which winds up anti-clockwise.

中世纪的旋转楼梯一般用石头制成，以顺时针方向旋转（从向上攀登的人的视点来看，为的是让习惯右手拿剑的人无法攻击）。这种不对称性使右手拿剑的人的灵活性要低于沿楼梯向下的防御者。在苏格兰的马赫尔斯城堡、克雷斯城堡和玛艾斯城堡都可以看到保留至今的 14～17 世纪的旋转楼梯。然而也有例外的情况，就如蜗牛府的旋转楼梯是逆时针的。

Recent developments in manufacturing and design have led to the introduction of kit form spiral stair. Steps and handrails can be bolted together to form a complete unit. These stairs can be made out of steel, timber, concrete or a combination of materials.

Fig. 20-12 The Tulip Stairs & lantern at the Queen's House, Greenwich

最近制造业和设计的发展带来了成套配件装配旋转楼梯的出现。踏步和扶手可以用螺栓固定在一起，形成一个完整的单元。这些楼梯可以由钢铁、木材、混凝土制成，或者几种材料相组合。

Helical or circular stairs do not have a central pole and there is a handrail on both sides. These have the advantage of a more uniform tread width when compared to the spiral staircase. Such stairs may also be built around an elliptical or oval planform. A double helix is possible, with two independent helical stairs in the same vertical space, allowing one person to ascend and another to descend, without ever meeting if they choose different helixes (there is one at Château de Chambord).

Fig. 20-13 Spiral stairway seen from below; Melk Abbey, Austria

螺旋或者圆形楼梯并没有中轴，两面都有扶手。

这些楼梯和旋转楼梯相比较，具有踏步宽度更为统一的优点。这些楼梯也可以围绕椭圆形或者卵形来建造。双螺旋线是可能的——在同一垂直空间中有两部相互独立的螺旋楼梯，一个人上楼的同时另一个人下楼，如果人们选择不同的螺旋楼梯就永远不会相遇（在法国香堡就有这样的双螺旋楼梯）。

Vacabulary

1. Slice　　*n.*　①薄片，切片，一片，一部分：a slice of bread 一片面包　②餐刀，（切薄片用的）菜刀，锅铲，火铲，刮子　③［建］泥板，泥刀　④［体］（高尔夫球）左［右］曲球，（乒乓球）削球，左旋球　*vt.*　①把……切成薄片：I sliced the bread. 我把面包切成片。②切下，切去，切开，分开（away,from,off）：slice off a piece of meat 切下一块肉　*vi.* 切

［近义词］cut,whittle,sever,pare,segment　*v.* 切成片

bit,cut,piece,scrap,strip,section,segment　*n.* 片，薄片

［辨析］**slice 片**：指薄而阔的一片。

Please cut me a slice of bread. 请给我切一薄片面包。

bit 小片、小块：指任何物体的一小片或一小块。

I have a bit of glass. 我有一小片玻璃。

cut 切片：指切开的片或块，尤指肉的切片。

I want a good cut of meat. 我要一片好肉。

piece 片：一般的用词，指分开的一部分，它常被认为本身就是完整的。

He ate a big piece of cake. 他吃了一大块饼。

scrap 碎片：指小而破碎的片，并常指无用的碎片或碎屑。

It is only a scrap of paper. 这不过是一片纸而已（指无用的纸）。

strip 细长片：指狭而长的片或条。

He tore the newspaper into strips. 他把报纸撕成一条一条的。

2. strip　　*n.*　①带，条，条板；带状地；狭长的一条：a strip of paper 纸条　②条幅式侦察照片；连环漫画　③支板，插座条　④［航］（＝air strip,landing strip）跑道，简易机场：a runway strip 跑道　⑤在市区或郊区两旁有商店、加油站、餐厅、酒吧密集的街道：Sunset Strip in Los Angeles 洛杉矶的日落大街　*vt.*　①剥去，脱去，揭掉，刮掉，摘掉，取去，使裸露：strip the bark off［from］a tree 剥去树皮　②剥夺，掠夺，抢去：strip a man of his honours 剥夺一个人的荣誉　③拆卸，完全除去　④从……中删除不必要的内容　⑤把……撕成带形，把……切成细条　*vi.* ①脱去衣服；表演脱衣舞；剥落：Bananas strip easily 香蕉容易剥皮　②抢劫

［近义词］remove,unwrap,uncover,skin,pull off,tear off,get rid of,take off　*v.* 剥，剥去

bit,cut,piece,scrap,slice,slip,band,stripe,long narrow piece　*n.* 窄条，长带

［辨析］**strip 细长片**：指狭而长的片或条。

He tore the newspaper into strips. 他把报纸撕成一条一条的。

bit 小片、小块：指任何物体的一小片或一小块。

I have a bit of glass. 我有一小片玻璃。

cut 切片：指切开的片或块，尤指肉的切片。

I want a good cut of meat. 我要一片好肉。

piece 片：一般的用词，指分开的一部分，它常被认为本身就是完整的。

He ate a big piece of cake. 他吃了一大块饼。

scrap 碎片：指小而破碎的片，并常指无用的碎片或碎屑。

It is only a scrap of paper. 这不过是一片纸而已（指无用的纸）。

slice 片：指薄而阔的一片。

Please cut me a slice of bread., 请给我切一薄片面包。

3. squeeze *vt.* ①挤压；握紧；夹紧；压榨（常与 out 连用）：Don't squeeze the kitten, you will hurt it. 不要紧捏那小猫，你会伤害它的。②挤，挤进；塞进：squeeze oneself into a crowded bus 挤入拥挤的公共汽车 ③压出，挤出；榨取（常与 out/of 连用）：squeeze the juice out of a lemon 榨出柠檬汁 ④使经济困难；引起财政困难 ⑤压榨，剥削，勒索，敲诈（from）：squeeze money out of [from] sb. 勒索某人的钱财 *vi.* ①榨，挤，压：The children squeezed together to make room for me to sit down. 孩子们挤在一起以便腾出空来让我坐下。②压榨 ③勉强通过［赢得］：squeeze through the crowd 挤过人群 *n.* ①挤压；紧捏：There's room for one more, but it'll be a squeeze. 这里还能容下一个人，但是会挤一点的。②挤出的微量：a squeeze of lemon 柠檬汁 ③拥挤；紧塞：We all got in, but it was a (tiger) squeeze. 我们都进去了，可是太拥挤了。④（因供应短缺、成本太高引起的）困窘，拮据：We can not borrow money during the present credit squeeze. 在银根紧的时候，我们借不出钱来。⑤密集的一群人：a squeeze of people 密集的一群人

［近义词］stuff, cram, crowd, pack, jam, thrust *v.* 挤，塞

compress, crush, extort, pinch, press *v.* 压榨

［辨析］**squeeze 紧握、紧挟**：指向对方或其他各个方面压紧。

Don't squeeze the kitten, you will hurt it. 不要使劲捏那小猫，这样会伤了它。

compress 紧压：指压紧、压缩以便置于较小的空间。

Wood blocks may compress a great deal under pressure. 木块受到压力时可以缩小很多。

crush 压破：指压碎或压伤。

Don't crush this box, it has flowers. 别把这个盒子压破了，里面装了花。

extort 强索、榨取：指强行向某人索取他不愿给的东西。

He extorted a promise from me. 他硬要我答应。

4. artery *n.* ①［解］命脉，动脉 ②干线，要道；中枢

［近义词］blood *n.* 动脉

artery, channe, canal, strait, main line, trunk line, main road *n.* 干线，要道

［辨析］**artery 干线，要道**：指在交通体系中的主要道路或河流。

The Yangtze River is one of the arteries of traffic in China. 扬子江是中国的交通要道之一。

channel 海峡：指连接两海的海峡，较 straits 宽广。

He crossed the English Channel. 他渡过英吉利海峡。

canal 运河：指开凿陆地以供船只航行的人工河流。

They made a canal through the two provinces. 他们在两省间开凿了一条运河。

strait 海峡：普通的用词，指连接两海的狭窄航道，常用复数形式。

The Dover Straits lies in the east of the English Channel. 杜佛海峡位于英吉利海峡的东部。

5. camouflage *n.* ①［军］伪装；伪装器材：Many animals have a natural camouflage which hides them from their enemies. 很多动物都有迷惑其敌人的天然伪装。②隐瞒，掩饰：under［behind］the camouflage of 在……的掩盖［伪装］下 ③幌子 *vt.* 使改头换面，伪装，掩饰，欺瞒：The military vehicles were camouflaged. 军车被伪装起来了。*vi.* 采取伪装手段；隐藏：We camouflaged in the bushes and no one saw us. 我们隐藏在灌木丛中没有被人发现。

［近义词］cloak，concealment，disguise，masquerade *v.* 掩护、伪装

［辨析］**camouflage 掩护、伪装**：指使人难以认出某物或其真实性质。

The white fur of the polar bear is a natural camouflage. 北极熊的白毛皮是天然的掩护。

cloak 掩饰、借口：主要用于比喻，指掩藏思想、目的等。

Some people use patriotism as a cloak for making money. 有些人打着爱国主义的幌子赚钱。

concealment 隐藏：普通的用词。

He had stayed in concealment until the danger passed. 他一直躲到危险完全过去为止。

disguise 伪装：指改变外表以欺骗或隐蔽其真实性。

He went among the enemy in disguise. 他化装混入敌人中。

6. greet *vt.* ①欢迎；致意，致敬；向……打招呼：greet sb. with a smile 含笑欢迎某人 ②被觉察到；映入眼帘，入耳：When we reached the top of the hill, a magnificent view of the sea greeted us. 当我们抵达山顶时，一片壮丽的海景映入眼帘。*vi.* ［苏］哭泣，悲伤

［辨析］**greet 问候、打招呼**：最单纯的用词。

She greeted him with a smile. 她微笑着欢迎他。

hail 招呼：指用欢迎的表情打招呼。

Cheerful voices hailed us as we entered the hall. 我们进入会堂时，欢呼声响了起来。

salute 致敬：正式的用词，常用来指军人的敬礼。

The military men saluted the national flag. 军人们向国旗敬礼。

Sentence

Historically the "terrace house" or "link house" were introduced during the Dutch colonial era in Malaysia, where taxes were based on the width of houses. In respond to this law, the locals started to create long narrow strips of living quarters to avoid paying high

taxes.

"连栋房屋"或"联排房屋"是在荷兰殖民时期被引进马来西亚的。为了应对当时按照房屋宽度来征税的法律，人们建造狭长的条形居住房屋以避免缴纳高额税款。

In modern times, these types of long and narrow plans are considered the most efficient method of planning residential estates for developers. As geometrically the narrow frontage would required less length of roads to service it, thus saving valuable land.

直到现代，开发商认为这种狭长的形式是最有效的住宅规划方式，从几何学的角度来看，这种狭窄的前立面需要更短的道路来为其服务，就可以节省珍贵的土地资源。

Therefore if we analyze the planning of the spaces we will find that most of the living spaces and bedrooms in these link houses do not actually have a garden or sufficient natural light and ventilation. And imagine this is occurring in majority of urban Malaysia's link houses.

如果仔细分析这些设计，将会发现这些联排房屋里的起居室和卧室都没有真正的花园，缺少充足的自然光照和通风，而这正是马来西亚大部分城市里联排房屋的现状。

Thus in this project we decided to challenge the typology of the link house in Malaysia with its insufficient light and ventilation and the lack of a proper garden.

于是在这个项目中我们决定挑战马来西亚联排住宅类型光线和通风不良，以及缺乏适合的花园这些问题。

What we have done is to demolish a 7 feet width of the (25×80) foot link house from the line of the shared neighboring wall.

我们将(25×80)英尺的联排住宅中相邻墙体的一侧拆除 7 英尺宽的一段。

The creation of this garden challenged the existing unfavorable layout of the link houses. It worked within the constraints of the lot sizes, while fulfilling the owner's spatial requirements.

花园的设计对于现有联排住宅不理想的布局方案是一种挑战，它能够在土地面积受到限制的同时，满足业主对空间的需求。

Though the project was not primarily a landscape project, however it was a project that showed how a garden can make a difference to link house living. Gardens should be created for the enjoyment of all typology of houses and should not be a luxury where only the rich can possess.

虽然项目并不完全是景观设计，然而它体现了花园对联排住宅居民生活质量的独特影响。花园应该在所有住宅类型中占有一席之地，不应只是一种奢侈品。

Translation

第 20 课 狭窄空间中的舒适体验——片层住宅中的花园设计

"连栋房屋"或"联排房屋"是在荷兰殖民时期被引进马来西亚的。为了应对当时按照房屋宽度来征税的法律，人们建造狭长的条形居住房屋以避免缴纳高额税款。于是，在马来西亚的城市里就形成了一种所谓"联排房屋"的建筑。这类旧式建筑在当地通常被作

为商铺使用，其内部设有庭院，便于采光和通风。

直到现代，开发商仍然认为这种狭长的形式是最有效的住宅规划方式。从几何学的角度来看，这种狭窄的前立面需要更短的道路来为其服务，可以节省宝贵的土地资源。事实上，马拉西亚的大部分城市都是这种"联排房屋"，城市的主要人口也都居住于此。

在约由 12～14 个住宅单元组成的街区中，这些房屋鳞次栉比，仅在房屋的前后设有窗户。现代的联排房屋并不像早期的内花园那样奢侈，仅有前花园（居住者可能用前花园的一半或者整个前花园来停车）和后花园（一部分人会把他们的厨房扩大至后花园，而还有一部分人会把它当待客庭院）。

如果仔细分析这些设计将会发现，这些联排房屋里的起居室和卧室都没有真正的花园，缺少充足的自然光照和通风，而这正是马来西亚大部分城市里联排房屋的现状。

在片层住宅中，我们受业主委托设计夹在联排住宅中间的一座占地 25 英尺×82 英尺的房屋。这座房屋的前部是主要的交通中枢，导致了对这座住宅前部的噪声污染。最初的住宅用地是 25 英尺宽，42 英尺长。我们的业主的要求是 3 间卧室加上 1 间书房。

于是在这个项目中我们决定挑战马来西亚联排住宅类型光线和通风不良，以及缺乏适合的花园这些问题。

将 25 英尺×80 英尺的联排住宅中相邻墙体的一侧拆除了 7 英尺宽的一段。再在联排住宅拆除的部分开辟出一条宽 7 英尺的条状露天花园。这新建的小型花园将充分的日照和通风引入通常会闷热和黑暗的联排住宅。卧室和所有的生活空间现在都朝向花园。

在标准化路缘外修建了一堵隔音墙，用以彻底阻挡来自街道的噪声与污染。并在墙上种植了攀援植物修饰墙体。因此所有的卧室都面对花园——隔离了噪声，并提供了视觉私密性，这是居住者能够真实欣赏花园的原因所在。

临街花园的地面由天然黏土砖铺设而成，与邻家的围墙相连。在入口处设计了一个小门，thunbergias（一种当地的开花藤本植物）在此攀爬并成为醒目的入口标志。将碎砖块沿着树阵铺设，可以指示入口道路，沿临街花园形成了一条自然的红地毯。在房屋的入口处，人们首先感到惊奇的是在联排房屋中间有一个内部花园。房屋的入口处树影婆娑，一丛树木首先映入眼帘。在花园中种植了一丛在大自然的森林中可以找到的槟榔树。

在内部花园里种植了一些龙脑木（很贵重的硬木）。

爬满了藤榕和常春藤的墙体将相邻房屋与这个花园分隔开。

在内部花园的末端，一个旋转楼梯成为了花园的视觉焦点，它盘旋而上直通上面的卧室和屋顶平台。

花园的设计对于现有联排住宅不理想的布局方案是一种挑战，它能够在土地面积受到限制的同时，满足业主对空间的需求。这个项目证明了中等收入人们的住宅要在花园和生活品质方面有所让步。我们希望这个项目可以向住宅发展商证明，盒子般、饼干切割机般平面布置的联排住宅可以进行极大的改善。

虽然项目并不完全是景观设计，然而它体现了花园对联排住宅居民生活质量的独特影响。花园应该在所有住宅类型中占有一席之地，不应只是一种奢侈品。我们相信花园是生活的重要组成部分，无论花园空间在我们的作品中有多小，我们都将创造花园。

Extensive Reading

Vintage Vienna's Imperial Flavor

Vienna is seeped in history and cultural heritage and you can lose yourself in the cafes, clubs, art museums and imperial places.

Vienna is as rich and varied its cakes. You can choose the medieval city, with its churches and narrow winding cobbled streets; Imperial Vienna a world of horse-drawn carriages, ornate baroque monuments and lavish red, white and gold recoco interiors. You may go in search of Haydn, Mozart, Beethoven, Schubert and Strauss. Perhaps you would prefer the artistic milieu of the turn of the century Secession movement, with its eclectic architecture and erotic paintings; or the post-war "Third Man" Vienna, with its stage set charm and down-at-heel cafes, places where spies like Harry Lime would meet their contacts.

As Vienna returns to the center of Europe as opposed (对立的) to being on the edge of what was briefly known as Western Europe, it is easier to see why it became such an important city and such a prize for passing conquerors and crusaders. The first church was built in the 4th century on the present site of the Peterskirche, but it is St. Stephen's Cathedral, with its Turkish-style multicolored roof, that is the very heart of the famous shopping streets of the Graben and the Karntnerstrasse. Found in the 12th century, the cathedral's Romanesque Western façade and Gothic spires contrast with, the ultra-modern curved forms of the Haas Haus, evidence of the continuing Viennese love of architecture and controversy.

The medieval part of Vienna is strictly for walkers. From the Cathedral, you can go shopping in the Graben or the Karntnerstrasse, wander through the courtyards of the Heiligen Convent and University area. Visit Mozart's house in Domgasse, where he lived from 1784 to 1787 and browse in art galleries and antique and book shops in the twisting backstreets, like Backerstrasse. Be sure to be in Hoher Market when the famous clock known as the Ankeruhr displays moving figures from Vienna's history as noon strikes. Then continue through the Jewish quarter until you reach the so called Bermuda triangle. During the day, it is quiet, its center piece the attractive ivy-covered Romanesque 11th century Ruprechtskirche and some Roman ruins, but at night, it comes alive with its bars and restaurants, cafes and nightclubs and discos.

To experience Imperial Vienna, there is no equal to staying at the five-star Imperial Hotel on the famous Ringstrasse, the great tree-lined boulevard that was created when the walls of the original fortified city were torn down in the last century. Occupying a former place, it's a luxury dream world. But then Vienna is still one of the few places on earth where ball gowns are routinely worn, throughout the winter season, to balls and the opera.

Imperial Vienna involves a tram ride on the Ringstrasse, a tour of the Hofburg Palace, a city within a city; and an afternoon at Schonbrunn, the summer palace, which Maria Theresa made her own, in which Maria Antoinette spent her childhood, Napoleon relaxed

between battles and Mazart played. A perfect day might involve a morning visit to one of the many museums, perhaps combined with the Spainsh Riding School, a tour of the old cobbled streets by horse and carriage, afternoon tea at Demel's café or the Sacher, a night at the opera, followed by a candlelit dinner at the Bristol. Expensive? Yes, but after all, this is a dream——who would want to be poor in Imperial Vienna?

古典维也纳皇家风格

维也纳到处都是历史和文化遗产，你会完全沉浸在咖啡馆、艺术博物馆和帝国皇宫之中。

维也纳就像那里的蛋糕一样丰富和多变。你可以把它当作古老的中世纪城市，有狭窄、弯弯曲曲、卵石铺砌的街道和教堂；帝国的维也纳到处都是马车、华丽的巴洛克建筑以及充斥着红色、白色和金色的洛可可室内。你可能去追寻海顿、贝多芬、舒伯特和施特劳斯的踪迹。也许你宁愿找寻世纪之交时分离派运动的艺术——它的折衷建筑和充满性爱主题的绘画；或者是战后的维也纳"第三人"（广播剧），他们的舞台是迷人和古老的咖啡馆，就像是 Harry Lime（第三人中的主人公）会见接头人的地方。

由于维也纳成为了欧洲的中心，同时位于我们所认为的西欧边缘，又是以前的征服者和十字军战士的必争之地（至高奖赏），于是很容易看出它为什么如此重要。第一座教堂是在 4 世纪修建的、有着土耳其风格多彩屋顶的史蒂芬教堂，现今这里成为了圣彼得教堂的基址所在。圣彼得教堂位于非常著名的城壕大街和卡特纳大街的交点（这两条商业街建于 12 世纪），教堂的罗马风西式立面和哥特式的尖顶与极具现代感的 Haas Haus 大楼的弯曲形态形成了对比，引起了维也纳建筑爱好者的注意和争论。

维也纳的中世纪街区对于步行参观者有非常严格的限制。从大教堂，你可以去城壕大街或者卡特纳大街购物，漫游在 Heiligen 修道院的庭院和大学区。参观莫扎特在多姆街的住所（他从 1784 年居住到 1787 年），在弯曲的后街浏览艺术画廊、古董店和书店。一定要在音乐钟敲响时来高市观看随着大钟敲击出现的小人。接着继续穿过犹太区到达被称为百慕大三角洲的地方。在白天，这里很安静，其中心是被常春藤覆盖的 11 世纪罗马风鲁普雷希特教堂和一些古罗马废墟。但是在晚上，它就会因为酒吧、餐馆、咖啡馆、夜总会和迪斯科而变得生动起来。

为了体验帝国维也纳，没有比呆在著名环城街的五星级帝国饭店更合适的了，在 20 世纪原有的城墙被拆除后，一排排大树形成了林荫大道。酒店占据了城墙原来的位置，它是豪华的梦想世界。但是维也纳仍是地球上少数在整个冬季穿着礼服去参加舞会和听歌剧的地方之一。

帝国的维也纳游览也包括乘坐环城街有轨电车，参观霍夫堡皇宫——城中之城；并在美泉宫——玛丽亚·特蕾西亚为其自己修建的夏宫——消磨一个下午，玛丽亚·安东尼在那里度过了她的童年时代，拿破仑在战争间歇到此休息放松，莫扎特曾在此演奏。一个完美的一天可能包括早上参观众多博物馆中的一个，也许还包括参观西班牙骑术学校，游览马车通行的古老街道，下午在德梅尔或者沙架咖啡馆喝下午茶，晚上吃完烛光晚餐后听一出歌剧。贵吗？是的，但是毕竟这是一次梦幻般的旅程——谁不想在帝国维也纳花光自己所有的钱？

London Art Galleries

You can see many art galleries when you travel around London. On the north side of Trafalgar Square, famous for its monument to Admiral Nelson ("Nelson's Column"), its fountains and its hordes of pigeons, there stands a long, low building in classic style. This is the National Gallery, which contains Britain's best-known collection of pictures. The collection was begun in 1824, with the purchase of thirty-eight, pictures that included Hogarth's satirical Marriage a la Mode's series, and Titians'Venus and Adonis'.

The National Gallery is rich in paintings by Italian masters such as Raphael, Correggio and Veronese, and it contains pictures representative of all European schools of art such as works by Rembrandt, Rubens, Van Dyck, Murillo, EI Greco, and 19th century French masters. Many visitors, are expecially attracted to Velasquez Rokeby Venus and Leonardo de Vinci's Virgin of the Rocks.

On sunny days, students and other young people are often to be seen having a sandwich lunch on the portico of the Gallery, over-looking Trafalgar Square. Admission to the Gallery is free, as is the case with other British national galleries and museums, which are maintained by money voted by Parliament. Bequests of picture have been made to the galleries, at times on a generous scale, by private individuals.

Just behind the National Galley stands the National portrait Galley, in which the visitor can see portraits of British monarchs celebrities such as Chaucer, Shakespeare, and Cromwell. Many of the pictures are by well-known artists.

The national Gallery of British Art, better known as the Tate Gallery, was given to the nation by a rich sugar merchant, Sit Henry Tate, who had a taste for the in arts. It over looks the Thames, not far from the Houses of Parliament. Tate also has a range of modern works, including some sculptures, by foreign artists. This, of all the London galleries is the Young People's gallery. It has been stated three-quarters of its visitors are under twenty-five.

The Wallace Collection at Hertford House was formed by Lord Hertford and his half-brother, Sir Richard Wallace, who inherited the collection, which was given to the nation in 1897 by Sir Richard's widow. There is here a very fine display of weapons and armour, of pottery, miniatures and sculpture. The first floor of the building contains an admirable assortment of Boucher's pictures, besides excellent examples of the work of Fragonard, to mention only two artists.

On a summer day, a visit to Kenwood House in Kenwood, on the northern side of Hampstead Heath, is well worthwhile, for here is a small collection of paintings, some by famous painters, that can be viewed in a relatively short time. Afterwards, one can go out into the charming grounds. One may sun oneself on the gruff of the spacious lawns, or stroll by the lily-pond and then enter the little wood that half surrounds it. Kenwood House is maintained not by the government but by the Greater London Council.

Translation

伦敦的艺术画廊

在游览伦敦的时候，你会看到许多艺术画廊。在以纳尔逊将军纪念碑（"纳尔逊纪功柱"）、喷泉和一群群白鸽闻名的特拉法加广场的北面，有一座长而低矮的古典风格建筑。这就是英国国家艺术画廊，这里收藏了英国最著名的画作。收藏开始于 1824 年，当时购买了 38 幅画作，其中包括霍加斯的讽刺画《结婚过后》系列和提香的《维纳斯和阿多尼斯》。

国家艺术画廊收藏了众多意大利画家的作品，如拉斐尔、柯列乔、威罗尼和所有欧州艺术画派的代表作品，如林布兰特、鲁本斯、凡戴克、牟立罗、爱·格列柯，以及 19 世纪法国画家的作品。许多参观者对《青春裸体维纳斯》和莱奥纳多·达芬奇的《岩间圣母》特别感兴趣。

阳光灿烂的天气里，在国家艺术画廊的门廊处常常可以看到学生和其他年轻人在吃三明治午餐和俯视特拉法加广场。进入画廊是免费的，其他受议会支持的英国国家画廊和博物馆也是如此。私人也常常将收藏遗赠给画廊，有时这些遗赠数量是惊人的。

在英国国家艺术画廊的后面就是国家肖像艺术画廊，在那里参观者可以欣赏英国君王和名人的肖像，比如乔叟（英国诗人）、莎士比亚和克伦威尔。许多肖像是由著名艺术家绘制的。

英国艺术画廊（更著名的名称是泰特美术馆），是由一位制糖商——亨利·泰特爵士——捐献给国家的，他对艺术有很高的品味。这座画廊俯视着泰晤士河，距离议会大厦并不遥远。泰特美术馆收藏有许多现代作品，包括一些外国艺术家创作的雕塑。在所有伦敦的画廊中，这座画廊是属于年轻人的画廊。三分之一参观者的年龄在 25 岁以下。

位于赫特福德馆的华莱士收藏博物馆是由赫特福德勋爵和他的内弟理查德·华莱士爵士创建的。华莱士爵士继承了这些收藏，1897 年由爵士的遗孀捐献给了国家。这里有保存得非常好的武器和盔甲、模型和雕塑的展示。建筑的第一层有许多布歇和法根勒的画作，只有这两位艺术家。

在夏日的一天参观位于肯伍德的肯伍德别墅（汉普特斯西斯公园北面）是非常好的选择。这里有少量的绘画收藏，其中一些是著名画家所作，可以在相对较短的时间内参观完毕。接着，人们可以走出别墅，进入迷人的室外景观之中。可以在宽阔的草坪上晒太阳，或者在百合花园中漫步，接着进入花园周围的小树林中。肯伍德别墅得到了政府和大伦敦市议会的资助。

Shanghai Returns to The Pinnacle of Fashion

Before the last war, Shanghai was known as the Paris of the East. The city was renowned for her film stars, gang-sters and, above all, fashion. Now, after decades of the Queen of the Pacific it wants her crown back.

Shanghai has woken from its slumber. Thanks to economic reforms, China's most populous city is flourishing again, the new shyscrapers gleaming in the sun and the constantly changing horizon reflect faith in the future. The new era has also resurrected the

most characteristic feature of the people of Shanghai: an unfailing business instinct that was stifled for decades by official repression. Every day, deals are negotiated and concluded in hotel lobby bars and the sumptuous nightclubs that are springing up all round. The guiding principle is"nothing is impossible".

The people of Shanghai have also been accused of smugness and vanity. They spend more money than any other Chinese group on clothes and beauty treatment. An evening stroll along the city's riverside boulevard, the bound, speaks for itself: China's most elegant women are still to be found in Shanghai. The people of the city freely admit their vanity, and indeed even have a dash of pride in their voices as they do so. "traditions oblige," the reply.

Behind the main performance area in the Shanghai Exhibition Center, the air is thick with powder and the wafting smells of perfumes. In front of mirrors, the cream of Chinese mannequins are feverishly preparing for the main event of the year, Shanghai's international fashion festival. The theme this time is evening dresses and wedding gowns.

The crowd grows quieter, spotlights care the edge of the catwalk. To the strains of the theme music from a popular movie of a few years ago, "Somewhere in Time", a string of Chinese beauties, each more dazzling than the other, step elegantly onto the catwalk in their evening dresses. Camera flashlights pop in a blitz of light. Alongside the foreign guests in the front row sit a group of stylishly dressed Chinese, New rich, film stars and other striking examples of Shanghai's"bold and beautiful".

Some of the top names European and American fashionare also present. Some have come in search of Chinese cooperation partners with a view to manufacturing in China market. The Hong Kong fashion designer who has choreographed the show is satisfied with what he sees: "In a few years'time they will be able to arrange fashion events as good as any in Paris or Milan,'he says.

The onward march of the fashion industry has undoubtedly been a stroke of fortune for local designers and manufactures. It has also introduced China to a phenomenon familiar to everyday in the West: supermodels. A culture once condemned as Western decadence has turned out to be goldmine for the Chinese fashion industry.

Schools of modeling are springing up like mushrooms in many parts of the country and beauty contests with the participants dressed in clothes from fashion shows are being arranged in bewildering numbers. Here, too, Shanghai is setting the trend, and beauties hopeful of achieving fame and fortune are flocking into the city. For many of them, adapting to the frenzied pace of city life and the whims of fortune in the fashion world is not easy.

"when I came to Shanghai a couple of years ago, I had no idea in store for me. Also the fact that the people of Shanghai have a quite different way of thinking from us Northerners makes life difficult. We have a very direct way of speaking, but here in Shanghai people hardly reveal what they are thinking,"says this year's Model Queen Ma Yan Li, 21.

Only a couple of years ago, the 179-centimeter physical training student was furiously

punching the ball on her university's volleyball team. The pretty girl from the province of Henan heeded some friends advice to go to Shanghai to try her luck in a beauty contest. It was one big Cinderella story from then on. Today you see her smiling face not only just as big a superstar as Claudia Schiffer and Naomi Campbell are in Paris.

Translation

上海重新回到了时尚潮流的尖端

第二次世界大战之前，上海被誉为东方巴黎。她以电影明星、匪徒闻名，尤其是时装。多年后的今天，太平洋的皇后想赢回她的王冠。

上海已经从熟睡中醒来。经济改革使这个中国人口最多的城市重新繁荣起来，新建的摩天大楼在阳光下闪闪发光，不断改变的天际线表达出上海人民对于未来的信念。新时代中上海人民的最大特点也重新复兴：多年来被政府压制的商业天性传统。每天在到处出现的豪华夜总会和酒店大堂中都在进行着商业谈判。主导原则是"没有什么是不可能的"。

上海人民也因其自大和虚荣受到责备。他们比其他地方的人在服装和美容上花费更多。夜间沿着河滨的林荫大道漫步，可以在上海找到最优雅的妇女。上海人民承认他们的虚荣，并且事实上甚至更以他们的语言和做法为傲，"历史传统造成的"，他们这样回应。

在上海展览中心的后台，空气中弥漫着火药味和阵阵香味。镜子前，一群群中国时装模特兴奋地为今年的大事——上海国际时装节作准备。这次时装节的主题是晚装和新娘礼服。

人们安静下来，聚光灯照亮了 T 台。紧张的音乐选自几年前一部非常流行影片的主题音乐——"时光某处"，一串串中国美女，每一个都更耀眼，优雅地穿着晚装在 T 台上走过。照相机的闪光灯闪如白昼。前排外国客人的身边是穿着时尚的中国人——新贵、电影明星和其他上海"勇气和美丽"的突出代表。

一些顶尖的欧洲和美国时尚界人士也参加了这次活动。其中一些是为了通过观察中国时装市场来寻找中国的合作伙伴。为展示会做编导的香港时装设计师对他所看到的一切非常满意："要不了多久以后他们就可以像巴黎和米兰一样举办时装秀。"

不断前进的时尚业毫无疑问地已经给当地设计师和制造商未来发展带来巨大冲击。它也给中国带来了西方非常熟悉的现象：超模。这一文化现象曾经被责备为西方社会的衰落，却成了中国时尚业的金矿。

模特学校像蘑菇一样在中国各个地方出现，参加者身穿时装秀服装的选美比赛多到数不清。这里——上海位于潮流前端，希望获得名利的美女们大量涌入其中。对于她们来说，适应这个城市生活的快速步调和时尚界对财富的追求，并不是那么容易。

"当我几年前来到上海，我的头脑中没有任何想法。事实上上海人的想法与我们北方人非常不同也使得生活变得非常困难。我们说活非常直接，但在上海人几乎从不表达自己的想法"，今年的模特选美皇后马艳丽(21 岁)说到。

仅仅在几年前，这位身高 179 公分的体育学生正在大学的排球队打球。这个来自河南的美丽女孩接受了一些朋友的建议，来到上海参加选美比赛，试试自己的运气。从此开始了一个灰姑娘的故事。今天她微笑的面孔已经像巴黎的克劳蒂亚·希佛和奥米-坎贝尔一样成为了超级明星。